"TO TREAD ON NEW GROUND"

"TO TREAD ON NEW GROUND"

Selected Hebrew Writings
of Hava Shapiro

Edited by Carole B. Balin and Wendy I. Zierler

Wayne State University Press
Detroit

18 17 16 15 14 5 4 3 2 1

Library of Congress Cataloging Number: 2014936562
ISBN 978-0-8143-3869-8 (paperback); ISBN 978-0-8143-3870-4 (e-book)

♾

Designed and Typeset by Bryce Schimanski
Composed in Gentium and Trade Gothic

CONTENTS

II. Diary, 1900–1941

III. Letters

IV. Reportage, Literary Criticism, and Essays

V. Essays about Hava Shapiro

ILLUSTRATIONS

PREFACE

The present volume is an anthology of the forgotten writings of Hava Shapiro (1878–1943), the most prolific female Hebraist of her day in the Diaspora. It is based on our edited collection of Shapiro's writings in the original, *Behikansi 'atah* (In My Entering Now: Selected Works of Hava Shapiro), but includes additional materials not found in that volume. After opening with a comprehensive introduction to both Shapiro's life trajectory in the context of turn-of-the-century Europe and a full-length literary commentary, we divide the rest of the volume by genre. The short introductory remarks that preface each genre section are meant to be read in conjunction with Shapiro's writings. Readers may wish to take a dip into each section as a self-contained unit or dive in for an extensive swim in the entire body of Shapiro's voluminous oeuvre.

This volume, while comprehensive, does not include the totality of Shapiro's published and unpublished writings. The bibliography in Appendix 8 contains her known work to date in Hebrew as well as in Yiddish and German.

Selection for inclusion in this volume was made primarily on the basis of historical and literary significance and importance to gender studies. We also considered the literary quality, narrative appeal, and gripping content of the writing and chose passages that encapsulate distinctive features of Shapiro's biography, refer to significant literary or historical figures, or demonstrate repeated patterns in subject matter (e.g., creative ambition, love for her mother and Brainin, longing for her son).

Wendy Zierler provided most of the English translations of Shapiro's writings. Other essays were translated by Deborah Greniman ("The Image of Woman in Our Literature," "The Woman Reader: Where Is She?," "Y. L. Peretz: The Man and the Writer," "Reuven Brainin: On His Intellectual Image," and "Memories of Frischmann's Life") and Saul Noam Zaritt ("Notes from Ukraine," "Letter from Prague," "Roaming the Lands," "'Habimah' in Prague," "An Exhibition of Israelite Artists in Prague," "The Curse of Language," and "PEN Congress in Prague"); and Jessica Kirzane and Sonia Beth Gollance translated "Elisheva the Poet" from German to English.

Biblical passages are based on the *New JPS Translation of the Jewish Bible*. Hebrew transliteration draws on the guidelines of the Library of Congress, except where words or names are ordinarily preserved otherwise.

ACKNOWLEDGMENTS

We began this project in 2004. Our six children—Shara, Nate, Yona, Eve, Amichai, and Joey—were still small. None had yet reached the age of mitzvot. And now, two of them will head to college come fall. We are grateful that we have been able to share milestones together, as well as to see this project come to fruition alongside our partners Daniel Feit and Michael Gertzman. Our intention is to honor Hava Shapiro's memory and also to show that creative, rigorous, intellectual work does not have to occur, as it did for her, in miserable isolation under the tutelage of mentors who doled out encouragement sparingly and rarely. Rather it can unfold under the aegis of a supportive educational institution, led by a remarkable president, who has shown abiding interest in our work, and in a spirit of feminist collaboration and friendship.

We thus express gratitude, first and foremost, to all of our colleagues at our homebase of HUC-JIR in New York, including especially David Ellenson and Michael Marmur, as well as Stanley Nash for his much-appreciated expertise. Additional thanks goes to College-Institute's librarians Yoram Bitton, who has transformed the intellectual culture of our community; Tina Weiss, who never says no; and Leonid Gontar; and to T.J. Williams for unstinting technical support. Our students, especially Nikki DeBlosi and Jodie Gordon, contributed literary insights, as did participants in the Leadership Institute and anonymous readers for *Nashim*; while Adam Lutz transposed pedestrian data into user-friendly tables and images for the appendix. Evie Rotstein graciously introduced us to Rhona S. Weinstein, a distant relative of Reuven Brainin, who in turn showered us with knowledge of her family.

We received as well assistance from the ever-ebullient Shannon Hodge of the Jewish Public Library, Montreal, and Dvora Stavi, Hila Zur, and Andy Kessler at Genazim Institute, Tel Aviv.

We are honored by grants awarded for this project by the Lucius L. Littauer Foundation, the Hadassah-Brandeis Institute, and the AJS Women's Caucus Cashmere Grant. Andrew Grant of HUC-JIR expertly guided us in securing such funds.

This volume of English translations of Shapiro's Hebrew writings followed naturally after Resling Press's publication of our *Behikansi 'atah* [In my entering now, Selected Works of Hava Shapiro] in 2008. A fortuitous concatenation of events led to that relationship.

Thanks to Yael Feldman of NYU for inviting Wendy to speak to her graduate seminar and to Ilana Szobel, who, as participant at that seminar, recognized the value of Shapiro's work and introduced us to Adi Sorek, editor of the Vashti series at Resling. A special shout-out to Zachary Baker, who offhandedly mentioned the name Hava Shapiro to Carole in the 1990s at the YIVO Institute for Jewish Research.

Our creative relationship with Wayne State University Press began with abundant support from Kathryn Peterson Wildfong and expanded to include generous help from Mimi Braverman, Kristin Harpster, Sarah Murphy, Emily Nowak, and Bryce Schimanski.

As she did for *Behikansi 'atah*, Rochelle Rubinstein crafted the gorgeous and meaningful image for the cover of this volume. Wowza.

Scholars near and far eagerly and generously shared their expertise with us, including Samantha Baskind, Tova Cohen, Diana Greene, Avner Holtzman, Hillel Kieval, Stanislav Kovalchuk, Iris Parush, Ephraim H. Prombaum, Michael Silber, and the members of the Ginor Seminar at JTS. Naomi Caruso and Rachel Yoktan contributed pioneering research on Shapiro; we are indebted to them for this as well as their willingness, many years later, to entertain questions about their findings. Nimble Hebrew translators Deborah Greniman and Saul Noam Zaritt worked alongside us with equal enthusiasm, as did Sonia Beth Gollance and Jessica Kirzane on German works, Anastassiya Andrianova on indecipherable Russian phrases, and Seth Goren on Czech documents. Katy Balcer's index enriched the contents of this volume with its painstaking attention to detail. The inimitable Kateřina Čapková of Charles University in Prague went far beyond the call of duty by not only responding to every query from American strangers like us but also securing documents from the National Czech Archives that proved indispensable to our work. Our gratitude to our indefatigable research assistants is equal to our regard for them as human beings: Jessica Kirzane, who cheerfully scoured Yiddish, Hebrew, and German newspapers for Shapiro's writings and quickly responded to endless requests at all hours, and Yael Shmilowitz, who assiduously deciphered and transcribed Shapiro's nearly illegible longhand. They share this project with us.

Finally, whether by fate or design, we would like to acknowledge the splendid and rare experience this has been of two women coming together to recover a third. In poring over Shapiro's handwritten as well as published writings, we were continually amazed by the power, prescience, and enduring relevance of her words. She has added immeasurably to our own lives, which have, along the way and to our good fortune, become intertwined on both professional and personal levels.

26 Adar II 5774/March 28, 2014
New York City

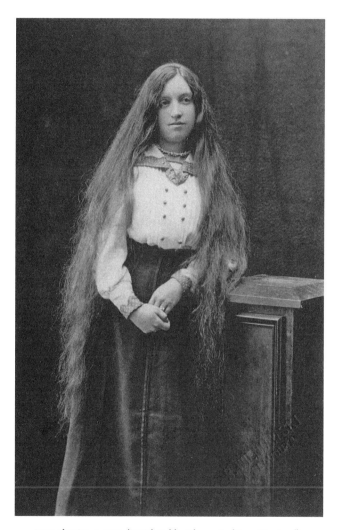

Hava Shapiro, c. 1894. (Jewish Public Library Archives, Montreal)

"Lasting, Literary Expression"
Shapiro's Life and Work

As she crept toward the age of 50, Hava Shapiro engaged in intellectual stocktaking: "Of all the things I regret—this is the greatest, truest regret, which pains me the most: Why is it that I did not give real and proper expression to all my feelings when they arose, a lasting literary expression?"[1] Such sentiment seems odd from a writer whose bibliography contains approximately 100 entries, ranging from fiction to literary criticism to reportage. In fact, Shapiro began her prolific writing career in 1901 and became a regular contributor to the Hebrew press over the course of nearly four decades.[2] She was one of the only women—and in many cases the only woman—to appear in the major Hebrew journals that were published in the Diaspora in her day. In addition, she turned out a collection of short stories and a monograph on the Czech president Tomas Masaryk (based on a face-to-face interview). Remarkably, she is also the *first* woman to have kept a diary in Hebrew (1900–1941). In it she mentions the literary luminaries of her day whom she knew well, such as Y. L. Peretz, Hayyim Nahman Bialik, and Nahum Sokolov. In addition, Naomi Caruso, a former archivist at the Jewish Public Library of Montreal discovered a bundle of some 200 letters written in Shapiro's Hebrew script and addressed to the editor and writer Reuven Brainin, her on-again, off-again lover and mentor.[3] This mountain of evidence belies Shapiro's regret. She left "a lasting, literary expression" after all.

Thirty-five years after the publication of her first Hebrew short story, Shapiro appealed three times to the American Hebrew journalist and editor Daniel Persky to publish an edition of her Hebrew writings in a single volume.[4] She described herself aptly to Persky as "one of the first women in our new literature" (*aḥat harishonot besifruteinu haḥadashah*) and presumably sought to solidify her legacy.[5]

In the present volume we go beyond Shapiro's appeal to Persky. We bring to light in English not only a large swath of Shapiro's published works but also her unpublished,

handwritten writings. After mastering Hebrew as a girl, Shapiro embarked on a literary journey that proved neither linear nor conventional. Her entrée to the world of Hebrew letters was highly unusual, given her sex, and she urged others "of her kind" to follow in her footsteps and "tread on new ground" along with her.[6] And so we do, inviting you to join us.

SETTING THE CONTEXT

Since the late 1980s, under the influence of feminist studies, literary historians have revealed the story of the emergence of modern Hebrew women's writing. As a result, new interest has arisen in the work of such Hebrew prose writers as Devorah Baron, Nehama Pukhachewsky, and Hemda Ben-Yehuda, all of whom immigrated to the Land of Israel. Conspicuously absent in this project of recovery have been the writings of Hava Shapiro, who remained in the Diaspora and died during the Holocaust.

Over the course of her career, Shapiro demonstrated a striking versatility as well as a persistent and nagging uncertainty about how best to use her literary talents. In contrast, her canonical female contemporary, Devorah Baron, concentrated her energies on writing fiction, especially after leaving her position as literary editor of *Hapo'el Hatsa'ir* in 1922.[7] Shapiro's work as a Zionist activist, journalist, and literary critic distracted her from writing fiction, resulting in a more eclectic oeuvre. In this volume we call attention to a female Hebraist trying her hand at multiple genres. For postmodern Hebrew readers especially who are cognizant of the ways in which writers (and people generally) construct and perform their various selves, Shapiro's multifarious writings provide a fascinating study in self-invention and reinvention. Add to that Shapiro's tendency to write and publish under various names, which reveals ever-shifting attitudes about her "self" as a woman and a writer as she attempted to make pioneering first steps onto the field of Hebrew literature.

That a woman was regularly writing good, readable Hebrew prose in the Diaspora in the early twentieth century is notable in and of itself. Equally significant, however, is the historical content of Shapiro's writing. As one would expect of an Eastern European whose life spanned 1878 to 1943, Shapiro bumped up against cataclysmic world events and thus chronicled publicly in the press and privately in her diary and letters the Russian Revolution and both World Wars as well as critical episodes in the Jews' past, including pogroms, mass migration, ruptures in traditional Jewish life, and the development of Zionism. Here, for instance, we read of Shapiro's uncles, who were imprisoned as the controversy between the Hasidim and the Mitnagdim raged;[8] there we learn of Shapiro's fear that her son might be drafted into the Red Army.[9] In addition, her pen flowed with firsthand accounts of Y. L. Peretz's famed Warsaw literary salon, which she frequented at the turn of the twentieth century, and Zionist Congresses

across Europe, where she interacted with the likes of Saul Tchernichowsky and Yosef Klausner, who penned a lovely tribute to Shapiro that called attention to her unique status in the 1930s as a Hebrew woman writer in the Diaspora, an essay we include in Part V. To her last known written word, a final diary entry scribbled hastily in 1941 in the face of chilling uncertainty, Shapiro captured an extraordinary historic era.[10]

Yet Shapiro did so from the perspective of one who transcended her own generation. That is, Shapiro was an anomaly: a female Hebraist in a literary universe not yet fully inhabited by what she called "the weaker sex" (*hamin heḥalash*).[11] In fact, Shapiro would use her writing tablet to express her experience as a female intellectual at odds with the patriarchal tradition in which she was reared. She did so in the wake of the *maskilim*'s efforts to transform Jewish society.[12] In their war on traditional Jewish life, practices involving women became part of their ammunition. This battle was influenced by the debate in Russia over the proper education and role of women in the family and society.[13] Specifically, the *maskilim* attacked conventional notions of Jewish marriage and family patterns in which matchmaking and early betrothal were de rigueur. Instead, they sought a relationship between husband and wife founded on romantic love and meaningful emotional and spiritual affinity. To further their cause, the *maskilim* engaged in a number of activities: composing literature critical of the inferior status ascribed to women by Jewish traditions,[14] promoting modern education for Jewish children of both sexes,[15] sprinkling their writings with independent and intellectually minded female characters,[16] and emboldening female authors in letters exuding praise.

Rarely, however, did the *maskilim* regard educating women as a necessary means to female self-fulfillment.[17] Instead, their seemingly progressive activities on behalf of women's emancipation were informed by ideas of the "enlightened" *philosophes*, who idealized the nuclear family and motherhood, thereby reinforcing differences between the sexes and the appropriateness of an exclusively domestic role for women.[18] Only the woman who had received an excellent education and who had fully developed her intellectual potential could properly fulfill her roles as wife and mother. This middle-class cult of domesticity, which came to prevail among Jews and Gentiles of the bourgeoisie in Western countries by the second half of the nineteenth century, was imported to the Russian Empire and gained momentum among its middle class.[19] The movement encouraged women to acquire the standard accoutrements of a bourgeoise to prepare her to be an enlightened mother to her children and a desirable companion for her husband. The hope was that daughters of the middle class would transform the traditional Jewish household into a fount of enlightened belief and action.

Shapiro came of age against the backdrop of such shifting ideals of femininity, which in some measure enabled her to pursue new educational and even professional aspirations. Beginning in the 1860s, Russian progressives began debating the "woman question," a controversy that pitted those who advocated women's higher education

as a means to female self-fulfillment against those who claimed that this would disrupt society by imperiling the family and the social order.[20] Clearly influenced by this debate, Shapiro broke nearly every conventional gender mold cast by the Jewish community: She divorced her husband, left her son in his father's care while she pursued higher education abroad, carried on a long-distance romance with Reuven Brainin, and ultimately became a published Hebrew writer of significance. Shapiro's literary oeuvre emerged directly out of existential turmoil caused in no small measure by her gender. In her early twenties, she began to write vignettes depicting the lives of self-conscious educated women and their nemeses. Before turning forty, she had published the first full-length article of feminist literary criticism to appear in the Hebrew language.[21] Her male colleagues noticed and in some cases remarked on her interest in women's issues.

Indeed, the aggregate of Shapiro's life experiences, as narrated in her writings, resulted in the making of a watchful feminist observer whose linguistic dexterity and broad Western education enabled her to enrich Hebrew with knowledge of Russian, French, German, and Czech literature even while leading to physical and emotional alienation and at times despair.

A SISTER FROM SLAVUTA

Hava Shapiro's paternal family (see the Shapiro family tree in Appendix 5) can be traced to her forebear Pinhas of Korets (1726/28–1790), a Hasidic leader and member of the Baal Shem Tov's circle.[22] His son, Moshe, settled in the heavily wooded town of Slavuta, Volhynia (modern-day Ukraine, approximately 200 miles west of Kiev).[23] Because his rabbinic position was unsalaried, Moshe made a living by establishing a Hebrew printing press in 1791. Under the stewardship of Moshe's sons, Pinhas and Shmuel Abba, the press flourished in the next century, gaining fame even beyond Russia's borders for its magnificent editions of sacred texts.[24] Given its financial growth, the printing press developed into a larger enterprise, with its own typesetting facility and paper factory. As Slavuta's inhabitants came to depend on the press for their livelihood, the Shapiro brothers proved philanthropic and built a synagogue in town. In 1835 the press met with its demise in a controversy that Moshe's great-great-granddaughter, Hava Shapiro, would recount in the pages of Hashiloaḥ eighty years after the fact.[25] Meanwhile, it fell to Yaakov Shammai, grandson of Pinhas (the younger), to carry on the family's lucrative paper-manufacturing business in Slavuta, where he brought his second wife, Menuhah Schoenberg of Kishinev.[26]

On 15 Tevet 5639, Menuhah Shapiro gave birth to a daughter they would call Hava.[27] Whether or not her parents chose the name Hava (Eve) because she was their first girl, Shapiro would eventually play on the resonance of her biblical namesake, adopting the pseudonym Eim Kol Hai (Mother of All Living)[28] as a byline

in numerous publications. We know relatively little of Shapiro's childhood, although her memoiristic literature provides glimpses into her family's traditional religious practice and her enthusiasm for Torah study.[29] Shapiro's embrace of tradition was tempered, however, by her recognition of the gendered differentiation of Jewish observance. By adulthood Shapiro sought and found spiritual sustenance almost exclusively in Hebrew culture and literature as well as in secular intellectualism. The very act of writing in Hebrew, even in a mundane context, became for her a transcendent experience, and she characterized her diary as "the embodied secrets of my soul. Hidden within is my holy of holies."[30]

Such passion for Hebrew upends conventional understandings of Jewish women's literacy in Eastern Europe, where use of the "holy tongue" had for centuries been limited to men. However, Shapiro's educational trajectory underscores how being a woman paradoxically qualified her to inhabit the masculine world of Hebrew letters.

Shapiro followed a course of study far different from that of her male peers. *Maskilim* were generally the offspring of families whose observance of Jewish law was axiomatic and who considered acquisition of a Jewish education an essential feature of childhood. Their exposure to Hebrew thus came only as a by-product of immersion in sacred Jewish texts. Talmud Torah, as is well-known, consisted of a standard, if unsystematic, curriculum. The learning was mostly by rote, and it neglected the essential keys to mastering a language: grammar and syntax. Consequently, would-be male authors and poets of secular Hebrew works began their writing careers at a disadvantage, to which their often awkward early attempts testify. At the same time, of course, reading beyond the prescribed curriculum was considered an unnecessary diversion, and so male adolescents began surreptitiously sampling the forbidden fruits, under the influence usually of an indoctrinated older sibling or acquaintance. They turned first to Hebrew works of philosophy and moral guidance firmly ensconced within the parameters of traditional Jewish culture, and then they pored over the staples of the Haskalah and finally literature written in non-Jewish languages.

By her own account, Shapiro's educational experiences offer a stark contrast. She entered the rarified world of Hebrew letters as a young girl under the tutelage of *both* parents, who exposed her to classical and modern Hebrew—the latter, of course, being developed into a modern literary and spoken language over the course of the nineteenth and early-twentieth centuries. Although Yaakov Shammai read the weekly Torah portion aloud each week to the entire household and took an interest in everything related to the Land of Israel, Menuhah was proficient in the ancient tongue and acted as muse to her budding Hebraist.[31] As her daughter recalled, her mother regularly indulged in Friday night reading of secular Hebrew books and newspapers, which were utterly illegitimate (*pesulim*) in the eyes of her family.[32] There was a tacit agreement between mother and children that she not be disturbed during these sacred moments.

Besides introducing Shapiro to secular forms of Hebrew and despite the notorious rabbinic dictum pronouncing Torah study for women a kind of licentiousness (*Mishnah Sotah* 3:4), Shapiro's parents even permitted their daughter to study Torah together with her brothers.[33] Members of her family exchanged letters only in Hebrew, and Shapiro attended weekly meetings as an adolescent at a local group of Agudat ḥovevei sefat ʿever (Society of Lovers of the Hebrew language).[34] Shapiro thus approached the Hebraic craft from an altogether different direction from her male colleagues.[35] The gendered differentiation of Jewish education, which exempted girls from Talmud Torah and fostered an attitude of indifference if not permissiveness toward girls' secular study in general, freed Shapiro to pursue a unique course of study that provided her with far better training in Hebrew than she would have received had she been a boy with the attendant expectations.[36] That same "benefit of marginality," a phrase coined by the scholar Iris Parush, gave her latitude to read and write in Hebrew—and foreign languages too.[37]

Indeed, a steady stream of foreign languages flowed across Shapiro's tongue. In addition to Russian, Yiddish, and exemplary Hebrew, she knew French, German, Polish, and Czech and had some familiarity with Latin. Like other parents of the emerging bourgeoisie—membership in which meant financial security as well as a desire to replicate behavior and thought patterns imported from the West—Menuhah and Yaakov Shammai provided their daughter with the essentials of a modern lady in the making.[38] As Russian historians have documented, fluency in European languages was a hallmark of educated women of the bourgeoisie;[39] and, as such, Shapiro came to impress readers of the Hebrew press with her sweeping knowledge of European culture in article after article devoted to subjects as wide-ranging as German Romanticism, Czech art, Christianity, and Marxist biblical interpretations.[40]

Shapiro's extraordinary abilities would not escape the attention of male writers. After all, since the rise of the Haskalah, the *maskilim* attempted to expand Hebrew's range as a medium of expression by translating various European genres and ideas into it. Who was better suited to the task than a capable Hebrew writer whose formative influences included Russian and Western literature? Initially, and in theory, the vanguard of the Hebrew literary world welcomed and even sought out the female perspective. Given their gender-determined exteriority to Jewish textual tradition, women were strategically positioned to assist in releasing Hebrew from the tradition's millennium-long stranglehold. Indeed, Shapiro would encounter prominent figures in the Hebrew revival who, upon learning of her exceptional skills, attempted to draw her to their cause through both mentoring and assistance in publishing her works.[41]

Such encounters, however, occurred only after marriage and motherhood. In 1895 Shapiro wed Limel Rosenbaum, the son of a Warsaw banker. Within two years she gave birth to a son, Pinhas. Their marriage was an unhappy one, though, and it received its death knell in 1899 while Shapiro was traveling with her mother and son to a spa in

Franzensbad by way of Berlin.[42] There, she fell under the spell of Reuven Brainin (1862–1939), the striking and accomplished Hebrew writer who contributed to almost every Hebrew and Yiddish periodical of the day as either author or editor.[43] At 37, Brainin was nearly twice Shapiro's age—a difference that reinforced the hierarchical relationship between them and that is captured in her description of their first encounter:

> When I first met him, he was already close to 40. I was hardly more than a girl then, and in coming for the first time from Russia to the German capital, I was also seeing a Hebrew writer for the first time. [. . .] In my eyes, every writer was like an exalted individual. [. . .] I entered the writer's residence in awe of greatness. At that moment, he emerged from an adjoining room, and I suppressed my bashfulness to hold out to him a letter of recommendation from a native of my town, who had lived with him for a long while in Vienna.[44]

For most of her adulthood, Shapiro remained smitten with Brainin and yearned for his attention—as evidenced in their Hebrew correspondence of nearly thirty years—even after 1910, when he traveled (and then moved) from Europe to North America with his wife, Masha, and four children.[45] Her longing for him would play a pivotal role in her emotional undoing and in the unraveling of her wedding knot.

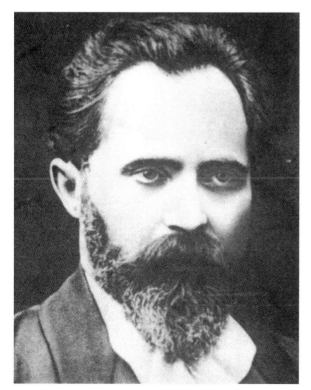

Reuven Brainin, c. 1900. (Jewish Public Library Archives, Montreal)

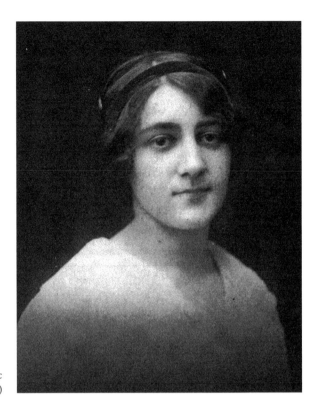

Shapiro, c. 1904. (Jewish Public
Library Archives, Montreal)

Shapiro's misbegotten marriage was further aggravated by a move from Slavuta to her husband's hometown of Warsaw. The couple's incompatibility became pronounced as she participated in the secular Hebrew cultural revival while he engaged in financial activities among the Jewish bourgeoisie. Warsaw was in the late-nineteenth and early-twentieth centuries the third city of the Russian Empire, trailing only St. Petersburg and Moscow in size and importance. It had an ethnically mixed population, with Poles making up a little more than half the total and Jews 30–40 percent. By the turn of the century, significant sections of the Warsaw Jewish community were adopting the culture of the surrounding Gentile world, but Shapiro found there a niche for her interest in Hebrew literature, which further estranged her from her husband.[46]

Shapiro found refuge at the home of Y. L. Peretz, where she joined his Hebrew literary salon.[47] Although the entire group may not have been privy to her writings, Peretz certainly was. Impressed with her skills, he offered her a job as his secretary and told Nahum Sokolov that "she knows Hebrew better than I do."[48] Moreover, perhaps because of his own personal unhappiness, having been divorced at 23, Peretz intuited Shapiro's anguish, supporting her and her development as a writer.

No amount of empathy could cure Shapiro's growing ennui. In 1903 she resolved to leave her husband. Securing promises of financial support from her mother, she

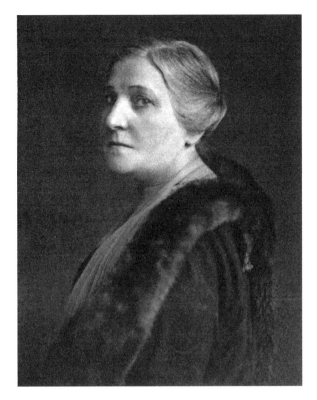

Masha (Amsterdam) Brainin. (Jewish Public
Library Archives, Montreal)

developed a program of formal study, requesting advice from Brainin.[49] While her
family reacted positively and devised ways to retrieve her dowry, Brainin urged her to
remain with her husband. Rosenbaum himself tried to intimidate her into staying, and,
when that failed, he resorted to coaxing her with enticements, such as permission to
study abroad so long as she kept his surname.[50] One of Brainin's acquaintances claimed
that "small-minded people" were spreading rumors that Eim Kol Hai had converted and
were blaming Brainin for it.[51] In the end, Shapiro did leave her husband, and her son
remained with his father in Warsaw until adolescence, although arrangements were
made for Pinhas to visit his mother, provided that a paternal relation was present.[52]
Laments over missing her son pervade the pages of her diary.

Pain notwithstanding, the separation enabled Shapiro to pursue a formal course of
study for the first time. Never having attended a Jewish school, a Gymnasium, or even a
class, Shapiro initially engaged tutors and then made her way to Vienna in 1904 to attend
lectures.[53] In the following year she prepared for the entrance exams to the University
of Bern, which had followed the lead of the University of Zurich, the first university in
Central Europe to admit women as matriculated students.[54] After rigorously studying
French, German, Latin, geography, and world and Swiss history, Shapiro enrolled in
the philosophy department and made Bern her home, where she lived with her brother
(December 1905–summer 1910).[55]

While living in Bern, Shapiro studied intensively and befriended Shmuel Abba Horodetsky (1871–1957), a student of Hasidism, in whom she would later have a romantic interest that was ultimately eclipsed by her enduring infatuation with Brainin.[56] While writing her thesis, Shapiro largely neglected her diary and correspondence; thus little is known of her activities during this period. Her thesis on the German philosopher Georg Christoph Lichtenberg (1724–1799) was directed by Ludwig Stein (1859–1930), who had studied at universities in Berlin and Halle and had been ordained as a rabbi by the Hildesheimer Rabbinical Seminary.[57] In 1909 Shapiro traveled to Göttingen to meet Professor Edmund Husserl (1859–1938), who helped her obtain manuscripts of Lichtenberg's writings.[58] Not a year later, she completed her thesis and earned a Ph.D.[59] But as the melancholy returned, she claimed that the laurels meant little to her, and she retreated to Slavuta.

Despite the doubts, by 1910 Shapiro had already become a published author and had begun to fulfill her aspiration of participating in the Hebrew press.[60] Her articles reflect a particular interest in Zionism. In 1911 she and her parents accompanied David Frischmann and his wife on a trip to the Land of Israel arranged by *Haynt*, the leading Yiddish daily in Warsaw.[61] Shapiro's three-part account of that voyage is one of the first Hebrew travelogues of a trip to Palestine penned by a woman. When she moved to Berlin in 1912, she forged links with the Zionist movement's leadership, then headquartered in the German capital.[62] Thereafter she began to write regularly for its organ, *Ha'olam*. The idea of moving to the Land of Israel continued to gnaw at her as late as 1923, when allegiance to her mother and son and financial troubles ruled out any possibility of returning to Zion ever again.[63]

Meanwhile, Shapiro's personal life deteriorated. According to her estimation in 1909, she and Brainin had "over these ten years [. . .] managed to be together only for a few months."[64] And by 1910 any hope of permanently uniting with him had been dashed on the shores of North America, where he would travel and then settle. Although their correspondence had come to a virtual standstill, they spent a month or so together in Europe in 1913.[65] After World War I, when her family's fortune was lost and Shapiro desperately needed help in securing work to support herself and her son, she revived the letters to Brainin. He did not respond. Gradually and painfully, she came to recognize the futility of such measures. When she saw him at the Zionist Congress in Vienna in 1925, she claimed to feel nothing for him.[66]

In due time the tragic world events that would directly affect Shapiro and her family—along with hundreds of thousands of other Jews in the eroding Pale of Settlement—began to drive away fond memories of Brainin and the charmed literary life he inspired. With World War I and the Russian Revolution raging, Shapiro shuttled between Kiev and Slavuta, tending to her ailing mother and worrying about her son's future. Initially optimistic about the transformations overtaking Russia, by the end of

1917 Shapiro had profound misgivings and felt called to publish testimony of what she had witnessed.[67] The following year, Hayyim Nahman Bialik extended an invitation to Shapiro to settle in Odessa and join his famed literary circle.[68] Whether Shapiro wanted to or not is unknown; within the year, however, external events would conspire against such a decision. When the Poles captured Slavuta in 1919, Shapiro had no choice but to leave her homeland for good.[69] With the help of her father's former employee, a Gentile forester, Shapiro and her son escaped to Czechoslovakia and remained in Munkács until settling ultimately in Prague.[70] Her mother's death in 1921 was the final undoing of her connection to the Old World of her childhood.[71]

Czechoslovakia proved a safe haven for Shapiro and her son. Arguably, it was the most favorable environment for Jews in Eastern Europe between the wars, especially for those with a nationalist bent.[72] Its first president, Tomas G. Masaryk (1850–1937), was a consistent advocate of the Jewish right to national self-determination in the Land of Israel and an opponent of anti-Semitism. With its independence in 1918, Czechoslovakia united the disparate Jewries of Bohemia, Moravia, and part of Silesia (formerly of the Hapsburg Empire) with those of Slovakia and Carpatho-Russia (formerly of Hungary). These communities differed substantially in their demographic, economic, and cultural aspects and began to compete for the right to define the future identity of Czech Jewry.[73] Assimilationists fought with the Orthodox, and together they resisted the Zionists. Such cultural heterogeneity needled the Zionists, who championed Masaryk and his 1920 Constitution, which granted Jews minority rights as a nationality. Shapiro would express her enthusiasm for the Czech president in a slim book published in 1935.[74]

Safely settled in Prague, where her son studied engineering, Shapiro returned to reportage. The money generated from the more than forty articles that she published over the course of the 1920s provided much needed income. She wrote on the rich cultural life of her adopted city[75] and on the trends in the many West European cities to which she traveled.[76] On 28 February 1929 Shapiro became a Czech citizen,[77] and she wed Josef Winternitz (1876–1944), a Jewish community leader of Prague who had been previously married.[78] Her diary, the sole record of the couple's marriage, weaves a tale of conjugal misery owing to Winternitz's mental illness.[79] And when her son, Pinhas, immigrated to America in the late 1930s, Shapiro could barely endure the sting of separation.[80] In dire financial straits, she sent a barrage of letters requesting work, and subsequently bills for wages owed, to editors near and far.

Shapiro's final years are paradigmatic of Jews in Czechoslovakia at the start of World War II. In 1941 she relinquished her diary for safekeeping, knowing that the Germans were then registering Jewish residents of Prague for deportation to Theresienstadt.[81] Less than a year passed before Shapiro was committed to a psychiatric hospital (September 1942) and then released (19 January 1943) to prepare for the impending

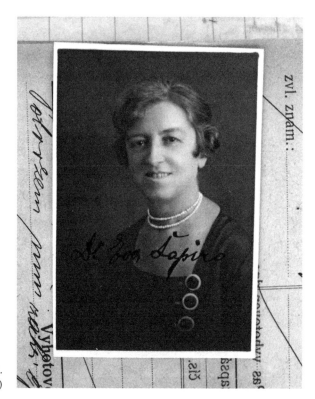

Hava Shapiro, 1927.
(Czech National Archives, Prague)

transport.[82] But she never saw Terezin. Shapiro died on 28 February 1943 in the apartment that her husband had leased in January of that year.[83] The cause given was "mental illness."[84] Six days later, on 6 March 1943, the Nazis deported Josef Winternitz to Terezin, where he was killed on 18 March 1944.[85]

Although Shapiro's work continued to be published until 1938, it is her diary that contains her last known words in Hebrew. In the final entry (21 October 1941)—composed sixteen months before her death—she describes relinquishing the diary that had "become part of [her] soul": "I have not written in Hebrew for over two years," she wrote, "and I am about to be parted as well from this diary." She continued: "My son is on the other side of the ocean, and I am going, who knows where?"

Having first surrendered her flesh-and-blood child, she was now surrendering an additional offspring—this one of a less literal, though indeed literary, nature. Shapiro, who after all called herself Mother of All Living, regarded her perspective—namely, a woman's perspective—as critical to the birthing process of modern Hebrew literature. According to the biblical story of woman's creation, God asserts, "It is not good for man to be alone," and so resolves to "make a fitting helper for [Adam]."[86] The woman, who is then formed from Adam's rib, is called Hava (Eve) "because she [would become] *eim kol*

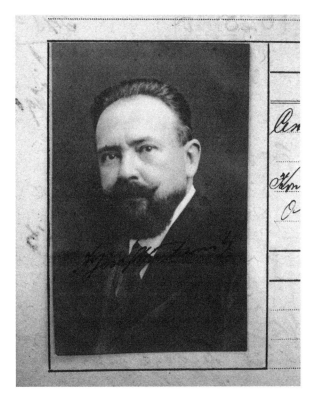

Josef Winternitz (Shapiro's second husband), 1921.
(Czech National Archives, Prague)

ḥai [mother of all living]."[87] In the case of the modern-day Eim Kol Hai, it is she, Shapiro, who casts herself as a partner to the male progenitors of modern Hebrew literature and urges them in the strongest terms possible to consider and embrace her viewpoint. The "lasting, literary expression" contained in this volume attests to the significance of Shapiro's contribution.

NOTES

1. Diary entry for 11 April 1927; see Part II.
2. Shapiro also wrote for the Yiddish and German Jewish press on occasion; see Appendix 8.
3. Caruso, "Shtetl Feminist." Thanks to Zachary Baker, who offhandedly mentioned this cache of letters in 1995 when he was at YIVO.
4. See letters from Shapiro to Persky (23 March 1936, 1 June 1937, 9 December 1937) in Part III.
5. Letter from Shapiro to Persky (9 December 1937) (see Part III); Klausner used similar language to describe Shapiro in "On the 'Only Daughter'"; see Part V.
6. For Shapiro's preface to *A Collection of Sketches*, from which these phrases are excerpted, see Part I.
7. Baron's first published short stories appeared in *Hamelitz* and *Hatsefirah*. Her feminist sketches (with the exception of "Haraḥmaniyah") appeared during the same period as Shapiro's *Collection of Sketches*; "Fedka," "Layzer Yossel," "Hasavta Henya," "Hakafot," and "Dayar" appeared in *Ha'olam* in 1909. Baron immigrated to the Land of Israel in December 1910.
8. Hasidism was a popular religious revival movement founded in the eighteenth century by Yisrael ben Eliezer (1700–1760), also known as the Baal Shem Tov (or Besht), and developed by his disciples in

Ukraine. The Mitnagdim (literally, "opponents"), led by the Vilna Gaon of Lithuania, challenged the Hasidim's alleged lack of intellectualism. See "The Brothers from Slavuta" in Part I.

9. See the diary entry for 19 February 1917 in Part II.

10. See diary entry for 21 October 1941 in Part II.

11. See Preface to *A Collection of Sketches* in Part I.

12. *Maskilim* are adherents of the Haskalah, the Jewish Enlightenment movement.

13. The extensive debate on enhancing women's education that ensued among Russia's progressive society in the 1860s was part of a larger discussion on the role and status of women in the Russian empire, which became known as the "woman question" (*zhenskii vopros*). See Johanson, *Women's Struggle*.

14. See Moses Leib Lilienblum's manifesto against the traditional view of Jewish women in his *Ketavim autobiographi'im*, 2: 89–93.

15. Between 1831 and 1881, 130 Jewish schools for girls opened in the Russian Empire. See Adler, *In Her Hands*.

16. See, for example, the protagonist Rachel in R. A. Braudes's *Hadat vehahayyim*; Rachel is modeled after Lopukhov, Cherniyshevskii's famous Russian "feminist" in the novel *What Is to Be Done?* See also Brainin's female characters in such stories as "Reshimot 'oman 'ivri," "Shoshanah," and "'Ivriyah" in *Ketavim nivharim*.

17. See Feiner, "Ha'ishah hayehudiyah hamodernit."

18. Kleinman, "Women in the Age of Light."

19. See Kaplan, *Making of the Jewish Middle Class*; and Baader, *Gender*. Diana Greene argues that female authors in Russia drew on but adapted Western literary conventions to suit their needs (Greene, "Gender and Genre").

20. For a diary relating to this debate, see Arja Rosenholm's "Chuzhaia domu i zvezdam: Female Stranger in the Diaries of Elena Andreevna Shtakenshneider," in Liljestrom, *Models of Self*, 119–40.

21. See "Female Types in Mendele's Stories."

22. On Pinhas of Korets, see Heschel, *Circle*, 1–11; and Dubnov, *Toldot hahasidut*, 104.

23. In 1765, 246 Jews were registered and paying poll taxes in Slavuta; by 1847, 1,658 Jews were registered, and in 1897 the number was 4,891 (57% of the total population). See Slutsky, "Slavuta." For more on Slavuta Jewry, see Kovalchuk and Friedman, *Sholom, Slavutchani*, and the website based on their book (http://jewua.org/slavuta/). Local historian Kovalchuk has no information on Hava Shapiro (letter from Stanislav Kovalchuk, Director, Slavuta Ethnography Museum, 3 September 2013). We thank Mr. Kovalchuk for sending a copy of his book.

24. See Assaf, "Shapira Family." In contrast to Avner Holtzman's "Havah Shapira" in *The YIVO Encyclopedia of Jews of Eastern Europe*, we rely on Hava's spelling of her surname, as attested in her German byline and archival records in Prague.

25. See "The Brothers from Slavuta" in Part I.

26. Shapiro's brother, Moshe, who would one day deposit her diary at the Genazim Institute in Tel Aviv, provided additional biographical details on his family, including that his maternal grandfather's name was Yisrael David and that his father had two daughters from a previous marriage. See the letter of M. Shapiro (13 May 1956) from *Genazim* given in Caro, *Kovets letoldot* 2: 36–37.

27. This Jewish calendar date corresponds to 28 December 1878 on the Julian calendar then in use in Russia (and converts to 10 January 1879 on the Gregorian calendar). There are discrepancies in Shapiro's birth date in biographical encyclopedias, but the Terezin Digital Resource Center Database of Victims indicates, unequivocally, the year of birth of Eva Winternitzová as 1878. Cf. the diary entry for 26 December 1920 in Part II. When asked her birthdate on visa applications, Shapiro would write 24 December 1878 (Files of Eva Winternitz-Shapiro, Fond PŘ 11-EO and Fond PŘ 1941-51, Central Office of the Prague Police, National Archives of the Czech Republic, Prague). When she was born, Shapiro's parents already had two sons (Pinhas and Moshe). A third son, whose name is unknown,

was born later, along with a daughter, whose death at the age of 11 made a strong impression on her older sister; see diary entry for 7 October 1901 in Part II.

28. See Genesis 3:20.

29. Cf. the female protagonist of "Sanctification of the Moon," who declares, "And my heart yearned so for the Torah!" (see Part I).

30. Diary entry for 15 November 1909 in Part II.

31. Letter of M. Shapiro, in Caro, *Kovets letoldot*, 2: 36. Moshe also maintained that his parents and siblings corresponded with each other only in Hebrew. For a postcard in Hebrew from Menuhah Shapiro to Reuven Brainin, see Part III.

32. See "Hanukkah Days" in Part I.

33. Letter of M. Shapiro, in Caro, *Kovets letoldot*, 2: 36. The few girls who did engage in Talmud Torah typically did so by observing their brothers' lessons. See Hyman, *Gender and Assimilation*, 64–67. Cf. Jelen, *Intimations of Difference*; Zierler, *Rachel Stole the Idols*; and Seidman, *Marriage Made in Heaven*. According to Kovalchuk and Freidman, there was a heder in Slavuta in the nineteenth century, although Shapiro does not mention attending it; see their *Sholom, Slavutchani*, page 3 of the unnumbered version of the book.

34. Agudat ḥovevei sefat ʻever was a national organization, with local chapters, created in 1909 in St. Petersburg to promote instruction in Hebrew and the study of its literature in the Russian Empire.

35. Letter of M. Shapiro, in Caro, *Kovets letoldot*, 2: 36; and Fogel, "Hava Shapiro," 28.

36. Cf. Stampfer, "Gender Differentiation"; Miron, *Imahot meyasdot*; Sadan, *Bein din leheshbon*, 367–70; and Etkes, *Lita biyerushalayim*, 208, 224.

37. Parush, *Reading Jewish Women*, xiii.

38. Shapiro claimed that she did not attend a formal class until she arrived in Vienna in 1904. Presumably she picked up her knowledge of foreign languages from tutors. Her brother Moshe described his family's intellectual bent. See Letter of M. Shapiro, in Caro, *Kovets letoldot*, 2: 36.

39. Kelly, *History*, 28.

40. In letters to Reuven Brainin, Shapiro speaks of reading Goethe, Mill, Gorky, and Chekhov, among others. See the listings of her writings in Appendix 8 for the range of subjects about which she wrote authoritatively.

41. Despite her tremendous devotion to her mother, compassionate references to her younger sister (who died in childhood), close friendship with her sister-in-law, Regina (diary entry for 4 March 1908 in Part II), and connection to her niece (diary entry for the summer of 1913 in Part II), Shapiro sought out none of the female Hebraists of her day (although she did comment on her pleasure at meeting Hebrew-speaking women and girls while traveling in Palestine).

42. Letter of M. Shapiro, in Caro, *Kovets letoldot*, 2: 36. For an analysis of the Bohemian "spa triangle" of Carlsbad, Franzensbad, and Marienbad frequented by bourgeois Jewry from the early decades of the twentieth century, see Zadoff, *Next Year in Marienbad*.

43. See Appendix 3 for Brainin's biography. All his papers, except for his diary, are at the Jewish Public Library of Montreal; his niece, Judy King, is the unofficial custodian of his papers.

44. Shapiro, "Reuven Brainin, On his Intellectual Image," 74. (This essay is reprinted in Part IV.)

45. Masha Amsterdam Brainin (1868–1934) was born to a prominent family in Vitebsk; her father was a rabbi, and her two brothers, Avraham and Wolf Beer, were active in the Bund. The couple had six children, although only four lived past infancy: Miriam (1890–1918, died from influenza), Berta (1892–1983), Moshe (Moe) (1893–1963), Joseph (1895–1970), Max (1897–1898), and Ferdinand (1899–1900). Moe and Joseph would fight with the Jewish Legion in Palestine. See Brainin Family Tree, Correspondence III, Box y, File 3, Jewish Public Library, Montreal. Masha apparently had a heavy hand in managing the family's financial affairs: "[Brainin] was almost childlike in his reliance on his wife in the routine of practical affairs." See tribute to her in *The Jewish Standard* (Toronto) (24 October 1934) and her obituary in *Keneder Adler* (17 August 1934).

46. Corrsin, *Warsaw*, 1, 2, 31, 55, 63.

47. See diary entry for 25 March 1915 in Part II and Shapiro's "Y. L. Peretz: The Man and the Writer" in Part IV.

48. Letter from Shapiro to Brainin (25 November 1901) in Part III; and diary entry for 25 March 1915 in Part II.

49. Letters from Shapiro to Brainin (29–30 June 1903, 8 October 1903, and fall 1904) in Part III. Menuhah Shapiro also asked Brainin for advice regarding her daughter's plans; see letter from M. Shapiro to Brainin (1903) in Part III.

50. Letter from Shapiro to Brainin (1 July 1904) in Part III.

51. Letter from Joseph Khelmer to Reuven Brainin (15 June 1908), Reuven Brainin Collection, Correspondence III, Box k, Jewish Public Library, Montreal.

52. Letters from Shapiro to Brainin (20 June 1904 and 24 June 1904) in Part III.

53. Diary entries for 20 February 1904 and 16 September 1904 in Part II.

54. Friedenreich, *Female, Jewish, and Educated*, 8.

55. Letter from Shapiro to Brainin (2 December 1905) in Part III.

56. Diary entry for 24 January 1910 in Part II. See Shapiro's reminiscence of Horodetsky in "The Historian of Hasidism of the Heart" (1931). Horodetsky was involved in Ivriyah, an organization established in 1905 to oversee Hebrew cultural endeavors, which had its headquarters in Bern. Shapiro does not mention it in her writings. See Levinson, *Hatenu'ah ha'ivrit bagolah*, 14–16.

57. Georg Christoph Lichtenberg, of the University of Göttingen, had a modest influence on the development of European thought, particularly in linguistics. Notably, however, Lichtenberg become embroiled in one of the foundational moments in the history of German-Jewish cultural interactions when he attacked the Christian theologian Johann Kaspar Lavater (1741–1801) for challenging Moses Mendelssohn (1729–1786) to defend his Jewish faith or embrace Christianity. Lichtenberg's satirical critique is titled "Timorus: The Defense of Two Israelites Who, Overwhelmed by Lavater's Proofs and the Taste of Pork Sausages, Converted to the Only True Faith." See Elon, *Pity of It All*, 49. See Shapiro's article on aphorisms ("Aphorisms and Typical Principles," 1914), an interest of Lichtenberg's as well. See Haberman, "Ludwig Stein." Brainin knew Ludwig Stein personally; see Brainin, *Ketavim nivḥarim*, 3: 473–74.

58. Letters from Shapiro to Brainin (24 April 1909 and 25 April 1909) in Part III.

59. Diary entry for 4 August 1910 in Part II. Shapiro affixed the title "Dr." to her byline in nearly all subsequent publications.

60. Postcard from Shapiro to Brainin (24 June 1910) in Part III.

61. See "Notes from My Journey to Eretz Yisrael" in Part IV. Shapiro's brother mentions that she traveled with her parents. See Letter of M. Shapiro, in Caro, *Kovets letoldot*, 2: 36.

62. Letter of M. Shapiro, in Caro, *Kovets letoldot*, 2: 37.

63. Diary entry for 25 February 1923 in Part II.

64. Letter from Shapiro to Brainin (24 April 1909) in Part III.

65. Diary entry for 2 November 1913 in Part II. Shapiro refers to receiving "one short letter" from Reuven Brainin from Quebec (in May 1914) and one letter after the war broke out (dated 25 May 1915). We do not include the letters with such references here.

66. Shapiro mentions meeting Brainin or anticipating a meeting: Letters from Shapiro to Brainin (23 June 1903 [not included in this book]; 5 March 1909; 24 April 1909; 24 June 1909; 22–25, 27, 30 November 1913) in Part III and diary entries for 5 August 1908, 1 May 1909, 2 November 1913, and 27 December 1925 in Part II.

67. For misgivings, see diary entry for 21 April 1917 in Part II; and for testimony, see "You Must Not Forget!" and "Notes from Ukraine" in Part IV.

68. For Bialik's invitation, see diary entry for 7 July 1918 in Part II.

69. Slavuta Jewry was devastated by three pogroms in March and April 1919 and September 1920. Twenty Jews were killed, seventy-three were wounded, and dozens were raped. See Joint Distribution

Committee, *Report on Slavuta Volhynsk Gubernia* (29 June 1923) at http://search.archives.jdc.org/multimedia/Documents/NY_AR2132/499-505/NY_AR2132_01011.pdf (accessed 21 August 2013). The same source indicates that seventy-five men (fifteen Jews) worked at the paper mill factory after the pogroms.

70. For her escape to Czechoslovakia, see Letter of M. Shapiro, in Caro, *Kovets letoldot*, 2: 37; letter from Shapiro to Brainin (19 October 1919) in Part III; and "Notes from Ukraine" in Part IV. Several diary entries indicate sojourns in Munkács, although Shapiro claimed Prague as her city of residence as of 1919. Files of Eva Winternitz-Shapiro, Document (10 November 1926), Fond PŘ 11-EO, Central Office of the Prague Police, National Archives of the Czech Republic, Prague.

71. For news of her mother's death (which arrived eight months after she passed), see diary entry for 30 August 1922 in Part II; and for loss of connection to her homeland and childhood home, see diary entries for 29 September 1922 and 9 October 1922 in Part II. For her father's death, see diary entry for 11 March 1912 in Part II.

72. Mendelsohn, *Jews of East Central Europe*, 132.

73. See Čapková, *Češi*.

74. Shapiro, *T. G. Masaryk: Ḥayav vetorato* (1935). For Czech Jewry's relationship with Masaryk, see Kieval, *Languages of Community*.

75. Note the overlapping interest in mainstream Czech culture and Zionism among Prague's Jewish elite. The writer Max Brod, for instance, was a deputy for the first president of Prague's Jewish National Council and a friend and editor of Franz Kafka. See Shapiro's review of Brod's book ("Paganism, Christianity, and Judaism," 1924). That Shapiro had some contact with Jews in Prague is evident from her reference to being at the "reading room of Jewish students in Prague," where she saw only one journal in Hebrew: *Hado'ar*. See Shapiro, "In Czechoslovakia" (1926).

76. Shapiro traveled to Austria, Switzerland, France, Germany, and Italy over the course of 1926–1937. See the numerous applications for temporary passports: Files of Eva Winternitz-Shapiro, Fond PŘ 11-EO and Fond PŘ 1941-51, Central Office of the Prague Police, National Archives of the Czech Republic, Prague.

77. Document (3 April 1929) confirming granting of Czechoslovakian citizenship to Hava Shapiro on 28 February 1929, File of Eva Winternitz-Shapiro, Fond PŘ 1931-40, Central Office of the Prague Police, National Archives of the Czech Republic, Prague.

78. The meager extant biographical data on Josef Winternitz derives from official documentation on him, Fond PŘ 1931-40, Central Office of the Prague Police, National Archives of the Czech Republic, Prague.

79. Diary entries for 10 April 1934, 27 February 1935, 11 December 1937, and 18 June 1939 in Part II.

80. Diary entry for 31 March 1940 in Part II. In a Russian letter to Daniel Persky (23 October 1938), Shapiro asked for assistance for her son, who was at the time unmarried and working in the United States. Pinhas Rosenbaum was struck by a car and died in St. Louis, Missouri, in 1953. See Letter of M. Shapiro, in Caro, *Kovets letoldot*, 2: 37.

81. For Shapiro's handing off her diary to a "stranger," see diary entry for 21 October 1941 in Part II. Her brother, who delivered it to the Genazim Institute in 1956, did not provide details of its recovery.

82. Handwritten note (January 1943) indicating that Eva Winternitz is incarcerated at the Ansalt für Geisteskranke in Prag-Bochnitz, File of Eva Winternitz-Shapiro, Fond PŘ 1941-51, Central Office of the Prague Police, National Archives of the Czech Republic, Prague. For the exact dates of her incarceration, see card for Eva Winternitz in the hospital registry. By 1942 the hospital had a separate section for Jews with its own Jewish doctor. See http://lebensunwert.nickol-design.de/de/prag.htm (accessed August 21, 2013).

83. Deportation cards for Eva Winternitz and Josef Winternitz, Deportation Card Index, Vol. II, OVS/KT-OVS, National Archives of the Czech Republic, Prague. The oddity of Shapiro having a "deportation card" even though she was never deported is explained by the fact that in 1941 every Jew in Czechoslovakia received a registration number, which was recorded on a card. These so-called deportation

cards were used to make lists for transports to Terezin. When a person was deported, an official would mark the person's deportation card with the number of the transport. The deportation card for Eva Winternitz has no such number. Rather, the date of her death (28 February 1943) is noted at the top of the card, which means that she died before the transport in March of that year. In contrast, Josef Winternitz's deportation card indicates his transport number as CV 806. For confirmation of the date of her death, see also the card for Eva Winternitzová in the Terezin Digital Resource Center Database of Victims as well as the registry of deaths of Jews who died before deportation, recorded by the leadership of the Jewish community in Prague, which lists Shapiro's name, at the National Archives of the Czech Republic, Prague. Shapiro's brother erroneously claimed that Hava died at Terezin (Letter of M. Shapiro, in Caro, *Kovets letoldot*, 2: 37).

84. This likely implies suicide.

85. Josef Winternitz, in the Terezin Digital Resource Center Database of Victims. Although the majority of Prague Jewry was deported in 1942, Winternitz's deportation in 1943 may be due to his being an official of the Prague Jewish community.

86. Genesis 2:18.

87. Genesis 3:20. The words Ḥava (Eve) and ḥai (living) share a similar root in Hebrew.

PART I

FICTION

Fiction
"A Bold Attempt"

"The single, greatest spiritual pleasure," wrote Hava Shapiro, "is when you have created something, when you have given shape to one of your ideas or feelings that lives within you, which had not let you rest and had suffused you fully."[1] As Russian literary scholar Charlotte Rosenthal explains, artistic endeavors "enabled women [of earlier generations] to define happiness for themselves in a self-contained way. Even more unconventionally, happiness was redefined in terms of the world within oneself—in self-exploration and self-assertion."[2] Shapiro's first attempts at creative expression, in large part based on her inner world, were in the area of fiction writing. Like many of her Russian female counterparts who avoided writing novels because of their association with the masculine literary tradition in Russia, Shapiro's earliest Hebrew publications were in the genre of short stories or sketches.[3] In this regard, Shapiro was also following the trend of Hebrew authors of the day—men and women alike—who were shifting from the novel to shorter forms of literature.[4] Indeed, the *sippur* (story), *tsiyyur* (sketch), *reshimah* (note), and *temunah* (picture) can be traced in part to European influences. In Russian, German, and French literature short forms such as the *ocherk* (Russian, sketch), *zapiski* (Russian, notes), *feuilleton* (French, short piece devoted to fiction, criticism, or light literature), and *physologie* (German, short work of psychological realism) predominated.[5]

1. Diary entry for 16 September 1904 in Part II.
2. Rosenthal, "Achievement and Obscurity," 153.
3. Marsh, "Realist Prose Writers," 181.
4. In the same period, Reuven Brainin took to writing fictional sketches as well; see "A Jewish Wife," in Anctil, *Through the Eyes of the Eagle,* 176–78 (original in Hebrew; Yiddish translation appeared in *Keneder Adler,* 27 March 1913).
5. Bar-Yosef, *Hareshimah kegener*; and Gershon Shaked, *Hasipporet ha'ivrit,* 1: 241–42. See also Yoktan, "Dr. Hava Shapiro," 22–25. For a discussion of Russian realist trends among women writers, see Rosenthal, "Achievement and Obscurity," 149–70.

The shift to shorter forms can also be attributed to the influence of *Mahalakh heḥadash* (The New Journey), a realist movement in Hebrew literature associated with publisher and author Ben Avigdor (Avraham Leib Shelkovitz, 1866–1921) and with Reuven Brainin. The movement promoted the writing of realistic or naturalistic fiction, and, according to the critic Ba'al Mahshoves, promoted literary forms far shorter than novels. In such pieces writers focused on specific incidents from the life of an individual or on a psychological moment rather than on issues of broader social significance.[6] By composing short stories and sketches, Shapiro was in good company: Uri Nisan Gnessin, Yosef Hayyim Brenner, Gershon Shofman, Hirsch David Nomberg, and Devorah Baron, to name a few, began their careers in these forms.

Shapiro assembled her sketches—including a handful that had already appeared in print and others that were newly minted—into a volume titled *A Collection of Sketches* (*Kovets tsiyyurim*), which appeared in 1909 under her pseudonym Eim Kol Hai. Like Devorah Baron, who published early in her career under the name Ishah Neviah (Prophet Woman) as an allusion to the biblical prophet and poet Deborah,[7] Shapiro asserted a connection to the biblical Hava (Eve, the primordial mother). That she dedicates this first (and ultimately only) volume of stories to her mother suggests a desire to construct a female chain of tradition (*shalshelet hakabbalah*), connecting those who (pro)create, one to another. Shapiro's mother appears as the link between the first "mother of all living" and the modern-day "mother of all living," namely, Hava herself.[8]

Readers will discover that *A Collection of Sketches* (reproduced in its entirety in this part) and later works featured in this part contain a remarkably prescient understanding of intellectual women challenging gender boundaries at the fin de siècle and beyond. Indeed, Shapiro's preface to the *Collection* is a feminist literary manifesto—the first of its kind in the Hebrew language.[9] It resembles that of Ben Avigdor, who prefaced his pathbreaking story "Leah mokheret dagim" (Leah the Fishmonger) with a call for the creation of a new realistic Hebrew literature with snapshots taken from life.[10] Shapiro's preface is a supplement to Ben Avigdor's manifesto, declaring that current Hebrew literature lacks an important feminine point of view and therefore an important realistic element.[11] More than that, in

6. Mahshoves, "Hatekufah ha'ahronah besifrutenu," 5.
7. See Devorah Baron's "Zug mitkotetet" (Quarreling Couple, 1905) in her *Parshiyot mukdamot*, 374–76.
8. See the dedication in *A Collection of Sketches* in this part.
9. See Tova Cohen and Shmuel Feiner's collection *Kol ʻalmah ʻivriyah* for feminist works in Hebrew that predate Shapiro's preface.
10. See Avigdor, "El ḥovevei sefar ʻever vesifrutah," 22. The photographic snapshot dates to 1890.
11. Not incidentally, the political philosopher John Stuart Mill, whose works Shapiro read, similarly argues in his famous essay "The Subjection of Women" (1869) that "we may safely assert that the knowledge which men can acquire of women, even as they have been and are, without reference to what they might be, is wretchedly imperfect and superficial, and always will be so, until women themselves have told all that they have to tell" (172–73).

the preface Shapiro insists on reconfiguring the exclusively masculine notion of creativity originating from the divine and upheld by the great male authors of the Hebrew literary tradition.

> Our literature lacks the participation of the second half of humanity: that of the weaker sex. [. . .] Time and again, when we [feminine plural] are amazed and awed by the great talent of a "wonder worker" [*mafli la'asot*] who "penetrates the woman's heart" [*ḥoder lev 'ishah*] we feel at the same time as though a strange hand has touched us. We have our own world, our own pains and longings, and we should, at the very least, take part in describing them.

> [. . .] This collection of sketches is only an experiment, only the beginning of the revelation of the female spirit, which has been forced to abandon the treatment of "its sorrows, joys, hopes, and wishes" to others.

Shapiro's reference to the male Hebrew writer as a wonder worker alludes to the liturgical God as Creator. It derives from the *asher yatsar* prayer: "Blessed are You . . . who heals all flesh, working wondrously." Together with her second description of the male author as "one who penetrates the heart of woman," she anticipates much later feminist theoretical objections to the idea of authorship based on a masculine God concept on the one hand and the pen as phallus on the other. The last line quoted here includes a reference to the opening of Y. L. Gordon's famous poetic diatribe against the secondary status of women in Judaism, "Kotso shel yod" (The Tip of the Yod [Hebrew letter], 1878), which opens with the following rhetorical question:

> Hebrew woman, who knows your life?
>
> You were born in obscurity and in obscurity will you depart,
>
> Your sorrows and your joys, your hopes and wishes
>
> Are born within you, and inside you they die.[12]

Shapiro's manifesto thus hints at the significance of Gordon's poem in the history of Jewish feminism while critiquing his exaggerated poetic portrait of the victimized woman. Moreover, as Shapiro instructs, women should be allowed and encouraged to depict their own experiences, and so she proffers her own contribution to the *Mahalakh heḥadash:* stories she characterizes as a "bold attempt to tread on new ground."[13]

12. For a bilingual version of the poem, see Nash, "Kotso shel yod."
13. Shapiro's attempt to "tread on new ground" casts her as a traveler, a motif that she would develop further, especially in "Notes from My Journey to Eretz Yisrael" and "Roaming the Lands," both in Part IV.

Against the grain of the *Mahalakh heḥadash,* however, not all of Shapiro's sketches assume a realist form. Instead, some take the form of seemingly simple allegories, featuring flowers or birds.[14] According to Sandra Gilbert and Susan Gubar in their classic study of nineteenth-century British and American women's writing, female authors frequently employed a poetics of duplicity, using symbolic language that covered over "submerged meanings," which they could not directly or explicitly transmit.[15]

"The Rose," Shapiro's first published story (1901) and the first story in *A Collection of Sketches,* is one such "duplicitous" work. In this seemingly naïve allegory, the title character is uprooted from the garden, placed in a flowerpot, given a drizzle of water, and becomes stifled by lack of air. Once transplanted back to the garden, the rose declares that she no longer fears anything and, after weathering a windstorm, she explains her survival "to her sisters": "My roots were planted with great effort deep into the heart of the land. I grew and became lovely, and it is my roots that allowed me to live and gave me courage and strength." The images of transplantation, rootedness, and survival in the face of adversity have led several Hebrew literary critics to interpret "The Rose" as a symbol of Zionist return to the Land of Israel. Moshe Ungerfeld, for instance, reads the sketch in light of the common interpretation of the Songs of Songs as a figurative rendering of the relationship between God and the people of Israel. As he explains: "In the story, 'Roses' [*sic*], there are allegorical hints of the situation of the people of Israel living among non-Jewish nations 'as a rose among thorns.'"[16]

Although this interpretation is certainly plausible, the story's subtitle ("From the Stories of a Woman"), which appeared when the story originally appeared in 1901 (but was dropped in the *Collection*), elicits an alternative feminist interpretation. In this reading the sketch depicts the experience of an extraordinary woman unwilling to be confined by social convention. The rose, who admonishes male scholars for plucking one of her species to study its nature, is a mouthpiece for Shapiro's veiled critique of the *maskilim,* who wrote about the problematic position of women in Judaism but nevertheless stopped short of welcoming them into their literary canon.[17]

David Frischmann, one of Shapiro's literary mentors in Warsaw, typifies the *maskil* who is decidedly ambivalent about female Hebraism. On the one hand, two weeks after "The Rose" appeared in *Hador,* the journal he edited, Frischmann lauded the appearance

14. See "The Rose," "The Hawk and the Sparrow," "Wilted Roses," and "Clipped of Wings," which open Shapiro's *Collection.*

15. Gilbert and Gubar, *Madwoman in the Attic,* 75–77.

16. Ungerfeld, "Dr. Hava Shapiro," 20. Moshe Ungerfeld, a childhood acquaintance of Shapiro, inaccurately reported that Shapiro was deported to Terezin and died there.

17. The ambivalence of the *maskilim* toward female Hebrew writers resembles that of Russian male intellectuals, who, as Mary F. Zirin posits, "greeted women's literary efforts with reactions ranging from generous enthusiasm to snarling dismissal—and, all too frequently, with an admixture of condescension toward the efforts of the frail sex" ("Women's Prose Fiction," 77).

of female Hebrew *readers:* "We have a people, we have a revival, everyone is reading, women have started to read, we have a new continent of readers."[18] On the other hand, he displayed far less tolerance for female Hebrew *speakers.* In a critical essay that appeared originally in 1887, he insisted that women have no business speaking Hebrew, because they are innately concerned only with beauty and never with utility.[19] Invoking the biblical prohibition against cross-dressing (Deuteronomy 22:5), he argued that a woman who speaks Hebrew turns the language into a "woman's dress." Later, in the same essay, he retreated from this position and encouraged female Hebraism, but only insofar as it enabled mothers to sing to their sons in Hebrew so as to instill in boys a love of the language.

As part of these earlier musings, Frischmann tendered an allegorical poem about a (female) rose kissed and adored by a (male) ray of light. Along come sinister winds that spread evil rumors and break up the two lovers. The ray of light ceases to visit the rose, and she withers and dies.[20] According to Iris Parush, this poem is meant to promote feminine lyricism (*haruaḥ halirit hanashit*) within Hebrew literature.[21] Yet a female (rose) permitted to participate in the Hebrew literary enterprise only by depending on a male (light) shows how limited Frischmann's invitation to women was meant to be.

Against the backdrop of Frischmann's pejorative characterization of female Hebraism, Shapiro's sketch takes on additional, subversive meanings as she dons the garb and wields the "tools of men."[22] Frischmann addressed his series of critical essays, *Letters on Literature*, to an imagined woman reader; yet Shapiro, an actual woman reader of Hebrew, rewrote his poem as the story of the rose's triumphal independence rather than her reliance on masculine "light." If Frischmann concedes the necessity of female Hebraism (only) for the sake of producing a future generation of Hebrew sons, Shapiro's rose-protagonist envisions a future generation of rose-daughters, self-confident and self-sufficient, who will shake off limitations and even transgress boundaries. Hava Shapiro hints at her own transgressive behavior by writing under the pseudonym Eim Kol Hai. Like the primordial Hava (Eve), she too dared to sample the fruit of the forbidden "tree of knowledge."

Not all of Shapiro's female characters are feminist heroines. Some remain doggedly attached to conventional feminine roles and thus meet with the author's disdain. In "Types of Women," for instance, she describes and derides (1) the maven, who is a love expert and spends her time arranging matches and living vicariously through other

18. "Me'et ha'orekh," *Hador* 1.50 (26 December 1901): 11.
19. Frischmann, "Mikhtav 1," in *Kol kitvei David Frischmann*, 1: 7–12.
20. This poem is in Frischmann, *Kol kitvei David Frischmann*, 6: 20–21.
21. Parush, *Nashim kor'ot*, 237–38, embedded in her discussion of Frischmann's letter on pages 227–40.
22. Cf. Y. L. Gordon's lyric poem, "Habat hasho'evah," in which winds destroy roses to depict the loss of modesty among the daughters of Israel, based on Jeremiah 49:4. Gordon, *Kol shirei*, 4: 40–41.

people's love affairs; (2) the lover, who disdains study and work and lives only to make men fall in love with her; and (3) the capricious one, who is passionate one day and indifferent the next.[23]

Alas, even some of those who outwardly buck such stereotypes succumb to them in the end. Take 28-year-old unmarried Deborah, the eponymous protagonist of "The Lonely One" as a case in point. Brainy and ambitious, she grows to resent her uncharacteristic characteristics and envies her beautiful sister's desirability in the eyes of potential suitors. In a heartbreaking denouement, she eavesdrops on the following exchange:

> "A naïve young girl attracts you, while an educated young woman ['almah maskelet] . . ."
>
> "Let it go! I know, I see, and I love only you! I respect your sister, but I shall never love her."
>
> "Really? But wouldn't you like me to be educated like her? Isn't that true?"
>
> "Like your sister—oh no! I love you just as you are! Under my tutelage you'll progress."

Such sketches, along with "The Dreamer" (about a youthful feminist revolutionary who grows up to become a jaded wife and mother), "Old Maid" (about a forlorn and jealous young woman who finally finds love), and "Woman" (about a femme fatale), reify certain Western stereotypes and then challenge them with other, countervailing types.

Nearly twenty years after A Collection of Sketches appeared, Shapiro published an additional sketch, "Types" (1928), which functions as a coda (and rejoinder) to the earlier volume.[24] "Types" is a reinterpretation of the hymn "'Eshet ḥayil" (literally "capable wife" but often translated as "woman of valor"), the 22-verse biblical poem (Proverbs 31:10–31), customarily recited on Friday evenings by a husband, that enumerates his wife's household responsibilities and praises her for "surpass[ing] all" in her performance of them. After all, according to traditional Jewish notions of gendered roles, a wife is to perform all pragmatic household activities so that her husband-scholar can study Jewish texts full-time. In this sketch Shapiro pits an ideal type, "the Mother" (ha'eim), whose "duty was her contentment," against her foil, the "woman of valor," an ironic misnomer for a carping wife who regards herself as her husband's martyr. "There is no way, she maintains, that he would survive in this world without her" (emphasis in the original).

The omniscient narrator likens the Mother to the biblical woman of valor: "All other nights of the week [besides the Sabbath] she is busy, for she runs her husband's

23. These types appear in literature by men as well. For example, see Uri Nisan Gnessin, "Zheniyah," in his Kol ketavav, 1: 7–43.

24. For more on this sketch, see Zierler, "Hava Shapiro," 18–19.

business. She has the brain of a man, they say. She neither boasts nor preens and is reserved in her speech. She oversees the activities of her household. She counsels her children. She aids the sick, the poor. Quietly. Modestly. She encourages, strengthens faltering hands, weakened spirits." Not only that but Shapiro describes how the Mother rewards herself on Sabbath evenings, "when the men are at shul [synagogue]" by entering "her special, hidden world." There, she "gives herself over" to the "pleasure" of reading secular books by the light of the burning Sabbath candles, "a modest light, the light of rest." In "Types" Shapiro turns the quintessential Jewish woman on(to) her head, so to speak. "The Mother," the sketch's authentic 'eshet ḥayil, has a man's brain, which she uses to engage in nontraditional study. It is she who is elevated above all other female types. "Beloved Mother in Israel," the narrator concludes, "modest woman scholar [tsenu'ah-maskilah], who compares to you?"[25]

Shapiro draws on her own life to portray both women and men in her fiction. Readers encounter, for instance, more than one male character cut in the image of Reuven Brainin. The position of a solitary woman in the company of eminent literary men ("The Famous One"), the tendency of these literary men to use women writers as muses only to discard them once their source of inspiration is depleted ("The Poet of Pain"), the struggle of the female intellectual to achieve some sort of real parity with her male mentors and colleagues ("Broken Tablets")—all these issues arise in the sketches.

Of particular interest with regard to male characters is "From the Writings of a Tuberculosis Patient" (1920–21), one of Shapiro's extended stories that features a man. Here too she defies gender binaries: Shapiro, the author and thus arguably the manly woman, identifies with the title character, whose physical ailments compromise his virility, which in turn contrasts with the vivacity of his female love object and her other vibrant male suitors. Significantly, this story may point to a link between Hava Shapiro and Franz Kafka, given its provenance in Prague, Kafka's identification with Zionist circles of which Shapiro was also a part, and Kafka's own death from tuberculosis.[26]

In contrast to "Patient," the typical man in *A Collection of Sketches* exercises control over a woman. In a particular pair the metaphor of imprisonment is central: the titles alone of "Clipped of Wings" and "The Hawk and the Sparrow" foreshadow Shapiro's use of birds as representations of females at the mercy of males.[27] Whereas the protagonist of "Clipped of Wings" is stripped of her ability to fly and is thus trapped forever in, literally, a gilded cage, the sparrow in "The Hawk and the Sparrow" eventually tests her own wings and steals/flies away from the confinement of the hawk's nest.

25. For discussion of Shapiro's mother's secular reading on the Sabbath, see Introduction.
26. For more on Kafka's Zionism, see Bruce, *Kafka.*
27. The broken wing imagery is similar to that used in the Russian diary (1854–1886) of Elena Andreevna Shtakenshneider, a woman of privilege who sought autonomy through intellectual activity. See Rosenholm, "Chuzhaia domu i zvezdam," 127.

In any number of her sketches Shapiro uses the verb *mitnagev* (to steal into or away) to suggest how women might transgress forbidden territory, roles, or social situations.[28] The antsy young woman in "In the Reading Room," for instance, is unsure of what to do with herself in the unfamiliar setting of the library and steals glances at her watch and the clock on the wall. In "The Hawk and the Sparrow" rays of sunlight, a standard symbol of the Enlightenment, steal into the eagle's nest, provoking the female sparrow (*deror,* whose name also means "freedom") to steal out of it. And the lonely man in "The Teacher" looks at his wealthy female student "like someone stealing into a forbidden place."

In some cases the verb *mitnagev* alerts the reader to a rebellious action, as in the semi-autobiographical closing sketch, "Sanctification of the Moon," where the female narrator is unable to restrain herself from stealing outside to join her brothers in their sacred ritual. Reminiscent of Devorah Baron's stories from the same period,[29] Shapiro's sketch is narrated by a girl whose sex precludes her participation in male rites, including Torah study. Early on in the story, Shapiro's narrator echoes the talmudic words of Ben Azzai: "My soul desires the Torah" (*nafshi ḥashkah batorah,* Babylonian Talmud, *Yevamot* 63a). In this way, she links her own transgressive, intellectual aspirations to Ben Azzai's unconventional refusal to marry so that he can devote himself completely to Torah studies.

Shapiro's focus on the rite of sanctifying the moon may very well be connected to her own identity as a latter-day Eve. Both kabbalistic and halakhic sources cite various reasons for women's exclusion from this ritual, including the belief that Eve's sin in the Garden of Eden caused "the defect or diminution of the moon" (*pegam halevanah*).[30] If in traditional Jewish practice women have been excluded from sanctifying the moon because of a link to the transgressor Eve, then Shapiro's story, in which the female protagonist participates in the ritual despite her brothers' dire warnings, insists that women challenge these attitudes and undo ancient forms of discrimination.[31]

At the story's end the protagonist trembles with fear when she hears menacing footsteps approaching her bedroom door, recalling her brothers' admonition that she will be severely punished for her brazen act. But the footsteps prove to be those of

28. Shapiro's choice of birds as protagonists—who fly as well as steal into or away—anticipates Hélène Cixous's classic essay "Sorties," in which she observes how women readers fly or steal into literature (*voler* in French means both). See also Zierler's chapter on Yocheved Bat-Miriam in *Rachel Stole the Idols,* 169–86.

29. Cf. Baron's "Genizah" and "Kaddishah" in her *Parshiyot mukdamot,* 415–16.

30. See Israel Meir HaCohen, *Mishna Berurah,* 126a; and Yeshaya Levi Hurvitz, *Shenei luḥot haberit,* commentary on *Parashat,* 311.

31. In the Babylonian Talmud, *Hulin* 60b, a femininely personified moon protests her diminution in status, compelling God to admit fault and institute an atonement offering for the sin of making the moon smaller.

the Gentile gatekeeper, not of a punishing God. As is his duty, the gatekeeper, having observed a waxing moon, had hastened to wake the men and boys for their requisite ritual. However, he mistakenly knocks on the girl's door, fumbling for the handle in the process. Unwittingly, by knocking at her door, the gatekeeper confirms the sister's fitness as a participant in the moon ritual; she will not be punished for her desire to involve herself in Jewish practice. The climactic appearance of the gatekeeper suggests that if the Jewish community refuses to open up opportunities for "its" women, the Gentile world will come knocking to entice them to the world beyond Judaism. That the gatekeeper gropes for the handle of the girl's bedroom door evinces the erotic language of the biblical Song of Songs (5:5), thereby adding an ominous, sexual layer to the story.

In contrast to the transgressor portrayed in "Sanctification of the Moon," in other sketches Shapiro trots out familiar "female" types, whom she largely censures.[32] Shapiro is a feminist who often derides women, especially those she considers "light-headed" or superficial. When she reinforces stereotypes, she often does so to harpoon those who remain faithful to them. At the same time, she challenges and overturns so-called associations between women and particular attributes, rejecting the notion that woman has an essential or true nature. Instead, she portrays women who yearn for self-actualization, as well as companionship, and who break out of traditional molds, even at great personal cost.

After publishing *A Collection of Sketches* and earning her doctorate, Shapiro began to devote herself to writing critical essays and journalism, which appear under the byline Dr. Hava Shapiro. Her production of sketches, stories, and works of memoiristic fiction did not cease altogether, though, and several are found under the pseudonym Eim Kol Hai during this period. Two such works, "The Brothers from Slavuta" (1914) and the previously mentioned "From the Writings of a Tuberculosis Patient" (1921), evince a different style from most of the sketches in *A Collection.* Whereas the sketches in *A Collection* are characterized by modernist prose largely devoid of Jewish content, "Patient" includes a string of biblical allusions and "Brothers" assumes a more pious register, perhaps because of the standards of Yosef Klausner's *Hashiloaḥ,* where both stories appeared.

According to Simhah Bloch, one of Shapiro's acquaintances, in the 1920s Shapiro was also ambitiously preparing materials for a memoir.[33] Apparently all that remains of the project are four works ("Days of Awe," "Hanukkah Days," "Passover Nights," and "Among the Nations"). With a skillful hand Shapiro blends vignettes from her

32. Shapiro's cataloguing of feminine literary stereotypes anticipates the inquiry that begins with the second chapter of Virginia Woolf's *A Room of One's Own* (1929) and persists in Simone de Beauvoir's *Le Deuxième Sexe* (1949), Mary Ellman's *Thinking about Women* (1968), and Kate Millett's *Sexual Politics* (1970).

33. Bloch, "Dr. Hava Shapiro," 57–58. Although an acquaintance of Shapiro's, Bloch's reminiscences of her are inaccurate in part compared to contemporaneous sources.

childhood with first-person accounts of contemporary experiences, inducing readers into a fuguelike state where reality and fiction blur.[34]

Jewish holy days became occasions for Shapiro's fond but also painful reminiscing, especially compared to the blighted present. Images of religious observances of the past are, in Shapiro's words, "veiled in glory and suffused with light" in contrast to the "shadows and impressions" of ceremonies of the day, which seem contrived at best but mostly neglected by Jews daunted by the exigencies of interwar Europe ("Hanukkah Days"). Although Shapiro chafes at her coreligionists' indifference to their heritage, she admires the Gentiles for their "natural, religious, and national tendencies to develop and to find sustenance [. . .] in memories of their childhood days" ("Among the Nations").

Shapiro herself seems trapped in a hazy borderland between nostalgia and wistfulness. As she writes in "Days of Awe":

> Now, when I return to those same places, those same laws and customs, I no longer recognize and find in them that same holiness, that same lofty exaltation that enveloped them then. Perhaps it is only in my enthusiastic imagination that I fashioned for them such vestments of holiness and purity. [. . .] I grieve for my imaginings and my visions that have steadily been destroyed without mercy. And my heart is filled with longings for that which is beautiful and lofty, the wonder of childhood that has been frightened away by what has become simple reality.

Indeed, the explosion of dire world events over the next decade and a half would erase nearly every vestige of girlish wonder, such that Shapiro would exclaim, "Childhood days—my longings for you are pursuing me!" ("Hanukkah Days").

Melancholy aside, these semi-autobiographical accounts provide welcome details about daily religious life in the Pale of Settlement,[35] along with a cast of characters that helps to fill out Shapiro's family tree. Relatives play leading roles in these scenes: Mother, brothers, grandfather, aunts, and uncles enter and exit, leaving behind vivid portrayals of elaborate domestic holiday preparations. "Passover Nights" is especially

34. For a discussion of the fluidity between the genres of fiction and autobiographical writing, see Ben Dov, *Hayim ketuvim*; and Stanislawski, *Autobiographical Jews*. Stanislawski cautions that because the genre is characterized by the "conscious and far more elusive unconscious distortions of memory and narrative selection" (4), autobiography should not be read as factual account (177). In some measure, Shapiro seems to anticipate these latter-day theoretical and critical insights by writing in a genre that almost self-consciously blurs generic boundaries. She included "memories" in her book of fictional sketches and continued to develop this mode in later works.

35. The Pale of Settlement was a territory covering present-day Poland, Latvia, Lithuania, Ukraine, and Belarus, to which 90 percent of Russian Jewry was restricted from 1791 to 1917.

significant in this regard because of its interest in the arduous tasks performed by women in anticipation, ironically, of the feast celebrating liberation.[36] Note as well the ubiquity and authority of servants enlisted not only in the care of the household but in the carrying out of Jewish religious duties. For instance, take Gittl the cook, the "simple, wretched creature" wrapped from head to toe in "a long cloth outfit, part dress, part nightgown, a new kerchief on her head," whose intermittent chastising does not upset the children, because even they "recognize her current importance and elevated status." Shapiro's mother appears from time to time to supervise the work. Ultimate authority rests with her in this domain.

Readers sense otherwise with regard to her daughter, who finds herself suspended between feminist aspirations and traditional expectations. During matzo baking, the servant girl Susil asks Shapiro to jot a note for her. When she demurs, Susil implores, "You write such lovely notes." At the seder, however, her skills go unnoticed. Although Shapiro knows the Four Questions (of the Haggadah) as well as her brothers do, she is relegated to the women's table, and no one but her mother seems to understand the offense. As she explains: "I also know 'the Questions' by heart, but no one pays any attention to me; the main attraction is my brother. Inside I am seething. I would have asked them even better than he did. But me they send me to sit with the women. Only my mother sees my pain and consoles me with the wonderful caresses of her eyes." Indeed, here, as in "Sanctification of the Moon" and "Hanukkah Days," Shapiro's mother is a crucial, inspirational model for the budding writer, Hava.[37]

In the second half of "Passover Nights," Shapiro shifts to a depiction of herself in perilous postrevolutionary Ukraine. As chair of the local Zionist organization, Shapiro finds that her life is at risk, and she goes into hiding with a Gentile family. She emerges on Passover eve, disguised as a priest, to attend her family's seder. Here, too, like so many years before, only her mother recognizes her for who she is. If the sketch begins with Hava's desire to "cross" over into the realm of Jewish masculine ritual practice, it culminates in tangible signs of identity "crossings," as she assumes a most unconventional leadership role and wraps her femininity in masculine Christian garb.

The specter of death hovers over the entire story of "Passover Nights." It opens with a description of the two town cemeteries, which are adjacent to the market where Passover shopping occurs; during Passover preparations, Susil, dressed in a white uniform, is compared to a dead woman in a shroud; and informing all this is the fact of

36. For additional examples of women's Hebrew writings about Passover preparation, see letters by Berta Rabinovitz and Miriam Markel-Mosessohn in T. Cohen and Feiner, *Kol 'almah 'ivriyah,* 112–14, 186–88; and the discussion of Wengeroff and Rakovsky below.

37. In "Hanukkah Days" (and in the later sketch "Types"), the descriptions of Shapiro's mother's piety and intellectualism become opportunities to challenge the rabbinic assertion of *kalut da'at* (female light-headedness or feeblemindedness).

the death of Shapiro's mother, in whose memory the sketch is dedicated. The strength of the piece rests in Shapiro's use of specific, detailed depictions and skillful combining of personal reminiscences with issues of larger communal significance.

Shapiro's memoiristic fiction calls to mind a staple of East European Jewish history, namely, the memoirs of Pauline Wengeroff (1833–1916), who began formally recording scenes from her past in German in 1898 at the age of 65 and did not stop until she had filled two volumes.[38] In stark contrast to Shapiro, Wengeroff characterized the so-called traditional way of Jewish life as "perfectly calm" and rued the day when modernity came to subvert it.[39] Shapiro's use of (secular) Hebrew to construct her semi-autobiographical stories necessarily links her to a modern and, in many instances, countertraditional perspective.[40]

Although lesser known, it is the Yiddish memoirs of Puah Rakovsky (1865–1955) that demonstrate how Shapiro was not alone in feeling straitjacketed by the societal and religious expectations borne by Jewish women of her generation.[41] In fact, the details of Rakovsky's life story bear an uncanny resemblance to those of Shapiro: She was tutored as a girl in Hebrew and in European languages and literature and later broke with the religious culture of her youth and began to publish in the Hebrew and Yiddish press; she fell in love with another man while in an unhappy marriage and not only carried on a clandestine correspondence with him but eventually left her husband and secured a divorce; she had a son as a newlywed (and a daughter three years later); she moved away from home to receive training for and pursue a career (as a teacher; she ultimately established schools for Jewish girls); she left her children, intermittently, with relatives; she was a fervent Zionist and attended a number of its annual congresses (in 1920, 1921, and 1925) while dedicating her life to the cultivation of Hebrew; she read and/or associated with the same literary men as Shapiro (e.g., Nahum Sokolov and Uri Nisan Gnessin); and, finally, she shared the hope that their

38. See Pauline Wengeroff's *Memoiren einer Grossmutter: Bilder aus der Kulturgeschichte der Juden Russlands im 19 Jahrhundert* (Memoirs of a Grandmother: Scenes from the Cultural History of the Jews of Russia in the Nineteenth Century); English translations of the German include Shulamit S. Magnus's *Memoirs of a Grandmother: Scenes from the Cultural History of the Jews of Russia in the Nineteenth Century* (Stanford, CA: Stanford University Press, 2010) and Henny Wenkart's *Rememberings: The World of a Jewish Woman in the Nineteenth Century*, Bernard Dov Cooperman (ed.) (Bethesda: University Press of Maryland, 2000). Wenkart's translation is abridged.

39. For "calm," see Magnus, "Sins of Youth," 102.

40. In comparison, Rachel Katznelson Shazar began her diary in Russian and Yiddish and turned to Hebrew only after she immigrated to Palestine, and Bella (Rosenfeld) Chagall wrote *Burning Lights* (*Brenendike likht*) in Yiddish in 1939. See Shazar, *Adam kemo shehu*; and Chagall, *Burning Lights*. See also Raider and Raider-Roth, *Plough Woman*.

41. Rakovsky, *Zikhroynes fun a yidisher revolutsionerin*. The book has been partially translated into Hebrew (*Lo nikhnati*, 1951) and into English (*My Life as a Radical Jewish Woman*).

autobiographical writings would inspire a younger generation of women.[42] For all their similarities, Rakovsky strikes a quite different tone in her autobiographical writings from Shapiro. Self-assured, despite a failed marriage and a love affair that dissolved in heartache, Rakovsky managed to release herself from the grip of harmful men and embraced professional opportunity and supportive colleagues, men and women alike.[43]

Shapiro did not chart a fiercely independent course surrounded by others. She was, after all, a writer, not a teacher, whose mostly solitary existence was oriented inward. Even as she broke with the religious practice of her childhood, her abiding attachment to her mother moored her to a past in which patriarchal tradition held sway. "The Brothers of Slavuta," more than any other work in her fictional oeuvre, demonstrates Shapiro's fealty to and admiration of her family's pietistic past.

In contrast to the memoirs that focus primarily on the personal, "Brothers" is spun from details relating to a historical event that happens also to be part of Shapiro family lore.[44] The story Shapiro tells is one chapter in the interminable dispute between the Hasidim of Ukraine and the Mitnagdim (literally "opponents") of Lithuania, which, in this case, involved publishing rights. The Hebrew printing press of Shapiro's great-great-grandfather Moshe established in Slavuta in 1791 specialized in religious books, including editions of the Talmud. When, in 1834, Menahem Mann Romm of Vilna began to publish a rival edition of the Talmud, with the approbation of Lithuanian rabbis, the Slavuta printers regarded it as an infringement on their exclusive right, guaranteed by Ukrainian rabbis, to publish the Talmud for a fixed span of twenty-five years.

In 1835, when the controversy was at its height, Russian authorities closed down the Slavuta printing press, after the brothers had been denounced for their part in the death of one of their employees, a bookbinder who had been found hanged in the town synagogue.[45] Although it became clear that the death was a suicide, Moshe Shapiro's two sons, Shmuel Abba (1784–1863) and Pinhas (1792–1872), who ran the printing press,

42. See Rakovsky's foreword in *My Life.*

43. In fact, it was a female confidant—fellow Hebraist Rachel Katznelson—who urged Rakovsky to publish her memoirs and then contributed an introduction to both the Hebrew and Yiddish versions.

44. Historians corroborate Shapiro's facts, including Zederbaum, *Keter kehunah,* 139–41; and Friedberg, *Toledot hadefus,* 104–9. Shaul Ginsburg (1866–1940) published "Di Slaviter drame," a series of twelve articles in the *Forverts* (12 December 1937–27 February 1938) about this incident, which he claimed was based on Russian archival sources. The articles have been translated from the Yiddish in Ginsburg, *Drama of Slavuta.* Ephraim H. Prombaum, Ginsburg's translator, claims to be a descendant of Pinhas of Korets and refers to his distant relative, Hava Shapiro, as a "heretic" (phone conversation, 6 December 2012). Incidentally, one of the last articles published by Shapiro is on Shaul Ginsburg: "From the Recent Past (On the Historical Writings of Shaul Ginsburg)" (1938). See also the letter from Shapiro to Ribalow (2 June 1938) in Part III.

45. Shaul Ginsburg described the synagogue sexton, Leib Tsenger, finding the corpse of Lazer Protegin, a relative of the Shapiros through marriage, who apparently suffered from "melancholia" (Ginsburg, *Drama of Slavuta,* 50–51).

were implicated in the death on a trumped-up charge. The brothers were arrested and languished in a Kiev prison while awaiting their verdict. Meanwhile, as a consequence of the printers' dispute and the supposed intervention of the *maskilim,* government officials shut down every Hebrew printing press in the Russian Pale of Settlement in 1836, except for those of Vilna and Zhitomir. After a lengthy investigation and trial of several years, the Shapiro brothers were found guilty and sentenced to severe physical punishment and banishment to Siberia. After intercessions authorities allowed them to be exiled to Moscow, where they remained for almost twenty years. In 1855, upon ascending to the throne, Alexander II pardoned the brothers and allowed them to return to Slavuta. By that time two Shapiro brothers of the next generation had leased the Zhitomir press and had resumed issuing books in the Shapiro name.

In "The Brothers from Slavuta" the reader revisits the past from the unique perspective of an insider. Shapiro's account is not a mere recording of but a compassionate look at her relatives' anguished reaction to a familial tragedy that had far-reaching implications for the whole of Russian Jewry.[46] It is significant that Shapiro is laying claim to narrative authority with respect to a story that others have already told. By doing so, she asserts her right to participate in the tradition of Hasidic folk legend, which was devoid of women's voices altogether. Thus readers should note her attention to female characters—the niece, the *rebbetzin,* and the wife of Rabbi Pinhas—and the voice of the female narrator. The woman who turned her back on the religious devotion of her childhood and lived her adulthood as a *maskilah* assumes here a densely pious tone.

46. Shapiro wrote Brainin that she published "The Brothers from Slavuta" in Yiddish and Russian translations as well (Letter from Shapiro to Brainin, 24 March 1920, in Part III).

A Collection of Sketches
(Kovets tsiyyurim)

Title Page

Dedication

Eim Kol Hai

A Collection of Sketches·

Warsaw. 5669.
I. Edelshtein Press. Nalevki 38.

Sbornik Razskazov', Kh. Shapiro
1909
Tip. I. Edel'shtein, Varshava, Nalevki 38.

Dedicated to my mother.

Preface

Our literature lacks the participation of the second half of humanity: that of the weaker sex.

In my entering now into this unfamiliar sphere, my strongest hope is that many others of my sex will be inspired to journey in my footsteps. So long as they do not take part, our literature will be impoverished and lacking a certain nuance.

Time and again, when we are amazed and awed [both verbs in feminine form] by the great talent of a "wonder worker,"[2] one who "penetrates [masculine form] the woman's heart," we feel at the same time as though a strange hand has touched us. We have our own world, our own pains and longings, and we should, at the very least, take part in describing them.

I know that I have not yet fulfilled the requirements that I myself have set before the male or female artist. This collection of sketches is only an experiment, only the beginning of the revelation of the female spirit, which has been forced to abandon the treatment of "its sorrows, joys, hopes, and wishes"[3] to others.

I also know and recognize the impediments and obstacles that have been placed [before women], both intentionally and unintentionally, on the path of literature in general; and I am aware of the weakness and relative insignificance of our literature in particular. Nevertheless, all the guiles of the niggardly will not deplete my strength nor distance me from my position.

Artistic perfection is my aspiration and my ultimate goal.

Now, in publishing this *Collection of Sketches* I am filled with confidence that it will be received as a bold attempt to tread on new ground.

Cand[idate] of Phil[osophy], Hava Shapiro.
(Eim Kol Hai).[4]

2. See Part I introduction.
3. From Y. L. Gordon's "Kotso shel yod"; see Part I introduction.
4. Cf. Genesis 3:20: "And the man called his wife's name Eve; because she was the mother of all living."

The Rose

Originally appeared in *Hador* (12 December 1901)[5]

"Tell us, tell us what happened to you!" the other roses requested of their beautiful and melancholic friend.

"Leave me alone! Let me breathe in air, soak in light, and revel in freedom . . . and then I'll tell!"

Some minutes later, the roses returned and asked again.

And so the rose told them:

"Yes, friends! I suffered greatly from the time I was separated from the place where I now stand! My mistress commanded that I be planted in a flowerpot with a handful of dirt from where my people are rooted, and placed in a corner of the house.

"There, indeed, the woman tended to my soul and my growth. She ordered her maid to give me lots of water, to sprinkle rain water on me occasionally, to open the curtains on the windows for my sake, so that I could gaze at times upon the light in the distance.

"But she forgot one thing, which is that there was not enough air there to breathe!

"I was suffocating—and yet she would close the window!"

"'Let's not let the wind in that will harm the rose,' she would say over and over again.

"I thirsted for the raindrops, like all others of my kind—but she gave me muddy water!

"I needed morning dew, dew of rejuvenation—but she drizzled water on me that had been trampled! All this was in a large room in which they cleared for me but a small corner!

"Sometimes, however, the mistress would allow her maid to lift me up and place me on the parapet under the cover of the sky.

"But this only enlarged the wounds in my heart.

"For then I saw—poured over the entire universe—light!

"From a distance I saw my sister roses, reveling in light, air, freedom!

5. "The Rose" is Shapiro's first published work. Note that *shoshanah* (rose) is a feminine noun in Hebrew. A work by Brainin appeared in the same issue of *Hador* as "The Rose": "Anashim ḥadashim (mikhtavim miberlin)" (*Hador*, 12 December 1901, 6–9). "The Rose" appeared in a German translation in 1929; see Appendix 8.

"I saw sparkling drops of dew upon several sister roses standing before the sun, and I envied them!

"A few rays of light also reached me, and I forgot my torments and my heart exulted [ga'oh ga'ah].[6]

"I forgot that I was standing on the parapet of the house; I forgot my strange situation.

"A few of my sister roses nodded to me with great sympathy.

"Ah! If you only knew how painful, poisonous, exasperating, and insulting were those expressions of sympathy!

"Soon the maid would come to incarcerate me again and stifle the soul that yearns for God's wide spaces. And there she came, returning me to that corner of the room designated just for me.

"The world thus darkened before me!

"The world seemed small and poor and even more suffocating."

"'Aha! Look how beautifully my rose has grown!' my mistress exclaimed, casting her eye over me.

"And beauty, what good does it do me if my life is contemptible in my own eyes? For what purpose is beauty if I have no air, no space, no sunshine! Please, take me out, you coarse creatures, closed off to beauty [stumei-hayofi],[7] protect me, for only out there will my beauty bloom!

"I pleaded, complained, prayed, but the mistress failed to understand me, for all was pleasant with me, and my voice could not be heard!

"At that point I resolved to suffer and bear all the trials that befell me with an upright carriage, with courage and great confidence.

"But before long, I began to wither and wilt; my head drooped, my leaves began to dry and fall off. My face looked as though I was dying. My glory and splendor had departed!

"The mistress then saw my impending death.

"She saw and commanded that I be returned to the garden where my soul was rooted.

"And now, the place is no longer too narrow,[8] I no longer worry nor fear![9]

"I laugh in the face of tempests and storms!

6. Cf. Exodus 15:1: "I will sing to the Lord, for He has triumphed gloriously."
7. Cf. Lamentations 3:8: "And when I cry and plead, He shuts out [satam] my prayer."
8. Cf. Psalms 118:5 ("In distress [min hametsar] I called on the Lord; the Lord answered me and brought me relief") in relation to Shapiro's "narrow" (tsar) place. Note as well that the Hebrew word for Egypt (mitsrayim) has been understood as "from the narrow parts"; Shapiro's "narrow" supports a Zionist interpretation of the allegory, whereby the rose stands for the people of Israel being uprooted from their soil and eventually replanted in their indigenous homeland.
9. Cf. Isaiah 12:2: "Behold, the God who gives me triumph! I am confident, unafraid [evtaḥ velo efḥad]; For Yah the Lord is my strength and might; and He has been my deliverance." This verse, which opens the Havdalah service that differentiates between the Sabbath and the rest of the week, is a fitting allusion, given the Rose's resolve to differentiate herself from the run-of-the-mill roses.

"Now I no longer pay attention to dirty hands, or those lowly creatures who come to me every minute with the aim of destroying and obliterating me,[10] of separating me from life for their good and pleasure!

"I laugh in the face of my many enemies and lovers alike! I laugh at these lovers, who, in their great love for me, in their amazement over my external and internal beauty, want to pluck me from the ground and remove me from the world!

"I laugh at all the great researchers and know-it-alls, who, in their love of truth and knowledge, believe that it is their sacred obligation to pluck those of our kind and research our nature, the secret of our greatness and our growth.

"I laugh at all those tiny crawlers and creepers, who cannot stand upright and reach my height, those who despise and envy me, and thus endeavor to subvert and undermine my roots.

"Now I laugh at them!

"I am taller than they are and their angry slings and arrows cannot reach me!"

Thus spoke the rose.

"But how is it that one of your place and height is not stooped over, that the light of your face has not dimmed and your brave spirit has not been put out? That you continue to grow and become ever more lovely!" cried out the other roses.

"Yes, my friends, even now I am taller than all of you! You cannot rise from where you are standing. For that reason, you can only hear my voice but cannot see my face![11]

"I am taller than you and you cannot reach me! I see the sun when it first rises in its proud splendor before it begins to illuminate those of small spirit, those who are immersed in their vanities and contemptible schemes.

"I see the first rays of the sun and they are filled with shining light! They penetrate my soul, fill me with life, joy and purity—and none of you sense any of this at all!

"I hear the language of the shadows, as they whisper one to the other. I speak their language. They turn to me and bless me, and none of you can understand this!

"I awaken to the song of the nightingale. I feel the song inside me, I become elevated, exalted, and strengthened.

"I know, of course, of no rest, and you—none of you can know or have the capacity to know my pains."

"Insolence, arrogance, haughtiness!" the embittered other roses complained, inclining their heads toward one another, whispering into each others' ears. They raged and fumed and vented their ire to one another.

They did not realize the rose could see it all from above, all their winking and whispering.

10. Cf. Passover Haggadah: "In every generation, there are those who rise up to destroy us, but God saves us from their hand." This motif is echoed in the book of Esther.

11. Cf. Exodus 33:17–23 and Song of Songs 2:14.

A strong wind rose up and blew.

It howled and raged as though seething with anger.

It stormed fiercely, seeking refuge in all the windows of the tall houses—but was refused entry by all.

All the windows were quickly sealed.

The wind stole into all the small, rickety houses, those dilapidated ones on the verge of falling over, into their dank narrow rooms, through the cracks in their walls.

In the field and the large garden the wind also used its force to bend over that which was upright,[12] toppling over and uprooting the plants. The roses trembled in its wake.

All of them kneeled and bowed and bent their heads.

Only the highest rose stood her ground in disobedience. She would not kneel, would not bend her head and submit!

She held her head high, laughing and mocking her friends, she did not fear nor did she tremble,[13] standing fast with strength and confidence.

The wind blew strong around her, endeavoring to uproot her from her place, but she remained rooted, like a nail planted in wood!

All around her the wind knocked over its victims. Many of the rose's comrades were uprooted, even the rose closest to her was tumbling to the ground. Before long it will reach her too.

"Take a look," the other roses call out, "Her end is near. Soon enough, even this haughty one will fall!"

But she paid no attention to their words and persisted in standing tall, as the wind continued to kill everything.

She simply turned her head to the side.

The storm passed. The wind quieted. Stillness even in the garden. "Tell me good friend," asked the rose closest to the highest rose, "How do you have the great strength to withstand the storms and the tempests? Tell me your secret!"

"My secret is well known to many, and yet many still do not understand. I'll reveal it to all of you.

"My roots were planted with great effort deep into the heart of the land. I grew and became lovely, and it is my roots that allowed me to live and gave me courage and strength. I grew strong and courageous because I believed in my powers.

12. Note Shapiro's reversal of the morning blessing, in which one praises God as "the One who makes upright all who are bent over" (*zokef kefufim*).

13. Note Shapiro's reversal of the biblical verse; cf. Job 4:14: "Fear and trembling came upon me, causing all my bones to quake with fright."

"And now, even if I were to be plucked or cut down—only I would perish, for a new rose would grow in my stead, ever stronger and more confident, a young rose who would believe in herself and her own powers, a free rose who would not submit to your yoke or to any boundaries you would put upon her.

"I may wither, but my stock[14] will live on forever!"

"A wondrous thing," said the other astonished roses.

14. Alternative translation: "my race" (i.e., the Jews).

The Hawk and the Sparrow[15]

Abandoned and desolate, the old hawk lived in his nest. His powers had deserted him, the sweep of his wings had weakened.

One day, chance brought a small, young sparrow [deror][16] to the hawk's nest.

The sparrow was confused and disoriented, having strayed from her native nest.

The hawk resolved in his heart to draw the sparrow toward him.

She would be a consolation to him in his old age, when the strength of his wings gave out altogether.

He resolved and acted. He began with affectionate words, a smooth tongue; he approached her and encouraged her, caressed her wings, spoke softly—and brought the confused sparrow under his wings.

And the innocent sparrow was happy to find a savior and a redeemer, and her heart trusted in him.

And the desolate nest was filled with life and movement, with joy and youth.

And the hawk was captivated by his small captive, and his soul was tied to hers.

In his love, he began to fear; he hardly knew his heart.

And he grew vigilant.

When the sparrow went out to see the lofty heights, he accompanied her to protect her.

And when she tried to alight into the air, high and strong, he would scold her about the foreseeable dangers.

And the innocent [sparrow] believed [in him], dared not do anything without him.

And when the sparrow raised her voice in song, the old one joined in as well, and he taught and trained her to adapt her songs to his hoarse voice.

And the sparrow sang no longer; rather, she thought gloomy thoughts.

Spring approaches and the sparrow begins to rejuvenate.

She tweets and chirps her chirrups.

15. The sketch appears to allude to the relationship between the older Brainin (hawk) and the younger Shapiro (sparrow).

16. In Hebrew, *deror* can mean both "sparrow" and "freedom."

The hawk hears and his heart trembles within, and he criticizes the sparrow's song, screeching and squawking.

And he detests the song [and heaps] criticism upon her.

The rays of sun steal into the nest, leaping and playing within.

The magic of spring brings yearnings to the sparrow's heart that grow ever stronger, ever bolder inside her.

Her heart pours out her song, and her song is filled with yearning, hope, and freedom [ḥofesh].

And the hawk cannot keep up with her. He listens and shakes his head.

One day the sparrow steals away and leaves the nest. She finds herself alone, outside—God's expanse is before her. The rays of the sun reach out to her, playing on her wings, illuminating her eyes, and a light breeze caresses her and warms her heart.

Enchanted, she pauses and marvels.

And an intense desire to sample her own powers awakens within her.

A moment [passes]—and she spreads her wings and alights.

Above her airy clouds and blue splendor arise, and around her a vast expanse and before her a splendid horizon [appear].

And the height captivates, the horizon attracts, and she rises ever higher.

And she senses that her flight is lighter than that of her protector, and he will not reach her up here.

And the horizon grows wider and her aspirations grow bolder.

And she casts [me'if][17] a backward glance and sees the nest in the distance, and it looks old and slight.

And she soars off on her own path.

And the old hawk—sits and waits for the return of the fugitive—the traitor, all the while grumbling and complaining.

17. Note the clever pun on "casts," as *me'if* shares a Hebrew root (ayin-vav-feh) with "to fly" (*la'uf*).

Wilting Roses

Originally appeared in *Hador* (21 October 1904)

The first frost occurred at night. In the morning, I went outside to the garden—how different the flowerbed looked!

The buds had changed their appearance. The leaves no longer had their color, and the roses—Oh, wretched roses, how difficult your fate!

The leaves that cleaved to them had dried up, shrunk, and separated from one another. They had darkened, blackened, [now] hanging dry, gaunt, and tattered all around.

Where were the green leaves that flourished just yesterday, widening and surrounding each and every rose, as if to protect them? They have all separated themselves, distanced themselves, turned away from the wretched ones, who until now had been splendid and majestic before them, displaying their glory and captivating every soul, bestowing their splendor on all those around them.

Are these your wretched faces?!

Just yesterday one marveled at your beauty and your unblemished whiteness; just yesterday you were so proud and conscious of your advantage over the others of your kind—your height, your splendor, your glory justified you in that.

How is it that you surrendered, proud-hearted ones? What is it that made you submit?

Those who were filled with hope and strength, life and bloom, gentleness and youth, have now become wilting roses.

Their heads have bowed, their faces have shriveled, their scent has dissipated, their beauty has disappeared, their color faded. All that remains of their flourishing proliferation and form is a mere shadow, the shadow of life passing by. The sight arouses pity, compassion, and heartache.

Oh, miserable roses! Only yesterday you despised such feelings; just yesterday you shook your heads with pride and laughter upon hearing such things. Will you awaken them today?

Even in death, you are different!

I approached one of the roses and plucked it. It seemed to me that she nodded her head and thanked me for this final kindness.

Perhaps it was painful for her to stand and be seen among the other flowers, having become accustomed to another sort of appearance.

I felt deep heartsickness.

I turned my eyes toward my surroundings and saw many flowers standing here and there. Their appearance and that of the surrounding greenery had all changed so much, but they still stood firm and endured; they were still alive.

But you, gentle roses, you could not withstand the first frost!

You are more fragile than your friends, and the frost destroys you.

I understood what made you submit, and I knew that you could never become used to or make peace with frost and frigidity.

This is what makes you different both in life and in death.

And I no longer pitied the roses; rather, I envied them.[18]

18. Like "The Rose," this sketch can also be read as a Zionist allegory. Here, the climate is at issue: The roses (i.e., Jews) are not accustomed to the harsh cold of the Russian Empire and thus succumb to the first frost. They would presumably thrive in the warm climate of the Land of Israel.

Clipped of Wings[19]

A sparrow [*deror*][20] flew, soared, glided along in the lofty heights, and hovered in the distance. Her eyes were lifted only skyward, to a lofty point. There she beheld the source of her contentment, the object of her longings and aspirations.

She did not lower her head, right or left—she only hovered and ascended. The air was crisp, the flight easy, the sky clear, and the clouds far away.

Suddenly, she changed course, descended, and came to rest on one of the tangled branches of a tree. Mischievous boys were waiting below, their net spread open to [catch] anything that might dare to fly away.

The bird was trapped by the mischievous boys. The boys clipped her wings slightly and placed her in a pretty gilded cage. They danced and pranced, calling to her: "Here she is in our cage! Here she is in our cage!"

The bird remained in the cage, desolate and stunned, hardly recognizing herself.

Days passed and the boys derived no satisfaction from their prisoner. She did not leap or whirl;[21] she neither chirped nor sang. She shrunk into one of the corners and remained silent all day long.

The boys deliberated over whether to cast the bird out or let her be, for she did not open her mouth to sing and did not turn toward her torturers. They decided to wait.

One day, the bird raised her eyes and looked out the window of her cage and saw a flock of sister sparrows passing by, setting out for distant lands, warmer climes. In flight, their wings rustled as they whistled and caused a ruckus.

The bird remembered the clear skies, which she longed for then, the pure air, and the boundless space. The air here was stifling, the cage narrow, and the sky overcast.

19. Cf. Letter from Shapiro to Brainin (22 November 1903) in Part III, in which Shapiro refutes Brainin's claim that the bird of clipped wings is a metaphor for her.

20. "Sparrow" in Hebrew is *deror*, which also means "liberty" or "freedom." For a similar motif, see "The Hawk and the Sparrow."

21. Cf. 2 Samuel 6:16: "Michal [. . .] saw King David leaping and whirling before the Lord; and she despised him for it." Michal regarded such displays as demeaning, as did the sparrow, apparently, who refused to indulge her (male) captors with a performance.

Her soul was poured out as she raised her voice in song.

Her song was sad and mournful, filled with heart's pain and black sorrow, soulful longing and a grieving spirit.

Those within earshot heard and reveled in this song of sadness.

The boys danced and clapped. "Behold the bird is awakening. Soon she'll sing our very own songs. Soon she'll be our very own!"

The bird hears and sighs to herself: "Oh, oppressors! Give me liberty, give me freedom" [*havu li deror*].[22] It would be better for me to die there, in God's blessed heavens, than to be crammed into your narrow cage."

The boys paid no attention to her pleas, and closed the door of her cage behind her.

Outside the window of her prison, the bird saw one of her friends leaping and frolicking on the branches of a tree opposite her cage. She whistled and bounded from one branch to the next, paying no mind to her surroundings. And the hunter lay in ambush below. She longed to warn her friend. She danced about in her cage and poked her beak out the small window, shuddering and shaking with trepidation.

Suddenly, trrr! Her friend fell, wallowing in her blood[23] on the ground.

The boys scolded the bird for her delusion and spoke to her tenderly:[24] "You see, there above your head hovers danger, whereas here you are safe, and yet you complain!"

The bird hears and chokes down her blood.

With her song, she gave emphasis to all her heartache and the pain of her soul, the sorrow of the collective and sadness of the individual, and the song overflowed with grief and filled the air with silent misery.

One day, she happened to open the door of the cage.

She crept forward and poked her head out. But she was frightened and retreated.

Just another step and she'd be on the branch where her friend was murdered.

The air penetrated her insides, intoxicating her. She spread her wings and flew.

The open horizon enticed her, and the sound of the sparrow greeted her happily. She gathered her strength, and behold she was fluttering slowly in the air but she could not ascend.

Suddenly she remembered: Oy, her clipped wings!

22. *Havu li deror* means "give me freedom," but the word *deror* also means "sparrow." She is asking to be allowed to reclaim her identity as a free sparrow.
23. Cf. Ezekiel 16:6: "When I passed by you and saw you wallowing in your blood."
24. Cf. Genesis 34:3. The same language is used to describe Shechem's pursuit of Dina, whom he subsequently rapes. Like Shechem, the bird's captors have dubious, selfish intentions.

The Lonely One[25]

In the large dance hall, aglow in electric light, the couples are about to begin the waltz. The young men, standing at a distance, whisper about "choosing a partner," looking, considering, arguing.

And the women, seated in their spots, wait to be "chosen." Signs of impatience and hidden expectation are discernable on the faces of the youngest and most beautiful. Their faces are pale from the excitement of their waiting, yearning, hoping hearts.

Their eyes shine, their lips tremble.

A forced smile hovers on the faces of the bland and unattractive women; it is meant to prettify them but disfigures their faces even more. They sit poised in artificial calm.

One more moment and the happy "chosen ones" will get up from their seats, clutching the arms of the men who will bow before them, and will disappear into the expanse of the hall. Their hearts beat and their faces emit great excitement.

That same wishful smile, which was set in place beforehand, remains frozen on the lips of those who remain in their seats, those not yet chosen for the dance.

The heart despairs, but the smile still hovers on the lips.

There, inside the hall, the dance begins and swallows up all the thoughts of those taking part.

The feet quicken their movements, the hands join, the hearts beat in unison, the bodies cling together and become united, the eyes shine and sparkle, the lips move and quiver.

A young woman of about 28 years old sits inside the hall under a huge mirror illuminated from both sides. Discernable on her thin, pale face is a certain hidden pain, which is reflected mostly in her eyes in their guarded and rebellious gaze. A fake smile, filled with bitterness and grief, hovers at the corners of her mouth. Her bright-colored dress emphasizes all the more the cloudy pallor of her face and its greenish hue. Her dark hair is chopped short, and the bangs are not sufficient to hide the lines on her forehead.

25. With "The Lonely One," Shapiro rolls out more realistic sketches.

"All this feasting and joy is for me, in my honor,"[26] she thought, "but even so, it's as though they have all gathered and forgotten me. They still think that praise and commendation are enough for me. Simpletons! I've had my fill of honor. I want *life*! Life! Life!"

And she looks out, as though against her will, at her beloved younger sister as she passes by, embraced by and firmly attached to the arms of a tall young man. A happy smile is on her lips, a wondrous gleam is in her eyes, and her whole being is trembling and overflowing with life.

Faint melodies from the hidden recesses of her heart are awakened. She shifts her eyes from her sister. Should she be jealous? Of her sister? Of such empty things? What is this sort of life to her? She was not meant for this.

She has always been distant from these joys of life; she has known nothing so far of these sorts of pleasures. Her sister knows how to enjoy it all. But then again, her sister has no concept of more important, lofty matters. But she! She! Why then did her heart ache so?

Before her eyes passed all the long nights, all the days and years she spent away from home bent over her books and journals. Back then she thought this and only this was the sum of all life's joys. The rest was nothing but emptiness and folly. And she focused exclusively on her studies.

But then, she met him—and the lines on her forehead broadened and deepened, her lips twisted, and the hidden pain became especially conspicuous. Her eyes blackened and a heavy sigh escaped from her heart, as though the place there were too narrow for her.

And then—then she realized that she was different from all other women! How that realization hit her!

She realized then that she lacked a woman's special charm. And then, at that moment she was willing to exchange her lot with that of her pretty maid or the poor flower seller! How she despised her talents and advantages and began to loathe the accolades and honors strewn upon her. And when he told her that above all other women he *respected* her most—then she realized how miserable she really was!

It was then that she recognized the nature of her misfortune.

At that very moment, the dance came to a halt. The musicians quieted down, and against this silence was the soft din of the tired dancers returning to their places.

"Deborah, do you know that even Dr. N. is coming today in your honor?" her sister said waving her fan before her face. But I forgot. "You surely know him from over there

26. This party appears to be a gathering in honor of the awarding of a doctorate, as in the reference later in the sketch to the protagonist's dissertation. Shapiro was 31 years old when she received her doctorate.

[from a university abroad where she studied]. You should only know how highly he regards your talents and how amazed he is by them!"

Deborah's face turned even paler. "He actually remembers me?" she asked in a frightened voice, trying with all of her might to contain her emotions and conceal her embarrassment.

"Why wouldn't he remember you? Does he meet [other] young women like you here?" her sister says with a giggle, her soft cheeks even more radiant, her white teeth visible between her bright lips, her eyes laughing. Deborah heard all barb in all this laughter.

"But why do I delay when they're waiting for me over there? Forgive me, please," her sister called out, and with a blink of an eye she crossed to the other side of the hall with wondrous lightness and extraordinary charm, and the fine silk of her dress accentuated all her rapid movements. A band of young men and women were waiting for her over there, arguing with one another with great enthusiasm.

"Hello to you, greetings and hello!" called out an older, bald man, as he approached Deborah, accompanied by a shorter young man. "I recognized you right away, but is this really little Deborah whom I knew back then?"

"Have I changed that much?" Deborah asked with a forced laugh.

"Yes, yes, you've changed, but for the better. Now it is even clearer just how different you are from all the others of your sex, who make themselves pretty and are hollow."

"Forgive us, Madame," said the younger man waving his gold-colored glasses, "for being so late. We don't take part in these sorts of vanities." And as he spoke, he alluded, with his closed eyes pressed against his glasses, to those preparing to start the next dance.

"I knew that you were *one of us!*" continued the older man, "That you'd always prefer an interesting discussion to these sorts of pleasures. Please accept our congratulations at this time!"

"Thank you," Deborah responded with a stifled voice, her lips crooked with bitter laughter. "Please do sit down!"

And the two of them sat to Deborah's right, the one with the glasses lifted his head and scanned the women passing by, their bright dresses, their bare shoulders and necks, as well as the men whispering in their ears, and a derisive, scornful grin passed over his lips.

"I'll tell you the truth, Madame, when I read your dissertation a few years ago, I couldn't believe that it was written by a woman," he said while turning toward Deborah and adjusting his glasses. "It never dawned on me that a young woman was capable of thinking thoughts *such as these.*"

"This *sort* of woman," said the older man, gesturing with his eyes toward the women in the hall, "surely couldn't manage it. But Deborah is different; she's not like them!"

"Yes, yes," the bespectacled one hastened to add, "Now indeed it's clear that our lady is different from all the others! And now I must beg your forgiveness."

"I don't know what I am supposed to forgive you for," Deborah said bitterly. "You wouldn't be demeaning me even if you didn't think that I was different from all other women." Wiping her forehead with her hand, she added, "But you'll have to forgive me, for I need to leave you for a moment."

She got up and turned toward the room designated for the party after the dancing. Her face was as pale as a sick woman, and her gait was heavy.

Surrounding her was light, warmth, movement, and life, and in her heart—a terrible emptiness. All she wanted was to distance herself from hearing any more compliments and praise, which pressed upon her and grieved her more than any insult.

As she walked, she cast her eyes once more on the life and the activity and the youth, and she went a distance, and not one person noticed her.

There in the second room, she sat helpless on the divan, closed her eyes, and attempted not to think any other thoughts.

She supported her head with the hand that leaned against the divan. A bitter laugh hovered on her lips, like the laugh of a neurotic, struggling to burst out at any moment.

Suddenly her entire being shook. A voice reached her ears, the voice of Dr. N. and the laughter of her sister from behind the screen. Deborah turned her head so as not to hear their words, but at that very second, Dr. N.'s words reached her ears, his voice speaking from the storminess of his soul.

"I have loved you from the first moment I laid eyes on you. You ravished me with your big beautiful eyes that communicate a whole sea of emotion."

"Certainly, you gave the same speech to my sister?"

"What? I? I speak that way? To your sister?!"

"She might even believe you . . ."

"Why?"

"Because she is older and wiser than I."

"Hah! Now I understand! And because of her intelligence I should love her? What a naïve little girl you are!"

"A naïve young girl attracts you, while an educated young woman [*almah maskelet*] . . ."

"Let it go! I know, I see, and I love only you! I respect your sister, but I shall never love her."

"Really? But, wouldn't you like me to be educated like her? Isn't that true?"

"Like your sister—oh no! I love you just as you are! Under my tutelage you'll progress."

"Yes, I'll study and become educated. But how shocked my sister would be! She must have thought . . . I feel for her."

"You feel badly for her? Hah, hah! She has entirely other thoughts on her mind, she pays no attention to such trifling matters," the Doctor said and laughed. "What does *she* have to do with *us*?"

Deborah did not hear the rest of what they said. She suddenly felt lonely and forlorn, her spirit deserted her. She was all alone in this building, and in the entire world.

She felt a huge, sharp, stabbing in the heart.

Her powers waned and her thoughts deserted her.

Old Maid

Originally appeared in *Ha'olam* (6 May 1908)

Every day before evening when she would return home from the office, she would go to the city park, choose a spot on one of the park benches, and watch the children play.

Sometimes she would kiss them furtively as she looked around with great apprehension. On more than one occasion, she had become the object of partial ridicule on account of this weakness.

The children were so adorable and full of charm. They had no idea yet how to sting or hurt others.

All adults, it seemed to her, intended to do just that. Even in the eyes of strangers she would see scornful smiles in the way they looked at her.

So she hated people and stayed away from them.

They all wanted to know the hidden recesses of her heart, her secrets, her pains.

She hated them and their pity.

She entered the garden and sat down opposite the children's playground. It was a summer day, nearing evening. The air was filled with pleasure and longing. The children flew about, passed by, separated into groups, joined together, made noise, jumped, quarreled, and played. The nannies sat, walked around, and talked among themselves. Two young boys, vibrant and active, strong and impudent, separated from their friends and began racing each other. The big one was about to beat his friend when he cheated and pushed him off course so that he reached the finish line, joyously and triumphantly.

"Mama, Mama!" he cried out loudly. "You decide who won!" And he stormed over to her.

Startled and shaken, she sat. She did not dare move a muscle. It was so pleasant to her [to be mistaken for his mother].

The boy hugged her knees and lay his head on her lap. A sea of emotion burst from her heart. Suddenly the boy lifted up his head and said in confusion, "You're not

Mama! I thought you were Mama." And he hurried away from her all red in the face and perplexed.

She stayed in her spot and did not move. Something bitter suddenly choked her throat and her heart convulsed in terrible pain.

The little ones—they inflict pain unwittingly and unintentionally. It is all so insulting and distressing.

And she recalled once again her neighbor, the student, whom she bumped into this morning, while the latter was strolling along with an acquaintance. "The Old Maid!" the student said to the one accompanying her, as they passed her by.

The words reached her ears, and a feeling of insult, grief, and pain mixed with anger filled her heart.

All day long she struggled to forget this, to erase this painful impression from her memory. In vain. The insulting sobriquet rung in her ears and would not depart from her.

In the office, she did her work like an automaton. She wrote the letters, answered the assistant's questions—in everything, she saw only mockery, only ridicule and derision.

"Old Maid," rang in her ears even now as she returned home to her desolate, solitary room.

With downcast head and stooped posture she passed the market. There were many pedestrians. A few couples hurried by, whispering to each other and smiling, oblivious to others.

She watched them. Those experiencing life. Her loneliness grew; her heart filled with a dark pain.

All through her body she felt lethargic.

Upon entering her building, just as she opened the door, the landlady's daughter burst upon her with her infant son in her arms.

"Look at him, take a look at my delight. He wants to dance. He's already tiring me out, this imp!" As she spoke, she tried to hand over the baby to her.

The younger woman exulted in the son of her delight[27] and showed off her happiness to anyone who came by, saying with pride: "Gorgeous, isn't he?"

The boy turned his small head with his eyes smiling at her, stretching out his chubby, naked arms and pattering away in his baby babble. Suddenly he turned his head toward his mother and pressed himself to her as though trying to seek refuge. He had encountered a cold and angry gaze—even his mother looked at her in shock.

She turned toward her room without saying a word.

27. Cf. Jeremiah 31:19.

In the room, darkness reigned. She did not light a candle. All she did was take off her coat and hat and sit by the window.

Through the open window the intoxicating air of summer evening burst through. From the foyer could be heard the voice of her neighbor, the student, singing and dancing with the boy. The entire building was filled with her playful, joyful laughter.

The activity and life outside intensified the pain and increased the emptiness and desolation inside her. Her throat felt even more strangled and her heart constricted ever more.

She was reminded of her childhood, her youth, the loneliness and desolation—work, life's struggle, and again, loneliness.

That is how the lovelier days passed—lovely for others, that is—but what was left for her? Not even the shadow of pleasant memories remained. She did not remember her parents, for she was orphaned as a young child. She knew neither love nor affection.

She had loved only once, but she was forced to suffocate even this love, to put it to death within her.

And how she thirsted for it. For affectionate, loving words—if only feigned ones—she would give up her life. She would devote herself to it more than all the light-headed young women. She would even accept the pain with the love.

And the pain of rearing children? A slight shudder passed through her whole being. She suddenly heard that same terrible sound—"Old Maid!"

Suddenly she stood up quickly and grabbed hold of the small mirror that stood on the table. By the light coming in from the window she strained to see the lines on her face, to find the specific signs that others found so terrible when they gazed upon her face.

And it struck her that her face was not so ugly at all, if not for the protruding teeth in front and the ones missing on the side, and the short, thinning hair, and the wrinkles on her low forehead and at the corners of her mouth.

The wrinkles . . . Oy, the cursed wrinkles! There's no way to remove them! And when she smiles, they only deepen and spread further.

She put back the mirror bitterly and collapsed onto the chair.

Is this how it is going to be forever? Forever? She—an old maid. She and her nickname.

A soul to be close to, someone to love—even in her old age she'll be deprived of this? And "Mama!" she won't hear?

The little creature, with the kissing mouth, the searching eyes, and the soft hands that lovingly embrace a mother's neck—such a being she will never know?!

That hidden thing that gripped her heart grew ever more heavy. Her eyes darkened, her hands were outstretched—and suddenly she heard the maddening sound of stifled tears.

———

The landlady was surprised. She told all her neighbors that a change has come over the "Old Maid." She no longer derides the younger women. Her voice rings out. She stands up straight. The assistant from her office comes over every so often. She asks the young mother surprising questions. Strange things come out of her mouth. She reiterates that she no longer pays attention to other people's judgments. The Old Maid readies herself for the future, hoping for the event of her life.

Types of Women

Originally appeared in *Ha'olam* (8 July 1908)

THE MAVEN

She was a woman of superficial intelligence and shallow thoughts. Only in one field did she show signs of uncommon talent: in speculating about the relationship between a man and a woman.

In this field, she had a finely tuned, developed sensibility. She would penetrate the very souls of the people in question and assess their situation, even before they became aware of it themselves. One runaway word was all she needed, one word, only partially uttered, a hint, a passing glance—and the inner situation was entirely evident and clear to her. Nothing was closed off to her. If one wanted to keep something from her, she immediately discerned it and chuckled to herself over the abortive effort.

There was neither a slight movement nor a passing motion that could be hidden from her. This sensibility was the "maven's" special gift. All other natural senses paled in importance.

She herself did not have many "affairs" in her life, and they did not interest her that much. They were degraded in her eyes.[28] Her life was devoid of content, she would say, of inner content. She was married, and everything was so regular, so everyday, so dull; so lacking in interest and special surprises. She treated them with contempt.

She did not envy her friends whose lives were more successful. But she would have been ready to give up her happiness and serenity if only there would be some "interest" in her life as well, some interest that would bring surprises, anticipation, powerful yearning, words full of affection and longing.

Slowly, however, by degrees, she gave up her hidden hope and absorbed herself in the affairs of others—and therein she found comfort. She saw her inner world in theirs and would inject her entire being into the weighty "business" of others. Her chief aspiration was to arouse envy—if not for herself, then at least for those creatures whose "affairs" she attached importance. The more complicated and unusual the

28. Cf. Deuteronomy 25:3: "Lest your brother be degraded before your eyes."

"affair," the greater her attraction to it. The greater the impediments and obstacles, the greater her strength and courage of spirit. Means and methods did not frighten her. She set out armed for battle. The devices and recommendations, the suggestions, and the stratagems sprouted and blossomed in her mind as though they were ready well beforehand. Her talents and techniques to remove barriers and bring "lovers" close were legendary.

Her physical appearance was entirely suited to her role and inclinations. Large hands and big ears, hasty movements, and yearning eyes, inquiring, longing. And when people told her about a specific "matter," her ears pricked up and her movements became even more rapid, and her eyes nearly fell out of their sockets from such intense longing.

As for those involved in the affair, she regarded them with exalted awe. Immediately the "matter" became hers, and she gave herself over to it completely without any concern for the effort. The triumph was hers.

But when the "business" was over, the people became simple and distant to her once again. They were to her merely a "prod," a strategic tool.

She fulfilled her role faithfully. This was the sum total of her life, its high point, its substance and essence.

THE LOVER

She despised those "learned women" and achievers. At every opportunity that came her way, she endeavored to negate their worth, to diminish and deride them. She vented all her half-scorn upon them. She would point out the difference between her and them through ironic comments: "I'm no student." "I wasn't graced with talents." Her words belied a smirk, meant to undercut others. She was complacent about the knowledge and learning that she had already acquired and gave no thought whatsoever to further study. Beyond the border of "necessary knowledge" she discerned demands and aspirations that were not becoming to the nature of a "*true woman.*"

She did not have a well-developed sense of self-awareness, but when the subject of "woman" came up, her senses would sharpen and she did not miss the slightest clue.

She had the unique ability to take a serious issue and render it laughable. Of course, this tendency was heightened among those who took everything seriously. Above all, she was ready to "love" anyone who showed her affection, though *in reality* she did not really believe in the idea of love.

She knew nothing of intimacy, and if she made a promise or vow to a lover or an object of "special interest"—it is hard to know whether she intended from the very beginning to deceive or whether she actually believed in her promises and vows.

The main point for her was "the hunt" for a man, and for this end all means were acceptable.

To each she promised she would love *only* him; and if the lover in question was familiar with her promises to others, she promised him that *he* transcended all others in her eyes.

Deep in her heart, she never came to any decision about who was better. It was hard for her to differentiate. In each she found something excellent in his appearance or character, something that "stole her heart."

But at the same time, she did not forget the second or the third—what she did not find in one she found in the other. In every walk of life and group of people she found someone "suitable" for her.

She was practiced and expert at sizing up men. From a first glance she could tell whether it was worth putting in the effort—whether she would succeed. If she knew the effort would be in vain, this would warrant—behind his back—[a barrage of] every possible humiliating moniker for a man. But if she saw even a glimmer of possibility, she immediately resorted to the methods with which she was so expert and confident.

She had a special talent for covering up and denying what needed to be covered up. When she denied to one her relationship with another, she put up an innocent front that would make it impossible to doubt her.

And she *believed* in her innocence. Why, she never told a lie in her life: *that* was her nature.

Indeed, she never lied to a single one of them.

THE CAPRICIOUS ONE[29]

She was filled with caprice. Filled with life, movement, smiles, and laughter. She loved life and was given over to it; but in the depths of her heart she would gnaw at [*menakeret*][30] and criticize both her feelings and actions.

She was impulsive. Amazed and enthused, she would give all of her self and nerve for a momentary impression. That's how she lived. That's how she showed herself to others.

A moment would pass—and then the faultfinding would resume and steal into her heart. She would become sad, gloomy, and miserable.

29. As a mix of traits that defies stereotypes, this third type of woman is closest to Shapiro herself. Cf. the diary entry for 14 February 1928 in Part II.

30. Throughout her oeuvre, both published and unpublished, Shapiro used the word *gnaw* (Hebrew root nun-kof-reish), which was, arguably, a reflection of her own agitated state. Cf. "In the Reading Room" and "From the Writings of a Tuberculosis Patient," both in this part; the diary entries for 15 December 1912, 2 November 1913, 24 January 1914, and 7 July 1921 in Part II; and "Letter from Prague" in Part IV.

Her attitude toward people was extreme. Either she loved and interacted [with them] or she loathed [them] and kept her distance altogether.

Her exterior matched her interior. At first glance she did not seem beautiful, but when you spoke to her, if something interested her or touched her heart—her entire outer appearance would change. The eyes—like two flaming torches—would flare up, sparkle, and shine. They would tell of feelings simmering deep down and reveal the endless depths of her soul. At that moment she was beautiful, her face and looks anointed with nobility, spirituality, and a special soulful loveliness. At moments like these, the faultfinding worm would bury itself in some deep corner of the soul and would only peek out from her eyes occasionally, like a raven in hiding.

She knew only how to live in the moment. And yet in the depths of her soul she sensed that these were but ephemera, temporary flashes; and in her eyes demands, aspirations, hidden and buried longings were reflected perpetually.

In general, her face projected an even temperament, and those who knew her from afar called her coldhearted. But when she let out a laugh, her laughter was so clear. It rang out so naturally and with so much joy that it was contagious.

She was always in and out of love, unable to stay in one situation, either emotionally or physically. When she aspired to something, it all seemed wonderful, lofty, alluring. But, as soon as she attained it, it became routine to her, quotidian, boring. And once again the longings, the desolation, and the yearnings overcame her.

Then new dreams would be born and take shape within her, and she would guard that inner place, her kingdom, lest it be revealed and violated by others—all this she kept to herself.

She did nothing halfway. When she befriended a man or woman, she gave herself over to them completely with all the resources of her imagination.

She lived in the moment and at that moment she made no tallies and skimped on nothing. With utter renunciation she would dispense of the pearls of her spirit and the treasures of her soul.

As for those who knew her, she would enchant them with her inner splendor, her courageous independence, and her childish innocence.

In the Reading Room

The two of them came to the library reading room at the same moment.[31] One of them turned with definite steps toward her regular spot. It was as though she owned the seat. She walked soundlessly and deliberately; the face serious, gloomy, with an ashen cast; the eyes set deep in their sockets; the hair combed straight back from the forehead.

With one glance, as though knowing the location of each and every book, she put together a thick stack from the various newspapers and journals and sat in her place to read from it.

The second one chose a place for herself opposite her friend and spread out a newspaper before her. She was a young creature, and the way she looked around indicated that she was a stranger to this place. Revealed in her walk and her appearance were glimmers of life that she sprinkled around, wondrous creature that she was.

Radiating the glow of youth and reddened from the cold outside, her cheeks looked as though they were blooming. Her eyes sparkled and, from under her hat, ringlets fell on her shallow, bright forehead and over her small ears.

She also sat down to read.

Her small head alternated between bending over and looking up, and in her quick movements and fleeting glances, which leapt from the newspaper to the large window and from there to the doorway, one could discern a certain impatience, a hope and an expectation.

Those who sat close to her looked at her for a moment, enjoying the rush of life which suddenly burst forth onto this place with her presence.

After a few minutes, she lifted up her head slightly and looked over at her friend and at the people sitting around her, and when convinced that all of them were absorbed in their reading, she stole a glance at the small watch attached to her dress. Then her glance darted to the large clock that hung on the wall, and she let out a light sigh, as though from an excess of emotion. She then got up from her seat and sat down in another chair, opposite the open door leading to the hallway.

31. Note the intertextual connection between the two female characters in "The Reading Room" and the two sisters in "The Lonely One."

She strained to absorb herself in reading the paper, and it seemed that she would pass the time in this way, without paying attention; but before long she realized to her chagrin that her mind was incapable of latching onto any idea whatsoever.

Her glance wandered out the window. There the clear sky, pure and strewn with glinting stars, was visible before her, and it seemed to her that all these stars were calling out to her to come outside.

The tumult rising up from outside, the clamor of cars, of those coming and going, walking and hurrying, the whistling of the snow and the frost under the feet of the passersby, and the light vapor carried aloft in the air—all of these seemed to disrupt her reading.

And there in the hallway, the door opened. She trembled all over and fastened her eyes on the face of the newcomer who entered the reading room. A moment later she lowered her head to the newspaper—false hope.

Her heart trembled in her chest, leaping and beating strongly. She felt a burning in the palms of her hands and her face. Her glance was drawn to the direction of her friend.

"Cold marble statue," she thought. "What's this world to her? What are its pleasures, amusements, delights, and the *joy of life* to her? What do the bright sky and the twinkling stars matter to her? Give her these thick books, put these dead letters in front of her, and she'll sit with her head bent over them for hours on end, without becoming distracted, without feeling a thing. She'll know nothing of a pounding heart, an impatient spirit, and this powerful inner feeling. Fortunate one!"

And her friend indeed sits with her head bent over, her face frozen over the book before her. It seems as though she is petrified in this posture. However, whenever her friend moves about and turns her head in the direction of the door, she unintentionally begins to think about the one next to her, and her countenance darkens as if from unexpressed pain.

A vague feeling stirs within her, and she knows that whatever one calls it, it isn't nice.

What is this: anger, animosity, jealousy?—Jealousy? She's jealous of her?!

She buries herself in her book, struggling not to pay her any mind.

Suddenly [her friend] jumps up from her seat and hurries out to the corridor. In the doorway, the image of a tall young man appears, standing in the middle of the corridor, hat in hand. Here he was, feeling the closeness of the young woman, and his eyes glinted. She approached him and extended her hand; he grasped it and looked into her eyes with frank admiration. Within a minute, they were whispering. The young man

remained where he was standing in the corridor, while the young woman re-entered the reading room.

My God! How changed was her expression! Her radiant eyes were twinkling, glowing, and shining with an abundance of light; on her lips was a smile of contentment, bathing her face with joyous grace and splendor.

"Hey, hello!" she said, extending her hand to her friend. "Forgive me, but I have to leave now. I'll come visit you tomorrow at your house." And with a quick, graceful movement, she turned in her place and returned to the hallway.

"Her gait—it's as though she has sprouted wings, all of her—like a bird fluttering," thought her friend as she watched her leave.

Once again she bent her head over her book.

Even now, she did not understand what she was feeling. But why was her pulse suddenly racing? And she felt this same throbbing in her temples—deep within, something quaked.

She was ready to burst out in great peals of laughter or to weep inconsolably, but she was not alone here. She remembered that she was among strangers, and the feelings of pity that her crying would likely evoke would humiliate her—and so she directed all her thoughts to her book.

"You need to subdue and defeat the feelings," she thought. Yet they were muddling her mind as she read, and here it was, a full hour since her friend left, and she had not read or understood a thing.

"What are these feelings?" Again, the idea overtook her. It can't be jealousy. Is she jealous of such a light-headed creature as her friend?! *She* jealous? The very idea humiliated and hurt her.

Suddenly an idea fleeted across her mind: perhaps what she was feeling, rising up within her, was a moral objection, a forceful protest against the light-headedness of her friend?

And she clung to this idea for dear life. And in this way, she felt entitled to elevate herself above her friend—and she struggled with herself to believe it.

"Yes," she repeated to herself. "Feelings imprison her intellect!"

But something inside gnawed[32] at her again and again.

32. Note the use of the word *gnaw* again.

Woman

(A Sketch)

Just now she returned from the dance. She took off her coat and white dress with the wilting flowers,[33] relieved her hair of the burden of the profusion of jewels and scattered it about her head.

And dressed in a light and loose dress, she paced back and forth on the carpet that was spread on the gleaming floor.

She was tired and fatigued, but this was her life and this was all she wanted! The elderly and ugly women who gave her menacing looks? Let them all seethe in their pent-up anger and hidden jealously as they beheld her success! Didn't she attract everyone more than the bashful and silly young girls?

Yes, it was necessary to know how to walk about with them. Even N. was now "captured," and she was certain that he would no longer escape from her. She looked carefully at how he gazed at her from afar, how he wanted to draw near to her, how he left the hall when he saw that she was about to leave, in order to leave with her, but she made herself seem as though she did not see, as was necessary.

And he? Hah, hah, hah! He trusts her so much!

Indeed, she had herself promised him, but it was impossible any other way. To them, it was necessary to make such promises—in other words, to everyone—that he has claimed your whole heart, and that your thoughts, deeds, and feelings are directed only to him, so long as you pay no attention to any other man, he is the greatest of the great.

And he believes her, and why not? Doesn't she know to ignore all other men and acquaintances when she speaks with him?

Yes, yes, to lie, to lie, and to lie! They will not pay attention to the truth!

But this young man, M., with the mocking smile always hovering on his lips—why is it impossible to "attract" him? What sort of sadness dwells within him that he looks at everything with jest and mockery as though from above—and precisely because of

33. Readers are reminded of the sketch "Wilting Roses," which appears earlier in *A Collection of Sketches*. Arguably, the theme of depletion that crops up in the sketches points to female or Jewish vulnerability and/or the ephemeral nature of love.

that one needs to work on him, the sort of man that stands aloof. That sort always captivated her the most.

Come what may, she will attract him to her!

A confident smile passed over her lips.

What's the sin in it, that she desired to live, even if these others didn't live? What was she doing after all? Don't the men deserve to be led on a bit? Why should they abuse us so, deceive, harm, lead us up the garden path, never paying for what they do, without receiving any payback or reward for their deeds?!

They still abuse. They jest and mock us. They blame us and criticize us and our behavior and habits, and how are we any worse than they are?

They ask us to be modest and innocent. Oh, defiled hearts, why? Surely you demand this only for your own benefit. Do you desire this for our sake?

A bitter smile twisted her face.

Have they not harmed her? Have they not set a trap and captured her?

As for "him," whom she truly loved, her first love, pure, innocent, before she knew of the "hunt"—then they hunted her.

And after that, they mocked her: her faithfulness, her frivolity [*kalut da'atah*],[34] her innocence.

Since then she has learned a great deal, has become wise, practiced, and well-versed in how to marshal her words. But what has all this done for her?!

And she remembered "him," her first love, her faith, her purity and innocence. Back then she did not know how to lie. She believed in him, she knew only him, and all of life and its direction were bound up in him. She knew that her whole heart and soul were given over to him; she had no desire or wish other than his. She offered all, sacrificed without regret, for back then she knew of no other way.

But then, later on, when he began to distance himself bit by bit, at first she did not notice that he had stopped promising her that she was the only one for him and that he loved only her.

But afterward . . . afterward . . . when she saw the shadow on his face, when she saw and discerned his worry. And then when she began to press him about things, and he no longer hid from her that he was obliged, that they were forcing him to marry a[nother] woman, that nevertheless he will never forget her, he loves only her, but it's impossible.

34. *Kalut da'at* can also mean light-headedness. See "light-headed creature" in "In the Reading Room" (in this part). Cf. Babylonian Talmud, *Kiddushin* 80b: "Women are naturally light-headed," or given to temptation, a statement marshaled to explain why a man may not be alone with two women, because even together, two women might give in to temptation. For more on this rabbinic expression, see Hauptman, *Rereading the Rabbis*, 38–39. See also "Hanukkah Days" (in this part), where Shapiro uses the same expression to refer ironically to the frivolity (*kalut da'at*) of mitzvot.

At first she did not believe what she was hearing—back then it seemed to her that all was ruined, lost, destroyed.

But she did not wish to show him her true emotional state. She was too proud for this; she didn't want to be a nuisance to him, a burden. And she did not want to teach him a lesson.

She hid her pain within the depths of her soul, but after a while, when the initial bitterness passed, she felt the need to seek her revenge.

She wished to quiet something within her, the abasement of her self-worth and honor, her authority, and perhaps, her love? Who knows?

Afterward she saw that it was possible to live, to forget the pain and take pleasure in the moment, and that was when she began to lie, to promise them everlasting love, and to receive their lies as holy truth.

And their lies, how many they were!

Love! Hah! Now from the mouths of these men she knows its true teaching!

And [these men] dare to mention this name [i.e., love], for whose sake they bring down curses upon the heads of their lovers! upon those wretched women, who are incapable of conceiving of love as a light laugh, as momentary games. So these women sacrifice their hearts and souls and in some cases their lives and honor for its sake, without knowing that the mocking jest, disdain, and laughter are directed at their "frivolity," at those quiet and complacent females, who sell their hearts for a price. It's all the same whether they do so for the price of complacency and tranquility or for some other gain.

For the laughter and the mockery of the tough men is their fated lot.

And these men still have the temerity to moralize before those who sacrifice themselves to them!

But her greatest sin was that which she sinned against her own soul. She—who loved in truth and in innocence and wished in truth and innocence to be loved.

For this wish, one pays a great deal, in the blood of one's heart, in one's happiness and in one's honor.

Now, she knew no other world than that of pleasure, and she wished to know nothing else.

But, every so often she felt a pain and aspired for revenge, when she saw young innocent girls or women.

Hah! Then her ire increased to the point of ruin. And she ruined . . .

She knew that the women considered her debased, destroyed. She knew how they judged her—therefore she delighted when she triumphed over them.

Now one of these silly ones was occupying her thoughts.

She met her a few times in the company of N., and the glances of this young woman were enough to kindle her ire and envy.

These glances offended her.

And thus began her habitual battle, as she turned to her trusty weapons that never betrayed her—here she knew her proper place.

And she, that innocent one, wished to compete with her!

"Oh," silly thing, "Do you in your innocence hope to capture his heart?"

"And I? I don't like to share. He will be all mine or all yours."

And her eyes flared suddenly like those of a predatory animal.

"No, he'll never be yours, and your lofty, exalted, idyllic love will be to no avail. I know the greatness of my power."

She turned and looked into the mirror before her.

Was there a man who could withstand her beauty?

She passed her eyes over her lovely body and tender, beautiful face, and her eyes glimmered and sparkled.

And a pleasing smile passed over her lips.

The Dreamer

Already, when she was a child, she had a propensity to dream. Often, she would keep herself at a distance from the other children, sitting off in a corner, not participating in the games of those her own age, and all their efforts to include her in their play were for naught.

They would stay away from her, calling her "Mrs. Melancholia." But when she would accede to their request to tell them stories, they would all be drawn to her and surround her.

She had a great gift for storytelling. She told of mysterious things, events that could hardly be believed; but she told them in such vivid color and with such great enthusiasm that all her listeners were unwittingly drawn into the storyteller's fantasies, as though they actually saw with their own eyes all those wonderful pictures she described for them.

As she grew, so too did her tendency to dream; only now, not only did she relate her dream, she also defended it: [her dream] of one law, equal rights for both sexes in society. She rose up against any limitation, statute, or law that came to diminish the worth of the weaker sex [women].

The customary honor, which was designated only for women, was in her eyes plain proof of how lowly they were in the eyes of men; the flattery and attention paid to them by young men [was] a kind of wily deceit, which covered over mere evil intent and hidden scorn.

Every idea, every feeling of pity specifically for them, toward the weak creatures, aroused particularly vigorous protest from her. She would get heated up, would protest, her eyes burning, her face alternately blanched and ablaze.

"Your feelings of pity are meant only to kill the courage and strength within us, all for your own advantage and pleasure!" she would call out, trembling all over. "Let us develop, don't trample our spirit, don't limit our sphere, and don't antagonize us by standing in our way. Then you'll see our strengths!"

And she dreamed and preached that the day would come when there would be no more law that would hold the weaker sex back to a lower rung or constrain them to a

narrow and limited sphere, that there would no longer be any limitations or obstacles to their rights and thus they would reach the highest echelons of society, of humanity.

Many days passed, the young girl married and became a mother.

All that remained of her demands, her aspirations, and her dreams was a mere memory, which would bring a smile to the lips of those who knew her back then.

Now she hid away all her inner joys and sorrows; she no longer trumpeted her dreams: They were born, they grew, and they have been buried deep within her. She regarded all personal revelation as a violation of the sacred.

She still dreamt now, but the dreams had changed.

"Tell me please, my friend, how did you change so?" asked one of her friends who knew of her former convictions. "How is it that you transformed your opinions and your nature this way?"

A smile of satisfaction could be seen on the dreamer's lips.

"Only a woman who feels herself oppressed as a woman can give herself over to ideas and aspirations like those I used to preach then," she would reply.

"Or more correctly, only [that kind of woman] is capable of fighting for greater rights for women," her friend retorted with a barb.

"Hah-hah; my crusty old dreams! Forget about greater rights! We have other rights that we can put at our disposal!"

"How could you? Are you actually denying the justice of their demands?" her friend asked angrily.

"No, but we do have special rights, and we shouldn't betray them," she answered confidently.

The friend grew angrier and angrier. "The narrow [woman's] sphere . . ." she blurted out as she looked at her friend with pity.

"But why did you fight so hard for these ideas back then?" she asked suddenly.

"Because those lovely sounding exaggerations, which I was silly enough to believe in, excited me then, ignorant [as I was] of the true essence of a woman."

"So now you know it?" her friend asked mockingly.

"Yes, not only her essence but also her true purpose," she confidently responded.

"If so, could you kindly reveal this secret to me as well!" her friend scoffed.

She departed from her friend, without saying a word. She would not reveal her secrets to her.

She had three daughters. But now her greatest, most secret dream was . . . a son.

She now had contempt for the woman who hopes and aspires for rights and other purposes alien to her nature.

None of her dreams was as desirable, as anticipated, as hoped for as this ultimate dream.

The Poet of Pain

Originally appeared in *Ha'olam* (3 June 1908)

Evening. The streets are lit—a little here, a little there. The houses appear in an imaginary light, and the adjacent forest is full of intimations. The skies are clear, bright, festooned with sparkling stars. The air is saturated with dew, warmth, and yearnings for springtime.

They walk hand in hand on the path leading up to the forest. She is clinging to him, and he gazes at her face every so often. When his glance meets her sparkling eyes, he squeezes her hand even more tightly.

She fills in his silences.

"Is it good for you to be with me?"

"An understatement. There aren't enough words to express my feelings!"

"And do you think that in me you have found someone worthy of you?"

"I don't think so—I'm certain of it!"

"What's your proof?"

He cast a glance at her and replied: "Your soul, as reflected in your eyes!"

"And what is my soul?"

"A pure and mighty soul—and I discovered it!"

"Leave me be! There is much that I want to say to you that I cannot."

"Why? I know that you are part of my soul, the light within."

"Don't say such things to me!"

"Why?"

"They confuse me . . . I'm afraid . . . that you'll change your mind [*pen tinaḥem*]."[35]

"What did you want to say?"

"Perhaps you'll tire of me, simple, poor young woman that I am."

"But you have a soul rich enough for me!"

35. Or "lest you regret"; cf. Genesis 6:6, where God regrets having created humankind because of the corruption in Noah's time, and Exodus 13:17, where the Israelites are sent on a circuitous route out of Egypt, lest they encounter enemies and regret their decision to leave Egypt.

"You'll leave, continue your studies, rise ever higher, and become distanced from me."

He squeezed her small hand, looked into her eyes, and laughed in a voice full of the joy of youth. She laughed quietly too.

"The whole world fills me and I fill the whole world when I feel your closeness!"

She didn't answer. She looked at the light, passing clouds; and a light, sad cloud covered her face.

"Perhaps you were created for greatness," [she said]. "Leave me alone.[36] Why arouse my longings? I'll be wretched then, without you."

"You without me? Only death will separate us!"[37]

A light smile passed over her lips.

"Let me hear your voice.[38] Why so silent?"

"Your words remind me of the things written in love stories. It is the 'language of the bards.' Soon I'll reveal the treasures of my soul to you, soul of my soul, you've stirred the strings of my soul."

"When are you leaving?"

"In the fall, but don't speak to me of those days. Already now my longings for you are awakening."

"Perhaps it's better for you go away from here."

"I'll go, make my place in the world, and then you'll join me, no?"

"I'll go my own way."

"Your way is bound up with mine. Don't slip away from me."

"I'm frightened of you!"

"You're doing me an injustice. My soul is cleansed and purified by you!"

"Don't drag me after you. I want my own path in life."

"Without you I am nothing!"

"Your path will take you elsewhere. Leave me be. Forget about me. I'll remain a friend, a companion."

"You'll be everything to me. I won't accept these boundaries that you're setting. I love you and until my dying breath, my soul belongs only to you."

A winter's eve. The small room is lit by a kerosene lamp on the table. Dark shadows sprawl across the walls of the room. A few books are scattered on the table, the chair,

36. Cf. Deuteronomy 9:14, where God asks Moses to be left alone to annihilate the Israelites as punishment for the sin of the golden calf. Here the female speaker assumes God's voice.
37. Cf. Ruth 1:17.
38. Cf. Song of Songs 2:14.

and the bed. From outside are heard the noise of the wheels of passing cars and the clanking of the electric tram. The frost and snow stick to the window.

They sit on the old divan near the stove.

"Why are you all wrapped up in your scarf?" [he asks]. "Are you cold?"

"Yes, a little, I'm happy that I've come."

"I didn't think you were strong enough."

She blushed a little. "Didn't I say to you that I wanted to find my own way in life!"

"But it's a great honor that you have come, my darling!"

She didn't reply.

"When I didn't see you, my head was filled with all kinds of crazy ideas."

"Like what?"

"I was angry, bitter, enraged, wrathful, and malicious."

"But didn't you know—I gave you my soul."

"Now I see."

"And your studies? Tell me about them!"

"My studies? What do I need this trouble for? Studies only darken, *only extinguish* the 'spark of God.'"

She ran her hand through his hair.

"What a change! Have you indeed discovered the spark within you?"

"No, others have revealed it. Now I know: I have a great future in this life."

In his eyes flickered an expression previously unknown to her. Conceit? Triumph? No, what confidence, what pure faith.

"My longings for you aroused my spirit, the 'spark' within me."

"And now, it'll be extinguished?"

He laughed out loud and grabbed her hand in his.

"You were the spirit that pulsed within me. When I didn't see you, my love grew ever stronger."

"Really?"

"You can't compete with me. Women have no concept of the depth of love and the pain within."

"From where did you get that idea?"

"Ideas, new perspectives have been born within me. A man is known only by the way he loves."

"And you too will reveal yourself through your love?" "My Song of Songs[39] will be the true measure of my self!" His eyes looked outward and glinted. But he didn't see her.

"And when you finish the poem?" she asked in a quiet voice, overflowing with longing, a cloud of quiet sorrow upon her face.

39. That is, his own book of love poems.

He turned his head toward her in surprise.

"Why the interminable questions? Like a typical woman!" Annoyance could be discerned in his tone.

"Ah, so that's how it is?"

"We all live as if only for a moment," he said, trying to appease her.

A clear summer's eve. The streets are lit by many electric street lamps. The large store windows shine with thousands of sparkling toys, drawing in the eyes of the passersby. Everyone is pressed into the crowd, wanting to break away and get some distance from it. She is pale, eyes downcast. He—his hair grown out, glasses on his face, his glance measuring, with an expression of disdain, all those who cross his path.

"So what would you like to do?" he asks.

"I still don't know."

"You have to understand. Neither of us is at fault."

"Why are you trying to justify yourself? That won't ease my pain."

"Tell me, when you're in need, will you turn to me for help?"

She trembled from pent-up rage.

"I won't be asking you for handouts!"

"You're angry. But I'll look after your fate."

"My fate? Hah-hah! Why didn't you worry back then?"

"I loved you."

"Such justification?!"

"You need to understand and not blame."

"I understand, oh yes, I understand."

"Feelings change . . ."

"I know. Enough!"

"Even now it's enough for me to look at you and my soul begins to storm. It strikes me again. Can you understand how torn I am?"

Her eyes pierced his. His glance expressed sorrow.

"When I remember those evenings, when you would run your soft hands through my hair," he spoke as though to his own soul.

"All you need are longings, and I gave you my entire soul, all my love."

"My pain is greater than yours!"

She fixed her eyes on him and pursed her lips mockingly: "A pity!"

"Please don't pity me. Pain is good for poets!"

"Yes. The pain. 'The imagined pain' . . ."

"But this pain derives from my character, from the internal split within me!"

"The word [pain] fascinates you."

He looked at her with pity.

"You don't understand. Without my pain I would become vulgar, infantile, run-of-the-mill."

A great sigh burst from her heart.

"For this vain notion you're ready to sacrifice your happiness?"

"My happiness is my talent [*oshri zehu kishroni*].[40] You'll see—the day will come."

They parted.

She sought consolation without poetry. He "revealed himself" in his poetry of pain.

And in every new poem, in every story, he would begin with complaints about his "former muse" who frustrated his hopes, about her evil betrayal of him. And he would sing of the great pain he carries inside him.

40. Note the rhyme in Hebrew, meant, perhaps, as a demonstration of his so-called poetic ambition.

Broken Tablets[41]

(Notes)

Originally appeared in *Ha'olam* (18 September 1908)

The two of them met on the mountaintop.[42]

He was tired of life, had had enough of work, suffering, trouble, concerns, despairs, unfulfilled hopes, and unattained goals.

In his heart he carried his own pains and the pain of others, the pain of the world and the evil within it, the pain of his constant sorrow and despair.

The pain of the wretched, the oppressed, the depressed, who suffer and recognize the reason for their troubles—and the pain of the contently despondent, who are aware of the beauty of the world and its joys, its pleasures and vanities, who feel the deep, earth-shattering sense of study and cognition, the pleasure of friendship and the pain of betrayal, the delights of love and its wounds; the pain of the contently despondent who don't understand the reason for troubles and their rationale.

He was depressed, oppressed, bone-tired.

She was full of life. Full of faith in the righteousness of people and their honesty of purpose, in the purity of their feelings and their truths. She was filled with the joy of life and thirsty for it all.

The two of them aspired; they both longed to ascend. But their demands were different. So too were the reasons behind their aspirations.

He wanted to distance himself from the valley of lies and hypocrisy. He wanted to cast off the burdens of humanity and its nonsense and to shake himself free of life's lies that had clung fast to him.

She strolled about in her innocence. She loved everything. She was stirred up and she believed, even here in the valley. How lofty and wondrous it is up there at the summit!

41. Cf. Exodus 32:19 for the "broken tablets" shattered by Moses upon gazing at the golden calf, after descending from the mountaintop. Here, the broken tablets symbolize the woman's shattered expectations of her relationship with the writer, as though he were her original revelation and now all of this has been shattered in the face of his betrayal and his genuflection before the critical regard of others (i.e., his golden calf).

42. The parallels between the characters here and Shapiro and Brainin are obvious. The same can be said of "The Poet of Pain" and "The Famous One."

Her hope was to find new wonderful things there, to have revelations and to look about.

He sought only to forget, to wipe away insult from his memory, to remove sorrow from his heart.

She sought to etch new things in her heart; she longed for the unfamiliar, the hidden, the lofty yet unknown to her.

In ascending the two of them met.

In her he found strength, support, a breath of fresh air.

In him she found experience, guidance, and knowledge.

She alternated between excitement and grief, between amazement and despair.

She yearned to know herself, to live the life she had always dreamed of and that he had spoken of. She longed for it all.

He became neither excited nor amazed; he neither aspired nor hoped.

He wanted only encouragement and to rest up from a life on which he had already made his mark.

She filled in that which he lacked. The budding, the blossoming, the becoming, waved over him with their life force—and he was rejuvenated.

New flowers sprouted in his heart.

And he sang her a new, wondrous, exalted song. He sang her *the song of his heart.*

And she heard and listened to him. And the buried longings in her heart stirred, the longing for that which was wondrous to her, for knowledge and understanding.

He was the one who awakened her, who guided her on her path.

But she wanted to take that path without him, to find that which she imagined.

And the flowers in his heart no longer attracted her. She wanted real live flowers. And the poetry he sang to her did not satisfy her. She yearned for the poetry of life.

And so she turned away and went down to the valley of life.

The scenes in the valley are many and varied.

Scenes of poverty and hurt, tension, distress, and confusion. Faces of worry, sorrow, and fear; faces twisted with imprisoned pain.

Sounds of groaning, the slight tumult of a stealthy complaint.

And the gaping mouths of others growling and roaring, a lion's roar, human beasts.

Scenes of private, solitary pain.

Lonely, alienated creatures, carrying in their hearts their hidden sorrow, guarding it from the eye of a stranger, from a brute hand.

The hidden sorrow of the sad soul revealed itself in her face; its signs were visible in her countenance.

Sorrow was becoming the essence of her soul, taking shape and spreading forth its shadows.

And she also encountered young and lively creatures, brave and courageous souls, eyes that blazed with passion, that demand and aspire, those with feeling heart and warm temperament.

A hidden unexpressed sorrow was reflected behind the brilliance of these eyes. From the trembling, demanding lips something flashed, and a heavy cloud hovered over the forehead.

She knew and understood people's sorrows: the sorrow of the collective and the grief of the individual.

She listened to their broken hearts and their despair and understood their thoughts.

The sorrow of her own sex and the mysteries of the hearts of all were revealed and made known to her.

She longed to heal them, to ease, assist, change, and overturn—to uproot the source of evil.

She turned away from that which enchanted and drew her heart—and devoted her entire soul to her new idea and goal.

She became estranged from her former longings and aspirations, distant from all who sought to be close to her.

But everywhere she met humiliation, servitude, jealousy, and hatred, small-mindedness, and narrowness of the heart, and her aspiring soul became appalled; it constricted and retreated.

And the ring of the songs that he had sung to her there at the summit grew stronger in her ears, and her heart began to reawaken; the hidden heartstrings throbbed because they were awakened by this song of his.

The sounds of the poetry—how marvelous! These were enchantments from another world, one that lived deep within her.

She rose up from the abyss of triviality and hovered in the kingdom of *her* visions.

A chasm opened up between her and that which surrounded her, the demands of reality, between her expansive soul and the puerility found [around her].

The splendorous, enchanting poetry, awakening in her soul, elevated and exalted her.

It seemed to her as though the echo of her voice was traveling back and forth from him to her. His soul's pain and his spiritual sorrow were also overflowing into her. She was hearing the beat of his heart calling out to her, a sound beseeching her, a voice of longing and loss in its suffering.

She was following the voice that was beckoning.

The two of them met.

The dream of the past stirred and came alive in his memory. His posture straightened; his eyes blazed and sent forth a divine spark. But moments later, the light was extinguished.

Then—when she left him—it was the final straw. His inner storehouse of strength was exhausted, as was the wide sweep of his vision. He collapsed.

His light disappeared, and his brilliance, the brilliance of his inner light—his advantage over others . . .

It became a flickering light, a sanctuary in which the light of God was extinguished, and the few remaining sparks scatter and go out.

Then his poetry was done.

The echo she heard that excited her was but the *song of her own heart*, the sighs of her own soul.

The grief, burden, and protest in her heart materialized within her and took on a voice.

The grief, the burden, and the protest in her heart realized themselves within her and took on a voice from within her throat.

Her heart's longings sought release, longings for that not accomplished in life, for the unseen and the fantastic, for the hidden dream.

The longings swept her away and she believed that they were about *him*.

But she was mistaken. She walked toward a misleading light, a false beacon.

She encountered it [the light] and was convinced.

The pain of the mistake, and the grief of nothingness grew ever greater.

A complete, living world, longing and searching, dreaming and seeing, encountered in the past, now null and void.

The Famous One
(A Sketch)

I was already acquainted with him.

He would stroll outside with his hands in the pockets of his tattered overcoat. He'd squint and stare at every person who crossed his path with fear, as though he suspected each one of harboring some secret that might harm him.

Sometimes he would walk quickly, without paying attention to anything at all around him. At times like these his eyebrows would arch and draw near to each other. His forehead would wrinkle all the way across, and the edges of his lips would quiver. He'd squint even more, mumbling something quietly as though speaking to himself.

He would always carry a book under his arm; his head and his shoulders stooped, as though crushed by his burden.

In those days he was just a poor teacher, happy to find a lesson. Occasionally he would publish something from the fruit of his pen. And when they would praise the creations of his spirit, to his face, he would melt from all the admiration. His eyes would begin sparkling, the lines on his face would sway, his posture would straighten, and everything about him would express vitality. But in the end, he would lower his head as though recognizing himself guilty in some way.

He would never defend his work with banalities, and when critics would level harsh criticism at his work and show its defects, he would be satisfied. His face would brighten with excitement, and on his lips would be a smile of acceptance. He would lower his head in assent to everything that would come out of the mouth of his critics, as though they were reading his mind.

They recognized that he had expressed only a small fraction of what he had in his heart, and when his words were published, he found them impoverished, slight, inadequate to express the stirrings of his heart and all that was taking shape and forming within his soul, and this endless spiritual torment besieged him.

He would treat the judgment of others with gravity, listening and paying attention to the words of his peers, who expected greatness from him, storing them away in his heart.

———

Many years passed. I met him again. I almost didn't recognize him. His hair had grown thick, and it surrounded his pallor. His face had rounded out, and his eyes gave off a sense of ease and faint mockery. All of his movements expressed a certain confidence and a singular physicality. Everything about him suggested that he recognized his self-worth and took pride in it.

"I can see in you," he said to me among other things, "that you still remember the man you knew ten years ago. But these are new times—new winds [are blowing]."

"Yes, your most recent work attests to that," I replied. "We expected otherwise from you, and if you would allow me to tell you . . ."

"What? What would you tell me!" he interrupted. "Stop speaking. I no longer need the reader's approval. Didn't the famous critic N. already tell me: 'You're a sublime writer, and the exceptional writer need not adapt his literary work to the demands of the masses who neither understand nor feel.'"

"But before you thought differently! You suffered over [others'] opinions of you."

"If I had known then what I do now, I wouldn't have suffered so. Back then I imagined that the inner world of the writer is his holy of holies[43] and that it is worth turning oneself into something unformed and void [*tohu vavohu*][44] for the sake of one idea, for the sake of one aspiration or opinion of the writer."

"And how did you suddenly change your mind?"

"It didn't happen suddenly," he answered me, and from the look in his eyes and the wrinkling of his brow and the arch of his eyebrows, I recognized the man he was ten years ago. "I suffered a great deal until I came to realize that the world will not be overturned, and neither will people's hearts be turned, mollified, or changed. It's all the same to them whether an author writes with his blood, sweat, and tears, baring his troubled, massive soul, or he serves them shallow ideas, if he jests and passes over everything with a light laugh, with a clever joke."

While speaking, he took a small notepad out of his pocket and began jotting something down quickly with a pencil.

"You mind my asking what you're writing?" I asked him.

A smile appeared on his lips and his eyes radiated desire. He himself reveled in his exalted brilliance.

"I don't let even a minor event or incident pass without reaping some benefit from it. As you were speaking to me, I got the idea to write down a few things about the innocence of readers of yesteryear—it's already here." And having finished what he was saying, he showed me his work.

"Yes, but before you used to revise and polish your words," I wanted to tell him.

43. Cf. diary entry for 15 November 1909 in Part II.
44. Cf. Genesis 1:2: "the earth being unformed and void."

"Hah-hah," the master interrupted once again. "So you remember the days when I would revise, amend, improve, and correct, a hundred and one times, everything that emerged from my pen before handing it over for printing. I still remember those days too. How I approached my work, trembling before the holiness! Ha-ha! These days, if I wanted to go over and revise all of my work that way, I'd need to work day and night, and even then it wouldn't be enough."

"In my opinion, you are sinning against your talent by making it profane."[45]

He looked at me with surprise and pity, as though despising me for not probing his opinions deeply enough.

"I know how to control my talent and bend it to my own desire. This is what you need to understand . . .," he said, "I have specific programs, grand ideas and original notions that are difficult for those infantile scribblers to understand."

"So why don't you stop them?"

"If they don't understand me now, they will eventually," he added, as though not hearing my question. "This is the fate of all great people: Only after our deaths will they know how to appreciate our worth and comprehend the extent of our ideas. This is our fate!" He ended by letting out a light sigh and lifting his eyes.

As I left him, I felt internal anguish, as though I'd lost something precious, as though a certain belief that had lived within me until then had been uprooted.

"What happens to those aspirations of yesteryear, the young writer's mighty desire and resolve, once he becomes a famous writer? Where is the inner life that once filled him with holiness and emotion? What became of his prior attitude toward his work?" Such questions arose in my mind.

45. Shapiro's remarks about holiness and profanity are interesting, given her participation in the secular literary project. To her, secular Hebrew literature was sacred so long as it was produced with serious intent.

The Teacher[46]

In a small room on the fourth floor of a cheap hotel a young man sits at a small table. His eyes wander out the window.

The window faces the courtyard of the building, and outside all that can be seen are roofs covered with softened snow and a small patch of cloudy, dark sky. Moist snowflakes are spinning around in the air. Everything is cloudy, damp, and gloomy.

The young man turns his gaze to the room's interior.

The table before him is covered in dust and ink spots. The walls are dark, and sadness is spread all over them. The only picture that hangs on the wall above the table repulses him. The shapes on it are strange. The colors are vulgar, offending even the untrained eye, and the frame is crude, lacking in taste.

Opposite the door is a bed, covered with a dark bedspread, and on the wall above, a small mirror, with greenish glass that so distorts the face reflected in it that it's preposterous. The floor is filthy; the ceiling is low and dark, with spider webs in the corners.

The young man's glances leap from corner to corner.

His head is lowered onto the palms of his hands, his arms resting on the table. His face is weak and pale, and his eyes emit a dark humor, a depressing sadness, a hidden sorrow.

Everything around him and every place he rests his eyes is liable only to depress him even further, given that he seeks only transcendence and emotional passion.

He searches his mind for heartwarming memories: an ennobling picture, a shining hope; but everything there is covered in a veil of poverty, pain, pressure, dejection, sorrow, trivial worries, and rare moments of joy.

Only his powerful desire, only his intense aspiration and mighty yearning to be freed of his lessons, the constant rushing, the empty-headed students with all their stupid questions—only these occasionally lift his low spirits.

And everything else—dark, daily life with nary a ray of light clamoring for contentment and mind-expanding pleasure; devoid, too, of trying incidents and events, of powerful and burning emotions, of anything out of the ordinary, the norm. There is

46. Shapiro portrays in this sketch the archetype of the *talush*, the young Jewish intellectual who abandons his past in pursuit of secular knowledge and finds himself living, impoverished, in one European city or another. See Jelen, *Intimations of Difference*; and Shaked, *Hasipporet ha'ivrit*.

no vestige whatsoever of feelings that might dislodge the boredom and darkness into which he has sunk.

Nothing happens, and it seems nothing will ever happen.

No one considers him at all. He has no friends or acquaintances here, in this strange place. Even in his students' homes they look at him as a necessary and fleeting hindrance that one must abide for an hour or two.

When he leaves, they forget all about him.

It seems as though he's not even thought of as a human being.

Only here in this room is he "at home." To the walls and the furnishings of his room he is no stranger. They are witnesses to his ideas and musings, but their participation is not enough.

What will be will be, but let him also come and be counted among the living, among those who strive and work and hope. Let all the troubles of the world befall him if only others would sense his presence and pay him some attention.

In his memory images arise that bring a bitter smile to his face. He remembers once arriving at a student's home. He had only touched the electric buzzer when quick, irregular footsteps were heard along the corridor. At that moment he saw the house-goddess: the head of household's only daughter, so beautiful and fair.

He understood right then and there that when she opened the door, it was not he she had been expecting. Like someone stealing into a forbidden place, he surveyed her face from the side. His delight and her dashed hope were expressed at one and the same time. At that moment, he felt as though he was to blame. He lowered his eyes, contracted himself, and quietly entered his student's room, his knees giving way.[47]

Even now he could not forgive himself for the idea that had passed through his mind: If only she waited for him in that way!

It also happened to him that he came one time to another student's home, and, as the servant opened the door for him, everyone in the family rushed to greet the visitor.

Dashed hopes: the beloved guest whom they had awaited had not arrived. Instead it was he. The members of the household returned at once to the dining room. And he overheard the mistress of the household responding to her husband's question: "Who arrived?" "No one," she answered, "only the tutor."

He paces back and forth in his room and feels his heart melting and sinking within him. An end has come to his patience and calm. Active power has been awakened within him with all its might. The bitterness and despair have passed, have been silenced—and a new feeling is growing strong.

47. Cf. Nahum 2:11.

A certain pleasure and soft indulgence have found expression within him, a special affection for all mankind. It seems to him that he might now love everyone.

He paces back and forth in his room and on his lips—a willing smile. An extraordinary light glows in his eyes, he smoothes his moustache with his hand. His glance passes over the books resting on his table and he turns away from them: How contemptible they are to him now!

A knock on the door. The maidservant appears in the room. Although she has known him for a while, she has never before seen his face, indeed all of him, quite like this. She stands in astonishment.

"Is the master going out?" she asks, glancing at him momentarily.

"No, but . . . please wait," he says, noticing her about to leave.

"Why?" she asks.

"I wanted to say," he begins to stammer, looking at her with joyful eyes. "Yes, what was it I wanted to say?"

He, who had so many thoughts within him, could not find the words to speak to this simple girl. He grew angry at himself, and he put on a serious face as he studied her.

"What?" the girl asked again and waited.

"I wanted to tell you . . . yes," he stammers as he curled his moustache and lowered his eyes. "Yes . . . how old are you?" he suddenly asks.

The girl's face expresses astonishment.

"Why are you suddenly asking this?" she inquired with surprise.

"Yes . . . I wished to speak with you . . . you see . . ." Yet again, he has no idea how to continue.

The girl looks even more astonished.

He stops walking around the room and stands before her. A strange smile hovers over his lips.

He is afraid, lest she leave and not hear him out.

"But will [the master] please say what he wishes to say?" she asks impatiently, with growing astonishment.

"Please, wait . . . but no, sit down, please, here . . . Let's talk a little," he says suddenly, not taking his eyes off her.

Frightened, the girl grabs the door handle[48] and flees from the room.

"He's gone out of his mind!" he hears her call out.

48. Cf. Song of Songs 5:5 as well as "The Sanctification of the Moon," which follows.

Sanctification of the Moon[49]

A tumult in the house. Outside they are sanctifying the moon, and one runner after another comes to announce: "The sanctification of the moon! It has already been revealed! Hurry! We can perform the sanctification already! In a minute it'll disappear!"

Everyone hastens, runs, hurries.

One of my brothers is looking for his prayer book, which seems to have disappeared from sight, now of all times.

The second one stands with his prayer book open. He flips through the pages so frantically that the pages almost rip.

He wants to find the place with the sanctification of the moon, but as though to spite him, the right place eludes him.

The small ones grab their coats and throw them over their shoulders in haste. They are worried about coming late and missing their chance.

I stand frightened at a distance.[50]

I know that at a time like this I will be the object of my brothers' ridicule! "Look at her! What is she doing here? What, do you also need to sanctify the moon?!"

At times like this, recognizing their upper hand, they liked to dig at me and provoke me with their jokes.

I was hardly more than a girl at the time, and this sort of thing pained my heart, because in every other way, I was considered like a boy among my brothers.

I always played a major part in their games. I would run, jump, and climb like a boy,[51] and no one in the house really distinguished between me and them in matters of mitzvot [commandments]. When they were busy preparing the sukkah, I'd climb and go up to the attic together with my brothers and help with everything. Like them, I would

49. Recitation of prayers outdoors, in view of the moon, shortly after it has appeared in the sky.

50. Cf. Exodus 2:4: "And his sister [Miriam] stationed herself at a distance, to learn what would befall him."

51. Cf. Baron, "Haraḥmaniyah" (The Merciful One), in her *Parshiyot mukdamot*, 377–78.

collect the *sekhakh* [thatching] and spread it on top according to the instructions of the old servant, whose voice we would obey and fear because of his rebuke.

With my brothers I listened to the lesson of the elderly rabbi, and he'd praise me to my face: "If only she were a boy! Oy, a pity!" he would sigh.[52]

And this sigh would pierce and descend into the depths of my soul.

Because I was born a girl, my rebbe whom I adored was compelled to exclude me from the community when it came to such holy matters as the study of the Torah!

And my heart yearned so for the Torah [*nafshi hashkah kol kakh batorah*]![53]

I yearned for it so!

And so the hour of the sanctification of the moon became a hidden torment: It seemed to me a terrible wrong that we, the girls, were made to suffer.[54] I could not be consoled, for it struck me then as a very severe decree.

If they had exempted only me alone [*ilu hotzi'u rak oti bilvad*],[55] my pain would not have been so great. But I could not tolerate the insult to the honor of my mother, whose worth was certainly as great, if not greater in my eyes, than many of those who danced before the moon.

Not only did they warn me against participating in the sanctification of the moon, which seemed to me then to be a source of great joy, but my brothers also warned me against even looking at those who were reciting the blessings. And as I walked among those praying, I was also told to cover my eyes with my hands, for any woman or girl who looked at those who were blessing and listened to their voices would be afflicted with special torments.

On one occasion, I just couldn't resist: I stole outside and purposely stood in front of those sanctifying the moon and listened to the sound of their melodies. And my brothers terrified me, saying to me: A disaster, God forbid, will certainly befall you.

52. Cf. Foner, "Mizikhronot yemei ne'urai," for an additional account of a girl's entrée to Torah study. Note that this postdates Shapiro's sketch by a decade. On Sarah Feige Foner, see M. F. Cohen, "Separation Along Gender Lines." Note how Foner's brother learns from his mother, like Shapiro.

53. Cf. Babylonian Talmud, *Ketubot* 63a, where Ben Azzai cites his desire to study Torah as justification for not marrying and consequently not fulfilling the commandment to procreate. Shapiro, in her desire to pursue a formal education and consequently leave her husband and child, arguably follows in Ben Azzai's footsteps.

54. In contrast, Wengeroff was unruffled by the gendered differentiation of Jewish life that relegated her to vicarious observer. "As a child," she "loved to watch through the window as [her] father, accompanied by ten other Jewish men, stood in the moonlight and prayed" (Wengeroff, *Memoirs of a Grandmother*, 168).

55. The phrase alludes, paradoxically, to "Dayeinu" in the Haggadah. Whereas the hypotheticals in the Haggadah enumerate divine miracles manifest in the Exodus story, the hypothetical here enumerates injustice not only against Shapiro but also her mother.

In the beginning, I paid no attention to what they were saying, but within a few days, I began to be frightened of every "driven leaf."[56]

Every little whisper brought fear to my heart.

My fear especially worsened at night. It would seem to me then as though all kinds of strange creatures were walking and stalking and approaching my bed, leaning over me and swaying. I closed my eyes from fear, and lo and behold, the creatures move about and change form. They stretch out ever wider and taller. I awaken with a frightened cry.

And one night, I lay in my bed but could not sleep. Quiet prevailed in the house. In our room too—quiet. My sister was already asleep, only I alone was awake. Strange visions and apparitions terrified me, and I lay afraid to raise my head or open my eyes.

Suddenly, I hear the footsteps of a man coming ever closer to the closed door of our room. Perhaps I am sleeping? Perhaps I am having a nightmare? I so wanted to believe this, but my heartbeats, which grew so loud that I could almost hear them with my own ears, convinced me that I was hearing actual footsteps.

I held my breath and barely moved . . . and the footsteps continue to come closer. Here they are at the threshold of the door. Someone is groping at the door in the dark to find the handle of the lock.[57]

A cold sweat covered my brow . . .

My heartbeat stopped . . .

Suddenly I heard the voice of the Gentile gatekeeper, calling: "Wake up, go out and pray before the moon! It just now revealed itself."

I remembered that the gatekeeper was instructed on these cloudy Heshvan[58] evenings to be on alert all night long to watch and check for the moment of the coming out of the moon.

And when it came out, [the gatekeeper was] to inform at once all the people in the house, except the women.

And wouldn't you know, he went astray precisely at the opening to our room, the girls' room . . .

56. Cf. Job 13:25.

57. Cf. Song of Songs 5:5: "I rose up to let in my beloved; My hands dripped myrrh—My fingers, flowing myrrh—Upon the handles of the bolt," which lends a sense of sexual danger to the episode.

58. Heshvan is a Jewish month, usually corresponding to October, during which clouds might obscure a new moon.

Later Fiction Writings

Days of Awe[59]
Originally published in *Hed Hazeman* (1908)

When the Days of Awe drew near, an eventful period began for us children, filled with interest. The preparations began already from the first days of Elul [the month preceding the Jewish new year]. The *talleisim* [prayer shawls], the *kittelim* [white ritual garments worn on High Holidays and, Passover, as well as for marriage and burial], the *attarot* [prayer shawl adornments], and all the other "sacred ritual objects" filled the house. Some were brought in and others taken out. These were bought, and those were repaired. [The servants] laundered, cleaned, and affixed the adornments that were made of silver and fine linen. The tables were covered with dough for *lokshen* [Yiddish, noodles], which had been prepared several weeks before the beginning of the "holidays" and folded carefully into white cloths. And for us, there was some time to relax: No one paid us any attention—[except for] our great aunt, who bothered us with the writing of notes for the ancestors' graves, which she would distribute to every place that grandfather and his sons would go to prostrate themselves upon the graves.

These notes would busy us a great deal. They were long and similar to those doctors write out for prescribing medicine for the sick. That great aunt already had children and grandchildren and great-grandchildren, and each one of them was recorded on a note in his own name and in the name of his mother, along with his requests and wishes. When my aunt began to write and [make a] request on behalf of her children, back in the days when it was possible to marshal the footsteps of those who dwell in the

59. Shapiro asked Brainin whether he had read her "Days of Awe" (postcard from Shapiro to Brainin, 8 October 1908; not included in this book).

89

dust [the dead] to intercede with heaven's entourage, she could not manage to complete it on her own and therefore would grant the privilege to write notes to the True World [afterworld] to both me and my brothers.

Later on in life, I would never be as punctilious in the writing of "notes" of any sort, as I was back then when I prepared them according to my great aunt's dictation. To my great chagrin, I never emerged meritorious before my aunt, the meticulous one.

Out of great confusion and anxiety I would always leave out some necessary name or word, I would mix up the requests, and it would end up sometimes that I would ask for a proper match for someone who already had a wife and children—and for progeny for one who had not yet found a good match.

In those cases my aunt would complain bitterly and praise my brothers to my face, who were innocent of this kind of absentmindedness and who wrote better than I did. I made every effort and concentrated all my thoughts on my writing, but the more I tried, the more flaws and errors the letters turned out—and my sadness was considerable.

The days of *Selichot* [penitential prayers] approached. The first evenings of *Selichot*! The notes of the sad, gloomy melody still ring in my ears, emphasizing the spiritual character of *k'lal Yisrael* [the Jewish community]. I still hear the sighs and modest complaints of the Hebrew soul, folded into that melody which was replete with dark sorrow. I still see the grief-stricken image of the cantor, which reminded me all year long of the sad days of *Selichot*.

On *Selichot* evenings, we youngsters would also participate. We resisted the sleepiness that overtook us and waited impatiently for midnight, when the adults would light the torches and "walk to *Selichot*."

I too would join the group of women and enter into some minyan [quorum of men] with them. There I would direct my heart toward begging for forgiveness and absolution of all my sins. I would turn my heart from all other matters and focus only on this point—however, to my chagrin, Satan danced before me with a ludicrous, twisted countenance and in a strange manner. As soon as I would hear the cantor trill the melody of "El melekh" [Lord king, a recurrent prayer in the service], I would see creatures who would tickle my funny-bone—and that was the end of all my serious intentions.

I directed my attention to the central *selichah* [penitential prayer] with the large letters. I took great pains to recall all my sins—the books that I read, having secretly stolen them from my mother, bastion of my enlightened ideas, the young people who used to gather at the home of her older sister, the dances that I took part in. I wanted to confess with a full heart and endeavored to imagine in my soul's eyes the Court of Judgment on High, the angels huddled [tightly] together over the large ledger books where my iniquities were recorded. However, to my great sorrow, my lips remained stubbornly silent and all my efforts were for naught.

On the awesome days of Rosh Hashanah, when I would stand, head bent, next to my mother in synagogue, by the "Eastern" row[60] of the women's gallery, and as I listened to the sound of the blowing of the shofar, as my lips murmured the names of the angels that I read tremblingly from my mother's large *machzor* [High Holiday prayer book], I felt as though my spirit had been transformed, and when I enumerated "the sins" and beat my fist against my heart,[61] I contemplated repentance with a broken heart. I confessed and expressed remorse in my own name and in the names of others for sins, the nature of which I had no concept.[62] And thus I lessened my heart's burden.

The "Ten Days of Repentance" began, and Mother, the aunts, and the relatives took off their wigs and covered their heads with velvet scarves, so that the men would not sin on account of forbidden thoughts as they looked at the[ir] wondrous beauty. Faces became cloudy, gloomy. The men's faces were serious. A certain exaltation of the spirit hovered in the air, in anticipation of the great day.

And that great day began on Yom Kippur eve, the eve of *kapparot*.[63]

Before sunrise, at night, everyone awoke from his sleep to the sound of the loud hammer of the town sexton. We, the little ones, hurried to get up and get dressed, all of our bones trembling from the cold and from the sleep that still gripped us.

In the house, there was gloom, semi-darkness, and on the walls hovered the shadows of people hurrying to and fro, the sound of the chickens and hens was heard from every corner—and outside their Angel of Death stood waiting. Mother swung the "chickens" over the heads of the sleeping babies; the servants screamed and bickered. The men washed their hands. Everyone was hurrying, grabbing hold of their *kapporeh*, swinging it over their heads, and while reading out the "B'nei Adam" [children of Adam, opening words of the *kapparot* service], casting it under the table and retrieving it quickly, in order to present it to the *shoychet* [ritual slaughterer], who was standing outside next to the door to the house. I too hurried with my *kapporeh*, and when I extended it to the *shoychet* and watched him as he received each sacrifice, plucking bare the throat of each one and passing his knife over each one with complete equanimity, I looked at him and at the chickens flapping their wings in their dying moment and letting out a cry of the slaughtered, as they were cast from his hands or returned to their owners. I hurried outside ruminating to myself, "Lord of the Universe, these sacrifices actually atone for sins?" And I feared my ruminations, which came to me unwittingly.

60. The eastern wall (i.e., the wall with the holy ark) is a place of honor in old-style synagogues.

61. Jews customarily beat their fists against their chests while reciting the litany of sins on Yom Kippur, not Rosh Hashanah.

62. Each member of the congregation stands together to recite a standard litany of sins of *all* types, regardless of one's own specific transgressions.

63. The ritual waving and slaughtering of a chicken, accompanied by a prayer, as symbolic atonement. See Wengeroff's description of *kapparot* in her *Memoirs of a Grandmother*, 159.

Outside, darkness struggled with the light that continued to burst forth. The horizon was covered with the clouds of dawn's light, and the air was filled with secrets and intimations.

All day the heart was filled with excitement, alternating between sadness, anxiety, and good mood until the great evening came, the night of "Kol nidrei" [all the vows].[64]

Holy trembling, exalted awe filled the heart when Mother lit the candles and made the blessing over them in tears, as everyone took off their shoes[65] and blessed each other for a good fast and the "fulfillment of one's requests." The heart softened; everyone felt a sense of kinship for one another and fear of the sacred upon this great and awesome day.

Laden with their *talleisim* and *kittelim* and *machzorim*, the grown-ups left the house and walked to the synagogue. Only the children and the servants remained at home. The window blinds and doors were closed, and a great terror suddenly descended upon the house.

When I awoke from my sleep in the morning and saw the image of my grandfather dressed in his white *kittel* with a white belt around his hips and a white skullcap on his head, his face white and pale from the toilsome night he spent in the synagogue, and everything about him bespoke honor, his figure enveloped in a kind of sacred splendor—I felt with my whole soul the great significance of this awesome day.

Now, when I return to those same places, those same laws and customs, I no longer recognize and find in them that same holiness, that same lofty exaltation that enveloped them then.[66]

Perhaps it is only in my enthusiastic imagination that I fashioned for them such vestments of holiness and purity and such a wreath of God's grace, honor, and splendor. I grieve for my imaginings and my visions that have steadily been destroyed without mercy. And my heart is filled with longings for that which is beautiful and lofty, the wonder of childhood that has been frightened away by what has become simple reality.

64. *Kol nidrei* are the introductory words of the first prayer of Yom Kippur eve.
65. It is customary to avoid leather (e.g., shoes) on the Day of Atonement.
66. Cf. diary entry for 17 September 1907 in Part II.

The Brothers from Slavuta[67]

(An Event that Occurred)

Originally published in *Hashiloaḥ* (1914)

A holy gloom obscured that particular "matter." Everyone knew of it, but no one spoke of it. "They" and "them"—even as a child I knew who was delimited by this shorthand. Only seldom would they spell out their names. When someone would reckon [by counting] "a year and a half after the banishment" or "two years before the return," I knew whose banishment and return, and I was not surprised by that odd sort of reckoning, even with regard to other important events. Still, the essence of the matter was hidden from me. It was all shrouded under a veil of vague legend that pulled at the heart and kindled the imagination. A sort of dazzling wondrousness hovered over it, and the slightest suggestions increased my desire to know more.

From the day I became mature [enough to understand], I heard about the matter of my great-grandfather [Pinhas], which was common knowledge among the members of our household, the inhabitants of our town, and shtetl dwellers near and far. And the older I became, the more I understood why it was that neither my paternal grandfather nor his older sister, who lived in our house, ever spoke of it: The "they" and "them" whom they hinted at were after all their father [Pinhas] and their uncle [Shmuel Abba]. The matter affected the elders directly too. They lived through it, and to speak about it seemed difficult for them, like *profaning the holy*. To me the matter was but a nice and intriguing story; to them—bitter reality.

Every now and then individual statements about "the matter" would escape from my old aunt's mouth. But from my grandfather it was impossible to pry out a single

67. To enhance the verisimilitude of "The Brothers from Slavuta," Shapiro adds the subtitle "An Event that Occurred" [*ma'aseh shehayah*], even as she describes, within the story, learning of this event from her rabbi years ago when she was a girl. In a similar vein, Baron labeled her stories "from the memories of a girl." Both writers use a type of realist strategy in which the story is made to look more credible (or "true") by incorporating autobiographical features, all the while calling attention to its constructed nature as fiction. Cf. Marcus Moseley's analysis of Berdichevsky's story "Gershayim," with its paradoxical subtitle "A Tale of an Event that Occurred" [*sippur ma'aseh shehayah*], in Moseley, *Being for Myself Alone*, 225.

utterance. His noble, joyful face, garlanded with a long, snow-white beard, would cloud over with seriousness as soon as one would so much as mention said "matter." Secret sparks would flicker in his dark eyes, and a silent sigh would slip forth from his mouth, like a light wind, blowing from afar.

And this sort of sigh would also burst out from the old "rebbe" in our house. To this day I cannot forget this sigh, with its unique characteristics. It would never burst out when the old man was speaking with people. When he was deep in thought, it would be heard suddenly, an emphatic contrast, properly extended and prolonged. It was as though the sorrows of the people, crouching over him and tormenting him without his knowledge, were expressing themselves in this sigh.

The old "rebbe" himself knew the entire story: It was from him that I retrieved most of the stories and their related details.

On winter evenings, after *minḥa* and *ma'ariv* [afternoon and evening prayers], when he would sit at the table by the warm stove, his entire body pressed against the table, with the thick volumes of the Gemara [commentary on the Mishnah found in the Talmud] heaped upon it, my two brothers sitting to his right and to his left, soaking up his explanations, he would sometimes yield to my brothers' entreaties, to which I would join, and between one *sugiyah* [section of the Gemara] and the next, he would tell us one of the stories—he was a masterful storyteller—and we all would sit in rapt attention, our breaths held, our hearts open.

The old rebbe would tell the details of "that matter" with particular seriousness. His words penetrated our hearts, and all the other impressions could not blot out traces of them.

As I grew up, my knowledge of the details and the unfolding of this "matter" grew along with me. But most of what I know remains in my memory as I heard it from the mouth of the old rebbe on those winter evenings of my tranquil childhood.

When the great "*tzaddik*" [righteous one] R. [Rabbi] Pinhas of Korets passed away, his son R. Moshe settled in the city of Slavuta. In this city people would call him the Rabbi of Slavuta, and that is how he is known to this day, even though he served very little as a rabbi. A man of exalted attributes was R. Moshe. He was worthy of his father and followed in his ways. He was a wonderful artist in the particular craft to which he devoted himself: in the fashioning of Hebrew letters. He persevered and established the printing press in Slavuta.[68] The sages of his generation supported him. The Rav (Rabbi

68. The local nobleman, Roman Stanisław Sanguszko (1800–1881), allowed R. Moshe to establish both a Hebrew printing press and a paper-manufacturing factory on his land. Within two years, as Russia annexed Slavuta in the second Partition of Poland, the press began to prosper. Friedberg, *Toledot hadefus*, 104.

Schneur Zalman of Lyadi) came and published the first edition of his *Tanya* here.[69] He beheld the splendor [*zohar* in Hebrew original] of the letters, returned and visited the Rabbi of Slavuta two to three times, supported his hand and strengthened his heart to go on printing holy books. It was understood that the printing press of the Rabbi of Slavuta had no place for books of the other sort—those of the Haskalah [Jewish Enlightenment] and of heresy. The books that were printed with his letters, with his handiwork, were a light unto the eyes. Their letters illumined and shone. It was said that "the *Shechinah* [God's presence] rested within them."

The printing press grew ever larger and became a source of sustenance for the rabbi and his sons. The rabbi's wealth grew ever greater; bags full of gold filled his house, from which he would dole out to every poor man and beggar. Throughout the days of his life, the rabbi himself barely knew the "shape of a coin"; his entire fortune, accumulated from the toil of his hands, was entrusted unto his wife, the mistress of the house and a remarkably wise woman. She could neither read nor write, nor pray from a *siddur* [prayer book]; her face was ugly, and the rabbi wanted to divorce her after they married. But his illustrious father reprimanded him and said, "I promise you, my son, that she will bear you proper, God-fearing children." The rabbi relented and continued living with his wife in peace and tranquility. And indeed, she bore him a son—in 5544 [1784], even before they moved to Slavuta, whom his father called Shmuel Abba. The boy merited that his illustrious grandfather, Pinhas of Korets, should rock his cradle. On one occasion, one of the great sages of the generation, R. Dovidl of Chechelnik,[70] came into R. Pinhas's house and found him doing so. The guest was astonished and stood dumbfounded until R. Pinhas explained to him, "This little one was created for greatness." The boy continued to grow, and his grandfather would ever delight in him, sitting by his cradle and looking into the eyes of his attractive grandson.

In 5550 [1790], the "great R. Pinhas of Korets" passed away. Two years later, a second son was born to the Rabbi of Slavuta, and he named him Pinhas after his father. He too grew and developed, excelling in wisdom and understanding, like his elder brother. The two brothers were distinguished by their fear of God, their purity of heart, their estrangement from all types of ugliness, and their love of truth.

And the father, the Rabbi of Slavuta, grew old as his wealth and greatness ever increased. He bought a house in the center of the city, built a synagogue and a special

69. Rabbi Schneur Zalman (1745–1813) founded the Hasidic dynasty known as Lubovitch (or Chabad). In 1796 Moses Shapiro published the first edition of the *Tanya*, the "Bible" of Chabad Hasidic thought.

70. Rabbi Dovidl of Chechelnik appears to be Rabbi David of Savran (d. 1912), who was known as *hakatan* (the little one) to distinguish him from his older relative, Rabbi David of Talna, thus the diminutive Dovidl. Rabbi David of Talna was the grandson of Moshe Tsvi Gutterman (c. 1775–1838), a rebbe of the Savran Hasidic dynasty. Savran is located near Chechelnik in Ukraine. Ironically, Rabbi David of Savran was exiled because of a dispute with a government official—a foreshadowing of the fate of the brothers from Slavuta.

bathhouse. He married off his sons and daughters, all of whom lived near him. All were respected and remarkable. The rabbi passed his printing press down to his sons, and they managed this highly regarded press and expanded its production. The sons held onto the teachings of the father, that each man should support himself by the work of his hands and not from gifts or handouts from other men. Many flocked to their door; the community knew that they were absolute *tzaddikim* [righteous men], the grandsons of R. Pinhas of Korets, and people would offer them "favors" and "notes," which they would not accept. They despised money that came from others' labors.

The sons of the Rabbi of Slavuta were famous, respected, and beloved men of ability who were generous and just. And the old rabbi was truly God-blessed. God did not withhold any good from his home or impede his greatness from increasing.

Present in the city were a few ignorant folk [*koftsim barosh*][71] who envied the rabbi and his sharp-witted and distinguished sons and held a grudge against them.

In those days the Haskalah was in the land [of Russia]. The tsar who ruled then was Nicholas I, who forced "enlightenment" upon his people with a strong arm.[72] At the same time, Hasidism was spreading among the people, R. Pinhas of Korets having been one of its first founders. And this movement, remarkable at its inception for its romanticism, was despised by the first *maskilim* [Jewish proponents of Enlightenment], the purifiers of the masses,[73] who sought to denounce the spread of Hasidism. And those who devised an evil plot against the Rabbi of Slavuta and his sons went and informed against them,[74] saying: Here is a rabbi and his sons—descendants of R. Pinhas of Korets, one of the founders of Hasidism—who hold fast to the dangerous teaching of their ancestor and are increasing darkness and ignorance among the people by dint of the books they publish, which disseminate harmful ideas and impede the spread of the Haskalah.

And at that time, at the zenith of the Rabbi of Slavuta's wealth and prominence, his granddaughter, a young woman of 25, took sick and became obsessed with one thing. She would lament and be desolate all her days, mourning the exile of Israel and the exile of the *Shechinah*, until one day an evil spirit seized her and she began to foretell

71. Cf. Babylonian Talmud, *Megillah* 12b, where the expression *hedyot kofets barosh* refers to a boorish man trying to pass himself off as cultivated and intelligent.

72. The minister of education under Nicholas I, Count Sergei Uvarov, sought to "enlighten" the Jews by weaning them from conventional talmudic learning, introducing them to secular studies, and training them to become artisans.

73. The *maskilim* sought to "purify" Jews of what they regarded as outmoded belief and practice and to bring them into line with modern standards of aesthetics, education, and livelihood. Cf. *Mishnah Avot* 5:18: "One who purifies the community causes the community to be meritorious, no sin will come by that person's hand." Shapiro uses the expression ironically, to hint at the transgression of the *maskilim*, who allegedly were involved in her relatives' arrest.

74. The act of one Jew informing against another to a Gentile official was tantamount to sinning in the eyes of the Jewish community, which feared endangering its survival as a result of the slander.

evil tidings about the rabbi's sons. All her visions whirled around this single point: a great calamity will befall the rabbi. Her uncles, R. Shmuel Abba and R. Pinhas, will be fettered in chains and will be banished and exiled from their city and their province.[75] All their enormous wealth will be plundered and wasted. The enemies will open their mouths wide, and the two brothers will undergo harsh suffering. She obsessed over this and prophesied visions day and night. The visions were evil, awful, and frightening, and they tortured her unceasingly.[76]

Everyone reprimanded the madwoman, endeavored to persuade her, spoke to her with candor, consulted with doctors—but all to no avail!

If the wretched creature so much as saw one of the brothers, her face would suddenly turn pale as plaster and become frozen with terrible fright. Her glance would become strange, fixing on one point, and she would wail and sob in a heartrending voice: "Look and see! They are imprisoning them! Don't you see! Here are the chains! Oy! Send them away! Hide them while there is still time! Behold, they're coming, they're approaching!" And when approaching her grandfather's house, she'd cry out: "You shall be ruined, dust and ashes. Hide my uncles! Oy, they'll imprison them in iron chains. They'll be exiled, sent away!" And she would grab a corner of one of her brother's clothing, calling out and sobbing: "Hide the wretched ones! Conceal them while there is still time!"

Once the elderly rabbi came, accompanied by his sons, to his daughter's home. As soon as the madwoman saw the brothers, she fixed them with her strange gaze, as though strange, terrible, and awful scenes were unfolding before her, and she cried out and sobbed as was her wont!

The elderly rabbi approached her, touched her palm lightly, and in a soft, careful voice, he said, "Look, my girl, and see: you are becoming agitated for naught and are worrying for nothing! See, my sons are here!"

The madwoman didn't even wait for him to finish his words. She looked dumbfounded at her grandfather and rebuked him outright, crying, "Grandfather, also you . . . they are sacrificing . . . Oh, don't you see?"

The rabbi's face immediately turned pale, his head lowered, and without another word he quickly left the house.

Only a few days passed and the year 5596 [1835]—a year predisposed to misfortunes for the righteous[77]—arrived.

75. "Province" corresponds to a *guberniya* (or governorate), into which the Russian Empire was divided for administrative purposes.

76. The granddaughter appears to be modeled after the ancient Greek prophet Cassandra.

77. Common rabbinic expression referring to inauspicious times, which are, if they occur, designated for retribution against the Jews. Cf. Maimonides, *Mishneh Torah, Hilkhot Ta'aniyot* 5:6.

From both sides they did not rest and would not be silent. On the one hand, those who wanted to plot against the Rabbi of Slavuta and his sons devised stratagems to bring evil upon them, which they could not escape. On the other hand, they conspired with the "higher spheres" [the Russian government] to destroy the root of the *tzaddikim* and remove their descendants from the land.

One day a terrible event occurred. In one of the synagogues in the city, they found the dead body of one of the bookbinders for the printing press belonging to the "Brothers of Slavuta," a known Jewish drunk, who hanged himself there. The informers seized on this event. They went and whispered about it in the appropriate place: *At the behest of the Rabbi of Slavuta the man was hanged.* They saw it with their own eyes. The rabbi's sons themselves had done the hanging. [The informers] are prepared to testify and swear to it.

The informers knew, and even those in the "higher echelon" knew, that this was a trumped-up charge. But they needed a pretext—and they made use of this unfortunate incident.

And so one day special emissaries appeared in Slavuta, who came to investigate the matter of "the murder." And their first action was to imprison the rabbi's sons, R. Shmuel Abba and R. Pinhas—they did not jail the rabbi himself because of his old age—and their close relatives. The jailers knew that they were afflicting innocent, blameless men for nothing: As soon as they arrived it became clear that the man had hanged himself in a drunken stupor. But this was the will of "the highest of the high" [presumably Tsar Nicholas I], and they were merely emissaries.

The chief investigator was Minister Vassiltchikov, a good-tempered man and a philo-Semite, like his distinguished father-in-law, the minister of defense.[78] He knew and was convinced when he came to Slavuta that this was all a mix-up and that the *tzaddikim* were innocent and pure-hearted, but the order went forth: Imprison the rabbi's sons—and he was required to follow it.

For weeks and months the emissaries stayed in Slavuta, "investigating" and "inquiring," and to this day the street where the emissaries stayed is called Petersburg Street, after the investigators who were sent from Petersburg.

Slavuta was the domain of the Polish nobleman Prince Sanguszko,[79] a member of the landed gentry. The old nobleman, who lived in Slavuta, knew the rabbi and his sons,

78. Ilarion Vassilevitch Vassiltchikov (1776–1847) served as chairman of the Council of Ministries (1838–1847), the highest organ of government in prerevolutionary Russia, which acted in an advisory role to the tsar. The father of his wife, Vera, was senator and lieutenant-general Peter Stepanovitch Protasov (1730–1794).

79. Roman Stanisław Sanguszko (1800–1881), a Polish aristocrat with a manor in Slavuta, supported economic development on his land, including the establishment of a paper factory.

knew of their uprightness and purity of heart, loved and esteemed them. And when this calamity suddenly befell them, he grieved mightily on their behalf, shared their sorrow, and would neither rest nor remain quiet in his quest to prove their rectitude and to save them from this evil. When it became evident that the investigation had been entrusted to Vassiltchikov, who was staying in Slavuta, he made a great feast for the officers and rulers, his relatives and acquaintances, and invited Vassiltchikov, even though he was not one of his relatives or acquaintances and did not originate from the landed gentry. And it came to pass that when they were sitting at the feast and when the hearts of all were merry with wine,[80] the old prince turned to the minister from Petersburg and said, "Give me your promise, my Lord, that you won't do evil to the rabbi and his sons and that you'll bring their righteousness to light. On my head, I swear that they are innocent." Vassiltchikov did not answer, he got up from the table and left the house. A promise of this sort, had it been made, was beyond the jurisdiction of Vassiltchikov, beyond the exalted directive he had been issued.

When the old rebbe would speak about Minister Vassiltchikov, he would praise him effusively and add, "Woe to the man who is appointed emissary for evil! However, even one greater than he, even Tsar Nicholas I, was an emissary of the evil that was decreed upon the righteous from on High [from God]." He would then pause and his face would become sunken with thoughts and extraordinary contemplation, and that sigh, which I knew so well, would escape from his mouth.

"The decree against the *tzaddikim* came down from heaven," he would add after a long silence. "And no human could rescind it. They suffered on account of the sins of the generation and were tortured on behalf of the community—not everyone, not even every *tzaddik* is worthy of that. The grandchildren of the great R. Pinhas—they were worthy!"

When one of them was born, R. Shumel Abba, his grandfather said, "These are worthy to be among those who escort the messiah, but the generation was not worthy of him."

The festival of Passover arrived, *leil shimurim* [the night of vigil].[81] But the *tzaddikim* remained in prison.[82] On this night light would always pour forth sevenfold into the old rabbi's home, and happiness and joy would rest upon it. All of the children and grandchildren would gather together, and the rabbi's face would shine from the holiness of the festival, and the *rebbetzin*'s [rabbi's wife] heart would fill with exultation as she looked at her offspring, who were all delightful and flawless.

80. Cf. Esther 1:10.
81. A reference to the first night of Passover; cf. Exodus 12:42.
82. Ironically, Passover commemorates liberation from bondage.

But on the night of this festival the happiness was locked out.

The parents knew that their sons were imprisoned not because of their own sins and iniquities but rather because these pure souls had been selected to expatiate for the sins of the generation. Even so the father and mother's heart grieved exceedingly.

The elders repressed their personal sorrow. They sat at the table, led the seder, and did not desecrate the honor of the festival. But the joy of the festival did not put an end to their woes, and those around the table looked about and wondered.

And the only son of R. Pinhas—the son of the younger of the imprisoned brothers—was absent from the old rabbi's home on this night. He obtained permission to go and visit his father on *leil shimurim* and to bring him Passover provisions.

The son entered his father's jail cell. The brothers were side by side in special shackles. A dreary candle illuminated a small desk and single chair, upon which sat the imprisoned one with his head supported by his two hands, and the shadows leapt and twisted on the dreary walls; the son's heart contracted and he couldn't utter even a word. And the father—his head raised, his face gaunt, and his pained look, as reflected in his bright eyes—was revealed to the son as his sad voice reached his ears: "*Leil shimurim*, my son!"

Leil shimurim for the son of the Rabbi of Slavuta is spent in this jail!

The son holds back his tears, looks at his father—and hasn't the strength to ask a thing. And the father glimpses his son's face and understands the question racing around in his mind—and he isn't able to respond. Suddenly he gets up from his place, raises himself to his full stature, and his face begins to shine. A ray of light accrues, and sparks of joy twinkle in the pupils of his eyes, and the entire cell is bathed in brilliance—sparks of hidden light glimmer and illuminate its interior. Even the son senses this extraordinary brilliance, this holy brilliance; he senses his father's exaltation, and the twinkling of light and joy convulses even within him, and the bitterness and condemnation of heaven have been removed from his heart, and he understands that there is a reason for the suffering of the *tzaddikim*, that they are receiving their punishment with *love*, and [thus] he complains no more. The son does not ask and the father does not respond. And the two of them know; the two of them understand.

A full year passes—and the guilt of the brothers is not proved.

The investigators conceal the truth and dare not reveal the righteousness of the accused. Those who lobby and advocate expend hundreds and thousands, and the property of the rabbi is being squandered, and even people on the periphery spend huge sums to prove the falsity of the mix-up. But all to no avail.

The order went forth—and one cloudy morning [*boker avot*][83] the brothers were transported to Kiev.

They were transported like utter criminals. Surrounding them, a distinguished squadron of soldiers brandishing swords, with iron chains on their feet, the hand of one bound to the hand of the other. And the "criminals" walk and pass by, their chains clanging.

However, the *tzaddikim*—their spirits wandered in free realms. Their feet have been fettered, their bodies bound in shackles, but their spirits are in the upper spheres. And their musings—holy sparks that illuminate their path. The *tzaddikim* neither see nor hear the lamenting and the wailing of those who accompany them.

As for the old rabbi—they hide his sons' exile from him. The man is very old, and the advocates endeavor to remove the evil of the decree [*leha'avir et ro'a hagezeirah*][84] that hovers over his head as well. The elderly rabbi doesn't worry for himself; rather he pleads all day: "Return my sons to me! Return my innocent sons to me! Take everything that I have, only return my sons!" And the elderly *rebbetzin* cries bitterly.

The brothers are exiled to Kiev and imprisoned there, they and their relatives. They sit locked away and sequestered and "no one has permission to enter or approach them until the judgment has been decided." Rabbi Pinhas's only son alone succeeds in gaining access to his father in his Kiev detention. And the tender son pays for this pleasure with a punishment of twenty-five lashes.

The brothers languished in jail for three years in Kiev. The end of 5599 [1838] arrived. A new century approached, and with the passage of time, the judgment was handed down with respect to the righteous brothers, the sons of the Rabbi of Slavuta. Each of the brothers will receive 1,500 blows, passing through two lines of armed soldiers with sticks, switches, and whips, [*prokhodit'*] *skvoz' stroy* [Russian, running the gauntlet]—*kostroy* in the language of the rebbe, the people's tongue—and if they emerged alive after their beatings, they'd be exiled to Siberia for the rest of their lives.[85] This kind of judgment no one expected, and those who esteemed the *tzaddikim* feared and trembled!

The meting out of the judgment was set for a day in August, which coincided with Rosh Chodesh [the first day of the month of] Elul.[86]

The evening before, one of their acquaintances was allowed to visit the brothers. The man entered the cell where the brothers were being detained, his soul embittered

83. The expression *boker lo avot* means "one fine day"; thus *boker avot* means the opposite.
84. Cf. the climactic High Holiday prayer, *Unetaneh tokef*, which states, "Repentance, prayer, and charity remove the evil of the decree."
85. Running the gauntlet, or *spiessruten*, involves being stripped to the waist and forced to run any number of times between two rows of 500 soldiers, equipped with long, arched staffs used to strike the runner.
86. The beginning of the season of judgment in the Jewish calendar; the month of Elul precedes Tishrei.

and his heart rent and inflamed. But the *tzaddikim* were quiet and complacent, not a single shadow clouding their faces. The man thought to himself, "They must not yet know what has been decreed upon them"—and he dared not utter a word. The brothers entered into conversation with him, encircling him with questions. The man stood there stunned, his soul greatly embittered. He didn't want to be the bearer of bad tidings. Lo and behold, the younger brother takes him aside and with a calm demeanor whispers to him:

"Tomorrow we are to undergo a *kostroy*."

The man was shocked, astonished by the *tzaddik*'s tranquility. He could not find it in his heart to say a word. And then R. Pinhas added, "We are accepting the punishment with a quiet heart. It comes not as a punishment for our sins. It is possible that the *body* will not withstand the punishment. If so, make every effort to see that we receive a Jewish burial."

And when the *tzaddik* saw that the man was about to faint, he added, "Strengthen yourself [*hazak vehithazek*] on our behalf. Do not leave the city until our judgment has been meted out."

And the man—the tears bursting into his throat—hastened to make his promise and escaped from the *tzaddikim*'s prison cell.

That night the imprisoned men from Slavuta did not sleep—all told, there was a minyan of ten in the Kiev jail—and morning had not yet dawned when the voice of one of the prisoners, who had reviewed the [Torah] portion of the week, reached the ears of R. Pinhas—that day was *Erev Shabbat* [Friday]: "And you shall have only joy."[87] The righteous man listens to the words of the holy Torah and immerses himself in thought. After all, this is also one of the principles of his grandfather's teachings, the Torah of Hasidism, for which he was being punished. And his soul was enveloped, blackness overtook him; sorrow stole into his heart, and shades of shadows darkened the glow of his spirit. The righteous man was saddened; he had no strength to overcome the rising shadows and remove them from his heart—and his sorrow was great.

Suddenly a smile passed over his lips. He approached the one who was reviewing the portion: "My beloved one, the Rabbis of blessed memory said: "'Altogethers' and 'onlys' come to restrict"[88]—and the righteous man felt better: the Gemara relieved a bit of his melancholy.

Nevertheless the black shadows kept on ascending, ever ascending and increasing. The *tzaddik* wrapped himself in his prayer shawl, as did the elder brother, R. Shmuel Abba, and the *tzaddikim* began to pray.

87. Cf. Deuteronomy 16:15.
88. According to some biblical exegetes, when the words *akh* (altogether) and *rak* (only) appear, they come to temper rather than enlarge upon a matter. Thus, although Rabbi Pinhas initially despairs that he will be punished for not being altogether joyous, he then finds consolation in the words of the rabbis, which permit him some sadness under these extreme circumstances. Cf. Rashi on Exodus 23:13.

R. Shmuel Abba often led the prayers in the synagogue, and his pleasant voice would rouse and enthuse the hearts of those who listened to it. They would see his erect carriage, his high forehead, his shining countenance, beaming with the splendor of inner joy, his deep eyes, and his beard sprinkled with gray. They would peer out over the edges of their prayer shawls and would feel the meaning of the prayer. This time too the *tzaddik* led the prayers. But none had ever heard before this kind of prayer from his mouth. The voice poured out melodiously and along with it the *tzaddik*'s soul. He was taking an accounting of his life in the mundane world, and in his voice was neither bitterness nor even request or entreaties. But the voice was sorrowful, as though the pain of all the tormented and oppressed was pouring forth with it, as though the *tzaddik* were expressing with his words the regret and contrition of all the sinners and criminals on whose account it had been decreed that he be tortured now.

R. Shmuel Abba offered the prayers of a "minor Day of Atonement" and melted into tears. R. Pinhas stood beside him, listening and hearing. He was weaker in body than his brother; his face was pale and noble, with hidden meanings meandering all over it.

And suddenly—the keys were jangling, the door opens—the prison officials enter, along with court officials and armed officers.

The brothers did not tremble. They were already prepared. But they had not yet wrapped themselves in the phylacteries of Rabbeinu Tam,[89] and so they asked permission to take them with them, wrapped them up, and followed those directing them, hurrying them along.

It was a clear day, the eve of Rosh Chodesh Elul, the rays of the sun spread, illuminating and warming the street surface, meeting the morning dew, consuming and imbibing it. The golden roofs of the many churches glinted and sparkled in the sunlight. The sound of bells rang forth, and down the noisy streets went the "Slavuta Brothers," the rabbi's sons, guided by officers, walking to the place that had been prepared for the retribution [*pur'anut*].[90]

The people they encountered, the streets, the churches—all of this was foreign to the brothers. The city was completely foreign to the brothers' spirit. And within this foreign environment, they breathed in the moment, perhaps the last seconds of their lives on earth.

They reached a wide-open square.

From a distance were seen two lines of soldiers waiting on the square, line opposite line, looking together like a long street. In the hand of each soldier—a long stick that

89. Jacob ben Meir (1100–1171), Troyes, grandson of Rashi, who disagreed with Rashi about the order in which the biblical scriptures are to be placed in the phylacteries. Thus extremely devout Jews don two kinds of phylacteries to satisfy both opinions.

90. The choice of *pur'anut* instead of *onesh* for "punishment" calls to mind the dictum from *Pirkei Avot* 1:7: "Do not despair as a result of retribution" (*Al titya'eish min hapur'anut*).

was a kind of whip, the measurement of which was allotted in advance: a cubit and a half in length. Two hundred and fifty soldiers with two hundred and fifty whips in their hands along the length of each line. They stood face to face, and between them only a narrow passage, designated for those decreed to pass through the *kostroy*.

The soldiers were replaced at the last moment by others, who were even taller and stronger than the former: A suspicion had crept into the hearts of the officials that the first ones had perhaps been bribed by the Jews and would thus strike with mercy.

Surrounding them—a huge crowd gathered to see the spectacle. Only Jews were absent. In their sorrow, the mourners had escaped from this vale of tears ['*emek habakha*].[91] All that remained were three close relatives of the brothers. They hardened their hearts, they deadened their senses with drink, and they stayed close to their masters in their time of suffering.

The heads of the court, officers, controllers, supervisors, and physicians encircled the square and the lines of soldiers.

The sign was given and the prosecutor read the proclamation of guilt and the judgment. All ears were attentive. *Each of the brothers will receive 1,500 lashes.*[92] And if their souls do not depart and they live thereafter, *they shall be sent to Siberia for the duration of their lives*, they and their wives and all those detained with them.

Upon hearing this, the heart of one of their close relatives went out to him, and he became confused, and R. Shmuel Abba saw this with his own eyes. When the reader concluded reading, the *tzaddik* requested, "Repeat the reading." And he turned to the confused close relatives and commanded, "Strengthen yourself and listen!" and the man understood that there was a reason for this, so he strengthened his heart, listened, and did not stop glancing at his master. And when the reader came to the words "they and their wives," R. Shmuel Abba gestured to his close relative with his eyes, and the relative saw the gesture and understood the rabbi's intention.

The man did not tarry for a moment and he rushed to Slavuta—to inform the *tzaddikim*'s wives and their children of the evil they were about to face.

The reading concludes. Everyone falls silent. The listeners don't dare make a sound. They wait, and the brothers argue among themselves:

"I'll go first," R. Pinhas decides.

"I am older than you, Brother," replies R. Shmuel Abba.

But R. Pinhas does not relent: "I beg you, my brother. Let me not see your pain!"

And the brother is persuaded. The younger one will be punished first.

91. Liturgical expression (derived from Psalms 86:7) for suffering of the Jews in exile, as in '*Emek habakha* of Joseph HaCohen (1496–c. 1575) and the sixteenth-century liturgical poem *Lekha dodi* by Shlomo Halevi Alkabetz.

92. Cf. Ginsburg, *Drama of Slavuta*, 124.

And the sign is given. Those appointed approach and remove the clothing from R. Pinhas except for his undershirt and this they rip in half, leaving it hanging on him.

The *tzaddik* pleads: Wait a moment for him.

He makes a belt out of the openings of his shirt, retires to the side, takes out his phylacteries and lays them on his head and arm. He finishes his prayers.

The crowd waits impatiently. The armed soldiers wait. They long to see the "criminals" beneath the whips burning in their hands.

The incriminated Jew prays. His voice is not heard. Only his lips move in a whisper. "He is making his final confession, the rebel," the soldiers conclude and say to themselves: He will not emerge alive from their whips! They will carry out their duty faithfully!

The commanders hurry him, and the *tzaddik* hastens to the end of his prayers.

He finishes, assigns his spirit to his God, and his body to the torturers.

The officers approach. They raise up his hands; they tie them to the barrel of a rifle, and pass the rifle to a soldier.

The order is given.

The drum beats and a special song is played—the song of the *kostroy*.

The soldier leads the *tzaddik* between the rows of soldiers.

His shoulders are bare, his hands are tied, but he walks upright.

The whips are raised and lowered onto the naked back.

The older brother averts his gaze—the shrieking of the whips buzzes in his ears. He suddenly fixes his gaze on his brother's eyes. The assembled people also look and see only the flinching of the body under the beating rods.

The face of the *tzaddik* beams with a mocking grin: "The Torah of my forefathers is *in my heart* and your beatings cannot destroy it."

Suddenly the *tzaddik* stops in his tracks. The soldier pulls at the barrel, but the *tzaddik* does not move from his spot, and the whips continue to rain down on his currently bent-over back.

All the onlookers fix on him. Everyone is stunned. [Then] they see and discern: The fur hat [of the Hasid] has fallen off the *tzaddik*'s head and he is unable to pick it up—his hands are tied.[93]

93. Y. L. Peretz's Yiddish tale "Shalosh matanot" (Three Gifts, 1904) recounts the self-sacrificing acts of three Jewish martyrs, including one who is forced to run the gauntlet. In his story, Peretz reimagines the fur hat of the Hasid as a yarmulke, which his character, like Shapiro's, upon discovering that it has fallen off, turns back to retrieve and is consequently whipped doubly. Peretz charges this moment with irony, deriding the piety of his protagonist, which seems trivial and even laughable for its diminution of the larger central values that ought to govern Jews. Shapiro, in contrast, hews to the traditional devotional lore around this incident. Peretz already knew Shapiro by the time he wrote "Three Gifts," although it is unclear whether he learned of the Slavuta incident from her or from the mythology surrounding it in the public domain.

He stands and gestures. The soldier sees and wonders, and lifts the fur hat onto the bare head of the one being beaten—and the procession continues.

The older brother beholds the terrible sight, and tears stream from his eyes.

"Well done [yeyasher koḥakha], my brother!"[94] his lips whisper, a contented smile illuminating his face as tears roll down [his cheeks].

The *tzaddik* was led through the lines of soldiers three times. Then he was brought to the hospital.[95]

He merited not having to see the torturing of his brother.

R. Shmuel Abba passed through the lines of soldiers with an upright carriage. He stepped behind the soldier who led him, the whips etching deep gashes in his body, but not even a slight sigh escaped from his lips.

The drums beat a third time. A third criminal: a broad-shouldered soldier. He is brought along the same path where the *tzaddikim* were led—between the lines of soldiers.

He passed through twice—and fell on the ground and died.

And R. Shmuel welcomed the Sabbath in his detention cell with song, as was his custom—as the doctors removed what remained from the switches that had been etched and grooved into his flesh. He sanctified the day, washed his hands, made the *Hamotzi* [blessing over bread], although he could not yet swallow bread, on account of his wounds.[96]

And in Slavuta they knew nothing of what had been done.

Yet suddenly on that day the elderly rabbi was seized with great fear. He got up from his bed early that morning, and on his face was immense pain, though he did not utter a word.

The people in the house and his close relatives saw that he was steeped in sorrow, but none dared approach him.

He was weak and did not wash, nor change his clothes in honor of the Sabbath. He mourned and sat alone.

Suddenly the relatives saw the rabbi get up from his seat, walk over and lean against the eastern wall, cover his eyes and call out in a terrible voice:

"My God, my God, why do you remain silent?"

And his voice was a sobbing voice; his whole body was trembling.

94. Literally, "May your strength be straightened," a common liturgical expression used to congratulate someone for proper performance of a public ritual.

95. Zederbaum recollects looking at R. Shmuel's shoulder twenty years after he ran the gauntlet and needing to steady himself after seeing the red lacerations. See Zederbaum, *Keter kehunah*, 141.

96. In his account, Friedberg strikes a similarly pious tone. See Friedberg, *Toledot hadefus*, 104–9.

"You, God, who knows that my sons are free of sin and iniquity. . . ," the rabbi demanded.

The people in the household did not understand why he was afraid. They were shocked and mustered the courage to approach him and ask. But he did not turn toward them, did not even sense their presence. His eyes were closed, as though seeing a terrible vision. He trembled and called out in a loud voice, "My sons, my innocent sons!" And suddenly boiling hot tears stream from his eyes.

Only afterward did the fact become known that on that very day the *tzaddikim* were exiled, after running the gauntlet.

When the relative arrived in Slavuta, the two wives of the *tzaddikim* hastened to leave the city. R. Shmuel Abba's wife [Shaindel] disguised herself as a cook in a stranger's house in a distant city and R. Pinhas's wife [Sarah] hid in a relative's home until both were able to be transported across the border.

A rumor spread throughout Slavuta that the old rabbi too had been sentenced to exile in Siberia, as per orders from the powers that be, "if need be by sleigh on a summer's day" [i.e., by any means possible].[97] If he be ill, doctors will accompany him, so long as he is sent. However, the rabbi mocked his pursuers.

One day clerks rushed into the rabbi's home and found him laid out upon the ground. Candles were lit at his head, and women were wailing all around him.

The clerks stood by, stunned.

"What if this is all a ruse?"

They refused to leave and demanded to be shown the dead body. And the relatives of the rabbi were thrown into confusion. They took counsel with and whispered to each other: "Shall we allow these men to approach our great deceased one?!"

The chief clerk saw and was suspicious. He approached and gave an order: "Remove the sheet!" The officers removed it and the face was revealed as that of the great dead man, and it was tranquil and content, as though mocking the clerks and the officers.

All this occurred in the year 5600 [1839]. The old rabbi was 78 years old when he left this world and found rest from his enemies and pursuers.

Before long the old *rebbetzin* also went to her eternal rest after mourning her sons, who had been exiled from her.

For several weeks R. Pinhas hovered between life and death until he recuperated from his infirmity. But life was bitter. According to the decree, the two brothers were

97. In *Drama of Slavuta*, Ginsburg claims that Moshe was exiled to Siberia for printing unlawful books but was spared corporal punishment because of his advanced age.

now forced into exile in Siberia, where there was then no Jewish settlement, where it would be impossible to observe the customs and commandments, and where there was no hope of being buried as a Jew. The pain and distress increased. Even the strength of the elder brother, R. Shmuel Abba, was sapped, and he was weak and frail.

And one day, officials from the jail entered the *tzaddikim*'s cell with barber's shears in their hands—to shave off the forelocks and beards of the imprisoned.[98] This order befell all criminals designated for exile to Siberia.

The *tzaddikim* were extremely frightened and their blood froze in their veins. They, who had been subjected to the most severe torments and had not complained, rose up with all their strength to oppose being forced to violate the Torah's commandments. In their eyes this was a greater form of torture than all the torments they had suffered. They begged and pleaded, defended themselves, and rose in protest until they were restrained and their forelocks and beards shaved off against their will. The razor cut R. Pinhas's flesh and scraped him until he bled.

The next day they were sent to Moscow.

Like utter criminals, with iron chains on their hands and feet, heads and beards shaven, surrounded by soldiers brandishing swords, the *tzaddikim* departed the city. Many streamed out after them both to admire and accompany them. And weeping and wailing and sighing were heard that shook the air. The only son of R. Pinhas was also among those accompanying them. The farewells began outside the city. The *tzaddikim* strengthened the hearts of those who accompanied them and preached to them that they must not succumb to sadness; rather, they should have faith and hope in the Holy Name of Blessing, who will shed truth on their sentence, and they ought not weep so much, and the main point: They should never, Heaven forbid, despair.

As for them, their spirits did not flag and they bore with courage all that befell them.

And the brothers arrived in Moscow. The respected and esteemed advocates begged and pleaded for the *tzaddikim* to remain in exile in Moscow. The idea of Siberia was too terrible for them. And this time the advocacy met with success: The elder brother, who was already reaching old age, was allowed to stay in Moscow.

To the advocates this seemed like a great mercy. But the righteous brothers, who had grown accustomed to bearing their troubles and hardship together, shuddered at the notion of being separated this time. The younger brother, R. Pinhas, had no hope of receiving a pardon—and the distress increased—and so they decided to turn for help

98. The practice of Jewish men maintaining forelocks and beards derives from an interpretation of the biblical injunction against shaving the *pe'ot* (corners, sides, or edges) of one's head; cf. Leviticus 19:27. Since the 1940s the image of forcibly shaving the forelocks and beards of Jewish men has become associated with the Holocaust, when such an act occurred with regularity.

to a physician who inflicted a wound on R. Pinhas's body—and the *tzaddik* could not get out of bed.

The illness intensified, and R. Pinhas tossed in pain all night long. R. Shmuel Abba sat at his head in the darkened room, in a jail in a foreign city, and his soul was greatly embittered. He hallucinated and dreamed in feverish delirium. He saw images of his father and grandfather. He recalled their battles against sadness, the aspect of the *sitra 'ahra* [kabbalistic term for the "Other Side"], may the All-Merciful One protect us. He spoke about holy service and holy musings—and his soul slowly receded. And R. Shmuel Abba did not take his eyes off his sick brother and was reminded of all their shared suffering and hardships. He sees his younger brother, before his very eyes, wrestling with the bitterness of death—and his soul poured forth with grief. The lips suddenly murmured and whispered verses from Psalms with whole and pure intention, as his soul trembled and his body convulsed with tears.

By the light of morning the crisis of R. Pinhas's illness passed. But the wounds that the physician had inflicted lingered on even after the *tzaddik* recuperated: His sense of hearing was compromised, his lips were slightly misshapen, and his left side was paralyzed, and he could move his left foot only with difficulty. But the goal had been achieved: R. Pinhas would stay with his brother in Moscow.

The days came and went. In their Moscow imprisonment, the *tzaddikim* became like residents of the city. They received news from their homes and city only very rarely. The wives returned from abroad; they received a pardon. The small children grew up, married, had children. R. Shmuel Abba's son, R. Hanina Lipa, and R. Pinhas's son, Yehoshuʻa Heschel, established a printing press in Zhitomir—only two printing presses were allowed in Russia, in Vilna and in Zhitomir—and they followed in the footsteps of their fathers: They published only holy books.

R. Pinhas especially longed for his family and his only son, whom he loved with all his heart. And even if it meant endangering his life, the son decided to go to Moscow to visit his father. His mother accompanied him. It was a dangerous journey in those days, as it was undertaken on horseback. With great difficulty the son and mother reached Moscow. And so it was, when they came there, that the mother suddenly took sick and died. And the righteous woman was buried there in that foreign city, in that very place where her husband had been tortured.

Days passed and the *tzaddikim* sat imprisoned in their cell. By now they had become famous and well-known, even in this foreign city, with many coming to visit and rising early [to wait] by the door of their jail. A special permit was attained so that a minyan could be assembled there daily—so that the *tzaddikim* could pray with a quorum. There was no Jew who came to Moscow who did not visit the brothers. Even old Prince

Sanguszko of Slavuta would come and visit them and bring them regards from their home and the city of their birth.

And thus twenty years passed since the day of the *tzaddikim*'s exile. During this entire period, no meat passed their lips, and as such their strength steadily diminished, and their troubles and hardships weakened them even further. However, the more their physical power ebbed, the more the tortured *tzaddikim*'s spiritual power grew, ever stronger and mightier.

Their heartfelt hope of returning to the city of their birth and to the graves of their fathers was never lost, and the bitterness of despair never penetrated them.

In the year 5616 [1855], when Tsar Nicholas died and Alexander II ascended the throne, a manifest was issued and the order was given for the exiled to be returned home.[99]

And on that day, the *tzaddikim* were praying in a quorum, as was their custom, and R. Shmuel Abba was leading the *shemoneh 'esreh* [eighteen daily petitions] when one of their admirers entered, face ablaze and panting from emotion and haste, and rushed toward the brothers, and the whole world looked on in astonishment. And R. Shmuel glanced at the man who hurried in, smiled slightly, and continued to pray. The man was confused—only then did he sense that public prayer was taking place—and he waited impatiently. Everyone whispered; they all wanted to know what was going on. Everyone converged on the man who had entered, though he remained silent and waited.

R. Shmuel Abba finished his prayers and turned to the man.

"I have news," he said quickly. But R. Shmuel Abba silenced him. "I knew it, I knew it! The time of our redemption has come."

The *tzaddik* removed his prayer shawl and phylacteries, folded them and placed them in their bag as though nothing had happened and as though he had already known that on that very day their salvation would come.

News of the manifest flew and spread all over the land, and every place where this news reached, there was joy and gladness for the Jews.[100] In Slavuta and all the surrounding cities there was a great holiday. The runners went out one after another, the message passed from person to person, and the *tzaddikim*'s kith and kin were greeted with blessings of "Mazel tov." All gathered to welcome the precious returnees. And every city through which the *tzaddikim* were slated to pass prepared for their arrival—word traveled from mouth to mouth, and each man invited his brother to the homecoming.

99. In addition to revoking the sentences of those exiled, Alexander II inaugurated an era of reform in the Russian Empire on a grand scale, including emancipating the serfs, lifting censorship bans, and revamping the judiciary.

100. Cf. Esther 8:17.

As the old rebbe used to say, "This generation has no concept of the joy and gladness that every Jewish person felt—and of the great honor, love, and endearment that everyone felt for the tormented *tzaddikim*."

The journey from Moscow to Slavuta was like a royal procession. Everywhere they passed, they were greeted with drums and gamboling, with song and dance.

When they reached Kiev, Minister Vassiltchikov invited them to his home, where he endeavored to apologize and beg their forgiveness for the sin he was forced to commit against them. The enemies became friends, and the sowers of evil became penitents. The informants and enemies in Slavuta regretted the evil perpetrated against the *tzaddikim* and waited anxiously for them to return so that they could ingratiate themselves before them and gain their forgiveness.

And the *tzaddikim* hurried on their way. They did not linger anywhere. They hastened. For twenty years—all the days of their exile—they had hoped, believed, trusted, and, with infinite patience, waited and anticipated. Now their longings overwhelmed them. Patience snapped. They rushed to their father's grave, their homes, and their families.

And when they reached their city of residence, the joy of the holiday reached a heavenly crescendo. Men, women, and children—there wasn't a person who stayed home—everyone came out to greet the returning *tzaddikim*. Everyone crowded in to see and behold their faces, if only from afar. And the only son of R. Pinhas rode upon a horse, and with great joy and passion, he gamboled and danced with his horse.

The *tzaddikim* arrived at their father's home—that very house where they were born and raised. Merry women clapped their hands and danced before them; men crowded around. The "'*olam*" [literally, world] blocks the entrance to the house, and the *tzaddikim* were unable to enter. The relatives became angry and ousted the *olam*, loudly rebuking: "Let them pass! Let them enter!"

But R. Pinhas appeased with a soft voice: "Please don't, please don't! Certainly the time has not yet come for our feet to step across the threshold of our father's house." And pearly tears slowly dripped from his radiant eyes and trickled down.

From the Writings of a Tuberculosis Patient

(Brought to Print by Eim Kol Hai)

Originally published in *Hashiloah* (1921)

I know the nature of my illness—I feel it progressing—and yet I do not believe in the imminence of death. I want to picture it before me, but it eludes me.

How is it so? Here I am, going about my business, walking, talking, moving—and suddenly everything comes to a halt! This "I" will sink into some strange nothingness, a gulf of oblivion, of which I have no concept!

I don't fear death. It is the "secret" within it that bothers me. The "beyond."

I know: the very rays of sunlight that please me now, will still shine afterward on all the flowers and the plants. But I wonder, having known and felt and still knowing and feeling their warmth and glow, where does it all go? And my "unbound" soul, as it were, where does it go?

Especially dreaded is the anticipation of death. The *preparation* for it. I would have already made my peace with it, if only it hadn't been spreading its wings and casting its shadows upon me while I still walk among the living.

A great envy fills me, hot and flaming, when I see those who have faith in their lives, who regard themselves as citizens or residents of this world. And I am but a "passing guest." That's how those who have faith regard me. I read their thoughts with a glance.

I despise them then—I despise their self-perception, their cold complacency, and certainty.

Only she, like a beam of light, illuminates my inner darkness and the lowliness of these twigs surrounding me.

The memory of her alone sets my imagination on fire. I know: all that is good and beautiful in life dwells within *her*.

I control myself. I don't let out even a word in front of her.

Only sometimes, when she gives me one of those pitying looks, do I long to pour out all my tears of agony. I want to beg for her forgiveness: Punish me with whatever punishment, but only not those looks! Only no pity, no pity!

Still, not even a word escapes me. I sop up all those looks together with the pain and agony and store them inside, and secretly I nurse them—and revel in them.

For isn't it a painful joke, an impertinence of the highest order: I—a living skeleton, the very image of death dances on my face—and I have the audacity to lift my eyes in her direction, she, who is the very symbol of wholeness, health, vivacity, and well-being!

Yesterday I saw her from a distance. I thought to myself, she'll pass me by, not even notice me. And yet she stopped walking and turned toward me. I could sense my own pallor when turning toward her.

"Your health seems to be getting better. Even the appearance of your face has changed for the better," she called out in a cheerful voice.

She was wearing a light dress, and everything about her was light and clear.

You lie out of *pity*, I thought and bit my lips.

Tears suddenly strangled me. I already know the script by heart, all the things that my "friends" feel obligated to say to me—these past three years. For a while already, it has become loathsome to me. There are times when I want to pour out my wrath on the speaker at the very moment he speaks such pleasantries, and *in his eyes* I read his *hidden* thought: This man belongs elsewhere.

How I long to prod my "sympathizers" out of their *own pleasantness*! And yet I always answer with an inexplicable laugh: Oh really? Yes, I do feel fine. Thank you.

This time she spoke. And her words hurt me sevenfold. Dejected, insulted, I stood before her, as though charged with a criminal offense. She dug her eyes into me. I knew—she saw my gaunt, emaciated cheeks, my slumped shoulders, my skinny neck. My bulging adam's apple. My sharpened chin.

A wave of fierce anger arose in my heart and coursed through me at the thought of my pathetic appearance. I felt every red blotch that appeared on my face. She stood shocked before me, her small mouth slightly ajar and her eyes expressing astonishment. "Is it that my words didn't please you?"

If I only I could explain to her. If only I could speak. But it was as though a collar were placed around my throat. Some strange, hoarse voice reached my ears—I didn't even recognize my own voice. I hid my face in shame. I sensed her scrutinizing glances.

If I were a sinner from birth, my torment at that moment would have atoned for my sins.

It's hard for me to remember those days when I too had the look of a human being. Those days before horrible shadows haunted my imagination, before that cursed poison

settled into me. All of this seems so far away, never to return. And only three years have passed. I was 20 years old back then.

I need to put an end to all of this self-torture. After all, right now I'm still alive, and so long as I'm alive, I'm like one of them, so I should go and enjoy myself like one of them. At the end of the day, life is not measured by its length but by its substance and happiness.

And perhaps I will have a long life. Maybe it won't come so soon. Ha-ha! I once read somewhere that a man condemned to death regards his last day as very long. His last hour. The minutes of his passing from cell to gallows . . .

I need to free myself of these troubling thoughts. After all, isn't it possible that the doctors made a mistake? And I am so bound up with life. I only regret that our senses are limited and that we cannot enjoy life even more fully. And I always hear people praising me: There is no one else who can relish life and have fun like you. For indeed, when the sun shines down on me and its rays penetrate, I soak them up and it is as though the failing lung has healed and my breathing has become easier. And then . . . then it seems as though my disease has left me for good and once again I'll be like other men: alive, well, and whole. At that moment, I feel as though I could make the whole world happy; I could entertain them all. At moments such as these, I get drunk on the riddles of life and dive deep into them. [. . .]

Hah, if not for my illness, her attitude would be completely different. I *feel* this—she's *deliberately* putting on an air of indifference and pride. We spend hours walking together, and she listens attentively to my words and musings. And when I get all excited and begin daydreaming, she perks up and adds her own weave to the thread of my dreams. Then she forgets my death sentence. Yet it's enough for her to give me an incidental glance—and immediately it's as though she has woken up from her sleep.

I bite my flesh from pain. With all the admiration that I have for her, I would like then to sting and provoke her.

And when she stretches out her hand to me in parting, it seems to me that she does so as if forced to. For touching my burning, scrawny hand must fill her with revulsion.

Hah! I dare to dream! I make myself so bold as to aspire to the greatest happiness in human life!

I still don't believe that my end is so imminent. This morning I was seized by a cough. I braced myself and said: This isn't new. But when I started spitting up blood, my heart fell. I saw death hovering before me, and I knew that I had no means of escape from it: My body quaked, my good mother leaned over me, and in her eyes I saw all of her maternal terror and pain. And suddenly I was filled with rage once more. Why? Perhaps because she'd given birth to me [in the first place] . . .

I felt my cheeks flush, and high fever overcame me. My forehead was covered in a cold sweat.

I now lay supine on my bed—pulling my pen [across paper]. The doctor *forbids* me from sitting up—he forbids any kind of movement, any kind of excitement. Let him go to hell with all his prohibitions! I have already lost all faith in him. And in all useless things. As if these prohibitions have the power to heal anything! I want to taste life, if it's possible for me to still taste of it. I want to retain at least the faint shadow of my ideas and feelings. I want to remain in people's memory, the way they once knew me. No, no! I'm deceiving myself. I'm not writing for that purpose. It's all the same to me whether or not they think about me after I die and how they might do so. I write because I *need* to write, for I am still impressed by life and I don't want to lie here like a living corpse. At these moments, a person freely admits what he might otherwise not reveal.

And she? My *thoughts* torture me. Isn't it one and the same whether she thinks about me or not? Does it matter whether, in her eyes, I am a tiny worm or a lofty individual, a lowly creature or a human genius? Does her relationship with me have the power to add even a minute to my life?

Nevertheless!

A strange thought: If I could soak up her memory, if I could hide her away in my soul, even in the "beyond" the magic of her light would illuminate my darkness.

How ludicrous are the thoughts of a person by death's door!

But this I know: My final thought will be of *her*.

The first thing I did after getting up from my sick bed yesterday was to go to the park. With how much affection did she greet me! My heart expanded and exalted [*raḥav va'alats*].[101] I ran into many acquaintances, laughed a lot, made jokes; I met her glances on a number of occasions and overheard her whispering to her brother, "I prefer him, the sick one, over all those healthy ones who don't know how to make use of life." Singular admiration flooded my heart. I could have kissed the hem of her dress. Moments like these are better to me than whole years of life.

Recalling what I wrote on my sickbed, I laughed inside, felt faint of heart. My life is still before me!

I chatted a lot, walked around, laughed. Suddenly, before nightfall, I was seized by a cough. I strove to stave it off. I turned aside to one of the paths, sat down. But the more I tried to stop it, the more it attacked me. I entered a grass hut. I tried to hide myself—let no stranger see me—as though I were being pursued for a crime. My veins bulged, my whole body trembled. The cough erupted each time with a strange ferocity, as though it sought to destroy me to my very foundation.[102]

101. Cf. 1 Samuel 2:1: "And Hannah prayed: 'My heart exults in the Lord; I have triumphed through the Lord. I gloat over my enemies; I rejoice in Your deliverance.'"
102. Cf. Psalms 137:7: "Even to the foundations thereof."

At that moment, she passed by the hut in the company of one of her ruddy-complexioned, hale-and-hardy acquaintances. She stopped in her tracks, agitated. But her escort cast a glance at me—a tad pitying, a tad loathing—and did his best to get far away as quickly as possible.

I have never felt such powerful hatred as I did at that moment for that man. I'd have given my last drop of blood to make him contract my illness and be attacked by a cough like mine.

Twenty-three years old—and standing by the mouth of the abyss.[103] Nevertheless, I do not believe that I am playing only with blind fate. Indeed, my fate has already been determined. If not for my natural resistance to limitations, I would never have gotten this far. This is my essence. I despise solemnity. I'd hate myself if I'd been graced with a cool, calm temperament. I complain neither about my nature nor my fate.

My spirit digs and gnaws [at me].[104] Hovers—and flees. Grasps for the abyss—at that which is beyond, hidden from my eyes . . .

I envy the hero who goes to war, who risks death. I'd offer myself to be killed a hundred times, if only I could feel that I am not a failure in life.[105]

This time I am afraid. Autumn approaches, and my blood is freezing in my veins. I can sense the coming of the heavy rains, the cold of winter, which I fear. And because I fear it, I hate it.

My friends continue to prophesy a glowing future for me. They continue to shower me with praise and tribute, to extol my depth of spirit, my talents—and in so doing, they deepen my emotional wounds. After all, is the future hidden away from me?

To what avail now are all the *ideals* that I have preached to them? Of what help is all my delving into the purpose and destiny of mankind, when my life's candle is about to be snuffed out? If my spiritual powers are decreasing together with those of my body? If my illness consumes and destroys the very marrow of my bones [my very essence]? I now scoff at ideals and deride investigation. There is no purpose in this world. A person has no destiny. There are only healthy creatures, who delight in their world, and sick creatures, who think about their end. There are neither good deeds nor bad ones. He who is strong in body and in heart—his deeds are good and beautiful. All of his deeds are brave and courageous of heart and spirit. And the weak—all of his aspirations and

103. Cf. Jeremiah 48:28.

104. Again, note the use of the word *gnaw* in Shapiro's writing.

105. On Kafka's compromised masculinity as a result of tuberculosis, see Gilman, *Franz Kafka*.

yearning are petty, small, limited. The ones in the middle are nothing, neither bad nor good. And their needs are neither good nor bad.

So long as life is *ahead*, it is possible to turn the heart away from individual fate and the present moment; it is possible to give oneself over to work on behalf of the group. But when thoughts of *the end* blow over you, when you see the open maw of the abyss that will soon swallow you whole—at that point, the mind is no longer available, no longer capable of considering *the future*, no longer has any connection to such thoughts. The fate of mankind in the thirtieth century no longer interests him; and if mankind rises to a higher cultural level or sinks to a lower level, this no longer matters to him.

These matters that engrossed me so much now seem completely trivial and irrelevant. I no longer have any relation to them. It is hard for a person to jump on his own shadow. I am dying steadily and, everything else has lost its value.

If I could simply ignore my impending end, it would be easier for me. If I could seek shelter under the shadow of faith, it would only be a misleading faith! If only I could actually see the ultimate end/purpose of my being. But I have never been one to embrace vain beliefs—and how can I be consoled by delusions?

One thing astounds me: My longings for life have weakened. My demands and ambitions have shrunk. I am filled with only the vaguest, foggiest longings. Perhaps their origin is beyond me. But my soul is thirsty; it longs and thirsts—languishes as it pines.

"You'll get better. You'll go to the baths," my relatives say to console. And in so doing, they add salt to my wounds. How will I ever find the strength for this? Once upon a time, I hungered so for that warm land, but now I no longer have the strength even to *aspire* to it. Behold, the rays of the early autumn sun still shine before my eyes. But I do not have the strength to enjoy it. My breathing is labored. My voice is dim. The angel of terror dances before me, and Hell's demons are buzzing in my ear.

I'm still alive! Alive, alive! Truly alive! I'm out of bed, and I no longer feel pangs and pains. My mood is good. The cough seeks vengeance against me only at night. And I overcome it. I'm going to give myself over now to everything "forbidden." I'm going to soak up all the pleasures of life, until I am sated, until the parting moment.

I'm going to detach myself from every bit of that former life to which I was once so attached. With my free will, I shall extinguish every last glowing spark of despair, owing to my complete awareness of the loss of my life.

Before, I was enchanted by the kindliness and softness of women. I longed for them. Now, they have lost their charm in my eyes. They all showed me the extent to which she is superior to them. They all make blatant their own inferiority.

God created her with a pure, untainted, lofty soul and shared His splendor with her. She strikes up the tune of angels in the heart, the joy of heavenly angels.

She conjured up a beautiful, splendid world before me. I was fickle last year. I thought she was presumptuous. She'd been hiding from me that she recognized my condition. I see. She expected so much of me. She had confidence, believed in me.

I pressed her before she left today until she agreed. She gave me her hand as a sign of promise that she will visit my grave.

She tried to make light of it, but how sad she seemed! Isn't it all a joke anyway? Won't it be the same to me either way after I am laid out there as a rotting corpse?[106]

For I know: The flowers will flourish then too. The sun will play; the birds will chirp. And these eyes that see and desire, this heart that yearns and longs, this mind that embraces worlds, will wither and cease from the earth.

Or perhaps I'll imagine for my own sake that all of the trappings of existence exist only within me and in my imagination, and aside from me there is no reality or existence.

Somehow I am kidding myself, but my thoughts disturb me. How then would life take shape? And she—would she be happy? Would she forget or remember her lover, with the stilling of his heart? Will she shed a tear at my graveside?

It's odd: I find a bit of consolation, a kind of equanimity, when I recognize that she will come and embrace my gravestone and will look out—perhaps in pain and longing— at that pile of dirt that has me buried within it.

Then I'll be sole ruler of her thoughts and feelings—if only . . . but for a moment . . .

[. . .] My temperature has risen and with it my pulse. The bad wind has departed and with it, my melancholia. I look in the mirror and see a new face: ruddy cheeks, twinkling eyes. What is the meaning of all of this?

Fall is passing. The days are getting shorter and the nights, longer. The rains are drizzling.

And I'm tired. I lie supine all day with a book and think in a strangely lazy manner that I've taken to. I try to put aside ultimate thoughts. I want nothing of them. It's enough for me right now to know that I am still counted among the living—this is my last refuge. And when this goes out, so will I.

I am frightened of this final snuffing out, the terrible nothingness!

The effort born of desperation, all the force of desperation . . .

I've come to the final point. I'm tasting the taste of insanity.

106. Cf. Isaiah 14:19.

My days are numbered. The doctor *warns me*: I'll get cold and my end will come. And I've become cold . . . there's no longer any hope . . . I know my fate . . . and still—there is rest in my soul.

She wrote me. I called out to her. She speaks to me about my worth, my *future*! as though she doesn't believe in the absolute fact of my end.

I don't believe it either, even if I know.

She doesn't mention my illness, pays it no mind, the adored one! I see the caresses of my *mother*, and I recognize in them her pain and her awareness of my approaching end. Only *she*—how I adore her for this!—she forgets my sentence. She speaks to me as though to a person from the regular population with a future ahead of him.

Even from afar, during these *last* hours she raises my heartbeat.

Everyone awaits my death. I recognize this. I read it in their mute glances. "Your fate has been sealed—so why do you tarry still?"

I'll prolong the end just to anger and enrage them. I'll continue to putrefy their air with that contagious illness they so fear. They'll catch it too! That'll be my final revenge upon them!

My loyal friend has fulfilled his promise: He has brought me a bottle of whiskey. I myself will put an end to my morbid self.

I prepared my final letter to her. I asked her to contact my family and tell them about my final moments.

I've placed her picture and her letters in a special bundle, with strict instructions to my sister to burn them—no one may see or touch them.

My handwriting is already uneven and illegible. My hands tremble. Everything dances and whirls before me.[107] But in my head—perfect clarity. My mind is clear.

A fire is burning in my bones.[108] I mustered that last bit of courage. I drank all of the whiskey.

Only not in the night! I still want to see the light, the light of day!

To see if from afar . . . if only for a minute!—vain hope!

My soul hovers in the heavens. Suddenly with splendid speed all the events of my life pass before me. They are all so far away . . . so far from me . . . I have already separated from them . . . it's already . . .

A wondrous light has blinded me . . . my mind is clear . . .

When is all of this happening? Before I died? Have I already died? My angel [of death] . . . here he is before me . . .

107. Cf. 2 Samuel 6:16.
108. Cf. Jeremiah 20:9.

Hanukkah Days[109]

Originally published in *Ha'olam* (1924)

Childhood days—my longings for you are pursuing me!

There is no escaping your memory when I approach the remote and roaring din [of these surroundings]. Even when I turn away from the springs of sorrow and seek cover from the wounds, my soul still yearns for you. I'm alone and suffering without it. If I retreat into myself, my soul will be wrapped in loneliness!

Only in death is a human being truly alone; in life he seeks friendship. However, "society" is strange to me, and the enemies of my imagination pursue me all day. And longings assault me in the form of bygone happy days, the days before I knew anything about reading and thinking, before I knew of doubt and desperation.

Ah! Where are you, where are you, those days of faith, happiness, and contentment!

Before my eyes are the holidays and festivals of those bygone days, days of childhood innocence. Images veiled in glory and suffused with light return and appear before me.

Back then I didn't appreciate your value, oh precious images. My soul's luster derived from theirs, and the radiance of their light keeps cover within me, like a surviving remnant in a hidden place.

Now I appreciate you—and you're gone. I search for you in vain. Every last trace of you is missing.

Even there, in the spot where you were planted, they are erasing every sign of you. Only your shadow, the shadow of a gloomy light, still flickers and hovers.

"Le-had-lik ner shel ha-nu-kah" [to kindle the Hanukkah lights][110]—the pleasant, gentle voice of my grandfather rings in my ears—and here too is his noble figure: a

109. For more on this story, see Zierler, "In Those Days."
110. The ending of the blessing said before kindling the Hanukkah lights; written as if chanted.

pale face with fine etchings, an upright bearing, and a long white beard. The polished Hanukkah menorah with its decorations of birds and cherubs gleams now in all of its beauty and is positioned on the chair by the door.

I can't reach the very top of the menorah, even if I stand on my tippy toes. Only by looking up am I able to behold the beauty of the menorah, its adornments and ornaments, the cruse of oil by its side, and the open mouths of the birds where the wicks of the candles burn and flicker.

My grandfather inherited this Hanukkah menorah from his grandparents, and there was nothing more precious in his eyes. All year long, it would be sealed away in a special cupboard behind glass. And only when Hanukkah arrived did they take it out from there, and as they did, great fear gripped my heart. They would very carefully remove the glass cover and hand it over to the servants for cleaning. The care lavished in its cleaning filled me with terror and joy. I looked at it and touched each and every one of the golden birds that flew at the top, and I studied every one of its limbs up close to my heart's content.

However, the special value and import of this menorah only emerged when they finally placed it by the doorway on a simple wooden chair, and my grandfather stood before it with the wax *shammes* [candle used to light the others] burning in his hand. While lifting his head and closing his eyes, he blesses: "she'asah nisim l'avoteinu *ba-yamim ha-hem* baz-man ha-zeh" [the One who made miracles for our fathers in *those days* of old, at this season; emphasis added].[111]

And the women inside the room listen to the blessing with devotion and watch my grandfather bend over to light all the wicks, as he sings sweetly, "These lights are holy"[112]—and every line on his face conveys devotion to the performance of this mitzvah.[113]

From behind the door the female servants are laughing and happy; the time has come for playing cards and [eating] latkes[114]—their reward.[115]

Nowadays, there is no longer such ambience in our surroundings, even in those places where they still light Hanukkah candles. That tradition has now disappeared, along with the memories associated with it. Back then, everything was steeped in spiritual exaltation. The children felt free and were given license to make mischief. Even the adults had some of their daily burdens lifted from them during those days; a faint feeling of hidden

111. The ending of the second blessing said before lighting the Hanukkah candles to commemorate the miracle of deliverance.

112. After lighting the new candle of the night, "Hanerot halalu" (these lights) is traditionally recited as the other candles are lit.

113. Cf. Wengeroff, *Memoirs of a Grandmother*, 107.

114. Potato pancakes eaten by Ashkenazic Jews as a remembrance of miraculous oil that lasted eight days.

115. Cf. Wengeroff, *Memoirs of a Grandmother*, 108.

pride was embroidered into their hearts. Somehow we were the offspring of that same Mattathias and Johanan the High Priest, that same Judah Maccabee of ours, who was strong like a lion and fought with great personal sacrifice for the sake of our holy sites. It is as though this pride is now directed at our enemies, saying, "See we weren't always so weak. Here are our brave warriors; and we are [a nation of] priests!"

And yet from this same joyful thought comes as well the lachrymose pain of a nation exiled from his father's table, given over to every passerby to trample on him.

And here's an image of my beloved mother. She was like a stranger in these surroundings. She was a well-read woman who derived her chief pleasure and comfort from reading her Hebrew books and newspapers, which were considered utterly *pesulim* [illegitimate in a halakhic (Jewish legal) sense] by the rest of her family. There was an unspoken pact between us children and her not to bother her while she was reading; in exchange for this she would always do our bidding. On *Erev Shabbat* [Friday night], by the light of the great candelabrum that hung in the middle of the dining room and that of the many burning Sabbath candles on the table, she would sit before a book clasped in her right hand, as though she were frightened they would take it from her, with her left hand on her chin and her cheek, and she would be completely absorbed in her reading and in her world—and we in our corner, quietly and contentedly, would look covetously from afar at those small letters that our mother commanded almost as well as any man. However, on Hanukkah evenings, even she, usually so focused, would shrug off her seriousness and give herself over a little to the frivolity [*kalut da'at*] of the mitzvah.[116]

And now, another scene. Other forms, shadows, and impressions arise from the recesses of memory. Male and female students are gathered at a tavern. A large illuminated hall. Speeches and homilies and attempts to arouse enthusiasm to diffuse the desolation and fan the hidden flame.

They rejoice, dance, celebrate, and sing, preparing to enjoy themselves. But the joy is not real joy, and the faces bring to mind only the court jester, who is *compelled* to perform.

Although the worry and pain may differ, the Jewish soul is the same in every place, every age, every situation. The inner pain floats and rises from behind a joyful veneer.

A representative from the group ascends the "stage" and lights Hanukkah candles in a strange and exaggerated fashion. And the days of childhood return to me again, with all their colors, contours, and enchantments. And the spirit of the generation of old breathes and passes by, passes by and flutters and is extinguished in the distance.

116. Shapiro describes the "Mother" in her sketch "Types" as similarly engaged in study; see later in this part.

All day long there were terrible rumors. Those who rose early saw with their own eyes all the signs and symbols scribbled on the Jewish gates. Others saw the vandals whose faces bore satanic smiles.

Every passerby bears a sad and sorrowful expression. They ask each other questions through hints and exchange information, quietly whispering from mouth to ear. The news is awful and terrifying, arriving from every direction, all cities and towns, near and far.

In the courtyards the young people are hard at work building barricades. As they work busily, they scatter among themselves shards of conversation, short comments dipped in "humor":

"Perhaps this will be our [eternal] resting place [as of] tomorrow?"

"You had better prepare yourself while there still is time."

"Either way you'll repose in peace on your resting place" [*tanuaḥ beshalom al mishkavkha*].[117]

"We'll fulfill our duty."

"They will lay down and fall [dead] before they [the pogromists] set foot on the doorstep of any Jewish home," whispers a simple Jewish woman as she wipes away the tears on her face with her apron.

With sundown, their faces become even more grim and their sprits more despondent. Their gazes wander, suspiciously.

Outside, women and children are nowhere to be seen. The number of those passing by has dwindled. The stores' doors and windows are shuttered behind wooden planks. A cloud of sadness suffuses everything. People who meet no longer greet each other with "hello" but only with quizzical and frightened stares:

"And what's with you?" . . .

"What have you heard?" . . .

"That in every Jewish household they are preparing themselves as if for death . . .," responds one young man, his eyes flickering with anger.

There is no dearth of bravery among the members of the Haganah [defense forces]. "We'll fight till the last breath." But the women—my mother will not stop crying and pleads with me not to go outside.

"Have you noticed—there's no soldier or guard on these streets. Where'd they go?"

"Don't be excited. They'll come when the time is right. They'll win the day."

"Damn, it's cold today!"

"Come in and warm up by the light of the candles. After all, today's a double 'holiday'—the days of Hanukkah and '*those days*' [*yamim hahem*; emphasis added]."[118]

117. Words found in "El maleh raḥamim," the prayer recited at a funeral or memorial service.

118. An allusion to the blessing for deliverance said by the grandfather.

Passover Nights

Originally published in *Ha'olam* (1925)

In Memory of My Mother

I

When the days of Passover would begin to draw near, the entire shtetl would become busy and full of activity. Rather than stroll across the town square, the young women walked hurriedly. The glances and jests of the young men did not affect them as they would on other days, during this twilight hour of strolling. The square was now given over to another purpose. On market days farmers would come here from the nearby villages, their carts laden, and a crowd of people surrounded them and crammed themselves in around the carts, the voices of the sellers and the buyers jostling and joining with the bleating of the animals and the chirping of the birds, creating a loud tumult, such that no one could hear or understand what the other was saying.

On one side of the square was the Pravoslavac [Eastern Orthodox Church] cemetery and opposite it, in the very middle, was the Catholic cemetery. But their presence didn't throw off the hagglers from conducting their negotiations, their arguments, and their competitions, in the same way that they didn't disturb the young people from their laughing and strolling and paying each other compliments. The living were in their quarter; the dead, their quarter. And the former did not fear the latter. Only when a body was transported to the grave on a market day and a procession would pass by here on the way to the house appointed to all living [the cemetery][119] would the people desist for a moment from their haggling; the farmers would doff their caps and cross themselves silently. Once the procession passed by, they'd put on their caps once again and carry on with their arguments and negotiations.

But on the days before Passover, there were so many kinds of precious and rare things on display at the square that the children's eyes would never tire of looking at them.

119. Cf. Job 30:23.

At home, the great preparations for the days of Passover began—immediately after Purim. Grandfather would begin cleaning his long beard after each meal, touching it with his fingertips and checking it for fear of bread crumbs. All the closets and crates and chests were opened, and we took out all the drawers and belongings whose purpose and very existence we knew nothing of all year long.

All at once Gittl the cook would don her most serious face, as befitting one of high station. This simple, wretched creature was now all aglow in her special uniform. She had strength and status. She castigates us children, from time to time, but we do not get annoyed at her on account of this. We recognize her current importance and elevated status. Why, here she sits, preparing the turnip soup, on a low stool in the middle of a special, newly cleaned room, completely wrapped in a long cloth outfit, part dress, part nightgown, a new kerchief on her head. Spread around her is clean straw, and upon it, to her right, a sack full of red turnips. Every once in a while she reaches her hand inside it, and pulls out a few, peels them with the knife in her hand and tosses them into a new crock filled with water that stands ready for this. From there she will take them out again and place them in a basin covered with a rug cleaned for Passover. Later, this basin will be placed in a distant corner, where it will remain until Passover actually begins. Every once in a while, in comes Mother, then the aunts and Grandmother, and they sit nearby for a brief while and supervise the work of Gittl the cook, who takes immense joy in her special status.[120]

A week before the festival is matzah-baking day at our house: a great holiday for us. Our studies cease completely. Extensive preparation bustles around us. In the large kitchen, long tables covered with white cloth are set up across the length of the room. All along the tables, from end to end, women wrapped in white aprons with new kerchiefs on their heads stand like a trained army. From time to time, the female supervisor brings in the dough from the room next door, carrying it aloft. She divides it into pieces, according to the number of women helping. Each one receives her piece and tries to best the others in smoothing and rounding the matzah, nicely, nicely. And grandfather hurries. He stands at one end of the table right next to the oven, his face ablaze and in complete concentration. Around him are the other men involved in the work. They are rolling little iron wheels, with sharp edges that are white with heat, over the matzahs. Their sleeves are rolled up, and with marvelous speed they are rushing to stretch the prepared matzah onto the baker's shovel while the baker, who stands in front of the oven, stretches out the shovel at regular intervals, his face aglow, his long *khalat* [Russian, robe] unbuttoned, and his yarmulke falling off his head. He coughs and coughs.

120. Cf. Wengeroff's mother, who "looms as fearsome overseer, tyrant of kashrut [kosher] supervision" during the frenzied weeks of preparation leading up to Passover. See Wengeroff, *Memoirs of a Grandmother*, 46.

In the next room, where the dough is being prepared, sits the servant Susil, completely wrapped in white like the dead and silent, with no sign of life. Only when they bring her a bowl does she measure flour with a measuring cup from a full crate that stands on the bench nearby, returning to her place without uttering a sound. She is forbidden from speaking out of concern for the vapors that might escape from her mouth into the flour or the bowl.[121] The same prohibitions against speech pertain to the other men and women who are involved with the work. All the same, great excitement fills the air.

In another corner of the room Gittl the cook leans over the bowl full of flour. Grand-mother stands next to her and pours water, drop by drop, into the bowl from a new small pitcher that she holds in her hand.

In the third room stands a basin full of water, which they rush to at intervals—after baking every tenth matzah—to wash their hands and wipe them off on clean towels that hang from lines that have been strung the length of the room. And here is a job for the youngsters: to pour the water for those washing their hands, from a pitcher that they fill every so often from the barrel.

The female supervisor who is armed with a small knife, like that used for a mani-cure, checks the women's fingernails in order to clean out bits of dough.

All is hurried, everything is rushed, and suppressed tumult prevails over every-thing. Grandfather's face is filled with worry. He frets [ḥared hu]:[122] Has everything been done properly? And outside the sun plays. Its rays skip; its light shines. One feels the approach of spring. I skip with joy. And suddenly, in the distant room of my elders, the deathly image of Susil the servant is revealed before me from within the gloom of the corridor, and she beckons to me:

"Come here, my good girl, write me a note."

I am startled by this profanation of the holy and call out: "Now? With you dressed like that?"

"No matter, my girl. He is waiting." And she presses me: "You write such lovely notes, he said."[123]

I am drawn to the image of the "dead" to write a letter on her behalf to the one she loves.

121. Cf. Wengeroff for a strikingly similar passage: "On the next morning, the cleaning woman nick-named Meshya Kheziche, appeared. [. . .] My mother ordered her to wash herself carefully; then a long white chemise was drawn over the clothes on her haggard body and her head covering was wound around with a white linen cloth, which also covered her broad mouth. In this attire, which gave her a ghostly appearance, she now had to sift the flour for the *matses* [sic]. [. . .] What a funny sight, to see this apparition at work! We children stood at a precise distance and watched atten-tively. Meshya Kheziche was strictly forbidden to speak, so that no drop would fall from her mouth into the flour." See Wengeroff, *Memoirs of a Grandmother*, 118–19.
122. In addition to "he frets," ḥared hu can be translated as "he is pious."
123. Compare Shapiro's exemplary notewriting here with her flawed performance in "Days of Awe," where her grave notewriting falls short of that of her brothers.

On the eve of the actual holiday the doors and shutters of the special Passover kitchen, which is closed off all year and which no person enters, are opened. Now the servants, wearing their special uniforms, are busy in there with their work, their faces shining. The work is considerable and rushed. They take out the sideboard designated for Passover and bring it into the dining room, along with the dishes, the glasses, and the bottles. They pour wine into the latter and seal the openings with clean pieces of cloth. They bring the crate of *shemurah* matzah [matzah prepared according to exact legal specifications] into the dining room and crack open nuts for the charoset [fruit, nut, and spice mixture used at a seder]—and a special kind of grace, the *Shechinah* [Divine presence], prevails over all.

And here it is, the eve itself—Passover night!

I also know "the Questions"[124] by heart, but no one pays any attention to me; the main attraction is my brother. Inside I am seething. I would have asked them even better than he did. But me they send to sit with the women. Only my mother sees my pain and consoles me with the wonderful caresses of her eyes.

Joy and radiance spread throughout the house. The delightful melody, in my grandfather's pleasing voice, seeps into the depths of my heart. The image of my grandfather still hovers over me, this gentle and magnificent image, as he sits at the head of the table on the small couch, leaning—"reclining"[125]—slightly to the left, wrapped in his white *kittel* [white garment worn by men at a seder], his glasses on the edge of his nose, his eyes occasionally closed, and his face illuminated with light from on high: "Bim-hera bim-hera yivneh beito beka-rov" [Speedily, speedily, let it be rebuilt soon][126]—the voice so sorrowful, pleading, sad, tired, plaintive. Others around the table join in, and the voice repeats again and again, an insistent, burning plea: "El beneh, el beneh, beneh beitkha bekarov!" [Lord rebuild, Lord rebuild, rebuild Your house soon!].

In my mind, I see the "house" already rebuilt.

II

Another Passover eve in the capitol of blessed Ukraine [Kiev]

No news has arrived from the cities on the Front. All we knew was that the peasants had rebelled and were steadily approaching Kiev under the leadership of Petliura.[127]

124. The four scripted questions of the Haggadah asked typically by the youngest male.
125. Reclining at a seder signifies the freedom wrought by having been liberated from Egyptian bondage.
126. Words of "Adir hu," a popular song of the seder, asking that the Temple in Jerusalem be rebuilt.
127. Symon Petliura (1879–1926) was the leader of Ukraine in its struggle for independence following the Russian Revolution. Under his leadership, rampant pogroms broke out against Jews. He was killed in 1926 in Paris by Sholom Shwartzbard, a Jew from Ukraine who witnessed the murder of his relatives in the pogroms.

Skoropadsky's government was about to be toppled, but it continued to put up a front that it had a firm hold.[128] Already the sounds of firing cannons had reached the city. The window panes shook at regular intervals, warning of impending danger.

The same day that the "leader of the people" [Petliura] entered the city with his army, it was rainy and piercingly cold. Prominent residents and masses of Jews flocked, with ambivalent emotion, to greet the conquering hero. One could say that a feeling of hope and confidence alternated with fear and trembling. The heart did not know what was yet to come.

Meanwhile there was something of a lull. The railroad lines were repaired, and masses of people rushed to their homes in the towns by the battlefront. The railcars were full of people. Miraculously, they crammed in. There was no changing one's mind, no turning back.

But then a rumor hit: The "liberated" people ran amok; the word "pogrom" escaped stealthily from mouth to ear.

This one word, its mere sound, had the capacity to freeze the blood in one's heart and send shivers down all of one's limbs, especially among those already fated to have known such things firsthand.

The rumors continued to multiply. The youth of Israel were fighting and giving up their lives. In every city self-defense units were established. All were ready, but the heart faltered. Bravery and courage—what use were they if the end was the same? And the authorities protest: Self-defense? For whom? Aren't they capable of protecting their own citizens?

In the Jewish streets, unruly brigades of soldiers rode by on horseback, with swords brandished, laughing wildly.

And if a Jew should happen to pass by the street at that very moment and if he didn't manage to escape the glance of these "watchmen," his fate was one and the same. The image of one of these "fugitives" still haunts me, a wretched tailor: Just one more step and he'll be safe . . . he's already next to the place of refuge . . . but just then, one of the riders senses his presence . . . with a savage laugh the Cossack straightens up on his horse, points his rifle: Poof! The Ukrainian "makes sport" of the Ukrainian "hero."

And the Jew rises slowly. Twisted in pain from his injured arm, he continues on his way to the place of refuge, his lips murmuring thanks and praise to his Creator for the "miracle" that has befallen him—that he has escaped alive.

The days of Passover approached and the "heroes" were still guarding the inhabitants of the cities. With every passing evening came new attacks, murders, and "searches,"

128. Pavlo Skoropadsky (1873–1945) was a decorated general of the Russian Imperial Army and a conservative leader in Ukraine's unsuccessful struggle for independence.

and with each day, new threats. Come evening, you couldn't be sure whether you would live to see the light of the next day. And in leaving your house you had no idea whether you'd ever return to it. And thus we lived and prepared for the holiday.

Quietly and clandestinely, the preparations turned into something that lurked about us. It was as though we were afraid to disrupt the pain and unease in our hearts. Everyone baked the matzah in his own house, although none of us was sure we'd actually survive to eat it. Awful news came from the nearby cities. The Cossacks continued to get stronger and to gain more courage, manufacturing ever new scenes of horror to terrify the Jewish residents. They demanded that the Jews turn over their weapons, for everything had value on the market. And this demand for arms itself became a pretext for murders and killings.

These messengers of destruction devised something special for Passover. They captured the most prominent Jews, placed them in detention, and announced that they would not be released alive unless their fellow Jews released the "wealth" under their control and the arms that had been turned over to the [Jewish] youth serving in the self-defense units. In the meantime, they tortured the prisoners and threatened their relatives with the sort of torments that only savage minds can invent.

As chair of the local branch of the Histadrut ha-tziyyonit [the Zionist Organization], I was also placed on one of these lists, for they hoped to capture a good "ransom" for my head. Miraculously, this became known to my friends in the nick of time, they were able to rush over and warn me, and I was able to seek refuge in the house of an acquaintance. There I stayed, locked up and alone in a sealed room. Not a single one of my friends or relatives dared approach this house, lest they arouse suspicions about my whereabouts and endanger the safety of those harboring me.

The confusion and terror steadily increased. He who lived in the center of the city sought refuge with friends who lived on the outskirts, and he who lived on the outskirts sent his family members to the city center, thinking it was "safer" there. The Gentile residents of the cities peeked out their windows, acting as though they sensed nothing, flashing poisonous smiles and expressions of festive [Easter] joy. At the same time, their pictures of saints were hung on the gates and the walls of the houses, as if to say: "Remember, here dwell proper [kesheirim, i.e., "kosher"] Pravoslavs."

This was how nearly all the Jews in Ukraine celebrated Passover six years ago.

That night, I left my closed room. My Gentile acquaintance, a friend of my father, took pity on me and agreed to bring me to the house where I knew my mother was staying.

Dressed in men's clothing, wearing a round miter on my head like a *papka* [Russian, priest], I was led by my Gentile acquaintance through the streets that were devoid of

even the shadow of a living creature. The windows, shutters, and doors were all closed and bolted, such that it was impossible to recognize whether these were dwellings for living human beings. Not a single ray of light escaped outside. And on Passover Eve?! Not a single voice was heard, as though all who lived on the earth were frozen and dead.

All that reached my ears was the faint tumult of moving chairs, bottles and glasses that had been upended, the hurried sound of footsteps, some distant door that swung on its hinges and closed from despair. My heart beat frantically but there was no turning back. After all, the people in the house would not calm down until it was made known to them who had come knocking at the door. I called out my name in a whisper outside the door, but my muffled voice sounded to them in their agitated state, of course, like that of a disguised "Cossack."

Footsteps were heard. I raised my voice slightly. The door opened, and confused and terrified stares fastened upon me—in my confusion, I forgot that my clothes would likely frighten my relatives. Only my mother recognized me immediately and charged toward me; then the others also recognized me. Joy and gladness, hugs and kisses. The women and the children came out of their hiding places. The man who accompanied me was pulled into the room and toasted with a glass of wine. And then I comprehended the upheaval wrought by my knocking on the door.[129]

"In the same way that a second ago our terror was turned into joy, so shall all the troubles in which we find ourselves be turned into gladness, and we shall all go out from darkness into light," said Mother, her face aglow, and [our] hearts were suddenly filled with shining, warm hope.[130]

They forgot—they wanted to forget for a moment—the looming danger.

Beloved Mother, you knew how to strengthen the soul in times of trouble! If any sparks of hope and confidence in the great future still burn within us, it is owing to you! Let your memory be for a blessing!

129. Note the intertextual connection to "Sanctification of the Moon," where the Gentile gatekeeper jangles the bedroom doorknob, which frightens the female protagonist.
130. In contrast to the earlier seder scene, where only men's voices were heard, here a woman's comforting words, in the form of a blessing adapted from a prayer recited at the end of the Maggid section of the Haggadah, caps the storytelling section of this Passover eve.

Among the Nations

(For the Days of Hanukkah)
Originally published in *Ha'olam* (1926)

I've been a wanderer [*na'ah venadah*][131] all my life. Among strange people, in strange surroundings, and in an atmosphere that is strange to me. I taste the pain of loneliness among the many, the pain of nostalgia, yearning, and inner longing.

And in one of the cities of Switzerland, in the days when those around me were preparing for Christmas, I was reminded of the Hanukkah days of my youth.

I was reminded and became nostalgic once again.

All around me, at home, in the street, on every corner and passageway, they are preparing for the holiday. There's more traffic outside. They are hurrying to buy and bring home the last gifts and decorations.

To decorate the "tree"—is there any mitzvah [commandment][132] greater than this? Is there any greater pleasure and joy?

The landlords brought the "tree" and its decorations into my room, after getting my permission, so that they could hide it there from the children until the "Holy Eve" [*ha'erev hakadosh*][133] When the boys who had been at school returned home and didn't see the tree, they didn't ever think that this treasure might be found in my room.

The landlady busied herself decorating and adorning it. She decked the tender oak tree with thousands of toys, little multicolored candles, decorations, and sparkling, glistening tinsel.

And as she moved about in my room, I saw how confused the good woman was in seeing me absorbed in the mundane. The books and journals were open as they were every other day. I could tell she wanted to ask about this but didn't dare.

131. A reference to Cain's punishment in Genesis 4:14, where he is condemned to wander the earth. Cf. Shapiro's diary entry for 15 December 1912 in Part II.
132. Shapiro's use of *mitzvah* here is ironic, given that she applies it to a Christian practice.
133. Note the irony, given the use of *'erev* to designate the beginning of Jewish holidays and Sabbaths.

But when she saw me gaze upon the tree decorations, she couldn't stop herself from asking me: "Madame, excuse me for asking, but back home in your homeland, don't you have a tree?"

I explained to her that Russians also "light a tree" for Christmas, but that I myself am Jewish and therefore do not take part in this holiday.

The French woman looked at me with visible astonishment. She had no idea how to distinguish between Russian, Polish, and Jewish students. Since they all came from Russia, they all seemed "Russian" to her.

And her amazement increased—civilized people, not barbarians, without the "Holy Eve"?

"'My own' [husband] is a Freethinker," she whispered, "But no Christmas? How is that possible?"

The very idea that her husband might not allow her to sanctify this evening frightened her so much that she could hardly speak.

Only when she was about to leave my room did she turn to me to invite me to spend the evening with them. It seemed as though she was scolding me for negating this celebration.

I explained to her that this holiday was not my holiday; this joy was not my joy. She could not comprehend my explanation. And in the evening, when the celebration was in full force at their place—the Christmas tree in the center of the room where they feasted, its candles shining and the boys surrounding it, whooping with delight—she knocked on my door again and pleaded with me to join them in their celebration.

I entered their place and saw how they celebrated their holiday. The boys jumped and danced. The mother rejoiced. The father's face beamed. He turned to me and said, "All of this is nothing but make believe," and suddenly he stopped, gesturing in the direction of his wife, not wanting to profane what was sacred to her.

He was Protestant Swiss and his wife was Catholic French.

I looked at him, astonished.

"One doesn't have to be a believer to enjoy the holiday, to savor the taste of this joy," he added.

And I was reminded at that moment of our "enlightened times." How many Jews these days will allow the celebration of Hanukkah in their homes? Will they kindle the lights?[134]

I was envious of the children of these Gentiles, who even in their freethinking father's home had a place for their natural, religious, and national tendencies to develop and to find sustenance as they grew in memories of their childhood days.

134. Note Shapiro's juxtaposition of the lights of the holidays (both Hanukkah and Christmas) with *enligh*tenment.

Perhaps if our children were to see revelry and rejoicing like this in their parents' home on the festival of kindling "these lights,"[135] as others see in their homes on Christmas when the "tree" is lit, it would be precious to them as well and become inscribed in their minds all the more.

But how many of our children even know about the "Hanukkah lights" in comparison to what they know about the "Christmas tree"?

Certainly, even the current Christmas mode is merely a "custom." But no one is ashamed of it. They observe it fastidiously—even many of our own, and in some places, not only enlightened Jews.

"These lights" remain the province of only those connected and devoted to our past.

135. The Hebrew is *hanerot halalu*, the words to a song customarily recited on Hanukkah after candle lighting. Cf. "Hanukkah Days," earlier in this part.

Types

Originally published in *Hado'ar* (1928)

I. THE MOTHER

On Sabbath evenings [Friday nights], she sits next to the lighted table. Her chin is supported by the palm of her hand. Her eyes are fixed on the open book, and she is entirely absorbed in her reading.

She permits herself this pleasure only on Sabbath evenings. All other nights of the week she is busy, for she runs her husband's business. She has the brain of a man, they say. She neither boasts nor preens and is reserved in her speech. She oversees the activities of her household. She counsels her children. She aids the sick, the poor. Quietly. Modestly. She encourages, strengthens faltering hands, weakened spirits. Away laziness! Away boredom and despair! There is so much to do in this world! To do for *others*. Others are the main thing. As for herself she knew no personal contentment. *Her duty was her contentment.*

A fountain of life and of vigor is within her. She neither carps nor tires nor complains. Why bother? One has so many responsibilities in this world. And there are so many lovely books!

On Sabbath evenings, when the men are at shul, she gives herself over to them, to the books. The rooms in the house have been cleaned. The white tablecloths are on the table. The Sabbath candles are burning, and a modest light, the light of rest, pours forth over the dishes and the furniture, on the challahs [loaves of braided bread] covered with embroidered cloths, on the bottles of wine for Kiddush [blessing to sanctify the Sabbath], on the gleaming goblets—even on the secular book opened on the table.

The children—there is a kind of contract between her and them. On Sabbath evenings, they do not disturb her. They play in the corner. They cast glances at Mother. They bathe in her modest glow, in the image of her noble profile. They sense something of her special, hidden world.

And the next day, Sabbath afternoon, she gathers them around her. They sit close, right next to her, and listen. In silence. Concentrating like adults. She reads them the

134

Proverbs of Ben Sira. And explains. Mother explains. Their eyes are lifted toward her splendidly radiant face, and their ears absorb her caressing voice.

What is more magical: The voice? The parables? The tone? The ambience? Mother's glances, or her company?

Beloved Mother in Israel, modest woman scholar [*tsenu'ah-maskilah*], who compares to you?[136]

II. WOMAN OF VALOR

Thin of flesh, abrupt, and hurried in all her movements. She is constantly filled with grievances. Grievances about fate, about "fortune," and mainly about him, her husband.

There is no way, she maintains, that he would survive in this world without *her*. Her and her counsel. She—the symbol of womanhood. The intelligent one. The compassionate one. The devoted one. She knows everything from the start and foretells it before it occurs. And he—he doesn't even know how to appreciate it, as he should.

"She's only interested in her own well-being," he says. And he compares her, concerned as she is for her every limb, to other females, healthy like the cows of Bashan.[137]

Nights pass for her without sleep, and days without food and drink. Everyone believes her. But he denies it. "Such things never were," he says.

All the worries are on her and on her head. Her health has broken down, and her beauty has faded. And still he denies. "No one remembers the time before 'the breakdown,'" he says. "She only worries about what others *have*."

He does not understand her. He, who is lacking in any and all attainments, cannot understand her attainments.

She traveled to the healing baths to recuperate. He upped and wrote her about bad business dealings and an unexpected event that has brought them to ruin. What is she to do about it? She is forced once again to travel to a different place of healing. To recover. Heartless man, who has no mercy for his wife's well-being.

Everyone knows and acknowledges: She is a Woman of Valor. Her tongue is learned. An incisive tongue. She knows how to get what she wants. Anywhere. And he: "They do for her only to avoid her tongue [lashing], her injurious tongue."

136. Shapiro's praise of her mother is echoed by her brother, Moshe, who refers to his mother as an *'eshet ḥayil*. See M. Shapiro letter, in Caro, *Kovets letoldot*, 36.

137. Cf. Amos 4:1–2: "Hear this word, you cows of Bashan on the hill of Samaria—who defraud the poor, who rob the needy; who say to your husbands, 'Bring, and let's carouse!' [. . .] Behold, days are coming upon you when you will be carried off [. . .] and flung on the refuse heap—declares the Lord."

When no one else is within earshot, she rains down on him her torrent of curses. She upbraids him: Others would exalt a wife like her. And what about him? He compares himself—in front of others!—to Titus, and her to his fly.[138]

Once, he feared her. But now—nothing. He hears, hears but does not respond.

When she finishes cursing, she sinks down on her bed and calls to him, and in the voice of a dying woman advises: "After I die, you can find yourself another wife."

He approaches her submissively. He stands—and grins. He does not have faith. Faith passed from his heart. . . .

138. Cf. Babylonian Talmud, *Gittin* 56b, regarding the legend of a gnat entering Titus's nostril and plaguing him for seven years.

PART II

DIARY, 1900–1941

The Diary

Unlocking the "Fire Imprisoned in My Bones"

The selections in this part originate from a unique historical and literary source—the *first* known Hebrew diary kept by a woman. Shapiro's private record of her thoughts, feelings, and longings over four decades is contained in a simple composition notebook. At 266 pages long in the handwritten original, it is as voluminous as it is unusual.[1] In contrast to many women's diaries that give an account of the everyday, Shapiro's diary is dedicated to the extraordinary. There is not a single account of her typical routine or a word concerning a domestic setting, not even her treasured Slavuta. Nowhere in the diary do we find a name of a relative, not even her beloved son. Nowhere do we find sexual confession or moral transgression. Rather Shapiro writes of (1) her aspiration to reach beyond the customary station assigned to Jewish women and the consequent emotional toll that takes on her and (2) major world events. Both invest the diary with singular historical significance.

At the same time the diary manifests a studied quality, as though its author is engaged in a dress rehearsal for a future performance. Whereas a "self-conscious diary writer" may sound like an oxymoron, it aptly describes Shapiro, who mentions on more than one occasion how she rereads her diary (16 April 1900, 20 September 1903). In some cases Shapiro would copy entire entries, verbatim, as in letters to Brainin (typically of the same date or within a day or two); and she mined the diary's pages for material for later publications, including reportage during the interwar years and memorial tributes to Y. L. Peretz, David Frischmann, and Reuven Brainin (included in Part IV).[2] She sharpened her thoughts on its pages and improved her dexterity with Hebrew over the course of the diary's forty-year life span, despite the fact that Shapiro wrote in fits and starts and rarely daily.

The diary, which Shapiro's brother deposited in Tel Aviv's Genazim Archive for Writers in 1956, begins in 1900. But there is plain evidence that Shapiro kept a diary well before then. As she states in the first extant entry, "I haven't written in a long while." Moreover, she recalls how her younger sister wished, years before, to emulate

her by keeping a diary of her own (7 September 1901). As we have it, the diary begins in Shapiro's early adulthood and offers reflections on family, writing, and love. She repeatedly gives vent in her diary to the searing pain of being separated from her son but offers no details concerning her divorce. The references to her relationship with Brainin early on are elliptical, as though betraying a concern that the diary might be intercepted and private matters laid bare. However, as the diary unfolds, the entries about Brainin become more open, even as the personal content yields to an enlarged communal perspective, most dramatically in the final entry of the diary, scribbled on 21 October 1941, when Shapiro declares that her fate is that of her people.

The overriding theme that emerges in the diary is an acute need for self-revelation.[3] As Shapiro maintained: "If one has so very much to say and tell, if these things are 'like fire imprisoned' in his bones,[4] and he has not begun to say even a fraction of what he longs in his heart to express, [. . .] to him pen and ink seem like doors to the Garden of Eden where one is forbidden to go" (diary entry for 2 August 1900). The diary was an entrée to linguistic paradise for Shapiro. Her words sweep across its pages in spontaneous, emotional gusts. We are held in the grip of maternal yearnings for a largely absent only child, the ongoing heartbreak of erratic love, and a pervasive loneliness wrought by a lifetime of perpetual wandering.

Although she writes in a language alien to most of those around her, Shapiro laments that she is alone and then yearns for this very state of being (4 August 1910). When Hayyim Nahman Bialik invites her to join the ranks of ḥakhmei Odessa (sages of Odessa)—an elite group that included Ahad Ha'am, S. Y. Abramovitch, Y. H. Ravnitsky, and Simon Dubnow—she declines (7 July 1918). She prefers the peripatetic life and thus identifies with the biblical Cain (14 December 1912, 20 November 1922, 5 February 1924). In the absence of a sense of at-homeness among her "own," the diary takes on a heightened importance as a site where she can be with her people, if not actually, then metaphorically. It was her life force; its "dead paper," she claimed, "nevertheless breathes the spirit of life from that which is written within!" (21 October 1941).[5]

In contrast to memoirs or autobiographies, which are subject to a process of selection, diaries are more haphazard and less refined—the very definition of a work in progress. Perhaps therein, amid the contradictions and inconsistencies, the rough edges and unvarnished musings, lies their special interest. This is particularly true of Shapiro's diary, a text that represents her ongoing effort to construct an identity, by means of writing, apart from the social expectations of her family and religious background.[6] Those who read Shapiro's diary will thus find themselves in a messy private world of raw emotion and rumination.

In Russian women's autobiographical writing, self-construction typically entails the author's adopting a sense of exceptionalism over and against the ordinariness of others.[7] In like manner, Shapiro regards herself as superior to unremarkable women, whom she disdains for their vacuity and frivolity (8 February 1903, 25 July 1907).[8] Upon returning to Slavuta, she rails against the simplemindedness and static existence of those who remain in her hometown (3 September 1901) but admires with fondness the "older generation" with their stalwart faith and unchanging practices (3 October 1903).

Literary critic Felicity A. Nussbaum suggests that diaries and journals by women often "produce and reflect" traditional gender expectations even as they "disrupt or transform them."[9] So, on the one hand, we find Shapiro adhering to a traditional code of feminine modesty, as when she declares, after meeting Peretz, that she has no interest in public recognition and detests the idea that anyone might think she writes out of pride (4 Shevet 5661). On the other hand, we see Shapiro affirm her abilities with confidence and determine to maintain her freedom at all costs (1 June 1908, 15 September 1908). Indeed, vacillation abounds, especially in entries pertaining to Brainin. Over and again, Shapiro is determined to extricate herself from his toxic grip but then offers herself up as his "sacrifice" once more (24 January 1914).[10]

These features of Shapiro's diary resemble those written by women in other languages. The mixed emotions echo sentiments recorded in Russian women's diaries, whose pages express a deep yearning for creative fulfillment amid "multiple experiences of isolation, aloofness, humiliation and rejection."[11] Such a pattern of fluctuating emotion brings to mind the diary of Shapiro's contemporary, Virginia Woolf, whose writing alternates jarringly between exhilaration ("How I interest myself!") and despair ("I shall make myself the fact that there is nothing—nothing for us").[12] There is a breathless wonderment that characterizes certain entries in Shapiro's diary: a sense of euphoria over the beauty of nature and the possibilities that await her as a free woman. And then there is the melancholy, the despair over the seeming pointlessness of it all.

On another theoretical note, some contend (logically) that the private nature of a diary encourages freedom of expression and form.[13] Yet at least one sizable collection of historical diaries by women has been characterized by "reticence and circumspection" rather than "confrontation with deepest feelings."[14] Shapiro's diary also epitomizes such a mix of unbridled expression and restrained utterance.

Literary historians, such as Toby Clyman, explain that autobiographical works by women posed virtually no threat to the Russian male writing establishment because self-writing was regarded as a lesser art form.[15] How much the more so in the realm of Hebrew literature. As it was, female Hebraists of the nineteenth century found it

especially difficult to seek literary expression in a language only then being revived into a modern vernacular and whose literature had been a bastion for males for millennia. Therefore, in the words of Tova Cohen, "many women [. . .] turned to [writing in Hebrew] less respected, non-canonical [genres] such as children's books, letters and diaries."[16] Yet, she continues, not a single Hebrew diary by a woman remains from the period of the Haskalah.

In 1923 Shapiro concluded in her diary that publishing "my private, spiritual thoughts [. . .] is impossible" (9 October 1923). She could no more envisage a time when her diary would be opened up to reveal to others "the fire imprisoned in [her] bones" than that lengthy excerpts of it might appear in English translation.

NOTES

1. The excerpted entries in this part form a greatly abridged edition of the diary. See "Notes to the Reader" for our criteria for selection.
2. For example, Shapiro writes Brainin about her sister's *yahrzeit* (anniversary of her death), which approximates the contents of a diary entry, and recycles material in her diary to create a published reminiscence of Peretz.
3. In contrast, Shapiro's male contemporaries tended to compose confessional autobiographies. For the impact of maskilic autobiographies on Jewish history, see Moseley, *Being for Myself Alone*, 368–76; and Stanislawski, *Autobiographical Jews*, 54–102. For a gendered perspective on the topic, see Magnus, "Sins of Youth." Rakovsky's memoirs contain confessions about her growing heretical nonbelief in God and her resistance to a match arranged by her parents (*My Life*, 28 and 34).
4. Cf. Jeremiah 20:9.
5. For the diary as refuge, see Zierler, "My Own Special Corner."
6. Feminist critic Domna C. Stanton refers to the genre of "autogynography" (self-writing by women) as having a "global and essential therapeutic purpose: to constitute the female subject." See her "Autogynography," 14.
7. Liljestrom, *Models of Self*, 12.
8. Cf. Brainin's critique of his coreligionists in Zadoff, "Travelling Writers," 97.
9. Nussbaum, "Eighteenth-Century Women's Autobiographical Commonplaces," 149.
10. This is how Horodetsky characterized Shapiro's relationship with Brainin.
11. Rosenholm, "Chuzhaia domu i zvezdam," 120.
12. Woolf, *Writer's Diary*, 270 and 141.
13. See Rainer, *New Diary*, 11.
14. Blodgett, *Capacious Hold-All*, 7.
15. Clyman, "Women's Physicians' Autobiography," 111, quoting Marcus, "Invincible Mediocrity," 120. Clyman elaborates: "Russian literature abounds in autobiographical works by women. The five-volume bibliography of pre-revolutionary Russian memoir literature is striking for the number of autobiographical texts by women it lists variously titled 'Reminiscences,' 'Recollections,' 'Notes,' 'Family Chronicles,' so on" ("Women's Physicians' Autobiography," 111). The five-volume work that Clyman alludes to is *Istoriia dorevoliutsionnoi Rossii v dnevnikakh i vospominaniiakh, annotirovannyii ukazatel' knig i publikatsii v zhurnalakh* (History of Prerevolutionary Russia in Diaries and Memoirs: An Annotated Index of Books and Publications in Journals), edited by Petr Andreevich Zaionchkovskii (Moscow: Knizhnaia palata, 1976). The diary of Mariia Bashkirtseva is

considered the most famous among those by Russian women of the nineteenth century. Published in Russian translation from the original French in 1889, and later into English, it had enormous influence on women's fiction and nonfiction. See Bashkirtseva, *Journal*.

16. T. Cohen, "The Maskilot," 65–66.

Shapiro's diary, first (extant) page. (Genazim, Tel Aviv)

Warsaw, Monday, First of the Intermediary Days of Passover, 5660 [16 April 1900]

I haven't written in this book for many days.[1] It is not because I didn't have anything to write, nor because life has so encircled me with its different excitements that I have had no space left for thoughts or ideas. Rather, because I see the emptiness of life around me, and within me, everywhere I turn and every time, more and more, as the days of my life become more numerous. But I have already spoken too much about this. It is for this reason that I did not want to describe those same things that have been said many times.

However, the times are changing, and even if the passing days have not brought many changes to the course of my life, my ideas are changing, multiplying, and expanding and increasing very greatly.[2] If only I could express even a part of them, I would be relieved. I do not wish to weep and grumble about my fate, nor complain[3] about the injuries, stumbling blocks, and obstacles,[4] but rather to speak about everything as it is, the way I experience it. But to my great sorrow, whenever I go back after a few days and read what I have written, I see that the essence is missing from the book; in other words, the words were written after contemplating the matter, but what I read are individual thoughts—and none of the original feelings. I do not recognize in what I have written anything coming from the depths of my heart, those many thoughts that had pressed upon me and engulfed me then, and whose traces I still recognize within me. I don't see any of this, only fragmented thoughts, splintered ideas, things said halfway.[5] And I wonder whether this is because they were not written right then and there when I felt the need to write them, rather only after much time had passed. And for this reason, they lack emotion.

In any case, psychology continues to investigate whether feelings come before ideas or the contrary. And I cannot say whether my self-perception accords with the rules of psychology or is exceptional. What I do know is that when I feel, I cannot think. And when I am overcome with ideas, I sense only the power of these cold ideas, without knowing whether my feelings engendered them or not. What I would give to be able to think thoughts and write!!! [. . .]

1. Although this is the first extant entry, this statement indicates that Shapiro began the diary before this date.
2. Cf. Exodus 1:7: "But the Israelites were fertile and prolific; they multiplied and increased very greatly."
3. Shapiro uses verbs reminiscent of the Israelites' grievances in the desert; for example, Numbers 11:4: "The riffraff in their midst felt a gluttonous craving; and then the Israelites *wept*"; and Numbers 11:1: "The people took to *complaining* bitterly before the Lord."
4. For similar language, see the preface to *A Collection of Sketches* in Part I.
5. See "Broken Tablets" in *A Collection of Sketches* in Part I.

Warsaw, Friday, 4 Iyar 5660 [3 May 1900]

How lucky are the people who do not seek out and consider things overmuch. But no! I shall not envy them or their happiness. I cannot envy them. Because it is impossible for me to live without questions running around in my mind, it is impossible for me to live without thinking thoughts and feeling them in every part of my soul. I cannot be satisfied and find my purpose simply in this: I am here, I am alive. More than that I feel within me strong yearnings, a mighty desire for higher things, for deeds more significant than those which one sees at every turn. I despise the pettiness of life, those things of inconsequential worth and those who promote them and fight for them their entire lives.

The questions Why and wherefore? For what purpose? and To what end? fill my mind. And I cannot find an answer to all my questions among the people I come into contact with here. I'd like sometimes to be alone in my room. Alone with my thoughts and ideas. Then it would be so "pleasant" for me.

All these people that I see around me—why is it that I can't find a single one who finds no consolation in the words "This is how it has to be!" Perhaps I am crazy, senseless? They are the majority. And judgment goes with the majority. Either way it makes no difference. Even if I know that they will not concede to me, even if I am crazy in their eyes, I cannot think like they do, just because they are the majority.

There is nothing that arouses my ire like the words "This is how it is done." You have to think this way because "this is how people think." Is there any greater idiocy and foolishness than to hang onto other people's ideas? Idiocy, hypocrisy, and pettiness in every direction I turn. I so long for another life, for different surroundings.

I cannot boast that my surroundings have no effect on me. And I cannot keep thinking that no one understands me. I have become accustomed to their behavior (and this hurts me most) and am used to hiding my thoughts and opinions. (I would like them at the very least to understand me after I die.) What if I didn't hide them? When I am by myself, I love the truth, even if it's bitter, but there are many who love lies because they are less bitter. But if my admirers are few now, they'd be even fewer if I spoke up.

Slavuta, Friday, 13 Tamuz 5660 [10 July 1900]

Is it possible to belittle and utterly deny the human spirit? That spirit that raises and elevates[6] one above the coarseness of life. Can one deny and vanquish it? Is it possible to do so using various ruses and ploys strewn about to expel it entirely until the heart is completely emptied of it? Is it indeed possible?

6. Liturgical language (*yinasu veromemeihu*).

These are the questions that give me no rest. There are times when I feel my spirit doing wonders within me. It lifts me up above all the trivialities around me. I feel this great urge to act and do. I feel I have broken through and that finally I am able to tell and express everything that I have to say, that I can describe all that presses and bears down on my heart. All my feelings and enthusiasms, my soul's longings that are buried within me. And I feel as though a wall separates me from those around me.

If I had that complete freedom, then I would describe all that is in my soul. But I do not have this freedom. Complete freedom! Freedom in every way, how good that would be, how I feel the urgency of it!

Friday, 7 Av [2 August] 1900

In the sketch "In My Child's Room" Brainin says, "Tinte und Feder sind mir lästig geworden. Sie kommen mir wie Marterwerkzeuge vor" [Pen and ink have become a burden to me. They seem to me like instruments of torture]. For me, however, pen and ink are like a good friend. Like a faithful companion, to whom, at all times, we are able to reveal what is in our heart and to ease our burden. But it's easy to assume that pen and ink have become loathsome to him because he has already attempted to describe and say so much of what is in his heart; his spirit pressed him and he spoke. But if one has so very much to say and tell, if these things are "like fire imprisoned" in his bones,[7] and he has not begun to say even a fraction of what he longs in his heart to express, for he who *cannot* speak, to him pen and ink seem like doors to the Garden of Eden where one is forbidden to go. He will long for them because through them he expects to reach the place of his desire.

Brainin has attempted to express his spirit many times. Many read him, and others even understand him. He is an expert. However, there are things that he cannot say[8]— thus he despises pen and ink. That's not the case with me! For me, they are much loved and adored!

Warsaw, Thursday, 4 Shevat 5661 [24 January 1901]

I was at Y. L. Peretz's house. The impression he made on me was better than I had expected. For this reason, I did not write immediately upon returning from his house, so that I wouldn't be under the influence of first impressions. This man is wise-hearted and, in my opinion, experienced, that is, an old hand at life and its many trials. His darkish eyes radiate wisdom, and on his lips floats a smile tempered with irony. His

7. Cf. Jeremiah 20:9: "I thought, 'I will not mention Him, No more will I speak His name'—But [His word] was like a raging fire in my heart, shut up in my bones, I could not hold it in, I was helpless."
8. A likely allusion to their clandestine affair.

sideward glances penetrate the heart of man, and in speaking he makes an effort to get to know and understand the person talking to him, his inner life: that hidden in the recesses of his heart. It seems that he doesn't judge based on what he sees—and this is his glory.[9] Peretz is a gentleman. He received me warmly, which I expected, and advised me to introduce myself to the Hebrew writers here. But this is something I know nothing about. I will not introduce myself to anyone—if that is what is necessary to go to his house. I consider myself to blame if he spoke with me only a bit. Thus it is hard for me to speak, let alone to introduce myself to people who do not know me and who might speak into my ears words they would not say if they knew me. And I will not allow them to suspect me of something that is not in me. For example, that I want my name to be well-known or that I write out of some egotistical impulse. After all, I would never have shown my writings to anyone and would not have thought that there was anything worthy of being seen or heard, except that I have so much in me that I want to say. If not for Brainin, who recognizes this from my letters to him and says that "I have lofty and exalted ideas" and that my style captivates souls, in his words. He commented to me many times and demanded of me that I not consign to dormancy and death my many talents (in his words). Nevertheless, I have not introduced myself to any other writer. Dr. [Mattathias] Hindes advised me to go to N. S. [Nahum Sokolov] but I went to one meeting and I saw his face. My God, whoever has not seen that face has not seen egotism and swollen-headedness in his life.[10]

Of course, every man, especially one bestowed with such honor and high regard, is entitled to recognize his own self-worth, but to look upon everyone around you from such a high perch, as if upon tiny insects crawling at your feet, feet of clouds, that is a bit much. I don't know how correct I am in this judgment of mine, and perhaps I am mistaken, but this is the impression he made on me. This is what I am saying: It seems to me as though the lines of his face gave off utter scorn for those gathered there who cannot grasp the depth of his exalted, high-minded ideas. But he, in his great kindness, relinquishes his honor and deigns to come to this gathering. Of course, all those who are with him there in this great auditorium need to consider themselves fortunate to have merited sitting in an auditorium with N. S.

I was frightened to go up to him.

But why was it that I specifically chose to turn to Peretz? Was it because I like his stories and books so much that I wanted to know who created them, or because the lines of his face showed that he was the complete opposite of N. S.? Whatever the reason, I turned to him—and I do not regret it.

9. Liturgical reference to the divine (*vezot tehilato; vehi tehilatekha*).

10. Shapiro plays on *Mishnah Sukkah* 5:1: "One who has not seen a *simḥat beit hasho'evah* [celebration held during Sukkot] has never seen happiness in his life [*lo ra'ah ga'avah vegodel-levav meiyamav*]."

He made an effort to understand me and to explain to me the mistakes in what I had written and to point out other things that I did not pay attention to, and he admonished me for not believing in the talent within me, according to his words.

3 September 1901[11]

I have come to visit my parents in their house. And once again I am in the city of my birth. This city where I was born makes a strange impression on me. I spent my childhood here, I grew up here, and I find so many memories here, the memories of my childhood.

I look around at the people here, and it seems to me that all of them are dead. I see them, and they speak and move, walk around and converse, and yet it seems to me that there is no life within them. Here I am hearing all the same conversations that I heard so many years ago.

All those same things, those issues and trivial conversations that occupied them back then, continue to captivate them now. Almost none of the people that I meet have changed their way of thinking, their opinions, their judgments, even in the slightest way. The way they were, lived, thought, and spoke years ago, that is how they are now. Only they look upon the younger generation with worry. [. . .]

7 October 1901[12]

I don't know what's with me today. Great sadness dwells within me.

No doubt this is owing to the many painful, worrisome memories that rise up before me on this day. The day on which my younger sister died when she was 11 years old. Before my eyes pass those same pictures that are so etched into my heart. That which I saw eight years ago (it seems as though it were only yesterday), I shall not forget until the day I die.

She was a beautiful girl, the likes of which I have not seen again in my life.

Her beautiful, big eyes radiated extraordinary wisdom for a girl her age. These eyes always reflected a kind of sorrow, but sometimes they flashed like stars. Her hair was blonde, in curls around her head. Her skin was white and her forehead lovely and high.

11. Cf. Shapiro's letter to Brainin with similar content (2 September 1901) in Part III.
12. Shapiro wrote a letter to Brainin on the same date using nearly identical language; it is not included here, but can be found in the archives: Letter from Shapiro to Brainin, 7 October 1901, Group III, Box t, Reuven Brainin Collection, Jewish Public Library, Montreal.

She was a good, pleasant girl, intelligent and wise.

She wanted to learn and know everything, and everything she heard, she understood.

This girl wrote in her diary, for many things bothered her, and she wanted to talk about them; therefore she yearned to write everything in her diary but feared that people would suspect her of merely wanting to imitate her sister.[13]

Nevertheless, she began to write indeed, but a few days later she suddenly fell sick with scarlet fever, and after battling with death for four days, she died.

Oh, my God! Whoever saw those eyes before they went out forever, whoever saw that gaze filled with sorrow and terrible despair, whoever saw the terrible pains and the glances filled with desperate cries for help—whoever saw all of this will never forget it until his last moments. Even now it is as though she is alive before my eyes. Tossing and turning on her bed from great pain, her words ringing in my ears: "Oh, Hava, you're going to live. All of you are going to live. Only I'm going to d-d-die! Oh! What a terrible thing! There in a narrow grave! The worms filling their hungry souls on my flesh! Why do I have to die now? After all, I'm still so young! Oh!" The tears suffocated her speech.

What I felt then—it is impossible to tell.

All four days and nights I sat there, but that last night when the doctor sat on her bed, and they calmed my spirits, I lay down to rest a bit. However, within a few minutes she called out to me and wanted to tell me something using her fingers. This was a private language, only understood by the two of us, from way back, but I couldn't seem to remember it at all during those moments and could not understand the signs in any way. And she could no longer speak, as her throat had been squeezed shut. In the end, she eked out the words "I cannot speak. Don't forget to care for the flowers so they don't wither."[14] She could no longer drink. But when my mother implored her to, she struggled with all her strength and drank a spoonful of milk. Her whole face twisted in great pain.

But she did not want to upset my mother.

On the last day, they did not let me go in there. But I insisted on getting in, and when I came to her room, she looked at me. I placed my head on her chest, and she whispered in my ear, "Live, all of you, with goodness! Oh, Hava!" At that moment, my only wish was to die together with her.

"Why her? Why not me?" I asked myself afterward.

I could not believe that this girl, this pure angel, had been cut off from life and with such terrible pain.

13. This comment is an additional indication that Hava Shapiro kept a diary earlier than the first entry translated here.
14. Shapiro published "The Rose" the same year that she wrote this entry. One wonders whether there is some overlap with her use of garden imagery and the memory of her sister's final words.

I could not believe that she was dead. And everywhere I turned, I saw her, whether in my dreams or while I was awake. I was like a lunatic, and the doctors ordered that I be removed from that place to B.[15]

Her memory stays alive still within me.

17 December 1901

These days, I visit the Hebrew library[16] very frequently—there, I live.

I look upon the books with such happiness, like a miser with his money, my eyes never entirely sated. I'd like "to uncover" everything, to penetrate everything. I feel as though I am going out, am liberated from all that pressures and constrains me. I rule the kingdom of my spirit as I wish.

I look, consider, plumb the depths of people's thoughts. It seems to me sometimes that these people live before me and make great efforts to share their thoughts, ideas, and reasoning with me. I join with them in spirit and take part in all their imaginings, meditations, and aspirations.

I do not experience the same joy that one experiences in sitting with a group of beloved friends, in happy joyous camaraderie. Nor do I experience that "elevation of the soul"[17] that one feels when attending the theater or the concert hall, in hearing those exalted melodies that transport us and lift us up on the wings of our imaginations, making us forget all other small things and taking us up further and further, or when one sees a *chef d'oeuvre* [artistic masterpiece]—nevertheless, I feel spiritual happiness. I capture the spirit for those who rise ever higher; I get closer to them, and I yearn to break my bonds; I feel inner aspirations. It is there—I live.[18]

Wednesday, 15 Tevet 5662 [25 December 1901]

Two weeks ago, my first story, "Hashoshanah" [The Rose] was published.[19]

I did not feel or know from it the pleasure and satisfaction that many young people speak about when they begin to publish the first "fruits of their spirit." I did not feel joy or elation to see my name in print. My heart does not thrill at the thought that others will read me. I know only this: that my heart is full and that I have a great deal to say, that in my mind thoughts and ideas run around ceaselessly. Various plans, pictures, and images appear before my eyes. I am not pleased with what I have already said because I do not

15. Likely a spa.
16. Either a Hebrew library or a library with Hebrew books. Such libraries existed in Warsaw and Odessa. Cf. Shapiro's sketch "In the Reading Room" in *A Collection of Sketches* in Part I.
17. Term relating to the soul ascending after death (*'aliyat haneshamah*).
18. Cf. the ending of "The Hawk and the Sparrow" in *A Collection of Sketches* in Part I.
19. See "The Rose" in *A Collection of Sketches* in Part I.

find in this all that I wish to express. I won't rejoice because I haven't told of my entire spirit. If I were to read afterward what I already wrote, I wouldn't find what I seek.

None of it is clear, or complete, and the very thing that I wished to be most prominent is always missing. Rather than joy, the printing of my story has brought me great anguish; would that I had never published anything, for I find none of them worthy. I feel that within me are much greater powers that need to be aroused, strengthened, and emboldened. Brainin's praise is not enough for me. Sometimes, when I read my writings, I want to burn them, to annihilate and destroy them[20] because they do not say what I want, because I have so much more in me than what I have managed to say; I feel there is so much more inside me than that which I am able to express, and that is why I am not happy to see it in print.

A week ago, David Frischmann visited me and sat here for about three hours. In him I also see conceit and much faith in his own greatness and loftiness. He advised me to write and write, but he is afraid to praise me to my face, so as not to cause me to be conceited and overconfident. Or so that I shouldn't believe too much in my talents, abilities, and strengths. *Sot qu'il est!* [Idiot that he is!] I don't know that even if he were to give praise, I would believe it. And more than he is afraid to offer his judgment and to praise undeveloped talents, I myself do not trust them. But my spirit—he does not know that. He asked me not to be afraid and not to retreat in the face of those who open their mouths . . . and those who make efforts to put down all new forces, but all of these people are contemptible to me—with their words, conversations, backbiting, and factions—and it is not because of them but of their tongues that I tremble in my place.[21]

27 March 1902

I am finished by now with writing, and so the many disparate experiences that come to my heart and soul, my spirit and perspective—I shall feel them all but leave them nevertheless inside my heart; I will not reveal them, even in my diary. For who will read, who will see, who will pay attention to the sighs, cries, calls to spiritual battle, questions, doubts, and inner struggles of some Hebrew woman?[22]

20. Shapiro's verbs (*lehashmidam ulehakhhidam*) are reminiscent of Deuteronomy 9:3, Esther 8:11, and 2 Chronicles 20:23.
21. Habakkuk 3:16: "I trembled where I stood" (*taḥti ergaz*).
22. For "Hebrew woman" (*'ishah 'ivriyah*), see the preface to *A Collection of Sketches* in Part I.

6 July 1902[23]

Why is it that we cannot put an end once and for all to all that suffocates and saddens us? Why is it that we cannot take off our chains and declare ourselves free to pursue all the aspirations of our soul? [. . .]

I am fed up with life, with other people, as well as with myself, in that I feel within me the absence of the kind of strength that would allow me forcibly to remove myself from that which holds me back, to destroy all the ropes that I have unknowingly placed upon myself and which others have excessively placed upon me, so as to bind me to a life like theirs.

I curse myself when I wake up in the morning until I go to sleep at night, when I remind myself that once again I am about to begin another day just like the one before it: Like yesterday, in which I spent nothing and in vain, so will be today and tomorrow . . .

Why all of this? Why live? For what purpose? What will the next day offer me? What shall I do with it and what shall I hope for?

But sometimes I wake up in the morning and walk outside and into the forest. I see the pure, clear skies; I see the earth covered with grass and vegetation, the refreshing trees, swaying and whispering, the flowers blossoming and playing before the light of the sun in alternating shapes and colors; I breathe in the pleasant scent and the clear air given off by the small, young trees; I hear the song and whistle of the birds, their melody that cheers the heart and does me a lot of good.

I behold the rays of sun that penetrate and reach the smallest flowers, the grass, and the plants that cover the earth and that fill everything with life and light. I see, hear, and listen to all of this, and unwittingly a feeling of pleasure steals inside me, as well as an exquisite sense of the elevation of the soul. My spirit rises and ascends, and all on its own a yearning for life awakens within me; then I forget all that is base and the emptiness of life, and everything appears to me in a different light. Everything changes and softens, and I feel within me the desire to enjoy life, to love, and do good, and to be together with every other man.

8 February 1903

I don't know what's with me.

I hate people. Their interests and deeds seem so lowly and so empty; their thoughts and opinions are so limited that I cannot bear their conversations. When I go outside and see their satisfied faces, I am truly revolted.

23. This entry immediately follows the 27 March 1902 entry; there was a four-month hiatus in Shapiro's diary writing.

Regarding the members of my own sex, I don't even want to comment: Such emptiness prevails among them that it is hard for me to believe that they are alive. They deal with such trivial matters, they are satisfied with such lowly interests, and in general, their minds and hearts are so empty that it is nearly impossible to believe that they find content in all of this to fill their lives. They are always so complacent, and if they complain, it is just lip service, just to arouse sympathy, but secretly, their hearts feel nothing and have no knowledge of deep feeling.

I do not want to blame others for the fact that I see the worst side of them and, of course, myself. The blame rests with my way of looking at things, but it is very hard and painful for me.

22 February [1903]

The play *Uriel Acosta* makes a strong impression on me.[24] It's already been a long time, but even so, every time Acosta gets on stage before us, all these same things come back to life: Acosta with his thoughts and logic, his strivings for the truths of his heart, with all his wounds, demands, and his soul's battles.

Here we meet him; we see his insults and his heart's shame, or more accurately, the shame of his generation, the shame of the nation, at that moment when he comes to confess that his inner thoughts are not true, at that moment when he comes to confess . . . a lie.

He, the hero, with his mighty spirit and his big ideas, compelled to negate before the people everything that he thought was true and right and admit to all that was not true, because . . . he could not stand the torment, if only for a moment! His demand for the truth increased and could not survive the shame. Ah, how terrible! He comprehended the extent of the insult, understood the lowliness of his opponents, drunk with jealousy and vengefulness. [. . .]

And here's the wonder, now that generations have passed since then, present has become past; now people dare not only to stand to the right of the chased, accused one but also to look upon the formerly respected folk with mocking eyes; now people share in [Acosta's] woes, search out his private feelings, thoughts, and desires; now they understand and acknowledge his correctness and the courage of his spirit!

How many things are there like this . . . where people dare to acknowledge their correctness only at a later time!

24. *Uriel Acosta*, one of the most frequently performed plays in Russia and the first classic play translated into Yiddish, was written by Karl Gutzkow (1811–1878). It is based on the true story of Uriel da Costa (c. 1585–1640), who was excommunicated for condemning Rabbinic Judaism.

29 April 1903

Spring has come, everything is waking up; everything is changing shape and coming back to life. A person feels within himself new feelings, potent, powerful feelings. Even within me, some spark seems to have ignited that I thought had long been put out. I thought all was dead within me, that I was not capable of waking up, of finding encouragement and making a stand. It seemed to me that it had become possible to live without "life," for all sparks of life were flown from me; my spirit and soul were depressed and downtrodden, and there was no reviving them. I didn't bewail it; I felt nothing at all, so convinced was I of my suppositions.

However, it appears that all was simply asleep within me, asleep and forcibly smothered, but at long last, all has awakened, come back to life. Ah yes!

I feel within my entire being, in my soul and the veins of my spirit, a mighty, strong, warm flow of life, of desire and feeling.

I feel as though my soul and spirit and my entire being have been liberated from sturdy chains,[25] from the harness and bridle that were been placed upon them, as though just now I have been restored to my youth, a warm stream having flooded my heart, warming and encouraging it.

Freedom, liberty, strength, power—Spring!

There are no borders, no fences; there are no burdensome, stifling decrees; there is no absolute command to follow the "majority"; there is no "golden mean" that will convince me forcibly to cling to and follow it! No!

The stifled, repressed desire is rising up to oppose, to destroy and throw off the burden and to seek freedom, freedom in all!

18 May 1903

The terrible events of Kishinev[26] have obliterated all personal troubles and issues. All of that now seems small, infantile, inconsequential in the face of the larger sorrow, the sorrow of the community that boils the blood, that pains and splits the heart, that weakens all other feelings—other than feelings of grief, desolation, and pain. It is impossible to say that we are empathizing with the pain of our brothers in K[ishinev].

25. Cf. Puah Rakovsky on separating from her husband: "I concluded that I finally had to break my shackles and begin to realize my plan" (*My Life*, 37).

26. For two days in April 1903, mobs rampaged the Jewish communities of Kishinev, resulting in 49 deaths, 500 wounded, 1,300 destroyed homes and businesses, and 2,000 homeless families. The brutality sent shock waves through the Russian Empire and around the world. Kishinev held special significance for Shapiro, given that it was her mother's hometown. At the age of 16 or so, Shapiro traveled to Kishinev with her mother and was enthralled by the "new world" she discovered there, beyond the confines of Slavuta. See Letter of M. Shapiro, in Caro, *Kovets letoldot*, 36. Also see the special issue of *Prooftexts* ("Kishinev in the Twentieth Century," 25.1/2 [2005]).

We are not so much empathizing as suffering ourselves. We feel: The sorrow is our sorrow, and the pain, our pain. Don't call it empathy.

They looted, destroyed, murdered, and spilled our blood throughout the city. The blood is our blood. The sorrow is our sorrow. The tears are flowing from our eyes; the heart aches, breaks open, and contracts; the sighs burst from within us—a heavy, bitter sigh—the sigh of each man of Israel, the sigh of the entire plundered, wounded Israelite nation.

Oy, when will it ever end? When will the sufferings of this unfortunate, persecuted nation ever end? When, when?

We are horrified to hear about the terrible acts of cruelty perpetrated in K[ishinev]. The black thoughts—alternating between despair and indignation. What angers me most is the death of the gymnasium student—that brave, fighting youth, who fell victim because he found the strength within himself to stand up against those who murdered and massacred members of his people.

Oy, how terrible! An innocent young boy, filled with the strength and youth, a boy who had only begun his life, was studying and saw a bright future ahead of him and within him—a full life. A boy like this falls victim to such people—dogs who are like animals of prey!

A boy like this who moments before was filled with strength and might, aspirations and hopes, a belief in the honesty of human beings and a great love for his people, stricken and plundered before his eyes. His heart was hot within him, and the strength did not fail him to take an opposing stand. But in exchange he paid the ultimate price: his vigorous life.

His heart was still tender and fair, innocent and pure, not yet sullied, corrupted, or demeaned. Seeing with equanimity the plunder and violence that they perpetrated against his people, he gave up his life to oppose it and did not spare his youth! When he saw that there was no one who could save these innocent souls from their murderers, that there was no one who found the courage to stand up and fight against those who plundered, tore apart, and spilled the blood of his brethren right before his eyes, the hero rose up and placed his life in danger and fired with a rifle upon his formidable enemies. He missed his mark and failed to save his people; nevertheless—the fervent desire, the strength . . .

And perhaps he saved others by his showing the plunderers that there are those who will stand up against them and not give their lives in mute sacrifice, and perhaps he quelled some of their cruel lust, but whatever the case, he fell victim; the thread of his young, vivacious life was torn and severed.

He fell as a hero, and his worth equals that of the great heroes of yesteryear who fell fighting for their people. [. . .]

The hand shakes, language fails, the bitter, hot, heavy tears stream down upon the grave of this brave, unfortunate heroic boy!

These are our sacrifices! These are our victims![27]

20 September 1903

After the noise and the tumult—a still small voice [*kol demamah dakah*].[28] After the changes and transformations that I have undergone, I have returned once again to the city of my former home. Many troubles and pains have come to me due to my own fault; I have brought a lot upon myself. However, one cannot deny that it all developed gradually and in due course. In rereading this diary now, I see this indeed. Yet I have written slivers of thoughts, fragments of feelings only very infrequently. I regret that I haven't written more than only a little of what has happened in my life.

But would it have been possible for me to analyze all of my strong feelings in all their particulars from the time I left Warsaw, that is, from the time I came back to life?[29] Would it have been possible for me to write down my thoughts that flooded me in their haste when they were awakened? Speaking more broadly, would it have been possible for me to write down that which I had up until then described and conceptualized only in my imagination and which now had become reality? Would it have been possible for me to write anything at that moment when I felt for the first time the strong stirrings of life in all parts of my soul and heart, when I recognized for the first time the exalted, mighty power of a true life, flooding, roaring, moving? My soul until then was sunk; my feelings were dead, slumbering, or silenced. Suddenly everything within me has come back to life!

And now, once again, I have returned here [Slavuta]. I have returned—and I see how distant I am, how separate and apart from all of them, even from the members of my family. I see myself as though I am entering an entirely different world. Has everything changed so much with me or with them?

I have returned, and my heart has been torn to pieces! I see that to be liberated completely from the burden previously placed upon us is impossible all at once. I have returned, but what is there for me here? Everything is guarded there!

I am not letting out empty words this time by saying: My heart has been torn to pieces. I have two hearts now, and both of them are wounded and sick, tortured and depressed.

27. Cf. Hayyim Nahman Bialik's epic poem, "'Ir hahareigah" (The City of Slaughter).
28. Cf. 1 Kings 19:12: "After the earthquake—fire; but the Lord was not in the fire. And after the fire—a soft murmuring sound [*kol demamah dakkah*]." *Kol demamah dakkah* also appears in the Rosh Hashanah prayer Unetanah Tokef.
29. A reference to the events involving the separation from husband Limel Rosenbaum of Warsaw.

A mother's heart! There are no words!

My son! I have left you, abandoned you, gone far away from you! Do you remember me, or have you forgotten me? Do you curse me or bless me? My son! Isn't that one word enough to make the bitter tears flow and pool, seething from my torn and wounded heart? My son! I think of you and my soul sighs! I see your picture and your tiny, tender body, your lovely small hands stretched toward me, your big searching eyes, wondering and seeking. I see, I see my son!

Where am I? Give back what is mine! Who gave you the right to cut off my soul, to rend my heart? What have I brought upon you—or myself, my son?! You cannot and need not see your mother! My son, have you forgotten me? Where are you, my son? Oy!

3 October 1903

[. . .] I appreciate the older generation above all.

They had religion that elevated, purified, and cleansed them. In all aspects of their lives, in their private and everyday behavior, they had something else, something exalted, poetic, lofty, and sublime, and in it they found their contentment.

But what about people today?

Emptiness of heart, pettiness, and lowliness. The majority of them bury their heads in their affairs, deeds, jokes, and jesting, unaware of their own arrogance, unaware of any hidden inner power, exalted and lofty, and unaware as well of being unaware.

The blind eyes do not sense their blindness.

25 October 1903

I was in Warsaw and saw my son again. I cannot describe with my pen the feelings that raced around in my heart from the moment my son came to my room until I was separated from him. Even I myself did not know what was happening within me.

Endless bliss and deep sorrow. Boundless pleasure and pain that tears the heart—all this I felt.

When my son said to me that he is sure I will love him forever, that he will not worry and be upset, and that he will not believe what they tell him and that he knows that I will never forget about him—when he said all of this, I felt as though the greatest pleasures of the world did not compare to these blissful moments, that I have something in the world that is greater than all the worthless vanities, all the material goods, all the greatness and precious things of others. I felt my heart swell and fill will love and affection for everything, because the world, the entire universe, had become more

beautiful, dear, and filled with interest for me.

When my son said to me: Mommy! When he called me *Mamusię* [Polish, mommy], my heart was filled with endless joy and gladness. This one word was like a *bal'zam* [Russian, balm] to my wounded heart. This is what my son always called me when I used to be together with him, but I had never felt that special tenderness, that wondrous affection, that pleasant charm that manifests in this word. Perhaps my son also felt a certain pleasure in saying this beloved and therefore delicious word—whatever the case, I felt an exalted happiness in hearing my son's voice as he called me Mommy! This one word gladdened my soul and was more pleasant to my ears than all the tender and affectionate words in the world.

I deliberately did not answer my son's first call so that he would say it again. Mommy! I turned my face so that I would hear my son's voice in his calling out to me— "Mommy" with all its syllables. I wanted to fix the sound of this word to my heart and sear it into my memory and in my hearing.

I lifted my son, hugged and kissed him, danced with him, laughed, and soaked him with my tears, and clutched him close to my torn heart. I saw the smile on his lips, his graceful and pleasant movements, his winks; I heard his joyous laughter—and it seemed to me that everything in existence was smiling at me and sharing in my happiness. Who was like me as I walked hand in hand with my son in the streets of Warsaw? It seemed to me that there was no happier or prouder person than I then. I paid no attention to those who passed by me; I saw only the sun smiling upon me and the glory that suffused everything. I never before saw Warsaw in that sort of light.

I spoke to him as an adult who was used to talking with others and almost forgot that he was not yet 6 years old. I did not want to deny or hide anything and made an effort as best as I could to explain my relationship with him. It seemed to me that he understood everything, and even though it was stupidity and foolishness to believe this, I wanted to ask him and to know his thoughts and his childlike judgments.

My heart was torn in pieces when he asked me, "Why does Mommy cry so much?" And when I answered him, "When you are a man you will understand," he was not satisfied with that answer. "Explain it to me now, Mommy!" he entreated. "Because I thought I would not see you." "But now you know, Mommy, that you will see me every time, and so please don't worry and don't be upset anymore."

These simple words, words of innocent consolation, the beloved voice and the glance filled with innocence, together with the shock that the boy sensed in his heart a sting that he could not quite understand, shot through my kidneys, and such a feeling of pain pervaded me.

It is impossible for me to explain my emotional state then as I spoke with my son. A deep love that does not spring from an external source but rather is my entire soul and

being, a part of my soul, my very essence, deep pain, great mercy, sorrow of the soul . . .

My heart melted inside me—I was separated from my son!

Even now, two days later, it is hard for me to hold my pen as I write these things, and I'm unable to continue. Anyone with a feeling heart will be able to imagine for himself what happened with me afterward.

20 February 1904, Vienna[30]

[. . .] Is it so? Is it so? Is it really I who is living, breathing air into her spirit, *in freedom*,[31] without encumbrance, and without pressure and inner suffocation? I am so filled with vitality, freedom, so filled with a certain inner ease that it is hard for me to believe that I am that same creature who lived as one anguished, oppressed, and saddled with such a strange burden during those years since childhood.

I have never felt so young and free and good (now I can be good and do good for others) as I do now. Even when I am sitting in my room hunched over my books all day, I feel this lightness, this freedom that those who have never felt trapped cannot possibly understand. I breathe in the air with this special feeling, and every breath brings a flood of life, dew of childhood, and, if one can say this, purity, freedom, and liberty! My Lord, what a lovely and beautiful word!

I feel within me that certain slumbering powers have been awakened: powers of my youth, of my childhood. Now I realize that I never felt them before. I live, that is, I feel life, development, awakening within me. Even though I did not want to feel sorrow (after all, I have more than enough to be sorry about), I was not able to do otherwise, and even so, I am brought back to the clear awareness of personal freedom!

Now, only now, do I understand how incapable I am of bondage, submission, or limitation and how unwilling I am to compromise, justify, or argue its utility. Finally, the power hidden within me has burst out, even if I had not felt it before and had denied it.

Like a child clinging to a most beautiful toy who fears that others will take it from him—looking around every moment in dread—so too I fear that they will attack me suddenly and descend upon me and steal my freedom, separate me from it, as though it were even possible for anyone to force this upon me. I fear losing it, only because it is so precious to me.

30. This is the next diary entry, although there are extant letters to Brainin in the interim. At this point, Shapiro is in Vienna taking classes to prepare for admission to university.

31. The emphasis here, and elsewhere, is based on Shapiro's own emphasis in the original diary.

28 March 1904

What is more painful and strong: physical or emotional inner pain?

From experience I know that the latter is more painful than the former. If we have physical pain, however extreme, emotional pain has the power to eclipse it until the physical pain is barely felt. But if we suffer internal pain, piercing and tortured, no external pain will expel it; rather, it will deepen and increase it.

My soul, my spirit, and my essence—when will they ever rest? A spirit of restlessness pervades me, and it appears I will never be still!

My longings will not sleep. They are constantly awake and arising. Occasionally they attack, lie in wait, and subdue me, and then it requires great strength to overpower them. My longings for my son are saddest and most sorrowful. Memory, thoughts of him and of his development, only increase and strengthen the longings. Every boy, his movements and actions, reminds me of my son, and the longings are hard, hard, piercing!

However, there are other longings that are unexpressed, because their objects are different, and I will never be rid of them.

Longings for exalted beauty, the great and lofty, and life, the essence of life, are always within me, and I cannot quiet them.

They demand a lot and are never satiated.

Such as: I have found, here it is . . . but no! This is not the true, exalted, lofty beauty that I imagined!

And the same thing with people. You think: Among these or those people, you'll find something, you'll encounter greatness, you'll learn and gain from them. But in the end you realize that what is called development, its blossoming, is dependent upon you, on your soul, your unique self-concept, apart and distinct from them.

It is impossible to be influenced if you recognize within yourself a stronger force.

In the end, you reckon with that which dwells within you: your soul. Your spirit rises, separate and apart, which admits no influence.

Influence has the power only to deepen and increase your spirit, showing it to us, highlighting it so that we recognize it more and more.

Perhaps this is a great boon!

14 April 1904

I am filled with such conflicting feelings that it is hard to find a connecting thread between them. The thoughts increase, the feelings intensify; everyone of them brings with it tens of others, and it is impossible to analyze the flood of it and cull the main thing. From all of them, one particular feeling sprouts and encircles all the others, for it is stronger than all the others: the feeling of pain!

I see the children outside, and everyone that I meet reminds me of my son. What is he doing? What is he saying? What is he looking at? What is he playing with now? And each one of these questions has the power within it to constrict the throat to the point of suffocation, to draw out tears that carry within them all the bitterness, all that seethes in the heart. It is enough for me to hear a woman calling to her child outside or to hear his cry, for me to hear my son as he calls me or as he laughs. The tears stream down on their own. It is spring—and I am not with my son! How is it that I am not with him? Ah—do you know, people, what pain is? Do you know what sorrow is? Do you know the sorrow of the soul?

For six years I cared for him, from his birth, and now I am apart from him! Now I am far away and I think every minute: Perhaps he misses me? Perhaps he needs me? Perhaps he incriminates me and is angry with me for not being with him? My God, perhaps my son is angry with me?! No, not because of me, no, no, but perhaps he is sad?!

My God, what would I give only to know, only to be confident that when he is a man, my son will understand me. If I only knew that he would not judge me according to the instructions of others and would understand my heart, if only after my death, if only I knew that—then the wounds of today would not be as difficult and cruel.

It does not matter to me whether others find me innocent or guilty, or what they say about me and how my judgment falls out; all this is the same to me because they will not understand me, and one cannot expect anything from them until the case is decided, and I am not the only one involved, and they cannot interfere overmuch.

None of this would matter if only I knew that my son would understand me, that I could trust in his judgment!

Right now the pain is so great, and the ideas and the doubts split the heart!

21 April 1904

If I say that I am bitter now, that my emotional state is more bitter than death, this will express nothing. All the bitterness in the world is sweet in comparison to that which I feel now. The longings for my son are too difficult to take, not just the longings, but the pain, the sadness, the wound, in the fullest sense of the word. The deep wound in my being apart from him, far away from him, gets bigger and deeper, rises and spreads.

I am his mother, and I am here, far away from him, and he—Oh, my son, my son! Do you hear all the pain in my voice, do you understand all the bitterness in my tears? Perhaps he mentions me? Perhaps he asks for me? My son!!!

It is impossible for me to see a child smiling, laughing, and playing without feeling a mortal pain, a sharp sting in my heart. What is my son doing? I am not together with him! What is there for me in the entire world? What is there for me in the entire universe? My son!!!

Oh, my son!

14 November 1904, Vienna

Once again, I am here. Once again, I have forcibly uprooted my maternal feelings and have separated from my son. I kept hearing the voice of my heart, "Your place is there, with him!" I quieted this voice with proofs and justifications as I set out on my way. But when the image of the child appears before my mind's eye, none of the proofs do anything. My son stands before me in my mind, and I hear his questions: Where is my Mommy? Come here! [...]

16 September 1904[32]

The single, greatest spiritual pleasure is when you feel you have created something, when you have given shape to one of your ideas or feelings that lives within you, which had not let you rest and had suffused you fully. This pleasure is now far from me. I attend regular classes in philosophy and psychology, and have diligently given myself over to my science books with extraordinary desire. There is a certain drunkenness to all of this: Belles lettres do not interest me, or to be more correct, they no longer hold the same value for me. However, these sciences, and even more my nagging thoughts, those nagging thoughts that have had such a power over me lately—because of this I have been barred from feelings of spiritual exaltation. From the outset I scorn and belittle the fruits of my spirit, because I know what is truly within me, that which lives and acts upon me especially, and I cannot manage to realize it the way I want to, and in order to create, in order to be devoted with heartfelt desire to a spiritual creation, one needs faith and self-confidence. For this reason, I have not even tried lately to work, unless I feel an inner need. Something is lacking in me when I do not respond to this inner need and incites me to turn to it, lest I not give expression to that which I am capable of.

30 March 1905, Vienna

All of my many great sufferings, all of my battles, the stories of my torments, have made me stronger, have emboldened me and made me grow. I now feel that I can achieve greatness; I feel that I can do, work, create, craft, think, and feel. It seems to me that only now do I really feel this; only now do I understand this, because my actions, my battles, torments, sufferings, made me understand and proved this to me. They taught me a Torah *sheleimah* [complete Torah]: vision, spiritual ascendance, strengthening of oneself, and purification through industry, self-liberation, and utter opposition to re-enslavement. The emotional torments and sufferings ahead of me will only further strengthen and

32. Note that in the diary itself, this entry appears here, even though the date is not sequential.

embolden my awareness of the great value of freedom from subjugation.

I feel that I am stronger, bolder; I feel the courage of life within me. The work of my life has elevated me. I feel that my soul has been freed somewhat and that it continues to be freed. [. . .]

Two years ago I would not have believed in this possibility. Two years ago my soul was so downtrodden, so submissive, that I could not have felt this. Only now do I see how suffocated my soul once was. Two years ago, I did not believe in the possibility of freedom. Thus I did not know how capable a person could be of becoming stronger and going higher.

If I were a person of faith, according to the definition of the traditionalists of prior ages, I would sing a song of praise to my God, a song of great thanks, for it would flow from the heart that feels gratitude. Whenever I sense my liberation from the heavy chains that once bound and strangled me, whenever I sense the workings of my spiritual freedom, whenever I feel my soul ascending ever higher, I would offer exceedingly deep thanks and praise to my God, flowing from a warm heart, for only now do I feel the full extent and glory of life! I feel filled with such life, such youth, such innocence, such cheerfulness and exuberance that had been suppressed and forcibly stifled within me, that had previously been blocked and stolen from me.

I have not felt any of this for seven years, and even in the past two years[33] these feelings were not particularly strong; they had not yet broken free and developed. Everything was buried and strangled.

I know myself now. I seem to myself as though drunk on life. Only now am I filled with youth, vigor, strength, and the joy, the gladness of life. [. . .]

23 July [1906], Slavuta

[. . .] Of all the deceptions in life, the most difficult is the evidence that shows plainly your mistakes in believing in the decency of people, their honesty and integrity. You act with a person in fairness, in truth, and with an innocent heart, you believe in his honesty, you do not even lay the slightest shadow of a doubt in his integrity—and behold, your faith is betrayed, your confidence is lost and disappears.[34] The deceit is proven, the betrayal is proven, which diminishes your confidence in your faith, and you remain shocked, pained, blaming yourself, despairing of life, truth, and goodness in the world. And if faith had taken root in the heart, if you are not able to blame the person, if you believe and believe—and in end, the premeditated deceit and betrayal are proven—the pain increases sevenfold.

33. Since the time Shapiro separated from her husband, presumably.
34. Although not explicitly stated, the guilty party here seems to be Brainin.

26 August 1906, Slavuta

The tumultuous days have passed, the internal and external battles, the swift changes on my part. Everything has come to a standstill. That which has changed over the past three years has taken on a permanent form. The routine has set in and helps. The great longings for my son, the painful thoughts about my absence, and the constant worry, that special care of a loving mother, which perhaps my son also misses—this painful feeling, that pierces and pierces insufferably, even this feeling has become routine. That is how it is, and it is impossible otherwise. This awareness compels me to make peace slowly but surely with an even more painful feeling, which tortures me at times to the point of bitter tears, so painful because there is no way to fight it, to make it otherwise: the awareness that I have been separated from my son, really separated, that he is growing and developing under the influence of others, and that I have no means of watching over him. I have neither the joys nor the worries nor the pleasures of motherhood—this together with my great longings for him, my only son, for whom at times my love flares to such an extent that I am willing to sacrifice my very life for him—this awareness reminds me of my deepest and greatest wound, hidden, stifled, but stronger than all the others *inside me*. But one grows accustomed slowly even to awareness of this most excruciating of pains, as it comes on and persists and remains constant, and perhaps this guards against utter stagnation.

For after all these changes and battles occurred, along with the critical change,[35] after the storm abated and everything took its final form, I feel as though my life is stable once again. I am not complaining. Every hour, every minute, I feel unequaled joy, for which I paid such a steep price, that is, the joy of freedom.

However, it seems that a destructive spirit dwells within me, which does not rest, or more correctly, never gives me any rest, especially when I sleep. It is this force that is the main reason for action. Even from a psychological point of view, this is the way it must be. And within me, it seems, there are terrible, damaging powers that build and then destroy. These forces demand that I be active, and my entire being rebels against stasis, demands activity and development, changes and transformations.

6 October 1906, Warsaw

That my spirit will not rest if I am prevented from learning, there is no doubt. I need truly to learn, to study, as a fish needs water. This is reality. But to be satisfied with this is impossible for my seeking soul. What really gives life and nourishes my soul is my imagination.

In my imagination I see everything in a different light. I see a different life, a different world. I create for myself this life and dwell within it, while forgetting that this

35. The separation from her husband.

other life is utterly impossible in reality.

There, in my imaginary life, everything meets my requirements, my feelings, my opinions and demands. I neither see nor encounter any desecration, any *Verletzeug* [harm]. I prefer the possibility of spending an hour on my own in this other life than many days in the so-called real world, which unfolds with regularity and fixed laws.

When my whole being demands a beautiful, complete life, I stand up and ask myself: How can I connect these two worlds? How can I make my imaginary world a reality?

19 March 1907, Munich

[. . .] Hidden deep within my soul. I have suppressed an event from my youth, strangled it within me.[36] Has this made things better for me?

No! My life has lost the value it had then.

This was the greatest, strongest, most deeply rooted thing within me, and also the most beautiful and exalted that ever developed in me.

For all of these things—the interests, the knowledge, indeed, all the wisdom in the world that I will ever learn and know—none of them is as deeply rooted and as strongly connected to every aspect of me as this "event" that I have suppressed, hidden, and buried within me.

This was the most genuine content, for it was the strongest force in me. And not only did the bitter circumstances of life steal it away from me and keep me from it, they also darkened and made it repulsive. This is the most bitter thing; this is the barb that stings and rips living flesh. I am still alive and yet I no longer believe in life.

25 July 1907, Franzensbad

When I go out to the Promenade here and see the [female] creatures passing by and floating, without a care in the world, with faces that betray no understanding, no freedom, and no aspiration, the "woman question"[37] is indubitably and explicitly resolved for me, at least in part. Admittedly, with the appearance of this sort of spectacle (and you encounter gaggles of them, with every step you take), you become aware of the weakness of these unfortunate creatures. They are weak in soul and in spirit; one cannot discern the slightest strength of spirit in any of these passersby. Here, as in all the spas frequented by those pampered by Fortune, one sees the fatigued, weary faces of those who lust for life

36. The event is meeting Brainin in 1899. In 1906 Shapiro wrote only two letters to him; and early the next year, she would determine to leave "these memories" behind. See postcard from Shapiro to Brainin (7 January 1907) in Part III.

37. What is known in Russian as *zhenskii vopros* (the woman question) became a topic of the intelligentsia by the end of the nineteenth century. See Introduction to this volume.

and the complacent faces of those who demand nothing and lack nothing. Everyone worries, but only for their health, which is dearer to them than gold. This is their only worry.

A feeling close to revulsion steals into me when I behold these creatures. How different are these throngs of young men and women from the throngs of female and male students at universities abroad? There at least is an aspiration, an insistence to learn whether for its own sake or not, whether a vast amount or minuscule. There are also ideas, perspectives, an *aspiration* to know. Here there is thickness of heart and mind.

17 August [?] 1907, The Hague[38]

If it's possible to call my emotional state over the past *years* an "illness"—well, I have recovered almost entirely from this illness. But at what price? What is left is a great void, an emptiness in the heart that opens its mouth like a yawning abyss, and this emptiness cannot, as yet, be filled. This emptiness did not come on suddenly, not at once, but at different stages, after awesome struggles, various hopes, aspirations, and proofs. And if it comes afterward as a necessary result of utter desperation—well, there is no hope of ever filling it.

17 September 1907, Slavuta

"The Holy Days," the "Days of Awe"![39] When I am in the city of my birth, in that same environment that I saw when I grew up, where I lived their life, was nursed on this life, and took in every breath of it and desired to live this life, to give myself over to it, I see how much it has been emptied out, that which once was like a *neshamah yeterah* [extra soul],[40] which has such unique and important value. [. . .]

The holiness has departed, the innocence of pure souls has been taken and replaced by profanity, clothed in compulsion. People practice and do what they do out of obligation, in order to meet their requirements. They sense it all as a burden and fulfill each in his own way. The holiness has been taken away, affronting the honor stored away in the heart.

When I hear the prayers today and the *nusah* [fixed musical formula of the liturgy], I no longer hear the innocence and purity of the former laments. I see nothing but the prolonged *galut* [exile], the bitter Exile that left its imprint on everyone. I see the individuals and the group, the people and the nation—and upon everyone the same imprint

38. The Eighth Zionist Congress took place in The Hague in August 1907.
39. This entry appears to be Shapiro's first foray into the subject of Yom Kippur. Cf. "Days of Awe" (1908) in Part I.
40. According to Jewish tradition, one receives an extra soul on Sabbath, which allows the individual to experience a taste of redemption and gain endurance for the week ahead.

of Exile, internal and external.

I won't speak about the external Exile, but how much have we lost, how much has been taken from us, and how much has died within us, because of the external Exile! Oy, the cursed bitter Exile within our soul! Will we ever be liberated from it?

2 December 1907, Munich

"Everything has already been under the sun."[41] When significant times pass, things that have value for the rest of our lives, we consider ourselves unique, as though only we endure these sorts of matters, the battles that rage from without or within.

But the storm eventually passes; the silence settles in or another storm comes in its place, and we realize that "it has been already."

When we read the books of the great minds, we see that they merely knew how to give form to that which lives within us "unformed and void."[42] They already knew the essence of the matter. [. . .]

4 March 1908, Lausanne

For the first time, I recognize the emotional workings of a true friendship. Regina has already shown me her friendship and devotion; however, this time this friendship has an inner, spiritual aspect that it did not have before.[43]

I found M.[44] here, but I do not know the inner motivations of this soul—this is what frightens me.

And there are a few other things that are like a riddle in my eyes. We have not yet spoken, for two forces are battling and tugging within both of us. And which will triumph in the end?

The thing is moving, and he is planning to convince me and win my heart forcibly, with elementary force—how will it end?

Will I give in? Will I be reconciled?

Fear overtakes me . . . of the hidden, the unknown. Shall I fight on?

41. Cf. Ecclesiastes 1:9: "There is nothing new beneath the sun!"
42. Cf. Genesis 1:2.
43. Shapiro's (former) sister-in-law, Regina Rosenbaum, is first mentioned here in the diary and appears in the letters as well. They remained friends for decades, as established by a travel document from the 1920s with Shapiro listing "Zinde" (a nickname for Regina?) Rosenbaum as the person she would be visiting. Files of Eva Winternitz-Shapiro, Fond PŘ 11-EO, Central Office of the Prague Police, National Archives of the Czech Republic, Prague.
44. Identity unclear.

The affirmations, signs, and indications have become much more numerous in the past two years! But my *heart!*—my heart does not let me. *I shall tell the truth*—that I do not love—and enough!

29 April 1908, Bern

God Almighty, all the hellish creatures and those risen from the Underworld have sated themselves before me, by showing and revealing before my eyes all the stench that is life.

Where is the modesty? The shame? Where is the heart?

Why did I need to know all of this? Why couldn't it have remained covered and hidden from my eyes, at least that which turns this woman[45] in my eyes into a . . .?

In such a simple, base, ugly, despicable way?!

And the purity within people? And *true* feelings? Can the holy be made profane?

Bless me or curse me, consider me stupid, foolish, unemancipated, unenlightened—but all my insides resist this.

One of my own sex? One of my own sex! *Veni, vidi, vici!* [I came, I saw, I conquered]. In the basest sense of the term, without thinking, without any sort of awareness . . .

I never believed that things could reach this point.

But what really raises my ire is that she can still call me "friend" without any hesitation—brazenness like this exceeds my ability to comprehend. To cheat, to lie, to tell tales, to cause harm, to embezzle, to betray, to pretend that she is my friend and looking out for my benefit when at that very moment and under my nose, she is denigrating and belittling and disparaging my worth unwittingly, acting innocently, putting up naive, truthful appearances as a means of achieving the desired goal: to cast me in a negative, suspicious light—using all the sincere and insincere means, and after all that, to expect my friendship and devotion. What am I to do? Where can I seek refuge from all of this? [. . .]

1 June 1908, Bern

Academic life—what does it get me? Mere external information, knowledge, and a broad education. However, more than this, I feel that everything internal is fixed in its character and essence. It may change form or be enriched, but its principal essence remains. This is the soul, the essence.

I remain a dreamer as I always was, demanding and aspiring, building and destroying.

45. The identity of Shapiro's false friend is unclear.

It seems to me that the years have passed in nothingness, have been erased from my memory and the book of my life, and even from reality. In essence, they never were. I did not *live them*.

Only since I became free, only since the day I stood on my own two feet, no longer enslaved and bound in chains, only then did I feel as though I had returned to my childhood; it is as though I am only now beginning to develop, to gain strength, to create for myself that which is necessary for my soul, my spirit, and my essence. For I am alive, I am free. Strength and eternity and life, albeit not without sorrow and struggles but they are *unverbraucht* [inexhaustible; cannot be spoiled]. I feel that I only need to commence, to do, to act, to achieve, to live, to create, to pursue higher studies and develop.

For thus I live and am free, and my spirit pulses within me!

5 August 1908, Slavuta

Not with "A."![46] Of course, I was so far from this. I did *not* love [him]. I saw B. [Brainin] again—and the self-deception was more and more evident!—for he is—or at least, he was—true and right. There, there was no deception, neither internal nor external. We were close to one another in heart and soul, in spirit and essence; there it was impossible to show and prove and deceive ourselves. On the contrary, the thing was *felt*. Felt from afar, even as we tried to deceive ourselves with something else, and how much the more so, when we were together.

Is it even possible to give oneself over to a man whom I will never be close to in spirit and soul—as I feel it—in the way that I was close to B.?

Obviously it is impossible even if I loved him. It's impossible!

Shall I regret or rejoice over this?

It is my fate.

Indeed, this is not *Love*, and perhaps it never was in any simple or base sense, but it was certainly a closeness of *Spirit*, it most certainly was, and this is what I am talking about.

Is there a man who can be—who can know me and feel for me like B.? To whom I can reveal my heart, my thoughts, and my *ideas* as before this beloved, faithful, elder friend?

15 September 1908, Slavuta

What utter stupidity, what craziness was it that got into me when I considered the *possibility*, even as I hesitated, that I even let *the idea get into my head* to tie myself, to place chains on myself? Even thinking about the idea that *I* might now find myself unfree sends a shiver down my spine. No, I must be free! It is too good for me, and I love

46. Identity unclear.

my freedom too much!

Now, I am able to do whatever my heart desires. I *long* to do whatever my heart desires and to go wherever my spirit *takes* me. I can only imagine how miserable I would have been, had I been bound right now to some situation . . . and to *whom*? My God! Was I insane?

Only now, only now do I know that I am no good unless I am free of ties.

All I need is freedom, freedom, and more freedom.

23 November 1908, Bern

I have never felt such intense, deep, piercing, burning longings.

I had grown accustomed of late to seeing my son (in Slavuta and Warsaw). It had become necessary for me, a response to a strong internal need: to see him, to look at his beloved face, to hear his voice. The longings are no longer for a little boy, who needs the hugs of a mother. They are now stronger: for a boy who understands, who feels the love of a mother, a boy who clings to me, who responds to a mother's requests. The longings are so scathing, so piercing, and they tear at the heart.

My son, my son, my son. You are dearer to me than anything in life. I do not like sentimentality, but . . . nothing stands in the way of this feeling!

I have work, I have a great need to write, to write and create, but everything seems empty to me. I, the strong, brave one have become weak, weak of spirit. The gash in my heart and the pain in my soul oppress me, lay me low. Can I lift my spirits? Can I gain strength? [. . .]

25 November 1908, Bern

There are people in whose eyes I would like *only* to be respected, and others by whom I wish *only* to be loved.[47]

1 May 1909, Bern

I am quiet and serene.

Serene in soul and spirit, and so was my meeting with Brainin. It was quiet and serene—for my sake.

It is painful for me to admit, but this is the thing: When I see him, I become aware every time that I no longer see in him what I used to see before.

47. Cf. Deborah's ruminations in "The Lonely One" in *A Collection of Sketches* in Part I.

Perhaps the blame lies with *me*. Perhaps I have an uncomprehending heart [*shelibi 'ani shamen*].[48] Whatever the case, I look at him now with different eyes, with open eyes, perhaps too open.

The blame certainly lies with me, for he is the way he always has been. When he starts talking and dreaming and gets enthusiastic and excited, not only do I remain quiet, but I also smile at him "goodheartedly."

The blame lies with me, in that I am looking at "the object," whom I previously beheld as an ideal, which I created then in my imagination when I was only a girl, though now I am subjecting it to free scrutiny.[49]

25 July [1909], Bern

Studying and studying!
Is this, indeed, life?
Quiet and silence.
But isn't this better than formidable longings, deep sorrow, and piercing pain?

15 November 1909, Bern

Once again, Bern. Once again, studying, quiet, and silence. Quiet in the house and outside. It's good for me. I do not miss the "storm" and have no desire for it. It's possible that I am no longer capable of it (?).

I regret that I have gotten so far away and have abandoned the Hebrew language altogether.[50] Against my will, I am immersed in another language entirely. And yet, the former is so intertwined with the strings of my heart. That which is hidden away in my soul finds expression in Hebrew alone. Therein lies my holy of holies.

27 December 1909

I would like to be able to label my current emotional state. But I know of no name for it. Expectation, waiting, *desperate longing* . . . what is this?

I am frightened . . . but of what?

I do want to disrupt my *equilibrium*. I do not want to, I do not want to!

48. Cf. Isaiah 6:10: "Dull that people's mind [*hashmen lev ha'am hazeh*, literally "make the heart of the people fat"], stop its ears, and seal its eyes—Lest, seeing with its eyes and hearing with its ears, it also grasps with its mind, and repent and save itself." Here, God enjoins Isaiah to prevent the people from repenting; similarly, Shapiro is trying to prevent herself from sliding back into reverence of Brainin.

49. Some of the newfound awareness about Brainin finds its way into Shapiro's sketches, such as "The Poet of Pain" and "Broken Tablets" in Part I.

50. At this stage in her life, Shapiro is engrossed in her dissertation, in German.

Nevertheless, the longings have grown so strong!

Disquiet has stolen into my heart—and I oppose it! I oppose it with all my strength!! And I will subdue it!

After all, it's a joke: I am frightened? I stop myself and retreat. From what and whom? I am afraid of *my soul*. But this is the thing: That which is taking place in my soul in unclear to me. If only Horodetzky would come!

24 January 1910

I am drawn to H. [Horodetzky]. Am I doing the right thing? Don't I need to take the high road and fence myself off, that is, for the sake of my feelings and inclinations?

I do not wish to reconsider from the beginning, to deliberate, and to clear a new path. It's good keeping company with him, being close to him. He knows not only how to turn my heart to him but also how to plant within me infinite faith in him. I am not awed by him, and I maintain my position when I am near him (as I had become accustomed), like an armed policeman.

His honesty and integrity of heart, more than anything else, suit my mood [*halakh nafshi*],[51] and it may be that because of this, I feel a special compatibility between us.

I say "compatibility" because this is not some blind, passing inclination. Rather, it is a deep feeling, pure and faithful. A tranquility of spirit with a man who is respected by and *dear to me*. Not a stupid storm but rather faith, honor, and high regard.

4 August 1910, Slavuta

I have completed my studies. I have graduated and been given the title "Doctor of Philosophy." But my self-estimation has not increased as a result of this. What I was, I still am. The knowledge that I have amassed is mine, but the title does not add anything to this. I have not gained any special self-satisfaction.

I only want to begin; I want to create, to work, to make use of my freedom.

The atmosphere and the environment in my hometown—despite my love and devotion to my family members—are suffocating and have an occasional bad effect on me, as they have had in the past. We have nothing in common with one another, even those closest to me. The ways and views, attributes and traits of my loved ones seem to me so strange and different from my own. They are so different from what I have become accustomed to think and assume that, willy-nilly, I am aware every moment of the great chasm that separates us.

51. The expression is also found in Y. L. Peretz's "Manginot hazeman."

And I would like to be alone, separate from everyone.

Sometimes I would like—what an odd idea this is!—to even be far away from myself, to strip myself entirely of everything, of all those things that are called "the suffering of inheritance." I would like to strip myself also of culture, love, aspirations—to be a point of light that has no contact with any other point, with any of the external world. Without aspiration, without memories, without hopes, without any tie to anyone else, that everything should be dim . . .

8 December 1910, Warsaw

After *seven* years, seven years of my wandering, I visited the house of Peretz—my old acquaintance—once again. The same people, the same "young people" surrounding him as always, the same old perennially joyful, vivacious "Rebbe." Such it is, but—it may be that *I* am to blame, that I am looking upon all of it with different eyes, or that things appear to me in a different light—but it is clear that these surroundings made a bad impression on me. Idleness, idleness, and more idleness. They speak about the same issues that they spoke about *then*, and they argue about the same things they argued about then, and they look at everything from the same narrow point of view as *then*—turning Yiddish into the dominant Jewish language, to run everything with Yiddish. They strive to speak Yiddish and to make a big deal of it. They argue over Yiddish and Hebrew and are giving vent to the same "wisdom" as back then.

To translate Ibsen into Yiddish. Which of his plays is more worthy? Nora? Borkman?[52] The same speculations that they undertook then—seven years ago.

I also visited Frischmann.[53] A sad, melancholy life. On the face of things, all seems well. He has all three things that make a man content.[54] However, a Hebrew writer! When I look at this tiny, gaunt body, those nearsighted, bespectacled eyes, when I see the study of this Hebrew writer, with the lamp close to the desk, it seems to me that this man is not a man at all. He, who gave all of his mind and vigor to his work—to Hebrew literature—he has emptied out his entire mind and spirit, leaving only a skeleton of bones without the strength of life, without aspiration, feeling, without storminess, without great desires, without the power and will to aspire.

It seems to me that everything—even his humor and joking and laughter—is buried in books and journals. His entire intelligence, his heart and soul remain there, and he himself, the man, is emptied out entirely. For him, nothing remains. He is merely

52. Nora of *The Doll House* and the protagonist of *John Gabriel Borkman*, both plays by Henrik Ibsen.
53. After this visit, Shapiro traveled to Eretz Yisrael with Frischmann. See "Notes from My Journey to Eretz Yisrael" in Part IV.
54. Cf. *Mishnah Avot* 3:1: "Akavia ben Mahalalel said, 'Keep in mind three things, and you will not come into the hands of sin: Know from where you came, to where you are going, before Whom you will have to give an account and a reckoning.'"

a vessel that is emptied. The container, the machine that gave rise to these and those thoughts and ideas and opinions and sentences—that has been emptied of its content. And even now, this same person *must* sit—and work. He must, and perhaps this has become his nature, a routine that no longer gives rise to anything. He *needs* to work—and he works. But in my eyes, his study, in relation to his gaunt body and his tired eyes and fatigued face, seems to be a murderous instrument ready to take its victim.

Is it worth it, after all, for one to remove the treasures of his soul, the treasures of his spirit, and give them up left and right to *others* only so that they will value him and recognize him and know him? Perhaps it would be better to leave his spiritual secret and the treasures of his soul for *himself* to recognize and value without surrendering his intellectual essence to others. Perhaps it would be better to closet oneself, to be separated in *spirit*, and to show only the outward sparks, and the interior, the soul, to close that *within* and not scatter its light to others.

11 July 1911

I hosted my [now 13-year-old] son here for about five weeks. I was with him and lived with him. If there were a shadow of doubt about the tender ties between a mother and her son, if it were at all possible to think that these would weaken after the constant separation, the time I was with him proved the truth, for it was as though we had never been separated at all. There is nothing that exceeds this devotion and love.

I so adore his every movement, every one of his expressions, such that all I wanted to do was to behold the more subtle workings of his spirit. In his childhood I see echoes of my own childhood. How captivating is that light melancholy about the passing summer vacation with its various amusements! How lovely is the childish sorrow over ephemeral passing things! He feels the present with all his senses, and it is hard for him to be separated from all these children and friends, to whom he relates with such childish regard. He senses that as time passes, these relations will change, and he regrets all of this. He senses that his relation to everything around him will change. He senses all that is fleeting and passing and misses it already now.

It was pleasant for me to hear what he said to me once, "I wish I could stay a *boy* forever." How different this is from most children who long to escape their childhoods! This is a sign that he experiences life more intensely, all his pure, childhood feelings.

For the first time he asked, "What happens to a person after death?" He wanted to hear the correct answer (that is, one that he could believe). That there is life even after one leaves this world. He waited impatiently for this answer, for his world seems so precious to him, such that it is impossible for him to accept that all of this will one day be lost. It is pleasant for me to listen to the innocent and pure emotional expression of my son.

11 March 1912[55]

My father has died. The nest has been blown apart. Truly, I never felt particularly connected to him emotionally in his lifetime. My brothers and I were accustomed to directing all of our love and devotion to our mother, who was prepared at any time to give her life for us. However, he was the Head, he was our Father. If he didn't worry about us very much, he also did not burden us or make demands, especially in recent years, to do his bidding, even in those areas of his principal concern. He made an effort to be easy with all of us, asking only that he be *ours*. And indeed, I felt, whenever I was in my parents' house, that he yielded on a lot, and I knew that he felt that *we* were his family and, and with everything, there was peace.

He was able to sacrifice everything for his love of the truth, and in this respect he was great, strong, and solid as flint.

His place in the house is missing. Whatever the case, he is the Head of it. I feel orphaned without a father. And childhood is becoming ever more distant. Seriousness is increasing ever more.

12 December 1912, Berlin

I was at my father's grave. That's it—that's everything?? This is the sum total of our lives, feelings, thoughts, and our existence! A heap of dust—and that's that! This is our final resting place after all of our toil in the world. This is where all of us come. Standing next to my father's grave, I felt all the enormous power of death. Before it we all kneel; we shall not overcome it, and with all its sovereign might it remains cold and eternal. Those who have found their rest here, it is as though they mock all the futility and cynicism of life. After all, everything is so very futile[56] and worthless.

15 December 1912

Horodetzky told me some things, certain bitter truths—not that the things themselves are bitter, and it's even doubtful that they are true. Nevertheless they touch upon the *truthfulness of life*, and they certainly are bitter.

I have never before been pierced in this way. I had distanced myself from inner things and given myself over to externalities. His words returned me to myself, compelled me to

55. There is a break in the diary between this entry and the one that precedes it, except for one entry (26 September 1911) not included here. There are no letters from this period either.

56. Cf. Ecclesiastes 1:2 and 1:14.

think, and to *gnaw at my heart*[57] the way I once used to. I am not complaining about this, and I do not consider Horodetzky's words the main cause of all of this. He only awakened and aroused (perhaps unwittingly) that which was obscure, meaning those things that were dormant within me, or more correctly, what I myself had endeavored to obscure or to lay to rest by turning my attention away from it. If this point were not buried within me, if it were not the most vibrant, the strongest, the *innermost* within me—such that I needed to turn my attention away from it and toward other tangential matters—if not for this, the words would not have affected me so much.

The bitter life truths are that I have been a fugitive and a wanderer[58] all my life, that I have not a single bright point, no special place where I can collect myself, where I can gather together the sum total of my life, my experiences, adventures, worries, feelings, and thoughts—and the consequence of this is that I am unable to concentrate, *sich konzentrieren*,[59] as Horodetzky says. I am not, thus, to blame; rather, it is owing to my difficult fate. Nevertheless, it is very painful. I would like to have my own special corner, sacred, beloved, where I could warm *myself* before a warm fire, where I could unload the burdens of my heart. However, I will not complain about this so long as I still have the strength and possibility within me not to capitulate to what others say is good for me, rather to live according to my own recognizance, [and] more than that: according to my own *inner feelings*. I would lose all benefit, for I cannot make my peace merely by acquiring external things, however spectacular, and that which is impossible for me *to give* would be harder for me to endure than all that I would gain. That is, those feelings which I cannot give would oppress me more than that which *I* would be denied. This I have already learned from experience. Therefore I prefer any situation, any difficult fate like that of my own life, for at least here there is no shadow of deceit.

Summer 1913, Slavuta

It seems to me that there is no longer any personal happiness for me as a woman and as a young soul.

I do not know it anymore, and in truth, I have never known it. Rather, only incidentally, fleetingly, for a moment. And now, I no longer have any desire or aspiration for it. I do not wish to seek it out. The only thing left for me is my son, and only in his eyes, his innocence, love, and devotion to me, do I see pure, personal happiness. In

57. Throughout her oeuvre, both published and unpublished, Shapiro uses the word *gnaw* (Hebrew root nun-kof-reish), which is, arguably, a reflection of her own agitated state. Cf. "In the Reading Room" in *A Collection of Sketches* and "From the Writings of a Tuberculosis Patient," both in Part I; diary entries for 15 December 1912, 2 November 1913, 24 January 1914, and 7 July 1921 in Part II; and "Letter from Prague" in Part IV.

58. Cf. Genesis 4:12: "You [Cain] shall become a ceaseless wanderer [*na' venad*] on earth."

59. Even Shapiro's use of various languages shows how scattered she is.

him, and in the love of my mother and brothers. Also, my brothers' children, who are beloved to me like my own son. For the happiness of my brother's daughter, who is so innocent, loyal, and pure, I would do anything, and her destiny concerns me as though it were my own. I myself no longer have a destiny. Once I did. The strongest and most significant thing in my life was not fulfilled—and so all proceeds without purpose and desire. I have no strong urges for anything. There is no great aspiration—none.

2 November 1913, Berlin

Who expected this? I once had a dream in my life, a wonderful, beautiful dream, and perhaps it wasn't a dream—it was reality, the strongest reality, only it was more beautiful than simple reality, and this is why I call it a dream. For this reason, and because it wasn't fulfilled; rather, it passed and flew away and faded like a nighttime dream.

I met once more with B. [Brainin].[60] But even without seeing him, I know that he was the event, my life's *destiny*, and all of the internal, and even external, events that happened afterward revolved around this central axis. I thought, however, that all of it had been extinguished and quelled within me. I thought I had succeeded in conquering myself, subduing and subjugating that which was stronger, and quieting the voice of my heart, putting it to death—and I was happy. I do not know whether people should pride themselves and be happy when they succeed in subduing forcibly and silencing that which is strongest within them. I did not want to gnaw at my mind.[61] I was happy because it gave me an imaginary rest and because people consider this courage—let it be!

However, the bitter truth came and proved itself before me.

I did not extinguish it; I did not dim the spark (perhaps not even the light!) in my heart, and neither did all the other gusting "winds."

That which was once ignited—the first time!—this kind of flame, so innocent and pure, is impossible to extinguish and dim.

Indeed, so much has changed. The circumstances have changed, the perspectives have changed, the opinions, and, most important, the object!

And how much he has changed! How much he has weakened, ravaged by various injuries, his many and frequent battles. And all this because "he fulfilled his duties"!

How he has changed and how he has stayed the same for my sake! *Längstvergessene Päne* [long forgotten pain] I heard, and the blood revived within my heart.

How they have bent him over and changed him! They stole from him all his bodily and spiritual powers; they oppressed him and ravaged him![62]

And despite this—the same flaring spark in his innocent eyes! If I could take away

60. Shapiro and Brainin may have met at the Eleventh Zionist Congress in Vienna.
61. Note the use of "gnaw" again.
62. By 1905 Brainin's literary stature had diminished; see his biography in Appendix 3.

at once the many wounds that he has known over the years, if it were possible to make him forget about them and leap over them, to *erase their very trace*—I could see that same strong spirit that I knew back then, that loved so much and took my heart prisoner forever!

The heart bursts. And perhaps I too have changed! Rather, he sees only my outward changes, sees the stupidity of my deeds, in my leaping over and evading and dancing around my *very basis*, and he does not feel that any of this is too distant for me, that is, distant from my *inner nature*, only that I am doing this for the sake of "the life" that other people are accustomed to calling life, because I have no other life to speak of!

24 January 1914

According to Horod[etzky], I am "Brainin's sacrifice" [*korbano shel Brainin*]. For fifteen years he has held fast to me and has not let me go. How much truth is there in it?

I was a girl when I met him. He became my ideal. But many days passed; I went and studied, and my perspective developed and changed. I looked at him with different eyes. I experienced different surroundings, I met different people, I moved from country to country, I saw and became acquainted with many things. Sometimes—momentarily—I became enamored of interesting people, and I attempted to convince myself that I was truly and wholeheartedly and *freely drawn*, with closeness of spirit, after whoever it was. But in some hidden corner, doubt dwelled, and poked and prodded [literally, gnawed].[63] And in the end, it overcame me.

When I saw B. [Brainin], I said to myself, this is no longer the ideal that I saw previously; rather, even so, I felt a certain spark within my soul when I met with him, that same spark that he first ignited and that drew us together so much back *then*. And I was ostensibly free in spirit, but in principle, bound in chains. Not that I felt those chains inside me, but he did strengthen them within me, as though only incidentally, unintentionally.

I have never felt this as much as this time. This time I was overcome by the extent and depth of his love. If I were not the "object," I would be merely surprised. And it seemed to me that I might be endangering his life if I turned my back on him. He did not come with grievances and complaints; rather, he was sad, unendingly sad and filled with pain. Only my reminiscences of him remain, he says. How much truth is there in *this*?

Who is right: B. or Hor [Horodetsky]? How shall I set myself free? From the sparks remaining for B.? Or: sacrifice before them all the rest?

And perhaps, really, he is merely my special tragedy, which perennially diverts me from my path and does not allow me to get close in any real way to an end that will

63. Note the use of "gnaw" again.

bring me any peace. Perhaps I need to throw off *all* my chains and prove to myself the same "truth" that Hor sees.

Had there been someone devoted to me, I might have been saved from this mistake or from this, my lifelong "tragedy"! If only someone had been able *to convince* me of this!

8 February 1914

Success, *Der Erfolg* [success], according to others, according to those who are alien to me spiritually—the honor or admiration that they show me gives me nothing and satisfies nothing within me and gives me no pleasure. On the contrary, it merely makes me aware that I must spend time with people who mean nothing to me and I mean nothing to them; it is not even worth laboring to get to know *them*, and I have no desire for them to know *me*.

I close up my inner world, and I have no desire for anyone to get inside. I circulate among them only ostensibly; I spend time with different people, but all of this is superficial. In spirit, I am a stranger to them, my world is strange, and they are strangers to me. How strange it is that we spend the least amount of time with the people who are especially close to us and to our spirit and are the same as we are, with similar attributes. B. [Brainin] does not write. When I recall all the reasons and explanations that he gives afterward—that he doesn't want to disturb me, my tranquility, my activities, my decisions, and together with this, his grievances (that he hides), that *I am able* to listen to others, to pay attention to whomever—when I remember his unshaking confidence and conviction such that it is impossible for me to take my heart away from him, that I cannot forget him, and turn away from him, and distance myself from him, when I remember all of this, the idea comes to me: Perhaps it is really true that there is something in our relationship that is stronger than all else, that exceeds everything and mocks everything, and brings us together willy-nilly.

And I do as he does: I do not bother him, for his sake, for the sake of his family life, and his work.

Let him forget if he can. I am certain that I shall *not* forget. A strange relationship!

1 September 1914, Slavuta

Worldwide events, a war of many nations! All of this came about suddenly, like a sudden, terrible storm, and before our eyes, all of these terrible things are being done. This is such a unique time, everything is completely out of the ordinary and thus seems to change the workings of the world. We are living this out, in our days, in our lifetimes; all of it is unfolding before our very eyes. The whole world is being destroyed. And we

are witnessing the destruction.[64] If a more peaceful, decent, and beautiful world should come to be built and established upon these ruins, fortunate is the one who merits to see this and not the old, rotten one.

Whatever the case, in these strange times, all the small, trivial matters are forgotten. Private matters have receded and shrunk and have been hidden somewhere far away, and what remains is the communal, the *big* issues. Space remains only for this, even in more private life, and there is no possibility to give attention to those issues that preoccupy us in other times.

25 March 1915

Peretz has died! The news struck me suddenly. It's difficult for me. I cannot imagine that those eyes, that man who was full of life, those gestures, that voice—that all of these are dead forever, taken from him, that all of this has passed suddenly from the world. Deep in my heart, it's as though a deep chord has come undone, a chord that connected me to my past. I had barely met with him in recent years; nevertheless, how precious was this man even from a distance. I felt in him a sympathetic heart.

My God, *Peretz* is dead. That same "Peretz"! What would he *not* have done for all of us, and how many memories connect me there, to Warsaw, to all of the novices and young people. And he was the youngest of us all! He awakened us, ignited us, spoke, lectured. I remember his house back then. A meeting house for every young person with a spark in his heart, and he, the master of the house himself, not like a rebbe chastising them all but like a friend, a comrade, a brother. It was enough to open the door to his house and immediately you felt that here they would bring you in close.

Hundreds of memories press upon my mind, and the pain in my heart is considerable. The main point is that it is difficult for me to envision that this same Peretz is no more, is no longer! What Peretz was for the community, it is hard for me to assess, but what he was for *me*—this I remember. I remember and feel, and I will never ever forget. Peretz!!

These were the days of my youth. I was just a girl when I introduced myself to him, and it was the hardest and most painful time of my life.

I went to live in Warsaw. I had a "home." I was 20 years old, closed up in my hiding place, completely inexperienced in life. I was heartsick, and the ever-increasing sorrow and pain threatened to rend it in two.

I began visiting him in his house, and he—like a father, a friend, and a brother—empathized with everything that affected me; he did not show me his empathy through various kinds of outpouring. I simply knew and felt that he could sense everything that was happening to me, as though my life was wide open and revealed to him. He never

64. Shapiro uses the Hebrew word ḥurban for "destruction," which is the designation for the catastrophic destruction of the Temple in Jerusalem in 70 CE.

asked me about anything that I myself did not mention, and he did not proffer advice when I did not ask him for it. I was so hermetically closed off back then.

In any case, I knew that there was no need even for a hint, for he understood me and my life better than others to whom I needed to speak and explain (which I obviously did not do) my situation and condition for days and years. When I visited him in his house, there was no need at all for hints, and from the very first time a relationship was established such that I did not have to speak and he did not ask, and only incidentally did I feel that he knew *everything* and even more than that. I did not make an effort either to explain or to conceal my situation—and he did not touch upon it. Rather, he took interest in that which he found or wished to find within me, and he made an effort to turn even my own interests and attention only toward this. He spurred me on to write, not to publish but to write. For now, just to write. And he himself would deal attentively with my writing, with everything produced by my pen. He would not miss a single line, never begrudging his time, taking care and reading them after he convinced me to show him everything I had written. At the beginning, I wasn't just embarrassed, rather I didn't dare come before him with "my writings," which I wrote for myself, and it didn't even dawn on me that one day I could publish anything.

Yet he would take interest in his simple and loving way, would read *everything* with such interest, and would give me his explanations in such a way that it was impossible not to respond with admiration and devotion all at once. I got used to speaking to him not as a regular older man but as a friend and companion (which I had never had in my life). I would visit him almost every day; there I saw various "beginners," young people, writers, and assorted guests. He would bring me into their group and introduce me to them and ask my opinion about each and every one of them. I would never have to ask him. With his exquisite sense, he always knew himself what was pleasant or unpleasant for others.

And so I became accustomed such that there were days when I would write something and even before I had completed it, I would hurry over to him, show it to him, listen to his opinion and comments, and only then would I decide whether to finish it or not.

To get to know my abilities and to give me an opportunity for practice and improvement, he would occasionally give me themes to work on so that I could see *how* I might adapt this material and how I might use it. Then he would awaken my attention to the corrections that needed to be made, specifically to the many details that I had missed. He liked to note every detail, but incidentally, not by way of many descriptions, which was something he considered repulsive. The hint, the sketch, the fine line—these were paramount to him. And after all of that, he would scold me for not paying attention to editing. "Even the shoemaker," he would say, "is not born overnight; rather, he needs to work and toil and improve his work until he finally perfects his craft, and you do not

even let yourself labor and go over that which comes out of your pen. Look, I am older than you and have become used to my work, but I do not publish anything that I have not gone over at least twenty times." There are people, even those close to him, who considered him frivolous, who were convinced that Peretz was a "poet by the grace of God"; when the spirit of poetry came over him, he composed, but he did so with wondrous ease, "when the spirit came over him"; and of course, they considered this frivolous from the point of view of literature. Indeed, Peretz lacked the ponderousness of the learned, of the researcher, but in his work and his ideas, he was a greater and deeper thinker than many researchers. By the time he would begin writing a particular work, his mind would penetrate and descend into the depths of an issue; he would look closely at the inner "soul," the content hidden from the eye, and his look was deep and wide and deeply incisive. His work was the "holy of holies,"[65] *the glory of his life*. [. . .]

It gave him great pleasure and satisfaction to *discover* a talent. Any spark of a talent, and to this end, he would not begrudge his time and effort. Sometimes, he would erase and write his comments or corrections or question marks in his own hand when he found something that he did not like. He loved to write himself; nevertheless, he would say occasionally, half-mockingly, that if I would like to be his secretary, he would pay me a lot, because he so liked the swiftness and exactness of my writing. In particular, he noted my language and my knowledge of Hebrew, and I remember that on one occasion, he brought me over to Sokolov, to his house—that was when I first met Sokolov—and introduced me to him saying, "She knows Hebrew better than I do."[66][. . .]

30 November 1915, Kiev

The encouraging external events, it seems to me, have no value for me. My real life is *internal*, and only in that, it seems, I live. But—it only seems so.

Really how valuable and how worthwhile is it to "turn things upside down," to confuse and to incite the affair of the times, the great war, that so confuses ideas, opinions, feelings, and brings individualism into the world. It has shattered my nest as well, my personal nest—my parents' home.

I am a refugee, a *bezhenets* [Russian, refugee], and once again I am alone, in a foreign city, by myself, once again alone.

But I am not judging or protesting this. The opposite, I feel so much that my disposition tends toward only this: I *feel* myself only when I find myself alone for a long while, because only then am I capable of looking at and collecting myself, only then do I glean what is *inside me*—until it is no good for me, like in the hour that I am by myself and the

65. Shapiro applies this term to her own work as well. See 3 December 1915 in this part.
66. Shapiro would later mine this 27-page (!) diary entry, the content of which is personal but not private, for a two-part article on Peretz; see "Y. L. Peretz: the Man and the Writer" in Part IV.

sole ruler in my room and no one can disturb my rest.

I returned two days ago from Petrograd, where I was for two weeks, and I found myself "among people." No, this is not a good time for me, except in my nest, in my room and by myself, by myself, by myself.

The desire that truly comes to my heart: to find myself with those whom my soul loves, to be among them, surrounded by their love.

But this is only the desire of the moment, that is I want to be among them only at times, a prescribed amount of time. To spend time always in their company—this I feel only now—inside me is the internal need, in my bones, everything that is inside me from the original spark. Everything is merged together.

3 December 1915, Kiev

Weeks and months pass in which I write nothing. And when I finally grab a pen, I already feel that I will not be able to tell and explain what I have experienced—certainly not the essence.

That said—I so yearn to speak!

Years ago, it seemed to me that I would speak—it relieved me—and so when my heart was full, I would write letters and sketches. Now I know that it is like giving your holy of holies to the blind, the idiot, or the fool if you give over the insides of your soul, the best part of yourself and your heart's feelings. Your pain, that which courses through your veins. Shall I petition others to feel what is in my heart, at that moment when you take out that which strangles, those things that fill the hidden recesses of your heart, the pain, the sorrow, capable of drowning your very being?

No, these are the things that a person must carry *within him* but should not bring outside.

Nevertheless, the need and the desire to write are so great, sometimes to the point that it is unbearable. [. . .]

28 December 1915, Kiev

Sometimes it seems to me that the entire material world is worth nothing in comparison to one small corner in another person's heart. And sometimes my heart rages like a volcano, I seem able to accomplish so much.

[Yosef] Klausner was here.[67] Lord of the universe [*ribono shel olam*], how limited that man is! How is it possible that this man, who has no sense of beauty nor any sense or comprehension of truly deep feeling beyond his own "perspective," how can this man

67. See Klausner's tribute to Shapiro, "On the 'Only Daughter'" in Part V.

judge and consider that which is created and born from feeling?

19 February 1917, Slavuta

World events continue to unfold, events that will be chronicled and will be seen by future generations as a disgrace, a horror and a nightmare, a war of nations unlike any other before in terms of the number of victims.

The deeds continue to be done; blood is shed; people have become like wild creatures, who have no opinions, thoughts, or goals other than to protect their lives and souls with all of their might. Before the angel of death, whose vision continually sharpens, one has only a single concern: to save oneself by any means possible.

It is a full year[68] since I last wrote in this book, and it seems to me, on the one hand, that it is not only one year but many years since I have been able to sit and write, and only because it was an inner *necessity* for me, a necessity that enabled me at least to quiet, somewhat, my inner demands. On the other hand, it seems to me that during this time I have not lived at all; rather, I just dragged forward the days of my existence without thinking, without feeling, without any real shining interest that stimulated my life.

I came to Slavuta for Passover. My mother got sick and was one step away from death. My mother's illness demanded all my attention and eclipsed everything else. Then came the fear that they would draft my son into the army, and the world completely darkened in my eyes. There was nothing else in the whole world for me other than this. Until I went out from darkness into light [*me'afeilah le'orah*],[69] and this fear became a vain fear. From this moment, I have had no rest, and every minute it feels as though the fear will return.

I spent all of last summer with my mother, in Kiev and in Slavuta, and this proximity to my ailing mother had a very bad effect on me. I became testy, angry, and nervous, lost my equilibrium, my energy, and my thirst for life.

All this winter I have been in Slavuta, that same Slavuta that was like a prison for me before, and the days pass and change, and not even a spark remains of those days that passed, not a glimmer of aspiration, vision, or expectation as before. Everything has died within me. There is only, if I tell the real truth, present-day life, day-to-day life, with all the trifles of the everyday, or more correctly, with no substance, only the substance of fear, of what is so strange about our times. [. . .]

21 April 1917

It is almost two months since the major changes occurred in Russia, and I have not

68. Only two entries appear between this one and the one that precedes it.
69. A liturgical reference to the closing blessing of the Maggid section of the Haggadah; cf. "Passover Nights" in Part I.

had a chance since then to write a single word. A revolution of the sort that even the most enthusiastic dreamers never expected—a revolution such as this that will necessarily spur everyone who is able to collective life, work, activity, and revival. A new life in every corner and direction, life full of expectations, demands, aspirations for life, a new light.

And in our world, we are filled with such joy and freedom, so full of hopes and aspirations such that it is difficult for the various streams to come together, to achieve balance, or at the very least to come to some sort of balance of opinion and demands. The heart is filled with joy and fear, and the aspirations and demands seem to have sprouted new wings.

My hands are full of work, and I have no time to write even a few words relating to timely questions.[70]

15 December 1917

Revolution. Fundamental changes. Revolution after revolution. Outwardly, life is filled with interest and work, filled with pain and sadness, as well as the drunkenness of victory. There is no free time; even in the small town one cannot escape public service. Two days ago I came back from Kiev. This is the third time that I have visited Kiev. I stayed days and weeks, and even there, life is filled with work—that is, hands are full of work. However, the heart is empty.

Public life, that of the collective, has perhaps taken on greater content; it has become interesting. But individual, personal life has become so impoverished, empty and impoverished. Life continues to develop and continues to dissolve, the inner "I" is dissolving in the mixed multitude[71] of collective service. There is no inner development, no inner completion. Rather, everything continues to merge together. And I regret this stupefaction of the human "I" and the possibilities of its further development.

6 July 1918, Odessa

No other natural phenomenon moves and affects me as much as the view of the sea.[72] There is such enormity, breadth, and eternality to the sea, and when you sit on one of the beaches and look at the expanse revealed before you, it seems as though you are partnering with eternity and endlessness. Large and wide it is, and the expanse spreads out before you without end and all you see is a map of blue, and from a distance it seems as though it is frozen entirely, not even moving. Only here

70. Eight months will pass before Shapiro writes again in her diary.
71. "Mixed multitude" ('eirev rav) is a biblical reference to the Israelites in the desert.
72. Cf. opening of "Notes from My Journey to the Land of Israel" in Part IV.

and there you see some boat or ship, but even these seem as though they are standing still, not moving, not budging, and tranquility and quiet surround them. Only after several minutes is it possible to see that they are not actually standing still but are sailing and moving. The closer you get to the sea, the more you see that it is not quiet. And this supposed stasis and tranquility are nothing but the constant movement of the waves that continue to ripple and strike the shore and move and roar without letup, without pause.

And you sit and look for hours on end at this eternal glory that is so far from the triviality and lowliness of human life, as though none of this has anything to do with that, and it seems to you that it is impossible for this wondrous sight *not* to silence inferior feelings and trivial matters that human beings get stuck in. And it seems as well that if they would pay attention to nature and its glory a little more, if they looked at its immensity for a while, it would willy-nilly divert their attentions and they would be saved from the smallness and triviality that fill up their world.

7 July 1918

I met with Bialik. I had not seen him in nearly ten years. He has gotten a bit older but is still full of life. He is a man in the best sense of the word, simple and without guile. He bears the simplicity and, it seems, the innocence of childhood.

He advised me to come live in Odessa (among other people!) and not to remain in Slavuta. In his opinion, the society of writers in Odessa will become more entrenched, and the writers' quarters will expand. He advises me to come settle here in whatever way I can, on the condition that . . . He will only tell me the condition when I come here. Even the disagreements between writers, in his opinion, demonstrate the development [of Hebrew literature] and life, and one should not be worried about them.

11 August 1918, Odessa

[. . .] In *Hatekufah*, edited by Frischmann, there is a critical article about *Hatoren*[73] by some Greenblatt, who not only criticizes Brainin harshly but also calls out with pathos, "This man was once a critic!" or something like that. Brainin has neither taste nor talent [according to him] nor any ability to say anything.

How humiliating! How they used to flatter and fawn all over that same Brainin, and behold—he has been ousted from his place, and already the little foxes of that same literary world to which he devoted all his life and energy, for which he worked all his days, with love, have come and are cursing and abusing him, as if all the work, taste,

73. Brainin became editor of *Hatoren* in 1918.

talent, and the many years of experience are worthless.

This is the respect that is given to the Hebrew writer among us; this is how they treat his work and his person.

Is this enough—to arouse scorn and provocation [*bizayon vakatsef*]?[74]

25 March 1919, Slavuta

Numerous important events. Much pain and trouble for the Jews, pogroms, trials and tribulations. The fear of death has not abated these past two months. The sword of revolution hangs in the air, and people are not living normal lives. Everything has become strange and exaggerated. My senses have become dulled. All these revolutions, transitions, and pogroms, it is as though they affect me and, at the same time, do not. I feel neither weird fear nor the stirrings of other feelings. The inner world, it is as though it plays no part at all in these external troubles and the fear of death. It is as though all of these are external things in which the heart plays no part, merely corporeal concerns, which one cannot touch.

Somehow all these misfortunes have somehow passed over my head and have not reached me. At the same time, the inner world is empty; the heart has been emptied out, and life has become a word emptied of its content.

20 May 1919

Endless troubles and tribulations are accumulating on the heads of the Jews these three months. A storm of pogroms has passed all through Ukraine, waves of murder and devastation, violent robbery and plunder. The actual war raging in our region with its horrors is nothing in comparison to the hellish torments wrought upon the Jewish people by its terrible enemies. These past three months the life of each one of the Jewish residents of our village has been hanging in the balance, and there is not a moment without injury.

I spent a week penned up in the home of a strange man, hiding myself.[75] Why? Because of my name. The pain is endless.

What have these past three months of toil given and taught me? They taught me and confirmed a lot. But my soul was not enriched by this.

These communal troubles provoked me, showing me much about the situation of my people, about its uniqueness, as well as about other nations in relation to it.

But no major change came to my inner world. I remain who I was. I learned nothing

74. Cf. Esther 1:18: "This very day the ladies of Persia and Media, who have heard of the queen's [i.e., Vashti's] behavior, will cite to all Your Majesty's officials, and there will be no end of scorn and provocation [*bizayon vakatsef*]!"
75. Cf. "Passover Nights" in Part I.

but to *think* more. And the thoughts do not lend themselves to be revealed. There were times when I could read nonstop, passing my days and nights in reading. Books were the joy of my life. I guzzled them down in a kind of spiritual drunkenness. They excited me and sated me. Now, they no longer are enough. I find that in my thoughts I yearn for much more than books. There are weeks when I do not open a single book, except the Bible on occasion. And I can spend entire hours with my thoughts alone. If I read a book, it would only distract me from them. However, I do not seek out these sorts of methods.

External benefit is worthless now, just a flash in the pan. Only that which we find in our souls gives satisfaction. In the end, we all return to ourselves.

At times such as these, when around us we see the cruelty of human beings, which cannot even be compared to that of wild animals (the animals could learn from them), or when we see their craziness when they are drunk on their prejudices, which repudiate all life and all feeling—at times such as these there is only one remedy, which is to flee into one's very *self*. To be conquered and to recede and to dwindle into our own souls without having to have contact or commerce with others.

I so regret the life that is passing and fleeting! After all, at this age—this is the time of life when one is most capable of working and accomplishing. I feel within me stifled powers, which might have developed, flourished, and borne fruit. All the powers of my soul draw me to this sort of work, to creative work *within* life. And it is so painful and difficult to recognize that I am caught sitting within a terrible emptiness—and life is passing. The years are fleeting by—and all the good within you that could bear fruit is being wasted, and there is no possibility to develop those powers, because in the midst of troubles and persecutions and sufferings, the heart hardens and the mind narrows. And people are so very small and minuscule, and their lusts and demands are so small and lacking in sweep and so simple, limited, and routine!

My heart, my heart, my mind, and my soul yearn for distant lands. Far, far away from here, a different milieu, different conditions. Will the time ever come?

Will I ever see again the one I love?[76] Will I ever live and work as my heart demands?

19 February 1920, Prague

I have been here more than four months.

It's amazing that during all that time spent in the midst of Hell I found no need to write. *There* I petrified completely. [. . .]

When I first came here—together with my son—this spiritual petrification began to dissipate only very slowly, and the frozenness melted incrementally. Bit by bit I began to feel like myself again—like a complete person, liberated, with needs and demands

76. Cf. Song of Songs 3:1: "Upon my couch at night I sought the one I love [*she'ahavah nafshi*]—I sought, but found him not."

and routines and personal, cultural strivings.

My God, how far I had been from them! However, one returns to all these very quickly. Only a few days passed, and I could hardly believe what I had seen and experienced *there*, that way of life—I could hardly believe that I had experienced these things, that I had found myself in the midst of this, and that I had been liberated from them.

There were many other things that I could not believe, and it is hard for me to describe or grasp how it was.

That whole life *there* seems to me now like a terrible nightmare, a distant imagining, which nevertheless left severe—terrible—impressions on me, although I am managing to overcome them. My reason and inclination are returning to me ever so slowly.

24 February 1920, Prague

After much deliberation and hesitation, I have decided after all to write to the president of the Republic [of Czechoslovakia, Tomas Masaryk (1850–1937)] to ask him for an interview.[77] It is only the sorrow of my people in the land of my birth that leads me to this sort of step. Never in my life have I stood before kings; neither have I conversed with great people and officers. Thus when I received the invitation today to come for an interview on the 27th, I could hardly contain my excitement. I am already worried that I will not speak properly, and I cannot calm myself down. If not for the idea that I might be able to help my tortured people in this way, there is no way I would have decided to go. My emotional anxiety is too great.

If only I could ask what I want to ask. If only I could be calmer!

It's not the *president* who is throwing me off balance; rather, it is the recognition that I will be standing before one of the Great Ones of soul and spirit, who is revered by his people because of his willingness to sacrifice himself on their account, to fight on their behalf—not with sword and spear—to bring them out of slavery and into redemption and to establish them anew. How I envy these people!

10 July 1920

I do not have much to say about my interview with the president, even though I spoke with him for some twenty minutes. He is a simple man, modest, innocent, and humble, but he has already learned the art of diplomacy. He received me kindly, attempted to calm my spirits—all the while praising his people and native land, from which one can expect a great deal.

Everything is changing steadily and taking on a new form! The heart widens—and

77. Shapiro published a Hebrew monograph about Masaryk, the first president of the Republic of Czechoslovakia, based on this interview (*T. G. Masaryk, His Life and Teachings*, 1935).

anticipates, waiting for news.

Will the news be *new*? Will it renew the downtrodden spirit? Long live encouragement and hope!

10 September 1920, Lausanne

I am wandering from one place to the next. I have no rest and no resting *place*. It's now a year since I left Slavuta, which had become more beloved to me over the past few years. I left the only place I could call home, my beloved mother, brother, all those corners that had become beloved to us because we had grown used to them and they had become part of our very being. [. . .]

It's now a month since I left my son in Prague and came here. In another month, I shall return to him. It's hard for me to live without him. Switzerland! Bern, Lausanne, etc. remind me so much of my youth, my years of study here, and so much has changed! Only the wonderful natural surroundings seem entirely new here, as though I am seeing it all for the first time in my life. The glory of the mountains covered in wonderful snow, the beauty of Lake Léman, the spectacular vista—it's exciting each time one sees it.

I met with Horodetzky in Bern. He's almost the same—and yet even he has changed. We change so much, without our being aware, without our knowing. Places, events, all of these have an effect on us, and one clear day—lo and behold, we are different to others, especially when we don't see each other for some years. It has been seven years since I last saw Hor[odetsky]. And four since I saw Regina. She too has changed a great deal, even though she seems almost the same. She works on her own and lives her life on her own, and it is hard for me to comprehend her life.

I would so love to live in my own house; I long so for my own corner. And I am even more upset about my son. If only he had his own house. He does not have a parental home. I worry about what is happening in Slav[uta]. It's all very difficult for me. It has been three months since I heard of anything from there.

Never would I have believed that Brainin would act *this way* toward *me*! Since I left Slavuta, I have written him many times, and he has not responded! He came from New York to London for the Zionist Congress and wrote nothing. This kind of treatment *now*, after all the events that I endured in Ukraine and after all that he knows, presents him in such a ghastly light such that my heart aches endlessly when I think about it.

For more than twenty years I believed in this man, in his honesty and integrity, especially in relation to me, for twenty years I believed that he was better than all the others.

1 December 1920, Prague

Everything changes. Yes. People too, depending on the environment in which they

find themselves and live. I became especially aware of this when I spent some time in Bern. Horodetzky and I—on the face of it, two people who grew up and were educated under almost the exact same circumstances and were very close to one another when we both lived in Berlin, before the war, even though our traits are very different, and he would always lecture me on my conduct. And now—either we have changed or we have grown distant from one another on account of the differing circumstances under which both of us have lived. He "developed" and remained the same measured, punctilious person, enslaved to public opinion, which he considers above all else and to which he submits readily, along with all other superficialities and norms. He went about in this alien environment so that he would acclimate to it, or make every effort to adapt to it, and genuflected before it; he lived with exactness, seriousness, and in a measured way, and—most important—according to the spirit of that particular environment, and he endeavored to habituate to its way of life and the length and breadth of its perspectives. I lived—among my people. (In order to deny the truth even to himself, Hor[odetsky] tried to joke and mock when I said these words. Which people? This people? Among certain idlers[78] . . . and to busy oneself with certain "needs of the community"[79] and to edit some "Fixed Room.")[80] I don't know if all of this has a good or a bad effect on me, but the fact is that I became much closer to my people than I was formerly. The fact is that I lived my life among them and with them. And it had an impact on me. I cannot free myself of it even now. Beside the common sufferings and troubles and experiences—even in the way I think, in my habits of thought and my behavior—I have surely been influenced by living with them.

And I do not regret this at all. On the contrary, it is important to me. I recognized and felt its importance (and I know that they, too, young and old, feel close to me) even more than the *foreign* life for which I no longer feel any attraction.

26 December 1920

My birthday.[81] There needs to be some sort of spiritual stocktaking [*ḥeshbon hanefesh*,

78. In rabbinic Hebrew the word "idlers" (*batlanim*) refers to Torah scholars (i.e., those who sit all day studying rather than being gainfully employed).

79. To busy oneself with the "needs of the community" (*tsarkhei tsibbur*) alludes to a liturgical phrase from *Av haraḥamim* of the *musaf* service of Shabbat, praising those who serve the community.

80. See David Frischmann's "Fixed Room," a satirical story about a man who attempts to find a goal in life or some sort of meaningful work. Frischmann's story can be found at Project Ben-Yehuda, http://benyehuda.org/frischmann/otiot_074.html.

81. When asked her birthdate on visa applications, Shapiro would respond 24 December 1878 (Files of Eva Winternitz-Shapiro, Fond PŘ 11-EO and Fond PŘ 1941-51, Central Office of the Prague Police, National Archives of the Czech Republic, Prague).

literally "accounting of the soul"][82] on this day, especially when one passes the age of 40. However, it is hard for me to believe and to envision that indeed I have lived this many years. It is difficult for me to put on a serious face because one "must" be *serious* and take on this obligation. I have the desire to laugh at myself about this "lofty role" that time has cast upon me. I want to laugh to myself when I pretend to play this role and remind myself of the little girl who tried in her games to imitate the grownups. In my mind, I can still remember the day when I turned 12 and I became, in the words of the old rebbe in our house, "an adult."[83] What is the meaning of all the years that have passed since then? [. . .]

I am still that same 12-year-old *bogeret* [a girl who has come of age] with her own world and her own character. My mother remembers me on that day, my beloved mother, who wanted to pass on and bequeath to *me* all the languages of her thought, feelings, experience, and seriousness!—and she is now sitting in her house by herself. But no. When I remember this, I find myself returning to that same "situation," the reality that brings down the mark of seriousness.

7 July 1921

It's not only reading books—all that we do at certain times is a kind of drunkenness, a kind of remedy to help us forget ourselves. A person is born not to *think* about his path but to do his work—to go. Each time he does it in one way or another, he is living, he enjoys himself, he dreams, he battles, etc., etc. However, as soon as he begins probing and nitpicking inside himself, in the recesses of his soul, it all begins to lose value in his eyes. He is no longer able to "fill in his certificate." Then he is a kind of "invalid." "Crazy," "insane," "melancholic," that sort of thing. But perhaps these people have a fuller, deeper comprehension of life and things as they are!—for they are not willing to give themselves over to work without *probing* it and gnawing at it.[84] One needs to forget, only to forget! This is the best way to adapt to life! To forget the past, the future, the personal, the communal, the reason, the meaning, and the value. The main point is to forget oneself—or more correctly, to use whatever strategies to make oneself forget. Only then is there a point to life.

14 December 1921, Munkács

Certainly it never dawned on me that I would ever live here for such an extended

82. "Spiritual stocktaking" (ḥeshbon hanefesh) is mandated, according to Jewish tradition, during the ten days from Rosh Hashanah to Yom Kippur.
83. Bat mitzvah, or the coming-of-age for a Jewish girl at 12 years and a day, was not typically acknowledged communally in nineteenth- and early-twentieth-century Eastern Europe.
84. Note the use of "gnaw" again.

period, and, behold, I am here in this place for more than two months. My fortune is so strange—like the fortunes of all my people. A fugitive and a wanderer,[85] with no permanent place, no permanent home—everything is so unstable—wherever happenstance takes me.

"From heaven" I was sent this "Gentile" [*goy*] friend[86]—not for my merit but the merit of my forefathers. If not for him I would certainly have not been saved two years ago from there [Ukraine] and I would not have come abroad—and the critical point, with my son. If not for him, my life here would be much more difficult—if not for him. I owe him a great deal, and I confess that I do not believe that—at least I have never met—among our people there are folks like this, so pure of heart that no sacrifice is too great for them when they consider it their obligation. [. . .]

And even so—Lord of the Universe, how can we demand love for others if we, in our mother's milk, drink only hatred, or, at the very least, suspicion, distrust in *them* and in all their deeds, and in their very insides, with respect to us? Here I am in this man's house, and I not only acknowledge his purity of heart, I not only appreciate and respect him, I am indebted to him with all my heart and soul; I recognize very clearly that he exceeds many others in his kindness, [including] many of my own people.

Nevertheless, I long for the company of my own people! It could be that this is just a vain belief. But I feel it: among these people and theirs. I am a stranger, a stranger, a stranger, a stranger—and even if I offer them respect and honor a thousand times, I will be a stranger to *them with* all my being.

There are times when my longings get so strong that I would agree to any condition so long as I could be among my people, *close to me in spirit* (for even here in Munkács there are many of my people, but those who are as distant from me in spirit as the *goyim*). I came here straight from Carlsbad, from the Zionist Congress, from that very place where I felt as though I was among my own, and the contrast is so palpable! What do *they* know or feel about our longings, aspirations, spirit, inner life, and pain? In their lifetime they will never grasp it, no way in the world, and I dare to declare that true pain is completely unknown to them, and completely alien to their souls.

30 August 1922

My mother is dead. (Am I writing these words?) My beloved, loving mother, is no

85. Cf. diary entry for 15 December 1912 earlier in this part and letters from Shapiro to Brainin (22–25, 27 November [1913]) in Part III.

86. In 1919, when Slavuta was under attack by the Polish army, Shapiro crossed the border into Czechoslovakia together with her son and a respected Christian family—the family of a forester who years before worked for her father. She may have lived for about a year with this family in Munkács. See M. Shapiro letter in Caro, *Kovets letoldot*, 36; and letter from Shapiro to Lipson (8 December 1921) in Part III, which lists her address in care of a forestry inspector.

longer alive! How much she wanted to live, how full of life she was—for her children she was ready to sacrifice her own life without any complaint whatsoever. Only now did I learn of this—she died on the 28th of Heshvan. I felt it, I knew it, but so long as I had a glimmer of hope, I wanted still to hope, to believe.[87] The heart has been emptied; all has been leveled now—Mother is gone. My Mother, my Mother! How much she wanted to see us, how much she hoped, the darling. For two years she was by herself, living without her children, far from them, but in her own house, and she waited and waited: Perhaps, perhaps, "I'll merit seeing them again"—and she died before even one of them was able to be with her in her last moments. My good mother, my unfortunate mother! The tears will not lighten, not for you and for me. It has ended; something has been severed in this life, and I feel the winds of death blowing. [. . .]

29 September 1922

And time is passing and passing and doing what it does. The young ones are getting older, and the old ones are dying, and pain and sorrow remain forever. *She* is no more, my good Mother, the wonderful Mother who was always so full of life and aspired so much to live, is gone. And with the death of Mother, the most beautiful chapter of my life has come to a close. The connection with the past has been broken. Now all is dry, all is alien in the world. I stand alone in life. My son is with me—this is my only consolation, the connection to the future. But now *I* am already beginning to become *the past*. Is it so? It all seems impossible! I am the same person I was years ago, nevertheless! Frischmann is dead. Many I was close to, close to in spirit, who lived with me and were a part of my life, have died and are no longer.

And I am so lonesome among these strangers, strangers to my spirit in *every way*.

I have no desire to work, to write, to create. I simply have no desire. There is no rousing cause. For what? For what purpose? For whom? After all, in the end, all shall pass, will pass, and elapse entirely. What comprehension do strangers, the "readers," have of your soul, your self, of beauty and of the holy sacrifice? Your words pass, your feelings and inner self—better that it should remain buried within you; at least then it cannot be desecrated.

9 October 1922

There are times when I feel as though Mother is here with me. I see her, I speak with her, and she looks at me with those kind, merciful eyes, and the pain is suddenly that much greater! She's gone. How she wanted to live and how much more she could have lived, if not for the terrible pogroms that separated her from her children. To be

87. Although her mother died on 29 November 1921, Shapiro only learned of it on 30 August 1922.

far from us, this was the hardest thing for her. And darling Mother was lonesome. It's so hard to think about it, my Mother, my darling Mother! How terrible and difficult it was for you! Her body was strong, but her mind worked too hard. Her spiritual and intellectual talents were extraordinary; her mind worked all her days in remarkable ways. By the end of her life, it had become dangerous for her. A mind like that! Talents like that, intelligence and understanding like that, and such enormous love, a love that knows no counterpart—Oy, my Mother! How difficult it must have been to be apart from your children, in your last days!

I feel so lonesome. And why all of this? Everything here is empty and to leave—to where? Why? The work for the sake of writing articles is not worthwhile, and to publish my private, spiritual thoughts, that is impossible.

20 October 1922

There are times when I want to say much about so many things; I regret the many thoughts (that lofty fount, our greatest source) that I am stifling within me, and there are times when I say to myself, "Why?" Do I or others care about these thoughts? Every man and his thoughts, to himself. In lonely times they do nothing.

It is my ironic fate that, as though it were predetermined to punish and anger me, I was brought to these surroundings that are not my own, that are distant from me and my spirit. My whole life, it has been my lot to be cast among people whose spirits and thoughts are not my own. I have always been distant from the people I lived with (in Warsaw, in the Peretz era, then I felt at my best; that is, more than any other time in my life I felt in my element). The more life passes, the more I feel this absence. I find satisfaction in my solitude. That said, the circumstances I find myself in *now* emphasize the external solitude so intensely that I have no desire to speak of it. All I can do is immerse myself in work! But despite everything I say to myself, the work has no value unless it has a connection to myself. Without this strong connection, there is no need or interest in most of it. [...]

25 February 1923

I am completely alone in a strange city, a strange land, among strange and foreign people. I thought: a city of Jews! Lord of the Universe, a person needs to be capable of living among people like these. It is better for me to have nothing to do with them at all. I would never have believed in the existence of such strange people, who have no world other than the stories of the wonder-working rebbe, their immersion in their business, their interests, their narrow world; and even the intelligent ones among them are no exception to the rule. I am pained because of my potential. We are getting older,

but I am still relatively young and would like to be useful. My son is about to finish his studies, and I—if only I were not a burden on anyone—I would so like *la'alot 'artzah* [literally, "to go up to the Land"; i.e., to immigrate to Palestine], to be among friends who are close to me in spirit, to work, to be active and useful. But my hands are tied; without money, it's impossible! And here I am suffocating. I have nothing. No friends, companions, relatives, or acquaintances. Is this indeed my fate? I need to fight against this!

14 April 1923

I spent two weeks in Baden and Vienna and saw my brother [Pinhas]. It's so painful to see him need to fight so hard for his very existence. He cannot help me. He himself has nothing, but it was good to see him again and to bewail our fate together, and to mourn our darling mother who is no longer with us. Only she was able to encourage; only she knew how to fight and encourage others in their battles.

I saw the former "bourgeois," the Hornsteins[88] and the others, who have forgotten their former prominence. None of the refugees that you meet anywhere have anything but a stomach. It's so painful to see people who are so worried and concerned about this issue and this issue alone. I know that it is not as though they had higher spiritual concerns before, but nowadays, everywhere you go, even among sophisticated people, you see everyone immersed only in their earning a living and in their stomachs. Everything is valued according to earning power. How much do you take in? How much can it earn you? This is the only measure for *everything*. Cents, cents. Everything is valued in cents and in small terms. Small-mindedness, limited, minuscule understanding.

22 October 1923

[. . .] I returned from roaming the lands.[89] I was in Carlsbad at the Thirteenth Zionist Congress—which gave me no enjoyment. All has become profane. I was also in Berlin and saw Horodetsky—after four years. How much he has changed! He has aged. Life has worked over him a great deal, life events that he could not overcome. "I was *pampered*" in Zafat,[90] by the sea where I stayed for a while with my son. I returned to Berlin. I met with Hebrew writers that I knew and did not know. I met Bialik; he visited me on Yom Kippur. We spoke a great deal. Everything as it used to be. That same elevation of my spirit that I experienced every time I returned from Peretz's house—that I did not find. It could be that it is *my own* fault, that *I* am not capable of it. In any case, the fact remains. And here

88. Identity unclear.
89. See "Roaming the Lands" (1924) in Part IV.
90. Identity of city unclear.

I am back in Munkács. And it is now sevenfold more difficult to live here. The old man whom I live with is without fault, but I get the sense from those around me that I am "the Jewess"—and I despise all of them for it. [. . .]

8 January 1924

My son returned today to Prague. He was with me for three weeks. I have never cried as much as I did then, upon returning from the train station. I have become accustomed to living without him close by, but I have never felt such loneliness as I do now that he has left. When he was staying here, there were things that we did not get along about, there were things we criticized about each other, but with his departure, I feel exactly how emotionally tied we are to one another. All is so sad and gloomy, without content. All is so empty; there is no desire to turn to anything, to busy oneself with anything. And if there is no interest, it is so difficult, so gloomy. At times such as these it is hard for me to understand how I immersed myself so thoroughly in matters that interested me and found within them the desire to live. I have no interest in writing or in anything else.

27 December 1925, Prague

Once again, I am in Prague. That (dark) corner where I lived for four years—which was nevertheless a home *of a sort* and as such there were *moments* of happiness and contentment—has now been abandoned. And once again—Prague. In the meantime, there was that event, which I thought would be an event: I met with Brainin at the Congress in Vienna.[91]

After twelve years! But it was a nonevent, rather a tiny episode. I do not know how much of an effect the hand of time has had on me (and surely it has), even if I do not feel it. But him! It's not that he has aged. Not that. We all age. It just seems to me as though time has endeavored to bring out those aspects that have surely always been there within him but were not felt. They were buried under the beauty. Now these character defects have been enlarged and made more prominent and can no longer be improved. The tendency toward self-aggrandizement and the hankering after honor have become so large as to be laughable, along with an immersion in the trivial issues of his children's lives that reminds me sometimes of a grandmother.

The flattery given to him by those who need him, or because of his status and influence or because they *think he will be able to be useful to them*, continues to give him a

91. The two met at the Fourteenth Zionist Congress in Vienna, 18–31 August 1925, even though Masha Brainin accompanied her husband to the Congress, as indicated in *The Home News*, v. 19, no. 321, clipping (Letters to Reuven Brainin, Correspondence III, Box y, File 14, Jewish Public Library Archives, Montreal).

sense that he is a *great man*, in American terms, and he finds spiritual satisfaction in all of this.

It is all so gloomy! He, Brainin, the one who always aspired (even if this tendency had already started to diminish) to expand boundaries, to personal development, now receives the flattery and obsequiousness of others like a "gold coin," a sure sign that he has indeed risen in status!

And anyone who intimates the truth—or who does not "recognize" him, or has been influenced by the words of his detractors . . .

11 April 1927

What's the point of this whole life that is passing by if I have not managed to give it proper expression? Of all the things that I regret, this is my greatest, truest regret, which pains me the most: Why is it that I did not give real and proper expression to all my feelings in life when they arose, lasting literary expression? It pains me, and I regret that I did not succeed in giving expression to my spirit in worthy creative works, that I did not focus my talents—if I have any—in one field. More specifically, that I did not continue to write stories as I did in the beginning. After all, they came out, as though on their own. And I turned away from this—whither? Now I regret it, not because I did not make a name for myself as a professional fiction writer—perhaps also because of this—but because I wasted and scattered my spiritual and intellectual powers. Why did I not gather them all in one place? [. . .]

14 February 1928

If my external life previously had been crammed and full and multidimensional, that's how unidimensional and boring my life is now, and it may be for this reason that I have grown close to a man[92] whom I respect and *believe* in—that is, I believe in his purity of heart. Perhaps because I currently lack that multidimensional life that I previously had, that I immerse myself in personal matters. I was so drawn in, I gave over so much of myself, that these other things have become insignificant in his eyes. Not good, it is not good what I am doing, and this is not the path I should be taking. But life lacks meaning when there is no feeling to illuminate it. The main point is that I am not *choosing* this or that; rather, circumstances have forced me to surrender to this or that. If I were placed, for example, in different conditions, I would not be drawn to a man whom I respect indeed, but whose entire life, past and present, is so abnormal. This strange fact causes me pain from which I cannot be liberated. Meanwhile, I am

92. Shapiro refers to Josef Winternitz (1876–1944), a Czech citizen and the secretary of the Jewish community of Prague, whom she married during this period.

completely given over to the situation. This trait of mine, that I am incapable of doing anything halfway,[93] is now my undoing. Because if not for this, I would not be losing myself by dragging behind a man whose whole life seems strange in my eyes.

23 November 1932

I have not written for about four years. There was no point.

Before there was hope, inspiration, and now, disappointment. *Spiritual* disappointment. I feel myself completely different than I was before. Different. She who was is no longer. I no longer have the imagination, the confidence in my personal desire, my personal powers. All has been cut down. Cut down by negation and by the strange disposition of the other one [Winternitz]. That same one who I hoped would be a source of support and inspiration. Who is the guilty one? I don't blame anyone. Life itself is to blame. And my life lacks content, interest, meaning. Anything that could be is prevented day by day, hour by hour, by the sick emotional state of the other one. And I grieve over my son's situation—my son, whom I would so much like to see succeed, and who, in his full life, *he* at least is great; I know that he does not complain ever, but I also know that he feels his loneliness very deeply, his lack of a home, and the emptiness of everything. If only I could give myself over to literary work. But the wings have been clipped.[94] And time continues to pass.

8 May 1933

I was looking for broad-mindedness, and instead I find narrowness. There are times when I feel such intense bitterness—bitter, simply bitter. I gave everything out of a desire to adapt, and in return I have received such a lack of understanding and am being ruled over by a man who has been despondent his whole life, although he denies it to others and to himself. This pains me on his account, but this cannot be. I am not the one to blame, and I am suffering very greatly. I am not used to such anger, such constant angry behavior, and even I am nervous. Life is dwindling and losing its rationale. I would bear it all without complaint so long as this constant, anxious, angry situation—without reason, or for reasons that are so slight as to be barely noticeable—would not prevail. This attitude toward everything that is precious to me, or that was such a great part of the meaning of my life—no. I have rummaged through my deeds, on all sides—and I find neither sin nor iniquity, even in thought. Perhaps he too is not culpable; rather, his life is to blame. Whatever the case, I suffer greatly. And life has lost its rationale.

93. Cf. "The Capricious One" who "did nothing halfway" from "Woman," in *A Collection of Sketches* in Part I.
94. See "Clipped of Wings" in *A Collection of Sketches* in Part I.

10 April 1934

It has been twenty-five years since the publication of my *Collection of Sketches*. A celebration, but not for me. For me it is all so bitter! I never thought it was possible to be so wretched, and only because this man embitters my life without any reason. Undoubtedly, he is sick. Certainly, I did not know this and did not believe this. And now, what is there to do? [. . .] I am not used to people not believing *me*. I am not used to people negating all that is precious and holy to *me*. I never thought one could suspect me of what I am incapable of. I am not used to this strange attitude and cannot bear it. It is endlessly difficult and bitter. And it is seven times more bitter because it so greatly pains my son, who is unable to help. I would bear everything with courage if only it did not hurt my son. So that *he* could be happy. Only to these pages can I reveal this: I feel that this situation is shortening my life. I feel that my heart is weakening—and there is no escape.

The man is ill, I understand—and I have tried all these years to sweeten the situation, to do whatever I can to help him so that he can recuperate somewhat and be cured of this illness. I have suffered greatly, but I see that it has all been in vain. The illness grows worse, and life becomes ever more impossible.

I wanted so much to adapt. I did what I would never have done under different circumstances and made every effort to ignore the indignities and the disrespect and the strange despotic treatment. I thought to myself, he is not responsible; it is his illness. But I am not to blame for this illness. And I am pained about my own life. It might be possible to live in peace if he himself would not make life so impossible.

What to do? How shall I influence him? How can I adapt and not completely forgo my entire personality?

9 August 1934

I never thought it was possible to suffer so much!

Evening of Yom Kippur 5635, 18 September 1934

What is there to do if everything is repulsive and futile to me? Besides my strong desire to help my son and my interest in *Hebrew* literature and journalism, I am so frightened of this terrible apathy. I walk around and move like a true automaton, and it is difficult to grab ahold of myself and do something, lest there be awful sadness, pain, and occasionally an emptying out of heart and mind. All has become flat. And I used to be so alert and vital.

7 October 1934

My younger brother died in Leningrad on 5 Elul, the 16th of August. The pain is endless. Why *him*? Why did he suffer so much? He, the honest and decent one! So loving and devoted! And so full of life. Why? Why? All is vanity, a futile imagining. All of life. Only pain and sorrow are actual and real.

And Bialik is dead. He too wanted so much to live. He toiled and he worked every day of his life. And nevertheless he longed to live. And suddenly it's over. Is there any purpose?

27 February 1935

One cannot explain the main point in writing. Only I can understand it. How did I get to this point? How did I not notice it sooner? The man *hid* his attitudes toward Jewish *nationalism*, and so much is related to that.[95] With respect to this, there is no way to reach a compromise. No way. Especially since the man suffers no view but his own.

28 February 1935

My son, my son, my beloved. I have given you nothing, and I so much wanted to make your life happy. And my own life is so gloomy and wretched, to the point that there is no way to be strengthened or encouraged.

11 December 1937

I want to note that my marital life is endlessly bitter. The "home" to which I aspired is no home at all, and he gives nothing even to my son, nothing but bitterness, bitterness, bitterness. I am so disappointed! The man embitters my life. Perhaps not because he wishes to but because his nature is strange and is made even stranger by his former life.[96] Whatever the case, he simply embitters my life, from the smallest thing to the greatest. And I bear it all in silence. Our ideas are as distant from one another as East and West, but he did not reveal this to me previously, and I never guessed that this was the case. I have tried my very best to adapt my way of life to his liking, but to my great chagrin I see that there is no hope. And thus I must bear my fate. If only I could

95. Although we have no further information, it appears that Winternitz opposed his wife's Zionist commitments.
96. Biographical data on Josef Winternitz is meager, and what little there is comes from police records on him in the National Archives of the Czech Republic (Fond PŘ 1931-40, Central Office of the Prague Police).

just do something for my son! My heart pains me so that his life is passing without satisfaction, and I wish there could be some way for me to be useful to him. My life is nothing and is beyond repair, but his! He hasn't tasted much good in his life, and he— such a loyal person, with such an excellent heart, and such devotion!

18 June 1939

World events. Again, endless persecutions of our people. Persecutions of a Western variety—unprecedented in kind. Private life is nothing now, and even so, I want to note: If only my son were happy, if I were able to help him, I would acquiesce to everything else, everything else. The whole point of my life is my son. Justice and righteousness suggest that he deserves a better life. My own life is the spoiled leftovers of what my real life once was. I was, I lived, I battled for my individuality. But now, nothing. My life has become embittered by attacks from a man who should have been closer, but to my great sorrow, he is alien. I thought he would change and get better in time; I am reminded of all the hours and minutes and days of troubles, suspicions, and anxiety that he has caused me—I cannot understand how I have borne it all! How I have become a rag, who listens with her own ears—I!—all of these humiliating things—and for nothing! Just because his temperament is the way it is and cannot be changed. I do not blame him. He embitters his own life along with mine. And I have become so depressed. I cannot resist anything.

And life is now filled with such personal as well as communal sorrow that there is a great need to cling to something. Why is it that people cause such pain *over nothing* to those close to them when they could make it easier and be helpful?

Perhaps he is not to blame; perhaps he cannot free himself from his constant angry temper, from his strange suspicions and his need to yell and rage, and perhaps this is the result of his former life, but this awareness makes it no easier on me and I suffer greatly. No one has ever spoken to me this way before, and I never thought it possible for an educated man to behave and rage and be suspicious in this strange way. It's a pity for him as well, for it's an illness, and he has no relatives, and I wanted to do everything for his benefit; I am devoted to him, and I do all that he wants and demands from me, but there is no way to explain anything to him, as he is incapable of listening to anything that does not accord with his own ideas. And it's not just that he can't listen. Even the very suspicion that others oppose him, even if they keep it to themselves, hurls him into an incomparable, heightened rage. It is all so difficult.

I know that this is not the most important thing, that there are far worse things, but precisely because of this, it hurts that even in such circumstances there is no way to speak to anyone about it, friend to friend.

31 March 1940

My son has departed for America. The pain of parting—Lord of the Universe! Can it be explained? Can it be expressed? Empty void in the heart. If I knew that it would be good *for him*, I would restrain my longings for him, which are endless and incomparable. But it especially pains me that not only will he have to struggle for a living but he will be alone, alone. He doesn't say a thing. He wouldn't complain in front of me, as he doesn't want to cause me sorrow. But I know this, and the pain is so great when considering his loneliness. Who knows when I'll see him again? I am doing all that is in my power to distract myself and hold back my scalding longings. I need to live for him, I need to be healthy for him, for if I am sickly, I will only be a burden. I know that, yet the tears fall all of their own accord. My son, my son, my beloved son. My inner life is so bitter, so embittered. I shouldn't speak about this; I accept my sufferings—surely this has been decreed upon me. Perhaps this is the recompense for the pain I caused in my youth unwittingly to others.[97]

Only those who have felt this way can comprehend my longings and the pain of being separated from my son.

21 October 1941

For more than forty years I have been writing from time to time in this diary. It has become part of my soul. I have not written in Hebrew for over two years, and I am about to be parted as well from this diary, as I am passing it along to strange hands.[98] My son is on the other side of the ocean, and I am going, who knows where? My fate is that of my people.

A month ago, I was still full of life. I even hoped—and perhaps I will hope until my end—to see my son again. Now I am so very weak, and I have so much yet to endure!

My son, my son, let him be happy in his life; may God allow him to be successful!

It is so difficult to part even from this diary, from dead paper that nevertheless breathes the spirit of life from that which is written within!

97. An allusion, perhaps, to Rosenbaum.
98. Shapiro's brother, Moshe, delivered the diary to the Genazim Institute, Tel Aviv, in 1956, but he did not provide details of its recovery. See M. Shapiro letter in Caro, *Kovets letoldot*, 36–37.

267 · 21.10.41

[Hebrew handwritten text — illegible cursive manuscript, not legibly transcribable]

267

א״לס

Shapiro's diary, last page. (Genazim, Tel Aviv)

PART III

LETTERS

The Shapiro-Brainin Correspondence
"The True Book of My Life"

Although she used her diary as an outlet for strong emotion, Hava Shapiro's letters to Reuven Brainin constitute her most dramatic and revealing self-expression. As she disclosed to him, "Why should I write now in my diary? My letters to you are the true book of my life" (15 December 1913).

Shapiro started to write this "true book" during the summer of 1899, a month after she met Brainin for the first time. By mid-July he had already received several of her letters, which would accrue to some 200 by the time the final one reached him in New York in 1928.[1] Disregarding her admonition to destroy them (letter from Shapiro to Brainin, [fall] 1904), he stashed away her letters and postcards, which came to light in 1985.[2] (Only one of his letters to her survives; it is reproduced in this part.) As the postmarks testify, letters and postcards zigged and zagged across continental Europe from Slavuta, Warsaw, Vienna, Bern, Paris, Prague, and other ports of call and later sailed across the ocean beginning in 1910, once Brainin traveled to and ultimately settled in North America.[3] Indeed, the couple's disparate and frequent travel, whether for work, study, pleasure, opportunity, or survival, pulled them physically apart even as their correspondence tied them emotionally and professionally together, at least for some time.

Like other aspiring women writers across Western and Eastern Europe, Shapiro initially sought the tutelage of a literary man to encourage the development of her talents.[4] All the while she became embroiled in a romance that itself became the stuff of literature. Hebrew literary critic Gershon Shaked theorizes about the ways in which letters between writers, especially when published, take on not only historical but also literary importance. As he observes, "Any exchange of letters between two personalities may be considered a kind of pseudo-epistolary novel."[5] Indeed, even without significant evidence of Brainin's part in the exchange, Shapiro's letters—with their narrative twists, Bildung, conflict, masking and unmasking of identities, emotional high points, and denouements—read like a fictional page-turner. With Brainin as a receptive audience, Shapiro, the author, creates Shapiro the character. The drama of the letters

is heightened by the secret nature of their relationship, which was carefully guarded from Brainin's wife and children,[6] although several of Brainin's siblings (he had eight) would come to know Shapiro personally.

The Shapiro-Brainin correspondence weaves a tale of a young unknown woman trapped and yearning to be set free by a knowing and renowned Hebrew writer. But there is no ordinary Cinderella rescue here. Alas, the princess and prince do not live happily ever after. In the end their epistolary affair remained primarily that: confined to paper with only occasional physical interludes. Nonetheless, a steady stream of Shapiro's letters reached Brainin over the course of the first decade of the twentieth century, although their correspondence came to a complete halt for three years beginning in 1910. It picked up again in 1913 but suffered thereafter from a marked lack of regularity and diminished intimacy. Shapiro's final letters to Brainin contain a decidedly perfunctory tone. The deep longing of lovers has given way to the formality of professional acquaintances.

This is nowhere more evident than in the various salutations Shapiro used over the years when addressing Brainin. The affable opening "my friend" (1900–1903) evolved into the adoring "my honorable lord" (1904), and the amorous "my beloved" shrunk to the formal "very honored editor" (1920). Over the course of thirty years, Brainin was to Shapiro friend, teacher, editor, lover, and employer.

Initially, Shapiro seemed to relish and romanticize the imbalance of power between her and Brainin, even playing on the inscribed hierarchy by describing him as her "rebbe" and herself as his "disciple" (no specific date, 1900 [follows 29 May 1900] and 10 March [1901]). Given his prominent stature in Hebrew (and Yiddish) letters, Brainin looms larger than life in Shapiro's words and thoughts. At the outset they would refer to themselves in the third person, lest their affair be revealed; Shapiro was alternately "sister," "daughter," or "Rachel," a character borrowed from Brainin's novella, whom she declared she would have liked to personify (15 November [1901]).[7] Hierarchy aside, the letters demonstrate how each profited from their regular correspondence. Not only did Brainin read and critique Shapiro's manuscripts and published works (8 October 1908, not included here), but he also insisted that she show him her drafts before anyone else (30 October [1901]). Likewise, Shapiro took great interest in Brainin's work, both as reader and critic (15 November [1901]). Remarkably, Brainin even allowed her to read his diary (Postscript, 18 November [1901]). Moreover, when Brainin suffered financially early on in his career, he sought and received money from Shapiro (3 Av 5660 [29 July 1900], 25 November [1901], 17 October [1903], and 23 June 1905), although when the tables turned and Shapiro pleaded with Brainin for assistance, he was unresponsive (Letters to Editor of *Hatoren*, 1920–1928).

For all that was unique in their relationship, Shapiro and Brainin were not the first man and woman to engage in Hebrew correspondence.[8] Tova Cohen describes "a

number of *maskilot* [female adherents of the Jewish Enlightenment] who turned the Hebrew letter into their central form of expression" during the second half of the nineteenth century and thereby "gained a noteworthy entrance into the world of the Haskalah."[9] Arguably, the most famous male-female correspondents of the era were Yehudah Leib Gordon (1830–1895) and Miriam Markel-Mosessohn (née Wierzbolowski) (1839–1920).[10] Shapiro's correspondence with Brainin stands out because of the many ways it differs from the corpus of letters by other *maskilot*. According to Tova Cohen and Shmuel Feiner, nineteenth-century female Hebraists who reached out to *maskilim* typically did so because their fathers were themselves *maskilim* and often friendly with the personages with whom their daughters would correspond. A *maskilah*'s interest in Hebrew reading and writing was ordinarily an outgrowth of the education her father afforded her and thus bound her to her family, unlike the case of so many *maskilim* whose secular Hebrew activity severed familial bonds.[11] Remarkably, the Brainin-Shapiro correspondence is the first exchange of Hebrew letters between a *maskil* and a *maskilah* in which the female correspondent is daughter of both a *maskil*—Yaakov Shammai wrote Hebrew letters too—and a *maskilah*. As demonstrated by the letter in this section, Shapiro's mother, Menuhah, was an accomplished writer of Hebrew prose in her own right.[12] Moreover, Shapiro's introduction to Brainin occurred while vacationing with her mother. Her father had no involvement in their meeting.

To be sure, the material represented in this volume is necessarily limited by what was preserved and what was not. All of Shapiro's known letters are addressed to literary men, not because she did not write to women or to other family members but because the papers of these public literary men have been preserved.[13] Woefully, the private letters of the Shapiro family have not been preserved. As letters written by a younger female Hebraist to older, prominent Hebrew writers and editors, Shapiro's letters follow a pattern similar to those of other *maskilot*, but only somewhat. According to Cohen and Feiner, the writing of Hebrew letters provided nineteenth-century female *maskilot* with a socially acceptable (i.e., private, modest, limited) means into the public discourse of the Haskalah.[14] They note that most *maskilot* wrote while unmarried and unencumbered by domestic responsibilities and that their Hebraic activity often ceased after marriage.[15] Not so Shapiro. She began writing to Brainin as her conventional marriage was shattering under the weight of her unconventional aspirations.

This part concludes with Shapiro's letters to additional men involved in the development of modern Hebrew literature. To Mordecai Ben Hillel Hacohen she writes about dues for membership in a Hebrew literary circle. To editors of various Hebrew journals she sends urgent requests for work. Of particular interest are her repeated appeals to *Hado'ar* editor Daniel Persky and also *Gilyonot* editor Yitzhak Lamdan to

print a volume of her collected works. The final letter, written to Reuven Brainin, is by Shapiro's acquaintance in Prague, Yerahmiel Rozanski, who seeks Brainin's assistance with publishing a volume of the works of "the only Hebrew woman writer in the Diaspora today."

NOTES

1. Cf. Letter from Brainin to Shapiro (14 July 1899) later in this part: "I received all your letters and read them innumerable times."
2. Naomi Caruso, who unearthed the letters, analyzed them in her Master's thesis, "Chava Shapiro: A Woman Before Her Time." The original letters are at the Jewish Public Library of Montreal, and copies are at the Genazim Institute in Tel Aviv. It remains a mystery why Brainin saved Shapiro's letters, which Caruso describes discovering as a ribbon-wrapped bundle (phone conversation, 8 December 2005). Perhaps he maintained a lifelong affection for Shapiro and/or recognized the unprecedented nature of an extended correspondence in Hebrew with a woman. In 1941 Brainin's sons donated nearly all of their father's papers (books, journals, manuscripts, correspondence, photos) to the Jewish Public Library of Montreal, as per his request. Only his voluminous diary was withheld because of sensitive material concerning people still living at the time. See Caruso, "Reuven Brainin." His diary, which consists of 106 notebooks, contains one elliptical allusion to Shapiro. In 1914 he described meeting a young Hebrew woman (*'almah 'ivriyah*) in 1899; she was holding a white rose (*shoshanah levanah*), a possible allusion to Shapiro's first published story, "The Rose." Reuven Brainin Diary (24 August 1914), File P8/14, p. 216, Central Archives for the History of the Jewish People, Hebrew University. Yehudah Leib Gordon used the same phrase (*'almah 'ivriyah*) to describe a woman who wrote in Hebrew.
3. Although Brainin left Europe for North America in 1910 and eventually settled there permanently, he subsequently saw Shapiro a handful of times. Most notably, they spent two to three months together in 1913. For Shapiro's travels and meetings with Brainin, see Appendix 6.
4. An acquaintance would claim that Brainin was responsible for "usher[ing] her into the sanctuary [of Hebrew letters]"; see Letter from Rozanski to Brainin (1937) in this part.
5. Shaked, *Shadows Within*, 40. Caruso refers to Shaked in "Chava Shapiro," 112.
6. Their use of postcards demonstrates some comfort with exposure, and/or perhaps Mrs. Brainin could not read Hebrew. (There are two extant letters in German by Masha Brainin [Reuven Brainin Collection, Correspondence, Box y, File 13, Jewish Public Library, Montreal] and a letter from Reuven Brainin to Masha in Russian [Reuven Brainin Collection, Correspondence, Box y, File 12, Jewish Public Library, Montreal]). Earlier in the correspondence, Shapiro refers to Mrs. Brainin as the "Policeman." For Brainin's siblings, see Brainin Family Tree, Correspondence III, Box y, File 3, Jewish Public Library, Montreal; and Letter from Shapiro to Brainin (15 November 1907) in this part.
7. The story is "Reshimot 'oman 'ivri" (Notes of a Hebrew Artist), in Brainin, *Ketavim nivharim*, 1: 3–116 (with references to Rachel on pp. 19–21 and 115–16). Rachel is described as the most beautiful woman ever and is compared to Tamar, Abraham Mapu's protagonist in *Ahavat tsiyyon*.
8. See Cohen and Feiner, *Kol 'almah 'ivriyah*, 95–128.
9. T. Cohen, "The Maskilot," 66–71, esp. 66–67.
10. For details on Markel-Mosessohn, see Balin, *To Reveal*, 13–50; as well as Yaari, *Tseror 'iggerot Yalag 'el Miriam Markel Mosessohn*, and Werses, *Yedidot shel hameshorer*.
11. Cohen and Feiner, *Kol 'almah 'ivriyah*, 38–39.
12. There are several extant letters and a postcard (reproduced here) from Menuhah Shapiro to Brainin: in Russian (25 July [1900]) and in Hebrew (18 July 1900, 19 September 1900 [postcard], and day after Yom Kippur 5664 [1903]). For the last letter, see later in this part.

13. For instance, there is a note from Shapiro to Micah Yosef Berdichevsky (15 February 1909) in Berdichevsky's archival papers that informs him of the recent publication of *A Collection of Sketches*. Thanks to Avner Holtzman for pointing this out to us. For a reproduction of this note, see Balin and Zierler, *Behikansi 'atah*, illustrations between pages 64 and 65. See also Letter from Shapiro to Brainin (25 September [1901]), where Shapiro writes of running into Berdichevsky.
14. Cohen and Feiner, *Kol 'almah 'ivriyah*, 49.
15. Cohen and Feiner, *Kol 'almah 'ivriyah*, 47.

Reuven Brainin to Hava Shapiro[1]

14 July 1899

Esteemed Friend, Greetings!

I received all your letters and read them innumerable times. Shall I thank you, friend, for this? No—"thank-you" is just an empty word. Everyone uses it thoughtlessly and callously. No, I shall not express my thanks to you. But in your expansive heart you'll feel and know what my heart says of you.

Your ordeal in Warsaw pained my heart greatly! Like drops of bitter poison in the cup of my joy, which your exalted letters poured for me. When I think one by one of all the things you did for my sake, my friend, I feel a holy duty in my soul to tell you to your face that you are a great Hebrew woman ['ivriyah gedolah], and there is none other like you among all our daughters.[2] Over these past few weeks I indeed saw and recognized that your soul is pure and virtuous, that your thoughts and feelings are exalted and wondrous, and that you are like a heavenly angel among womankind— but now it has been made known to me that a strong and courageous soul dwells within you and that you are truly capable of great deeds. I hereby kneel and bow before you! From the day I met you, my soul has been elevated, for I have become convinced with my own eyes that indeed there are excellent and wondrous Hebrew women—at the very least, I have been privileged to see one of them and speak with her for many hours.

Your modesty, innocence, and purity won my heart and soul forever. Who is like you,[3] my friend. You know, my friend, it is not as a "female," as part of the "fairer sex" that I respect and cherish you (in a whisper I'll say to you: love), rather, as an exalted creature, the very symbol of innocence and purity. What I love in you is your great soul and your fine intellect. In your presence, even the wicked become upright, and the upright and innocent (I consider Brainin of the latter sort) become holy and pure.

You inquired once again about my beloved sister,[4] although I do not know why you

1. Reuven Brainin Collection, Group III Correspondence, Box t, Jewish Public Library Archives, Montreal. Note that this letter predates the extant letters of Shapiro to Brainin and is the second letter he sent her.
2. Brainin's praise of Shapiro will be echoed a decade later in correspondence between Yehudah Leib Gordon and Miriam Markel-Mosessohn.
3. Cf. Exodus 15:11: "Who is like you" (mi khamokhah), used as a liturgical reference to God.
4. "Sister" is a cipher for Hava Shapiro.

want to know about this. But I wish to do your gentle bidding and so I will tell you a few things about her:

All my thoughts are now given over to my beloved sister, and I think about her all day long. The angel of dreams transports her to me even in dreams. I know that I would be a laughingstock among men were I to say to them that I love my little sister more than my own soul. The love of a sister is something incomprehensible to many in our day—but let them say what they will. I love my beloved sister with all my heart and soul. I was angry at her when she asked me whether I would advise her to pass by way of Berlin[5] and whether I would like to see her face?

Would I like to see her face? How bitter is the laughter! Wouldn't I happily give my life to see her face for just a brief moment and to speak with her about a few things? And doesn't my sister know this herself? And so why would she ask me these sorts of things? And what can I tell you, my friend, in response to this question? If I truly knew today that my little sister would be here on her way to Marienbad, then I would be content and would find a remedy for my mortal illness. I do not know myself why it is that my heart pains me so and why my wounds are so deep, why there is no rest in the recesses of my soul. If not for my literary work, which consumes most of my time, if not for my obligations to my people and my children,[6] my sorrow, which has already taken the sunlight from my life, would overcome me and destroy my life.

I never would have believed in my soul that I could be so sorrowful, that I would go so insane. My feelings are stronger than I could have believed. I didn't write to you yesterday because it was difficult for me to write, as I do not have the words in my mouth to express the storminess of my spirit and I am angry at my pen, which has always been faithful to me and now betrays me. In addition, I do not know whether my letters will reach your hand. Were I to know that my letters would reach you without any harm, then I would write you, my friend, a long scroll every single day. Two days ago I sent you my first letter: Did it reach you? When you receive this letter kindly let me know about its receipt and the same for other letters I will write to Slavuta, for I fear that my letters will not reach your hands because you are preparing to depart on your journey. Please calm my soul specifically with a telegram as soon as my letter comes into your hands. How much I'd like to know about everything pertaining to your well-being, your health, and the goings-on in your house.

I can only tell you a few things about me. In recent days very unpleasant things have overtaken me, which have angered my spirit greatly. I won't mention the issue and its essence at this time. But I will say that thanks to my courage and strength of spirit,

5. Brainin was living in Berlin at the time.
6. Brainin and his wife had six children, although only four lived past infancy: Miriam (1890–1918; died from influenza), Berta (1892–1983), Moshe (Moe) (1893–1963), Joseph (1895–1970), Max (1897–1898), and Ferdinand (1899–1900). See Brainin Family Tree, Correspondence III, Box y, File 3, Jewish Public Library, Montreal.

I have thrown off these things and been freed of them. If not for my thinking about my beloved sister every day, these frequent occurrences would have had the power to overcome me. However, now they no longer touch my essence or my soul, because my soul has hovered in the highest realms. Perhaps, or certainly, my latter remarks will seem to you like an indecipherable riddle.[7] But at some point, you will come to know them. My beloved sister's letter awakened all my slumbering powers, and I am filled with the spirit of hope and life and I aspire to do great things.

Through the kindness that you did me, my friend, I have been saved from many evils, and I will surely remember this all my days. My friend, send regards in my name to all those with you, send my regards to your esteemed mother and kiss your son.[8]

Be strong and courageous![9]

I send my regards with feelings of loyal friendship.

<div style="text-align: right">

I am all yours,
R. Brainin

</div>

Hava Shapiro to Reuven Brainin[10]

Wiesbaden, Tuesday, 1 August [18]99

Brainin!

I must speak with you this time as those who chant from the scroll of Esther. Certainly, I must count the sons of Haman.[11] Do you remember, darling, the lyrics of the song: My love for you grows day by day, hour by hour. But I don't know whether my

7. Cf. Judges 14:10–19.
8. Shapiro's infant son was along for the trip when Shapiro met Brainin. See letter of M. Shapiro in Caro, *Kovets letoldot*, 36.
9. Cf. Joshua 1:6: "Be strong and resolute" (ḥazak ve'emats).
10. The letters in this section are from the Reuven Brainin Collection, Group III Correspondence, Box t, 1899–1913, 1914–28, and undated, Jewish Public Library Archives, Montreal (received from Joseph Brainin in 1941).
11. Traditionally, one chants the names of Haman's ten sons on Purim from the Scroll of Esther (Megillat Ester) without taking a breath to indicate that they were simultaneously hanged. Shapiro's allusion to this custom shows a desire to express her feelings all at once. It is also a witty retort to Brainin's letter to Shapiro (14 July 1899): "Were I to know that my letters would reach you without any harm, then I would write you, my friend, a long scroll (*megillah*) every single day."

love exceeds my heart's sorrows or vice versa. Waves churn in my heart, and were I to let them burst out, they would rise and flood the waves of the sea. Here I am, in straits.[12] "Sadness has crept into me, pure sadness."[13] My darling!

I had myself a laugh over your words: "If I only knew that you were healthy and content, cheerful and glad." But how bitter the laughter! You asked me to write you about some other things. But I shall not do this because I cannot. Do you remember how, when I rode with you through the streets of Berlin, I neither saw nor heard anything except for ——; you managed to understand this on your own, even though, in my opinion, one cannot understand what goes on in the heart of a young "woman" who has been stricken for the first time by this kind of dangerous ailment. But now, here in W. [Wiesbaden], there is nothing that captivates my heart, and I neither see, hear, nor understand anything happening around me. I am far away from the noise and throngs of people who pass by me. It is as though this world were not mine; this life, not mine. I have another life there within me, deep within my heart, another world, another life. [. . .] I still hope to see you and speak with you! This time I'll open up the sealed part of my heart! And I'll speak with you about everything. [. . .]

<div align="right">Hava</div>

[P.S.] I have no interest in your dreams except for those "with me," but then, only in wakefulness not in dreams!

Warsaw, 29 May 1900

[. . .] As for your request that I share details about my life, I haven't answered you until now, and even now, I need to tell you that what pertains to my inner life and my inner world shall never be made known to any man. What happens there will remain a hidden secret until I die.

I have no desire to amend that which almost all women claim, namely, that there is no man who can understand them and their souls.[14] But if you seek explanations for this silence, I must tell you that, really, you neither know nor understand me. I have resolved to say nothing, for I already know (from experience) that I can say neither in

12. Cf. Psalms 118:5: "In distress I called on the Lord" (*min hametsar kara'ti yah*).

13. These appear to be additional lyrics from the song alluded to in the opening of the letter; origin unknown.

14. Shapiro's notion that men are unable to understand women seems like an inversion of a misogynistic stereotype. If typically men complain that women's behaviors and emotions are inexplicable and thus exasperating (see David Frischmann's "Letter No. 14" in Part V), then Shapiro presents this lack of understanding as an essential failing on the part of men. In her preface to *A Collection of Sketches*, Shapiro suggests that although (male) readers may marvel at the ability of (male) writers to portray women, these depictions feel inauthentic to female readers.

written word nor out loud (at least the way one tells other kinds of stories) that which *I feel and think*. These sorts of things are not meant to be said; the moment they escape from our mouths, they lose their true meaning and are no longer what they ought to have been. It doesn't matter what language we speak; what is *said* is never understood in the way it was originally felt. So please, do not ask me again. [. . .]

[Warsaw, June 1900][15]

My Friend!

Just this minute I received your letter. I won't rebuke you for your silence since it is futile. I would like to hear what you'd have said, had you been in my position, for it seems to me that you would not have trusted as I had. Several times I have asked you to let me know, at least, whether it will be impossible for you to write me for two or three months in a row. But you do not heed me, and you forget each time what you yourself wrote in your previous letters. For example, you wrote: "From now on I will answer your letters the very day that I receive them." Or, "On the day I receive your letters I'll reply." And then many times, "the day" grows into two months or more—and I am still waiting for it! Oh, why do I talk about this? You won't understand or admit it; you'll still complain about me, saying that my time must be so precious such that I do not desire to make my letters longer. And what if I were to write you ten times in that vein? Would you answer me? But then you're always right! What's permitted for the "rebbe" is forbidden to the *talmid* [male student] (or should I say, to the *talmidah* [female student]). You've written more than once: "When we work out how to receive the letters," or "If Satan doesn't dance between us, we'll be able to write everything." And here it seems to me that Satan is already tired and weary from his dancing and is ready to rest from his toil. But you continue to be satisfied with your promises. The promises of the rebbe are precious indeed, but even the most devoted Hasid [pious follower], it seems to me, will begin to doubt them when he sees that the rebbe promises only that which has yet to come.

But even the very distant future eventually becomes the present moment, and afterward, even the past. But let's desist from this.

Indeed, you didn't gladden my spirits with your words. Your troubles have reached my soul and saddened my spirits. Even so, I want and need to know *everything, everything*. [. . .]

15. When no date is given, letters appear in logical sequence, based on content.

[July 1900]

My Friend!

[. . .] Wednesday

A[lexandre] Dumas said that tears are very necessary for genius, but why they are necessary for me, I do not know. I haven't been able to send this letter until now, and until today I haven't received a single letter from you. I told you my address and asked you to write me immediately; please, at least answer me this time right away as to whether you'll be going to London. And when? Will your children be going to Md. [Marienbad]? And will you be going there as well? My mother will return from Cd. [Carlsbad] next week and will stay over in Berlin for a few days.[16] Without doubt she'll visit you at your house.[17] Listen, B, do you remember what your little sister[18] told you: that if you were to sit before her always, she could not look at your face constantly, for if so, she would be sitting for several hours consecutively without speaking a word. But then she would be capable of great deeds, and only then would you be able to know for certain that "God had given her a great and deep soul," as you say, but not now, I don't believe her.

Aren't these her words: To live among people who do not think or feel the way I do is very difficult and has a bad effect. That which amazes me with its greatness and beauty is nothing in their eyes, and everything that preoccupies them, I scorn in my heart. But her whole happiness is that she is able to rise above the lowliness and pettiness she encounters. And when she feels her inner spiritual being coming to life, there is nothing that can restrain her. You tell your little sister, "Weeping is not for a rich soul like yours." Here you could ask your own question but in a different form: "For whom were tears created, if not for you?" Is there another person who feels my pain all the time and every minute like she does? Woe to the person who knows "that he has a great and deep soul" and is *not able to develop* according to his desire. Better for him not to know what he knows. But she knows[19]—do you remember she used to tell you that she feels what you do not know or do not understand.

Please answer me right away. Write your little sister and tell her everything. I feel sorry for her. She's small and young, and her thoughts are so gloomy and sad. Perhaps you can dispel even for a few moments her black thoughts. Perhaps you can strengthen and encourage her! The world is beautiful, the sky is fair, nature is filled with glory, but

16. For spa culture in Bohemia among the Jewish bourgeoisie in this era, see Zadoff, *Next Year in Marienbad*.

17. This is additional evidence of the independent friendship between Menuhah Shapiro and Reuven Brainin.

18. Hava refers to herself as "little sister," echoing Brainin's letter that opens this part.

19. Cf. Genesis 3 and 4 for repetition of the verb "to know" (*yad'ah*), that is, "tree of knowledge" and Adam's carnal knowledge of Eve.

I cannot see or enjoy any of this because I am shortsighted, and all looks black to me.

I'll desist from speaking, for these words are not good for a poet's ears. You should forget all about this (though do not forget your sister for many *days*) and be happy in your world. Please answer me right away. And write me whether you're interested in my long letters that are nine-tenths full. I wait everyday for your letter.

Your friend, Hava.

Slavuta, Sunday, 3 Av 5660 [29 July 1900]

On my mother's order, I am sending 100 rubles along with this and ask that you let me know if you receive them on time.[20] I cannot write you a great deal, as I know, after all, how busy you are such that you cannot even write two or three words in response to all my letters. Therefore I cannot heap upon you this work of reading my letters. My mother wrote me that in another two weeks you'll be traveling to London. Thus I have no hope of getting some kind of letter from you. And yet I still want to hope that finally you'll *benachrufen* [German, remember me] and visit me with your letters.

Your friend, Hava.

[P.S.] Today I read in *Hamelitz* about a speech given by "Our Esteemed Writer, Mr. Brainin," and how envious was I of those assembled there on the twelfth of July. Last winter I heard many speeches given by many esteemed men. But here I am imagining to myself in my mind the impression that it would have made upon me to see you standing in the midst of a Hebrew assembly. I cannot write any more. If you so desire, answer me right away, for I am waiting.

Sunday–Thursday, 19–23 August [1900]

[. . .] I was ill for several days; thus I didn't send this letter. Only today did I get up from my bed, and still my hands are shaking from weakness.[21]

I can't even write you now, for I am still so weak. If you answer this letter, I'll write you at length. My heart breaks inside me when I recall that even this year I was not able to come to the [Zionist] Congress despite your hope and promise last year that "we'll travel to the Congress together without any excuses,"[22] despite my heart and soul's

20. This reference to an enclosed sum of money is evidence of Shapiro's occasional financial support of Brainin. Note that her mother initiated this.
21. Like upper middle-class women of an earlier generation, Shapiro complained of recurrent illness, including loss of weight, fatigue, and melancholia. Such symptoms were diagnosed in the nineteenth century as hysteria ("womb disease"). See Wood, "Fashionable Diseases."
22. Fourth Zionist Congress, London, 13–16 August 1900.

aspiration to witness with my own eyes the beautiful sight of hundreds of people from different countries gathering together to express their views about the fate of the Jews and endeavoring to improve and save the people Israel from their plight, and to hear with my own ears the words of the "greats" of our people, who gather together in this place with hearts full of love and kinship for their people and their homeland.

This sight, it seems to me, must stir within the heart of each man of Israel memories of his People: of a time before he was exiled from his land, when his leaders and officers gathered together to consult secretly about matters related to the nation's well-being and happiness, when he lived in peace on his land and didn't bow his head before enemy or oppressor, before he believed or even imagined that a day would come when his sons would deny or be ashamed of him. The day would come when they would put to death every feeling of love and zealous protection for their homeland and every proud senti-ment of the sort felt by those who stand up for themselves and refuse to turn a cheek to their assailants. The day would come when the factions would become numerous, such that those who worried and fought for the people would become the minority, mocked and scorned by the other factions. One would mock them on account of their concern for what in their eyes was a scorned people, the second faction, stuck under a cloud of wretched slavery,[23] would not even perceive the bitterness of their lives and, in hurling barbs upon the best of our people, would not even understand that they were harming and destroying their own souls. Forgive me if in my innocence I have once again spoken words I did not intend. And now I can no longer write because my head is spinning so. *If you wish*, write me about everything.

<div style="text-align: right">Your friend, Hava</div>

P.S. I have several pieces of writing that I would have sent you now, but I am afraid they would not withstand the criticism of a *kritiki-estetiki* [Russian, aesthetic-critic] (as [Yosef] Klausner has dubbed you) such as yourself. Tell me straight away how you are doing, write me *vsobs. ruki* [Russian, abbreviated, in your own hand].

<div style="text-align: right">Eva Rose[24]</div>

10 March [1901]

My friend!

[. . .] As for your question about how I am, I'll answer that I am well but very pale. Everyone who sees me asks if I am ill. You might not recognize me if you saw me. Let

23. Cf. Ahad Ha'am's famous essay "'Avdut betokh ḥerut" (Slavery in Freedom) in *Hamelitz* (1891), in which he attacks the Western notion of emancipation.
24. The surname is a shortened form of Shapiro's married name, Rosenbaum.

me know whether there is any hope. Will your sister ever see her brother? How happy she would be if she knew she could expect to see and speak with him. Perhaps now if he heard what she had to say, he would understand everything. My friend! Fulfill the wish of your S. [sister] and explain to her the meaning of the words, "Even this that I write exceeds that *permitted* (?) me and that which my pen is allowed to speak." Please don't hide these things so much. Who told you that I lend an attentive ear to people who don't know you or who hate you? You speak of these petty creatures, but who else knows and detests them as I do? Who else knows their pettiness and lowliness, their inability to understand or imagine anything beyond their world of calculations and practicality? But let's desist from this. You don't wish to be beloved by all, and neither do you wish to *awaken by force* the love of your sister.

You've chosen to jest this time! Please do not continue teaching me through subtle barbs, for I will learn from you and will do as you do, and I no longer want that. Or perhaps I am not worthy to be your student? I have chosen you, and were you not to keep forgetting that you are my teacher and rebbe, I, from my end, would be your attentive student, listening to all your words and advice. I indeed listen frequently to *lektstii* [Russian, lectures] from my father-in-law and mother-in-law, meant mainly to teach me to treasure money and recognize its great value, although according to them, I'll never learn this properly. But I cannot be satisfied with these [kinds of lessons], and so I continue to study and read a great deal, and the more I continue to think about the books, the greater my desire becomes for them, such that I spend almost all my time on them. [. . .]

13 March [1901]

I didn't send you my letter until now because I was busy and couldn't send it. I was at a reception, and this is what I beheld.[25] I came to a ballroom that was so large that it was impossible to see from one end of the room to the other. A warm and pleasant light poured out upon everything there. The band played a waltz, and several of the young men and women went out on the dance floor, as though forgetting the whole world. I could see that some of the women were incapable at that moment of understanding anything, spinning as they were, their hearts aflutter, without a thought.

At that moment perhaps I too might have danced (I remembered that once upon a time the waltz used to make me forget everything too), only I saw the *kavaleri* [Russian, cavaliers or gentlemen] gathered together on the side. After preparing themselves and donning their gloves, they went out to "steal someone's heart." I studied them, their brazenness and lack of humility, the way they rose from their seats and observed the

25. This episode serves as the basis for Shapiro's "Lonely One" in *A Collection of Sketches* in Part I.

congregations of women, comparing one to the other and measuring them from head to toe with their scornful and sharp glances. Studying each one's outward appearance to decide to whom they should grant an advantage. And when finished, they'd go straight to the one who pleased them. And they carried this out as though it were their right, with no shame and with no concern as to whether the women saw this themselves. And the latter paid no mind to this and made as though they neither saw nor understood anything, although in their hearts they knew full well; it made them angry and fearful and gave them no pleasure. The one who knows she is pretty—she sits, her face aglow with a joyful expression. But she whose beauty is held in great doubt sits with a sad face of worry and fear. And the third, who has grown accustomed over these past ten years to seeing and being seen at such evenings, sits with more ease than the first two, her appearance suggesting that she has already grown weary of all of this, though she still harbors a secret hope in her heart that hovers on her face, and when a young man draws near, she greets him, and with grace and desire she gives him her hand to dance.

All these sights revolted me, and especially those cursed men with their despicable glances, who filled me with such utter contempt,[26] and I was astonished by all these women who didn't notice any of it. I didn't dance; I merely sat there and studied everything happening around me. Along came two women with one man of the "upper class" in very costly dresses, according to the latest fashion. After looking at their faces, I commended them in my heart for wearing such beautiful dresses to the ball. It seemed they were merciful women who, comprehending the revulsion their ugly faces would provoke in a man who looked their way, wore exquisite clothing so that he would avert his eyes away from their faces. They were clever indeed, but why did they have to reveal everything to everyone, their shoulders and their upper backs covered in thick powder such that I was ashamed to look at them or at anyone else who saw what I did.

Then, the dancing started again; it was the *mazur* [Polish, mazurka], and nearly everyone got up from his seat and danced alongside the "chosen women" and whirled around. Here was a young man and woman very pleased with their moves. The joy of life was evident on their faces and in every movement of their bodies. Their dancing befitted them. Yet here was a man getting on in years, whose age had thrust him together with a woman who likewise was not so young, and his countenance and movements betrayed him; he did not dance out of excitement or enthusiasm but rather thought ponderously about each and every step. And there was a very short man dancing with a woman who was so tall that he reached only to her shoulders.[27] It looked to me as though this woman

26. Cf. Ezekiel 36:5: "I have indeed spoken in My blazing wrath against the other nations and against all of Edom, which with wholehearted glee and with contempt [*bish'at nefesh*], have made My land a possession for themselves for pasture and for prey."
27. Cf. 1 Samuel 9:2: "He [Saul] was a head taller than any of the people" (*vam'alah gavohah hi mikal ha'am*).

had decided to rest her entire weight on him, taxing him to the limits of his strength, and that the man was about to buckle under his heavy load.[28] After a few minutes you could see the beads of sweat on his brow and his labored breathing. It pained me to see the travails of this man who was fated to bear this heavy load that exceeded his strength. Don't be angry with me for stealing your time even from a distance in having you read these worthless words.

Pyrmont, Tuesday, 16 July [1901]

Brainin!

I'm writing not because I promised but because I need to write. It's impossible for me not to write. Everything was as it was before! Do you remember? I am what I was—aha, how pleasant! Everything is coming back to life. All my slumbering feelings, all my aspirations, longings, ideas, thoughts, and dreams. Yes! All this is pleasant, and yet I am filled with a bitter feeling, but this feeling you do not know! My God! How I loathe all these people. I can't speak with any of them; I can't even look at them. They're all like dogs in my eyes. Leave me alone, alone, to sit without anyone bothering me. I am no longer afraid. I never feared suffering or pain (not material pains!), and now I accept it all in love. I will not complain about my inner torment, perhaps because hope has stolen into my heart. Aha, how good, how pleasant is hope!

I forgot to tell you that Pyrmont is a very lovely place. Although I'm tired, everything is pleasant to behold.[29] I'm surely not expecting to be healed of all my ailments because it's impossible in a place like this, in Germany, and I generally doubt that the water will help me, even if it were to come from the fountains of salvation.[30]

For the first time in my life I am going away to be cured, and this time the doctors are not familiar with the illness, but nevertheless they have advised me to take this cure. That's why I don't believe in medicine. But I am no longer like an angel of God;[31] I am eating and drinking and sleeping like all other human beings.

Wed. I still haven't gotten a letter from you, why? I am sitting here alone in the garden near my room, alone. My sister-in-law has gone for a walk, but I didn't want to. What are all of them to me? Let them go where they want to and I'll stay here, alone; I have no need now for any social group. You breathed the spirit of life into me,[32] and this spirit lifts me

28. Cf. Exodus 23:5: "If you see the ass of your enemy lying under its burden [*rovets taḥat masa'o*] and would refrain from raising it, you must nevertheless raise it with him."
29. Cf. Genesis 2:9: "Every tree that is pleasant to the sight" (*kol ʿets neḥmad lemar'eh*).
30. Cf. Isaiah 12:3: "Joyfully shall you draw water from the fountains of salvation" (*mimaʿayanei hayeshuʿah*).
31. Cf. Zechariah 12:8: "angel of the Lord" (*kemalakh Adonai*); Shapiro uses *elohim* instead of *Adonai*.
32. Cf. Genesis 2:7 (God breathes life into Adam), Job 33:4, and the prayer Elohai neshamah from the morning liturgy.

up above all the coarseness, the pettiness, all the empty things that at some other time might have been in my heart and that chased me. It's so pleasant to sit on my own in a quiet, tranquil place, after spending an entire year in a noisy, loud place where the tumult never ceases. I sit all day at home (since I do not need to drink the waters) and wait for your *first* letter. Even today I didn't receive a letter from you, and how is it that you're not ashamed, Brainin? Not a single word since you left Berlin! Didn't you promise me? But I shall not do the same. I promised to send you a letter today, and I shall not wait.

<div align="right">Your friend</div>

28 July [1901], 9:00 a.m.

Brainin!

Yesterday evening I received your letter. Thank you! Just now I read S.'s [sister's] words to her brother. Darling! I will not tell you all that is happening within me. No! It's impossible to tell these things. I am so wretched that I have no words.

And I believed in this sort of happiness! I, a stupid girl, am solely to blame. I should have known that happiness of this sort was not meant for me. A few days! I should have known that it was not for me, I who am always expected to make room for others. I am the sort of creature to whom everything is forbidden, who knows only how to hurt others. A creature whose own life is forbidden to her, who, according to some (or one female), ought to lie down under a heap of —— and not disturb honest people. I should have known that a creature of my sort would never be allowed to approach the gates of Eden. I should have known that I would suffer for at least a few years from the anguish of Hell and the distress of Gehenna. If, however, I were to fight, if there remained within me even a spark of aspiration to approach the holiness, the forbidden gates—nevertheless, I would still be a sinner, in whose face one is commanded to spit;[33] I am to be shamed, scorned, a cursed obstacle to be removed from the path of the honest. Thou shall not aspire, thou shall not desire, thou shall not mention her existence; rather, let her sit quietly in one of the corners of Gehenna and gaze from a distance at the righteous men and women who sit in honor in the Garden of Eden. For you are theirs, and they must never relinquish, heaven forbid, their privileges nor allow the loathsome wicked ones to enjoy even for a moment what is rightfully theirs, as commanded on high. For they are pure and blameless. Oh, cursed sinner! You allowed yourself the desire to enter that place where only the completely righteous stand? And all this when you had not yet confessed with your own mouth that you intentionally sinned!

While, in your conceit, you crave your wickedness! And while you aspire with all

33. Cf. Numbers 12:14: "And the Lord said unto Moses: 'If [Miriam's] father had but spit in her face, should she not hide in shame seven days?'"

your soul and all your heart to live (a real life) and to feel (if only for a few days), to know a higher joy, pure and spiritual like this!

O! Happy is the wretched one! How much I yearn to understand you, to know you well!

Even before I knew you![34]

Pyrmont to Berlin, 14 August 1901, 12 noon [Postcard]

Dear friend!

We didn't travel to Hanover; therefore I am writing you from here. Why haven't I received a response to my two letters from Sunday and Monday? Are you angry at me perhaps? Or perhaps I upset you in telling you that I'll be coming next week on Thursday instead of Friday? Let me know.

Please write me as to whether you have been getting letters from R. [Rosenbaum?] and if he is still annoyed with you.

One thing I know. I have forgotten everything but one thing. Day and night, when I lie down and when I wake up,[35] when I lie down alone or when I am in the company of others—just one thing. And many different thoughts and ideas about this preoccupy me. You know what it is. Can you save me? I also remember this, that in two more weeks I will be home. How pleasant [that will be]!

And in my mind's eye, I sometimes see the picture of you standing at the station, seeing me off, as I traveled to another land! I look forward and *wait* to see this again on the 25th of this month. I am so weak. Tell me how you are. Write to me.

Your friend, E. [Eva]

Slavuta, 2 September 1901

My friend!

I received your letter from Monday only today, even though it arrived here on Thursday. My brother was not able to receive it. Until today they said there was no letter. The small-town way of life is evident in all of this. By no means should you write any more via the *sapozhnik* [Russian, shoemaker], even though I wrote you so, but *no more*. I hope tomorrow to receive your response to my letter from Warsaw.

It's very difficult for me to write to you from here. My mother, my husband, [and] my brother surround me all the time. As I write I am constantly afraid of being caught

34. Cf. Jeremiah 1:5: "Before I created you in the womb, I knew you" (*beterem 'etzrekha vabetem yeda'tikha*).

35. Cf. Deuteronomy 6:7: "When you lie down and when you wake up," allusion to the Ve'ahavta prayer.

in this terrible sin: writing what they cannot understand.

It saddens me that you will be waiting, unrequitedly, for my letter and will receive it only on Thursday. But I am not to blame. I also waited for your letter until Friday. I have been very worried about you. Thanks so much for this letter. I see and sense that you have not forgotten your muse,[36] nor will you, as she will never leave you. Do not turn away from her, even if you don't believe in her. If you wonder, "Perhaps she'll betray me?" No! She will not betray you! I am *maintaining* my health. Since last year I have put on 9 pounds.

My mother, my brother, all of them want me to sit with them all day, saying to me that if I come only once a year for two weeks, then I am all theirs. I'd like these two weeks to pass so that I can go back to my house in Warsaw. I cannot be here. It seems to me as though I'm in the city of the dead. I see all these people moving around, but they seem dead to me. This whole city is despicable to me, so I don't need to answer your question about how I am spending my time. In two weeks I'll be back home.

I am asking you emphatically to write me everything. Your letters will certainly reach me, even if I can't write you everything I might want to. [. . .]

Warsaw, 24 September [1901]

My Friend!

Until now I haven't received any of your letters. Perhaps today? I do not know yet. And I so much want to know what is happening there in Vienna.

Yesterday I afflicted my soul by fasting,[37] but for me that affliction is not so great, as you know. It seems to me that people suffer much greater afflictions, and not necessarily on Yom Kippur! I was at my father-in-law's house all day. Young and old went to pray, but my sister-in-law and I spent the day as we ought to have. I also prayed, but Satan (perhaps I should call him the Prosecutor) came and confused me and, as if to spite me, put before me images that aren't conducive to awakening the heart to prayer.[38] [. . .]

25 September [continuation of previous letter]

Yesterday too there was no letter for me. What is this? I don't even know where you are.

Tonight, I don't know why, but I couldn't sleep at all.[39] Bad thoughts. Terrible ideas

36. Cf. "The Poet of Pain" in *A Collection of Sketches* in Part I, written when Shapiro had become jaded by men who fall in and out of love for the sake of conjuring a muse to inspire their writing.

37. Fasting on Yom Kippur is mandated in Leviticus 23:32: "It shall be a Sabbath of complete rest for you, and you shall practice self-denial."

38. Cf. "Days of Awe" in Part I: "Satan danced before me."

39. Cf. Esther 6:1: "That night, sleep deserted the king" (*nadedah shenat hamelekh*).

encircled me. It's impossible to describe what one feels on a night such as this.

To know full well that I am not as I appear. That I must be that which I am not. To feel inner contradictions every moment. To want to cry out and tell all that you must keep hidden. [. . .]

I just remembered that I have to tell you that yesterday my sister-in-law came and told me she saw P. [Peretz], who is very happy that we have returned and asked why I hadn't informed him at the very least that I was back in Warsaw.

That's what she told me. And today on the street I ran into [Yankev] Dinezon and Berdichevsky. I spoke with them a bit, and Dinezon told me that they had already heard that I had come. They had spoken with Peretz and didn't understand why it was that I hadn't sent word that I was back. After all of this, I had to send word at the very least to Peretz. So I wrote him as follows: "I am letting you know that I came back here a few days ago, but I cannot yet receive anyone at my home, because it is being fixed, and everything is in disarray. How are you?" And that is all. (I am writing you all the details, because I want to write you everything as I had promised.) I am assuming that this note will please you as well! [. . .]

26 September [continuation of previous letter]

Yesterday I went to speak on the telephone and bumped into P. [Peretz] himself. I walked with him for about fifteen minutes. He asked me to come see them at Otwock.

Warsaw, 30 October [1901]

My friend!

[. . .] I read "Shetei re'iyot" [Two Views][40]—and I don't believe you. I am not ashamed to admit that I do not understand your intention. If you wanted to make sure that the details weren't recognizable, you might have chosen another way to go about it and not have portrayed the second one in that manner, and afterward, killed "her" off! I feel badly for her, miserable one! After all, it's not her fault if "the vision was revealed before you," and "you saw her in the company of her husband, in the company of a nice young man, in an everyday setting," and it seemed to you that "she" was no longer herself, she was someone else.[41] Perhaps you were mistaken?

The first one, you killed off; and the second has been obliterated from your heart,

40. This may be an earlier draft of Brainin's published story "Shoshanah," in which the protagonist considers the fallen woman Shoshanah from "two points of view" (*beshtei re'iyot*).

41. Shapiro playfully responds to Brainin's lament about her unavailability when she returns to Warsaw by evoking the biblical Reuven, who, like "her" Reuven, is left alone. Cf. Genesis 37:30: "Returning to his brothers, [Reuven] said: 'The boy is gone! Now, what am I to do?'"

as if dead; and as for me, whither shall I go?

I only received your letter yesterday, but I already know it by heart, and you have no idea what effect your words had on me. But what do my words matter to *you*, if the "the second one has been obliterated from your heart, as if dead." I would have written to you every day.

As for me, I have little to relate. I am sequestered and separated from the world. I don't even go to the theater or the concert hall or that sort of thing. I wish neither to visit these places nor "to waste money." Last week I went for the first time to Peretz's house, and they all expressed shock that I hadn't visited them earlier upon returning from abroad, as though I had forgotten them entirely. One of my acquaintances told them that I had been in Otwock and hadn't visited her either. She wanted to visit me but didn't know where I was staying. Despite his desire to visit me, [Peretz] could not because he isn't acquainted with my husband. He asked why I was hiding from him and not coming by as before and why I wasn't showing him my writings, which satisfy him greatly; that he is always ready, until the day he dies, to read my work.

I wanted to show him my recent writing, but I recalled your request that I not show them to anyone before you read them yourself. For that reason, I am sending you my manuscript with the request that *you read it*, and, when you are done, return it along with the previous ones, to my home address, as you said you would. Please return them right away. This time, please fulfill my request. Since I heard virtually nothing from you for the past six weeks, I was not able to send you my manuscript before now and was ready to send it to David Frischmann, but I remembered once again that I was not allowed to do so until you read it. You ask me why I do not send my articles to be published, but I doubt whether they are print-worthy and why I should publish them.

And all of this before you have pointed out my mistakes and before you have given me your opinion and told me whether you liked them. I know nothing at all. At this point, I would like to publish my writing for the purpose of *earning money*, and if I continue to write, perhaps I'd earn a lot of money! (Surely "she" is no longer she; you see that you were correct in this matter.) In any case I am asking you please to return my manuscript immediately.

You are not correct, my friend, in saying that you did not sin against your friend M. M. [Hurwitz]. Perhaps he's in the right, and only S. [Sister] is the guilty one, for had she not . . . Perhaps then everything would still be fine and beautiful.

Hurwitz explained to Peretz that I was at the meeting of S. B. [Safah Berurah][42] when you spoke about him. I told him that this was a lie, that Hurwitz made a mistake, because I wasn't there. I am reading a lot these days and studying Bible. I'm reading books by Maeterlink, Ibsen, and Anatole Frances, only in French.

So here, I have answered all your questions, my friend, and I would therefore like

42. Safah Berurah, an organization founded in Berlin in 1900 for fostering Hebrew language and culture, was headed by Brainin, who delivered a speech in honor of Peretz's fiftieth birthday.

to ask or request that you write me. I would ask many other things, but I am frightened of asking too many questions, lest you tire and forget to answer even these questions, and I want to hear back from you. I understand that which you did not say directly, that I should believe in you, and I believe that you will write now, if you can; and if not, let me know that you can't, but as to the request that I made in this letter, please fulfill it.

<div align="right">Your pleasant friend</div>

15 November [1901]

My friend!

Just yesterday I read the beginning of your story in the two recent editions of *Hashiloah*,[43] and insofar as you have asked me many times to give you my judgment, here I am hurrying to write you immediately after reading them, even though I doubt very much that I can properly judge your stories nor anything else that comes from your pen.

Regarding the first chapter, it is impossible to judge, because not much is seen there, although as with everything you describe, here too the characters are alive before us. The depiction of the small artist who wants to see his face and looks into the water, having no mirror in their house, his return from the house of study on a winter's night, his imaginings and feelings upon first rendering a drawing on paper. The picture of the mother and the father—this lives before our eyes. The depiction of the mother is especially wonderful. She provokes many feelings and precious memories.

The last Sabbath in his parental home, the sadness and silent confusion that prevail in the house, the mother sitting and "supporting with her left hand, her right arm, and with her right hand, her chin," even the speculations of the townsfolk, their stories and mannerisms in coming to see and consider what is transpiring in the house. All of this is beautiful, correct, and lovely.

A special thread of grace[44] is drawn upon all that is depicted by your hand. But I saw no more in the first chapter.

(Incidentally I will tell you discreetly that the portrayal of the black-haired but not black-eyed painter hovers continually before my eyes.[45] But do not reveal my secret, for your sketches are not the cause of this. Even before reading them, I was afflicted with *mania presled* [Russian, paranoia] and it seemed to me his spirit, his shadow,

43. "Reshimot 'oman 'ivri" (Notes of a Hebrew Artist) in *Hashiloah* 8 (5661–62): 119–31, 212–29, 307–20.
44. Babylonian Talmud, *Megillah* 13a: "thread of grace" (ḥut shel ḥen miyuḥad mashukh).
45. Presumably a reference to Brainin's ever-present image on her mind. Note that Brainin's son, Joseph, confirms that his father was "not black-eyed" when he refers to his father's gray eyes in a poem written in honor of Reuven's seventieth birthday; Reuven Brainin Collection, Correspondence III, Box y, Folder 7, Jewish Public Library Archives, Montreal.

accompanied me everywhere I turned. I believe it is some kind of witchcraft, but you surely don't believe in this . . . isn't that so?)

In the second chapter, I find exalted ideas, great aspirations, and in all of it, a great faith in and love for art in general and for Hebrew art in particular.

Your Hebrew spirit is discernible throughout.

Your images are suffused with grace, and your sketches awaken within us a special feeling of beauty, because you feel so deeply the exceptional grace that is concealed within Hebrew art (in the way that you explicate the sketches of Mendele M. S. [Mokhher Seforim], and not some blind admiration for every little Hebrew intonation and impression but rather a faith in "the sleeping soul of beauty," which endeavors to locate, recognize, and show it—to adopt, establish, rejuvenate, expand, and enlarge it.

A recognition of the limitations and impediments, the obstacles and enervators [. . .] the special feeling and necessity for beauty, and the opposition to them. The quest for different conditions.

Here you soar, and I feel all your striving, all your aspirations for *greatness*.

Everywhere you cast your eyes, you find a place to show, to work, and to grieve. Your words are faithful and wonderful: "Art speaks to feeling in the language of feeling, which is why it speaks to all men, all nations and tongues, in every generation."

From what I see in these sentences, your story might have been written in any language, and nothing would have been lost in terms of its ideas, content, characters, and plot.

You describe two workers, the father and son, and I hear in their speech more than mere words; theirs is the long-standing conflict between the old and new generations, who, through you, speak so clearly.

There is a sting to your description of those "writers who pursue splendor and glory through their work—who are petty, weak, ugly, and vulgar in their love, hatred, jealousy, and vengeance."

However, there is one thing for which I cannot permit myself to forgive you, and you mustn't ridicule me for it. Indeed I have grown accustomed to reading the descriptions by great writers of their . . . first sin, their fall, in all its detail. How they explain everything so that it's entirely explicit. But still I cannot read these details without them provoking a sense of revulsion within me. No matter what they say, I cannot hear these words without shame casting a pall on my face, as though I were the guilty one. Even though there are those who justify these sorts of descriptions on the basis of their being "natural," I cannot assent, and I cannot read without feeling anger and revulsion.

So you will understand of course why it is that I cannot forgive *you* for something like this, even if it is true. I don't even want to talk about it.

I don't understand why you had such a strong need for my judgment on this story.

I don't know if I can really give a proper judgment, even though, in every single word I understand you (and feel) more than anyone else might.

I have written what I have written because you requested it, but I doubt whether you will be pleased with it, and in general, if I am to pronounce judgment on *your stories*, I am somewhat suspect. Even before I begin reading, I am absolutely certain that I'll find something, and in reading, I sometimes find what I am looking for and always I see more than others do.

I must add that Rachel's eyes, which "perpetually hovered before the eyes of your soul"[46] unnerved me somewhat. I will unabashedly admit that I envied her: I wanted to remain there in her stead! My desire to see "the purity and innocence of her big, black eyes" grows, and I thank her and bow before her glory—that she could arouse these feelings, such that longings for her could "make a poet"—"Bless you, Rachel!" [. . .]

18 November [continuation of previous letter]

Just yesterday evening I received your letter from Friday. I cannot adequately express my thanks *to you* for this letter, and for the efforts that you made to show me [my mistakes] and correct my manuscript. Even if I said it *with my own mouth*, I wouldn't be able to express enough thanks, how much the more so with my pen. Therefore I won't say a word but will strive to be a good student, attentive to my dear teacher. I will listen to your advice and send my sketch to Frischmann. I am hurrying to send you this letter right away, so please write me how I should send Gorky's [in Russian] books and whether I should send it to you or to Federmann.[47]

I have the *Vessenniia Melodiia* [Maxim Gorky's novella *Spring Melody*] manuscript, which they will not permit me to print here. If you would like to read it, I will copy it for you and send it. Write me.

Please answer my questions from my previous letter. How are you and how is your health? Why haven't you responded about whether there is a need for another surgery? What happened then in your house? Was there no "scene" concerning your travels?[48]

Please write me everything, everything.

Your friend

46. Brainin, "Reshimot 'oman 'ivri," *Hashiloaḥ* 8 (5661/1901): 130.

47. Pseudonym for Brainin; Caruso conjectures that Federmann is a play on *Feder* (German, feather or pen). See Caruso, "Chava Shapiro," 118. Similarly, on occasion, Shapiro addressed letters to *Kulmus* [Hebrew, feather or reed used by a scribe].

48. Among other issues in the Brainin household, an infant son (Max, 1897–1898) died the year before Reuven first met Hava, and another infant son (Ferdinand, 1899–1900) died not long after their meeting. See Brainin Family Tree, Correspondence III, Box y, File 3, Reuven Brainin Collection, Jewish Public Library Archives, Montreal.

[P.S.] On Sunday evening I was at the university students' *sifrut* [literature] meeting. Now that I've written to you briefly about your story, and I see that you are asking repeatedly, wanting to hear what I have to say, I find myself remembering what you wrote in your diary two years ago: "It's all the same thing to me whether a [female] reader[49] praises or defames me!" Really, I cannot understand what it is you're looking for in my opinion: perspective or judgment.

Warsaw, 25 November [1901]

My Friend!

[...] P. [Peretz] wants to pay me 15 rub [rubles] a month to be his *sekratar'* [Russian, secretary] and to take dictation for him three hours a week. What do you say to that proposition?

I am asking you once again that you not mock me and tell me whether this small sum that I might earn could be of help to you. But please, speak to me as you would a *trusted* friend. Obviously, no one needs to know about this, and even your loving friend need not know about it, as you will not use this money for immediate purposes. Without doubt you can see that I have good intentions, and if indeed you will see this as beneficial, I will be very happy. True, my powers are limited, but I would do this with all my heart, if it would be useful for you. I will reiterate that this will not be for everyday purposes, that is to say, not so it winds up where your money ordinarily goes, and so that you will never be able to leave them. [...]

Warsaw to Berlin, 1 December 1901 [Postcard addressed to R. Federmann]

My Friend!

I just received a reply to my letter of a week ago Monday. And I expect to receive a response to my letter mentioned above tomorrow. I received your letter of the twenty-seventh of the month.

Listen, my friend, to what happened here: They put Peretz in jail, and he has been locked up since a week ago Tuesday for something for which he is blameless.[50] For being good-hearted and exceedingly compassionate, even more than is permissible, and he has been dragged into a matter that is not his. This incident is upsetting me greatly. It's clear all of them know he is innocent of any sin, but all our city's newspapers publicize

49. For more on the female reader, see Shapiro, "The Woman Reader: Where Is She?" in Part IV.
50. The information about Peretz's imprisonment is echoed in Shapiro's diary on page 191 of the original (excerpt not included in this volume) (Hava Shapiro Diary [1900–1941], Folder 48058, Genazim Institute, Tel Aviv). Note that Shapiro's timing of Peretz's imprisonment (winter 1901) does not accord with that of his biographer, Ruth Wisse (August 1899); perhaps he was imprisoned twice.

this news. They hope that by week's end he'll go free and will be redeemed.

Please write me about all that's happening with you. I barely leave my house. Frischmann, it seems, still hasn't come. One of the "fine young men" drew this letter [postcard] for me. Do you like it?

Answer me and write me about everything.

Your friend

25 February [1902]

My Friend!

To see you, to see you, only to see you and to speak with you, that is what I need. And if not, all is futile.[51] All the written words are worth nothing, as I saw and was convinced of from your last letter.

How can you possibly think for even a second that I am being disrespectful or diminishing your honor, that I am hinting at something, that I believe the words of your detractors? I could have responded that way when you wrote me that you heard bad things, for why did you have to inform me of this if not to show me that you knew?[52] Whatever I hear about you that is not good "goes in one ear and out the other," and everyone who speaks to me knows they need to be careful with your honor. I . . . well, why do I need to go on, when you write me "Go ask your friends, etc."? Ah. Aren't you ashamed, my friend, to write things like this? What sin did I commit against you? [. . .] You write here, "Your letter came and it brought me down from the heavens to the earth, 'to the lower depths.'" Which letter? What did I write there?

I don't understand a thing. "You [feminine] are to blame, you and no other." For what am I to blame?

Please clarify all this for me.

You should be proud of yourself because you see deeply into the hearts and souls of human beings. If so, then one of these [applies]: Either I am not a human being at all, or there are some human beings whose inner depths you cannot reach with your glance. As for me, in brief, you see completely [. . .] you are my brotherly friend, my darling, but where are you? In person, I'd tell you everything. You would know, understand, feel everything! But will you understand [now]?

51. Cf. Ecclesiastes 1:2: "Utter futility!—said Kohelet—Utter futility! All is futile!"
52. For the bad things said about Shapiro in the wake of her separation from Rosenbaum, see Introduction, based on Letter from Joseph Khelmer to Reuven Brainin (15 June 1908), Reuven Brainin Collection, Correspondence III, Box k, Jewish Public Library Archive, Montreal.

Slavuta, 29 June 1903

Dear friend!

You've gone and I am left behind.[53]

But how am I left?

Depressed, abandoned, desolate, and sorrowful.

But none of this can describe the condition of my soul. There are many times that I have attempted to separate from you, and every time it became more and more difficult. I imagine that this is what it is like when the soul separates from the body. (Obviously, you are the soul.)[54]

Why did you come? Why do I even see you? How is it that for a few moments I manage to forget the entire world? And then afterward, I fall down as though from the heavens into vulgar, despicable reality. Why glimpse at the light only to have to walk afterward in the dark. Darkness before me and around me, for my eyes went dark the very moment the carriage transported you further and further away from me. No, darling, you do not know; you neither understand nor believe that when you are here and near me, even if you are speaking with other men (or women) as much as you like, the minute that I feel that I am near you, I change completely.

I do not even know how great my love has grown, but why speak of all of this? Perhaps I shall not love you at all?

Brainin! If I knew that in doing so, I would make things better for you—if I knew it would redound to your happiness and well-being—I would once and for all put an end to my life, so that you could forget and so that I would cease to be a stumbling block for you (for I cannot put to death my love [for you]), but what if doing this would do no good at all? Brainin, why do I love this way? I am going insane! I don't even know what I'm writing. Forgive me for writing this way. From the railway station I walked with your sister[55] to a park, and there was a corner there where I let free the tears that were

53. Shapiro mentions meeting Brainin or anticipating a meeting in her letters to him (23 June [1903]; 5 March 1909; 24 April 1909; 24 June 1910; 22–25, 27, 30 November [1913]) and in her diary entries for 15 August 1908, 1 May 1909, 2 November 1913, and 27 December 1925. Menuhah Shapiro scribbled a letter in Russian to Brainin regarding her daughter, who had just read the day's mail, which included a letter from him: "For an hour, [my daughter] was very agitated. She wished to be strong, but she couldn't. [. . .] She wept all evening and nothing [could soothe her]. I still don't know the reason for Eva's mood, and I'm writing you because I think you're her best friend. [. . .] Eva doesn't know about this. After reading this letter, please destroy it immediately" (Letter from Menuhah Shapiro to Reuven Brainin, 25 July [1903], Reuven Brainin Collection, Correspondence III, Box t, Jewish Public Library Archives, Montreal).

54. See Sherry B. Ortner's groundbreaking gender analysis, which Shapiro anticipates here in some measure, in "Is Female to Male as Nature Is to Culture?"

55. Brainin had eight siblings. Although two of his brothers are mentioned by name elsewhere in Shapiro's writings, this sister's name is not given. The friendship is notable, especially given the few references Shapiro gives to female companions altogether.

choking my throat. I could no longer stop them. You can call me a *baba* [Russian, old woman] if you'd like, but I felt as though my heart was rending. A great pain that was impossible to bear. How difficult it is, Brainin!

You want to know everything, and therefore I must write. My mother noticed, of course, but she thought about it and said that you are a *true* friend to me and so certainly it is not pleasant for me when you go away and I have no one with whom to talk and confide. I spent the night in the best and most pleasant way.

Today I received a letter with tears, requests, and pleas, to add to my pleasures.

At this very moment, 3:00, I am informing you of the results of my conversation with my mother. We spoke for about four hours. Your words worked best of all. She is ready and willing [*mukhenet umezumenet*][56] to help me with all of her wherewithal.[57] She agrees with anything I find correct and good.

Regarding money, she said that I shouldn't worry at all, as she will give me what I need. Even the jewelry, I shouldn't sell it, because whatever I need she will give me. She has agreed to do whatever I think is best. I know what to say and how to say it. I want to send you my letter now so that you won't worry. Ever since you left, everything disgusts me. Only with you do I live, and I wait only for your letters. I live for the good! I asked you to leave yesterday so that you wouldn't have any issue afterward. So how are things? I am completely yours.

[. . .] Don't forget this, and remember that my whole life depends on you. Be at peace, darling! Your daughter will not forget you even for a moment. Her love for you will not cease, even if heaven conspires against the earth. Come what may! There is no way in the world that they will drag me away from you and keep us apart. I shall remain faithful. You can trust in me and have faith.

<div style="text-align: right">

Your daughter,
Rachel[58]

</div>

30 June 1903, 2 p.m.

[. . .] I am convinced that even from you I will not receive the help and support I wish for; I realize that you are advising me to give up. You are advising me things that I can hardly believe I am hearing. You, you are saying these things: that I should return

56. A feminization of the liturgical formula uttered to signify readiness to perform a commandment.
57. Note the contrast to Puah Rakovsky, whose family opposed her self-declared separation from her husband and provided no financial support; see Rakovsky, *My Life*, 37–39.
58. Rachel is a character in Brainin's novella, "Reshimot 'oman 'ivri." See Brainin, *Ketavim nivharim*, 1: 3–116 (references to Rachel appear on pages 19–21 and 115–16). Shapiro declared that she would have liked to personify Rachel. See Letter from Shapiro to Brainin (15 November [1901]) in this part.

to Russia! I held my peace as you said that I was not capable of this, that I could not do this on my own, all the while understanding that you would wait, that you wanted to see for yourself, to have it proved, but then when the words came out that I should go back to Russia, I fell from the heavens to the earth! I have lost my only hope, my only support, the help I needed!

In spite of all this, I shall stand on the opposing side! In spite of all this, my spirit will not flag; on the contrary, I shall fight with greater strength! If you will not stand by me, if you will not heed me, then I'll do what it is that I have to do. I have decided once and for all, and I shall not return. Let me fall, plundered, but I shall not submit. No way in the world shall I return to Russia! I must study, broaden my learning, develop myself. I feel that I have enough talent within me to attain my desires, to reach my goal: to cast off all the chains that others have placed on me, come what may![59]

And here you are, counseling me to return to Russia! No, darling, I realize that I must walk my way alone, without help or support, that even you are turning your back on me, that even you will not strengthen and embolden me, and you parrot what the others say, all the rest whom I shall not listen to: that I must return to Russia, must be enslaved, must submit, as it is my fate. I must bear my burden. But now, perhaps precisely now, I shall find greater strength in myself to stand up against them and fight on my own. Now the time has come; I have suffered for six years;[60] I have waited. I cannot any longer. If only I will not listen to others and find enough strength within to walk my own way, then there will be hope for my future;[61] however, if I return this time, once again, to Russia, then I'll be lost forever. No, I'll rise up, break out, stand on the opposite side, and triumph!

<div style="text-align: right">Your friend</div>

[Slavuta], 8 October 1903

My father, my beloved! My precious, my darling!

I wrote you a postcard today, and just this minute the shoemaker brought me another letter from the fifth of this month.[62] And I hadn't even expected this sort of joy. Yesterday evening I went myself to the post office. (My mother said that I set out with

59. Similarly, Puah Rakovsky strategized to extricate herself from her ill-matched marriage; however, in contrast to Shapiro, without parental support, Rakovsky sought a formal education as a path to financial independence as well as for self-fulfillment. See Rakovsky, *My Life*, 51–52.

60. The duration of Shapiro's marriage to this point.

61. Cf. Jeremiah 31:17: "And there is hope for your future, declares the Lord" (*vayesh tikvah le'aḥaritekh*).

62. The shoemaker presumably acted as liaison for Shapiro and Brainin's correspondence; note how quickly letters were received.

great devotion. Outside it was pouring rain, thunder and lightning.) The shoemaker received your letter from the 4th of the month—and now, another letter! A choice "surprise"![63] As for me, how can I thank you, my father, my beloved, the one light, that eclipses all my praise?! Shall I thank you with all my heart? But my heart is already yours!

I am rushing, darling, to write you, because I want to answer your questions. With regard to the interview, you already know from my first letter to Geneva, and I have no information other than from Reg [Regina]. I'll be traveling to Warsaw in another ten days and will stay there at a hotel, and no one will be told that I am there. Reg and Z. [Zigmund] will arrange everything.[64] Should I make a stop at the editorial offices of *Hatsofeh* to let them know that I am in Russia? Write me!

As for my mother's attitude toward you, I don't have words enough to describe it to you. She is willing to raise you up and exalt you like God, only because you are devoted to me, you worry about me, and perhaps even love me. You don't have the slightest notion of my mother's love for me, and because of this love, she is willing to relinquish all her prior opinions and attitudes. I have read your words over and over again, and I have to tell you, truthfully, that I am annoyed with you. Why do you love your daughter? Why do you ignite this fire in my heart? Why do you awaken my soul? Why? Why? Do you know that it causes me only grief? Do you have any idea how wretched I am without you?

O, my God! Why are we so far apart? You—and I! How many stumbling blocks, how many obstacles,[65] how many thorns and thistles between us!

I need to hurry up and answer your questions because I want to send this letter yet today.

And so darling, as for your question about whether I have the wherewithal to travel abroad, I must answer that not only do I have the wherewithal, but I must and shall travel. And what after all is the question? Will you return only if you know that I have the wherewithal to travel? The only question is your second one: "When and how?" I am thinking of traveling in a few weeks. I would like to go to a place where I have acquaintances, such as your relatives in Vienna.[66] My mother would like me to be under your supervision only, but I consider this a bit dangerous. I told my mother that all I would like is for you to meet me, arrange everything, and find a place for me to live and *ustroit' menia* [Russian, settle me in], and I think that indeed this is how it must be; that

63. Shapiro transliterated the English word surprise into Hebrew characters.
64. Regina is Shapiro's sister-in-law; Z. is likely Brainin's brother Zigmund.
65. In her preface to *A Collection of Sketches,* Shapiro uses similar language to describe impediments before female Hebrew writers; see Part I.
66. Brainin's brother Zigmund lived in Vienna; see the postscript to the letter from Shapiro to Brainin (15 November 1907) in this part.

is, you'll arrange everything and then return to where they order you to go. I think this way only because I understand the spirit that prevails between the lines of your letters. I understand from your words, "If I also travel from Geneva and wander to the cities or other places" and "When and how are *you* planning to travel?" that it's as though you have no "connection" to any of this. I understand from these words . . . a great deal. But in any case, I will indeed travel abroad. And it's possible that I will also study as part of a program that will allow me to be admitted later to a university.

Perhaps you will be so kind as to tell me, finally, without hiding or denying anything what your opinions are about my coming and being there?

And perhaps you will be so kind as to explain and reveal to me which "other cities and places you plan to wander to," so that I'll know from whence to distance myself?

Perhaps you can reveal to me *your* thoughts and *plani* [Russian, plans]?

I beg your forgiveness for asking things that pertain only to you. Perhaps I have no right to ask, but still . . .

Beloved father! Forgive me for the difficult things that I say out of the bitterness of my spirit, and answer my questions properly. The second I write something bitter or ironic, I regret it. Believe me that I am not that mean-spirited, but I like to torment myself by picking at my own wounds. I am laughing only at myself and mocking only your daughter! If you only knew how deep, how great and painful are my wounds. If only you knew . . . But why should you know?

My father, my father! Why did I ever come to know you? And what's the point of my life now without you? Please, do not try to console me!

Just do not rob me of my only joy: your letters! Not those where you raise me up but rather those where you speak about your love, what greatness, what poetry, what strength, what grace! I don't exaggerate when I say that even if these words were not written to me, I would read them with the same pleasure with which I read them now. Your love is lovely in and of itself. And how strong, how great, how lofty and exalted is your love . . . in your letters!

Only according to the capacity to love can a person be judged.

I cannot write you more at this time.

<div style="text-align:right">

Your daughter who loves you beyond the regular measure,

Rachel[67]

</div>

67. Note once again the signature of Rachel, a character from Brainin's novella "Reshimot 'oman 'ivri."

Slavuta, 11 October 1903

My Father!

I am marshaling all of my strength to stop from writing you every time I wish to. Were I not able to restrain myself, I would be writing you long scrolls each and every day.

My father! The mere memory of you encourages me. How, my father?

You're all I have in the whole world!

Without you I have nothing.

I'm reminded of you, my father, and my heart beats, my longings for you intensify, and the pain . . . grows continuously! Until when?

Everything aside from that is nothing.[68] Disappointment and futile burdens, except for that one great strong and deep love that surges within me!

And why should we deceive ourselves? Why should we close our eyes from seeing that this alone sustains our spirits? And without it, we are dead bodies!

Forgive me for not being precise in my language and for using the plural form here.

I am telling you once again that only this love can sustain me! It lifts me, strengthens me, and encourages me!

Without it, that is, without you, I have nothing.

Let me add one more thing and say, that even here, in my parents' house, where I am surrounded by people who love, exalt, and admire me, I miss you. Without you I have nothing!

Only with you is everything good and beautiful.

12 October [continuation of previous letter]

Beloved Father!

Today I received your letter of the 7th of this month. As I said yesterday in my letter, it was lying there, and they passed it on to the shoemaker. Your letter from the 6th was received only yesterday, and today I received this second one.

Don't think or worry about the letters. They are being delivered properly, don't you see? If only you would write every day and send the letters you want to send, I'd receive all that you write and send. I'll tell you the truth: I don't believe my eyes—are you actually writing me so often? I was so afraid of those silences of yours to which I had become so accustomed. And now such joy! Thank you with all my heart, my love, many thanks to you! If only you'll continue behaving this way going forward. Write whatever you can, when you can. Only, write! [. . .]

68. Cf. Ecclesiastes 1:2.

13 October [continuation of previous letter]

Darling! Yesterday I could not write you any more, and therefore, I did not send my letter. Now I sit, closed off in my room, and am writing you. After all, it's a holiday today and I am writing, in my parents' house![69]

And so, darling, I return to you. I'm repeating now what I wrote yesterday: as for your life with the Policeman [Brainin's wife]. Tell me whether Satan, that is to say, I, were not dancing between the two of you, whether he would change his attitude and behavior toward you. I promise you this because I worry only about you and seek only your well-being.

Darling! I feel my freedom in every vessel of my soul,[70] each and every minute. Imagine this: I awake from my sleep and leave my room, and I no longer see that face, those eyes. I sit and eat, and I no longer see that same mouth admonishing me to eat, drink, and the like. Aha! Let the heavens rejoice and the earth be glad,[71] and let all the creatures of the world share in my joy! If I were able to sing, right now I would write the greatest, strongest liberation song. My love! I went out from slavery to redemption, from the burden of exile to freedom, from darkness to, well, darkness, from sorrow to sorrow, because without you I have no light and no happiness.

If my life were as long as Methuselah's, I'd trade it for a minute together with you—I wouldn't survive even half my life being far from you.

My father! My life here is filled with boredom. I am not *otbykla* [Russian, accustomed to] this kind of life, and I'm incapable of becoming used to it. I cannot bear it any longer.

I wrote you, darling, that from the 16th of this month you should write me in Warsaw at the same address that you are writing here, simply Warsaw, Regular Delivery, and nothing more. I am going there on Sunday. I don't know right now how long I'll stay there, but certainly no more than a few days because I will need to be cooped up in my room, going outside only in stealth, lest anyone see me or recognize me.

Right now, beloved father, I cannot write any more. Please write me everyday and tell me *everything*.

<div style="text-align: right;">

Your loving daughter,
Rachel[72]

</div>

70. Diary entries from this period contain similar sentiments.

71. Cf. Psalms 96:11.

72. Note the signature of "Rachel" again.

Slavuta, 17 October 1903

My father!

[. . .] You are righteous indeed in all your ways, and I have no doubt even for a moment that you have no desire or intention to bring ruin upon me or to violate my honor unnecessarily in ways that do not benefit even yourself. Nevertheless, you cannot demand that I swear in writing that I won't blame you, heaven forbid, and won't come to you with complaints or that sort of thing, because I do not believe that I will bring ruin upon myself through my actions. Whatever the case, your hands will be clean. I myself wanted to separate. I myself wanted to go abroad. "To live and be with you"—I won't even think about that. I won't even think of living in the same city as you. I won't hope for it and thus will not harm your Policeman [Brainin's wife] or arouse his wrath. You bear no responsibility, and thus you can answer all my questions. I can even offer you a bit of help and support, without your seeking excessive justification, if only you were not so afraid.

But really, what need have we for all of this? I see that we cannot understand one another from afar. Only when we see each other will we understand: you, my emotional situation; and myself, your actions.

I have only one more thing to tell you. You blame me that in my anger I paint you in my imagination as an "awesome and terrible deity" and so on and so forth, the point being that I am critical of your deeds and that what I see is not the way you might have wanted it to be described, every deed and every thought like this, from your side—all this pains my heart. It is true that in my mind I imagine you as a great man, exalted and supreme—a great man who exceeds others in his ideas, thoughts, feelings, expectations, and in his ability to comprehend all that he finds around him. Not an "awesome terrible deity," rather an exalted, supreme god. And this idea, this picture, can admit no blemish, no *reproche* [French, reproach]. I know that this god is great, holy, exalted and that no trace of —— can adulterate his purity. Only a god of this sort can fill my heart, and strengthen my position during this time when I am undergoing such difficult torments. Therefore you must understand why I am pained even by the slightest suspicion on your part.

I need to know what I am suffering for, and I want to maintain this ideal in my heart, in all its greatness, purity, and loftiness.

More than that, darling, you are teaching *me* a chapter from the Laws of Patience. It seems to be that I have been graced with an extra measure of this attribute, even more than the authentic, true Hebrews.[73]

I want to tell you everything, even though it is somewhat difficult for me.

With my mother, everything is old and new at the same time. And I needed to

73. A probable reference to the Judeans awaiting their return from Babylonian exile.

promise her that I'd stay here through the summer. And I'm thinking I'll do this, although it's hard for me to imagine not seeing my son for so long.

If only you knew, my father, all my troubles and all the sufferings of my heart and soul, all my pains and the wounds—then you wouldn't judge or blame me.

May I tell your brother [Zigmund] in advance that I am coming to Vienna?

My passport will be under a different name, completely new. And when it comes, there'll be another name on top of the many other names . . . who?[74]

And with all this, I so love my father; with all my soul am I given over to him, with all my heart and all my soul.

<div style="text-align: right">Your daughter</div>

22 November 1903

My father!

I received your letter yesterday—your critique of my sketch.[75] If I should want to thank you here in writing, I would not manage to do so, even if I were to write for an entire day. This time you fulfilled my wishes and exceeded my expectations. I see here much more than I had hoped for. Since we first met, you have not written such a detailed critique. Thank you, darling!

But one thing upsets me. You're saying that you cannot free yourself from the influence of my personality, and when reading my sketch, you are assuming, etc. If so, darling, I fear that had you been able to "liberate yourself," you might have offered a much sterner judgment; I fear that you have sweetened the verdict.

And I want to hear from you not only about the deficiencies of my sketch but also of my person. And I don't have to tell you that you would insult me were you to apologize for telling me the truth, that is, for telling me what you think.

I'll second your judgment even this time and will quarrel with you only about one point. I do not know whether I have ever read the poem "Freedom," which you refer to; in any case, I do not remember it. However, if you have decided, correctly, that real tragedy comes only as a result of inner necessity and not as a result of external factors—now that you've told me about this bird of M. M. Hurvitz "who was placed in a narrow cage"—don't we need to acknowledge that, there, tragedy comes not only because of inner necessity? They came—whoever it was who came—and placed the bird in a cage. Had they not placed her there, she would have been able to fly. It was all because of external factors. *And for this reason*, she forgot how to fly—only as a result of an external factor. Had they never placed her in a cage, she'd have been able to fly. Tragedies do

74. Shapiro's meaning is unclear here; perhaps she means that she reverted to her maiden name, having separated from her husband.
75. Reference to "Clipped of Wings." See Part I.

come, therefore, as a result of external reasons. And it would have been the same thing had her wings been broken or whole. Either way, she could not have flown.

Your view that even in the narrow closed cage she can be free, if etc.—that may be so; however, if her physical wings are broken, in any case, the bird cannot fly. In order to reach her destination, up in the sky, the wings of the imagination will do her no good. It may very well be that she can create in her mind the sky, the expanse, the height, the lofty freedom, but this will only deepen, expand, and intensify her longings for the real sky, the splendor, the light, the real freedom, that she sees as so beautiful in her imagination.

Another thing: I did not intend in this sketch to describe my own life. This I must categorically deny. I hadn't wanted to; in fact, it never dawned on me to describe or portray my life story. And if you hear my own personal song in the midst of all the rest, that's not my fault.

Therefore there is no reason for what you suspect, that is, that I see myself as lacking or clipped of wings. You do not need to console me with regard to my freedom and hopes. There is no connection between my attitude about these things, that is, about my personal freedom and hopes, and my sketch. About this there is no doubt.

Forgive me, please, for refuting and responding to these few things. I receive your verdict with love. Would that you would always indulge me and respond to me this way, showing me what I lack and telling me the truth!

You bestowed upon me special attention, and I very much want to listen to your advice with respect to the paring down of language. And the first person with whom I would attempt to speak in this way would obviously be—you. I shall do my best to be sparing with my words even in my letters to you.

Indeed, I can even manage to say something in two words. For example, I can say to you: love forever. Darling, you be the sage who understands the clue! Who? Whom? How much and until when? (You'll certainly not know the latter.) Is it even possible to say and explain such a thing in two or, in fact, many words? It's almost better to say nothing. [...]

Vienna, 20 April 1904, Midnight

After making a Shehecheyanu [blessing said upon arrival of an anticipated occasion], I read your letter, which they just brought me. So finally you remembered your forgotten, abandoned daughter! What or who resurrected her in your memory? Who brought about this transformation? [...]

Thirty days I didn't write. You didn't know what was with me, if I was still here, what I was doing, what my life was like now that I am far from home in a strange place. You had no idea if I was well, if that creature whom you hastened to promise that life

without her was impossible for you. [. . .]

And you, you are righteous and upright all your days! You shall be happy and you shall prosper![76] But let us look at your righteousness and examine your uprightness: to promise that which is forever impossible to fulfill, to speak all the time about dreams and imaginings, transformations, internal and external changes—but to remain *beim alten* [Yiddish, exactly as you were]. To stop writing and to leave one's "beloved" on her own and in a dire emotional state, just as she is searching for answers to urgent questions—does this qualify as great uprightness?!

You can call me whatever you like. You can say that *I* betrayed *you* (!), but I will repeat my words that "one cannot worship two gods." Enough of this game. I have told you a hundred times that I will not be your second god when you find *otpusk'* [Russian, time off] or when you manage to steal away, taking advantage of your vacation only to return in the end to that which is primary. It's impossible to be a thief and at the same time a "respected householder." If it's possible for you to stay the way you were, to be a "respected householder," or if reasons dictate that you cannot be otherwise, I have no control over that. I demand nothing of you, only for you to recognize that I am incapable of being the "other woman." It is difficult for me to say these things, but I find that I must say this when you go about justifying your behavior with respect to me and demanding *of me* that which I cannot fulfill.

That which was possible five years ago, that is, staying in the same situation, is *neprost* [Russian, not easy] to forgive now. If nevertheless you want to continue this way, even though I have repeatedly told you that I will never agree to this, I will have to oppose you with all my strength, that is, to tell you plain and simple: Stay where you are, with —— if you've proved that you can, and why muddle the thoughts of your little daughter? If you are a captive in chains, you are not permitted to dream and imagine; but if you dream despite this, you are not permitted to promise the fulfillment of those dreams to one who would believe in you, that when you behave in a completely different way . . . I must use hints, for reasons that are well-known, but you can answer me in a clear way.

I will not finish what I am saying because I want to send this letter right away and tell you that the name of our acquaintance is *Grosser* [German, large one][77] and that you need to write her immediately all that you need to say. Certainly she will write then as well. But be so good as to erase the name of our acquaintance if you do not finish the entire letter. Are you traveling now to your children? How are you and how is your wife? There is much that I have to write after a month of silence, many stifled ideas and thoughts—but not this time.

Your daughter

76. Cf. Psalms 128:2.
77. An additional assumed name for Shapiro.

[P.S.] Much news has transpired in my house, but I cannot tell you all of this at once. Tell me everything that is happening to you.

Vienna, 5 June 1904

Esteemed Sir!

I wanted to thank you, sir, for being so kind as to remember me with a letter (after eight days) in response to my previous letters. Obviously, I have no right to ask or demand anything else, but tell me in all honesty: How can I call you "my father"? Would that you related to me even slightly in the way one does to a daughter or a close relative, because then you would surely not abandon me and leave me on my own at a time when clearly you recognize from my letters my true situation; in that case, the telegrams would surely go back and forth, with letters twice a day, questions and answers meant to calm, to apprise, as is customary; but since it is not that way, and "daughter" is just a name for appearances—in that case, maybe it's better, in your estimation, to write only eight days later and then to announce: I have come here. And the daughter already knows that you're "here," that on the very day that you sent your letter from Munich you must have left there. But I have no desire to argue. It's enough for me to see things as they are, such that I am able to make decisions on that basis, according to my own determination. [. . .] And if in any case I still write, my attitude from now on will be different, completely different! [. . .]

With feelings of friendship—

Vienna, 6 June 1904 [Postcard]

To My Friend, Comrade, and Companion, Mr. Reuven Brainin!

I have not yet dared call you this [i.e., my (boy)friend] until now. I have not permitted myself to do so until now. I now have permission, which you granted me by your recognizing me as worthy to receive your picture as a (girl)friend. Are you expecting to receive my thanks for this? No—despite all the compliments. Despite all I have been hearing, my head has not yet swelled. I am still very much aware of my limitations at this moment. I shall not even attempt to release even the faintest sound from my heart. Even before the fact, I know that everything I write will only bring me to despair on account of my limited powers. I don't know what makes me happier: the gift itself or the fact that I have been pronounced fit for it and recognized as worthy of that which I longed for so mightily. Now you yourself have sent me this precious gift and thus have given me the sign. Today is a holiday for me, a veritable ḥag ha'aviv! [literally, spring holiday; a name for Passover] In my imagination I have truly drawn for myself

pictures such as these: Here you are suddenly coming to me, here you are astounding me with your arrival. I saw you for a moment—and the image fleeted like a dream. Now, truly, I am seeing only your picture. But we have established before us a precedent and thus have grown accustomed to learning how to concentrate and live "in spirit," which is, for the two of us, the most precious life of all. Therefore I bequeath and pass on to the spirit of R. Brainin the spirit of Eim Kol Hai [Mother of all living].

Vienna to Marienbad, 10 June 1904 [Postcard]

My Friend!

I must tell you the truth that the more I look at your picture, the more defects I find in it (which are not present in the original). Obviously this has no "relevance" to the value and importance it [the picture] has in my eyes—you could send me no better gift and I am delighted with it "more than all the fortune in the world." I do not ordinarily use this sort of phrase since I am careful with my language, so as not to let a single lie escape my lips, and anyway, you know that I am not capable of delighting so much over fortunes. I will thus tell you simply that I am as happy with this gift as I can be, given that it reminds me at every moment of the soul, spirit, and person who is most precious to me in the world. You and my son—the two of you are everything to me! And so the defects that I have found and that have outraged me from the first moment are that you [appear] here as an older gentleman. Have you aged that much during these months that I have not seen you? It's possible to believe that you are in your 50s here at least when you are [actually] in your 40s. And the smile on your lips is not natural. I explain this to myself only on the basis of your having been with your friend [i.e., his wife] for fifteen years! She has that sarcastic smile of yours. But why didn't I see it on your face until now? Maybe only recently you acquired it. Your smile was always filled with good-heartedness. I just now received your three letters from yesterday. Your advice: that I not harbor a love in my heart that has yet to be born, etc.—it's entirely unnecessary. If I could do that, I might not listen to your advice at all, but, to my great chagrin! I do not wish to argue with you. Good, good, you did good in going to Marienbad! But I do not like the crooked paths. I have studied the logic of John Stuart Mill[78] and have read the essays of Wundt,[79] but even so I cannot understand the logic of *I love my children,*

78. John Stuart Mill (1806–1873) was an influential philosopher of utilitarianism whose overarching aim was to develop a positive view of the universe and the place of humans in it—one that contributes to the progress of human knowledge, individual freedom, and human well-being. Mill campaigned strongly for women's rights, women's suffrage, and equal access to education for women. His essay "The Subjection of Women" (1869) is an enduring defense of gender equality.
79. Wilhelm Maximilian Wundt (1832–1920) was a German physician, psychologist, physiologist, and philosopher.

therefore I travel with my wife. Of course, you will have a great many things to answer for and to refute, but I do not wish to argue any further. If in Marienbad you have your ray of tranquility and you can work and rest there, I do not oppose that at all. But then you don't have to tell me all of this, as though I had lost my mind in suggesting previously that you go to Marienbad. I told you a hundred and one times before that you ought to go to Marienbad. A hundred and one times I told you that if this is the case . . .

Vienna to Marienbad, 10 June 1904 [second postcard that day]

[. . .] Why do you need to justify your not coming to Vienna? After all, both of us know the real reason you did not come. I did not even ask you to come, and so why do you seek excuses that never were and never existed? You were suddenly frightened on account of my mother! Isn't this because you acknowledge yourself the extent of your own misdeeds and therefore you must always seek out crooked paths to justify and explain the "contradictions"? This is specific to your relationship with me. It is not at all correct, in that with me you must always acknowledge the truth. I don't know why you are angry with me for saying goodbye! Obviously, it must be so when I leave. In the summer "season" you are in Marienbad (for a few weeks as you say), and in the winter season you will be in Maren in some other cure location; and if I go abroad once again (which is highly unlikely), I have no desire whatsoever to "steal my happiness again"; therefore I must tell you: goodbye, since I don't expect us to see each other.

I did not write you about myself because your brother made a *lebengrosse* [German, life-size] bust of me, and it is standing in my room (in gypsum) [material often used in plaster] for some months because I believed you when you said that it was impossible for us not to see each other before I returned to Russia, and I wanted to surprise [the English word *surprise* is transliterated into Hebrew characters] you by showing it to you. However, now I shall be bringing it to Russia and you will not see it, which troubles me greatly. I cannot go on without saying this to you. Why, why did you not come from Munich to Vienna if only for a few days? Would I have stopped you from going to "the ray of tranquility" [see previous postcard]? A sigh bursts from my heart despite my desire. Please return my sketch immediately.

<div style="text-align: right">

Your pained friend

</div>

Warsaw, 20 June 1904

My Friend!

On Thursday the 16th of this month I came to Warsaw. No one was waiting for me here. The letter I wrote to Regina about my coming was held up. I didn't sleep the entire

night and didn't put a thing in my mouth all day. But I didn't want to stay in Warsaw even for a minute. It was 6:00 when I arrived, and immediately I went to the other station to travel to Otwock.[80]

And guess who I met there? The youth! [i.e., Shapiro's husband, Limel Rosenbaum].

My uncle Moshe Shapiro and his wife and daughter, whom you saw there, still live in Otwock (I am being hosted by them), and the young one brought me my son right away. What can I tell you about how lovely, pleasant, and intelligent my son is, how he is studying, how he explains and understands everything, how eloquently he speaks (he speaks only Polish), and how much he loves me. I've gone nearly insane from how intoxicatingly I love him. He told me that even if I had gone away for an entire year, or for many years, he would still know that I love him, because he feels this and knows that it could be no other way, that it's impossible for me not to love him, my only child. From then on he came to me twice a day for only a few hours, but only accompanied by his father. You can only imagine how pleasant this is for me. The boy asks questions and makes an effort to connect. For him too it must be painful, but he's afraid to send my son to me for fear that I'll take him away to Sl. [Slavuta]. Without him, no way. I don't know why he agrees to come twice a day (before he leaves from and comes back to Warsaw) and bring me my son: Perhaps because he still maintains hope. Or because his good temper doesn't allow him to prevent me from seeing my son—in any case, it's all very tormenting. [. . .]

24 June 1904, Otwock

My friend!

Yesterday I returned here. My son was happy about my coming, but he won't be coming with me to Sl. [Slavuta]. He only comes to me accompanied by his father. We barely talk to one another, but he makes clear to me that his entire life is a burden and he must suffer it all for the boy's sake. All of this is very difficult for me. The boy says to me, "Father was always so good to Mother, but Mother doesn't want to listen to him when he asks for us to be together. She doesn't want to speak to Father, which means that Father is kinder." And other things of this sort. [His father] stands by and listens. I explain to the boy how much I love him, but he is only a 6-year-old boy, and of course, he asks childish questions and decides that "If my mother really loved 'us,' then she would stay with us." There is no way that he will permit me to travel with the boy to Sl., and repeatedly tells the boy to say that he, my son, doesn't want to travel there, because he cannot be apart from his father. I'll stay here until Thursday the 30th of this month, and then I'll go to Sl.

80. The Rosenbaum family kept a home in Otwock, outside Warsaw.

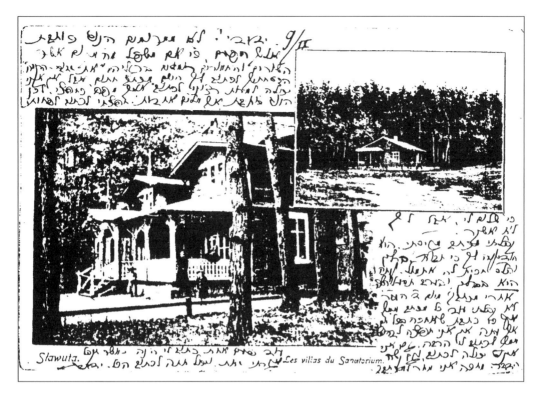

Postcard, Shapiro to Brainin with images of Slavuta. (Jewish Public Library Archives, Montreal)

26 June [continuation of previous letter]

I cannot tell you how difficult it is to be in my uncle's house. I'm sick and tired of their ways and habits, their stupid questions and comments. I want already to be at home, my parents' home, but you can understand how difficult it is for me to separate from my son, and it is only for his sake that I'll be staying here until Thursday.

More and more I recognize how connected and attached you and I are to one another. We become only more and more attached and united (in spirit, of course) at all times and in all situations, and therefore I know that there is nothing that will separate us, that we, the two of us, must always turn to one another: partnering, understanding, connecting. Isn't it so? [. . .]

Slavuta, 1 July 1904

My Friend!

I came here yesterday morning, to my parents' house. Once again, I have separated from my son and have come to stay here. Everyone is happy with me, especially, of course, my mother. My sister-in-law T. [Therese Shapiro] is not here; my brother

[Pinhas] doesn't want her to return here. They're going to settle where her parents live [Vienna], and my brother will come from time to time. My third brother finished his studies at the Gymnasium in Zhitomir but did not get the diploma as he had hoped.

You should write me at the known address, and then you can write everything, everything. You no longer need to fear. No one will read or see the letters, because they know that I receive letters from abroad, not just from you.

For me now entirely different kinds of *martyres* [French, sufferings] have begun, and because you are, in any case, "a friend," I want to reveal all of it to you immediately, so that perhaps you can advise me. This is the thing: They are all making a big effort to show and convince me that there is no sense, hope, and point to my behavior, whether I settle in Vienna or in Sl. [Slavuta], since "the youth" is now prepared to acquiesce to all the conditions, provided that I continue to be called R. [Rosenbaum]. And why wouldn't it be good for me to agree to all these conditions, that we stay husband and wife (at least for appearance's sake—this too, he will agree to) and I could do whatever I wanted to as before; I could travel abroad to study, and he'd even come and visit me now and again, and I could live and act as I wished, that sort of thing. And these are the benefits that would ensue: My situation would be strong and secure, I'd be with and see my son often, I could use my name and would not need to masquerade, I'd be respectable in all quarters or wherever I lived, and I would not need to worry about means of support, even as it pertained to my studies. And what would I lose? These are the arguments and the conditions according to which they want to maintain a connection between the youth and me. And of course, they heap on all kinds of things pertaining to my boy, but I am shortening things, as I rely upon you to understand on your own that which is superfluous. I only ask you (Do you know what you are to me in all of this?!): What would you say to all these suggestions? How might you reply? In other words, how would you advise me to reply?

I'm asking you to think a bit, *sich iberlegen* [Yiddish, think carefully] and then tell me the results. Surely, you would acknowledge that this is a very important issue, and I must know *your opinion*!! I must add one more thing: Do not judge this according to your own experience. In your making certain compromises, between you and your friend, in order . . . in order to remain together and see one another and in order to be seen as respectable in the eyes of others, I cannot explain all of this to you, but you know "what I hint at in my words."

I'm sending you my sketch, which you corrected back in Vienna, so that you can read it again and so that you can tell me in your reply where I should send it. Perhaps to *Hashiloah*?

Tell me everything that I have asked you, and tell me the truth about your current situation. Write me at the known address [. . .]. You can write *everything*, without any hesitation. The shoemaker of old is, thank God, still alive and well and forever loyal. Regina and my brother who is here (I showed it only to them) both liked your picture. [. . .]

I am what I was: your familiar friend

[Fall] 1904

My Friend!

You finally remembered me. To what occurrence do I owe my thanks for this? Perhaps the beginning of the New Year? If so, blessed will it be in its arrival!

I'm happy to hear a joyful, jovial "tone" in your words. I am so stuck in my own troubles and mourning, such that not many happy things make much of an impression on me. If those who are close to my heart are happy and joyous, however, that's enough for me! For me there is neither remedy nor cure. Your words about the offer of —— are strange and astonishing to me. That's not what I asked, and your answer was entirely superfluous. I am not accustomed to asking about that which pertains to my own heart, and to my great chagrin, I do not have the power to change (teach me if you can!). If I asked *you* about this, it was not because I have doubts (is it indeed you, you who have known me since way back when?!) but for another reason entirely. Whatever the case, you didn't understand me this time, and I do not wish to elaborate upon this. You distressed me with your reply. Don't say any more about this. I suspect that you would advise me without shame. But I shan't go on.

My friend, do you comprehend the depth of my great pain and brokenness?

You shouldn't know from such great pain, such trouble, and such despair as mine.

Don't turn to me! I am losing and all is lost to me.

With respect to my brother [Moshe], you also erred, my friend. I wasn't asking you about this. I never mentioned the word Germany. I asked you only where life would be best and most comfortable for him to live in *Switzerland*. Which city would be best for him to do his preparatory studies, where is life more interesting, and where would he have a better chance of being accepted at the Polytechnical Institute after taking exams there? Now I have altogether other questions that demand *immediate* answers. My brother has already decided to go to Zurich, and, since it frightens me to be by myself in Vienna during the coming winter, I have just about made up my mind to join him there, even though Z. [Zurich] doesn't thrill me at all. There are additional reasons to convince me of this: protection from the Policeman [i.e., Brainin's wife] (is she as miserable as I am?), my mother's request, and so forth and so on. But I didn't want to make a final decision without your opinion, and so I am asking you to answer me *immediately* with your opinion on this. Will life be good for me there? Will I be able to study there? Will there be a hope for me to develop my "literary talents" in this place? Does one have to travel there by way of Vienna or Berlin, after being in Warsaw? (Right after the holiday I am going to Warsaw.) I am also asking whether you will be traveling from G. [Geneva] to Berlin or to another place, and where will you be during the winter? Will the Policeman stay in G. or go somewhere else or accompany you wherever you go? I am asking you in the hope that you will not keep anything from me and tell

me everything as it is. What is your current situation and relationship? The dove now despises the Policeman and tells me that the Policeman did despicable things this past summer. Has he ceased firing his arrows of wrath against his sister-in-law, or does he continue to chase and humiliate her? Even now, when all is according to his every whim and desire, he still doesn't relax and isn't at ease?

I'm sending blessings for your time together with your beloved children and feel your joy. Enjoy, dear friend; kiss them for me, and tell me how they are, about their studies and their circumstances.

Please answer all my questions promptly, as we can only travel, whether to Z. or to V. [Vienna] (that is, I to V. and my brother to Z.) until the end of next month, and I need to know everything immediately. Please answer *all* of my questions.

Why didn't you return my sketch?

I'm asking you to destroy this letter and to let me know if, because you're with the Policeman, you cannot. [. . .]

As for that which pertains to me, my inner and outer world—if I can, I'll write about that when I receive your letter. It's impossible for me to do so now. Please do as I ask in this letter (destroy my letter right away, see I have asked you!) and let me know about everything.

Your friend

23 June 1905

My beloved Grandfather!

Just now, I received your letter from Warsaw. My eyes lit up (incidentally, every *blesk'* [Russian, glimmer] of light in my eyes is in your hands alone!). I was with you in all your wanderings and travails until the Holy One, Blessed be He, took you out from the sites of persecution and brought you peacefully to the room where we were together three weeks ago. Here I recoiled a bit and withdrew; it was dangerous to accompany you any further. Why did you keep emphasizing the word: by yourself?[81] It was your own request, darling! The winds of truthfulness blow upon me from your letters, and I accept it with love! Blessed is it in its coming. I will reciprocate face to face.[82] When will I be able to bless you in your coming? [. . .] Today my brother is coming here, and he'll be staying here through next week so you will see him. I saw Ben Avigdor today very briefly. He recognized me as I passed, distracted as I was with my brother's arrival.

Darling! I'm sending *you* "The Old Maid" so that you can submit it (not the maid herself, rather the story about her) to the journal *Hazeman*,[83] so that you can earn a

81. Cf. Exodus 21:3: "If [the slave] came single [*begapo*, literally "by himself"], he should leave single."
82. Cf. Exodus 33:11: "The Lord would speak to Moses face to face, as one man speaks to another."
83. "Old Maid" eventually appeared in *Ha'olam* in 1908 and is included in *A Collection of Sketches* (see Part I).

great deal of money from it, as befits an old maid like her.

I'm writing you in a hurry, because I want to send you this, so that you can receive it and submit it before you leave there and to tell you again that I am waiting for you with great longing.

Your friend.

Come!

Bern, 2 December 1905

Darling!

I wanted to write a lot this time, at least a little of what I have to tell you. And to tell you, as you know, that each time I have more and more. And my love, if you don't know this already, develops and expands and grows unto the heavens (the heavens of B. [Brainin]) and requires words that aren't in my Hebrew vocabulary at all. How shall I explain, for instance, my powerful longings, when I yearn for you with all of my heart and all my soul, when I feel your closeness, see you, speak with you, and feel as though we are together—and my heart aches so, longs so. How can I live without you, B., if I have already given you my whole soul, that which is the best of me?

Others are so small, so stupid, so lowly, in everything only intrigue. Willy-nilly, the idea arises that one ought to trust no man. But you, darling, are so different from all the others. You are that which is good in man, isn't it so? Tell me, my darling, that I should put all my trust in you, tell me! Regarding your letter from yesterday, I can say only that it seems I never loved you, was never given over to you with my complete soul, the way I was during our last encounter. Reuven, why did you take my soul from me? [. . .]

You wanted a word about what's happening with me. And so I'll tell you. The impressions of the last few weeks in Russia have not faded. All the changes, events, and upheavals still live on within me.[84] The perennial awakening—and suddenly a new land, new skies. A quiet land, quiet skies, quiet people, peace.

I feel as though I have been sent to a hospital to calm down, to quiet the heart, a place where everything is done carefully, in peace.

But you also wanted to know about my physical and spiritual life. These are lacking a great deal. (Don't call me here by my given name.[85]) And this is the thing: I have decided to prepare myself for the entrance examinations in order to be admitted as a student at the university. Once I have a passport under the name S. [Shapiro], and already by summer, I'll be able to take the tests. They'll count this semester, because

84. The Russian Revolution of 1905 initially raised expectations that Nicholas II would transform his autocracy into a constitutional monarchy, especially in light of the October Manifesto that promised civil liberties and popular elections.

85. By this Shapiro means that "Hava" (life) would be a misnomer for her present state of being.

I am enrolled already as a free student.[86] But it may very well be that I'll manage by February to take the exams, and of course, for this I will have to work very hard. I need to know French and German very well, world history *Weltgeschichte*; I'm already studying the history of Switzerland in depth, geography, and Latin. With regard to the latter, I spoke with the professor and he suggested that I get myself a private tutor (in addition to coming to his lectures at the university) because I won't manage otherwise to catch up to what they have covered in six weeks of study. If I can find someone who will teach me without pay, good; but if not, I'll study on my own. And so, you know I will not be wasting my time. In fact, I have a lot to do, perhaps too much. But it's good for me that way; perhaps if I immerse myself in my studies, they will make me forget the terrible pains and longings. Is that possible? [. . .]

Bern, 17 January 1906

Darling! I received your letter yesterday and I wanted to answer you early with a short letter, because I don't have enough time to write a great deal; however, I consoled myself and said: I'll start writing a letter (a real one! but one that doesn't say much really) and perhaps over a few days I'll manage to finish it. In any case, I began at a good time—that is, I have come to tell you that I am peaceful and content. And what peace! If you would only know, darling, how much life I feel within me, cheerfulness, freedom, the joy and happiness of life! Everything within me is singing a song.[87] I do not know the reason for this situation, but this I do know: There is an ocean of life within me, life that I have not yet lived but whose beauty I sense.

And yet there is that which clouds over and pains: *die alte geschichte* [Yiddish, the old story]. I don't have that one soul close to me, and that is enough to darken everything within me.

But I cannot elaborate now on these matters, so I'll say it all in short form: It is precisely when I am cheerful, when joy and life rise up within me, that I feel even more

86. "Free student" here means auditor, that is, one who has not matriculated at the university but is permitted to attend lectures nonetheless. Preparation for university entry exams presented a hurdle for Shapiro, who had not studied at a girls' school or gymnasium. Thus she studied assiduously for nearly a year to pass the exams. She was one of many Jewish women and men who, when new quotas were introduced for Jews and new restrictions were imposed on the education of women in Russia in general, decided to go to Switzerland (and later Germany and Austria) in order to attend university. In 1867 the University of Zurich became the first university in Central Europe to admit women as matriculated students; Bern and Geneva followed soon thereafter. See Friedenreich, *Female, Jewish, Educated*; and Balin, "Call to Serve."

87. Common rabbinic and liturgical expression connoting joy through song (*'omer shirah*) (e.g., Babylonian Talmud, *Megillah* 10a, where God complains about the Israelites' joyful reaction to the drowning of the Egyptians).

acutely how beloved that soul is to me, *above* all, and how without it, life is so empty and worthless.

19 January, after midnight [continuation of previous letter]

Despite my desire, I cannot manage to find even a few minutes to write, and so I write you on one foot[88] to show you that I am not behaving like you, that even when every minute is precious to me, nevertheless I write you.

And so, darling, I am informing you that I am making great strides with my studies; while I am not yet satisfied, my professor praises me. But as to whether I will manage to complete my studies for the exams, I am extremely doubtful.

In any case, the prayers that you say for me, darling, are completely unnecessary. First, that "forlorn one" (?) whom you speak about is breaking neither her head nor her teeth, the proof being that my head and teeth are strong and intact here with me; and second, I do not believe in the benefits of prayers by a *tzaddik* [Hebrew, righteous man] of your kind, who is not content with what he has and thinks these strange thoughts.

All that pertains to you. But the crux of the matter is that it cannot hurt a person to learn an additional language, nor to enrich his knowledge in general, nor to continue his studies in languages that he already knows. But what does any of this have to do with my relationship with you? I perceive something of a change in . . . (I don't know how to say this, but it seems to me that it has weakened. [. . .] Is it on account of the Latin?) In any case, I would ask you not to call me "my friend." I detest it already. You'd do well to tell your friend Mr. Federmann[89] that in that letter which he addressed to H. he might as well spell out the full name [i.e., Hava]. If you have any hesitation that one shouldn't touch the other, you can keep them at a certain distance apart. Another thing, darling, I must admit and confess that while you are indeed a righteous man and that I am your maidservant, I am not as happy with my lot as you are. To explain: I, for example, cannot make my peace with the great injustice—with her being here and he being there. And you find your satisfaction in lines of print, written in black and white. That is the major difference between us!

I, for one, dream of traveling to Italy, to Milan, in time for the exhibition in April,[90] and specifically together with ——. And other such thoughts and aspirations, and

88. Cf. Babylonian Talmud, *Shabbat* 31a: Hillel is asked by a prospective convert to teach all of Jewish tradition while he stands on one foot.

89. Mr. Federmann is a pseudonym for Brainin; Caruso conjectures that Federmann is a play on Feder (German, feather or pen). See Caruso, "Chava Shapiro," 118. Similarly, on occasion, Shapiro addressed letters to Kulmus (Hebrew, feather or reed used by a scribe).

90. The Milan International Exhibition on transportation in 1906 inaugurated the Paris-Milan railway, which connected Milan to the great capitals of Europe; 10 million people attended.

you—Bah! You "want to hope" that in April you'll be able to travel to Switzerland, but this is dependent, of course, not on you, and so on and so forth. I could enumerate all of it, but time doesn't allow. I'd therefore like to answer your questions briefly: The bad letters are because my second brother is ill and my mother was forced to travel with him to V. [Vienna]. He's in an *Anstalt* [German, institution] near Vienna and my mother is with him there. My mother wanted to come and visit us, but it seems she will not be able to. She'll stay on there for another two weeks.

Address: Glasberg, 36 Sohnarrtorstr

Thank you, darling, for your lovely comments on the pages of my manuscript. And thanks as well for your concern about my physical health, and thanks from the bottom of my heart for your suggestions. I want to advise you as well as to the health of your body and nerves, but I am hesitating, lest my advice come after the fact. I will add only my request that you write, and write me a lot and not come *to me now* with an accounting. If I am able despite everything to write such a long letter, you must write me three times for every one time. Write, write! And be at peace, my darling! And together with this, rest assured that even in the midst of studies, she will not forget, and her longings are mighty even then! Goodbye!

Hava

[P.S.] I didn't understand what you meant by being busy only in the morning? You said that your friend [i.e., Brainin's wife] is not earning anything in B. [Berlin], and so what is the nature of his work in the morning? Let me know: Is there peace and quiet between the two of you now? [. . .]

Paris to Berlin, 7 January 1907 [Postcard]

My Friend,

Why? Why prod and inflame old wounds? I bled a great deal in order to cover, stifle, and silence them. And here you come inflaming them? Why?

I wrote to you that at this point we can speak to one another (in writing) calmly like old friends, and here you come, speaking in that familiar style, which inflames old wounds, in that painful and endearing fashion that triggers a complete upheaval within me, a veritable revolution, stormy and tempestuous. Why?

Let the dead rest in peace! Let's not awaken and agitate them! Once upon a time, neither East nor West could separate those who cleaved together (in spirit), will North and South now succeed in bringing together those who had been separated?

I have suffered too much and have learned too much to be able to submit to this powerful mark, which resurrects and awakens all my deep wounds, pierces my heart, and implants together with it these visions for the sake of which I had once been willing

to sacrifice my life.

I am still alive and still crave life—life has betrayed me. Do not dare to awaken that which lies deepest and most powerfully within it. Do not stir up (old) dreams—the visions that once were [. . .], do not awaken them, for they are too deep and beautiful and strong! Be at peace, my friend from long ago, and write merely to your old friend. Write *only* as you would to an old friend, and on that basis I will permit the exchange of letters between us. I return today to Bern. My address is Poste Restante [regular mail].

<div align="right">Your friend</div>

Vienna, 15 November 1907[91]

My Friend!

I am writing you from a café in the presence of your brother [Zigmund]. This morning I arrived, and tomorrow at 10:00 I will depart for Munich. I haven't written you of my whereabouts even as I announced to all my friends and acquaintances my good news, as I did not have your private address and they didn't send you my letters, I presume.

So this is my news: I am free! I am from now on officially free [of marriage to Rosenbaum]. All this took a great deal of work, and finally I am truly "Hava Shapiro" in the mouths of all. You must congratulate me. Even from the financial perspective I emerged whole, and my fate has been improved: They returned my money [her dowry].

Due to this matter, I have been staying until now in Warsaw. I thought I might see you here, but alas, it didn't come about. Perhaps you can come to Munich? [. . .]

<div align="right">Goodbye from your friend</div>

[On the bottom of Shapiro's letter is a handwritten note in German by Brainin's brother, Zigmund.]

Dear Brother!

We are all sorry that you can't come visit us now. Hopefully you'll still be able to come after your Hung. [Hungarian] tour. More next time.

<div align="right">[*Ich küsse Dich heiss und innig*] I kiss you ardently and deeply,</div>

<div align="right">Zigmund</div>

91. During 1907, Shapiro sent Brainin only four postcards until this November letter.

14 January 1908

My Esteemed Friend!

I wanted to write you. I must write you. I cannot agree to many things, especially to the idea that someone should forbid *me* from writing you—against this I rebel with all my soul.

This is a spiritual sin that cannot be forgiven.

She who sacrifices so much and renounces so much cannot acquiesce to her spirit being put to death by a strange hand.

Tell me what sin or iniquity there is in writing those innocent and upright things that others say and prattle about every hour and minute. What sin is there in writing someone to whom you've grown accustomed to writing over the course of many years and have considered a spiritual confidant, friend, teacher, brother, to whom, because of the affection and respect born of years, you have been able to confess and share your feelings, and before whom you customarily have revealed your heart and bared your soul? What sin and iniquity is there in reading such things?

It is [imposed] muteness. Terrible, stiff-necked, hard-hearted muteness.

You know what I have lacked so much of in my life. Much has been imposed upon me by force, and much has been taken away from me by force. And above all of this: What about that which I have myself negated, that which I willfully *aufgegeben habe* [German, renounced]?

And things coming from this soul, thoughts and feelings born in the soul of someone who has known renunciation and such deep and enormous pain and sadness—these things are considered invalid and inappropriate?

I ask you to respond to this letter.

At times when these thoughts weigh upon us, it is difficult to write much. Intentional suffering. My address is: Road of the Turks 63, 3rd floor. Please let me know whether you received my letter and my article on Peretz?[92] I have many things to tell and share.

 In friendship

Warsaw to Wiesbaden, 14 October 1908 [Postcard][93]

Dear Friend,

I want to answer your letter, in which you spoke literary words to me, that your verdict that I err in *everything* (!), and instructed me in an authoritarian tone that it is difficult "to probe into the substance and reasoning of psychological sketches" and therefore [concluded] that I solve riddles "in a slightly crude way." When you speak

92. It is unclear which article Shapiro refers to here; she would not publish anything on Peretz until 1918.

93. Because postmarks are visible on postcards, it is possible to discern to which cities they were sent. When available, we have added this information.

about style and form, I accept all your decrees lovingly, but in other matters, I have also learned a thing or two, and it has not yet been ascertained that you and only you have mastered all matters pertaining to psychological fiction and the riddles of the spirit. Forgive me for my tone, but know that when it comes to literary matters, I will not allow even you to get to me. I have neither prosecutor nor critic who doles out criticism as harshly as you do. I'll willingly accept it from you but *only the truth.* To my joy, you liked my second piece, although didn't you know that Chapter B. will forever remain the most successful one in my eyes?[94] You should have waited before pronouncing your judgment. *Many* thanks for your letters from the day before yesterday. I await your answer tomorrow as you promised. I am busy now with a weighty matter. You'll know all about it when it's finished (don't be suspicious with me about matters between her and him. It's not that!)—please, only without the harsh criticism!

I've been meeting with Frischmann but not Peretz. Yesterday I was invited to a reading of his at Harmony Hall, close to where I am staying, but I didn't go. It seems to me that he hates me completely. God be with the elderly!

Write and don't be angry with me! Don't forget with whom you are speaking (!), a writer in Israel who is about to become a doctor (by her own powers), and do not make light of my honor!

<div style="text-align: right">Your friend</div>

Warsaw to Antwerp, 18 October 1908 [Postcard]

My Friend!

I am writing you only a postcard because my time is not in my hands. B. [Brainin], I am afraid that in a long letter, I would say bitter things, overly bitter things. It's now ten years since we first met, and it has not dawned on you to visit me so that we can see each other and meet together when you or I wanted to, and so we've met only incidentally if you happened to be passing through Berlin or Vienna anyway, or if you had to attend the [Zionist] Congress (against your will) and I traveled [there too] and we met [there]. [. . .]

Perhaps you were the first to ignite the desire within me to give birth to spiritual offspring [i.e., art], even if this was more *indirekte* [German, indirect] than *direkt* [direct]. That is to say, the desire was ignited within me and so forth because of you, but you have never endeavored or done anything to help me or support me spiritually. To show me the way even as I depended only on you, even during those times when I thought I might find in you someone to lean on, [. . .] and now here you are inflaming old wounds. I recognize that same old tone, those promises for the future. Why these? [. . .]

94. The discussion presumably pertains to the stories in *A Collection of Sketches.*

Warsaw to Antwerp, 27 October 1908 [Postcard]

My Polite Friend!

While you are a man of manners, darling, I am neither an "angry friend" nor bearer of grudges like an Old Maid[95] (May God watch over me!), and in general, I am slow to anger and quick to forgive.[96] How many favors?![97] And thus I'll let you in on a secret: Even when I am angry at you (outwardly), at the very same time I want to say good things to you, encouraging, enthusiastic things. But I restrain myself because you're so far away from me. Do you understand?

Why the rebuking! You yourself know who is guilty and who is innocent here. As for the future, we'll see.

Did your friend [i.e., Brainin's wife] return home? And as for you, where will you go now? What's with your daughters?[98] Are they studying or will they marry? Are they at home or are they leaving Berlin?

I'll be staying here until Sunday, November 1, and on Monday I'll be in Vienna, where I'll be meeting my sister-in-law, who is returning from Mar. [Marienbad]. Therefore, write me please in Vienna: Hotel Nationale. Write me please, my dear, my only one (not in number, God forbid, I'm very far from that kind of lie), my beloved. Write me, and forgive me for all my jesting.

Bern to Paris, 8 December 1908 [Postcard]

Darling Beloved!

Only to you and to my son do I write immediately upon receiving a letter. I am so very busy, so absorbed in my work (in my doctoral dissertation) that I don't answer letters, and I only use the time that is neither day nor night to write in Hebrew. I want to submit my dissertation either at the end of the summer or the beginning of the winter and then to prepare for the doctoral examinations. While I acknowledge that "[living] one moment of a true and full life is good, etc.," as you say, but where is "the true and full life"? Where is it? If only we were together!

Yes, my beloved, my darling, *chosen one of my heart*, one cannot flee from fate. I see and am convinced that we are too strongly tied to one another. I deceive myself when

95. A reference to the protagonist of "Old Maid" in *A Collection of Sketches* in Part I.
96. Cf. Pirkei Avot, 5:11.
97. Cf. "Dayeinu" in the Haggadah, in reference to favors that God bestows on the Israelites.
98. Brainin's daughters, Miriam and Berta, were 18 and 16 years old, respectively, in 1908. Conceivably, Shapiro was advising Brainin on their education, as Miriam Markel-Mosessohn did for Yehudah Leib Gordon's daughters. For Markel-Mosessohn and Gordon correspondence, see Balin, *To Reveal*, 13–50; Yaari, *Tseror 'iggerot yalag el Miriam Markel Mosessohn*; and Werses, *Yedidot shel hameshorer*.

I say that I have freed myself completely of you. I have no one else like you in this world—and *no one else will ever be!* Accept these true words that flow from my mouth as though unwillingly—accept them as they are. I will not go on about this. And as for you? Answer all the questions that I have asked. Would you care for a picture of us?[99]

It's possible that I'll go with my brother at the end of the month to Paris for Christmas but—not to you. I'd rather not meet you in Paris or at the moment.

Are you in Bern? If only you were here with me! But not really, for then I would not be able to focus on my work. And don't you want "your friend" to become a doctor? Or do you pay no regard to diplomas? Perhaps even now you'd advise me to abandon my studies?

I am sending you many, many (May God not consider me a sinner for this) of those, which people call "kisses."

Bern to Glasgow, 5 March 1909 [Postcard]

My Dear!

I am writing on a postcard. An hour ago I wrote you all about our meeting, and now I want to respond to the rest of what you wrote, that is, about your assumption that I would become angry at you after hearing what you have to say about my "Collection of Sketches." You know from before, my dear, that not only would I have allowed but would have welcomed your telling me all that was on your mind, *even* if it were "unpleasant" for me. But I am hoping to see you in a few days, and so then I'll hear it from your own mouth. [. . .] I am asking you to write me immediately after receiving *this* letter as to whether you agree to this request, that is, to meet not in Frankfurt but in Göttingen, as I wrote in my previous letter. On March 21, I absolutely need to be in Warsaw. I'll tell you why in person. I shall not be going to Kishinev, as my mother will not be going there.[100] But I do need to be in Russia *no later* than March 21. Under no circumstances would I have waited until March 16, but I am ready to do this in order for us to see each other. I await your telegram.

Göttingen, 24 April 1909, Hotel National

My Beloved,

I came here to visit with Professor Husserl.[101] Never before have I met such a pleasant and lovely person. He received me warmly; I already like him very much, and I will very

99. A photograph of Shapiro and her brother appears on this postcard. For the image, see Caruso, "Mi hi Hava Shapiro," 20.
100. Menuhah was from Kishinev.
101. Edmund Husserl (1859–1938), a philosopher and mathematician, was of Jewish descent and was baptized as an adult.

willingly fulfill his request that I visit him again, for he has captivated me with his intelligent face, his eyes that radiate wisdom, and his patient lovely words. The city has also found favor in my eyes. A cultured city, small but lovely, and Torah [i.e., wisdom] peeks out from the walls of the Bibliotek, the largest and richest of all the libraries in Germany.

I need still to see another professor, and then I'll know whether I will be able to travel straight back to Bern or whether I need to stay here some more. I'll only be able to see him on Monday. For now you can write me c/o of the Hotel National, Göttingen.

My love, if I tell you that I miss you, that it is so difficult for me to part from you, these will be only banal words. I know only this one thing: With each time we meet, our hearts' inclinations will never be uprooted. The main point is that we found each other as if instinctively; we know each other instinctively, and not more, because over these ten years, we have managed to be together only for a few months and we have not managed to get to know one another—but even so, I know you better than many of the people I am with all the time. And yet, how much I wish, how much I long to know you (!), to open before you that which is closed within my soul, the hidden recesses of my heart, and the riddle of my life, to know you, to be near you, and to discover the treasures of your spirit.

This has become my idée fixe, my strongest purpose: that we should live together at least once in our lives!

And what is it that you desire?

To my great sadness and pain, you have neither the desire nor the inclination—or more correctly, your desire is so enslaved that it cannot be considered a real desire, but were this not so, were this not so! [. . .]

Brainin, why are we forever apart?

Göttingen, 25 April 1909, Hotel National

Brainin, Brainin, why aren't you here with me? Why aren't you near me? Why? Why? [. . .]

Brainin, I shall not separate from you; I shall not forget you and shall never leave you. It is important for me to know that I am yours in spirit forever. This no one can forbid of me.

Brainin, if only you could recuperate, if only you could be encouraged.

As for me, all the powers of my soul have awakened; all the gifts of my spirit have come to life; my soul has blossomed, and I feel the spring that has entered into all the vessels of my heart. You do not know that which is hidden within my soul.

You met me ten years ago, when I was still an undeveloped girl (although already the mother of a child), submissive to others, not knowing that it was even possible to

raise up one's head and revolt, with a wig[102] on my head and with backward, childish thoughts inside it, but with a pure heart and an aspiring spirit.

And I did not disappoint your hopes!

Head high and neck outstretched, I can say that all that I have acquired I have done so with my own powers. [. . .] God gave me a pure heart, and I have not sullied it; despite the pain, the longings, and the perpetual renunciation, my spirit is intact. And you? [. . .]

Whether this time I am speaking from my throat words of love and affection or of hatred, you can decide for yourself.

The One Who Is Forever Close to Your Spirit, Hava

Bern to Marienbad, 24 June 1910 [Postcard addressed to "Kulmus" (Hebrew, pen)]

My Beloved!

The dream became a reality (Koblenz and so forth)—and reality is now a mere dream of the days we spent together.[103] Brainin, what do the simple, vulgar creatures understand? What do others know about love, devotion, attachment, amazement. No, others are not capable of feeling and living as we do for just one hour, without even speaking a word. Reuven, my love, I was quiet and content. I thought that I had killed off all feeling within me . . . and behold, you came—and the abyss of Gehenna has opened up. All you needed to do was awaken me, and now all that inner poetry has burst out. I cannot say anything more now about my inner state. I'll just say this one thing to you: Each and every syllable, each and every letter you utter, every hidden feeling in all its aspects that is born within your soul—I feel them with every single one of the "248 organs and 365 sinews"[104] of my being. I am your living echo. My entire soul is singing.

I forgot to say thanks to you in person, so I am saying it now in writing. You spent too much on me.

With ever-lasting, pious devotion [. . .]

[P.S.] Please write Sokolov [editor of *Ha'olam*] and tell him that I am willing to accept a position on the editorial staff as soon as I finish my studies here. Tell him good things about me, because I love the Hebrew language and very much would like to work for a *Hebrew* newspaper. If he replies with something clear, I can meet with him in August upon my return to Russia.

102. Shapiro refers to the requirement that a traditional Jewish woman cover her hair after marriage. Puah Rakovsky speaks of her wig (or lack thereof): "When I fell into 'depravity,' I threw away the big wig that had been put on me after I was married," *My Life*, 42.

103. Brainin and Shapiro met in June 1910, despite Brainin's move earlier that year to North America.

104. Expression for one's entire body. The sum (613) corresponds to the 248 positive commandments and the 365 negative commandments traditionally understood as appearing in the Torah.

Slavuta, 20 August 1910

My Beloved Friend!

Your letter, which I *just now* received, made me happy and sad at the same time. But the pain is greater than the joy. What sort of things did you hear from your brother that if "you had heard them from a stranger you would have spit in his face"? This angered me to the core. I am innocent in all aspects with regard to this matter. [. . .] I have never related to him in any way that I would not be able to answer for. I always regarded him as *your brother*, and it is too bad he didn't show you my letter, and I would have told him the same thing myself. I remember asking him once: "Don't you know that it is *your brother* whom I love?" I have no desire to speak about this any more in writing (when we see each other, we can talk about this more), but this much I'll say, which is that your words made such an impression on me that I hardly know what to think. [. . .] I won't speak about this any longer, but if you so desire (and I am begging this of you), tell me what he told you.[105] [. . .]

Klatzkin asked me to write a review of the *Geklibine shriften* of Ba'al Mahshoves. I harbor a grudge toward this man, who wrote about you in such a crude way, and so it's unpleasant for me to write about him, but in any case, I may do it. I still haven't read his writings and asked Klatzkin to send them to me. What is this Hebrew publishing house that you established?[106] What is its nature, and what sorts of books will you publish? I am waiting for the time when you'll come to Warsaw. We have a great deal to discuss. Will you stay for long? I may also go with you to [St.] Petersburg. And I'll *certainly* go with you to Palestine (if you'll take me!). [. . .]

Opatija,[107] 10 September 1910

[Written on hotel stationery of Pension Vermes, "Villa Irene"]

My Darling!

I received your letter from Wiesbaden and just now your letter from two days ago from Md. [Marienbad]. Thank you. I wrote [Eliezer] Kaplan, but he told me that the editorial staff and the assignment of work are all in the hands of the editor himself, Sokolov, and it is a mistake to ask him about editorial issues. Sokolov will arrive this

105. There seems to be romantic tension between the brothers over Shapiro. Cf. Postcard (10 June 1904) in this part.
106. Brainin claimed that if *Haderor* succeeded, he would start a publishing house for Hebrew literature. This did not materialize. See Letter from Brainin to Ephraim A. Lissitzky at www.kedem-auction.com (accessed 22 September 2013).
107. Between the two world wars, Opatija was the town of Abbazia in Italy. Today it is located in Croatia.

hour, and I'll pass on my letter to him along with letters from other writers, and surely I'll receive an answer from him. That's what Kaplan told me. I do not know why Soko-lov told you otherwise. Why did he have to do that? I received a letter of blessing from Klausner, who told me that he would like me to submit an article for *Hashiloah* compar-ing German and Hebrew Romanticism but that the article ought to treat this important issue *in depth.*

I received Eliyashev's [Ba'al Mahshoves] book from the editors of the *Welt* with the request that I write a review. I read the book and wrote everything that I thought of, and it seems to me that what I wrote was a bit too severe. I don't know, therefore, whether they'll publish it *all.* That's it for literary matters. [. . .] My beloved, you're right: Our lives are short and so on, but when I think of these things especially, I wish I were with you. Have no fear: It will all go off well! Perhaps these are forbidden "thoughts"?! My God, but they are true and correct!

Nu, and what about you?

I'm leaving this whole thing at that.

With regard to my travels, I'll stay here another three weeks or so, because I'll be making a trip to Venice; moreover, after three weeks I'll travel not to Vienna but to Budapest for two or three days and from there back home. We could meet in Budapest. That would seem better to me than Vienna, where I am thinking of being on the second or third of the next month (for Rosh Hashanah). Let me know if you can arrange to go there.

Are you going to Wiesbaden now *on your own*? How long will you stay there? Let me know in general what your *Reiseroute* [German, itinerary] is going to be for the next while, for the next two months, at least, and where your children will be. How will you arrange things? Are you going to stay in a particular place? Tell me *your thoughts.*

Your Friend, Hava

22–25, 27, 30 November [1913][108]

[. . .] Why did you leave me, Reuven? Why did you abandon me? There is great value to my life when I am with you, near you, but it has no value when I am without you. Have I not suffered enough on your account? I have grown accustomed to missing you, accustomed to moments of joy and *years* of sorrow. So many years! But now, my love, I can't, I cannot! I have never felt before what I feel now. Reuven, why did you move across the ocean? If you fled from me, why did you return? Why did you raise up ghosts and resurrect that which had been stifled with great force? Why did you re-ignite a flame that I worked so hard for so many years to put out (did I ever truly put it out?)—or

108. There are no extant letters dated 1911 or 1912.

at least, I tricked myself into believing I had? At the very least there was a seeming peace within, I rose above all of it. I conquered myself, made great efforts to subdue it within me and to put to death *all* my feelings. I admit that I made great efforts to do so from the very moment you moved to loathsome America. You surrendered me *proizvol sud'by* [Russian, to the hand of fate] and went. Perhaps you were escaping?

And here you come—and the rest, you already know. And now I cannot go on any longer. I can't suffer the way I did when I was young and bore it all in silence. [. . .]

For twelve years I have been a wanderer,[109] perpetually separated from my only son, without a soul near me who feels my pain, without a teacher, counselor, or protector, without a home or anything at all, and you have not worried about my situation; rather, you have acted as though it were self-evident that this was how it had to be (for others) and that you were beholden only to your children. I didn't complain or make any demands of you, but then, once your children were grown and you had sacrificed all your energy, strength, and spirit to raise them and educate them as you wished, you moved across the ocean and sacrificed, and continue to sacrifice, all that is good and beautiful and excellent within you—at this point it seemed to me a bit too much.

But I did not turn to you and say a thing, neither good nor bad: You did what *you* thought was right, and I made every effort not to get in your way. And now, why did you come, Reuven? To show me how much they have sucked out of you? How much you sacrificed and how much you gave? Why did you come back here to inflame and deepen the wounds of my heart, so that upon your return there, you could keep your chains in place, along with the saving remnant and the dark reckonings?

Reuven, Reuven, forgive me for these words. Things are so bitter for me that it is impossible for bitter words not to escape as well. My beloved, my dear, all I wanted and demanded was peace, and now you have taken that away from me too! [. . .] I promise you that for your sake I'll make every effort to be well and whole, to eat and drink!

Your friend from youth, who truly loves you with a whole heart.

Dr. Hayim Schoenberg[110]

15 December 1913

My mother left just now, Reuven, and I am sitting here (in the evening) alone in my room, and to allay my sorrow, or perhaps to scratch at it, I am doing the one thing I can do to draw me closer to you and to establish a connection between us: writing to you. Obviously, it is not the same connection that we might have on the telephone. Oh, my beloved, what I would give now to speak with you awhile on the telephone and hear

109. Cf. the description of Cain (*na' venad*) in Genesis 4:12.
110. The surname is Shapiro's mother's maiden name.

your words. Your voice alone calms me! Reuven, I do nothing but stifle my tears (I cry so much these days! A complete disgrace for a *ḥatsi zakhar* [Hebrew and Yiddish, half-man])[111]—and write you. If only you knew how great and formidable are my longings! I try so hard to overcome them with work. I write and read a lot, and I promise you that there is no greater good for me than this, but, my love, if only you knew how desolate everything is within me, how it aches and hurts! I am lonesome . . . lonesome with my longings, my pain, my demands, aspirations, and great agony. Why should I write now in my diary? My letters to you are the true book of my life. All those other things are superficial, there to help me forget the pain, to put the ache to rest, to help me forget myself, but none of them can take the place of the innermost essence, which alone gives meaning and delight to life and work.

1st of Spring—(May) 1914, the very same month in which we met fifteen years ago

My Friend! You must be shocked: How is it so? In what manner? How *am I so bold*; how does my vanity permit me to write you? After all, you did whatever you could to prevent such strange thoughts from entering my heart. You paid no attention to your promise, nor to my requests or my pleadings, to my well-being or my health; you hardened your heart[112] and made yourself like one of those people who never hears about anything—and you didn't reply with a single word. From the moment you set foot on American soil, you permitted yourself to ask only if I was alive. I received but one short letter from Quebec—and no more.

And yet—I write! The fact is—isn't it so?—you are my friend, my remaining father, my brother, my beloved. I don't want to come to you now with judgment, to place you on the bench of the accused and to read before you a writ of guilt. You know and feel it yourself. If I write to you now in any case, it's only a sign and wonder[113] to you that even now I cannot take account of myself anymore than I could fifteen years ago, and I know that I feel an inner compulsion to write you now.

My friend: fifteen years of pain and agony, of contradictions, sorrow and sighing, of a complete revolution, inward and outward, of strange troubles and constant fear that, try as I might, prevented me from making decisive changes, to erase from my heart that which can never be erased. I write you only because I believe that it was the most beautiful thing in my life, despite all the suffering and wounds, something that contains

111. *Ḥatsi zakhar* is an expression for a woman who demonstrates conventionally masculine traits. Brainin uses it in "*Ḥaverah*" (Female Friend) in *Ketavim nivḥarim* 1: 213.

112. Cf. Exodus 4:21, as in God hardening Pharaoh's heart.

113. Cf. Deuteronomy 26:8 (where the words appear in the plural form): "The Lord freed us from Egypt by a mighty hand, by an outstretched arm and awesome power, and by signs and portents." This verse is inscribed in the Haggadah.

nothing negative and cannot be destroyed. [. . .]

If you have it in your heart "to remember me with your letters and regale me with your words," let me know how you are and how your family is and do this without delay. You know my address: my name, my surname, my hometown, and no more, and no longer does anyone else touch or look at my mail.

With respect and in friendship, as I have become accustomed to writing to Canada and elsewhere,

<div align="right">Dr. Hayim Schoenberg</div>

5 May 1914

My friend!

Surely the Lord is in this place![114] Not only that, rather, I am inclined to believe in Divine Providence and in miracle-working!

My friend, you have called out to me—and here I am. You have sought me out—and I am answering you. I will not pay you back what you deserve; I will not reciprocate.[115]

[. . .] Most of all what angers me are the circumstances surrounding your family life. Now I can tell you everything. So long as your children were small, I understood everything. You owed them; you could not leave them behind. "But these sheep, what is their sin?"[116] However, that time has long passed. Long ago you finished raising them; you gave them an education that cost you more than you could afford. They sucked out the marrow from your life; you gave more than is fair to ask of any human being. And now? Why do they need now? They have greater means than you do. You have permission now to rest from your toils. What more do you owe them? [. . .] My friend, I also have a son; I also love him with my soul, and I understand the soul of a father or mother. However, forgive me for telling you, heart to heart, the truth as I see it. I am also worth something and not just my son!

I do not understand why it is that only your sons have value and you are nothing, only their lives have worth but what about yours? [. . .]

If only I knew that I had the power with my words to set you free, to draw you here—I would speak from dawn until evening. I wouldn't leave your side until you made a final decision. Tell me, is there any hope?

Reuven, the idea alone makes me completely drunk, that idea that you might come this summer, that you are capable of such steps.

114. Cf. Genesis 28:16.
115. The biblical parallelism (i.e., chiasmus) is evident here.
116. Cf. 2 Samuel 24:17.

No, I shall not speak. [. . .]

My hand is on my mouth and upon my heart, so that it doesn't burst out with a cry so great that it would reach all the way to Montreal!

Reuven!!!!!

I'll write you again.

Be at peace, be strong and courageous, please, and you will emerge victorious!

Your friend, Hava Shapiro

25 May 1915

My Friend!

From the moment that the war broke out, I have received only one letter from you from New York, and I haven't written to you either, for what can I tell you? If there are moments when I am completely withdrawn, if there are hours when I am preoccupied by dreams and aspirations!—what can I tell you about any of this if it is so difficult to provide details about even one upheaval, if it is difficult to express even a tenth of a tenth of it.

Brainin, especially during these terrible times, especially now, things rise up—and not just memories but also powerful longings, and I cannot tell you how much I succumb these days to my ideas and my desires, ever-increasing desires to see you again. I cannot describe to you how much I yield, errantly, to this vice.

[. . .] I hope to see and meet with you, and then we can say what we have to say, and when you get this letter, please reply immediately about how you and your family are.

I just recently returned from Kiev. You certainly have heard about the death of Peretz. His death shook me. It is so hard for me to believe that Peretz is dead!

I'm asking you to write me at length; but write whatever you write, so long as you tell me what is going on with you.

I seek your well-being and your loyal friendship with great love.

Prague, 19 October 1919

Beloved Old Friend!

I am alive, I am alive, I miraculously escaped death.[117] I came here from the Ukraine just now and also brought my son here from there. He will enter the Polytechnic [Institute] here, and I'll stay here now as well. It is hard for me to believe that, indeed, I am still in Europe. I don't know your exact address. Let me know what it is right away.

117. For her escape to Czechoslovakia, see letter of M. Shapiro in Caro, *Kovets letoldot*, 36–37; and "Notes from Ukraine" in Part IV.

Where are you? How are you? What is your situation? You can easily imagine how badly I desire to go to the Soviet Union and be with old friends, whom I thought I'd never see again. I await your reply and will write only then. I am begging you to show me the way—where can I pursue my work, in which newspaper in *America*, because I must earn a living and help my son, and our money from the Ukraine is worth nothing here. If there is a Hebrew paper that I can write for there and if not—I'll write in Yiddish. Just let me know what and where to submit.

I'm shaking your hand, my friend.

In former friendship, Hava

17 November 1919

My Friend,

I am sending you a copy of my article from the *true vale of tears*.[118]

I sent some brief articles to *Ha'olam* and have also promised to send some of them to Greenbaum in Warsaw.

You have my permission to shorten them and also to copy and publish them in Yiddish, only on the condition that you do not disclose their author. For obvious reasons, it is impossible [to write under my name].[119] The matter is impossible for me as you know. I wait for your letters and your communiqués. Write me only at Poste Restante [French, general delivery]. What's going on with you? What are you hoping for?

In abiding friendship, Hava

Prague, 23 December 1919

Brainin, My Friend!

Just now I received your address from London. I wrote you upon coming here two weeks ago at the old address in Montreal and also c/o the Editor of the *Forverts*. I regret both, because I doubt if you will receive either. I am notifying you, therefore, that I have escaped this time from the Ukraine, that is, from death, and I managed even to rescue my son. We came here to Prague three weeks ago. My son has entered the Polytechnic [Institute] here, and I'll stay here too. I didn't plan to return to Europe, nor do I expect to be able to return to the Soviet Union, where I have old friends and acquaintances. Let me know all that is happening with you, and only then will I write you a bit more.

How are you? What are you doing and what is your situation? Do you still know

118. Cf. Psalms 84:6. The referenced article is likely "You Must Not Forget!" (see Part IV).

119. Shapiro's not being able to write under her own name is a reference to personal peril because of her Zionist activity, as in "Passover Nights" (see Part I).

who I am? Do you have any knowledge, at least, of what has been happening to us here?

My mother and brothers remain *there*, and I am concerned only about them—to rescue them from Gehenna. How it is that I managed to escape I'll tell you another time. Suffice it to say that I am here.

I must earn a living for my son and me since the money that we brought from Russia is not worth anything here.

In a day or two I'll send you my articles from Ukraine for *Hatoren*. You have my permission to shorten them as you wish. I do not wish to sign my name to them, for the reason you already know, only my initials.

Please, you must send me the payment that is due me from *Hatoren* for my article that was published back at the beginning of the war, which has not yet been sent to me, in addition to the booklet, if possible, which includes my article.

I would be grateful to you in general if you could send me any published reading material in Hebrew, because for the past year and a half I haven't seen a single Hebrew letter and for the past five years I have seen nothing that has been published in Europe. Forgive me for troubling you, but you must understand my emotional state in coming now to Europe.

Do you still remember me, my friend? I am holding back until I receive your answer. Shaking your hand in friendship, as before,

<div align="right">I am, Hava</div>

Prague, [27 January 1920]

To the Editor of *Hatoren*, Greetings!

Esteemed Friend,

Because I have not received *Hatoren* for two months now, I don't know which of my articles were published, for the editors have not replied to a single one of my letters. I have never encountered such practice among editors. After all, if the editor thinks himself too important to respond directly to a writer, certainly another member of the staff should reply. I have asked this many times, but I am asking you once again to return especially my article on Buber.[120]

I also ask that you send me *Hatoren* to my address here because Prague doesn't receive it and I am staying here permanently. I wrote the enclosed article for *Hatoren*, but because of my illness, it was delayed somewhat. I hope to hear from you finally about these matters.

<div align="right">Shalom to all,

Respectfully, H. Shapiro</div>

120. "Martin Buber," *Hatoren* 9.2 (1 April 1922/3 Nisan 5682): 45–49; and 9.3 (8 April 1922/10 Nisan 5682): 45–52.

Lausanne, 15 February 1920

My friend,

After writing you a hundred and one times since coming here to Prague and not receiving a single word, I decided to try one more time to send you a letter via Regina through Switzerland.

It is hard for me to believe that knowing that I finally fled the land of blood, you didn't jot me at least a few words. It is hard for me to believe that just because you are in a better position, in a happier land, that just because you are far away from the suffering and didn't see the pain of your brothers and sisters with your own eyes, that you are ignoring even your sister—she who is so close to you in spirit and nevertheless so far from you now. It is hard for me to believe, and therefore I am writing you again.

I also sent you my articles from the Ukraine when I came here—three months ago—and I do not know if you received them, and therefore I am not sending you anything else, even though you know how much I need it. After all, I am forced now to find my living only through my pen. And with regard to this matter, I asked you—given that now you are the "rich uncle" in America—to send me a certain amount of money in the form of *a loan*. But the only thing you do is remain silent. I am thinking that perhaps the mail in Czechoslovakia isn't secure, and so I am sending this letter from Prague to Regina in Lausanne so that she can send it to you, and I am asking you again to write back to Lausanne, given that you have Regina's address and she will send the letter to me. [. . .] How I wait to hear from you, you yourself must understand.

Greetings to you. Hava

Prague, 6 March 1920

Very Esteemed Editor,

Tomorrow we celebrate the seventieth birthday of the president of the republic. The newspapers here are pleading with me to give them my article for publication; however, I have not agreed. I visited him in my capacity as a *Hebrew* writer, and so I will give my articles only to *Ha‘olam* and to *Hatoren*.

I won't be going to Switzerland as I do not have money. They sent me the 240 francs from Bern.[121] Soon I will receive them. I ask you please to send my salary directly to me.

I haven't received a single word from you, esteemed editor. Perhaps you can impress upon *the staff* to write me?

Respectfully, Dr. H. Shapiro

[P.S.] Please, I prevail upon you to send me *Hatoren*.

121. Shapiro provided Horodetsky's Bern address for monies to be mailed, Letter from Shapiro to Brainin (14 January 1920) (Reuven Brainin Collection, Correspondence III, Box t, Jewish Public Library Archives, Montreal).

Prague, 11 March 1920

Very Esteemed Friend,

I do not know the formula I should be adopting to speak with you, in that after all the letters I sent you, you haven't had the courtesy to respond with a single word. If I continue to write you even so, it is first of all because *I am forced* to deal with you and, second, because despite all of this, I would like to know the real reason for such treatment. If I have sinned or acted wrongly in any way—why, even criminals are told *of what* they are being accused. Whatever the case, my friend, there is *no excuse* for this kind of treatment. I am choking back the tears in my throat as I think about this.

With all that I have suffered and my many current troubles, I would have expected to find in you a friend from long ago whom I might rely upon in some way, and who might have some compassion for me in some way—but this.

No, my friend, I can find no excuse in the world for this. Enclosed is my article for *Hatoren*. You can change its title as you see fit. I ask you kindly, esteemed editor, to send me my salary directly to Prague, because the money from Switzerland has not yet reached my hands, and I am certain that it is better to send me the money directly via the bank. Many here receive dollars from America by *letter*, but I consider it better to go through a bank. Thank you in advance, as I am in need of this salary.

I have been receiving unhappy news from home, and I am living here with my son, whom I need to support, and the two of us await better times.

<div style="text-align:right">In friendship, Hava</div>

Prague, 24 March 1920[122]

Esteemed Friend,

To my great sorrow, I am *forced* to turn to you once again, even though under other conditions I would not do this under any circumstance. [. . .] This is my situation: All my money is now worth nothing. I cannot get any money from my home. It is impossible for me to travel there. Even my mother writes me and says that under no circumstances should I come there because there is a typhoid epidemic and the external conditions are as they were. [. . .]

My request now is as follows: I am sending you my story "Brothers from Slavuta," which was published in *Hashiloah* during the war, in a Yiddish translation, and I am strongly beseeching you to endeavor to publish it in a special edition (it was already published *in Russian* by others) or—if you think it best—to publish it first in a Yiddish

122. For all her solicitations, Shapiro published one article in *Hatoren* in 1920, three in 1921, one in 1922, two in 1923, and one in 1924. She had more success with *Ha'olam*.

journal. [...]

In order to make it even more secure, it would be better, please, to send money via our acquaintance, a *resident here*:

Dr. J. Winternitz[123]

Praha I Miloserdna ul. 6

He'll pass it on to me, *for my sake.*

 With respect and great friendship, and with regards for your well-being, Hava

Lausanne, 7 August 1920[124]

Mr. Brainin,

And so, you were in Europe and you neither remembered nor visited [*lo zakharta ve lo pakadeta*] your friends.[125] Of course, this is no longer surprising, and so I won't even deal with this matter. I would just like to say that with all that I have gone through, and even when I stared into the face of death and into the faces of those who wanted to kill me, I did not feel the strange bitterness that I feel when I think about your behavior. For more than twenty years I regarded you as a shining star, a friend, the belief in whose spiritual integrity was my mainstay—I never asked this friend for any other kind of support. I suffered his sufferings; I was pained over his pains and enjoyed his joys. For more then twenty years I placed my boundless faith in him, and this gave me the strength to sustain all the torments of life.

And *now*, during this difficult and bitter time, after seven years of toil,[126] after rescuing my own life and my son's life from the awesome Gehenna, after finding myself in a condition of spiritual depression, after turning to you endless times—you don't consider it *your obligation* to "honor me" even with a few words. Brainin, Brainin! I call out to you again! Don't make yourself liable for regret later! Don't extinguish the last spark of my faith in human beings!

Forgive me—I can hardly speak.

And still I trust you (despite it all!) and believe me: If not for this trust and my great confident hope that I will yet live and work in the Land of our Fathers in the company of friends and kindred spirits, I would not be able to survive all these troubles and pains

123. Shapiro would eventually wed Josef Winternitz.
124. In the autumn of 1920, Brainin asked for an accounting of all monies paid to Dr. Hava Shapiro. In response, the manager of *Hatoren* informed him of two payments: $43 on 23 January 1920 and $22.20 on 29 September 1920; Reuven Brainin Collection, Correspondence III, Box t, Jewish Public Library Archives, Montreal.
125. Cf. Genesis 21:1 and Exodus 2:24, 4:31: In contrast to God who remembers and visits Sarah and the children of Israel, Brainin does not.
126. Cf. Genesis 30:18.

and the conditions in which I find myself.

With all of the respect that I have for the *former* Brainin, I am asking him to remember this once what he owes *me*, for there are things even more important than money (!)—I ask [you] to give this a bit more thought.

In friendship, Hava

Prague, 9 May 1921

To the Editor of *Hatoren*, Shalom!

I received your administrative letter. I am asking you *to send me Hatoren* to my address in Prague.

I repeat my request that you send a certificate (in English) from the Editors of *Hatoren* for my travels in the Czech Republic. Here they assign great value to a certificate from America and make every effort to grant access to correspondents.

If the Editor himself does not usually reply to requests, I would kindly ask one of the *members of the staff* to reply to me as to the status of my writings that still have *not been published* in the weekly *Hatoren*.

Respectfully,
Dr. Hava Shapiro

Prague, 17 May 1927 [Postcard]

To the Editors of *Hatoren*, New York
Esteemed Sir,

I received the booklet, but not my salary. *Please send it to me* at last.

I also wish to know whether *Hatoren* will continue to appear and ask you please to send me those writings that remain with the Editors.[127]

Respectfully,
Dr. Hava Shapiro

Prague, 21 December 1928 [Postcard]

1 Bennett Avenue
N.Y.C.

To Mr. Reuven Brainin,

More than a quarter of a century ago, when you were in great financial straits,

127. *Hatoren* ceased publication in 1923.

you turned to me with the request that I lend you 200 rubles.[128] I responded. I have not reminded you of this until now. Times have changed, the creation prayers have been switched,[129] and now *I* find myself in those same straits. And *I am forced* to remind you. Please do not tarry!

And one more thing: I am asking you to return the manuscripts that I sent you in your capacity as editor of *Hatoren*, as well as my salary for the last article in it, which I *did not* receive.

<div align="right">

With regards, H. Sh.
Prahah II Malo Stepaunska 7

</div>

128. See Letter (Sunday, 3 Av 5660 [29 July 1900]) in this part. The amount indicated in that letter is 100 rubles.
129. Prayers that precede the recitation of the Shema during weekly and Sabbath morning prayers; this expression, which means "the tables have been turned," is tantamount to saying Sabbath liturgy on weekdays and vice versa.

Menuhah Shapiro to Reuven Brainin[130]

Day After Yom Kippur 5664 [2 October 1903]

B"h [*B'ezrat hashem* (with God's help)][131]

Esteemed Sir!

First let me wish him a *shanah tovah* [good year] for this new year![132]

And now, I express my gratitude to him for advising my daughter to travel to my house. I would request that he please do me another kind favor and write me now his advice as to whether I should allow her to travel abroad, for as I told his honor, I shall not stay because it is not good for her. I cannot bear all these proposals [rattling around] in my mind at the moment. She for one cannot be otherwise and so she rebels. As for me, I am a mother whose entire soul is concerned for the welfare of her beloved daughter. Surely he can understand how this matter tugs at my heart and then some, knowing himself that it is not good for her. For ever since she was a girl she has been greatly indulged and has had no experience being on her own in a strange land among foreign people.[133] His words still ring in my ears, when he told me that I shouldn't leave her there, as he is well acquainted with life abroad and thus knows that it will not be good for her to be there. And for the reason that I know his honor to be a loyal friend, I am fervently asking him to write me with his advice now as to whether I ought to let her travel. I have complete confidence in his honor's goodness that he will fulfill my request and write me a clear response.

As to what my daughter told him, based on what I wrote her about your honor, he should know that I do not believe any of it and thus I wrote her. Surely he knows that he should give me the benefit of the doubt, and when we see one another, I shall explain everything and my rectitude will be proven. And since there is nothing more [to add], I [end by] seek[ing] his welfare with feelings of esteem.

M. Shapiro

[The letter ends with a mailing address.]

130. Reuven Brainin Collection, Correspondence III, Box t, Jewish Public Library Archives, Montreal.
131. B"H is a notation that observant Jews affix to written documents.
132. Menuhah Shapiro addresses Brainin in the third person as a sign of respect.
133. For Shapiro's fear of traveling alone, see Letter from Shapiro to Brainin (15 July 1901) (Reuven Brainin Collection, Correspondence III, Box t, Jewish Public Library Archives, Montreal).

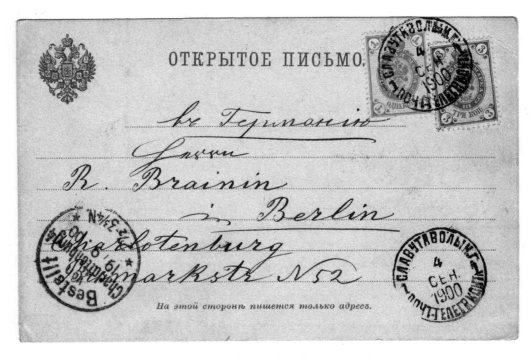

Postcard (front) Menuhah Shapiro to Reuven Brainin. (Jewish Public Library, Montreal)

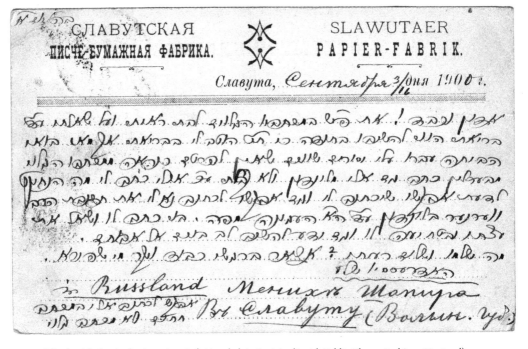

Postcard (back, with Shapiro business imprint), Menuhah to Brainin. (Jewish Public Library Archives, Montreal)

Hava Shapiro to Mordecai ben Hillel Hacohen[134]

8 October 1902

Esteemed Sir!

I rejoiced when I heard that you succeeded, Esteemed Sir, in establishing a "[Hebrew] Writers Association."

It is my heart's desire to enter into the covenant of this association. And so I am including in this letter 2 rubles for the entrance [membership fee], with my blessing that it succeed and yield fruit. With feelings of respect,

<div align="right">

Hava Rosenbaum
(Mother of All Living)

</div>

Hava Shapiro to Mordecai Lipson, Editor of *Hado'ar*[135]

8 December 1921

Esteemed Editor,

I read the announcement about the appearance of *Hado'ar*, and I am sending my blessings for its success. I was not invited to participate in it, and therefore I was not able to send the fruits of my pen. Nevertheless, I would ask you to let me know if they need work of any sort, as it would be desirable for them to have more contributions from writers outside Israel. And also if you could tell me what sort of salary they pay. And I would also very much appreciate if you would send me *Hado'ar* at my address.

<div align="right">

Respectfully,
Dr. Hava Shapiro

Dr. Eva Shapiro
bei Forstinspector [German, Forestry Inspector] Aruost[136]
Mukačevo
Czechoslovakia

</div>

134. Hava Shapiro Letters, 45235/1, Genazim Institute, Tel Aviv.
135. Hava Shapiro Letters, 44400-1, Genazim Institute, Tel Aviv.
136. At this time Shapiro was residing with the forester who helped her and her son cross the border.

Hava Shapiro to the Editors of *Gilyonot* [137]

7 December 1933

To the Editors of *"Gilyonot,"* Tel Aviv

Esteemed Sir,

Please let me know if you have any desire for a long article that I invested a great deal of work on about Masaryk and his philosophical and sociological teachings. I am also working on a review of the poetry of Werblitzky (the greatest Czech poet), who is of Jewish origin, and whose greatest and most famous work is his "Bar Kokhva," which is excellent, indeed.

<div align="right">

With respect and blessings,

Dr. Hava Shapiro

Prague I U Milosrduych 6

</div>

Hava Shapiro to Yitzhak Lamdan, Editor of *Gilyonot* [138]

25 April 1934

To Mr. Yitzhak Lamdan, Tel Aviv

Very Esteemed Sir,

As soon as I received your letter, I went to see the chairman of the committee that deals with all matters related to the library, and he promised me that the money will be sent immediately. Now you will receive it, as you should. I no longer wish to speak with the head of the library. He did not send the money to be spiteful. Now you see what kind of environment I am living in. Certainly you have received the subscription fee that I sent by mail as a subscriber. I have still not received the journal. My intentions were good even in the case of the library. I was hoping to expand the number of your subscribers. If not for the fact that I do not want you to waste the money on postage, I would ask you to let me know if you received the money.

137. Hava Shapiro Letters, 53285/1, Genazim Institute, Tel Aviv.
138. Hava Shapiro Letters, 53287/1, Genazim Institute, Tel Aviv.

I have another request: Perhaps I can consult with you about the matter of publishing a collection of my writings, which have appeared in various places, in one or two volumes. With whom would it be best to entrust this matter? The editing, proofing, and sale? Here, in the Diaspora (in Munkács, for example) the printing would definitely be cheaper, but the main thing is not just the printing. Thanks in advance if you can advise me.

With respect and blessings, Hava Shapiro

Hava Shapiro to Daniel Persky

23 March 1936

To Mr. Daniel Persky, New York:

Dear friend, thank you for your words, words of admiration and also of a kindred spirit. Give praise to the Creator that, at the very least, you live in a place where people recognize you. I *cannot* say the same. Not only is there no encouragement but also no friends or [Hebrew] environment, as it were. Last year there were still a few, and the Hebraists celebrated my anniversary.[139] I would concede everything if only there were a different attitude toward Hebrew and her partisans. And the close friends—all of the younger generation—'alu 'artzah [literally, went up to the land; i.e., they have moved to Palestine]. For this reason, I was not able to fulfill your request immediately. The editor of *Selbstwehr* doesn't have much space, and he is cutting literary materials, reviews, and critiques. Nevertheless, I will endeavor to give them an article about you. I'll make an effort through the friends that I still have here to publish something in Czech or Yiddish, and I hope that I'll have better luck than others. I'll have to battle with the editors of the German and Czech weeklies, but I will not shirk my obligation—and I also want to do this. You deserve it as a writer and for your devotion on behalf of Hebrew.

Perhaps you can tell me whether there is a possibility for you to publish (that is, there is certainly a possibility, but the terms of such) a book of my writings, as I very much would like to collect them, for example, as an anthology of sketches, critical essays about Jewish and Gentile personalities, about the Jewish woman [ha'ishah ha'ivriyah] and her image in Hebrew literature, etc. I would be grateful if you could let me know in a clear manner. Similarly, I would ask you to let me know the address of

139. Twenty-fifth anniversary of the publication of *A Collection of Sketches.*

Sh. M. [Shmuel Moshe] Melamed in California. One more thing: Please let me know if I can send you twenty or thirty copies of my monograph [on Tomas Masaryk] to sell. [. . .] Each one costs 6 crowns, so with shipping (approximately 20 or 25 cents).

Be well and blessed.

In friendship and appreciation,

Dr. Hava Shapiro

1 June 1937

Dear and Esteemed Friend,

I received your letter of May 11. Thank you very much, dear friend, for your warm, encouraging words and for your interest. If only I were among people and friends like you!

I still have not received the eight dollars and I do not know *how* you sent them. You only wrote, "Today I sent it." In any case, you need to inquire about this and let me know, and I am letting you know that if you didn't send it yet, or you don't plan on sending it immediately—please wait at this point, because next month I won't be at home, only in August.

I have a large favor [to ask] you: to inform me once again of the address of Israel Matz.[140] An incident occurred whereby I lost your earlier letter that contained the address for Israel Matz's foundation. Forgive me, please, for troubling you, and do tell me the address again. I have not corresponded with Mr. Reuven Brainin for many years, and even now I will not write him, but only to people who want this. My broken spirit [*ruḥi hanekhei'ah*][141] has not healed, and it appears it never will—I, who was always so cheerful and optimistic.

I definitely would like to collect my writings in one volume—at least, the most important among them. Please advise me regarding that. If only you knew the conditions and surroundings in which I live!

I always read your words in *Hado'ar* with interest. I know the young Rozanski[142] and will send him regards. He is studying medicine and is devoted to cultural work. I will send my article about you and your jubilee to the Yiddish paper.

Be well and much success in all your endeavors!

Dr. Hava Shapiro

140. Israel Matz (1869–1950) was a founder of the Ex-Lax Company. The Israel Matz Foundation was created to help indigent Hebrew writers. (There were advertisements for Ex-Lax in some of the Hebrew newspapers of the day.)
141. Cf. Proverbs 15:13, 17:22, and 18:14.
142. See Rozanski's letter to Brainin in this part.

9 December 1937

Dear and Esteemed Friend,

I was informed by my friends that they wrote you and received money from you.[143] The matter is unpleasant *to me*. I have no interest whatsoever in a jubilee volume that includes only praise of me, as is the custom, as I do not consider myself worthy of this. For the time being, the money has been set aside until plans become clearer, and you will be the first to receive money back from whatever publication ensues—I have no interest in making money from this. What I would like to see is the publication of a book with a collection of my writings and to include in it some critical "appraisals" and such. I know that I could have said a lot more in my life, but things remained unsaid, as a result of my fate, and how can others "appraise" us anyway?[144]

In any case, what I would like is that a selection of my writings be gathered in a book because, in any event, I was one of the first women writers of modern Hebrew literature, and Hebrew literature was my entire soul, the core of my being, and the content of my life, and a person needs to see with his own eyes and in his own lifetime a *kinnus* [Hebrew, ingathering][145] of the words to which he devoted most of his years. I am sure that you understand me. I am turning to you to request your help and counsel. Let me know to which editor *ba'aretz* [literally, in the land, meaning prestate Israel] I might submit the collection for editing, commenting, and publishing. I have thought about Yitzhak Lamdan.[146] Or perhaps you know of someone else capable of doing this? Of course, he would receive payment for this work, but it needs to be a writer who has literary taste and knows what to choose and how to arrange the content. You are more expert than I in these matters and more familiar with the people now in Israel. Please send me your advice.

I am sending you my thanks in advance and trust that you will not get angry at me for troubling you. I know that wherever there is work to be done on behalf of our literature and items related to it, you are the very first to do it, and not just with good intentions but with real action. This attribute of yours, I would naturally contend, ought to be recompensed sevenfold.

You have not informed me of Matz's address, and I did not write him—regarding the money owed me from *Hatoren*. I sent the German translation of my article about you

143. See Rozanski's letter to Brainin in this part.
144. This is a rather odd remark for someone involved in developing the genre of Hebrew literary criticism.
145. *Kinnus* (ingathering) is Bialik's term used to describe his project of anthologizing midrashic literature, as in his essay "Al kinusah shel 'aggadah," which serves as the introduction to Bialik and Ravnitzky's *Sefer ha'aggadah*.
146. See letter to Yitzhak Lamdan in this part.

to *Literarische Bleter*, but they are not in the habit of replying and so I do not know when it will be published.

<div align="center">

Be well, dear friend, and may you succeed in all your endeavors.

In great friendship,

Dr. Hava Shapiro

Prahah I U Milosrduych 6

Czechoslovakia

</div>

Hava Shapiro to Menahem Ribalow, Editor of *Hado'ar* [147]

19 April 1938

To Mr. Ribalow—Greetings!

I wrote about "Yearbook" and sent my article to *Ha'olam*—to my chagrin, late, as I was not able to do so earlier—and behold, today I received a letter from [Moshe] Kleinman [editor of *Ha'olam*] informing me that he already had an article in hand about that same book and that if in the future I would like to write about a book, I should inform him in advance. If he knows that I am writing something, he won't accept any other articles on the same. Because this fell by the wayside, in the meantime I am placing the article in your hands: Either send it to Buenos Aires to the journal *Darom* or pass it on to *Niv*, near you. I leave the decision to you and your judgment, and let me know about this.

<div align="center">

Respectfully and with holiday [Passover] blessings,

Dr. Hava Shapiro

</div>

2 June 1938

Dear Friends,

My eldest brother [Pinhas], who lives in Vienna, is begging to be taken to America. Perhaps you know how this can be accomplished? Or perhaps you can help him?

147. The letters in this section can be found in Hava Shapiro Letters, 72326/1, Genazim Institute, Tel Aviv.

His name is Pinhas Shapiro and his address is:

Wien II

Untere Augarteustr. 4/10

Greetings,

Dr. Hava Shapiro

[P.S.] Esteemed Mr. Ribalow, why haven't you found a place in *Hado'ar* for the article I sent you on [Shaul] Ginsburg's historical writings?[148]

Yerahmiel Rozanski to Reuven Brainin[149]

23 June 1937

R. Rozanski

Journalist

Prague[150]

Dear Brainin,

In a year we will be celebrating the thirtieth jubilee anniversary of the literary work [*A Collection of Sketches*] of our dear woman writer [*soferet hayekarah*] Hava Shapiro. It is incumbent upon us to publish for this anniversary her "collected writings" or at the very least a selection of the writings together with a critical booklet. Therefore, perhaps it will be understandable to you why I turn to you first of all and ask advice of you, our great critic, with a capital "C." After all, you know the writer, the only Hebrew woman writer in the Diaspora today. You were the one who ushered her into the sanctuary. And now, when it is our privilege to celebrate her jubilee, surely you must be *rosh hamehutanim* [literally, head of the in-laws, that is, the one in charge of the wedding]. Need I remind you of your friendship with our dear woman writer, both with her and her family. I trust in you, both as Brainin the Hebrew writer and as Brainin the esteemed friend of the woman writer, that you will assist in "the appearance of the jubilee volume."

148. Note that Shapiro makes the request about publishing her article on Ginsburg just months after his series of twelve articles on her family's printing press appeared in the *Forverts*.

149. Reuven Brainin Collection, Group III, Correspondence, Box r, Jewish Public Library Archives, Montreal.

150. This is the imprint on the stationery.

To our great chagrin, this woman writer is not in the best circumstances right now. Her recent marriage has not been successful, and she is now experiencing a life of pain and loneliness. This affects her entire being and blocks the wellspring of her creativity. By celebrating her jubilee properly, especially if we have success in publishing her writings, we shall do a great thing. We shall rejuvenate the soul of the dear woman writer; we shall encourage and invigorate her. After all, she is currently the only Hebrew woman writer in the Diaspora. It pains the heart that we have no means for creating more comfortable conditions in which the woman writer could work. Believe me, dear Brainin, that I have given this much thought; I could not sleep at all one night, until I decided to turn to you, for you will understand the matter. Your vast experience and ability will stand us in good stead and set us on course. With your help, we will merit to bring the matter of the jubilee to fruition and to fulfill the commandment [*mitzvah*] incumbent upon us. I know that the matter is close to your heart, and it is in your soul. I shall not thank you, rather I confidently shake your hand.

Yours,
Yerahmiel Rozanski

PART IV

REPORTAGE, LITERARY CRITICISM, AND ESSAYS

Shapiro as Journalist, Essayist, and Feminist Critic
"It's Impossible for Me Not to Write"

In his study of the emergence of modern Hebrew poetry by women, literary critic Dan Miron refers to a number of female Hebrew prose writers, all of whom immigrated to the Land of Israel and began publishing fiction at the beginning of the twentieth century. He then cursorily mentions a single female prose writer who remained in the Diaspora: "[At this time] Hava Shapiro, the first female critic/essayist began to publish her essays, sketches, and parables (under the declaredly feminine pseudonym Eim Kol Hai) in the periodicals published by her friend and mentor, David Frischmann."[1] For Miron, Shapiro is important primarily as an essayist—and the first female Hebrew essayist at that. Such a judgment follows from her long list of published essays compared to her relatively scant output of fiction. From 1911 to 1938 Shapiro regularly produced travel writing, reportage of Jewish interest, critical essays on contemporary literature, art, and philosophy, works of feminist literary criticism, and reminiscences of important Hebrew writers. Contrary to Miron's observation, however, Shapiro did not publish these articles chiefly in journals edited by Frischmann. Indeed, several of her works—creative and critical—appear in Klausner's *Hashiloaḥ*, whereas the preponderance of her publications are found in the Zionist weekly *Ha'olam* or in American Hebrew journals, such as *Hatoren*, which was edited by Reuven Brainin, and *Hado'ar*. In addition, although Shapiro did publish a few scattered pieces of journalism under the name Eim Kol Hai, especially in essays aimed at stirring up emotions for suffering Jews ("You Must Not Forget!" and "Notes from Ukraine"), most appear under the byline "Dr. Hava Shapiro," indicating her desire, as the lone female literary critic writing in these journals, to assert intellectual authority.

With no attachments to a husband and with her only child in the care of his father's family, Shapiro was free to roam, even after being forced to flee Russia for Czechoslovakia. Before the Russian Revolution, resources were forthcoming: Her family's money enabled her to traverse Europe by rail with ease.[2] Thus it is logical that her first published essay is a travelogue.

In "Notes from My Journey to Eretz Yisrael" (1911), Shapiro reports on her first (and only) trip to the Land of Israel, accompanied by her parents and mentor David

Frischmann, who was then traveling as a correspondent for *Haynt* and *Hatsefirah*. In this essay Shapiro passionately describes the developing Jewish community, with especially marked enthusiasm for its adoption of modern Hebrew as its vernacular and for the resultant proliferation of female Hebrew speakers in the various communities and institutions she visited. "Notes" was Shapiro's first work to be published after the appearance of *A Collection of Sketches*, and it playfully extends the journey metaphor invoked in her preface, where she "enter[ed] into an unfamiliar sphere," hoped to inspire other women "to journey in [her] footsteps," and promised to "tread on new ground." Like her book of short fiction, "Notes" was published under her pseudonym Eim Kol Hai to underscore, it would seem, the firstness of her venture. After all, the travelogue catapults Shapiro into new territory once again as one of the first women to report in Hebrew on a visit to the Holy Land.[3]

The travelogue is marked by an awareness of Shapiro taking her place as a female writer in a long line of literary men.[4] Take, for instance, the opening depiction of the nighttime seascape, in which Shapiro subtly alludes to Yehudah Halevi's famous poem about a voyage to Eretz Yisrael, "Hatirdof na'arut aḥar hamishim."[5] "The heavens and the sea seem as one," she describes, "only the white waves left in the ship's wake distinguish between them." Shapiro's invocation of the medieval poet seems deliberately muted, however, especially in comparison to Frischmann, who quoted Halevi by name in the opening sections of his own travelogue.[6] In the same passage Shapiro portrays herself standing brazenly on the ship's deck, separated from her fellow travelers, as though to symbolize her entirely new authorial point of view. As she considers the seascape over the course of her voyage, Shapiro takes in "some change or other," each time discovering "something new that [she] hadn't seen before." Her fascination with what is pathbreaking comes across particularly in her effervescent descriptions of the young female pioneers (*ḥalutsot*) she encounters, who display passionate commitment to the land, its culture, and its language, which they speak fluently.[7] It is there, in Eretz Yisrael—and only there—that Shapiro records any sense of real (female) community.

Shapiro repeatedly reaches for this kind of Hebraic community through her essay writing. As one triply marginalized in the Diaspora—not only by language and geography but also by gender—Shapiro occasionally uses the pages of the Hebrew press to speak to other Jewish women in order to summon the enthusiasm for Hebraism and female empowerment that she seemed to discern in the Land of Israel. In her article "Rights and Obligations" (1917), she urges her sisters to participate in the feminist movement, but mainly for the sake of Jewish causes. "The hour of liberty" is at hand, she maintains, when "entire peoples, diverse human beings [. . .] are making themselves heard." Among this "raging symphony" is "the soprano of

woman," who is "demanding equality and recognition." Feminism, she asserts, is to be harnessed for the Zionist cause:

> This is not the place to advocate for women's rights or to plead for the righteousness of their demands. I only wish to point out that the voice of the *Hebrew* woman has yet to be heard in our camp. [. . .] In those places where it is possible to bring about good for the [Jewish] people and their land, we are obliged as members of a people [to do so and] to forgo all other work, come what may. [. . .] We will not discharge our duty simply by forming women's associations for the sake of achieving our equal rights. We must remember at this time that our first obligation is to that which we owe our *people* [her emphasis].[8]

Jewish nationalism, and its attendant cultural manifestations, became a mainstay of Shapiro's reportage. Whether remarking on the unusual hum of Hebrew in the halls of a European consulate ("Roaming the Lands") or reviewing a performance of the Hebrew repertory troupe ("Habimah in Prague"), Shapiro's attachment to the Jewish people remained unflagging. As a regular at the annual Zionist Congress, Shapiro provided accounts of the proceedings ("Letter from Prague"); and, as a Czech citizen, she reported on issues of identity politics ("An Exhibition of Israelite Artists in Prague," "The Curse of Language," and "PEN Congress in Prague").

In addition to reporting on politics, Shapiro assumes the role of literary and cultural critic, demonstrating an astonishing range of expertise in literature as well as art, drama, and philosophy. As she mediates capably between "the Western culture in which she is entrenched and the ancient culture that she bears almost subconsciously,"[9] she brings issues of broader concern to light and provides surveys of new trends in both. In her first essay on literature, Shapiro calls for a higher level of professionalism in Hebrew literary criticism, a conviction that persisted throughout her career and which she reiterated in one of her final publications.[10] By insisting that criticism is a necessary element of Hebrew literary culture and that it needs to be practiced with more rigor, Shapiro assumes a brave, pioneering stance and plays a role in developing the genre.

Shapiro also consistently calls attention to issues of feminist import. Following on the heels of her pathbreaking preface to *A Collection of Sketches* and anticipating the first two major trends in twentieth-century Anglo-American feminist criticism, Shapiro wrote essays that explored the treatment of female characters in writing by men and expressed the importance of cultivating a separate female Hebrew literary tradition. In 1919 she published an important essay on the representation of women in the fiction of Mendele Mokher Seforim. And in 1930 she expanded this material into a comprehensive survey of female images in three generations of modern Hebrew literature ("The Image of Woman in Our Literature"), which is the first such work of feminist criticism in Hebrew literary

history. In her discussion of Haskalah writers, she observes that despite their ostensible concern for the miserable fate of Jewish women, Yehudah Leib Gordon, Abraham Mapu, and Peretz Smolenskin were far more interested in attacking their traditionalist enemies than in faithfully depicting and ameliorating the troubles of their female contemporaries.

Only in the second generation, led by Mendele Mokher Seforim and Y. L. Peretz, did more realistic depictions of female protagonists begin to appear. Even so, Shapiro argued, this pair of literary greats continued to define the Jewish woman solely by her role as wife. In the third generation, according to Shapiro, Hebrew writers such as Micha Yosef Berdichevsky and Uri Nisan Gnessin fixated on the image of the uprooted Jewish intellectual but virtually ignored women who fell into this category. She did single out Yosef Hayim Brenner for his complex female characters; however, she rejoined, "One has the impression that he visits them only incidentally."

Shapiro blamed the dearth of credible female protagonists in Hebrew literature not only on the limitations and biases of male Hebrew writers but also on the absence of female participants in the enterprise. Presaging the observations of Iris Parush, Shapiro noted that as readers of secular literature, Jewish women often surpassed the men in their community, whose obligation to Torah study limited and impeded their opportunities for learning and reading other languages. Such patterns of reading notwithstanding, few Jewish women extended their literary interests to the realm of Hebrew literature.

Shapiro's historical observations are well taken, although by 1930 her lament over a lack of female readers and writers of Hebrew had already become dated, especially if we take into account the vibrant literary scene among women in Palestine. By this time, Nehama Pukhachewsky (*Biyehudah hahadashah*, 1911) and Devorah Baron (*Sippurim*, 1927) had each published collections of Hebrew stories, whereas Rachel Bluwstein (*Safiah*, 1927), Anda Pinkerfeld Amir (*Yamim dovevim*, 1928), and Esther Raab (*Kimshonim*, 1930) had published their first books of poetry. The omission of her female contemporaries is all the more curious when we consider that Pukhachewsky and Baron were publishing in *Ha'olam*, the very journal in which Shapiro's earliest sketches appeared.[11] Neither her correspondence, her travelogue, nor her diary provides evidence that Shapiro made contact with any of the female Hebraists just mentioned, although in 1931 Shapiro did write a brief, admiring essay about Elisheva ("Die Dichterin Elisheva" [The Poet Elisheva]) in German directed specifically at non-Hebrew readers.

Elisheva is the pseudonym of Elizaveta Ivanovna Zhirkova (1888–1949), the Russian-born Gentile poet who moved to the Land of Israel with her Jewish husband, Simeon Bichovsky, and wrote for the Hebrew press.[12] Zhirkova began to write poetry in Russian as an adolescent and at the same time befriended a Jewish girl, who sparked an interest in Jewish culture. She taught herself the Hebrew alphabet from a grammar book (owned by her philologist brother) and began more formal study at classes of the Society of Lovers of Hebrew (Agudat hovevei sefat 'ever) in Moscow. In 1915 she began producing

translations from Yiddish into Russian that were published in *Evreiskaya zhizn* (Jewish Life, a Russian journal) and then turned to translating into Hebrew. Elisheva composed approximately 200 poems in Russian that portray, in large measure, her attachment to Jewish culture. And in 1920, after writing her first poem in Hebrew, she ceased writing in Russian altogether and changed her byline from Elizaveta to Elisheva.[13]

The fact that Elisheva was a Gentile author who had enthusiastically embraced Hebrew was extremely moving for Shapiro. She eagerly anticipated her speaking engagement in Prague[14] and described Elisheva as "a living reproach" to those who excused themselves for not knowing Hebrew because they were not taught it as children and failed to learn it later. Such Jews, she admonished, "do not want to know any of the intellectual achievements appearing in that language" or anything of Hebrew aside from what is their "'duty' [. . .] to pray (even without understanding the meaning of the words)."[15]

Shapiro expressed a somewhat similar sentiment earlier that year in "The Woman Reader: Where is She?"—an essay published in *Hado'ar*. Her concern over the paltry number of female Hebrew readers and the general inattention to this problem struck a defensive chord on the part of the paper's editors. In a short editorial comment that precedes her article, the editors of *Hado'ar* could acknowledge the importance of the issue "raised by this distinguished writer" but cautioned against "exaggerat[ing] the shadows and [. . .] mak[ing] the existing situation look darker than it is." Like Shapiro, they, too, claimed to be "seeking a way to raise a generation of both male and female readers."

Be that as it may, Shapiro's lack of connection to female colleagues is puzzling. Her distance from the centers of Hebrew literary activity partly explains this,[16] as does her persistence in defining herself in opposition to other women.[17] Yet one cannot help but notice how forgiving Shapiro is of her male mentors, whose writings she trumpets in several published laudatory reminiscences included here ("Y. L. Peretz: The Man and the Writer," "Memories of Frischmann's Life," and "Reuven Brainin, On His Intellectual Image") while barely noticing the talents of her female counterparts.[18]

Ironically, in this regard, Shapiro resembles later critics who attribute women's full-scale participation in Hebrew letters exclusively to one stratum of the population—namely, those female literary figures who settled in the Land of Israel—while virtually ignoring the significant contributions of others who remained rooted in the Diaspora. The swath of diverse materials in this part demonstrates Shapiro's wide-ranging contributions and places her, once and for all, on the Hebrew literary map.

NOTES

1. Miron, *Imahot meyasdot*, 13. Avner Holtzman makes a similar observation in his entry on Shapiro in the *YIVO Encyclopedia*: "During the interwar period she was prominent as virtually the only female Hebrew critic and essayist."

2. Charting the course of her copious travels across continental Europe during this period depends mainly on the postmarks of letters to Brainin, and, later, the spare documentation in the Czech archives (see Appendixes 6 and 7).

3. Cf. Pukhachewsky, "Mishut ba'aretz." In contrast to Shapiro, Pukhachewsky is not a visitor; she had settled permanently in Eretz Yisrael in 1899. Natan Shur's *Book of Travelers to the Holy Land* contains travelogues by sojourners to the Land of Israel, including a list of Jewish pilgrims, all men except for Judith Montefiore. See Montefiore, *Private Journal*.

4. For the significance of gender in travelogues by women, see Schriber, *Writing Home*, 89.

5. Halevi writes in "Heart at Sea": "The abyss looks just like the heavens / the two great seas are bound— / and my heart, a third, between them, / pounds with waves of praise." A bilingual version of Halevi's poem appears in Carmi, *Penguin Book of Hebrew Verse*, 350.

6. Frischmann published his travelogue serially in *Hatsefirah*, beginning with the 5 May 1911 issue, and later in monograph form in 1913. The introduction, in which Frischmann quotes directly from Halevi, appears only in the monograph, suggesting that Frischmann might have "borrowed" the idea from Shapiro's travelogue. In his early articles, Frischmann repeatedly invoked Halevi's "Tsiyyon halo tish'ali." See Frischmann, *Ba'arets*, 3, 4, 5, 6, and 10, for repeated allusions to both poems by Halevi.

7. Cf. Frischmann's negative assessment of women's Hebrew speech, "Letter No. 14," in Part V.

8. Cf. Rakovsky's call for the establishment of a national Jewish women's organization within Zionism and for female suffrage in Jewish communal elections in *Di yiddishe froy* (Warsaw: Bnos Tsiyon, 1918), 28, as cited in Rakovsky, *My Life*, 14.

9. Shapiro's own words about Jewish women in "The Image of Woman in Our Literature," later in this part.

10. See Shapiro's essays "On Literature" (1908) and "On Our Criticism" (1934).

11. See *Ha'olam* 2.40 (9 October 1908/14 Tishrei 5669), for example, where Pukhachewsky's story immediately precedes Shapiro's essay.

12. For a biography of Elisheva, see Yaffa Berlovitz's entry in *Jewish Women: A Comprehensive Historical Encyclopedia*, s.v. Elisheva Bichovsky, http://jwa.org/encyclopedia/article/elisheva-bichovsky (accessed 1 September 2013).

13. In addition to poetry, Elisheva produced prose, essays, and literary criticism.

14. To raise money for her family, Elisheva left her husband and daughter in Palestine in the 1920s and embarked on paid tours of Jewish communities in Europe. See Berlovitz, "Elisheva Bichovsky."

15. See "Elisheva the Poet" in this part.

16. Shapiro had no access to Hebrew periodicals for five years; Letter from Shapiro to Brainin (3 March 1919), Letters to Reuven Brainin, Correspondence III, Box t, Jewish Public Library Archives, Montreal.

17. See the discussions on stereotypes and self-fashioning in the Introduction.

18. For the proliferation of memoirs of great men by Russian women writers, see Zirin, "Particle of Our Soul," 100.

Reportage

Notes from My Journey to Eretz Yisrael
Originally published in *Hed Hazeman* (1911)

Frequent travel is one of the distinctive signs of the era in which we live.

People travel not only for research, out of curiosity, or for the sheer pleasure of a trip. Some travel for none of these [reasons] at all—they *suffer* traveling only to discharge their obligation—so that they will be regarded as "cultured."

But how different is our journey—that of the people of Israel—to the Land of Israel!

It has nothing to do with research or for the sake of taking a trip or curiosity in the ordinary sense.

I've been in different lands and different states. I thought that no new journey could surprise me anymore. After all, lands are similar as are people; up close, even the customs and ways of the various European peoples are the same.

Although I hadn't yet arrived at my destination, I sensed already the vast difference between this journey and previous ones.

"The Land of Israel"—the ring of the name alone is enough to arouse extraordinary feelings in us as we draw ever closer to that land, which we have dreamed about since childhood, been told of forever, and read about from the time we began to understand our holy books.

We yearn to see not only the "the Holy Land" but also that land where our heroes fought, where our kings ruled, and where our forefathers "created" our chronicles.

After all, with each and every step, we will be encountering the memory of those events, and that alone will be enough to rouse our hearts to beat with strength, with reverence.

This is what I myself assume from the start, even before I set foot on the land of our forefathers. I am sure that this is the expectation of most Jewish travelers as they draw close to the Land of Israel.[1]

For the Hebrew heart that suffers in foreign lands, in a place where people humiliate him mercilessly and trample upon his feelings without pity, the Land of Israel is a like a cup of consolation, a beacon of light and a safe harbor bequeathed to him by our forefathers, from the days of yore. To our sorrow, it is a mere memory [of what it once was], and yet it is a memory nonetheless, of greatness and glory.

That same suffering heart takes some comfort in the memories of this great past and yearns to ignite the dimmed sparks, his former appreciation of its value. By way of this, it yearns to rouse and strengthen its presently crushed spirit.

Onward, onward sails the ship, and I stand leaning on the railing, my eyes cast toward the distance.

It is a dark night. The heavens and the sea seem as one; only the white waves left in the ship's wake distinguish between them. The air is filled entirely with mystery. There is a hush all around. All of existence has been gathered up from the earth, or somehow I have become sequestered from it. There is no memory of the noise and tumult of the earth's creatures. Here the sea rules. It alone pours out its dominion and its might.

And even so, we have triumphed over it: We are sailing and passing over it!

And I am looking out at my surroundings. The sea is one thing entirely, wrapped in stillness, quiet on its face. Its waves are lifting us toward the land of our forefathers. Blessed it all is to me!

I have always admired the vastness and the splendor of the sea, its secrets and mysteries, its vastness and glory. I am now connected to it. For two days I have been upon it, looking at it, the changes in its appearance and its numerous facets. At any time and moment, I find some change or other; I discover something new that I hadn't seen before.

And the other travelers are hiding away inside the four cubits of their compartment, or they are gathering in the hall and busy playing their games. It is hard for people to separate from their mundane diversions even at these exalted times.

The sea has had its revenge on me, as though wanting to show me that it is not we who have triumphed over it; rather, it rules over us. For two days I have been lying down unable to move from my place. The waves have been flinging the ship around

1. Before journeying to the Holy Land, visitors would typically envision it in these mythic terms only to confront a different reality upon arrival. See Ross-Nazzal, "Jaffa and Jerusalem."

cruelly. The sea wants to presents itself to us in all its exaltedness—not in its tranquility, rather its anger.

From every corner one hears the groaning of travelers, all of whom have not yet acclimated to this and have become seasick.[2] It was difficult to stand in one place, and even when lying down, I almost fell out of my bed.

This situation continued for two days; however, on the morning of the third day, we approached the coast of Egypt.

All the travelers hurried to go up to the deck. In just a short while they will leave the sea and its murmurings, the sea and its sicknesses. Eyes are jubilant and tired, greenish faces start to change appearance, and gazes are all fixed on the city and its coast—the coast of Alexandria.

Feet have trodden on land and here it is: a different land, different air, and such different and strange people!

Among the types of people assembled on the coast, pressing and being pressed one to another, there is one of every kind: Arabs, Egyptians, Negroes, Jews. All of them are speaking some queer tongue, which apparently isn't rich with words, for the speakers are filling in with cries, grimaces, and strange sounds. And all these creatures are rushing, running, and pushing one another; everyone is screaming, snarling, and shouting.

And the European stands and is stunned.

What sort of strange place has he entered, a place where no one recognizes or acknowledges his customs, ways, and manners. They push and press upon even him and pay no mind to him or to his shock.

Everything that we are seeing is so interesting, so new—an utterly different world!

It's not just the newly encountered language and mores that are strange, but also their clothes and manner of dress.[3] No man seems embarrassed before his peers, and no woman seems to adorn herself for others. The men—their clothes are part tunic and part coat. Their heads are wrapped in various shawls or covered in a striped cloak that unfurls all the way in [to the ground]. And the women—there, too, is no sign of millinery. There are no traces of ostrich feathers or flowers, and instead of these—a huge woolen black kerchief; and in the nose, a gleaming nose ring tied from below to the

2. Shapiro returns to this subject in her reminiscence of Frischmann, see "Memories of Frischmann's Life" later in this part.

3. On Western women's fascination with the veil, see Fischer, "Pantalets and Turkish Trousers," 123.

ears, and the same black fabric that is on the head is tied to the nose ring as well and covers the cheeks, the mouth and the chin, and falls all the way down [to the ground].

How one of our women would shudder if forced to wear such a getup! How her eyes would blaze were she compelled to act the role of a woman with mouth and face covered up.

We travel on from Egypt—from Port Said to the actual Land of Israel. Today is a clear day. The sea and the sky share the same depth and color. The glow of the sun is reflected in the sea, which submerges its rays and raises them up once again onto its surface, refined and purified by the radiance of its waters.

The sky is reflected in the sea and the sea in the sky, and all is steeped in magnificent light.

And underneath that clear sky, covered by not a single cloud, and upon those very sea waters that were frozen in their radiance, one's personal demands are quieted, silent and hidden for a moment in a moonlit corner of one's heart, and one forgets for a moment even the sadness and sets aside even the throbbing pain. Only longings grow here.

They are many and sad; they spring up and rise and wind around the heart—and hum with distant hopes.

In the distance the hills of Judea are already visible—and the heart quickens its beats, for soon we shall be arriving at the shores of the land that we've been dreaming about since the days of our childhood.

The time has come. Upon the land that our forefathers mourned the sweat of their brows and the blood of their hearts—our feet are now treading, the feet of Hebrew travelers, and I am bowing down before the spirit of our great forefathers that hovers over this land, our homeland.

Haifa is the first city in the land where I disembarked, or more correctly, where I climbed and rose and was taken out of the little boat onto its shores.

Its appearance, with its hills and valleys and lovely grounds, brings to mind one of the cities of French Switzerland.

However, its most beautiful spot is Mount Carmel, which rises miraculously from its midst. When you ascend this mountain and look from a distance at the entire city sprawled out before you, and when you turn your eyes and see the Kishon River that runs and twists and is drawn forth there in the distance, and when you see the beautiful paths and boulevards, the olive trees and the fig trees and the palms planted on the right and on the left and the red flowers peering out between them—and above all of these the blue skies, the clear Eastern skies—then a feeling of beauty steals into your heart and you say: How lovely and splendid indeed is *our land!*

But the reality, the bitter reality! As soon as you reach the summit of the mountain, you find homeowners, residents, and none of our kind. One resident is a German who

has lived here thirty-five years—on this mountaintop—who has worked this land and made it a lovely dwelling place, planted gardens, built himself houses, and carved out a wine cellar, and his spirit did not falter when he did not succeed at first, and finally now he sees the great reward for his toil.

This is the power born of desire and labor!

And this Christian shows us the trees that he himself planted and that have now become a little forest, covering the lovely lot opposite his house—at the top of Mount Carmel. Bitter irony! And this same Christian speaks to us with confidence: "*You will yet return to this land.* It is impossible otherwise, this land, where your prophets were, it must become yours!"

And I look at this Gentile who is making the promise—at his house, his gardens, his orchard, his land, and his portion—I look at him and envy him more than our brothers of the first rank who live in Moscow.[4]

And from the mountaintop the German colony can also be seen, and it is splendid and wide as the eye can see. Indeed the Germans there can serve as an example for our brethren settling in the land.

And one can also see the place that has been set aside for the construction of the Hebrew polytechnic [ultimately, the Technion in Haifa]—and the desire grows great to see it already built.

The road from Haifa to Zikhron Yaakov[5] is gorgeous. One travels the length of the shore, close to the sea itself.

The route brings to mind the Riviera in Italy, but here one travels not in rapid transit but in wagons hitched to horses, and the horses make their way slowly through the deep sand on the beach, and the waves cover and reach right up to the wagon where you're sitting. The view is so beautiful, so gorgeous and original—you don't complain at all that the forces of refinement and "culture" have not yet arrived here, and nothing is lacking in the natural beauty. Even when the wagon driver stops his horses and asks—or to be

4. A reference to imperial Russia's estate (*soslovie*) system, which classified inhabitants according to occupation as well as ethnic and religious minority. Jews who resided in Moscow and St. Petersburg, in Russia's interior (beyond the Pale of Settlement), were regarded as the most privileged of their society.

5. In 1882, 100 members of Hovevei Zion (Lovers of Zion movement) from Romania purchased land in what became known as Zikhron Ya'akov with the hope of settling it. When rocky terrain proved difficult to farm and malaria broke out, resulting in deaths, few remained. By 1883 the philanthropist Baron Edmond James de Rothschild decided to develop the land and named the city after his father James (Yaakov).

more exact, decrees—that you disembark and walk by foot, you accept this decree with love and you take small steps so that you can savor the views before you.

On Friday before evening we arrived at Zikhron Ya'akov. I had barely shaken off the dust from the trip when I set out immediately to see the place. For the very first time in my life I felt myself in an *entirely* Jewish atmosphere.

The houses are Jewish houses on a Jewish land, and the men, women, and children are all entirely Jewish, Jews who are free in spirit and soul—this is what I felt the moment I went outside.

A young woman who stood with her friend next to the gate of her house, whom I asked where the road led, immediately entered into a conversation with me and offered her services to accompany me. Right away she told me her name and that of her friend—farmers' daughters—and we became like sisters. Such a closeness we felt between us. They looked at me with curiosity and compassion—as though at one of their sisters who had come from a terrible place about which they had heard only rumors. After all, they had never seen any other land. Here they were raised, and here they wish to remain for the rest of their lives.

We turned and walked to the hospital, a beautiful large house that stands at the foot of the mountain with a beautiful garden. This institution, like several others, was built with the money of Baron Rothschild, who spent immense sums on this settlement. Only two sick people were found in the house, and the female medic, an intelligent young woman from Odessa, took us around and showed us all her plans, and in the midst of that she told about all the tribulations she experienced until she grew accustomed to the conditions of this place. The physician, Dr. Yafeh, an accomplished physician, beloved and respected all over the district—one of our idealists—lives in Zikhron Ya'akov. When he settled here, he didn't even know how to read Hebrew. Now his children speak only Hebrew and they are being educated in a Hebrew spirit, and also he and his wife have already learned how to speak Hebrew.

Next to the hospital there is a large field where the men and women of the settlement like to stroll in the evenings when they have finished their work, especially on the Sabbath. The young women showed me this field with particular fondness. Indeed, illuminated by the light of the moon, the field appeared as though it were bathed in tranquility.

When we returned to the streets of the settlement, we met up with an entire convoy of girls walking and strolling and laughing. I asked them to sing some song for me, and they immediately assembled into a semicircle and lent their voices in song.

The impressions that I received in the Land of Israel were many, but the strongest impression and the greatest pleasure that I had was when I stood amid that semicircle of girls as they sang folk songs.

Here were Hebrew girls, healthy in body and soul, each one of them pulsating with a united Hebrew spirit, free of any internal or external burden, singing songs of Zion on their land and earth—is there a better sight to gladden the heart?

I appreciated the eastern land, the blue skies, and the beauty of nature here most of all while standing under the canopy of the sky, and the ringing, invigorating voices were heard ever stronger: "To be a free people in our land."[6] And from a distance other children's voices joined in, approaching ever closer.

On the Sabbath the youngsters go outside the settlement to their most beautiful hiking spots, walking, humming, and singing the song "Teḥezaknah"[7] among the hills and valleys there.

And the groups of hikers who meet converse in Hebrew, and the children play in Hebrew—*and the speech is so natural, so alive!* They should come here, I thought—all those who say that the Hebrew language is dead and cannot be revived, they should come here and listen to it ring out from the mouths of these young boys and girls playing here, and let them deny the viability of speaking in Hebrew!

But there was one thorn in my happiness. I remembered our youngsters in the lands of the Diaspora; I remembered their shame in play, when their friends mention the name "Jew." I remembered—and my happiness here ceased.

He who is forced to educate his children in the lands of the Exile is filled with envy when he comes here and sees these youngsters who have grown accustomed to an environment that is close to their heart and to their language and their spirit—the spirit of their people.

My soul grieved also in my remembering *here* in this place of spiritual freedom, those youngsters *from there* who are situated under entirely different conditions.

The second settlement that I visited was Hadera, where many Hebrew souls fell victim to the evil malaria, which prevailed there before diligence, patience, and strength of spirit succeeded in transforming this swampy place into a lovely place, spectacular to the eye.

Hadera is one of the settlements that brings to mind the most beautiful and tranquil summer resort.

The entire settlement is nestled amid refreshing boulevards of young trees.

And the residents of this settlement?

Nowhere else have I seen people so devoted to their ideas—no, not to their ideas, rather to the realization of that which has already become for them an absolute fact, a reality, which they would sooner die for rather than deny: that is, the revival of their people on their land, which they are preparing with their blood and souls.

In no other place have I seen people so connected and conjoined with their soil and their land as in this settlement—people entirely prepared at every moment to sacrifice

6. The words derive from "Hatikvah" (The Hope), anthem of the Zionist movement and, later, the national anthem of the State of Israel. The words were written by Naftali Herz Imber in 1877, and Shmuel Cohen set them to music based on a Moldovian-Romanian folk song (which is used as well by Bedřich Smetana in *Má vlast* [My Fatherland]).

7. Hayyim Nahman Bialik, "Birkat 'am" (Blessing of the People, 1894, also known by its opening phrase, *teḥezaknah yedeikhem* (Let your hands be strong); Cf. 2 Samuel 2:7 and Zechariah 8:9 and 13.

their lives for its sake. And they give themselves no special credit for this, no more than a mother who is devoted in her heart and soul to the child of her womb would, which is after all a natural thing.

That which one cares for and cultivates with the sweat of one's brow and with the blood of one's heart naturally becomes beloved and precious.

And the people there, how great is the excitement of their souls! How immense their enthusiasm!

It is enough to see them for just a few minutes to be convinced that some holy spark burns within them and some exalted idea impels them. Even one who essentially opposes this idea bows his head [reverently] before the sight of the innocence and purity with which this idea is reflected, the courage of heart and strength of spirit and the unrelenting desire with which it is being realized.

There are people in this settlement who know nothing else and speak their minds about nothing else, for whom all else is trivial in relation to the grand principle that altogether fills the content of their lives.

And the principle is—it is self-evident—the people of Israel and the homeland!

And this principle is not theoretical for them but actual.

I was full of pride in this settlement when I beheld the *shomrim* [guards], the watchmen of Israel, who actually endanger their lives on a regular basis, by defending the settlement and its property in the face of angry Arabs who attack them. And when I beheld these youth of Israel, riding on their horses like real brave men, their upright carriage and their direct glance, once again, memories arose of our youth in the lands of the Diaspora.

How long the journey and how vast the difference between these brethren!

Oh, the bitter conditions!

In the evening, we arrived in Jaffa.

Jaffa is a large city, but there are no pleasant smells at all that waft from its streets.[8]

The hotels are large, the shops are large, the restaurants are large, but everything is so foul. The Arabs are not a clean people. You have to see the shops and their owners. When, for example, they decide which fruits to put on display, the Arab merchant will grope the figs and the dates with his filthy hands, so that you become repulsed by anything you choose. And he is astonished if you to ask him to pack up the fruit in a cleaner wrapper.

The Arabs pay no attention to anything that transpires beyond here. I did not see a single Arab reading a newspaper in their cafes, but I did see Arabs, both inside and

8. Cf. Pukhachewsky, "Mishut ba'aretz," 518, for the dirt in all sections of Jaffa, not only the Arab ones; and also Frischmann, "Hayada'ta et ha'arets," 2. A third traveler wrote: "Jaffa means 'beautiful' but somehow that meaning was lost on its inhabitants" (Ross-Nazal, "Jaffa and Jerusalem," 205).

outside these cafes, sitting around all day long and smoking at rest and in tranquility, which is a wonder to the born-and-bred German.[9]

The complete opposite of this city and its smells is the large suburb right outside it, the new Hebrew urban settlement Tel Aviv.[10]

All the buildings found there have been built over the last five years—the settlement was established after Herzl's death [1904]—and already their number is vast. Cleanliness and fresh clean air prevail throughout the suburb.

From a distance the Gymnasium rises up [like a flag] in its glory, a large beautiful building, and pretty, wide streets branch out from it, which are called only by Jewish names: Herzl Street, Lilienblum Street, Ahad Ha'am Street, etc. And all these streets and all these wonderful buildings are inhabited by nationalist Jews, and the Hebrew language predominates there, an altogether Hebrew atmosphere.

And from the balustrades of the attractive buildings erected here and there on the rooftops one can see the sea from the distance, the nearby orchards and the distant fields, and the beautiful mountains and valleys.

In this part of the city, no one needs to be ashamed, not even before the German owners of settlements in the Land of Israel.

Here the Germans might even be able to learn something from the Jews. If we recall that five years ago this was an open expanse without any settlement, one cannot but be astonished by the Hebrew diligence with which all of this was created.

And the Gymnasium? Many have already written about this institution, and I would only like to mention those few things that I hadn't at all anticipated.

I entered the Gymnasium a few times, each time accompanied by different people. One time, people came with me who were very distant from the "spirit of Judaism," [that is,] they were not at all ready to devote their souls to it; another time I went there in the company of men who zealously defended antiquated educational methods. Upon leaving there, there were two in the first group who decided to send their children—a 10-year-old and a 12-year-old—to this Gymnasium. And there were those in the latter group who, despite their misgivings about this type of education, bore expressions that attested to the fact that they too were won over. Indeed, people see here before them a Gymnasium designed in good taste, boys and girls being inculcated with a national spirit, and teachers who recognize their mission; they see a friendly and close relationship between teachers and students, children who *eagerly* pursue their studies, young boys and girls, for whom

9. Motivated by the belief that redemption would come only by inhabiting the holy land, a group of German Protestants (Templers, members of the Tempelgesellschaft [Temple Society]) founded an agricultural colony in 1871 (the third settlement in the Land of Israel, after Haifa and Jaffa), which they called Sharona. The colony became a model for Jewish nationalists, who began to settle in the area in 1909 and built a modern city they called Tel Aviv.

10. A group of writers in Tel Aviv allegedly held a party in Shapiro's honor. See letter of M. Shapiro in Caro, *Kovets letoldot*, 36.

the Hebrew language and Hebrew legends are routinely on their tongues—can one see all this and not be taken in?

No extra exertion is even needed there to plant the Hebrew spirit within the hearts of the students. After all, the entire surroundings are Hebrew, the language that prevails is Hebrew. One hears no other language among the children. The teachers who supervise them and even the guards in the Gymnasium are Hebrew nationalists.

One female student, who came from Russia and who studies now in the Gymnasium in Jaffa, responded to my question as to whether she misses the country where she was born: "I would not want to return to the land of Exile, if only for the reason that there one must study in a foreign language rather than in *our own language.*"

I, a daughter of the Exile, who comes from a land where people do not take pride in "our language," from a land where the educational conditions are so abysmal and miserable, where the children are distanced from their fathers even from childhood, and the eyes of the parents see this and become rheumy—how I envied the happy parents here when I recalled the tragedy of parents in the lands of Exile.

Here in Jaffa, in Petach Tikvah, I saw homes where parents were compelled to speak Hebrew with their children, homes where *parents* are being inculcated in nationalism by their *children*, the [so-called] *students.*

Can you imagine such a sight among us [in the Diaspora]?

On Purim eve I saw the play "The Sale of Joseph,"[11] presented by the students of the sixth grade.

Watching the acting on the stage and hearing their melodious words, in the language of Joseph, his brothers, and their elderly father, I said to myself: These are the true grandchildren and great-grandchildren of these legendary forefathers; only these little mouths, who know how to speak this visionary language, are worthy of it.

And it seems to me: Indeed *only here*, in this land, in which our forefathers spoke thousands of years ago also in *their language*, in this place where the thread is sensed that ties us to thousands of memories from back then—only here is the national revival possible.

And indeed, anyone who sees this younger generation here that is filled with self-awareness, who sees the healthy and happy young boys and girls exulting in their freedom, their language, and their exalted land, who sees their erect carriage and disdain for enslavement and submission, cannot help but proclaim that these are our free people and that hope is reflected for us only in a generation such as this one.

From Jaffa to Jerusalem—the only place in Judea with a rail line—the journey takes approximately four hours.

The environs are beautiful and strange—mountains, valleys, rocks. Each one evokes another chapter in the chronicles of our people, and each is so near and dear to the heart!

11. Cf. Genesis 37:25.

Suddenly, here is the stop for Beitar[12]—how many memories! The multitudes of brave men who fought on these mountains and in these valleys emerge and materialize in our minds' eye, and it seems as though their spirit hovers here, not wishing to depart from the places so beloved to them.

We have arrived in Jerusalem, and the great past in its entirety, along with our destruction, rises up before us.

The pious Jews rend their clothing. The heart fills with emotion. Here is that same city, our former glory—here is that place, that same place.[13]

The eyes open wide and beseech, and the heart trembles here and overflows with sorrow.

The city is a wonder of its kind. Its natural sites are singular and spectacular. Walls and valleys surround it, all recalling ancient days.

The first pathway for the Jew who comes to Jerusalem is most obvious—to the Western Wall!

Whether or not there is holiness here, it is, ultimately, a remnant of that same house "named for God," and the entire people mourn its destruction.

And leading to that edifice are streets so narrow and filthy, such that I have never seen stench and darkness like this in any place before, and the poor and the beggars there pounce upon you from every side. I am reminded in this place of the aphorism[14] "Poverty is befitting for Israel." I object to it with full force. No, poverty is not befitting Israel at all!

Even the Jew is more capable of awakening the heart and becoming one with God in a spacious, majestic place. A splendid building, like that which once was *beit beḥirateinu* [our Temple, literally, our chosen house], is more likely to arouse him both to prayer and a soulful outpouring; and no one back then said about those who made a pilgrimage to it that poverty befitted them.

Remembering this is enough to make us lament that destruction, which led us to such aphorisms and to detestable poverty and banished us from home and land.

Who knows how much ornamentation, glory, and beauty used to reside in these particular streets that we pass through now but that bear no trace thereof, as though there were no memory of the joy of those who previously passed through here with drums and dancing.

12. Beitar is the site of the final battle of Jewish rebels against the victorious Romans in 135 CE.

13. Note the repetition of the word *place* (*makom*), a traditional Jewish designation for the divine found in the customary blessing expressed to a mourner: *Hamakom yenahem etkhem betokh she'ar 'aveilei tsiyyon viyerushalayim* (May God console you among the rest of the mourners of Zion and Jerusalem).

14. Shapiro's use of an aphorism is noteworthy in light of her dissertation, which she had only just completed, on Georg Christoph Lichtenberg (1742–1799), who gained renown as one of the Western world's great aphorists. See also Shapiro's article "Aphorisms and Typical Principles" (1914).

There is only a single memory, a remnant of what once was. It stands as a testament to and reminder of our past glory.

Can those of other nations, who come here to the Temple ruins and see only the remnants of an ancient holy place, understand the emotions that these Temple ruins provoke?

The first moment that I stood directly before the *kotel* [Western Wall], I was dumbstruck. The same remnant that stands before us is as it was then, in the time of its destruction. The markings of thousands of years that have been imprinted upon it do not attenuate the impression of the ruin. This same remnant suddenly reminds me of entirely different times, when the House was perfect in its splendor, and the people, who made the pilgrimage to bow down within it, were joyful and merry, a happy and strong people, living on its land, conscious of its dominion and bravery—and then the Great Destruction, the destruction of the Temple and the nation.

It is not for nothing that the *kotel* is referred to by other nations as the "Wailing Wall of the Jews" (*Klage-wand der Juden*). The ululation and ear-splitting cries that are perpetually heard when one is nearby rend the heart—the cry of despair of a chased and tortured people who pour out the pain in its heart and lament its destruction before the extant monument that reminds [the people] of the good days of yore.

But I myself didn't sense anyone around me then. I did not absorb the laments and the wailing nearby. I was alone with my own pain, which was sharpened amid the thousands of my people's sighs that permeate this remnant.

And here I am on the Temple Mount. The great pride of our ancient people. Here is the place where our forefathers battled to protect it from the attacking enemy.

And their [i.e., the Arabs'] place of worship stands in its stead and the Temple is *their holy place*, and we are forbidden from entering there.

And from there, onward to our ancestors' tombs: the graves of the kings of the House of David, the holy graves on the Mount of Olives. But my heart does not follow the dead when I stand on this mountain and I behold the wondrous sites that surround me: the site of the city of Jerusalem that reveals itself below in all of its glory, the hills and the valleys now illuminated by the dazzling rays of the sun, the Jordan that is visible from a distance, and Mount Zion that I am scanning right now, bringing greetings from those distant children who long for it.

Here is Mount Moriah. Here is Absalom's memorial. Here are all those same places from back then, where our kings, wrapped in glory and splendor, would pass by, where our prophets, seers of God, strode. Here they dreamed their dreams and expressed their thoughts so that they would not be forgotten from the land so long as the last man was upon it.

And the sites everywhere are wondrous, and the entire place is enveloped in holy splendor.

Rights and Obligations
Originally published in *Ha'am* (1917)

The hour of liberty and freedom [is at hand]. The many voices of all those who had been stifled and subjugated until now are rising up and merging.

Multiple [political] parties, entire peoples, diverse human beings seeking rebirth, light, liberty, a free life, are making themselves heard.

The voices have joined together in a unique harmony, a raging symphony.

Citizens have begun to recognize their worth and strength and are demanding their due. Work, freedom, air, light, and a life of liberty.

And in the midst of this cacophonous symphony the soprano of woman is also expressing itself increasingly.

While the voice is gentle relative to the many other strident voices, nevertheless this gentleness does not weaken its impact.

Even strength and bravery have been heard from the women's camp. A brigade of [female] soldiers, a "Battalion of Death," intends to prove this at the front line, by going out first to battle.[15]

This is a demand that testifies to exceptional and surprising courage.

But even beyond this, one hears women's voices demanding equality and recognition, the abolition of slavery and the conventional derision and negation [of women].

One can now enumerate three main types of women's groups in Russia:

1. An association for the protection of women that has no political agenda whatsoever

15. The First Russian Women's Battalion of Death was the first and most famous of fifteen all-female units created during World War I. Maria Bochkareva organized it in 1917 under the direction of the minister of war. This was not a feminist initiative on the government's part; the underlying idea was that the formation of female battalions would motivate demoralized male soldiers to fight by shaming them.

2. An association with an agenda that includes only the demand for a democratic republic,[16] which is engaged in no other matter, in that their main objective is to attract a sizable constituency of nonpartisan women, who would be afforded the opportunity to be counted among its members

3. A democratic republic association whose political agenda consists of different platforms

At the Women's Conference in Russia, which took place in Petrograd, there were disagreements among the different parties, although the essential demand shared among most of the female members of the various groups is the affirmation of their equal rights.

Differences between the various associations notwithstanding, their principal demand is one and the same.

The women's liberation movement began in Russia in 1893. The first [female] fighters [for this cause] were those thirsty for knowledge and higher education, before whom [the doors of] Russian [schools] had been closed.[17] That was a cultural movement. Its basis was learning [Shapiro uses the word *Torah* here]. Now the times have changed and so too the demands.

This liberation movement has now taken on a political form, and women whose needs are not only cultural are participating. Thus the movement has taken a new direction.

This is not the place to advocate for women's rights or to plead for the righteousness of their demands. I only wish to point out that the voice of the *Hebrew* woman has yet to be heard in our camp. If women are organizing in the general society, this does not exempt us from our national obligation.

We Jews have always been the most enslaved [people] in Russia, and now that we have thrown off the yoke and achieved liberty, we the liberated feel first the great obligation cast upon us as a people: the obligation to be concerned about *the perpetuation of the people and the freedom of the people*. A people who has been made free must safeguard its existence and its freedom, and *Jewish women* are no exception to this rule.

We are not allowed to forget that this obligation bears down on us now more than ever. It is incumbent upon us now to remember that many of our brethren are found on the battlefield, in the crosshairs, in exile, in captivity, and their places are obvious to us.

16. The Russian Democratic Federative Republic was a form of government proposed during the Russian Revolution of 1917. It was formally declared by the Russian Constituent Assembly election, 1917. However, because the Assembly was dissolved on the same day, so too was the republic.

17. For a discussion of women's education in Russia, see Introduction.

And if we are forbidden in general from standing at a remove from a folk, political, or national movement, from retreating into our narrow interests, then now our brethren, who are separated and distanced from us against their will, compel us to engage in any work whatsoever of which we are capable or possibly capable.

Right now we are not allowed to discharge our obligation through pretty phrases or not-so-pretty phrases alone. We are not allowed to pay heed to the stinging ideology of some of those in our midst.

The obligation cast upon each *one* [female singular] of us now is to help and work wherever possible.

Like that women's battalion, which calls itself the Battalion of Death, we need to help out on the front lines of *our people*, even if it is far from the killing fields. If we are fated to live in a historic era such as this, we must bear witness to it. We are not exempt from the responsibility that fate has cast upon the people, which the people have given themselves. In those places where it is possible to bring about good for the people and their land, we are obliged as members of a people [to do so and] to forgo all other work, come what may.

I am not outlining here a work program for the daughters of Israel. I am certain that each one will find her own suitable way, so long as the awareness of the obligation cast upon her lives within her heart, so long as she realizes that she must help, provide benefit, and work. This is needed everywhere, in every place, and in every area of expertise. But what is needed first is *awareness*, an *awakening* from inertia. Where there is living awareness, there is also fruitful work.

Awareness is the principal catalyst for the development of the individual as well as a people. Thus the success of a people's work depends on the measure of its awareness. It is pointless to think that it means nothing if the vast majority of the weaker sex has no awareness of the importance of this era in terms of national demands and aspirations and considers its participation in all of this beside the point.

We [Jews] are not so large in number that we can forgo such a sizable and crucial force [as women].

I know personally many of the sworn enemies of women's liberation who were in the habit of responding to this emancipation movement with ironic laughter and who celebrated every time there was some impure incident that would allow them to lay blame on all who strove for emancipation in every aspect and in every field.

How they mocked and belittled those who were thirsty for learning, as they referred to those who sought higher education in the universities abroad. How much determination these women needed, immense desire and courage, to stand their ground and

maintain their autonomy, when they were being mocked from all sides and treated as though guilty in some way.[18]

By now they have changed their method: Some of the sworn enemies have, in their great kindness, admitted that indeed there are some fields in the sciences and arts where women *should* be allowed to participate. Now they have opened the gates of institutes of higher learning in free Russia before those women who aspire to an education, and women no longer need to be ashamed of themselves, not one iota, for their [formerly] forbidden aspiration.

To our chagrin, as shocking as it may seem, we have [female] *opponents in our midst*, that is, among the ranks of women themselves.[19] They oppose [education] not with known proofs but rather, simply, out of negligence and a habit of stupidity, out of a lack of energy and self-confidence. The slavery of many generations has imprinted itself on those of our sex.[20]

The women of the democratic ranks have too much faith in the intelligence, reach, and abilities of their men and are overly confident that "they" [the men] will arrange everything in the best possible way. And among the bourgeoisie, most women distrust the women's movement in general as a threat to a system that is all well and good in their eyes.[21] A husband is inclined and *obligated* to give his wife all kinds of jewels and pretty dresses and so on. So why change the established order?

Even in free Russia, where they already acknowledge women's rights and concede to matters yet demanded, women have still not stood up themselves for their needs. This now depends on them, on how much they make it a point to organize and demand equal rights in practice.

However, this is not what I wish to treat here. I want to repeat that we will not discharge our duty simply by forming women's associations for the sake of achieving our equal rights. We must remember at this time that our first obligation is to that which we owe our *people*. [. . .]

I attended two regional Hebrew conferences, and at both the number of woman delegates was almost nil. This attests to the fact that Hebrew women still stand at a remove from all social movements. I blame the women themselves. Were they not to stand at a remove, were they to participate and prove themselves in the various fields

18. Shapiro's praise seems self-directed as well, given her own efforts to study abroad.

19. See Shapiro's sketch "The Dreamer" in *A Collection of Sketches* in Part I.

20. Such an argument echoes those by advocates of Jewish emancipation in the eighteenth century who blamed external historical factors for the Jews' failure to thrive in the mainstream rather than the Jews themselves. See John Toland and Christian Wilhelm von Dohm's passages in Reinharz and Mendes-Flohr, *Jew in the Modern World*.

21. Cf. "Types of Women" in *A Collection of Sketches* in Part I and diary entries for 3 May 1900 and 25 July 1907 in Part II.

of social, cultural, and educational life and not act like exceptions to the rule, then they [the men in the movement] would *have* to take them into account. Were the women to organize and demand their rights, we would not feel so keenly the lack of Hebrew women activists and delegates. We Jews have been at the forefront of so many things and among the great innovators. Why shouldn't we also be at the forefront when it comes to the development of women and their participation in communal and cultural matters? [. . .]

The "weaker sex," however, inclined in particular to the fashion of the day, is largely drawn to those parties that favor the established pattern. Hebrew women often forget that it is incumbent upon them not only to side with the majority but also to be a sign and a wonder [*le'ot ulemofet*], to walk at the forefront.[22] In the same way that they stood at the forefront among those who attended schools of higher learning abroad and stood in the first row among those women in Russia who carried the flag of culture, now too they must show that they understand the great obligation that has been cast upon them as citizens and as loyal daughters of their people.

We must participate in all work for the benefit of the general community but not just as an act of grace [*gemilut ḥesed*] but with a clear awareness of the responsibility we all share. It behooves us to arise and rouse others. The greatest evil at a time like this is paralysis and apathy.

My sisters, arise! Let us not give an opening to our opponents who say that even at a time like this, we [women] stand at a remove. Let us have no need to incriminate ourselves later for our absence when we were needed most.

There are those who say that we have no Hebrew women delegates, no women activists, no women orators, because they [the men] do not choose us; they put us at a distance and do not afford us any opportunities. But it seems to me that the collar is dangling from our own necks. Were we not to retreat to our individual, personal matters and were we not to hang all our hopes on our protectors and consorts, who are *obligated* to care for us, we would not be so distanced, however gently, and so sidelined.

It may be that the coming generation will empathize with the fact that we have been living at a time *so* rife with pain, worry, and blood. Even so, they will surely judge us as part of a generation that made great history: If just for the sake of generations to come, it is incumbent upon each one of us women to do all the good, beneficial, and necessary work that we are capable of doing.

Slavery and submission were never counted among those things that exalt the soul, and if we fight for our liberation as women, we need along with this, or even first and foremost, to remember the cause of our liberation as a people.

22. Cf. preface to *A Collection of Sketches* in Part I.

A vital movement, vital work, and vital deeds save a human being from ossification and from moral and intellectual somnolence. It is not through doubts and lethargy that we shall achieve personal development and spiritual liberation from the yoke of convention, communally and individually. Rather, it is by a spiritual movement of awakening.

Work will be found for us. Let us [women] not remain in the background at a time like this. Let us not surrender to indifference at a moment like this.

You Must Not Forget!

Translated by Saul Noam Zaritt

Originally published in *Ha'olam* (1919)

To repeat things already known to the entire world is to waste words.[23] But the following things ought not only be repeated and memorized in people's somewhat deaf ears but rather be blasted[24] over and over until they enter into the hearts of those who are hard of hearing.

After all, it is impossible for the annihilation of an entire people to take place, for revenge to be meted out against one nation alone, for thousands and tens of thousands of souls to emerge with a clean slate and with no fear of standing trial, the only measure that might stop the beasts of prey and their leaders from rioting to their heart's desire.

What is being done to us is unheard of in the whole world. Do they not kill and violently rob and plunder for nothing at all? The children of Israel are brought to slaughter by the thousands, not by war, not by battle, but without the capacity to stand up for their own lives and the lives of their infants, and not for the sake of some "ideal," whatever it may be, but solely because Judaism is considered unacceptable.

Killed for the sanctification of God's name, slaughtered because of no wrongdoing, tortured with all the most terrible kinds of torture, such that only the insane or the drunk minds of half-savages could think up—and all that not even for the sake of the "ideal" held by the great Inquisitors.

Only one who lived in that environment, now soggy with the blood of our casualties and the marrow of our youth, only one who has heard the howl of an entire nation groaning in its destitution, the outcry [*tsaʿakat shever*][25] of many groups of people of destroyed communities, of those victims who waver between life and death, only one

23. Evocative of the halakhic concept of *berakhah levatalah*, which means a wasted blessing, uttered when there is no obligation to do so.
24. As in the blast (*tekiyah*) of the shofar (ram's horn).
25. Cf. Isaiah 15:5.

who has nursed the sorrow of those who survived, who would be better off dead than living, knows the greatness of this calamity.

These things cannot be expressed in words. One would need to roar like a lion to release the pain buried in the heart.

How can it be understood? How can it be expressed before those who stand outside our experiences?

How can it be described for them, so as to move the heart to action?

Not to force them out of their complacency—that is not my intention—but rather to force them to see and hear matters as they are and not to give a hundred and fifty excuses [for not listening].[26]

From the day I escaped from the bottom of that abyss, not a single hour has passed during which I have been able to forget the horrors and deeds that I witnessed there and that were witnessed by thousands more of my brothers and sisters. When food gets caught in my throat, memories rise; the [simple] sound of musical instruments frightens the mind, transforming into familiar voices crying out, into the groans of those hidden in basements, caves, caverns, and pits.

I do not know if raising a voice will do any "good," if it will cause more loss than gain,[27] if it will resound *appropriately* among those who are impervious to thought or feeling. All I know is that silence is impossible. Turning a blind eye and ignoring the heart are out of the question.

During the time that I was there, among them, amid my tortured brothers, lips were sealed, silence was enforced. And not by others. Our own brothers were too fearful to utter a sound, to be embittered, to express anger. The individual stifles his own sorrow lest he injure the community. Such fear is so immense and strange over there that in the face of it one bears in silence all the troubles and insults, the sorrow and feelings of vengeance, the private agonies and tortures, so as not to rain destruction on kinsmen or the whole community. Yet when I left there, the cries followed me: "Raise your voice over there, open their eyes. They should know what is being done to us. Are we indeed to be annihilated?" Which "over there" and whose eyes I am to open I do not know, and it is clear that neither did those who called out. But they are convinced that there is a place in the universe where their tortures would receive attention, if only their sighs could reach the right ears. They are convinced that as soon as the forgery and disguise are exposed, their salvation will be quick to arrive.

One who has seen how our brothers greet military personnel, whose uniforms testify that they hail from one of the Western countries, knows their great confidence in

26. Cf. Babylonian Talmud, *Eruvin* 13b, where a veteran student in Yavneh would find 150 different ways of rendering vermin pure. This expression bespeaks legal acumen or flexibility but also a kind of tortured reasoning.

27. Cf. *Mishnah Avot* 5:10.

these countries' integrity. If only our brothers knew the answers given by these heads and leaders to the many questions addressed to them: "The official reports have yet to be received." "The exact number of casualties cannot yet be determined." "It is necessary to wait."

If only they knew—perhaps they would lose some of their confidence, and perhaps, in their innocence, proof for the need to open eyes would grow further. All that is needed is to expose the aggressors, and no more.

And their brothers in faraway lands? Those surely do not know how far matters have come; our brothers in the Western countries have no concept whatsoever of the state of affairs in many of the domains that are being born again [politically]—the domains of pogroms—because it is impossible to describe it even to those who lived there and experienced all its horrors.

It is only possible to call out to these, our brethren: Brothers, remember the wretched, have mercy—not for the casualties, who arouse the envy of many of those left behind, but for the thousands who suffocate in their imprisonment, who waste away in their sorrow and the tortures of their souls, who have no finality, no end, who fade away from cold and hunger and the fear of tomorrow.

If they are to remain there, our communities will turn into one large insane asylum; nerves are stretched to the extreme, and people quake at the faintest sound and view themselves as persecuted every single day. They are terrified of visions and sights that will not leave their eyes; their lives are nothing but a cup of sigh and woe, bitter and embittered by memories. These people have no worldly remedy if they stay there in this condition. They will be sentenced to a life of the same terrifying dreams and horrifying nightmares that will not leave them, so as long as they remain in the places where the deeds happened, their little ones too will suffer the same sentence, growing up in this sick environment.

We have come to realize there that those half-savages who seek to annihilate us are no heroes of spirit. They are not brave of heart either, in the sense of risking their own lives. For the most part they are cowards and faint of heart, submissive slaves by nature, ready to kiss the whip of their tormentor—as long as he has more power than they do or is their commander.

For such humans there is no cure. Or more accurately, there is no defense against their acts of savagery except to threaten them. If they knew that there was retaliation for their actions, they surely would not be so bold and, needless to say, would not put their lives at risk. But they are certain, to our great tragedy, that no harm will come to them. On the contrary, in some instances their leaders will reassure them that they have participated in a fine endeavor, worthy of praise.

Several times I heard these "military men" blame the Jews for all the troubles that befall them, such that they have no means of sweetening the verdict in the face of their worst sin and offense—"aiding" the Bolsheviks.

And those same accusers, as soon as the Bolshevik army enters a well-known province, they take up its cause. These people do not surrender except to whomever has the upper hand. Before him they will grovel like lowly slaves, not daring to utter a sound.

How many times have I heard about the sins of this rebellious[28] people—the Jewish people—from the mouths of those very same murderers who attack innocent souls and put them to death in broad daylight? How many times have they dared to stand and publicly denounce the "Jewish people" in its entirety, knowing there would be no one raising a voice to oppose them?

And how insulting it is to have to listen to "words of reproach" from scoundrels and vile people, from annihilators of lives, without being able to remove the veil of lies from their words; how much spiritual sorrow—not to mention, the heartache—there is in listening to a villain boast about his acts of bravery regarding the *Zhids* [Russian, Jews; generally pejorative].

When one hears these words from the speaker himself, they remain forever etched in his memory. And all the arguments regarding the forgetting of wrongdoing, about forgiveness and absolution to criminals—none of this will remove from the heart the burning sentiment of revenge. In the same way that the faces of the instigators of the pogrom approaching a Jewish home cannot be forgotten.

If in your lifetime you have ever seen a predatory animal preparing to attack its victim, you already have an accurate grasp of the appearance of the *pogrom instigators*. But if you have also paid attention to the other creature, *the would-be victim*, as it senses the gaze of the one about to devour it, if you glanced at it at that very moment, standing there frozen and mesmerized, without even attempting to run for its life, if you saw that miserable and wretched creature at the time of its greatest danger—even then you would not have an accurate picture of the souls of those mesmerized Jews.

The gaze in the eyes of their killers who are about to attack them is lodged within and controls them, freezing the blood in their veins. They are not *capable* of escape anymore; they only nod their heads in memory of a possible salvation.I read words of truth in the declaration of the Kiev Physicians' Association:[29] *The real reason for the pogroms is a desire to plunder and be cruel.*

28. Cf. Deuteronomy 21:18: The Bible calls for the execution of the rebellious son, who is beyond rehabilitation.

29. This organization likely issued a statement protesting Jewish suffering caused by pogroms. Others, most famously Tolstoy and Gorky, had done the same following the Kishinev pogroms of 1903.

All those who have seen the matter up close can testify that it is a veil of lies and a vain accusation, a blindfolding of the truth and a false pretext on the part of those who endeavor to make the pogroms appear "political," to find reasons and other "root causes" for them. The real reason is a desire to plunder and be cruel. And in the face of such desire there is no counsel and no trick—*until the hearts are trained in means*—other than *a mighty hand*.

For in these acts of pogroms and deeds of cruelty the perpetrators do not differentiate between our different factions and class affiliations. Rich or poor, leftist or rightist, extremist nationalist or one who sacrificed his energies to fight for the "downtrodden and oppressed" peasant or farmer—all are considered the same so long as they are part of the Israelite people. The son of that "oppressed" farmer knows how to differentiate nation from nation. Everything is disqualified in his eyes, however, if it originates from Jewish seed.

My relatives and family members, who were slaughtered and killed in different cities, were completely nonpartisan—Jews completely unengaged in any political matter. One was killed by the Bolsheviks; the other for being responsible for the acts of the Bolsheviks; the third for no reason at all. Just being Jewish is enough.

And deeds such as these—some dare to argue—are done to "save Russia" or "save" all of humanity from its oppressors, as though it is possible that such robbers and murderers can save anyone or any "ideal" whatsoever. When they receive their reward, the "saviors" immediately forget that ultimate goal entirely.

And the destroyer, given permission, destroys everything from beginning to end.

The victorious are "preoccupied with higher affairs," and the investigative delegations return as they come with "promises"—or without them, which all come down to the same thing. The heart melts, despair intensifies, and there is not a single spark of light.

They wait only for supernatural salvation and redemption, for miracles from heaven, and in such a state they swallow up every conjecture, every piece of news, and every strange and exaggerated tiding, even if they do not believe any of it.

And if these people no longer had faith and belief in the integrity of the *cultured* nations, if it weren't for that bit of faith, that those who suffer, do so only because the truth is being hidden from the nations—they would not be able to withstand the calamities that rain down on their heads.

Do not extinguish this flame in their hearts! The one salvation that the nations can offer is to increase their actions, thereby reinforcing faith in the hearts of those wretched ones.

For unfortunately and to our great chagrin, the facts speak for themselves, even if intentionally or not, many turn a blind eye to them. We must illuminate these facts *as much as possible*—let people know about them and be horrified. Entire communities are

being destroyed. The bereaving sword goes about and harm is being done. The torture is increasing, senseless torture, and there is no escape from its consequences.

As an eyewitness, I can testify that not only is there no exaggeration, but quite the opposite: I have not seen a descriptive account that even vaguely approximates what is being done there. And this is understandable: Over there we became so accustomed to horrors, to eyes bulging with fear, to mute sorrow, crying and wailing, to the horrific sights, the kind from which the heart either melts or turns to stone—and therefore one who comes from there cannot adequately describe these impressions in the way that he has internalized them.

And if this is the case for eyewitnesses, how much the more so for those who have not lived there and were not "impressed" firsthand by these occurrences that they cannot describe these events as they are.

Do not, brothers! Do not believe the words of those who try as they might to paper over *the events*! To our great chagrin the *real voice* of your brothers who call out for help does not reach you. If it could penetrate the proper places, it would horrify even the most complacent hearts.

Much will become known only with the passage of time.

Raise your voices! Protest with all your might! Demand with every possible means available to you! Try to find proof for the tortured and oppressed that the spark of hope in the hearts of the European people has not gone out, that their distant brothers are with them in their time of trouble.

A thousand arms are outstretched, a thousand eyes are raised, and the voice is the moaning of one heart: Help us, rescue us, hurry and give us refuge, because a pointed sword hangs over the throat of our children and infants!

You must not forget for even a single moment!

Notes from Ukraine

Translated by Saul Noam Zaritt

Originally published in *Ha'olam* (1919)

I

At the beginning of the month of May, the Bolshevik forces conquered the southwestern region of Ukraine that borders Poland. We left our hideouts where we had been sequestering ourselves from Petliura's forces;[30] we started negotiating with Kiev and thought our saviors had arrived.

The Bolsheviks performed the "searches" we had heard about. They looked for weapons, even though it was well-known that the previous regime did not leave such things in the hands of Jews. During the searches, the inspectors did not just seize things that were forbidden to their owners, such as linens, shoes, clothes, and the like. Rather, they took other possessions that they permitted only themselves. They dared to go to the villages only in rare cases, even though the weapons they were looking for were located there by the hundreds and thousands and could be used even now by their owners, who had "served" in Petliura's army, to attack the few Jewish families in the villages, to murder them and steal from them. Now they just adorned their caps with red ribbons and were free to go. No one could take them to court anymore.

And these farmers with red ribbons did not conceal their deceitful schemes. They incited hatred against Jews and Jewish commissars in all public places, in the stations and on the rails. Jews could not travel. The murder and massacre of Jews was an everyday thing that no one paid attention to anymore. And the common folk's gossip about "the Jewish regime" seemed like a bitter farce.

But the Jewish workers knew what to expect from their Ukrainian comrades. The workers in the village factories were forced to flee. In a few cases, where Jews lived in

30. Symon Petliura (1879–1926) was a leader of Ukrainians during the failed struggle for independence after the Russian Revolution. Under his leadership (1917–1919), some of the cruelest pogroms of the period were perpetrated. In 1919 Petliura fled Ukraine and was killed in Paris by Sholom Schwartzbard, a Ukrainian Jew whose fifteen family members had been murdered during the pogroms.

higher concentration, they established self-defense groups. But there were cases, as in the village of M. in Volhynia region, where this did not please the attackers, and they descended upon the defense groups in the middle of the night, killed them, and left their bodies by the doorsteps of their homes so that those who remained would see and know their boldness.

The situation for the city dwellers was even worse. Besides the bourgeoisie—both real and imagined—who lived in constant fear and danger, all those whose livelihoods hung on the air, a type that is widespread among Jews, were considered part of that category. It is clear how much "their lot fell upon pleasantries" [*halakim naflu bane'imim*; idiomatically, how much depended upon luck][31] in the days of the Bolshevik regime.

The situation of the *Hebrew teachers* was even more bitter. Considered counterrevolutionaries, they were hounded. Hebrew schools have been outlawed; the Hebrew language deemed unclean and forbidden, in particular, in the eyes of "our comrades" who hunt the language and its admirers with open hatred. Zionism and the Tarbut[32] have been outlawed as well, and from Kiev one hears rumors out in the country towns about searches and arrests of the heads of organizations and committees. The fear and danger are great out in the country, and friends are destroying all notes, lists, certificates, and writings. The situation was so very depressing. No one comes or goes. All negotiations have stopped. We are separated from the world outside by a wall, and on our side there are just pogroms and much killing.

I once heard one of the Petliureans [Petliurites], who had become a Bolshevik, telling a friend about the great delight of "stabbing Yids." He himself stabbed tens of them with his own hands. And to prove it, he shows his friend the basics of the task, stabbing his sword into a wooden fence with great force and with the laugh of a wild man.

From all the corners of blessed Ukraine come reports of the glories of the battalions of Makhno, Sokolovski, Zelyony, and all the terrible names that will be written in letters of blood in the book of our lives, who set out to fight for Petliura or against him, for the Bolsheviks or against them, but essentially just against us, the forsaken Jewish residents.[33]

31. Cf. Psalms 16:6.

32. The Tarbut (literally, culture) was a network of secular, Hebrew-language schools in Eastern Europe founded just before World War I.

33. From 1917 to 1920, 2–3 million Jews were caught between revolutionary conflicts. The Russian civil war led to the conflict between the movement for Ukrainian independence and the Bolsheviks. Jews were identified as supporters of Bolshevism, which turned them into "natural" targets of anti-Semitism and extreme Ukrainian nationalism. Ultimately, the Red Army was also responsible for much Jewish bloodshed. Between 100,000 and 150,000 Jews were murdered in these pogroms. Nestor Makhno was a Ukrainian anarcho-communist who led an independent anarchist army in Ukraine during the Russian Revolution. Vasily Danilovich Sokolovsky and Zelyony (Daniel Terpilo) were atamans like Petliura during the Ukrainian civil war. Cf. "Passover Nights" in Part I and the diary entries for 25 March 1919 and onward in Part II.

Our youth had the idea to arm themselves and to stand up for their lives, and so they created Jewish battalions. But the Bolsheviks bore down on them[34] and oppressed their spirits again and again until the battle was abandoned from all directions. The Bolsheviks denounced the youth for not joining their army, whereas the other side sentenced these young people right and left for "aiding" the Bolsheviks.

The fear of the latter spread over everyone endlessly; their speedy judgments, or better their settling of accounts without trial, were only too familiar. And fear of the former trumped the desire for revenge.

Besides all this, during the Bolsheviks' liberation everything was strictly forbidden. It was forbidden even to *think a single thought*, let alone to speak it. For this purpose, eyes and ears lie in wait for you, preparing for your "trial" before one of the "comrade" commissars from which you have no hope to emerge innocent.

Sometimes we remember the first days of the Revolution, the lifting of the yoke, an end to the persecutions, the freedom to criticize. But we could allow ourselves such memories really only in private, behind closed doors when no stranger was in the house.

The contributions were largely paid by Jews. The "forbidden" goods were taken from the Jews, while the grains they needed remained in the granaries of the farmers, already stored for several years, or they rotted in the earth where they were, buried so that they would not fall into the hands of the Bolsheviks. Despite all the commissars' chatter about the village *kulaks*[35] who "needed" to be uprooted, the many different weapons remained in the hands of those who possessed them, and searches were only conducted on Jews who did not even know how to use them.

And after all this they told tales about the "Jewish regime," and our enemies and pursuers made all of us responsible for the deeds of another commissar—even though he announced to all that he has no relation to the Jewish people. And they did not just spread rumors; they also made good their promises and took vengeance upon us for this "regime."

The Bolsheviks set fire to every corner of Novograd-Volynsk in their battle against the "uprising," and they murdered and slaughtered Jews by the hundreds, while bands of plunderers before and after them exacted retribution for all the "aid" the Jews had given to the Bolsheviks.

In the city S., in the Volhynia region, the inhabitants took revenge on the Jews for the schemes of the Ispolkom [the Russian central committee] before it left the city in a

34. Cf. Job 33:7.
35. *Kulak* is a Russian word that literally means "fist," but here it refers to affluent farmers who emerged from the peasantry in late tsarist Russia; the Bolsheviks used *kulak* as an insult against those presumed to be greedy and above their station.

different manner. When the Bolshevik authorities sensed the Polish army approaching, they quickly collected the contribution tax and any remaining possessions and fled.

The Polish inhabitants, whose houses were also visited by the members of the Ispolkom, could not forgive the Jews for this, and when the Polish forces entered the city on the 15th of August, seven young Jews, who had been drafted by the Bolsheviks or joined the army because of hunger, were seized and, on that very day, at that very hour—during the celebrations of the entering Polish army—executed by firing squad in the very center of the city.

The Jews, who had welcomed the Polish army and rejoiced at their new redeemers, despaired anew.

In Sh. in the Volhynia region, the conquering Poles set fire to a few of the Jewish houses and guarded them so that their owners would not be able to save even a pin or a shoelace; instead, they forced them to dance in front of their burning houses as the fire blazed on and to sing well-known songs.

Such deeds as fit the practices and traditions of the Poles, like the clipping of beards, forcing one to kiss the soles of a shoe, and the like, were performed in many cities.

Our city was lucky. Haller's army[36] that arrived there behaved politely and justly; the soldiers and officers were thankful for the expressions of affinity and amity shown to them, and they were polite even to the Jews—something the Jews had been unaccustomed to for some time.

The demand for hidden weapons was pronounced, although this time openly—with notices pasted on the city walls—just to the Jews, and the charade never changed, the "world went about its business." The common folk who had served previously in Petliura's army and then with the Bolsheviks kept their weapons, and this time just removed the red ribbons from their caps, remaining in their occupations and professions without paying attention to the change in power. And those in power, for their part, pay no attention to them either—and turn to the Jews with the order to hand over any weapons located in the city, and if they do not, they will take as guarantee some of the city leaders so that they will reveal the hidden weapons.

However, the new military regime did not make good on this threat. Perhaps because they did not want to follow in the footsteps of their enemies that preceded them. Everyone knew that the Bolsheviks put a few of the city inhabitants behind bars for the same purpose and sent them to the nearest station, and if it weren't for the chaotic retreat from the oncoming Polish army, their judgment would certainly have been meted out upon them.

The Jewish residents began to accustom themselves to the Polish army and to trust them, which in general behaved differently from its predecessor. In the cities, Polish

36. Jozef Haller (1871–1963), of Austrian descent, was the general in charge of the second brigade of the Polish army in 1916.

*gmina*s [municipal governments] were elected. Even Jews participated. They began to think about founding schools, clubs, and various public institutions—and suddenly rumors arrived about how the Bolsheviks were coming, about Denikin's approaching forces,[37] about Petliura in Kamenets-Podolsk.

Again, refugees arrived with frightening stories. It seems that we will forever remain under this circle of spells as the scapegoats for those who own *ḥad gadya* [one little goat, from the song at the end of the Passover seder].

But rumors also swirled about the full repentance of the Petliurovitzes, who now distributed a lot of money to the victims of the pogroms (that they themselves perpetrated on the Jews), even though we recognized the very faces of those responsible—and our blood froze in our veins at the sound of their names; the fear and the pain, the constant sorrow and worry, turned the people into terror-stricken, distrusting cowards.

II

The desire for news, to know what was going on elsewhere, grew and grew. There, *in the faraway world*, everything appeared as though touched by a magical light.

"The news" in our parts meant a new decree, a frightening rumor, a change in the regime, an imminent tragedy.

The most important thing was not what happened on the other side of the wall that set apart those awash in a sea of misery—and still they listened intently.

"To be saved, to escape to over there!" Such a thought came to very few people. In the hearts of the *majority* there wasn't even a spark of light.

The word *Palestine* was heard suddenly with a tremble of hope.

The elderly did not dare to dream of it. The young—they revealed their heart's yearning desires only to each other.

"We will lick the earth with our tongues *over there*, we will plow with our fingers, we will water the earth with our blood and our tears, and only there, only there!"

And eyes that were filled with gloomy despair caught fire. Cheeks reddened.

If only there were a shadow of shelter, a ray of light of protection and refuge, just a moment of forgetting, complete forgetting, without feeling like one hunted. Forgetting the giant sorrow, the terrible affronts.

If only not in this land of blood, which had drained so much of our own blood and marrow.

37. Anton Denikin (1872–1947) was the lieutenant general of the Imperial Russian Army and then a general of the White movement in the Russian Civil War.

But it is hard for a human being who has already encountered these well-known experiences and feelings to find such a moment.

Even in the crowded streets of one of the European capitals, to which I've escaped, the same terrible visions will appear before my eyes such that I will not forget so long as I feel deep inside me the strong bond and special intimacy that exist between me and my distant brothers and sisters, which only shared sorrow and pain can create. So long as I know they are there, in that lower rung of hell . . .

With tears in our eyes we heard tell of how our brothers in Poland showed their support, how they called for a day of fasting and loud protest. When I read about the statement of French intellectuals, with Anatole France[38] chief among them, I wished that such words would make it to our brothers over there. It would not give them any relief, but they would know, at least, that voices have been raised, that there are people who pain over their ruin, their sorrow, their incomparable sacrifices.

For there were times over there that great despair consumed us, when it seemed that our cries and our groans were reaching no one's ears, that even our brethren knew not of what was being done to us, that no one was paying attention to us over there, that we were choking in the darkness, in the cellars. And only every once in a while did the rumors match the mood of the speaker to inspire strange hopes in the hearts of the destitute: Jabotinsky with his Hebrew legionnaires was on his way.[39] In America Israelite battalions had been established, to defend us. They were coming to avenge our countless dead.

But, for the most part, we did not *believe* them.

And here in the West they do not believe, even our brothers, sometimes, when they hear about terrible things that are difficult to imagine. I sometimes can read in their eyes their heart's doubt: "Can it be? Maybe things are a bit exaggerated?"

But they do not know that much is still *hidden* from them, that there are things that cannot be spoken on the lips or rendered in writing. The wild yelps of human-animals still ring in my ears, calls for help and calls of despair, such that the one who hears them feels that he will instantly lose his mind. I can still see living pictures of mute victims, the mute question frozen in their eyes: Why? What for? And many other visions *that cannot* be transmitted to others, that will remain on my heart like a fatal wound that cannot be touched.

At the end of September we received some newspapers from Warsaw. People came from Kubel, Lutsk, and other places that were already in Polish hands.

38. Anatole France (1844–1924) was a French poet, novelist, and journalist.
39. Vladimir Jabotinsky (1000–1940), Zionist leader and founder of the Revisionist Party, helped to found the Jewish Legion of the British army during World War I and later the Jewish defense force known as the Haganah; his Betar movement educated youth in increasingly right-wing militant Zionism.

I submitted a letter of request to the military authority for a permit to travel abroad. I brought documentation of all kinds that testified that I lived there until the war broke out, that I never participated in the Bolshevik party; they sent me to the *gmina*. The head of the council answered that he did not know of my activities abroad—or even my activities in my hometown—and he demanded reliable signatures. The required signatures—he was interested mostly in those of the Christian residents—had to be verified with the local authorities, and only after guarantees from all the Jewish members of the *gmina* did I receive the necessary certificate.

But when I appeared before the head of the military authority in the city, he answered, with particular rudeness, that I could wait.

Around that same time news arrived about the Bolsheviks who returned to Zhitomir, Novograd-Volynsk, and Korets and how the Polish forces hastened to meet them and block their path.

The head of the battalion went with them, and his second in command who took his place gave me the required permit to travel to the train station, although according to his adviser, it was dangerous to let a non-Polish person leave the front.

In a train car packed with refugees returning to their homes, I traveled to Zdolbuniv to get a new permit. Once again: letters of request, documentation, references. But here judgment would be only according to the views of the high commander's secretary—with the high commander himself they did not allow an audience—and when my turn came among the packed crowds, the secretary declared that I would receive no permit for travel onward and that the *gmina* had testified on my behalf in vain, for he did not believe them. I brought documentation and proof; even Christians offered testimony that I had hidden from the Bolsheviks; but he answered curtly, "It is impossible that a Jewess would be a non-Bolshevik."

Only when I managed to gain entrance to the high commander himself, who received me courteously, did he write me a permit himself to travel onward, wishing me peaceful travels upon hearing my justifications and seeing my certificates. In Brody—a new permit, and after so many travails I arrived in Lvov.

In every place I passed through, especially in the last cities, "the stone cried out from the wall"[40] about the blood and many murders it saw. The walls, punctured with many holes, stand as silent witnesses to the victims whose voices will never be heard again. They are saturated with a dense solemnity, and silent sorrow covers over them.

40. Cf. Habakkuk 2:11.

The passersby are gripped by a deep sorrow that cannot be expressed. They were witnesses. A hidden secret floats in the air filled with concealed sighs.

In Lvov I received a permit to travel to Warsaw, and I entered the express train with heart thumping.

As I entered the car, an old Polish man sitting in the compartment caught my ear, saying that it was necessary to get rid of that "rude Jew" from Haller's army that had been sitting there and had left for a moment. The second Pole agreed with him. But the woman who entered, who talked ceaselessly about her husband the officer and about her father the high commander who accompanied her to the station, defended him. The Poles knew of my origins, and the face of the woman who entered gave her heritage away like a hundred eyewitnesses, even though she did not stop talking about her Catholic faith; an argument immediately began, the Poles reporting about how the Jews, their mortal enemies, fired their weapons from every hidden corner when the Polish army entered Lvov.

The wife of the officer, a native of Lvov, who was a reliable witness to the pogrom, got worked up and agitated, offering valid evidence, relying on documents that her father received and on her own experience as a nurse, to the loyalty of the murdered Jews, who were brought by the hundreds, night after night, right in front of her eyes, to the Jewish cemetery.

She knows who exactly fired from the foxholes.

And the accusers know as well. The Polish people should be ashamed of themselves. Even those who argue know that Jews fear the rifle and will not touch it, and still they stubbornly repeat the abhorrent false reports.

Amid this endless argument we arrived in Warsaw—that oft-mentioned city, that recalls the memory of Peretz, Syrkin, Dinezon, who have departed never to return—it gives the impression now of a modern European capital.

The traffic has increased exponentially. Life is bustling and buzzing; people are steeped head and shoulders in the vim and vigor of this country that has renewed its youthfulness.

It appears as though all is good and beautiful here.

Warsaw is, according to one of its critics, the Polish salon. A Pole cannot be without his salon. Warsaw is the salon of the state.

Beyond the salon, there are moments when not everything sparkles.

I procured a permit for travel abroad easily. The Poles want to get rid of foreign guests and so they give out these visas willingly.

Thanks to a Bohemian friend, I crossed the border in peace—and now behold, Bohemian territory.[41] Already he is embarrassed to speak in another language.

In the train cars the same arguments start, only in a different language. The Jews stand on the side of the Germans. Now that Bohemia rules itself and recognizes the rights of minority nations, Jews should be *real* citizens and not stand at Germany's right hand. At least they should be neutral, which does not seem to be what is happening. And they deserve punishment.

Again, evidence, claims, and accusations without end.

And in my heart a thought rises: by *now* don't the children of cultured nations have more important things to deal with than to concern themselves with us?

41. For information on Shapiro's escape and on the Jews of Czechoslovakia in this period, see Introduction.

Letter from Prague

(The World Convention of Hapo'el Hatsa'ir and Tse'irei Tsiyyon)

Translated by Saul Noam Zaritt

Originally published in *Hatoren* (1920)

The capitol of Czechoslovakia was the meeting place for a world convention of members of Hapo'el Hatsa'ir, who work in the Land of Israel, and of Tse'irei Tsiyyon from Eastern and Western Europe who aim to join them.[42] Representatives from both movements met and got to know one another.

Until now thirty or forty delegates have arrived, ten from the Land of Israel. The rest are from Warsaw, Minsk, Vienna, and Berlin. Many guests have also come, and Prague is suddenly full of Zionist energy.

"Central Café"[43] reminds one of the Casino in Basel,[44] and all the meetings that preceded the convention also recall one of those long past meetings so dear to the heart. In particular for us, for those who come from Russian and Ukraine, these meetings are so beloved and have more value to us than the many meetings and conventions that we witnessed there, which caused us only anger and bitter disappointment.

The delegates know their path. Their will is strong and they give it full expression. The delegates from the Land of Israel express it with particular simplicity and innocence but also with a certain strength.

These are the real workers, and not people "who speak for the workers," a type we had become accustomed to in the land of the Soviets; they walk around the streets of Prague speaking in our national tongue, in our Hebrew language. And the local Jews

42. Hapo'el Hatsa'ir was a Zionist socialist group in Palestine founded by A. D. Gordon in 1905. Tse'irei Tsiyyon, founded in 1903, was a Zionist youth group in Eastern Europe that focused on preparing for aliyah, including Hebrew instruction. Puah Rakovsky was involved in this organization; see Rakovsky, *My Life*, 131–32.

43. Café Central, on Graben Street, was a meeting place for Prague's literati, including Egon Erwin Kisch, Hugo Bergmann, and Max Brod.

44. The concert hall in the Casino in Basel was the site of the first Zionist Congress in 1897.

stare in astonishment. They see real workers, children of Israel who are connected to their land and live off it. They speak among themselves, and others join them, in Hebrew. This is not just for show; rather, the language lives in their mouths as any other language lives in the mouths of its speakers. It is already a fact and not just "something spoken about in newspapers." They consider it and listen to the strange sound with special attention.

Right now you can hear the Hebrew language everywhere in the city, and those that do not understand the language feel this as a lack. Even aside from the public meetings, they speak and give lectures almost exclusively in Hebrew. Just a few years ago we would not have even dreamed of such a thing. When we gathered, decades ago in Basel, the few who spoke Hebrew were mostly the Hebrew writers, and when they thought about its rebirth, they did not imagine that in just a few years the language would be used regularly, even by those in the Diaspora. Those from the Land of Israel complain, though, about the rotten Hebrew accent of Diaspora Jews and about the multiplicity of accents, none of which resembles their own; even so, they are pleased to hear Hebrew speech, for it goes to show how much the youth understand how essential our national language is and how they put every effort into mastering the language for themselves.

The guests and the great number of people who have gathered are most interested in the situation in the Land of Israel. The delegates are inundated with endless questions: The situation of education? Teachers? Development of the land? The settlements? The female worker? Labor in general? The question of the Arabs? Relations?

The delegates, as much as they can, try to provide adequate answers to each of the questions.

And the essence of their answers is the following:

The land awaits its children, its builders. There is space for great masses of immigrants, for millions. All that is needed is the desire and strong will to make aliyah [literally, going up; move to the land of Israel] and to work and create—and the land will become fertile. What already exists was achieved only through the total commitment and work of the lonely few. Now the time has come for the entire nation to come and improve the land. The individual who wants to make aliyah does not have to gnaw at his own heart very much.[45] He who carries in his heart the strong will for work and creativity already carries within himself the ability to get along in the land.

Zionism does not mean contributions, donations, and the jangling of charity boxes, or even sympathy and aid from afar; and "the nation" is not some abstract term. Zionism is a fact on the ground, and whoever understands this must make aliyah to support the building and the rebirth with his own labor. If this had been acknowledged a long

45. Throughout her oeuvre, both published and unpublished, Shapiro uses the word *gnaw* (Hebrew root nun-kof-reish), which is arguably a reflection of her own agitated state.

time ago, we would already be a great power in the land and our situation there would be altogether different. There would not have been such occurrences as those that took place at Tel Hai or Metula.[46]

We live in peace with the Arabs, the delegates from the Land of Israel say. They have learned much from us: Tel Aviv and our settlements are a model for them, and they recognize the value of what we have created for them as well. We live with them one settlement next to the other, house next to house, as good neighbors, and only in those places where foreigners get involved with incitement and agitation are we forced to defend ourselves. The Hebrew people must now show its energy, strength, and commitment to the land, that it is able to transform the land from an abandoned wasteland to an improved and fertile place. All that is needed is the strong will and clear recognition that the time has come, that there is no reason to defer, that we should not delay even for a moment.

These, in short, are the answers of the practical people who are familiar with the situation. [...]

The upcoming convention is attracting the attention of the Jewish community, and the interest of the youth is very high.

For now there is only preparation for it. Two days ago there was a public Zionist meeting, which included the participation of the guests and delegates. The big hall was filled to the brim. Most of the speeches were in Hebrew since not only did the delegates from the Land of Israel speak Hebrew but nearly all of those delegates and guests from other countries did as well.

I was astonished only by the patience of the Zionists who sit here for hours on end listening to conversations and speeches that they do not understand, and only when their ear catches some word that they know do they awaken with joy.

I observed a similar phenomenon in the great synagogue during a gathering of mourning that was arranged in honor of the heroes that fell at Tel Hai. Here too Hebrew was spoken and most of those that gathered certainly did not understand a thing, and yet they heard and listened to the speeches with particular attention and took joy from the simple fact that so many young people speak Hebrew.

Yesterday evening was the opening of the convention. Great masses of people, guests, delegates, and representatives of local newspapers came to the opening

46. There were widespread Arab riots in Palestine in March and April 1920, leading to the fall and abandonment of settlements, including Tel Hai and Metula. The stand at Tel Hai became famous for Yosef Trumpeldor's much mythologized death.

celebration. The journalists did not understand a word of what they heard and wrote in their notes whatever translations and explanations were fashioned for them.

Mr. Sprinzak,[47] one of the leaders, opened the meeting with a long and beautiful speech, thanking the government for hosting the convention and showing such sympathy; Czechoslovakia too only recently experienced a national rebirth, and it understands that if one wants to live in peace, one has to show love and sympathy to other nations.

Mr. Gordon,[48] the representative of the young workers, with a beard flecked with gray, speaks with exuberant fire:

> We have been sent by our brothers the workers, and the reason we were sent is so great that it seems that it is beyond my powers to speak about it. We have been sent to unify the people of Israel for the Land of Israel. There is a need for a new creation. When we came to the Land of Israel sixteen years ago to revive the land, we really came to revive the nation. What we have done until now has only been preparation, preparation for ourselves so that we could come speak before you, before the entire people and announce to you that the land is waiting for you. If the nation does not make the declaration, nothing will come of it. These things need to be living in each one of you. We need to renew the people. We have forgotten the taste of a living nation. We are living the life of a parasite nation, in all our lives' occupations—even in our literature, because we do not have ground beneath our feet. There is no need to argue about whether it is possible to move the entire people, for there is no way of knowing such a thing. But it is clear that if we can only become a large group there, then already we shall cease to be parasites, even if others remain outside the land. For even in other nations a significant portion of their people lives among different nations. We need to become a productive nation.[49] To live based on productivity, not on parasitism. And the task of Zionism is to transform the nation into a working nation also in the Diaspora. Therefore we will go to the nations with the request to give us—to all those who work—the opportunity to live as a living nation through its land and its work. The power is in the hands of those

47. Yosef Sprinzak (1885–1959) was a prominent Zionist activist and in 1920 served as the president of Hapo'el Hatsa'ir. He would become speaker of the house of the first Israeli parliament and served as interim president after the death of Chaim Weizmann.

48. A. D. Gordon (1856–1922) was the spiritual father of socialist Zionism and the founder of Hapo'el Hatsa'ir.

49. Productivization, one of the goals of the *maskilim* that was adopted by Zionists, is an attempt to make the Jews useful (i.e., productive contributors) to society beyond the traditional Jewish occupations of moneylending and commerce. Through vocational training and agronomy, Jews would master the skills necessary to build a nation in the Land of Israel and ingratiate themselves in the diasporic countries in which they lived.

who work and create to come to the land and indeed create, for we will not be saved by the good graces of the nations but by our own hands.

Gordon's speech was the apex of the opening celebration. His words flowed with emotion and were expressed with energetic proof.

Those who came after him simply repeated the old tune: the need for labor for all whose time has come and so on. Then came the many greetings and blessings and telegrams—this is a way for everyone to speak without saying anything at all. [. . .]

The representative of the youngest of Prague also spoke, describing the character of Martin Buber. Dr. Weltsch[50] of Berlin spoke about the normal relationship with the ways of the earth and of nature, about how socialism needs to be different for us than with other nations, about socialism as a *soziales Gewissen* [German, a social conscience] in the life of each one of us. Many more spoke, until, finally, they stopped speaking.

And I thought: My lord, why all this talk and exhortation about the need for labor and the need to make aliyah? It just spreads salt on the wounds of those who want to make aliyah, for it mocks their existence, for they do not ask about conditions or relationships or situations—they only ask that the gates of their big prison be opened for them. Even just to work slave labor they would make aliyah.

50. Perhaps Felix Weltsch (1884–1964), the Jewish philosopher, originally from Prague.

Roaming the Lands

(Notes and Thoughts)[51]

Translated by Saul Noam Zaritt

Originally published in *Ha'olam* (1924)

When you take a breath and turn away for a moment from your regular, daily life, and perhaps even from your communal and public work, and venture forth into a different practical world, beyond your boundaries and limitations, you find yourself somewhat taken aback: The world apparently hasn't changed at all. The people haven't changed—nor have their thoughts, instincts, and inclinations, as though Heine had composed his travel sketches just yesterday.[52] The substance has not changed, nor have the creatures.

And it seems to you as though people bear no mark whatsoever of all the upheavals, or only the slightest mark, and they long to recompense themselves of this mark ten-fold. Behold they have seen blood, fire, and columns of smoke.[53] They have seen sorrow and destitution so dreadfully and frightfully exposed. They have seen what cannot be forgotten, what cannot be erased from one's memory; hence they put every effort into erasing the past, the memory of the past, to restore balance to their spirit and to unite the torn pieces of their souls.

Worthless toil!

But still a certain strange skittishness has gripped human beings. Everyone is confused and alarmed by too much haste. It seems as though they have for once grasped the meaning of the verse "Eat and drink, for tomorrow we die."[54] And we, the children of Israel, the most harried of people to ever walk this earth, are certainly not the last of the agitated.

51. Cf. Job 1:7.

52. Heinreich Heine (1797–1856) composed four lyrical accounts of his voyages in Italy and Germany, known as "Travel Pictures." On some level, Shapiro follows in his footsteps by writing her observations as she wanders through Central Europe.

53. Cf. Joel 3:3; see also the Haggadah on plagues. Shapiro draws a parallel between the biblical plagues and those of her own day.

54. Cf. Isaiah 22:13.

One other change can be observed in the world: Strange creatures have risen from the depths and stare with the wonder-struck eyes of those who rush to the forefront, anxious on the inside but arrogant on the outside.

To be sure, some folksiness is perceived here, although very little, for the noble "aristocracy," with all its manners, customs, and attributes, has fallen from its throne, while in its place stands a different kind of nobility that has nothing to do with bloodlines or spiritual pedigree and now aims to stand in the place of the ancestral aristocracy, which has apparently disappeared from this world. And the imitation is always worse than the original.

Blustery winds. The news arrived about the attempted assassination of the president of the Republic of Poland, and it stunned the skittish and panicked people. They become agitated, alarmed. And one can tell the nature of one's interlocutor from his reaction to the news that the assassin was a Jew and a Zionist.[55]

But there is no time to dwell on this. Onward, life flows onward, and onward rush those who try to keep pace. "Time is money" for those who lust after wealth, and "time is money" as well for those who seek entertainment and pleasure, for behold—our time is nearly up.

This worry consumes the people, especially those women who frequent the pools and spas a little later in the day. Will the sun still give them a tan? Do they have time yet to be bronzed? Certainly there are greater worries in the world; but for these women this is their highest concern. It is puzzling to me. Everywhere people moan and groan about the difficult times, the "crisis," the situation, and so on, at the very same time that people are being summoned to [attend to] communal matters, charity, nationalism. Even so, see: All the spas and baths are full of people. People without worry—at least to the naked eye—doling out thousands for the sake of pleasure. It is as though they have been stricken with a ravenous hunger: Make merry, make merry as much as you can and at any price.

One needs to observe the stress and pressure in the various consulates of this transit capital. They stand crowded together ['omdim tsefufim][56] for hours on end to receive visas: to Italy, France, Belgium, etc. One hears all the languages of the world here. People are pushed together but make conversation and get to know one another in the meanwhile. In one of the central European capitals, in one of the consulates while standing among the mass of people, the sound of the Hebrew language reached me. It was a young couple from the settlements in the Land of Israel. No other language heard there attracted as much attention. Some of our brethren that were in the same line, the look on whose faces showed that not moments ago they had been idly chatting and

55. Stanisław Steiger was falsely accused and later acquitted of the attempted assassination of the Polish president Stanisław Wojcechowski during a visit to Lublin (5 September 1924).
56. Cf. Mishnah Avot, 5:5. "There were ten miracles in the Temple. [. . .] They stood crowded but prostrated themselves with ample space."

joking, could not now hide their sudden interest. Some force compelled them. They listened attentively to the couple's conversation, as though that foreign sound told them things that touched them deeply. One lady could not hold back and turned to the couple with a question: "What is this language? Is it really alive? Do people really speak it daily and use it to express all their hearts' desires?" She hadn't imagined it would sound so beautiful. Her husband[57] followed her by asking more questions about the Land of Israel, where this language lives and prevails. And those who stood around them stared and were astonished—and moved. Could it really be?

I too was astonished: These same people, who just a moment earlier did not dare to reveal that they are the sons of Abraham, Isaac, and Jacob, now seem to regret their earlier ways. They turn back, perhaps innocently; they didn't know, didn't understand, didn't imagine.

This is the power of living facts! Not a secret or hidden power, but a manifest and demonstrative power.

"They who go down to the sea in ships [. . .] they have seen,"[58]—you begin to understand this when you look out upon the transparent sea, into its pure blue waters, when you see the variety of colors splayed across the expanse before you, when you look upon that point where the moon shimmers, leaving a long silver path along the water, which seems from a distance to be frozen in place. In that moment you reflect and think how frivolous and ephemeral man's life is, even with all its tumult and commotion, even with all its sorrow and wars—for the individual and for the nation—even though each one—the single person and the collective—tries with all their might to lengthen and improve their lives as much as possible. The joke of the late Sholem Aleichem, whom I visited at the sea (in Nervi),[59] when he already knew of his fatal illness, comes to mind: "I keep a distance from the dead. It is in my nature not to like the dead."

Man's trials and tribulations evolve and run their course. The lives of nations, cities, and countries change shape. Yesterday this kingdom ruled, today another. Yesterday German was spoken here in every corner. Today—Italian. And you wonder how these trivialities change their outward appearance so quickly: certificates, advertisements, placards, and signs—everything is already rendered in a new language with new names. The inhabitants get used to their new situation and the new conditions—those who are forced and those who do it gladly or even for spiritual fulfillment. Either way, all you see are bright and kind faces. Only here and there the old people groan about the

57. Here Shapiro uses the modern word for husband (*'ish*) rather than the conventional *ba'al* (literally, master).
58. Cf. Psalms 107:23–24.
59. Shapiro seems to be referring to Nervi, Italy. Besides this passing comment about Shapiro meeting with Sholem Aleichem, see also "Memories of Frischmann's Life" later in this part.

good old days, and there are times when youthful voices join them, though discreetly, anonymously.

A burning jealousy seizes you when you see the peoples and nations who truly have become free, who have something to be happy about, who were freed from the yoke of their slavery and sense their freedom and independence, who got what they wanted and maybe even more. If there are a few among them who have the right to be bitter, who will pay attention to these individuals and loners when the collective is so happy?

I saw a national celebration in one of the cities of Serbia. The processions of the Romanian army in the city streets. Romanian happiness, Romanian language, Romanian and Romanian.

And now here before me is the national celebration of the Italians on the third anniversary of d'Annunzio's entry into Fiume with his army.[60] Endless processions, wreaths of flowers, draped laurels, flags waving, raucous joy in the style of the peoples of the south. Happiness and mirth on every corner and every street. The stores are closed, a Sabbath of rest for the houses of business. People are in holiday dress. Public and private buildings are decorated with flags. There is singing and kissing in the city streets, and even those who are in a bad mood try to appear celebratory, even though their hearts are in another place.

And the Jew? His "heart is with him"[61] in all the lands of his exile.

Not too long ago, just before the war, most of the Jews who frequented the baths and healing springs were Russian Jews. They would pay handsomely, people of means who did not count every penny, and they took interest in every new thing and idea found abroad. Now—you won't find them here. Now they are caught in a situation in which at times even the desire to live fades. Now—but these matters are all too well-known. Even so, there is none to remember or give it a thought or notice it at all. Others come in their stead and sprout like grass on a field, and they spread their money around for their pleasure, while those who came before them are forgotten—and the world goes on its way. The inhabitants greet their new guests with the same pleasant faces with which they greeted the others. And the European capitals will surely not complain even now about the absence of "the children of Russia" among them; rather, they will make a ruckus about their superfluous presence.

60. The Italian writer and general Gabriele d'Annunzio led the so-called Impresa di Fiume (Exploit of Fiume, modern-day Rjecka, Croatia) during World War I.

61. This appears to be a sarcastic barb at Jews who live contentedly in the Diaspora in contrast to Yehudah Halevi's famous poetic line in which he mourns the fact that he is in the West though his heart is in the East (the Land of Israel).

However, there is another unexpected vision that now appears before the inhabitants of the capitals, as it does before those who live by the shore. Suddenly appearing before my eyes in the Austrian capital and in the port city of Trieste is a mass of emigrants who are leaving the European lands with triumphant song and raucous cheer. The inhabitants of these cities stand in awestruck wonder and stare at the odd spectacle of such a scattered and strange people, who one day came to loathe all its powers, with which it had "dominated every nation"[62] and left to build its own home in its own land.

62. This appears to be a sardonic reference to the *Protocols of the Elders of Zion* and other such anti-Semitic allegations of a Jewish plan for global domination.

"Habimah" in Prague[63]

Translated by Saul Noam Zaritt

Originally published in *Ha'olam* (1928)

The activity and value of the pioneers of the art of Hebrew theater—the members of Habimah—are well-known. However, every time someone sees their magnificent artistry, the mixture between religious ecstasy and primitive cultural folklore, it is a fresh new event for him; Habimah is an enriching and invigorating event for the entire Jewish public in every city that it passes through.

One of the Jews of Prague who is hostile to the Zionist movement and everything associated with it said to me: I went to a play of Habimah to see what kind of impression the language of the Bible makes from the theatrical stage. And what a great impression! (even though he didn't understand a word of what was being spoken).

Indeed, the actors of Habimah make such a deep impression in the heart not only because of their artistry but also, in equal measure, because of the language, because of its rhythm and the sound of its expressions in their mouths. It is a great honor for a writer when the actors of Habimah bring his works to life: They elevate with their acting even works of lesser artistic value and add life and meaning with their bodies and their spirits.

The pieces they are performing now, save for *The Dybbuk*,[64] are not of great worth. In *The Eternal Jew* (by [David] Pinski)[65] there is almost no action—besides the appearance of the prophet who prophesies the birth of the Messiah on the day of the Temple's fall

63. The Hebrew theater troupe Habimah started in about 1905 and then was officially founded in 1917 under the auspices of the Moscow Art Theater. The troupe toured internationally, arriving in Palestine to stay in 1928.
64. *The Dybbuk* is a play by the Yiddish writer S. Ansky (1914). It is about a young bride who is possessed by a spirit—a dybbuk—on the eve of her wedding. In its Hebrew translation the work became the most popular play in Habimah's repertoire.
65. *The Eternal Jew* (*Der eybiker yid*, 1906) is a messianic one-act play set during the destruction of the second temple.

and the returning messengers who bring proof of the terrible news of the Temple's destruction. Even so, the actors know how to turn even this piece into a full drama. It goes without saying that there is plenty of room for them to show their powers in a play of such quality as *The Dybbuk.*

Jews and non-Jews came to see the wonder of *Hebrew* theater, and they were astonished: such artistry, such actors—and the *living* Hebrew language! The mouths of the local newspapers were also filled with praise, although there were exceptions; they praised the actors' dedication to their craft, which they developed and enhanced until they achieved such a high level. Even so, a few "sons of the religion of Moses"[66] did not miss the opportunity to make the point that even though Habimah is a Hebrew stage and the actors perform in pure Hebrew, among themselves they speak Russian—and all the other languages of the world. Therefore one shouldn't pay attention to the cheerfulness of the Zionists, and in addition pure assimilation remains unperturbed by the fact of the Hebrew language of Habimah. But despite these comments, the fact of the appearance of Hebrew art in the Hebrew language has made an unmistakable impression on the citizens of Prague. And one of the newspapers (not a Zionist one) suddenly came out with the astounding idea that there is no real reason to be surprised by Hebrew acting, just as there is no reason to be surprised that there is French or German theater. Indeed, this is a strange and amazing sentence to the ear of a Jew from Prague!

66. A barb at those Jews who regard themselves as Jewish in religious terms only, eschewing all forms of Jewish nationalism, including Zionism, as well as a desire to speak in the national tongue of Hebrew.

An Exhibition of Israelite Artists in Prague

Translated by Saul Noam Zaritt

Originally published in *Ha'olam* (1930)

What is the meaning of Israelite art? Is there a difference between it and the art of the nations of the world? And what are the markers of this difference? What is different about Israelite art, and what makes it remarkable? Questions of this sort have often been asked with regard to the Prague exhibition put on by WIZO (Women's International Zionist Organization),[67] and the answers that have been given in writing and in speeches have been just as varied—according to the spirit and understanding of those who ask or answer. Israelite art does not exist and never was but instead is a legend.[68] It has nothing to do with other arts, and the curators boast in vain when they give it such a name—so decide critics of another type. Israëls is, in their opinion, Dutch,[69] and Liebermann is German,[70] and there is no basis for causing such confusion in the mind over the meaning and nature of art, which is one and the same for all nations and races. Others answer them by saying that one can see in the Israelite poets and artists positive Jewish energies and values. And others, while they do not acknowledge the idea of a particular Israelite art, still take note of the fact that there are many Jews who are skilled at art and therefore that there is a need to establish a special chapter on "The Jews in Art."

And I ask myself a bit of a strange question: What if there were an exhibition that would give expression not to the *talents* of the Jews but to their *deficiencies and*

67. WIZO was founded in England in 1920 and quickly spread across Europe as a women's social welfare society active both in Europe and in Palestine.

68. Cf. Babylonian Talmud, *Baba Batra* 15a, for the rhetorical phrase about Job: "Job never existed but was instead a fable."

69. Jozef Israëls (1824–1911) was a Jewish Dutch painter associated with the Hague school of realist painting. His son Isaac Israëls (1865–1934) was also an important painter, considered a central member of the Amsterdam Impressionism movement.

70. Max Liebermann (1847–1935) was a Jewish German painter, one of the leading figures of German Impressionism.

defects—how eagerly and with such immense pleasure would [these critics] adduce and demonstrate to others the "typicality" and "uniqueness" of Jewish people or of the entire Israelite nation! For isn't love of profit, for instance, an attribute that can be found among other nations as well? Even so, were an exhibit created of people who have this terrible attribute, certainly "researchers" and critics would come immediately, gathering from all directions, to search and find and publicize these particularly Jewish markers, aiming to prove how much this attribute from its very foundations has a Jewish essence, signifying the character and "skill" of the Jew especially.

Either way—here we have an exhibition distinguished for having works by Israelite artists, which has opened in Prague and continues to draw large crowds of visitors every day, showing us Israelite art as expressed in paintings and sculptures that are praised by all. How much of a Jewish character or Jewish meaning, content, and spirit they contain—perhaps the experts will tell us. However, even the nonexpert will observe the feeling, power, and unity in the artistic painting of the great Impressionists—Liebermann, Pissarro,[71] Lesser Ury,[72] and so on, the special emphasis on tranquility in the pictures of Neuschul,[73] the vivacious humor of Rachel Shalit,[74] the ordered chaos of Marc Chagall with its mysticism hovering above; the powerful protest of Jacob Adler[75] expressed in the colors of his paintings. And if all of these are not the expression of a "Jewish essence," they at least come to light in the works of Jewish artists. If art is above all nationalities, it will not bother us that an artist's self is expressed in his work, and this time the self is that of a Jewish artist.

On the occasion of this exhibition the editorial board of *Selbstwehr*[76] distributed a short questionnaire to famous Israelite artists concerning their relationship to Judaism and Zionism, their opinions about the relationship between Judaism and art, especially the forms of painting and sculpture, and what they, the Jewish artists, feel that they owe Judaism and their Jewish race. The answers to these questions are very interesting. We offer here only excerpts of the most important ones:

71. Camille Pissarro (1830–1903) was a French Impressionist painter. His father was of Portuguese Jewish descent.
72. Lesser Ury (1861–1931) was a German Impressionist painter born to a Jewish family in Poland.
73. Ernst Neuschul (1895–1968) was a Czech artist associated with the New Objectivity of the Weimar period.
74. Rachel Shalit's art did not meet with posterity, according to Professor Samantha Baskind (personal communication, 2 October 2013).
75. Jacob (Yankl) Adler (1895–1949) was a Jewish Expressionist painter, born in Poland. He was a close friend of Paul Klee.
76. *Selbstwehr* (literally "self-defense") was a German-language Zionist weekly published in Prague between 1907 and 1938. It was the most widely read Jewish newspaper in Czechoslovakia.

Josef Budko[77] of Berlin writes:

For a long time now, my central topic has been a Jewish one. I see it in the study house, on the street, standing looking at a door or sunk in thought about the growing generation. It is not a coincidence that I try, each time anew, to actualize this topic in form, in image and in color. Once I myself stood there and lived the life of those Jews. This cannot be uprooted from my heart by experiences that came later. Sometimes it seems that the Jew whom I have depicted looks at me from within the aura and demands from me that I love his tradition, that I suffer and hope with him. Though now, after I have painted the old Jew and with him the youth who has grown up and longs for another life, I have sought a form of expression that will fulfill the desire of a new generation *in the Land of Israel.*

Marc Chagall[78] writes from Paris:

In reality I think I don't need to speak publicly either about myself or my God, nor about my people, my art, or my wife. Let others discuss these things! The latter [the critics] grant us their love only infrequently. More often they hate us, and much too energetically.

Is there a need for the strong and the powerful to speak about themselves?

It is not enough for someone to command a Jewish language, to have Jewish papers, or deal with a Jewish subject to justify his being a Jewish writer, artist, or worker. Sometimes actually those who emphasize their Jewish heritage are not remembered in history as the greatest Jews. On the contrary, true artists are those who create at a certain distance from the flow of life, whose Jewishness was uncertain in the eyes of contemporaries and yet they remained truly the greatest Jews.

Spinoza, who wrestled with God, Pissarro, who never painted a Jewish face, Einstein and Freud, who are completely buried only in general science—are they not Jews? And also that young painter Modigliani,[79] who died not long ago as a

77. Josef Budko (1888–1940) was a Jewish painter from Poland. He would make aliyah in 1933 and become one of the founding figures of the Bezalel Art Academy.
78. Marc Chagall (1887–1985), one of the foremost modernists of the twentieth century, created his unique style by drawing on elements from richly colored folk art motifs, the Russian Christian icon tradition, Cubism, and Surrealism.
79. Amedeo Modigliani (1884–1920) was an Italian painter and sculptor of Sephardic descent who is known for his modern style, characterized by masklike and elongated forms.

Christian and according to historians was against the Israelite faith—wasn't he a true Jew?

The genius, who possesses one hundred percent talent, creates without his Jewishness being known. But if he is without just one percent of his power, he is no Jew, and he is nothing at all.

Perhaps I haven't explained my ideas in a clear way, but is the artist required in the end to speak clearly?

Georg Ehrlich[80] writes:

I am consciously a Jew, but without Zionist nationalism. I think there is much Judaism weaved into my art; even so, I don't believe in "Jewish art." I only believe in the art that Jews create.

Rachel Shalit from Berlin writes:

I feel that I am a Jew—I love my people. I am a Jew of the East, and the Jews of the East are very close to me. As for religion, I am closest to the way of thinking of Hasidic mysticism. What I need for my Jewish origin is a certain self-irony, the "request out of tears," as our Sholem Aleichem put it.

These are just a few of the answers that the editors received, and already one can see from them how each senses their Jewish identity in their art, and how ridiculous the attempt is to deny this identity's self-expression in art.

80. Georg Ehrlich (1897–1966) was an Austrian-born sculptor.

The Curse of Language

Translated by Saul Noam Zaritt

Originally published in *Ha'olam* (1930)

The State Statistics Council[81] of Czechoslovakia has prepared new ordinances regarding the population census to be held at the end of the current year and has submitted them for the government's approval. In the clause regarding the designation of one's nationality there is the following regulation: "Nationality is registered for each resident according to the language that he has learned and speaks the best. This language is most often one's mother tongue. The Israelite language is to be considered equally Hebrew and Yiddish. It is forbidden to register for more than one nationality or mother tongue."[82]

This regulation has aroused much opposition among the Jews, for one can estimate how many will be able to register themselves as Jews, to be counted among the Israelite nation, if they follow the regulation. And not just for those in Prague, but for those in the entire country. In the Czech districts as well as the German ones, most of the Jews will not be able to mark down Hebrew or Yiddish as their mother tongue, which they know better than any other language. Even in the Russian Carpathians or in Slovakia, where a *great number* of Jews live who do indeed speak Yiddish, most of our brothers, and in particular our sisters, more often speak Hungarian than they do Hebrew or Yiddish. The result therefore is that all these people are denied the ability to be numbered among the Jewish people and must instead register themselves as Hungarians, Czechs, or Germans.

Of course many of our brothers will protest this regulation, saying that they have no desire to deny their nationality and be considered part of a foreign nation, even if they lament their luck and predicament of not knowing their national language at a level that would allow them to register it as their mother tongue. They will demand that the registration of the nationality of each person be free, without compulsion, according to one's inner feeling and not according to language, which, to our great calamity, is just a temporary marker in most cases for Jews in the Diaspora.

One can expect that the government will not approve this regulation.

81. The State Statistics Council was a government organization that developed and supervised statistical surveys for national needs.
82. For nationalism among the Jews of Czechoslovakia in this era, see the Introduction.

PEN Congress in Prague

(A Letter from Czechoslovakia)[83]

Translated by Saul Noam Zaritt

Originally published in *Hado'ar* (1938)

A pleasant, relaxing atmosphere of those who wield the pen, people of books, people of the spirit. More than 200 delegates from various faraway countries. Here is the short Chinaman, smiling and staring curiously at everything. Here is the tall Spaniard with quick gestures; here is the Belgian, the Estonian, and so on. The delegates have enjoyed all the amenities of Prague. The Czechs have made sure that these guests would not be lacking for anything and that they would see and become acquainted with everything there is to see and become acquainted with during their four-day stay here. A "baroque" exhibition was prepared for them, plays at the theater, the Sokol,[84] day trips, balls and banquets. They were invited for audiences with the president of the republic, the foreign minister, the education minister, the mayor—and on each occasion it was as though incense was burned in their honor.

The conference was opened by the prime minister, Dr. Hodža,[85] who emphasized in his speech that *literature* created the Czech *nation*. The Czech writers ignited the hearts of the simple folk of the nation, gave them strength and faith, and became their leaders. To ease the recovery of the soul through art is the practical duty of literature, far removed from politics but still the best possible politics.

The opening speech of the president of PEN International, Jules Romains,[86] was excellent both in content and in form. The speaker emphasized that the PEN club does not intervene in politics, but it cannot make peace with the fact that one of its most

83. PEN, founded after World War I to unite writers, regardless of culture, language, or political opinion, transformed from a dinner club to an international organization with political influence and an annual "Congress." PEN is short for "Poets, Essayists, Novelists," which was later broadened to "Poets, Playwrights, Editors, Essayists, Novelists."

84. Sokol was a youth sports movement and gymnastics organization founded in 1862. Shapiro is likely referring to an exposition put on in the writers' honor by the Sokol athletes.

85. Milan Hodža was the prime minister of Czechoslovakia from 1935 to 1938.

86. Jules Romains (1885–1972) was a French poet and writer.

important members, the former PEN club president Raoul Auernheimer,[87] sits in a detention camp, or that Sigmund Freud will follow Thomas Mann into exile.[88] He concluded with encouraging words for the Czechs who are putting their lives and their honor on the line in the face of external threats.

The four days of the conference passed with many discussions, arguments, conversations, and speeches, as expected. The arguments were not tempestuous, nor were the subjects very upsetting. But suddenly something happened that stirred people's hearts, and a ruckus broke out in the conference hall during the last session, the concluding session. And the cause of the upheaval—a small resolution suggested by the Yiddish PEN club of Warsaw. Its content was roughly the following: On the basis of Clause 3 of the resolutions from the PEN conferences in Brazil and Edinburgh, the congress in Prague condemns the anti-Semitism and the racial hatred and propaganda that has been disseminated in its name in several countries. The congress demands of its members to fight with all their strength this intellectual barbarism.

This was, roughly, the wording of the resolution, which was read after all the other resolutions about opposition to the wars in China and Spain, opposition to the shootings and bombings of undefended cities and innocent citizens—and this after they welcomed with thunderous applause the delegations from China and Spain (Madrid), who read their pronouncements in front of the conference. This resolution too would have been accepted as a matter of course if the old president of the English PEN club, the well-known writer Wells,[89] who had been almost completely unheard and unseen during the rest of the four days of the conference, hadn't stood up and announced his opposition to the resolution. Why did he do this? An old writer like him who knows how to find reasons has a right to make claims that aren't really to the point. He spoke about the freedom to have opinions and the freedom of the spirit of the artist, even if he is an anti-Semite, that one cannot deny his right to create according to his own spirit, mentioning Gobineau[90] and Chamberlain,[91] who shouldn't be condemned for their books. It seems that he did not understand the meaning of the resolution. A fiery argument

87. Raoul Auernheimer was an Austrian jurist and writer and the nephew of Theodor Herzl. He was the PEN president from 1923 to 1927. In March 1938 he was interned in the Dachau concentration camp; later that year, after the intervention of other writers, he was released and immigrated to the United States.

88. Freud would flee to London in June 1938. Thomas Mann had moved to Czechoslovakia in 1936, only to flee to the United States in 1939.

89. H. G. Wells was president of the PEN club between 1933 and 1936 and oversaw the expulsion of the German PEN club in 1934 for its refusal to admit non-Aryan writers.

90. Arthur de Gobineau (1816–1882) was a French intellectual who, most agree, developed the theory of the Aryan master race used by the Nazis.

91. Houston Stewart Chamberlain (1855–1927) was a British-born German intellectual whose research about the foundations of European civilization was used by the Nazi Party to demonstrate "Teutonic supremacy."

erupted, the likes of which had not been seen during the entire conference. Some made a distinction between anti-Semitism as an "idea" and anti-Semitism as it is realized in real life. Others explained that the creative act finds its basis in the intellect and in the spirit, whereas anti-Semitism's basis is in man's base and vulgar urges. The argument inflamed people's hearts and became very serious until president [Jules] Romain suggested a small change to the wording of the resolution to which the entire congress agreed: The congress condemns all persecutions of nationalist and religious pretense, requiring all PEN club members to fight all persecutions, whether they be of a nationalist or racialist nature. The president of the congress explained to me afterward that those who offered the original resolution made a mistake in presenting at the end of the conference rather than at the beginning.

It is difficult to convey the impression that this argument had on the audience. For instance, a well-known German writer, a refugee, Oskar Maria Graf,[92] stood up and said that the anti-Semitism in Germany was forced upon the nation by its rulers. Cremieux,[93] a well-known French writer, whose writings on twentieth-century French literature, the history of Italian literature, and more are very famous, got up suddenly when the argument had broken out and announced excitely that his forefathers, from the tenth century, were already French citizens, that his family was well-known. He himself had no religious connection to Judaism and did not even have an interest in politics, but now he stood and announced his Jewishness publicly.

In the last session, that same tumultuous closing of the congress, the Swedish delegation was received with much admiration when it proclaimed its invitation for the next congress, to be held in their country in 1939.

Other resolutions were accepted, among them the protection of works of art during wartime and private literary rights.

The congress was heartwarming due to the prevailing spirit, which provided a bit of comfort after the great excitement in this country over the past few weeks. It is too bad that the Hebrew delegates from the Land of Israel did not come and that from Jewish Warsaw only two people attended. [. . .]

92. Oskar Maria Graf (1894–1967) was a German author well-known for his autobiographical works about Bavaria. In 1934 he emigrated to Czechoslovakia, before leaving for the United States in 1939.
93. Benjamin Cremieux (1888–1944) was a French critic and novelist who died at Buchenwald.

Literary Criticism

Y. L. Peretz: The Man and the Writer

(On the Third Anniversary of His Passing—
Third Intermediate Day of Passover
5675–5678 [1915–1918])[94]

Translated by Deborah Greniman

Originally published in *Hashiloaḥ* (1918)

I

Peretz was an enormous personality. Whether you loved him or hated him, he drew attention. And not only as a writer and poet. He also had a coterie of followers and fans simply because he was an extraordinary person, a man of outstanding character and vitality, the likes of which are few among us.

This man had a particularly wonderful attribute: the waves of vitality that incessantly welled and surged in him, with full strength. Anyone familiar with Peretz knew that nothing in his personal life could ever bring him to a state of despair or unmitigated pessimism. Even in the midst of the most difficult events in his life—when he was locked up in prison or suffering from disease, or when he was attacked by nervous distress, such as came over him sometimes as a result of his detractors' scheming or, even worse, when he encountered human stupidity, obduracy, aggression or vulgarity, envy or hatred—even then he never cursed life or became bitter. He was only a bit

94. Cf. diary entry for 25 March 1915 in Part II.

downcast—but then he would immediately begin anew, believing, exhorting, expecting, and hoping for a day when all would be well [*leyom shekulo tov*].[95]

By nature, Peretz could spare little time for human evil: He believed that "the devisings of the human mind are good from youth."[96] It was impossible for him to remain in a "state of depression": A fount of glorious, glowing vitality burst ever from his heart, and whenever he encountered ugliness or evil, his inner life rose up to veil them and would not allow him to dwell upon a spectacle so foreign to his spirit. He would pass over it to arrive at what was beautiful or inspiring and find in that the main thing, the real stuff, the part most suited to himself.

Peretz was a true democrat even when that was out of fashion. In his milieu, at the time, "members of the elite" prided themselves on the manners of nobility and aristocracy. And they thought of Peretz as rather a "coarse" type, because he made light of all those displays of avowed "nobility." Peretz was a true lover of the people. Anything that he found within the people, anything that the people created or made, captured his heart and gave him special pleasure. Frippery and finery, superficial dandying and glitter, and vainglory caused him nothing but unease and pain. In his heart he disdained the world's great men and tycoons. He took much greater pleasure in a tidy home devoid of luxury than in all the superficial shine and shimmer lavished upon the abodes of the rich.

Peretz was a searcher. He longed and thirsted constantly for new ways, new truths, new revelations. But searchers usually cannot stand reality; anything having to do with the present gives them no mental peace or satisfaction. Peretz was not like that. He found a positive aspect in everything. Not that he was happy with just anything new. On the contrary; there was none to equal Peretz in mocking, satirizing, and poking fun at anything that deserved a joke. But the fount of vitality in him, which had to say yes to any new thing, any beginning, any demand or aspiration that had life to it—this would not allow him to be among the naysayers, those who see only shadow and anticipate only the worst.

When the news of Peretz's death reached me, I could in no way imagine that this man, who was so full of life and so life-affirming, this man with the lively, eloquent eyes, suddenly was dead. Even now, as I think of Peretz, I cannot count him among the dead.

I was hardly more than a girl then when I first met Peretz. I remember a winter evening. It was terribly cold outside. A full moon was shining, limpid and lovely, so that even the electric street lamps could not obscure its clarity.

95. From Birkat hamazon (grace after meals) for a festival.
96. Cf. Genesis 8:21: "The Lord said to Himself: 'Never again will I doom the earth because of man, since the devisings of man's mind are evil from his youth.'" Note how Shapiro flips the Bible's word "evil" to "good."

I enter Peretz's study. It is nice and warm there. Peretz is sitting at a big desk next to the only window, through whose panes, coated with frost and snow, shines that unsullied moon. A singular oil lamp, crafted to the taste of the householder, stands on the desk, casting its light on a great number of scattered papers, files, and writing implements and on the writing hand in their midst. Peretz's head and face are partly concealed in the shadows.

I knew I was in the presence of a great poet, and I was a bit overawed. But I saw the look turned to me over his glasses, his eyes, beneficent and encouraging, which told me that none but a pure, good, open heart was before me—and I relaxed.

"How can I be of service?"

Later, whenever I reminded Peretz of how he had put this question to me, and when I imitated its tone and inflection, he could not refrain from laughing.

A tinge of embarrassment seemed to color his whole face.

Peretz had to finish something that he was writing—the boy from the editorial office was waiting in the same room—and I sat in the chair opposite him, on the other side of the desk, trying with all my might not to disturb the writer with the slightest movement. His face had turned serious now, the eyes were directed to the sheet of paper, and the hand was writing and crossing out and correcting.

Every day, from the hour of five in the evening on, young people began gathering at the entrance to this little sanctuary, their eyes falling willy-nilly upon the small copper plate affixed to the door, on which were engraved the Hebrew words: "Y. L. Peretz, Reception from 5:00 to 7:00." From behind the door they would hear the quick steps of the master of the house, who would sometimes emerge from his study himself to open the door. They would see that so-familiar face, with its gay look of amusement, and the eyes, glowing and rousing, giving you a sidelong glance to try to divine your mood, and the encouraging voice speaking straight to your heart: "Hey, shalom!"—while the hand grasping yours drew you into the room, and Peretz would already be telling you something, passionately or in fun.

The young people saw him not only as a teacher and guide but also as a brother and friend, although he might have been twice their age or more—a brother and friend in whose presence one's sorrow would dissipate a bit. He knew how to create relationships with his young friends that blurred the difference in years between them—relationships not of awed respect for him, but simple, sincere, and heartfelt, because he was the youngest among them in spirit and he related to them not as a reproachful rebbe but as a friend and comrade. Anyone who was in his close circle will never forget what Peretz was to him for the rest of his life.

And which of the young people wasn't here? Which of them could forget those wonderful hours that he spent here, in the company of writers and friends, in all manner of

discussion and debate? Sometimes Peretz would make a few remarks about one of the young people—and it would amount to a whole character analysis, one that brought the essence of that person to light. In conversation and to their faces, he would sometimes make fun of some of his guests, but he never cited the failings of his friends or students in writing or in public. He was not afraid of harsh expressions, but when they cut too close to the bone, there was no stopping his spirit.

Sometimes I was amazed at his patience to read through all the manuscripts that these young people daily brought in or read to him aloud—ad nauseam, I would have thought. Yet not only did he read all of them himself, but he would also sometimes convene get-togethers at his house, to which he would invite various writers, and he would propose to discuss and debate the new creations of the young people, crowing like a child if he managed to find a pearl—a good sketch or poem produced by the creative spirit of one of his protégés. And if it seemed to him that he had discovered even the least spark of talent, then, without a care for his own time and effort, he would go over the manuscript of this talent and mark it up with his comments and corrections and question marks, and afterward he would discuss them with the writer and explain to him the reasons for his corrections.

Peretz did not hold back any sharp words he had to say about the creative efforts of these beginners, and these could sometimes be not at all pleasant to their hearers. However, when he met with a fine literary creation, he would exclaim and enthuse and lavish praise upon the writer and predict a great future for him—"but only," he would add, "as long as he doesn't stray from the path or run after honor and fame, and just goes on and on working."

"No shoemaker," he would say, "is born quick at his trade. A writer must constantly perfect himself; he must labor and toil until he can achieve really polished works."

He asked three things of a young writer: (a) that every single detail, even the tiniest and most trifling or obscure, which related to what the author was writing about, be studied by him from its source down to its last jot and tittle; (b) that a description not be too detailed, but that the details should emerge and strike one by way of the literary craft, as though by allusion; and (c) that the portrait should be vivid, the dialogue flowing, and that it be from these that the character of the protagonists and their surroundings should emerge and take shape.

The young people saw him not only as their beloved mentor but also as a guide. Because Peretz really did guide them in finding their way in life.

Many people thought of Peretz as an intellectual lightweight, and they even attributed a certain intellectual lightness to him where it came to literature. "A gifted poet; when the Muse strikes him, he versifies and composes with the greatest of ease." But anyone who lived around Peretz and learned his nature, his character, and his way of working knows that while Peretz in his day-to-day life really did lack the dignity and

"ponderousness" of the learned gentleman and scholar, he was ultimately, in his literary work and artistic creations, a great and profound thinker. When an idea arose in his heart, the raw material for a composition, he would penetrate into its deepest parts, gazing into its soul, into its very guts. And when he went to work, his whole heart was given over to it. His work was his holy of holies, the glory of his life.

Half of his Sunday—the day when he was beholden to his work for the Warsaw community—was like a weekday. But from the moment when he left the place, he would throw off his coarse fur [coat] and go into his own world—the world of literature, poetry, and art, which were his great love. From that moment on, there was no distinction for him between literature and his literary work, and life. He loved life, and he worshipped literature, art, and poetry. And they all came together in his soul. Life was embodied in art, and art and poetry were, for him, the realization of life. His soul was contained in them: He was bound by every fiber of his soul to the more beautiful part of life—to art and poetry.

But although he was so full of vitality and motion, he had a great deal of patience when he was working on one of his compositions. He would go over them dozens of times, polishing them and seeking the briefest and pithiest expression, the most precise phrase or word.

Peretz's soul knew no rest. He could never suffice with merely telling a story. He had to find the way leading *straight into the human heart* and to dress the children of his spirit with a form befitting a truly living vision, the one embodied in their content. And his visions really were alive, right from the start, for Peretz was original not only in the content of his writings but even in his single remarks, in his private conversations, for everything he expressed, its form, too, was original. And Peretz was brilliant at this. The thoughts that sprang up in his mind did not languish there waiting to take form. The expression best befitting them was born with them. But he would perfect that form and polish its style until his composition could realize its proper role.

Peretz took special pleasure in reading old books, folktales, and Hasidic stories in their primary sources. As for the many modern compilations and anthologies that filled his house, he would run his eye over them quickly to skim them. "What others write doesn't interest me," he would sometimes say in jest, "and what I write, well, I've already read it before it was printed!" But that was just a joke. In fact, he was interested in every new work, because he was always looking for new pathways, and that is why he was always so fond of Ibsen, and Gorky always attracted him with his strength of spirit and originality. But the model of perfection in the belletristic realm, for him, was Maupassant, the master of an artistic form that could incorporate and engulf even the most polished and precise idea.

Peretz did not think much of the criticisms that were written about him, and he did not put much credence in the obsequious flatteries that were uttered into his ears

either. He himself would sometimes criticize his own works. In the years when he was participating in the newspaper *Hatsofeh*, he liked to read his feuilletons out loud to his intimates before sending them to the editors, and he was glad whenever one of them, discussing the issues of the time, was understood and made an impression upon the hearers.

Sometimes, even before we went into his room, we could hear his voice ring out. Peretz would be singing Jewish folk songs and striding around his room in good cheer. That was a sign that he had finished some literary work that had not let him rest for some time. And sometimes the visitors would be chatting in the next room while he was by himself in his room, lost in his work. Outside, in a place where he could not get to know people or hear what the masses were talking about, strangers did not interest him. Thus as soon as he entered a coffeehouse, he would gather up a pile of newspapers and journals around him, put his spectacles to his eyes and lose himself in them. But the crowds, the masses, whose thoughts he longed to comprehend, captured his heart. While strolling in the Saski Garden [in Warsaw] or while riding on the tramway in the city or on a train from his summer home, he would start up conversations with the ordinary travelers and listen attentively to what they had to say. His own community, the Jewish community, and his own people, the Jewish masses, were dear to him. It was to them that he listened; he learned to recognize their thoughts and their yearnings, and it was for them that he toiled.

Peretz set no curb or bridle to his emotions, which gushed in him like a mighty stream and sometimes even sank his powerful will. Great-hearted people were dearer to him than those of even the greatest of great cold minds. The worst deprecation that he could say of a writer, as he read one of his texts, was "That writer has more mind than heart."

Peretz never wrote anything that did not issue from the depths of his heart. And when he experienced an event, it burst forth[97] from his pen in the shape of a poem, almost against his will. And when he read the creations of his spirit, he would feel, with all their force, the very same impressions that had spawned them. I shall never forget how he read me his poem "Es zenen keyn wunder geshehen" [Yiddish, No Miracle Took Place][98] (which he considered the finest of his writings). Together with the tremendous passions packed into this poem, it epitomizes the whole endeavor of the poet coming to terms with life gone by. Peretz read it in my home, at my request. Each and every syllable that issued from his mouth was enunciated with its own special intonation. Each and every phrase as

97. Shapiro plays on the similarities in the spelling of Peretz's name and the verb lehitparets (to burst out).

98. The Yiddish title of the poem is a play on the acronym, found on the Hanukkah dreidel, which spells out "nes gadol hayah sham" (a great miracle happened there). The negative-valenced expression in the poem's title is used among Hebrew speakers today.

though it sang its own poignant song in his mouth. Peretz's voice, then, was low, straight from the heart, and packed with emotion. His breath caught from time to time—and I did not dare stop him. It seemed to me that his soul was caught up in his poem, and when the latter ceased, so would the slender thread of the former's life be cut off, and the poet's heart fainted as he read, at the sorrow of his confession. Suddenly he stopped reading, rose quickly, and went out into the hall, put on his coat, and without uttering a word nodded his head in farewell—and left the house. It seemed as though he suddenly lacked air to breathe, as though his heart was too constrained to bear all the feelings and impressions that were stirred back to life in him at that moment.

Peretz did not avoid people, even when he was in a somber mood. At such a time, however, he liked the company of a kindred spirit, and so he would stroll for long hours through the boulevards of Warsaw.

He was companionable to all, but only a few individuals were really close to him.

Bialik was his favorite, Dinezon—his one bosom friend, to whom he was devoted in heart and soul. From a distance, Peretz especially admired Mendele the Grandfather. Berdichevsky and Steinberg were kindred spirits. He grieved terribly over the latter's early death. He was grieved to the heart by the harsh conditions in which this brilliant writer lived, or rather, died.

Everybody liked Peretz. Even his opponents used to come and go in his house, and he would receive them affably.

They said of him that it was in pursuit of honor and adulation that Peretz surrounded himself with young people and students, but it wasn't so. No, he simply liked them and felt, with them, that he was in his element.

"Which of us is the younger?" he would ask of those sitting by, as he lined himself up with one of the youths and straightened up to his full, not very imposing height. And indeed, one had to admit that the man with the lively, eloquent eyes and joyous spirit, full of freshness and vitality, was far younger in spirit and in the intensity of his zest for life than the stooped youth with his load of world pain [*yegon ha'olam*, a Hebraized version of the German *Weltschmerz*].

And among the youths who surrounded him, he was the life of the group. In his personal life as in his literary works, he was a restless spirit, demanding, inquiring, searching, and seeking, and filled with all sorts of plans. Yet together with that he was also quite practical, even in his personal life, able to foresee the consequences of what people did on the basis of his life experience.

Peretz believed in life; he believed in love and in the power of love. However, he was realistic about life and did not go after false hopes. He was not a dreamer in real life, and he did not like to delude himself. He always saw things as they were; he only demanded and wanted them to be different.

And so, in his works as well, the ideal and the real marvelously came together. By temperament and proclivity he was an idealist; his soul was all wrapped up and entrenched in romance—but in his mental world, he was entirely a realist.

He did not like emotional outpourings or sentimentality in writing. These, he believed, ought to be implicit and subtle. But things that everyone could appreciate, that were not only the private province of the writer, that the reader, too, could feel—that's what had value as a creative work.

Peretz did not long for faraway lands. He loved Warsaw and its streets and alleys, and when he had to go abroad for the sake of his health, he was unhappy about it. About two years before his death, he received an offer to come and visit America. He rejected the offer. America held no attraction for him. But when I returned from a trip to the Land of Israel, he did not stop asking me about it.[99] That country had a special charm for Peretz, even though he was not counted among the Zionists. In the last year of his life, he was to make a trip there, but—then came the war, and death overtook him.

When I ran into Peretz in the last years of his life, I sensed an enormous change in him. I remembered the early days, when I came to live in Warsaw and first got to know him. That was in his fiftieth year. On Lag ba'Omer[100] 1901 his admirers and devotees celebrated his fiftieth birthday at his apartment. Peretz did not want a public celebration. Only in the evening did some other people hold a banquet in one of the large halls in Warsaw, and afterward his closest acquaintances assembled in his apartment—with its three cramped rooms—surrounding him with affection, making some short, heartfelt congratulatory speeches, and reading the telegrams that had arrived. Suddenly they lifted up the somewhat embarrassed jubilarian and carried him aloft. Then they presented him with the gift for which he had longed: a full edition of his works. Until then, Peretz had been better known to Hebrew readers, because his books had been published by the Tushiyah [Hebrew] publishing house, and Peretz had dreamed of a complete edition of his books and writings in Yiddish[101] for the masses. One had to have seen his joy when this gift was presented to him. Only Peretz could exult like that. Those tokens of affection and appreciation that had been shown him—tears of joy, a touch of embarrassment, and a childlike happiness on the part of the jubilarian—were his gestures of gratitude. Of the dignity befitting a jubilarian there was no sign at all.

99. See "Notes from My Journey to Eretz Yisrael," earlier in this part.
100. On Lag ba'Omer, the thirty-third day of the seven weeks counted from the second night of Passover until the festival of Shavuot (see Leviticus 23:15), the partial mourning customs traditionally observed in this period, after Passover, are relaxed. Lag ba'Omer is a popular date for celebrations and parties.
101. Shapiro uses the Hebrew word jargon here to connote Yiddish.

Dignity was not among Peretz's attributes. He was full of life then; he thirsted for life and was intoxicated by it.

Now, however, when I met him again, I sensed a huge change in his spirit. To be sure, he was "young" even now; nothing much had changed in his outward appearance, nor, as it would seem, in his inner self. But only—as it would seem.

His mood was truly strange to me. Peretz was not among the complainers,[102] and he did not like whining. I had never heard a sigh escape his mouth. But this time, a powerful inner anguish looked out from his eyes, and a sense of desolation filling his whole being showed its mark. I sensed in him enormous sorrow and a powerful yearning. A yearning for the past, for the life that had passed and gone, and a powerful anguish over the steady approach of old age.

During one of his talks [with me] his mood had a very depressing impact on me. To be sure, he did not complain of old age, but the young people had drifted away one by one. The flow of life had overwhelmed them and swept them onward, far away from him. And those that remained nearby lacked the enthusiasm and devotion of the former ones.

I talked to him of the students he had raised up, of his many friends and admirers—and I saw such anguish in his eyes that I broke off speaking. I did not dare say more, because I did not believe in my own words after I looked into his eyes. "Friendship? Admiration? For me, as I am for myself?!" A smile of bitter irony played around his lips.

The famous man grieved for his fame, the venerated man—for the expansive spirit within him, which exalted him above other humans.

I did not dare look in his face. After a brief pause, I heard his voice, filled with pining: "You see, I'm right!"—never had I heard such a melancholy tone emerge from his mouth—and he immediately tried to speak of other things.

Marks that had once been foreign to his spirit were now noticeable in him. That inner sorrow and that great loneliness—these were new engravings on his character that I had never before discerned in Peretz.

And what I saw in him now was that, above all, he was alone.

Now, after his death, he is mourned and eulogized by people and "friends" who were in fact remote from his spirit. They probe and pick at and rummage in his inner self and in the creations of his spirit, in his holy of holies, with no excess of affection, no profound comprehension of the depths of his soul. "Friends" who had harassed him in his life, who had given him the cold shoulder or distanced themselves from him out of jealousy (and some from whom he had distanced himself) and had not refrained from making cutting remarks in the open or behind his back. And how he had suffered from this in the last years of his life, when he finally did get old, despite his youthful spirit!

102. Cf. Numbers 11:1: "The people took to complaining bitterly before the Lord."

And one more thing I wished to note: In vain did the radical "Yiddishists" call Peretz one of their own. Peretz loved the Hebrew language, and it seemed obvious to him to write in Hebrew. When he was working for [the Hebrew] *Hatsofeh* and for [the Yiddish] *Der Jude*, he gave of his spirit to both. I never saw him give the upper hand to either language. It was only the excessive rhetorical flourishes sometimes used in Hebrew that he despised. He prided himself on having been the first to note the difference between a true poet and a mere "linguist" (in his well-known Hebrew article "What Was Gordon— A Linguist or a Poet?"). In his later years he did take to speaking mainly in Yiddish. In writing, however, he would never even jot a note in any other language to someone who knew Hebrew.

For Peretz, life itself was a work of art, and when he no longer had the strength to live and create, when the war broke out and he saw with his own eyes all the impoverishment and suffering that it caused, the wicked regime and the human evil that ensued, the thread of his life was cut off.

"A person who wants nothing, hopes for nothing, and fears nothing cannot be an artist," said Chekhov in one of his letters. Peretz wanted a lot, hoped a lot, and feared a lot. Then came that devastation—and he saw no escape or end to it; he saw with his own eyes all the oppression and distress, all the slanders and calumnies against his unfortunate people, the expulsions and persecutions that overtook the members of his nation so catastrophically in the first days of the war—and his seething heart could not summon the strength to go on beating at a time of such carnage and destruction, such tyranny and evil—and so it ceased from beating.

Memories of Frischmann's Life

Translated by Deborah Greniman

Originally published in *Hatoren* (1923)

The generation that comes after ours will know neither Herzl nor Mendele; nor Peretz, Frischmann, and Berdichevsky; nor Brenner, Levinsky, and Sholem Aleichem. For [that generation], all of these will be just *names*. Admired, "classic" names, perhaps, but names that are but an echo of *the past*. Names that it will know only from their works and endeavors.

For us, the men and women of their generation, who lived among them, who knew Herzl not only as a "dreamer" but also and especially as a man of endeavors who knew no rest or quiet; who knew Peretz, the man with the evocative, amused eyes, whose every movement was full of vitality and joy [*ḥayyim vesason heḥayyim*, a Hebraized version of the French joie de vivre]; who knew Frischmann, with his short, sharp aphorisms and his slightly derisive look; Levinsky the "serious one" and Sholom Aleichem the "simple one"—in our memories, they live on as beloved men whose endeavors and works were only a part of their personalities, only part of their beings and their lives. We did not know them from their works; rather, we knew their works and endeavors as the necessary and appropriate outcome of who they were.

They left us, in their works and endeavors, only what could be said and done; yet each one of us knows that not everything can be expressed and not everything can be done, and the writer often bears within himself much more than what he is able to fulfill in writing: living speech, in our own hearing; living movements; well-known glances—all those immediacies that disclose the writer's essence and inner world to us—such as do not always emerge, at least not to the same extent, from his works.

A single gesture of Herzl's when he was excited or insistent, Peretz's expression when he was speaking or listening to someone else speak, Frischmann's look when he was *contemplating*, Sholem Aleichem's probing eyes as he perked his ears to take in something of interest—all these things live on in our hearts, and whenever we hear one of those names, a living picture of that writer, whom we knew face to face, at once rises before our eyes.

I first got to know David Frischmann in the years when he was publishing *Hador*. I gradually overcame my shyness before this writer, with his reputation for derision and criticism. I hardly dared speak in his presence; I only looked and listened to what he himself had to say. But "the devil is not as black as he is painted";[103] and every time he came to our house, or when I would run into him at Peretz's house, which was a meeting place for all the Hebrew and Yiddish writers living in Warsaw or passing through it, I saw that Frischmann was not the loner that I had imagined him to be or that had been described to me by others. On the contrary, he was involved with those around him and enjoyed mingling with them; it was just that he preferred observing and assessing their characters to opening his own self up to them.

Frischmann spoke no flattery ever, either to the crowds or to the great men of letters. With his keen mind and sharp tongue, he did sometimes inadvertently upset them, but behind the mask of nonchalance and mild derision hid a sensitive, impressionable heart.

If a person can be judged by his likes and hates or by what he finds beautiful or ugly, this was especially so of Frischmann. Not only did he have a special sense for literary works and for the nature of the people he knew [but] his whole being was part of that sense, which was so well developed in him.

In Peretz's home, the subject of every conversation and remark was literature, always and exclusively literature. Politics, which has now become the basic substance of every social conversation, did not stir up people's imaginations so much in those days.

Of course, the heart of things was the master of the house, who would receive his guests with special affection and was always the live spirit among them and whose benevolence stirred them to feelings of rapport and camaraderie.

Frischmann was the most cultivated of those writers. His manner of speaking, his dress, and his comportment differed from those of the others who congregated in Peretz's home, and so people related to Frischmann a bit carefully. Everyone feared his derision, and so, to buck themselves up, they would dismiss his remarks beforehand and make fun of his cultivation.

But Frischmann's special sense allowed him to recognize immediately the nature of the person he was dealing with. He straight away made his assessment—but he kept it to himself. I never saw him show any disparagement of others, but those others who knew his sharp glance, his ready judgment, and his irony were afraid of him, and so they would anticipate him by dismissing his opinions, his judgments, and his criticism.

Frischmann knew this. He knew these people and their "refined tastes," but his heart was too taken up with the great men of literature for him to take much interest in them. He lived in the spheres of literary art; in them he took his pleasure, and they absorbed him utterly.

103. Idiom derived from Dante's *Divine Comedy*.

Unlike the many authors who talk continually about their own works and endeavors, Frischmann did not like to speak about his own literary work. Only once, I remember, when our conversation got around to the English poets Shelley and Byron and to his own translations of them, Frischmann asked me to bring him Byron's *Cain* in his translation (published by Tushiah Press)—I had it in my house—and began reading me his foreword to that book, and he was so thrilled by the cadence of his own words, which he intoned with great expressiveness, that he did not put the book down until he had finished the entire foreword.

It seemed to him that everyone must discern his way of thinking, his essential self, and his ideas and feelings in each and every one of his utterances. And he believed in his power, believed that he had the ability, in his hand and mouth, to realize and explicate the notions that filled his heart, in such a way as to make others feel and comprehend them. But even that was not the main thing. The main thing was that he expressed them, gave them shape, and dressed them in form and that he himself could sense in them what he had wanted to express and what it was that filled his heart.

And of this Frischmann, people said that all his activity could be summed up in his negativity, in his constant "no!" To be sure, those people did not know him. And those who judge us without knowing us cannot hurt us.

When *Hador* was already on its deathbed, *Hatsofeh* began appearing in Warsaw, under the editorship of A[braham] Ludvipol. The period was one of great enthusiasm and interest in Hebrew literature. [. . .]

After *Hatsofeh*, the time arrived for the daily *Haboker*, under Frischmann's editorship.

Frischmann invested a lot of money and enormous amounts of work in these publishing ventures (*Hador* in its first and second incarnations and *Haboker*), and yet these forums that he established never succeeded. They did not succeed, that is, in the material sense, because Frischmann was unskilled in the practical, financial (or business) side of things. But in the intellectual sense, from the point of view of their literary content and form, Frischmann was the first to give this genre its proper form. All that he edited was elegant and imbued with clarity and charm. There was a special sheen to them, to the daily paper as to the weekly. Frischmann's wish was to create "a little discernment and good taste," and he succeeded in this. A great many readers and authors were educated and influenced by his publications, serving to develop that sensitivity and taste to a large extent, even among those who never stopped criticizing, denouncing, and assailing Frischmann. But nevertheless, neither *Hador* nor *Haboker* was able to sustain itself. This is not the place to explicate the reasons for that. The main thing is that Frischmann became despondent each time, despite his faith and confidence on each occasion in the new publication's staying power, because he knew the force of his

diligence, his ability, and his prodigious will. "Whoever wants to join the fight, let them come to me!" he would declare. "Whoever has the truth on his tongue, a spark in his heart, and reason in his mind, let them come to me!"

Yet they called Frischmann, habitually, "the skeptic," "the pessimist," the one who saw only the bad, and so on.

It was not so. The place that was only bad—he did not see it. He never sought and never found the bad, rather the good and the beautiful. But he had some resonant phrases for abomination, for writings that do not say anything, for words, phrases, discourses, and articles empty of content or reason or of any captivating form. Had he really seen only the bad, he would not have begun anew each time with publications into which he sunk so much of his mind and effort; he would not have devoted so much work and vitality for the sake of creating that good, by means of which he sought to create "good taste and discernment." But people always like only to have a nice—out-dated—tune sung to them.

That art was unfamiliar to Frischmann. He said what was on his mind. To dissemble and mask his face with delight and admiration when his heart wasn't in it, that he could not do.

He was not a loner and did not see only life's ugliness; everyone who knew him will confirm what a sociable person he was. He loved life, and mainly what was beautiful in life. But he could not stand idleness or vanity. He used quite often to sit and while away his hours with groups of friends in coffeehouses and concert halls. But more than he would talk, he would listen to the talk of others. He preferred observing them to entertaining them.

When he was bitter at heart, he would talk at length, but when he was disgusted by some deed or sight, he would be silent. And for that they could not forgive him. People would see Frischmann sitting there, watching, with that look in his eyes through his glasses, which could at times also be disdainful, and it gave them no satisfaction. But Frischmann was not disdainful out of contempt for others, for he did not see himself as being above them. His contempt was reserved for what was petty or mean in life. And he could not restrain himself when such things were flaunted in his face.

He would come to Peretz's house only on rare occasions. Indeed, it must be admitted that even Peretz, for all his empathy and sensitivity, was not always correct in his judgment of Frischmann.

Frischmann was by nature a man of good taste—any good thing and any fine work made a profound impression upon him—but he did not show his feelings to everyone. It was easy to gain his admiration, but he did not expose that admiration to others. He was closed within himself. [. . .] In temperament and sentiment, he combined passion and coolness, seriousness and jest, to the point that it could be hard to tell them apart.

[. . .] Only very rarely was he passionate in speech. Usually his voice was low and his words brief, and he would utter them as though against his will, puffing on his cigar.

Once we were talking about feuilletonists and the art of the feuilleton. It was the first time I had seen Frischmann get so fired up. He spoke about everything that the artist brings together in this form, which is belittled by people who have no idea whatsoever of the beauty of a fluttering lightness.

People of great and eminent talent had expressed their intellectual thoughts in [this genre]. But it could not be learned in the same way that, for example, the scholarly style could be learned, through perseverance. Precisely because of that, however, because its apparent lightness sometimes incorporated the most profound seriousness, and its overt superficiality concealed a subtle profundity—precisely because of that, people took this attitude toward it.

Frischmann himself was a master of prose style, as of poetry. But his feuilleton style too must be acknowledged as almost without equal. His *Letters on Literature* were written in a feuilleton style that is lovely, appealing, and clean of obscurity on the one hand and of frills on the other.[104] And there is of course no need to elaborate on the good taste and acuity that he brought to Hebrew literature and the marvelous garments in which he clothed it. [. . .]

As he never lavished praises even within earshot of the people he liked and admired, so too he never boasted or showed off or flattered himself about his own great works. Appreciation and, where possible, apposite criticism—yes, indeed.

In this context, a collection of articles commemorating Reuven Brainin's sixtieth birthday, which reached me just a little while ago, comes to mind.

As someone who knows Brainin, I asked myself: Did this collection really give him satisfaction? Brainin would always place greater demands upon himself than what others would put upon him, and now those people come to sing his praises and buzz in his ears about what he has done already.

Yet far more than Brainin has already done and created, he has still the potential to do and create, and far more still is stowed in his character and soul. So what more will these articles give him?

Every time I passed through Warsaw (the city where I had once lived), I found Frischmann absorbed in some new literary work, to which he was utterly committed and to which he would devote all his time and energy. And every time, he would be

104. This is high praise from someone whose work Frischmann was critical of in the same *Letters on Literature*. See Frischmann's review of Shapiro's *Collection of Sketches* in Part V. Frischmann showed similar disdain (in the name of others) for the women he met at the Gymnasium in Jaffa who had earned doctorates from Swiss universities. This, of course, was equally critical of Shapiro, who had the same credential.

doing it without much accounting, out of love and commitment, even though, on the basis of his previous experiences, he could have allowed himself to doubt whether it would enable him to meet the needs of his household.

In 1911, we traveled together to the Land of Israel—Frischmann and his spouse, myself and my parents, together with a whole convoy of people from *Haynt* along with its editor.[105] At every station through which we passed, from Warsaw to the border—we were traveling via Trieste—we were greeted by Jewish throngs, whose main purpose was to glimpse Frischmann's face.

When the train had barely stopped, crowds of welcomers would push themselves into the carriages, and all that was on their lips was the name "Frischmann." "Where's Frischmann?" Only to see Frischmann's face—that is all they asked.

One could tell then just how far the name of this writer of ours preceded him, how beloved and adored he was by the large audience that read his works and savored the beauty of his poetry, despite the sting of his criticism and the bitter words he sometimes told this very same audience; how they respected and revered him, and how beloved was his fine artistry by all those simple Jewish "Hebrew readers," who bore the name Frischmann on their lips with such honor and esteem.

Of course, in Frischmann's eyes too, all these simple tokens of affection and esteem were greater than any "uproarious ovation."

He was elated, and he—the great "skeptic," "pessimist," and scoffer—looked out upon these crowds of fans and admirers with the eyes of an amazed child.

On the third day after our departure from Trieste, there was a storm at sea. On our ship, all the passengers disappeared one by one into their cabins. Everyone got sick. Frischmann was the only one walking around, wrapped up in his coat, visiting the sick ones who lay groaning on their beds and doing everything he could to help and succor them.

Only on the day that we reached the Haifa coast (we couldn't reach Jaffa) did the "patients" begin emerging from their hideouts and showing their faces, which had grown thin and pallid from being ill.

Mt. Carmel was revealed in all its beauty, and already early in the morning, Frischmann was sitting at the ship's rail, gazing upon that picture so familiar to us in our imaginations from childhood, which Frischmann was now seeing with his own eyes for the first time. He sat in silence, entirely given over to his thoughts and emotions.

From the day we set foot upon the soil of the Land, the gestures of respect and affection for this poet only multiplied, in every town and settlement, from Haifa and Zikhron Yaakov to Jaffa and Jerusalem. Everyone wanted to see him, to greet him, to hear what he had to say. Frischmann, however, was rather tired, and in any case chatter

105. See Shapiro's travelogue of this trip, "Notes from My Journey to the Land of Israel" earlier in this part.

and idle talk were not among his strong points. He had never been a speaker or "ora-tor" to the crowds. He kept his thoughts and feelings to himself.

One time—it was in Rehovot or Rishon LeZion (I don't remember which)—some young women came to him with a gripe about things that he had written about women in his *Letters on Literature*, occasioned by the publication of my *Collection of Sketches*.[106] They surrounded him with their tirades, and he stood before them like an accused man, bereft of his marvelous language and style, particularly when confronted with the vital, flowing speech of women in the Land of Israel.

It was surely the first time in his life that Frischmann heard his poetry ring out so beautifully, when one of the lads, at a party held in his honor, recited his poem "Messiah."

In Jaffa, a grand celebration was held in the poet's honor. All the writers, teachers, and local dignitaries took part in it. As is the custom in the Land, the festivities featured "Oriental" dancing. The teachers and writers lifted Frischmann up on their shoulders and danced with him. Everyone cheered him, and that heartfelt joy, such as can be found only in the Land of Israel, infected him as well.

Many speeches were made in his honor—and this was the only time in his life that Frischmann responded with a "speech" of his own.

Throughout the journey, I never saw Frischmann write down his impressions.[107] He just smoked his pipe and watched and observed. Everything was impressed upon his heart and mind. One had to have seen him at the Western Wall, walking up and down and looking—the same place that makes such an intense impression upon every one of us, like it or not.

Frischmann traveled once more to the Land of Israel. I visited him many times already in Warsaw and its environs when I passed through there, and I saw his work, constant, meticulous, and diligent. The reams of foolscap pages on his desk, covered in his handwriting with its tiny, precise letters, the pages piling up under his special desk lamp, attested to this copious work through the long winter nights.

During the war I saw Frischmann one more time in Kiev. Despite the predations of time, his spirit was very lively; he was full of many literary plans for which he was off to Moscow, and he spoke of them with enormous energy and new hopes.

We spoke of our old acquaintances. Peretz, Sholem Aleichem, Dinezon, and other writers we had known were already among the deceased. So fine and pertinent, then,

106. For Frischmann's critique, see Part V.

107. Whether or not he took notes, Frischmann published a travelogue of this journey to the Land of Israel just weeks before the first installment of Shapiro's "Notes from My Journey" appeared, though in a different journal. The beginning of his travelogue is strikingly similar to that of Shapiro. See Frischmann, "Hayada'ta et ha'arets?"

were his assessments of them. Only with regard to Peretz were his criticisms, to my taste, inaccurate. Perhaps because he demanded more of the greatest of the poets than was right or appropriate.

Frischmann could never accept mediocrity, and what rose above it he assessed according to his temperament—severely.

Regarding literature, he had an overriding desire to clear the atmosphere of the mediocrity that he could not stand. Literature was the profession to which he devoted all his talents, and it was obviously what he held dear above all else. He aspired to see Hebrew literature on the highest level, and it is no wonder that if, to his taste, it did not fall into line in its current form, this pained his heart. He strained with all his might to elevate and refine it, but also, simultaneously, to clean it up, to sweep away its inner maladies and arouse attitudes of appreciation and affinity toward it.

It was because of this, and only because of this, that Frischmann was considered such a great pessimist.

And terrible indeed is the situation of a man who is aware of the principal object of his desire and proclivity and also of the impossibility of achieving it, and at the very same time he cannot relinquish it, because this very thing is bound up with his entire being and selfhood.

Frischmann's skepticism and pessimism were not a function of any particular philosophical system or outlook on life. They rested partly on his natural inclination and partly on his frequent despondency. But if only there were ever more such pessimists and skeptics among us, who enrich (out of skepticism!) Hebrew literature; more diligent workers like him, who work and produce all their lives, holding back nothing—if only out of "skepticism"!

Art is the foundation of the soul. And art is unlike science, which has to do only with the human mind. Art is bound up with the inner essence of humanity. It is in art that man discovers his true essence, what he really is.

Far better for us is such a distinguished "skeptic," one who fructifies and enriches our literature with the marvelous products of his spirit, never resting or desisting from his diligent labors—for the sake of developing good taste—throughout his entire life, that genius whose lively spirit and clear mind (and if you wish, also his derision for everything devoid of content and spirit) never ceased up to his last day, than thousands of puffed-up, conceited show-offs, priding themselves on what they haven't got and "aspiring" without knowing to what they're aspiring, feeding off the creative products of the really great artists.

Frischmann's memory will remain blessed for us and for our literature forever.

Reuven Brainin, On His Intellectual Image

(On the Occasion of His Sixtieth Birthday)

Translated by Deborah Greniman

Originally published in '*Ein hakore* (1923)

I hadn't wanted to write about Brainin. It has always seemed to me that writings aimed at evaluating and enumerating the sum total of a person's lifetime of activities are a kind of living monument to him. They are a final accounting presented to him. And Brainin, in my eyes is that dreamer, that seeker and searcher, who does not pair well with old age. But if a person comes out and asserts of himself "I'm old," and others sing his praises to him for all that he has already accomplished and achieved in his life, then one must necessarily take cognizance of the fact that, ultimately, the greater part of that person's accomplishments and works already belongs to the past, and even if he goes on filling them out, broadening and completing them, the main thing is that greater part. The stuff of it is already laid out before him as his life's work and productivity, if perhaps only to sustain him for the sake of carrying on his endeavor.

I did not know Brainin in his youth. When I first met him, he was already close to 40. I was hardly more than a girl then, and in coming for the first time from Russia to the German capital, I was also seeing a Hebrew writer for the first time. Each one of us remembers what this picture was in his imagination in the early days of his youth. In my eyes, every writer was like an exalted individual; not just anyone merited coming into his presence.

I entered the writer's residence in awe of greatness. At that moment, he emerged from an adjoining room, and I suppressed my bashfulness to hold out to him a letter of recommendation from a native of my town who had lived with him for a long while in Vienna.

I dared to observe the writer as he read. A gaunt, tired face, pallid and lean; a high forehead, topped by a lock of black hair, thin and straight; a small black beard and brows; and handsome eyes. The face gave the impression of torment and suffering. A

critic? And the eyes—they were the eyes of a dreamer. Perhaps it was sorrow in them, perhaps longing. They yearned and demanded, doubted and dreamed, and a profound, wordless melancholy peered out of them.

Those eyes conveyed a singular world, cryptic and inward, that of a longing, hungering soul, one whose aspirations and sancta were concealed from the gaze of others.

The writer addressed some questions to me. His voice was soft and warm, and it seemed to me as though the man took care not to molest anyone with so much as a rough tone. I listened to what he said. The questions were the usual ones; only the way they were expressed was different. From his eyes glowed sparks of that life which their owner made such efforts to guard as a private holy of holies, but which, despite that wish, arose and manifested themselves and were reflected in them.

Beforehand, I had pictured the harsh image of a critic, a stormy, wrathful man, yet here before me was a man with a tender soul, with qualities more usually associated with the soul of a young poet.

Brainin then was a dreamer of dreams, but not one who dreamed only in the spheres of the extraordinary; he was a dreamer in the usual sense: No, he also dreamed his dreams in ordinary, everyday life, which on the face of things, does not suffer dreams. He did not bring his dreams into his life; rather, all of life, for him, was like a dream.

It happened too that he could not quite distinguish between the life he created in his imagination and that which he was living in reality. I am quite certain that Brainin, in thinking back upon the past, is unable to distinguish between things that really existed and those that he envisaged or aspired to, between things that happened when he was awake and those that happened in a dream.

Brainin was not one of those types who "dream" about the future and meanwhile are immersed in trivialities and prosaic matters of the moment. His world was entirely poetic, even in the course of hard, everyday struggle, and his aspirations were things that already existed for him. He lived them, and he did not care if, in the present, they were no more than a dream. He believed in them with all the force of his feeling—that is how he lived his dreams of a return to Zion, of the reestablishment of the Sanhedrin,[108] of the revival of the [Hebrew] language, and all his other dreams, which he created in his fevered imagination and which, for him, were concrete certainties.

His heart was wakeful;[109] his emotions burned; his imagination soared to the skies, free of any formula or convention. He marveled and raved about anything new and beautiful and cheered it on wherever he encountered it. He sought it out and aspired to it and was never sated from it. And whatever he found in other worlds or in foreign fields, he

108. The supreme court of ancient Israel.
109. Cf. Song of Songs 5:2: "I was asleep, but my heart was wakeful."

made efforts to transplant into the tents of Shem.[110] He was zealous for Hebrew literature, which he sought to enrich with every treasure and pearl that he had learned. He wanted to bring into the Hebrew world all the beautiful and new things that he had assimilated.

And the youth were open to it, and their hearts longed to hear not only the things he brought them from the world outside but particularly and especially what Brain had to tell them of the stirrings of his heart and the musings of his mind. Whenever they heard Brainin, they anticipated some new word or revelation.

Even if they did not always find what they were looking for, Brainin's name always guaranteed that beautiful things were in store.

If what he said was not always new, the garb in which he dressed it was always new, thrilling, captivating. And that made even the old look new. Not for naught was Brainin's language considered the epitome of style.

All of his enthusiastic and excitable personality went into creating this style and tongue, which was practically all his own. Brainin's style can be recognized from a single page. It is not just fluent; it is thrilling and fascinating. One cannot disbelieve if he believes; one cannot deny a thing if he proves it. He draws you along effortlessly with the charm of his tongue. However, the richness and charm of his style are also its downfall. He beguiles his reader with aesthetic pleasure and charms him to the point of turning a blind eye to the essential, which sometimes was missing from the book—only sometimes, of course. For most of Brainin's ideas during that period of his writing were likewise filled as well with glorious beauty, with boldness and insurrection. There is in them something of a revelation of new horizons, and more than that, of powerful longings for those horizons; there is a singular splendor to them, and they thrill and captivate the youth, creating a kind of *Stimmung* [German, mood] of uplift and enthusiasm.

But their creator grew stifled and subdued. His rebellion and his new discoveries petered out, as did his raging battle[111] against the standard and the accepted. Those "standards," as it were, clung to him as well. The force that influenced the younger generation lost its hold. In speaking of him now, we recall that period when Brainin not only was wealthy in spirit and imagination but also spread his wealth, for that is Brainin's nature. He spreads it on—and he spreads it on too thick. He believes in beautiful notions born in the world of poetry and leads his readers on after them, turning the future into the present, immersing himself in a world that is all glory and splendor, and breaking all bounds with his aspirations. [. . .]

Brainin's character and disposition comprise an amazing duality. There are times when he can deny everything [like a heretic] and simultaneously believe devoutly in his own

110. A metaphor for the Jewish world, because Noah's eldest son, Shem, was considered the forefather of the Semitic peoples; cf. Genesis 9:27 and 11:10–32.

111. Cf. 1 Samuel 4:2.

dreams and imaginings. He can be as needy of reinforcement as a child and simultaneously as sturdy as a cedar in holding steadfastly and stubbornly to his own opinions. [. . .]

Brainin was a poet by spirit and disposition and a critic by literary "profession." But his basic disposition emerges strikingly and distinctively in his literary work as well. His love and talent for disclosing even a modest light give him the ability to plumb the recesses of the soul that he is critiquing, to remove the outer shells and expose the inner essence, to discover talent wherever it may be. And he marvels at it so greatly wherever he discovers it; he is so very capable of this kind of true admiration, giving him the ability to expound upon this person's positive attributes as well—something that is not all that commonplace.

This talent enables him to make just appraisals. He finds in everyone what is fundamental and crucial to him, the essential selfhood that is usually hidden from the eyes of others. Long before anyone envisioned that Tchernichowsky would take a place as one of the great Jewish poets, Brainin had already enthused about his talent and his distinctive essence and had appraised him truthfully.

It would be hard to find another writer in our time for whom life and literature are as undifferentiated as for Brainin. At times, to be sure, he may weary of pen and ink as unfaithful and imprecise couriers of living thoughts and emotions[112]—he would wish to express with precision everything that arises in his mind and imagination—but without literature, that is, without the art of writing, he could not go on living. And art, for him, is soul expressed in style. Just as his own style is art in and of itself.

Brainin's life is also very rich. Rich not because he has seen different countries and known distinguished people but because his soul knows no rest and desires no rest. Life without reaction, without actions, without creative work, without wonder, is no life for him. A day gone by without some new impression, without new insight, without some feeling never felt before, is worthless to him. And I cannot imagine Brainin without an environment that he has influence over because of his great talent—for endearing himself to others. He has met many of the distinguished members of his generation—and been liked by them. And he has a special talent for discovering the light and shadows, the beautiful and the absurd, in even the most famous of them. He does not need to ponder this; with that special sensitivity of his, he grasps straight away their true essence and that which may be obscure even to themselves.

Most wonderful of all is Brainin's love of Hebrew.[113]

112. Cf. diary entry for Friday, 7 Av (2 August 1900), in Part II.
113. Shapiro seems to be defending Brainin here against those who criticized him for abandoning Hebrew for Yiddish upon immigrating to North America.

When I met him, not many people dared to dream of the revival of the language to the extent that Brainin did. But he did not actually dream about it. For him, it was already a certainty. It was something that just had to come. And to this dream-certainty of his he devoted himself with all the warmth of his spirit. Doubts and worries, even justified ones, never weakened his devotion but only enhanced and strengthened it. He could not do otherwise. Hebrew was the very stuff of his soul. He could change his mind in connection with anything, only not that. Take Hebrew and his great love of it from Brainin, and he would be wretched and plundered in spirit. Perhaps he would have gone on deluding himself for a while, but his heart would have remained empty. It was this, in particular, that brought him his spiritual exaltation and imaginative excitement.

Hebrew and his love of it were part of his selfhood, and the latter cannot be imagined without the former. Should he ever have denied this, he would have betrayed his very self.

And from his selfhood and magnitude of feeling ensue his opinions and views as well. And that is his distinction. They come from the heart. We have plenty of cerebral critics, but critics of such magnitude of feeling as Brainin are surely few in our literature.

An appreciation of the value of Brainin's writings, as critic and artist, will be possible only once we have all his books laid out before us. At present, they can be judged only by the impression they have left upon our memory, by Brainin's personality, his aspirations, and his talents. Chekhov once remarked, "When I wish to understand someone, or even myself, I look not upon their deeds, which are always conditioned, but upon their aspirations. Tell me to what you aspire, and I'll tell you who you are."

And Brainin's aspirations? It is hard to make an accounting of them. What doesn't he aspire to? He himself would be hard put to express his aspirations in words. Bliss unimagined by mortals, spiritual wealth without end or limit, total freedom, creativity, poetry, and beyond all this, beauty, magnificence, and embrace of worlds—contentment with little is not something Brainin has ever known. He aspires to the highest and presages great things and always demands more, even from himself, perhaps because the world that he bears within himself is richer than anything that might yet be revealed.

Reviewers of his literary work say: It's a shame that Brainin has not focused his powers on the field of criticism; he could have done great things. In my opinion, this judgment is pointless. Brainin's talent and temperament cannot be restricted only to such concrete things. Brainin writes about everything that he has seen and heard and that has affected him. But lovely as well, sometimes, are the things he has not seen or heard, the offspring of his imagination, his wonderment, and his enthusiasm.

That aside, a man like Brainin is incapable of focusing on any particular field.[114] Even all the fields of literature could not satisfy him. He has mulled over and searched

114. Note how Shapiro defends Brainin's eclecticism here, when she later criticizes herself for not focusing her own energies. See diary entry for 11 April 1927 in Part II.

incessantly through all the arts—in painting, sculpture, dramaturgy, poetry, and song—which have interested him no less. In all of them, he has always discovered and proclaimed new things.

And his proclamations and presages are filled with passion. That is why there have always been so many who thirst for his voice, and also why there have been so many who detest and envy him, who could not forgive him either for the confident, reproachful tone in which these things were said, or for his aspirations and dreams, which, according to their own narrow point of view, he held only to make himself look grand.

"Society often forgives the criminal," says O[scar] Wilde; "it never forgives the dreamer."

In one of his sketches, Brainin describes the fantasies and feelings of a lowly artist, the first time he puts his drawings on the page. This destitute artist, spending his winter nights in the *beit midrash* (house of study), is forced—for lack of a mirror in the house—to peer into water in order to be able to see the image of his own countenance.[115]

It is enough to read only that sketch to know Brainin's aspirations, his great faith in art, and his powerful love of it in general, and of Hebrew art in particular.

A special sense of beauty emerges from it: the Hebrew charm (such as Brainin also finds in Mendele's sketches) inherent and latent in Hebrew art. Nor is it any blind infatuation with that charm and flavor that drives Brainin, but rather faith in the "dormant soul of beauty" that he strives to discover and to comprehend, to revive, extend, and expand.

He knows the motives that weaken that sensitivity and that special need for beauty, and he rebels against them. He demands new conditions, a vanquishing of obstacles.

"Art speaks to feeling in the language of feeling," he declares, "and so it speaks to every person, every nation and tongue, every generation." And Brainin too speaks in this language, the language of feeling, so that the effect of his words differs to the extent that his readers' feelings differ. Faith, conviction, and the burning passion in him for everything to do with the revival of life, art, and the Hebrew spirit evoke the following statements from him:

> Don't say that we have no original forces, for the power of public hypnosis is great! On the contrary, search hard[116] for those original forces, for they do exist in the people of Israel. And in this generation more than any other. ("A Word to the Reader," *Aḥiasaf*, 1903)

Or

I know that, to many, my proposal to establish a Sanhedrin in our time will look

115. See Shapiro's letter to Brainin (15 November 1901) in Part III.
116. Literally "search with candles" (*badku neirot*), as in the pre-Passover ritual of searching for leaven (*bedikat ḥamets*), where one scours the house for traces of bread using a candle.

like a remote fantasy, a hazy dream. But that very thing arouses in me a desire to set out my plan before you, dear reader, in its general outline and form. This very thing propels me to relate my dream to you.

"Here comes that dreamer!"[117] So many a reader will respond to me. "But a day will come, and it is not far off, when his dream will become a reality."

This is typical of Brainin's fervent statements. The dream will become a reality—that is the apt declaration for his spirit and temperament. Existing reality is merely passing and ephemeral, not worth our concern. The main thing is that what we hope for shall come to pass—it must come to pass! Now, when many of Brainin's dreams are indeed being realized, we can but wish the jubilarian that he will yet see them all fulfilled.

"I dream of a generation of dreamers and poets, and thought and poetry stand forever. Mountains shall topple and suns fall away, but human thought and the poetry of beauty will swallow up death forever."

This is his 'ani ma'amin[118] [I believe] declared in his ardent style.

The goal of his essays in this period of his work—"On the Establishment of the Sanhedrin," "To the Dreamers of Dreams," etc.—was, in his own words, "'to bear witness to the reader's heart' and to bring the urgent need for a Hebrew University within the bounds of our people's consciousness." And he rises in warning: "If you don't establish a lasting Institute to house the Spirit of Israel, Zion too will not be rebuilt. Build a treasury for the spirit of Israel while that spirit remains fresh!"

Those calls struck many a spark in the hearts of individual Jews. Now—and even more in the days to come—let them be recalled with rightful gratitude for the person who first struck them.

These were the first blooms of the revival, but, to use Brainin's phrase, the aspiration for revival is already halfway to revival. And Brainin did a lot to bring about that aspiration, not only by disseminating his ideas and harangues but principally by means of the powerful faith and the emotional excitement with which he imbued them.

"In the twentieth century," declares Brainin, whispering his inner thoughts into the ear of his reader, "it will be a Jewish ideal to reconcile and mediate between the heart and the mind, between past and future, between love of the nation and of humanity, between the individual and society at large, between Orient and Occident, between the man of the old world and the superior man to come after us" ("On the Cusp of the Twentieth Century").

117. Cf. Genesis 37:19: "[Joseph's brothers] said to one another: 'Here comes that dreamer!'"

118. Maimonides, in his commentary on the Mishnah, compiled what he referred to as the "Thirteen Articles of Faith," a distillation of Judaism's 613 commandments. This has in turn been rendered into an abbreviated poetic form that begins 'ani ma'amim (I believe).

That is his thirst, his aspiration, his hope, and his conviction, and that is the appeal and pronouncement whose existence and advent and fulfillment he heralds.

The secret of Brainin's effect on his audience was that he made the audience a partner to those things that were born of his mind and that he lived on. They received him with love. Because they learned from him. And the pleasing language, so easily absorbed, accustomed them to seeing the innovations and new ideas as their own.

And in Brainin's writings they always found a new aspiration, a new ideal, a hope, or a new tiding that stirred them, that encouraged them to believe that it was about to happen, that it was waiting in the wings.

Any literary project that Brainin headed and brought others together around always had a special tinge. He brought something to it that distinguished it from the rest. So it was with *Mimizraḥ umimaʿarav* [From East and West], which he published, and so did the tenth volume of *Aḥiasaf*, which Brainin edited, differ from its earlier, fellow volumes.

His above-mentioned ideas "On the Establishment of the Sanhedrin," [which] made him the father of *the plan for establishing a university and higher institute for the humanities in Eretz Yisrael*,[119] the creator of a dream, an aspiration that has gradually materialized and is already taking shape, were first published in that volume, under his editorship.

His thoughts and musings, draped in a veil of dreams and fantasies, as are most of his writings from that period, and several of his studies, including some of his finest (the man wrote more than 200 essays and monographs), found their place in that collection.

Brainin has had several periods of creativity. The time from Smolenskin to Herzl—both of whom he evaluated marvelously—when the seeds of national revival were just beginning to be felt in the Jewish world, was his first creative period. I did not know his sketches and essays from this period, which surely were replete with youthful dreams. But his books from that time attest to his indefatigable work. Mapu and Smolenskin found in him their critic par excellence. The poet, the writer, the publicist, and the first champion of the national idea in the modern era were revealed in their true stature.

The revered Gordon was demoted—justly or not—from his lofty throne by this rebellious upstart, but it was Brainin who first critiqued Mapu, with his powerful imagination, and Smolenskin, with his fiery soul—justly, precisely, and with love and devotion.

The buds of Jewish revival had sprouted by then. But its paths, as idealized by Smolenskin, despite Brainin's admiration for him, could not satiate Brainin's soul. The ways of battling for "the beauties of Japhet,"[120] as understood by Smolenskin and Gordon,

119. Brainin's sons ultimately deposited their father's diary at the Jewish National University Library at Hebrew University.

120. A metaphor for European culture, because Japhet is traditionally considered the forefather of the peoples of Europe; cf. Genesis 9:27 and 10:2–3.

were also too antiquated for him. Neither their freedom nor their beauty could gratify him.

And then Herzl came along. Brainin was one of the first to realize who he was, to bond with him, just as he sensed the true value of what was then about to come to light.

Brainin's path has not always been strewn with roses. There were times when he was doused by a bitter reality, when he was imperiled by various factions. In Berlin, he was surrounded by many of the young people, men and women students of the Hochschule.[121] His home was a meeting place for all their different factions. But Brainin followed the inclination of his heart, which led him to the aspirations of his people. He fought stubbornly and courageously for the old-new idea of its revival, even though he was far away and did not live among the masses of his people.

This was Brainin's second period of creativity, in which his inner life, which had, as it were, been stifled or lost in a fog, came to fruition. Now it manifested itself, bursting forth in plenitude and beauty, having shaken off some kind of repression of which it had been unaware. Brainin showed himself then in a different form.

He was not only a biographer, not only a critic, but a man of vitality and enterprise, of inspiring visions and a beautiful, rich soul, full of passion and wonder.

The powers of his soul and the talents of his spirit were released and redoubled. The revival went to his heart, [and] then he sang his life's song. And it was a true song, in literature and in life.

This was the finest and most important period of his artistic creativity.

Brainin—the man of vision—bends his knee before the grandeur of life and of art. Never sated by the richness of spirit; ever interested in all phenomena of life, and ready to learn from one and all. Drawing in those thirsty for his greatness of spirit. Indulgent and spendthrift, creating in his imagination a world that is entirely good, in which eternity can be experienced in day-to-day life. Taught by many trials, but nevertheless a devoted believer in life. Scornful of trivialities, aspiring to the highest, thrilling in his aspirations and yearnings. Light shines forth from his fantasies, greatness and majesty from his dreams and hopes, and splendor from his personality.

One of the best of our generation.

121. The Hochschule für die Wissenschaft des Judentums (Higher Institute for Jewish Studies) was a liberal rabbinical seminary established in Berlin in 1872 and destroyed by the Nazis in 1942.

The Image of Woman in Our Literature

Translated by Deborah Greniman

Originally published in *Hatekufah* (1930)

Unlike other peoples' literature, ours deals little with female images. In our ancient texts, we find several marvelous and engaging models of the "fair sex." Yet, although they have been of considerable significance in the life of our nation and have ignited the imaginations of Gentile artists and poets, our own modern literature has averted its attention from them. Gentile poets have spun ballads about Herod's wife, Mariamne; about Judith (Hebel);[122] about the wives of Shabbatai Tzevi (Zeromski)[123] and of Rabbi Akiba (Heimann);[124] while our own literature has ignored them.

As for the Hasidic movement, which found its bards almost as it began to wane, its poetry too has been limited almost entirely to the world of men—those who traveled to the "rebbe" and gave themselves up to piety and cleaving to God. The poets of that movement believed women incapable of comprehending the holiness and sacred teaching of the rebbe, and they made no effort to capture the image of woman in the Hasidic movement.

Abraham Mapu, who helped found our modern literature, knew no heroines but those of yore, heroines who were all romance. Apart from his historical novels, his works focused on the battle against the "vultures"—hypocrites of all types—and the writers who followed him too were also almost single-mindedly absorbed in their struggle against the opponents of the Haskalah [Jewish Enlightenment].

Yehudah Leib Gordon was the first to pay attention to the status of the woman of his day: "Hebrew woman, who knows your life, your sorrow and your joy, your despair and your desires?"[125] He appointed himself her advocate and sallied forth to take her part. But even he was totally absorbed in his war with "those who resist the light," and his

122. Johann Peter Hebel (1760–1826) was a German writer, poet, and theologian.
123. Stefan Zeromski (1864–1925) was a Polish novelist and playwright.
124. Moritz Heimann (1868–1925) was a German writer and critic.
125. Gordon's poem "Kotso shel yod" first appeared in *Hashaḥar* (1875). The poem is reprinted in Gordon, *Kol shirei Yehudah Leib Gordon*. For an elegant translation, see Nash, "Kotso shel yod." Shapiro quotes this in her preface to *A Collection of Sketches* (see Part I).

description of woman's fate in his poems was meant only to serve the struggle against the obscurantist hairsplitters who stuck to *kotso shel yod* [tip of the (Hebrew letter) *yod*], those who clung to the fossilized law in all its rigidity, against the small-mindedness and obtuseness of the money-grubbing rabbis on whose account the young life of "the lovely one" had come to a dead end, *shomeret yabam* [a widow awaiting the levirate rite].[126]

Fair and delicate is this wretched woman [in Gordon's poem], just 22, her "face pale as plaster, her eyes like blood."[127] She watches over her ailing husband, knowing no rest, morning and night, for "a daughter of Israel knows her duty!" And when he dies, she will "keep the levirate rite" and be bound to her brother-in-law, a widow in the bloom of youth—for God has not granted her fruit of the womb, "but He has remembered her mother-in-law and given her an infant son" [who must attain the age of majority before he can release her]. "I grieve for you, my sister, my dove," cries Gordon. "Has my God really commanded thus, does my law really so require?"

To avert this dire outcome, the parents have deliberated and decided to tell the sick man his true situation. The right and proper thing for him to do is to give his beloved wife a bill of divorce "before he closes his eyes forever." They rush to bring in the scribe and the witnesses; all is in readiness—but then the devil arises from a different place. For arranging the divorce, the rabbi demands 200 *zuzim*, and such a fortune the penurious parents don't have. They beg and plead, but he will not reduce the sum by so much as a *perutah*, "and as they endeavor to raise the money, the sick man waits no longer and expires." Gordon concludes his poem with bitter scorn and irony: "I grieve, my rabbi and teacher, I grieve for you; after all, she will not remain bound to her brother-in-law forever, but who will restore those ten shekels to you?"

The woman's fate is grist for [Gordon's] polemic and his struggle. In "Ashaka derispak" [The Shaft of a Litter],[128] his description of that fate is again meant to demonstrate the unreasonableness and callousness of the obscurantists, of the rabbinic authority whose prohibition brings to ruin the once-peaceful home of poor, miserable Sarah, wife of Eliphelet the wagon driver.

The fate of the Hebrew woman, dependent as she was on the judgment of others, indeed was hard—among the Gentiles too women in those days did not take much part in public life—but, ultimately, she was not alone in her subjection to the law's rigidity, and on the other hand, this was hardly her only hindrance. The law cannot be seen as the only source of her distress and suffering.

126. Gordon's poem centers on a young, childless widow who is prevented from remarrying because of the biblical law binding her to her brother-in-law to ensure the perpetuation of her dead husband's line, known as levirate marriage; cf. Deuteronomy 25:5–10.

127. Y. L. Gordon, "Shomeret yabam." See http://benyehuda.org/yalag/yalag_087.html

128. The title, derived from a midrash in the Babylonian Talmud, Gittin, 57a, refers to a small incident that causes a great disaster.

Our grandmothers told us, and our mothers knew it too: The status of the Hebrew woman in that time, inconsequential as it may have seemed, was considerable, and even the Hasidim, despite their single-minded dedication to "Him, may He live long," were devoted and faithful to their wives, with whom they shared their lives, and they held them in great honor and respect.

[Peretz] Smolenskin too, the writer of tales, concerned himself with the image of the Hebrew woman in his time, but he too described her in the context of his struggle against fanatical religious views.

The girl who falls in love with the "German," the "Gentile," or the apostate is an angel of God, a paragon of perfection, demureness, and purity, but her heart is not drawn to the *'ilui*, the talmudic prodigy chosen for her by her parents. The German's smooth talk and dapperness have captured her. She is abject, and so is her love.

However, "the fate of the Jewish daughter who has fallen in love is not like that of Gentile girls in the same situation. She will not die of 'bottled-up ill-feeling and suffering'; she will not be struck by madness; she will not renounce her faith in rage at her forefathers; she will not break the law or take her own life; her destiny—like that of other Jewish daughters—is to marry, that is, to marry a pious Hasidic man and bear sons and daughters."[129]

Smolenskin was not disparaging this custom of his people in that time—that of giving their daughters to Torah scholars. On the contrary, he endorsed it, along with the parents' marrying off their sons while they were still all but children and taking wives for them of the same age. And mainly he looked positively upon their "bringing up their daughters in the parents' home, so that the girl is still an innocent maid even at the age of eighteen." "On this account," preaches Smolenskin, "the woman's good sense will abide to a ripe old age. Because she did not spend her youthful days reading stories that stir up the passions of the heart and her nights in revelries that suck the marrow of life by giving pleasure while rotting her bones with jealousy and ruining her looks much faster than pregnancy or birth pangs. So shall man and woman esteem her name all the days of their lives." Meanwhile, "according to the European way of education, a girl of twenty" (by now one could lower that age) "would no longer blush upon encountering a group of men except from having caked her face with makeup, for already in school she would have learned the ways that those who tremble with fear at God's word would be taught only a month before being brought to the chuppah" [marriage canopy].

The daughter of Israel in the stories of Smolenskin and his comrades is a symbol of innocence, demureness, and modesty, and even if the feeling of "forbidden" love—that is, love for a man not intended as her bridegroom and spouse—should steal upon her, she will know how to suppress and smother it, by calling to mind that it is disgraceful

129. See Smolenskin, "*Ga'on vashever*" (Pride and Destruction), in his *Kol sifrei Peretz ben Moshe Smolenskin*, 4: 84. For the title, cf. Proverbs 16:18.

for a Jewish girl to fall in love—all the more so with a beardless man, "a German" (in Smolenskin's stories), "on which account, according to her mother, her forefathers will find no rest in paradise."

She is passive and subservient to her parents' will, conducted to the chuppah "like a sheep to the slaughter," and the chuppah, for her, is the end of her passionate life.

Or—there is also the type of girl who has already been affected by the "divinely inspired" Haskalah. Two or three students of the rabbinical seminary arrive in the small town and "breathe a new spirit into the hearts of its inhabitants." The town and its inhabitants are transformed. The urge to show off some foreign languages takes wing. The wealthy pay buckets of money to have their sons instructed in the Gentiles' languages and send them off to school, to the extent that "even Mahlah the *mage-det*[130] sends her son to school." The aforementioned girl, the widow's daughter, makes friends with some other girls, and every Sabbath they gather in the home of one of their wealthy friends, where some men have gathered as well, and they converse and sing songs together "in a manner heretofore unprecedented among the Jews." The *shadchan* [matchmaker] offers the mother a match for her daughter—the butcher's son, "a good boy who knows some Torah." The happy mother tells her daughter of "the happiness that's in store for her." The daughter retorts that she has no desire to be wedded to the butcher's son. The mother is thunderstruck, for "she has never heard of a Jewish daughter refusing the man to whom she's bespoken." But even after the mother talks to her daughter, heart to heart, the daughter is adamant that "she won't marry the butcher's son for any money, and when the mother presses her to explain why she disdains this man," the daughter replies "that another man has already taken her heart and her innermost parts, and he has already revealed his intentions to her and told her that he will speak with her mother as well" (Smolenskin, *Ga'on vashever* [Pride and Destruction]).[131]

Such is the "enlightened" daughter, who, being fatherless and so beloved by her mother, succeeds in standing her ground. At first the mother cannot fathom it, for "who would dare open his mouth and speak that way to a girl, without his face being covered in shame?" However, the girl reproaches her: "That's how it is with this generation, a free generation, in which fathers no longer sell their children, but each chooses or rejects [a mate] according to his heart's desire."

What is critical for Smolenskin and his comrades, the writers of the Haskalah generation, is not the personality and image of the woman [per se], but a description of the practices, atti-tudes, and behavior of the religious obscurantists, the struggle of the maskil [enlightened

130. A *magedet* is the female equivalent of a *maggid*, the traditional East European itinerant preacher, skilled as a narrator of Torah and religious stories.

131. Published in *Hashahar* (1874).

man] *or* maskilah [enlightened woman] *against them, and the victory of the challengers, or their capitulation and defeat.*[132]

And so, as we read the works of our great writers of that time, we do gain a deep impression of the way of life and customs of that generation, but the image of woman remains blurry to us. At most, we have the impression of a passive figure who largely throttles her feelings and her inner world. The enlightened girl's statements about "the free generation" in Smolenskin's book are largely exaggerated. In truth, the custom of matching up the boys and the girls without seeking their consent had not yet passed from the world and was still very widespread even in the time of Mendele [Mokher Seforim] and [Y. L.] Peretz, but these writers had other concerns and were not preoccupied with the struggle against religious fanaticism.

The works of Haskalah writers originated in and centered on the opposition between religion and life; they aimed to demonstrate the senselessness of customs and laws whose time had passed and the damage they did to the world and to the people who remained beholden to them. Even the woman's "distress and suffering," as they saw it, was produced by nothing but the stubbornness of those who held to those petrified customs and laws, which had no place in life. Were Gordon's contemporaries, for example, not so fixated on the tip of the *yod*, the woman would not have been wretched and would have had no cause for complaint; and had the mother agreed to her daughter marrying the German, everything would have been good and right, and there would have been no reason to carp about woman's fate.

In the love stories of that time, the woman was an angel of God or a dumb sheep who did not know how to open her mouth. All of her calamities were visited upon her only as a result of this opposition and conflict between religion and life. She herself was not responsible for this [calamitous] sentence. Her life was described with a particular intent in mind. But her own inner life and soul, her yearnings and ambitions, held no interest for these writer-advocates of hers, who exploited the description of her fate for the purpose of their war against "those who reject the light."

Mendele was the first to depict the women of his time with *an artist's paintbrush*—not only her true status in life and in the family, "her distress and suffering, her sorrow and her joy," but also her authority and assertiveness, her apparent subservience notwithstanding, her character and nature, and her habits and inclinations. He gave her the image that he actually saw in her, depicting her just as he did the other people, the natural surroundings and the figures on the Jewish street.[133] From him, from his work,

132. Shapiro's argument that the *maskilim* defended women only for the sake of battling their traditionalist enemies predates (by more than a half-century) the same conclusions drawn by both Iris Parush and Shmuel Feiner.

133. Shapiro uses a Hebrew translation of Judengasse, literally "Jewish street" in German but customarily used to connote the Jewish quarter of a city in the Diaspora.

we learn not only of her situation in the "vale of tears,"[134] not only of her passivity toward her fate, but also and especially of her character and personality, her efforts to broaden her dominion, so as to rule not only over her own house[135]—something, a kernel of the woman who will emerge, albeit in a different form, in the next generation.

In his stories Mendele displays before us a whole gallery of models of women on the Jewish street: simple Jewish women with all their quirks and foibles, old and young, sometimes beautiful even in their homeliness, and usually languishing in their poverty. He shows them making do with little, lording over their homes, their narrow, limited worldview, their lives and habits. The women, the girls, in stories by other authors—[Yeshayahu] Bershadsky, for example—are already progressive. They argue about the issues of the day, keep company with the young men, and do not differ from them in their worldviews. In Mendele's books, the woman is still a type from the Jewish street, her image illustrating an entire era not only of her own life but of the life on the street as a whole. She is an element in the overall drama. Mendele's female figures do not have a segregated world of their own, utterly different from that of the men. No "chasm" lies[136] between them and their husbands. All of their lives, both their external and even their inner worlds, are inextricably connected to their husbands' lives, their way of life, and their perceptions.

But Mendele also knows assertive women, women of mettle who aspire to dominate. A whole series of women who rule over their husbands pass before us in the tales by grandfather Mendele.

Haya Treine Kozak (*Sefer hakabtsanim* [The Book of Beggars, 1902]) dignifies her husband with such "polite" epithets as *golem*, "the world's biggest fool," and so forth and complains of her "enormous load of housework, for she cares for each and every member of her household, and were it not for her, the house would collapse." The husband is self-effacing before his wife; even "from his gait and manner of speaking it can be seen that he is under his wife's thumb, and she rules over him."[137]

The wife of Senderel (*Masa'ot binyamin hashelishi* [The Travels of Benjamin the Third]) pounces upon him like a sudden calamity: "Where's my jewel? May his name be blotted out! Let me be! Let me be, and I'll send all my plagues into his heart, so that he'll know!"

And there's *Hodel "the saint,"* denigrating her husband with taunts and jeers, calling him "a beast, a fool, and a degenerate," and sometimes slapping him for the heck of it. And the wretch hears all this demeaning of himself without any rejoinder, bowing his head and accepting it all with love (*Be'emek habakha* [In the Vale of Tears]).

134. Cf. Psalms 84:6.
135. Cf. Esther 1:22, where Ahasuerus is advised to banish Vashti on account of her disobedience and to make this known to all, "so that every man should rule in his own house."
136. Cf. Deuteronomy 33:13.
137. This is the reverse of Genesis 3:16: To the woman He said, "and he shall rule over you."

These women are different even from the women in Peretz's sketches. The latter accept their sufferings with love and without complaint, make a living for their husbands, and their whole purpose in life is to become footstools for their husbands in the World to Come. But the women in Mendele's stories hurl their declarations heavenward, like the same Hodel with her protestations that the Holy One, blessed be He, does not, so to speak, rule His world fairly: He gives bread to the sated and silver and gold to the wealthy, while the poor starve and waste away. If they do not succeed in marrying off their daughters, their distress makes them as cruel as evil beasts. Not so the depictions of other Hebrew writers of Mendele's time and before, in which the women accepted most of the troubles meted out to them in silence and never dared to protest or grumble about what was beyond their ken.

In Mendele's writings, we find female figures like that of *Sarah* in "Ha'avot vehabanim" [Fathers and Sons], who constantly bemoans "her bitter fate, though she was the happiest of women." Her husband respects her, consults her about everything he does, and "will not go against whatever she says," although she is an ignorant woman;[138] as she keeps telling her husband, she is "like a beast of burden, hard at work all day long." By contrast, there is the hardened woman hurrying to the synagogue [on Hoshana Rabbah, the last day of Sukkot] with the willow branches [for beating on the floor in that day's ritual] in her hands, who has not slept all night for being so hard at work and has rushed early in the morning to the synagogue. "Scarcely has she stepped over the threshold of the prayer-house when the fount of her tears bursts open, and she pours them out before Him who sits in the heavens, for to Him alone are the souls of Israel's daughters laid bare."

And *Braindel the firzogerin*,[139] who renders the prayers for the women in the synagogue, and the mother of "Isrolik" in "My Mare," who entreats him not to go out to the Gentile schools and study their learning. The mother's heart sees where her son's new ways are leading—and Mendele would never belittle the feelings of a mother!

Toyve-Susi, the wife of Ḥone ("Bayamim hahem" [In Those Days]), is an utterly common woman, an untrained calf, but she is good-hearted and God-fearing. "She cries as she lights the candles on the Sabbath eve and sobs when she hears the recitation of the *firzogerin*, even though she doesn't know what it means."

From this series of female types, we see that Mendele made no effort to prettify the women he was describing. But he does not allow us to mock them for their ways and habits either. He does not inflate the worthiness of Jewish women; he depicts them in their own shape, as they were, with all their foibles and blemishes; and he recounts the praises of simple Jewish women with their "Jewish hearts." "In whom will you find love

138. Cf. Jeremiah 10:14: "Every man is proved dull, without knowledge."

139. Besides acting as prayer leader for the women, a *firzogerin* would provide vernacular translations. For more on this phenomenon, see Weissler, "Prayers in Yiddish."

of Torah, wisdom and love for their fellow humans? In the daughters of Israel, those of the common people, seemingly so insignificant, lowly and humble" ("Bayamim hahem" [In Those Days]).

There is also his portrayal of *Yahne-Susi*, also called Leibchiki, for Leibchik, her husband. She specialized in horror stories, affecting young Shloimele with those stories "to the point that all the people looked to him from then on like ghosts," for Leibchiki "saw even a cat lying contentedly on a bench as a kind of ghost." Mendele asserts of her, of this Leibchiki, "of whom it was said that the Holy One, blessed be He, had created Yahne-Susi for the specific purpose of presenting a perfect stereotype of a woman— that she should be a consummate chatterer and gossiper, such as not a woman in ten thousand can match her." This seems more like mockery than reproof, but even more— a sharply and artistically crafted description of things as they were.

And then there are his portraits of the "saintly" types, *Auntie Shayntse* and the above-mentioned *Hodel*, who, from their youth, had practiced a "proper" profession [as madams], and then, having reconsidered and become wedded wives "according to the law of Moses and Israel," continued practicing the very same profession in their homes. But they are pious and modest women in their old age, scrupulously adhering to the smallest custom enjoined by the law of Jewish women, "frequenting the synagogue, hearing the prayers and weeping," with not the slightest sense of the baseness and sordidness of their activities, thinking of themselves as proper, modest Jewish women.

And that same custom of marrying off the boys and the girls without asking their consent—how wonderfully and clearly does it emerge in Mendele's sketches! The story of innocent *Hantsi* in "Fathers and Sons" is that of an entire generation of Jewish girls; it is a striking, lucid portrayal of that generation, with its attitudes, its life, its ways, and its frozen passions, which clash under the changing conditions, or in spite of them, with the new sensibilities that are developing in the hearts of these young men and women. And so we comprehend the emotional tragedy of a Jewish girl forced to strangle the natural feelings of her heart and suppress them with all her soul.

Hantsi is but a tender young girl; as her young mind awakens, she begins to make distinctions between people and to muse about them; her passions storm within her, and at the very same time, she feels remorseful and rebukes herself. These are the feelings of a Jewish girl when the first stirrings of passion arise within her—when she is already given to a man. Mendele knows those feelings and the way they rush up when the woman's husband walks into the house and his face reddens "like a swan puffing itself up" at the sight of a strange man. Not out of jealousy, "God forbid! Why should he be jealous? Would anyone in the world permit himself a married woman? No, he is filled with rage because this very thing in itself is a sin. A man being alone with a woman who is not his wife is forbidden by the law! It would have upset him similarly had he seen a pot of meat boiling next to a pot of milk, even if their contents hadn't mixed with one another."

The grandfather's heart is familiar with the overt troubles of the Jewish woman as well as the inner struggles buried deep in her heart.

Therefore the daughters of Israel will always regard with honor and respect grandfather Mendele, who was able to reveal the recesses of their hearts, their intimate world, their pain and bitterness that no one else could comprehend, this grandfather who justified their rebellion against the peculiar attitudes that other members of their people took toward them and their roles and pointed in bitter satire to the absurdity of those attitudes: "A woman isn't nothing; she's a woman." A Jewish girl is told: Here's your man—and she is bound to him in holy matrimony. "The woman is acquired."[140] "Neither hate nor love[141] has the Jewish daughter. She must be a good wife and do the bidding of her husband—without reflecting upon it or straying into vain fancies like the daughters of the uncircumcised."

Mendele knows that the kind of love that other Hebrew writers were striving to depict according to the model of foreign love stories did not exist on the Jewish street: "This ailment, when it happens upon our dwellings, occurs only to the very wealthy or to the poorest of beggars; the ordinary householders have never known it."

Love has no relationship or connection to the subject of marriage. A Jewish man must wed a woman, beget children and raise them, and those who attach themselves honorably to a woman who is married according to the law of Moses and Israel pay her honor and consult her, even if she is an utter nitwit. But to look upon another who might be better looking or more clever would never cross their minds, not to speak of "unbefitting and inappropriate"[142] thoughts of love. And, needless to say, even if the Jewish man should look at another woman, he would not compare her with "his own," the woman whom God appointed to him, with whom he shares his life: "A Jewish man," declares Mendele, "has affection for his wife and honors her because she is his wife, mistress of his home, and mother of his children, who labors and cares for them— that is his duty, and he fulfills it and gives his all for her." But "libidinous love, like a bleach bubble that pops and dissipates at the slightest puff, our fathers never knew." In such marriages, both sides viewed their lives with contentment, and when the time was right, "they would say a blessing and declare: If only our children would have good lives with their spouses as we do." The Kabtzielites [inhabitants of Mendele's imaginary Jewish town, Kabtsi'el, or Beggartown] have no part in that kind of love, which is a gift of God that graces only the chosen few. The life Mendele describes has no need of it. And this great portrait artist must perforce see the life he is depicting *as it is*, although his heart is so often pained by it.

140. According to rabbinic law; cf. Mishnah, *Kiddushin* 1:1.
141. Cf. Ecclesiastes 9:1.
142. This is a play on the phrase *ki lo na'eh, ki lo ya'eh*, from the Haggadah and other classic sources, which extols what is fitting and appropriate for God.

The image of women in Peretz's sketches is different. He too describes woman's life situation, her notions of her own value and status, and those of the society. "We're partners," says one of these women (in his sketch "The Kaddish") when she is asked why it is that she works while her husband gets the benefit: "I do business that bears fruit in this world, and he does business whose fruits are in the World to Come. [. . .] He relies on me for his livelihood in this world, and I shall be his footstool in the World of Truth!" Most of the women in Peretz's sketches take this view, which eases their terrible burden—and only occasionally, when the troubles become overwhelming, does a woman's repressed suffering erupt (in the sketch "Ka'asah shel 'ishah" [A Woman's Anger]) to make her curse life—but he also comes to the support of his creations, standing at the woman's right hand, not as a fighter for her "rights" but as a fellow warrior in the struggle of a passionate, aspiring soul. For it does happen that a woman in one of Peretz's sketches desires not to be a footstool for her husband in the World to Come but to be his spouse, his glory, his love in this world. She wants to give her youth to a man after her own heart,[143] and then she does whatever she does ("Hanidaḥat" [The Rejected Woman], "Mussar" [Morals]) without thought of the future—if only she may satisfy her natural passions.

Peretz feels the sorrow of a young girl married off by her indigent parents to a husband she cannot stand, a "Reb Zanvel." He feels her longings and aspirations, her strangled, unspoken sorrow. And he knows full well that this pitiful person will be the cause of new distress, for she herself is the "soul" of her lover ("Mah zot haneshamah?" [What is this soul?]). Peretz had a special sense of others' sufferings—especially sufferings that went unexpressed and unclaimed. The life of a Hebrew woman is not rich in external events. Its course is ordinarily depicted in Peretz's sketches as follows: A life of suffering and poverty in the home of an ill father or a widowed mother. The first stirrings of development, the bloom of youth. A young man with handsome eyes and a pleasant voice, the son of a doctor or a pharmacist, muddled feelings, engagement to a strange man with a wild beard, for whom the woman is "a wife and nothing more" ("Mendel Braines"). Immobility and apathy: If he calls, she is asleep. She hasn't the slightest interest in his world, nor he any understanding of hers. His world: "The principal categories of damage are four" [the opening mishnah of tractate *Baba Kama*]; and hers: Jewish folktales. It might seem that the Jewish woman whom Peretz describes has nothing but the worry of earning a livelihood and the expectation of becoming a footstool for her husband, the Torah scholar. But Peretz actually reveals, in this submissive creature, a whole world of internal emotions and desires. But her secret suffering makes of the Hebrew woman a "log," an "inert stone," so that not a word of her grief escapes her mouth. She will not speak up to express her sorrow, because there is

143. It seems likely that Shapiro had imagined that of herself with respect to Brainin.

no way to express the depth of the tragedy in her heart or the full dimensions of the pain in her soul.

The life and mind-set of the Hebrew woman and the conditions that determine her existence are utterly different from those of other women. The Hebrew woman, once she has stood under the wedding canopy, even at the very outset of her development, in the time of her most tender youth, is divested of any opportunity to demand another way of life; nay, God forbid that she should have even the slightest thought of another way of life. But even so, although they try a thousand times to strangle and slay the passion in her heart, it will arise to demand justice and vindication. A Gentile woman is capable of sacrifices when she is in love. But for a Jewish woman, no sacrifice is beyond her, even if she is not in love. And the first things to come up for sacrifice are her very soul and her freedom—and the love of a Hebrew woman is as strong as death. Such is the love of Shulamit (in the sketch "Vinus veshulamit" [Venus and Shulamit]), so that even the love of the mythological goddess of beauty cannot compare with it.

Peretz himself believes in the power and dominion of love in life, and I know of no other of our writers who is so deeply sensitive to a soul in love, in any figure in which it should emerge. That is why he rebels against the laws, fences, and boundaries imposed upon love by human beings. People view love as a good thing, but only if it submits to their laws, if it emerges from within the framework they have ordained for it; otherwise, they will pelt it with stones—they will throttle it and those who realize it outside that framework ("Hashtraymel" [The Fur Hat]). But love, that profound stirring rooted in the depths of our souls, since it is ever unbidden, sometimes comes to light in precisely those places where it is not meant to be.[144]

Peretz also knew how to sense and describe a mother's love ("Mussar" [Morals]). The mother in this story, quashing her sorrows, her opinions, and her attitudes, her "embarrassment," and her inner protest, makes no complaint against her daughter's actions so long as her daughter will be happy, experience life, and have pleasure. Her two daughters, to whom she had preached "morals" all her life—the one, fair as the sun, is still a virgin at the age of 36, by now an elderly spinster, full of bitterness, her eyesight fading and her face pallid; while the second, frail and virtuous, married to a man not of her liking, is tubercular, a mere shadow of a person—the fate of these two now whispers to their mother that she would do better not to go on preaching morals to the third daughter, the youngest.

Peretz describes the attitudes of the men of the older generation toward women almost in the same way as Mendele. But he is also familiar with the vapidness and degeneracy of the younger generation, which sees in marriage a kind of commercial contract and relates to "the chosen one" only according to the size of her dowry ("Binveh kayits"

144. Shapiro's interpretations of Peretz's female characters seem largely autobiographical, given what we glean from her diary and letters.

[In a Summerhouse], "Kakh tsarikh lihiyot" [That's How Things Should Be]). A new type of attitude—worse even than the first.

Peretz also knows the Hebrew woman of the big city, and he knows that her life too is in need of repair.

These are the images of women depicted by our leading writers, portrayals of ordinary women, on the basis of which one may discuss the *disposition, character, and traits* of the Hebrew woman.

To be sure, other portraits can also be found in our literature. In the books of [Reuven Asher] Braudes, for example, Rosalia, wife of Ahituv, hero of the book *Shtei haketsavot* [The Two Extremes], and his sister Liza represent the wives of magnates, our Jewish tycoons, their lives filled with ennui and their hearts empty and barren as well. But these are exceptional types, few in number, that prove the rule.

These figures have nothing in common with, for example, Ben Avigdor's "Leah mokheret dagim" [Leah the Fishmonger], who sacrifices her life for her spouse, an ailing Torah scholar whom she loves without limit. Or with Amalia, sister of Miguel the converso in Ben Avigdor's *Lifnei 'arba me'ot shanah* [Four Hundred Years Ago]—for whom there is no such thing as acquiescence before her people's persecutors and tormentors. Or, needless to say, with the female character in Peretz's sketch "Miktarto shel harav" [The Rabbi's Pipe], who knows full well that "a letter of [her husband's] learning will outweigh"—in the World to Come—anything that she does for him, and so she serves him his dinner without eating herself, busies and concerns herself only with him—and never complains.

Self-sacrifice, devotion, and love, these are among the true attributes of the ordinary Hebrew woman—as opposed to those of the magnate's daughter, whose world has nothing in it but narcissism and ennui, pretension, assimilation, and the pursuit of pleasure.

Devotion and love are also the fount of her spiritual life.

Unjustified too is the complaint that our writers' portraits—of women as well—are all painted in dark hues, as though they are imbued only with grief and suffering, sorrows of soul and spirit. These writers' women characters are also clear and appealing, and if life has dealt them a bitter fate, they do not parade their resentment, pile it with words, or slap it in people's faces.

Moreover, the disposition, habits, and ways of this faithful Hebrew woman lead not only to grief or to a life of misery and melancholy, as demonstrated in many of the descriptions of Mendele and of [Jacob] Steinberg. [Saul] Tchernichowsky's idylls too—"Motsei Shabbat" [The End of the Sabbath], "Brit milah" [Circumcision], and

others—attest to the joy instilled in the heart, to *the soul's pleasure*, which that unsullied way of life with its joyful family occasions afforded the devoted Hebrew woman.

[A. A.] *Kabak* too, in his trilogy "Ha'ahavah, ha'emunah vehakorban" [Love, Faith, and Sacrifice], evoked images of Hebrew women with the same basic traits, which enrich not only their obstacle-ridden private lives but serve as a source of consolation and salvation, inspiration, and encouragement for others.

To be sure, you won't often find a "heroine" in our literature who puts an end to her own or someone else's life on account of unrequited love, such as you'll find frequently in the most acclaimed books by Gentile writers. After all, literature is ultimately but a mirror of life. Even in the depictions by our romantic writers (Peretz, Steinberg, etc.), the woman's image is usually that of the long-suffering daughter of Israel, bearing her yoke in silence, toiling and denying herself for the sake of the happiness or Torah education of her sons. The main thing is the sons and the Torah.

But precisely for those sons and daughters, the last laugh of fate—so often too cruel—is that they were *not* happy. Life mocked their mother's good intentions and sacrifices.

On came the conflicts and internal wars that ensued when a youth brought up in the House of Study "broke out" into the foreign world outside—the contradictions between that world and his inner world, his "heart torn apart," his life engulfed by "changing values" (sometimes beyond what was really necessary), which the writers of that generation elucidated so volubly. But again these writers, who devoted themselves to depicting the soul of the Hebrew *intellectual*, the heralds of those "changing values" [*shinui 'arakhin*, the sea change in Jewish attitudes toward European culture advocated by Micha Yosef Berdichevsky], were concerned only with the "torn hearts" of that generation's young men, with the *maskil* thrashing about in his struggle "both within and without," with the man who "went out and returned" or who went out and entered an alien world—with the heritage of the past still imbuing in his soul and burdening his shoulders and with the sing-song of Talmud study still ringing in his ears—with the youths who set out to learn about sin and ended up with an internal conflict. So fierce is the war between the charms and enchantments of that raucous alien world and the remnants of *Oraḥ ḥayim* and *Ḥovot halevavot* [traditional texts] whose roots still grip the heart of this Hebrew intellectual—with he who, on the one hand, bears this heritage of the past in his heart and cannot put it aside, though he hungers, on the other, to absorb and digest that alien world. It is with this intellectual that our writers have dealt; their descriptions are of him and his ambivalence. The woman is not their concern, as though she had never encountered any perplexities or conflicts, as though she was an utter stranger to soul searching and a "torn heart."

Yet it cannot be imagined that she simply jumped with ease out of her religious, pious upbringing, out of the habits and traditions, the attitudes and remonstrances, that made

up her own milk and blood, straight into that other world. It cannot be imagined that she was able in one fell swoop to free herself of what she had absorbed with "her mother's milk," to deliver herself, without any hesitations or internal contradictions, to that other world, those other views, and that other life. If it was hard for her male contemporary to break out of his boundaries, as much as they pressed in upon him, it was certainly just as hard for her to do the same, even if she was not brought up in the House of Study. But, just as the early Haskalah writers depicted only her life and her "fate" and dealt only with the travails of her love and family life, so did their successors take the same path—or else they did not deal with her at all. We all recall the *heroes of* [Mordechai Ze'ev] *Feierberg and Berdichevsky* with their cataclysms, ravings, and inner struggles. The woman—*man dekar shemeih* [Aramaic, why should she even be mentioned]? In the former's works, her figure is totally absent, and even the second, the dreamer and warrior who knows the *Hebrew intellectual* so well and all the tragedy inhering in his soul and character, allotted but little space to her, the woman, in his depictions.

And yet we know that the woman was not left for last, neither in the early days of the Haskalah nor in the period of "changing values," that she too left her bounded world to "seek the light" and that she committed herself to the same aspirations and ideals to which the male intellectual committed himself. On the contrary, she had learned about them even before him.[145] She had been educated in the literature of the Gentiles—exempted as she was from the burden of Torah study—while her youthful male counterparts were still entrenched in the "four cubits of the law." That was also the reason for the chasm between her and her husband, which subsists to this very day within a significant portion of our people. On the one hand, Dostoyevsky and Tolstoy, or Przybyszewski and Żeromski;[146] and on the other, *Yoreh De'ah* [in the *Shulḥan Arukh*] and Jewish texts. And beyond that—for her, everything was permitted, while for him, everything was forbidden.

Our later authors did not concern themselves with describing these circles or the situation and world of the woman to the extent that Gordon had in his time. They were too absorbed in their own world and in *their own* ambivalence. Our younger writers did woman an injustice by *overlooking her*—perhaps simply following in the footsteps of previous generations. *In life*, there certainly are positive female figures of many different stripes: women who aspire, labor, and struggle, women whose images are deserving of preservation, as there have been in every generation. But they have found no advocate and fighter on their behalf, as the daughters of Israel did in Gordon's time, nor any consummate portrait artist to do them justice with his paint box, as they did in Peretz's time. A whole line of our younger poets and writers of standing and gravity have never

145. This predates similar conclusions drawn by Iris Parush and Paula Hyman.

146. Stanisław Przybyszewski (1868–1927) was a Polish poet, and Stefan Żeromski (1864–1925) was a Polish novelist.

even mentioned her. And you'll seek in vain for any expression of her real nature, or even for a description of her mental world, in the work of the greatest poet of our time [Hayyim Nahman Bialik]. Our writers too have not seen fit to any appropriate extent to incline their ears to the whisperings of her soul, as they have—particularly those who are more individualistic—to every subtle variation of sentiment and to every secret of the heart and every treasure vouchsafed in the inner world of their contemporaries of their own sex. And so the image of woman in our modern literature is deficient, and her full and true visage is absent.

For this, the Hebrew woman herself is partly to blame. *Our literature has always lacked her participation.*[147] And if, in fact, other peoples' literature has also, until the last few decades, lacked woman's participation as an authoress, but her condition and personality, her character and disposition, have nevertheless come to light and to expression there, that is because her participation was lacking *only* as an authoress. As a reader, she has always been a presence in literature, perhaps even more so than the man. And not just the Gentile woman; the Hebrew woman too has long distinguished herself as an enthusiastic, *seasoned reader*, ever since she learned to read the Gentile tongues. It is from *Hebrew* literature—ancient as well as modern—that this female reader has always been missing.[148]

How many of our intellectual women, for example—those who steep themselves in world literature—know the works of Mendele and Peretz as well? And these two are the most common writers. We cannot even talk about Berdichevsky or Feierberg, Brenner or Shofman. There is no denying this truth: The Jewish woman has mostly been ignorant of what has been written about her and how she has been described. She has never seen her own image in Hebrew literature. They have spoken in her name, and she has not known. It cannot be denied that most of our poets and writers have been—and still are—read, admired, and critiqued by the members of their own sex. The second sex is almost entirely unfamiliar to them.

This realization may have had a subconscious effect upon the imagination and creativity of the Hebrew poet and author. And that is why the image of the Jewish woman—not her external visage but the description of her true condition and her soul—has been so lacking in our literature. A kind of mute creature, a log or a wretch, a likely victim of brutality and abuse.

U. N. Gnessin did manage in several of his sketches to describe the image of his Hebrew female contemporary.

In "Ma'aseh be'otelo" [The Othello Case], a young woman's heart is drawn to her brother's teacher, who brings her books, converses with her, and enlightens her about

147. Here, Shapiro quotes nearly verbatim from her preface to *A Collection of Sketches*; see Part I.
148. See "The Woman Reader," later in this part.

a few things. Her husband is a boorish shopkeeper. She is young and pretty. Yet she is an utterly proper Jewish woman, fulfilling every religious custom known to her. The teacher—she enjoys conversing with him and being in his company. The husband senses something and sends the brother home. There is no more need of a teacher. After several scenes with her husband, the woman turns her eyes away from the teacher with a quiver when he meets them as they are walking away from the house of prayer with the crowd.

The midwife Flescher, in Gnessin's story "Zhenya," is an intelligent girl, intrepid and full of life. Upon returning to her hometown, she is caught up in working for the Zionist movement. She is enthusiastic about every new thing, even about public affairs, which capture her heart. She is capable of working with great devotion and skilled at motivating others as well. She is excited about meeting other forceful and productive young people, and her spirit rails against the "slumber of her sisters." She galvanizes, establishes local branches of organizations, convenes gatherings, opens a private school, reads lessons, is thrilled by Feierberg's "Le'an" [Whither] (in Russian). "To be able to read this blazing work in the original," she declares, "It's worth learning Hebrew." And she learns and is amazed at herself at how, up to now, she had been "without roots, with any [. . .] spiritual homeland."

And she might as well have remained a "lost sheep" even after that, forever, had she not now come here [to Warsaw]. In Odessa she had never encountered such enthusiastic ferment. She devotes herself to learning Jewish history, "feeling all the lofty aspirations stirring in the hearts of our people's finest in these years." She is, after all, "one of those great women dreamers of whom the Jewish people are in such dire need, and in which it would be so rich, if they but knew how to value them properly."

After a while she starts to get bored. "Everything, everything—that's been our world is so narrow," she moans; "there's no open space." The place is too small for her. Women join her organization in growing numbers, to be sure, but she sees no use for them. They are sent out to collect funds—and they go. They are asked to do something—and they do it. But there is no fiery spark to them. She senses no real fundamental step forward. They learn Hebrew—and chatter in their living rooms: *Shalom, adonai; todah rabbah; ahavti, ahavta, ahavt* [Hello, sir; thank you very much; I loved, you loved (masculine), you loved (feminine)]. "And what next?—Nothing. No-o-othing." It is as though the whole purpose of the organization was only for this: that these fashionable girls could toy not only with the French words they had learned from the pages of Ignatovich[149] but with Hebrew words as well.

It all becomes odious to her. Her life in this city grows desolate, "Together—with whom? With whom?" And she drops everything and leaves: "She's no philosopher, she

149. Inna Ivanova Ignatovich (1879–1967) was a Russian historian.

says as she goes, otherwise in her place and situation she'd already have drawn some incontrovertible conclusions and made some firm decisions, but she . . . she can only take her staff and rucksack—and hey-ho!"

That is what she is like also with respect to affairs of the heart. She has been in love many times, she confesses to her newest lover, whose friend Lerner has warned him that he will end up with sorrow and heartbreak: "I fell in love with Lerner two years ago already . . . and with Raphael Gilden, the realist. I was also in love with Saroyzov in Odessa, and with his friend Bely, and now I'm in love with you." Yes, she loved them all, all of them! She loved them with all the heat of her youthful spirit, with all the fire of her heart, her tender years. "I loved them and surrendered myself to them utterly, utterly," she confesses, "just like I'm surrendering myself to you now. But they didn't care to understand me. They . . . they were foolish and crass. Did I keep anything from Lerner? I told him straight away: Lerner, I'm finished with you. What's so surprising? I'm finished with you—and that's it. A person makes mistakes. And what did he have to say? And what did Raphael Gilden have to say? And Saroyzov? Who's to blame? They ask me, but does the blame lie with me? With me? From whose face was the mask lifted? Whose? As for Bely, I spat in his face. The fool!—My shoulders were trembling—the cad! He called me a tart. He—Bely, that oaf, that . . . cad, that ant!" And, pressing herself against her lover's breast, she cried—and her voice blazed—quivered and cracked, "David, my dear . . . please . . . don't you be like them as well."

A short time later she left him too—and went her way.

A similar type to Felscher the midwife—"Zhenya"—is Penina in [Y. H.] Brenner's "Bein mayim lemayim" [Between the Waters], a young woman who finds no rest anywhere. Life in the land of Israel is "monotonous" for her, and despite her long-standing relationship with the one man, Saul Gamzu, who loves her with every fiber of his soul, she leaves him to go after another, David Yaffe, a poet with nary a feeling in his heart for anyone. Off she goes. Where to? It doesn't matter. London, Vienna. From there she once again desires the first one, who "was and has ever remained her one true friend in the world," as she writes in her letter to him, which attests to the wisdom of its words. It attests, that is, that anyone who comes into contact and converses with her is sure to suffer.

"She may be my daughter," says her mother Shayne-Hinde (a small, lean woman, but vibrant and nimble, who would dress on the Sabbath day halfway according to the colorful fashion of the Bukharan women, and then "she seemed for some reason as though she held all the affairs of the city and the life of her surroundings in the palm of her hand"), "but we all know the truth. What can we do? Fleeting air. She'll never tire of the nomadic life. She has to be held down with gloves of iron."

Her antithesis is Ahuda, daughter of the widow Leah, who adores that same callous "poet" David Yaffe, and when he leaves the Land of Israel together with Penina,

she marries the widowed farmer Issachar ben Gershon out of boundless despair and sorrow. Ahuda is a pure soul but innocent and devoid of life experience. She has no understanding of the relations between a man and a woman, as Penina attests about her, except in the way of marriage. She has been raised and educated in the spirit of pious Judaism. "She's governed by tradition," says Penina; "she even believes in God."

Brenner was skillful in capturing many types of the modern Hebrew woman in the land of Israel and in the Diaspora.

The Hebrew woman feels the call of the blood, even unconsciously, in a stronger, more elemental way. It is hard for her to free herself from it, though even for a man it is sometimes easier to free himself "of his God than of his forefathers."

Brenner's mother is the very image of a Jewish woman of the older generation. Brenner says of himself that in the beneficent, idyllic days of his youth, he used to enjoy thinking about her in poetry, playing her off in his imagination against his father, as though to say, "You're just Sholom Getsel the schoolteacher and nothing more. But she—she is modest, she is pious, she is patient, she is devoted to her husband and children, she is, in short—'a Hebrew woman'! And now . . . now—nothing. 'A Hebrew woman'—certainly: a humble Jewish woman, suffering terrible distress."

However, the characters in his books themselves demonstrate how many other traits— apart from her humility—distinguish the character and nature of the Hebrew woman.

Here is the Jewish woman waiting for her husband, who has gone during the days of a festival to visit the homes of strangers, and this is how she responds to a neighbor's suggestion that she go and eat lunch: "What? Without him? Am I a *goyah* [a Gentile woman] that I should sit down to eat on a festival day without him?"

Or Leah the widow ("Bein mayim lemayim" [Between the Waters]), who keeps repeating, "My husband, may he rest in peace, would say," and who frets and worries "not about the want" in her own house "nor about her debts" but "about the destruction [of the Holy Temple]." "Once, she said, she had heard in a gathering of young people about something from history. In some faraway place—in India or somewhere else—there's a custom, or a law, they said, that a widow must . . . is obliged to go after her dead husband to the grave. She'd see her people's consolation if that wasn't a worthy custom," she added, looking with tears and heartache upon the perplexities confronting her children, whom she could not help.

And here's one from the new generation. The young woman Lerner ("Baeḥoref" [In the Winter]), with her aspirations "to do things to educate the common people, to teach them understanding."

"Who wouldn't acknowledge that she's remarkable," asserts her friend Haimovich, "honest, sincere? Who wouldn't admire her for having left her parents and come to a foreign city, to suffer want and indigence, only for the sake of gaining her independence and completing her studies? And her aspirations for the sublime and the good?"

And Hava Blumen ("Misaviv lanekudah" [Around the Point]), with her devotion to "the universal ideal." "And because the Jews are in such a dire situation, worse even than that of everyone else—should we betray the universal ideal?" She argues, "And will we always be strangers here? Russian society is starting to make progress."

She is always in the know about some event, just around the corner, that has the potential to make for change in Russian society.

And there are others too. Yova Isakovna, for whom pogroms "are something she doesn't like to talk about. We know where they come from." And here's some proof: "Petrov, for example, is distressed about them like any honest man of Jewish descent."

Or Zinaida Maksimovna, for whom "it's not nice to talk about that subject—about the pogroms—in front of Grigory Nikolayevich."

These types, with their individual traits are clearly drawn, and their characters stand vividly before us.

Here's a young woman, Dobe ("Me'ever ligevulin" [Beyond the Borders])—daughter of Kaplan, the former "envoy" [of a yeshiva, sent out to raise funds]—who has "been in Switzerland and studied there in courses." Her fiancé has died in prison, and she worships his memory. However, "mysticism is foreign to her," and she calls upon the dejected writer Yohanan, who is in love with her, to go with her to Russia. "The party is calling her, and she mustn't concern herself with what's good for her. Were she to think about her own wishes, then—even she knows that there's nothing better than climbing mountains in Switzerland." And she also pays no mind to the objections of her father, for whom all those socialist types—he does not make distinctions between them—are his personal enemies, and he does not want his daughter to mix with revolutionaries—and she goes.

It may be this dual culture that makes for the character and image of the modern Hebrew woman: the Western culture in which she is entrenched and the ancient culture that she bears almost subconsciously. At any rate, it is a fact that her nature and personality are much more multifaceted than those of other European women. She can be full of paradoxes sometimes, and she is always aspiring for transformation and change.

Brenner, who was well acquainted with Jewish life and with all the paradoxes and probings of the Jewish soul, was also well acquainted with the soul of the Hebrew woman of our day, in her many different manifestations. In his writings, he—who favored nobody, not even himself—created characters and portraits of all different types.

There is Diasporin's beautiful sister ("Mikan umikan" [From Here and from There]), with her spacious chambers in one of the fancier streets of Kraków, with lots of elegant furniture, but she is—miserable. Her portly, rasping husband, the commissioner, is never at home. He has a mistress in Warsaw, upon whom he spends great amounts of money, and she, Diasporin's sister, to spite him in his absence, presents a most amiable face to his (her husband's) next of kin and disports herself with him "as people disport

themselves in all the aristocratic homes in this elegant street, whose name is that of a well-known Polish king." In the depths of her heart, however, she actually loves that portly commissioner, her husband.

From Diasporin's sister to the small, former Gymnasium student, simultaneously naïve and cunning, in "Hu sipper le'atzmo" [He Told Himself] who "didn't know the people from whence she came, who had given up everything to a foreign, foreign world" and yet was nevertheless a true daughter of her people. One of those pure, deep souls "who have a tendency to think about their needs, their feelings and their desires, plumbing them to the bottom; who can find some kind of great fulfillment only in devoting themselves, in experiencing a flutter of aversion, in resisting satisfaction or indifference." A daughter of life was this Jewish soul—"life-force was in her very shoelaces—but life is just a mistake"—and she loved *him*, him, who had passed through all the chambers of Hell, whose "melancholy had stripped her of her jewelry," him, the gloomy, sickly, lost one, who had nothing left but the sorrow of the universe. She called him to her, wanting to "rise up and sanctify herself by virtue of his holiness," pining for him to begin loving life, while she tried to solve the vexing question of "how to make people like him stop being so absorbed in their ponderings and pinings and move straight into life, to try to get their wheels turning, and to take at least some satisfaction from it." She called to him, awaited him, but he never came (he was in the hospital; his days cut short, numbered, and all because of a stupid disease). And in the list of cities [where pogroms had occurred] was also the name of the city where she lived. He had not been there, at her side. "Yes, you wouldn't have saved her," he reflects. "You haven't the strength to save anyone. None of you has the strength to save your sisters. But you wouldn't have fled, either. You'd have fallen together with her."

This is Brenner's description—and Brenner's *spirit*.

Brenner does not recite the merits of his characters or cover up for them. And it would be wrong to think that covering for them or prettifying them would improve their value or their standing in literature or in poetry—they can sing their own praises. His characters are clear and understandable, despite the inconsistencies that mark so many of them. Our generation is neither simple nor naive, and so the characters of our finest writers too are neither simple nor naive. The ambivalence, doubt, despair, restlessness, and wanderings that Brenner knew so well are the lot of our time. And not only of the men; women too are well acquainted with them. Brenner is nearly the only representative of our literature who was able to comprehend the nature of the Hebrew woman of our time and capture her image faithfully in his writings, even though one has the impression that he visits them only incidentally. His characters realize the many facets of the contemporary Hebrew woman's nature and temperament, in all her various manifestations.

"Art is the soul expressed in style."[150] The artist's soul imbues his each and every work. But to the extent that he succeeds in distilling what is typical, elemental, and essential about his generation, nation, sex, or race, and in giving character and expression to the figure he's dealing with—to that extent his work will abide. To the same extent, the contour of a generation, race, or sex that is favored with such fine writers will abide. By virtue of the talents and writings of a Dostoyevsky or a Tolstoy, a Shakespeare or an Ibsen, the character types of their generation, sex, and race as portrayed in their works—including those of women—were immortalized.

For us, it was our "grandfather" [Mendele] who determined the image of the Hebrew woman in our modern literature. His art set down the image of his female contemporary, and it became the essential characterization over several generations. But even though woman is conservative by nature—and therefore most inclined to maintain her national and familial attachments—the women of our time are not identical to those of Mendele's generation, and their contours, as fixed by the grandfather and his colleagues, no longer suit their current form. I believe in the talents and steadfastness of our people's writers— what has not been accomplished in this generation will be accomplished in the next— until a generation of Hebrew women writers shall arise[151] to compete with them in filling in the gap in our literature: the image of the new Hebrew woman.

150. Shapiro described Brainin's literary pursuit in these exact words; see "Reuven Brainin" in this part: "And art, for him, is soul expressed in style."
151. Shapiro uses similar language in the preface to *A Collection of Sketches*; see Part I.

The Woman Reader: Where Is She?

Translated by Deborah Greniman

Originally published in *Hado'ar* (1931)

The question raised by this distinguished writer is a very important one and greatly deserving of our concern; but at the same time there is no need to exaggerate the shadows and to make the existing situation look darker than it is. And the truth is that in the present day, we do not distinguish—with regard to Hebrew education—between boys and girls. In our [afternoon] Talmud Torahs and day schools—in America and in the other countries of the Diaspora—the girls have all the same privileges, and they often use those privileges better and more successfully than the boys. And it cannot be doubted that the comrade who declared, in the course of his argument in New York, that "a people whose sons don't know its language . . . is dead" was referring not only to sons but also to daughters. We are seeking a way to raise a generation of both male and female readers—and it is in that direction, of co-education, that we need to forge ahead.—*The Editors* [of *Hado'ar*]

We are used to hearing and reading the harangues of those who tremble for the fate of the Hebrew newspapers published in the Diaspora: for the fate of our only son in Europe—*Ha'olam*; of our only son in America—*Hado'ar*; and of *Hatsefirah*, just now twisting in its birth pangs in Poland.

Alarmed to the core, they regret, they argue, they consult, these experts and authorities, as they make their calculations: If only we had one reader for every 3,000 of our Jewish brothers, the newspaper could maintain itself with dignity!

If only, if only . . .

But there is one particular "if only" that they seem willfully to be ignoring: If only the Hebrew newspaper had *female readers*, not even to the same extent that other newspapers have them, but even to the minute extent that it had *male* Hebrew *readers*, it could maintain itself without any trouble.

And not only the newspapers, but our entire literary endeavor could maintain itself without any trouble, for where have you ever seen newspapers or literature that could maintain itself without women readers?

Our literature lacks the participation of the second sex.[152] Although this fact has long been a matter of concern, it seems that a deliberate effort is being made to overlook it. And not only her participation as a creative and active force, but also her passive participation, itself stimulating and influential—the woman as inveterate and steadfast reader is completely missing from our literature. And even if we could manage without women authors, we absolutely, positively cannot manage without women readers.

This is an unnatural phenomenon, and cognizance of it certainly influences the quality of the literary output of our writers and poets. The effect is far from positive.

Those writers and poets know from experience that they are writing only for members of their own sex. The second sex will not read their works or become familiar with them unless they are translated into foreign languages.

And a literature lacking the participation of interested, steadfast women readers is very poor indeed.

To be sure, the Hebrew woman cannot be faulted for lack of interest in written matter. Our grandmothers were always reading [Jewish ethical works such as] *Menorat hama'or*[153] [Candelabrum of Light] and *Nofet tsufim* [The Book of the Honeycomb's Flow].[154] Even in the next generation, the women of Israel did not lack readers; and not only readers, but also writers of books of Jewish content. The literature of the ghetto was read particularly by Jewish women. And who were the readers of the first Yiddish novels?

Nor have readers disappeared from the ranks of the daughters of Israel [*benot Yisrael*] in our own day. On the contrary, there is no more steadfast reader than the Jewish woman. The many different libraries throughout the Diaspora bear witness to this, as do the many editions of the works of the world's great writers, with whom most educated Jewish women are well acquainted. So what is the problem? It is only the works of "the world's great writers" that the educated Jewish woman knows so well. She knows and understands and is interested and takes part in and is familiar with many different literatures. She has given herself over to various foreign literatures, but her ears are stopped up when it comes to our own literature. She does not know even the names of our finest writers.

And I am reading (in *Hado'ar*) about the need to "raise Hebrew readers." "A people whose sons don't know its language and don't understand its literature is deaf and

152. Shapiro uses the language here from the first sentence of her preface to *A Collection of Sketches* but changes "weaker sex" to "second sex"; see Part I. This predates Simone de Beauvoir by eighteen years.
153. Fourteenth-century Hebrew ethical tract by the Spanish Jew Isaac Aboab.
154. Fifteenth-century volume of Hebrew rhetoric by the Italian Jew Yehudah Messer Leon.

blind; it is dead," says one advocate for raising Hebrew readers. That is absolutely true. But no less deaf and blind, no less dead, is a people whose *daughters* do not know its language and or understand its literature.

Where that lack of knowledge and understanding is leading us—we pretty much realize. But nevertheless they are always demanding ways and means only for the boys—how to teach them in their Talmud Torahs or even in their brief hours of free time, which method to use to educate a generation of male Hebrew readers. But the girls are entirely ignored. For even the Talmud Torah pupils, the Hebrew tongue and Hebrew literature are not entirely foreign, whereas for the Hebrew woman, whose education has been so neglected, it must necessarily be foreign. The Talmud Torah pupils at least hear the language and understand it in one form or another. But the woman never hears it and does not understand it in any way whatsoever, neither in the religious nor in the cultural sense.

The attitudes of the old Jews toward girls' education have come in for plenty of criticism and remonstration. But back then at least there was a Jewish milieu and ambience, and Judaism's values and literary output were not entirely foreign to women, even if they did not know Hebrew. Now, however, the situation is completely different. Now both the milieu and the language are absent, so from where will the understanding come? Is it any wonder that assimilation and acculturation have become so widespread? The Jewish woman, after all, is the cornerstone of the Jewish home. She, as mother, sister, and wife, has the overriding influence. And if she is remote and distanced from understanding the language, from religious education and culture alike, what right do we have to complain about the absence of female readers? And if no one is concerned about her and her education, what chance will there be in the future for improving the state of our literature or changing its fate?

Elisheva the Poet

Dr. Eva Schapira-Winterniss

Translated from German by Sonia Beth Gollance and Jessica Kirzane

Originally published in *Selbstwehr* (1931)

The well-known Hebrew poet Elisheva is sojourning in Prague for a while, where, a native Russian, she is expected to speak before a large crowd about her path to Zionism.

Years ago, when Elisheva's poems first appeared in Hebrew literature, I thought it was an impossibility that these poems could come from a non-Jewish woman. I thought it was a very odd ploy for the anonymous author.

But it proves to be an undeniably true fact: The author was none other than the poet Elizaveta Ivanovna Zizkova [Zhirkova is the correct spelling of her surname], who until this point had written in Russian. She is now known under the Hebrew name Elisheva and writes only in Hebrew.

Elisheva—a living reproach to all those whose fathers are not named Ivan, who did not grow up in an atmosphere filled with hatred against Jews and Judaism, who on the contrary are proud of all the intellectual accomplishments of the Jews yet know next to nothing about them.

She is also a reproach to those who claim that because they were not taught Hebrew in childhood, they could not acquire it later. She is a reproach to all those who do not want to know any of the intellectual achievements appearing in that language or believe that their "duty" is discharged by learning to pray (even without understanding the meaning of the words) and haughtily discard everything else as dead, "impractical" knowledge.

Well, a non-Jew has proven that, even in an environment that is not permeated with sympathies to Jews and Judaism, one can make Jewish culture and Jewish knowledge one's own, which is reason enough for many of the Jewish tribe and Jewish blood to undergo heartfelt contemplation and self-reflection. This "stranger" is filled with a glowing love for Hebrew culture, the Hebrew language, and *Erez Israel* [German

401

transliteration of the Hebrew Eretz Yisrael, Land of Israel]. She can be a good example for many Jews who do not know the language, the culture, or the land of their ancestors.

Elisheva has been called a second Ruth,[155] and she even sings in one of her poems: "How I envy your fate, you Moabitess! Under its wings you, the stranger, were hidden in tender love by the great people whose spiritual fire has also penetrated into my innermost self."

Elisheva brings to Hebrew literature the tender melancholy of a true Slavic woman, combined with a profound Jewish longing. Therefore it is not only her stories and novels that are significant but primarily and above all her poems, which reflect the most personal aspects of her being.

For her, Jewish customs and *Minhagim* [German transliteration of the Hebrew word for "customs"] are symbols, holy symbols: "On Sabbath evening I will not ignite candles in the sublime twilight. But there is another light that will not go out for all eternity. This evening I will not bring candles to light, but rather stars,[156] up there in the sublime pure heaven; I will receive the Sabbath of the heart—and a silent wordless prayer will wrest forth from my soul."

This "foreign" Elizaveta Ivanovna, born in Ryazen [Ryazan] and raised in Moscow,[157] who absorbed a very different culture throughout her childhood and youth yet was already able to teach Bible and Hebrew language to children of Jewish refugees during the war, knows the star that announces the Sabbath. She knows the distant *Bachur* [German transliteration of the Hebrew word for "youth"], sitting brooding over the ancient book, humming an old *Nigun* [German transliteration of the Hebrew word for "tune"] in the old *Bethmedrasch* [German transliteration of the Hebrew words for "study hall"]. And this *Nigun* became the present-day Elisheva's "sweet lullaby."

Elisheva's poems and stories can be found in almost all journals and books appearing in Hebrew.[158] Her essay on the work of the late Russian poet Alexander Blok and her treatise on Hebrew poetry excited astonishment at the quality of her [critical] judgment.[159] To put it briefly: Her depictions are splendid in their simplicity. The poet sees with clear, unclouded eyes the pain and suffering of everyday life, the chasing and

155. Ruth is the famous Moabite of the Bible who pledged to remain with her Israelite mother-in-law, Naomi, and from whom, according to Jewish tradition, King David is ultimately descended.

156. The Russian-Jewish writer Isaac Babel, in "Gedali," identifies a star as the beginning of the Sabbath. See Babel, *Collected Stories*, 116.

157. Elisheva, whose father was Eastern Orthodox and whose mother was of Irish Catholic descent, was born in Ryazan, Russia. Upon her mother's death when she was 3, Elisheva moved to Moscow to be raised by her aunt. See Berlovitz, "Elisheva Bichovsky."

158. Most of Elisheva's works appeared from 1925 to 1932 either in the Hebrew press of Palestine (*Moznayim, Do'ar, Hayom*) and abroad (*Hatekufah, Hatoren, Ha'olam*) or in books published by her husband's publishing house, Tomer.

159. Bichovsky, *Meshorer ve'adam*.

clinging, the yearning and striving of our generation, and gives stirring expression to them with a deep feminine sensitivity, depicting them with a masterful hand.

In one of her stories, "Haemeth"—"The Truth"—in the collection *Peret*,[160] she describes the love life of an aging girl, a love life that takes place solely in her mind and is expressed through written memories. She depicts the delight of aging virgins in their loneliness and world-weary wives who become engrossed in those pages and envy the author of those memories for her beautiful, sublime world of love. They read and admire and kneel before her, although they hate her on account of her rich happiness from which they themselves were excluded. And yet the entire happiness was imagined. In reality none of it ever existed. She received the glowing card from no one. No one climbed through the window into her little room. The poet she raved about did not know she existed. Her life, in reality, is poor and empty, as is that of the women who envy her. On the long, lonely evenings when her heart flinches in recognition of her unhappiness and in pain of her isolation, she sits before her pages and spins with rapidly flying letters the stuff that excites their imaginations.

160. *Peret: Sippurim veshirim*, edited by Gershon Shofman, is an anthology that includes Elisheva among other authors and poets.

PART V

ESSAYS ABOUT
HAVA SHAPIRO

Eim Kol Hai Is *Habat Hayeḥidah*:
The Mother of All Living Is the Only Daughter

The two essays presented in this part function, in effect, as bookends to Hava Shapiro's career; the first appeared in 1908, the second in 1938. Written about, rather than by, Shapiro, each is a review of her work by a distinguished Hebrew literary critic of the day.

David Frischmann composed the first essay. It was he, as editor of the journal *Hador*, who published Shapiro's literary debut. Yet his review of her compendium of short stories, *Kovets tsiyyurim* (*A Collection of Sketches*), is riddled with errors and condescension.[1] He carelessly refers to the book by the incorrect title *Kovets sippurim* (A Collection of Stories) and reports that it contains "types of women, and only women"—a false assertion, given the inclusion of sketches devoted to male characters (e.g., "The Poet of Pain" and "Broken Tablets"). Most significant, Frischmann misconstrues Shapiro's preface to the volume as an admonition to male writers to refrain from portraying women, because only women themselves hold the key to unlock the "holy of holies" of their hearts.[2] Based on this misreading, Frischmann petulantly resists offering any critical appraisal of Shapiro's writing, because that too, he argued, should be left to a woman. But given the lack of female critics of Hebrew literature at the time—Shapiro herself was the first—Frischmann's evasion is a disingenuous way of positing the book as undeserving of recognition. Adding insult to injury, he uses the rest of the review to comment in frustration on the inherent inexplicability of women's language, an ironic decision in light of the generally lucid, spare, and straightforward quality of Shapiro's language.[3]

In contrast to Frischmann, Yosef Klausner strikes a positive tone in his essay, "Al 'habat hayeḥidah'" (On the "Only Daughter").[4] Of course, he was writing with the advantage of thirty additional years' worth of material, which made up Shapiro's expansive bibliography across several genres by that time. A literary historian first and foremost, Klausner begins by situating the arc of Shapiro's career within the growing circle of female Hebraists in prestate Israel. Although female Hebrew prose writers

407

during the First (1882–1904) and Second Aliyah (1904–1914) could be counted on two hands, there were several dozen by the 1940s, giving at least an impression of a vibrant community of women who wrote and read in Hebrew.[5] Klausner had high praise for "the only daughter" composing Hebrew prose outside the Land of Israel. He admired her doggedness in turning out "sketches, critical essays, [and] portraits of writers and Jewish public figures in many of the famous Hebrew publications," including *Hashiloah*, the prestigious literary monthly he edited. His concluding blessing that she "merit to see many other Hebrew women writers in Israel and the Diaspora" returns us full circle to Shapiro's own aspiration, as articulated in the preface to *Kovets tsiyyurim*: "My strongest hope is that many others of my sex will be inspired to journey in my footsteps."

The three-decade interval between Frischmann's and Klausner's essays provided Shapiro with sufficient opportunity to gain her footing on the "new ground" she began to tread with the publication of her sketches. Unwilling to have a male writer mediate between Hebrew readers and her, she framed a creative world of her own and structured a narrative space that enabled her to reveal aspects of herself in sources both published and unpublished.

Klausner had it right: Eim Kol Hai (Mother of All Living) was *habat hayehidah* (the only daughter) of her day. Shapiro's singularity marked and shaped her writing and its reception, making her the target of special criticism at the beginning of her career and the recipient of extraordinary praise toward its end.

NOTES

1. Frischmann, "Letter No. 14," in his *Kol kitvei David Frischmann*, 1: 190–95.
2. For an additional misreading, see Harif, "Dr. Hava Shapiro."
3. In a similar vein, read Brainin's generalization: "At first glance, it seems women do differ from one another. But essentially they are all alike and have the same psychology. But, despite their equality and similarity, every one of them is a world in itself. They are the same and not the same. While they differ from one another, they are, more or less, the daughters of Eve [Hava!], and possess the qualities of our grandmother Eve. And it seems to me that I am acquainted with the character of women, especially of the well-educated, intelligent ones [such as Hava Shapiro, presumably]" (Brainin's diary entry "Today I Have Been Grinding Ground Flour," 12 May 1908, Warsaw, in Brainin, *Ketavim nivharim*, 3: 257–59, as translated for Rhona S. Weinstein). We thank Rhona for furnishing a copy of this manuscript.
4. Klausner's "Al 'bat hayehidah'" was originally published in *Hado'ar* in 1938.
5. Berlovitz, "Prose Writing in the Yishuv."

Letters on Literature: Letter No. 14

David Frischmann

Warsaw, 1908

My [female] Friend!

For you this will be especially important: Today, laid out on my desk is a Hebrew book that was written by a woman. The book is called "A Collection of Stories" [*Kovets sippurim*][1] and the name of the author is Eim Kol Hai. The stories are small, three or four pages long: descriptions of types of women, and only women, although I do not wish to write you about the stories themselves. In her introduction, the author writes, "Time and again, when we [feminine plural] are amazed and awed by the great talent of a 'wonder worker,' one who 'penetrates the woman's heart,' we feel at the same time as though a strange hand has touched us. We have our own world, our own pains and longings, and we should, at the very least, take part in describing them." And so: a division of labor, even in this field! Fine. I would like to please the author, and so I will leave aside even the critical review of these stories so that a woman can come and write it. After all, I am a polite person. I do not want to insinuate myself into a realm that is not mine and, in doing so, to be that *stranger*, whose hand fumbles about in a world of pain and longings, that in the end he can never understand. Let the males sit in this corner and the females in that corner. The same division occurs, after all, in the field of "fashion": Male tailors sew for males and seamstresses sew for females. It is self-evident that it does not matter whether the male tailor occasionally opens a women's fashion magazine, or vice versa. If once and a while a certain Shakespeare arises or even a Guy de Maupassant or a Marcel Prévost, who writes and gives us types of women with their world, pains, and longings—from where would you learn that [Aramaic, *meheikhi tita*]! We women are not closing the door on anyone who reaches for a pen. But the main point is that the correct key can be found only in the hands of women, and ultimately,

1. Frischmann misremembers the title of the book; it is *Kovets tsiyyurim* (A Collection of *Sketches*).

they should open for us the door of that holy of holies, which is a woman's heart. "So long," says the author, in her preface, "as they [i.e., other women] do not take part, our literature will be impoverished."

And nevertheless, my [female] friend, and nevertheless! A certain mocking demon sits in the secret places of my heart and does not let me believe with complete faith that this is the correct way. I do not fear that she will not open this secret door for us; rather, I am frightened that she will write and write, and we men will understand nothing, because we do not understand the language of women.

And now I have arrived at the essence of the matter, a few things about which I wanted to speak into your ear.

The Language of Women—this is an utterly unique subsection of philology, a subsection that no professor has as of yet mastered. We study Chinese, Sanskrit, Tatar; we study Esperanto; we even study that foreign and difficult language spoken and written by our brethren who live in the Land of Israel which they call Hebrew, with an emphasis on the *beit* and an emphasis on the *tav*.[2] Only the language of our ministering angels, [namely,] our mothers, sisters, wives, and daughters, do we not study. And this language is of the utmost necessity, for it is the language of those souls most beloved to us, with whom we have commerce twenty-four hours a day. Oh, this wondrous philology! For many years I have been preoccupied with this idea: Who knows whether the great distress that surrounds us would be as great if the idea came to our minds from time to time that really the two sexes speak two entirely different languages, and perhaps people would not suffer as much if they understood this, that in the same way that they raise their sons and have them study geography, history, and trigonometry, they must at the same time teach them how to understand the language spoken by women, something which would afford them goodness all their days. Obviously my intention here is not language in a linguistic sense; rather, we should learn that a word might have one meaning coming from the mouth of a man and an entirely different meaning coming from the mouth of a woman, and that a verse, whose interpretation from the mouth of a man is such and such, when it leaves the mouth of a woman, even if it is the same verse word for word as with the man, its interpretation might become entirely different, even diametrically so. Ostensibly, they are speaking the same language. He says "yes" and she says "yes"; but when she says that same "yes," we do not know what it is and whether she really intended with her "yes" to tell us "no," and we do not know if the "yes" from before noon has the same meaning as the "yes" after noon, and if so, if she says it to us on sunny days, whether it has the same meaning as that said on rainy days. All this needs to be taught to our sons in school, so that the great distress that surrounds us can be lessened somewhat. Why do we need Sanskrit? Why Japanese? What we need to learn is the language of women!

2. Frischmann is mocking those who attempt to use the Sephardic pronunciation of Hebrew.

I am sitting at a table and opposite me sits a woman. Every so often she turns to me for something. Suddenly I hear, "Would you be so kind as to bring me the glass that is next to you." I rush and bring her the glass. And suddenly the woman becomes upset. I was an attentive gentleman and she has become upset. It is clear that I have made some mistake here; it is clear that she has no desire for the glass, rather for something else, and I did not understand that clearly the word "glass," in that particular context and at that moment, did not mean "glass" at all. So you [masculine] guess yourself what she wanted! Did she want me to answer her, "But my lady! Why do you wish at this time to drink wine, when your cheeks bloom like roses without wine?" Or did she wish for me to say, "But my lady! You are weak right now, and wine will not help you; rather, you should travel a bit along the banks of the Riviera!" Or did she ask so that in stretching out her hand to me, I would say to her, "But, my lady! Is that a new ring on your finger! I didn't know that you bought yourself a new piece of jewelry?" You go and guess. Only this is clear: She wanted all of this, but not the glass, and I, who gave her the glass, sinned against her and made a mistake, and therefore she is justified in being annoyed with me. And if verily I were to say to her, "Madame, you asked me just now for the glass. I swear that is what you asked for!" Well, then she'd say that this is not at all what she asked for; she swears that she didn't ask for anything, upon her life, she did not ask—and in this she would be justified as well. For in actuality, she did not ask for this at all, and the words that she spoke from her lips were never understood and she has no obligation to remember them. And if verily I were to insist on my opinion and would seek to remind her what she had said word for word, she will see me as deceptive and abusive, as though coming to her with a grievance—and in this she would be justified as well. The words themselves here have no inherent value. Rather, it is the intention, and I did not understand the intention. In short, she is the righteous one and I am the sinner; and not only that, I am a boorish man who pursues trifles and searches after words and half-words.

You will say that I am speaking disparagingly of women? No, all of this I say in *praise* of women, only in praise. I see in this a kind of attribute of modesty. A woman is accustomed to hiding her body. All of her flesh is a great secret—how much more so does she hide her soul? She might agree occasionally to surrender two or three insignificant body parts to the sight of a stranger, but under no circumstances would she be willing to show a stranger the slightest part of even one of her true thoughts. Words are never the real content of her thinking. A woman uses a word the way she uses a glance, a smile on her lips, eau de toilette on her flesh—all of it in a decisive and precise manner, but the meaning of all of these change and depart from the common meaning. Have we seen a woman use a hat simply to cover her head? Does she use a sun visor to protect herself from the heat? Does she use a watch to tell the time? Does she wear shoes in order not to walk around barefoot? So why is it specifically that in the case of words we

expect her to use them to express her true thinking, like a merchant on Gencza Street who says to his friend, "I am selling you twenty pieces of Heinzl Camelhair." He says this because he really sold him these twenty pieces?

This woman is a kind of mimosa, a plant that shrinks and folds up and dies the moment it is touched by a finger, and often it dies only when touched merely by a glance of an eye. All of a woman's instincts lead her to hide and conceal herself and to wear veil upon veil. So how can we expect her, this sensitive creature, this work of art who hides abashed, to reveal that which is seven times as hidden as her flesh: her thoughts?

And if in conversation, how much the more so in writing. When was there a woman who wrote a personal letter the same way as a man? Consider her as she sits by a table: Like him, she takes a piece of paper and dips her pen in ink and writes letter after letter, according to the dictation of her thoughts, and, like him, she is happy when she sees that she succeeded in conveying her thoughts exactly, so that she can pass them on to her addressee. This is naïve thinking! When a woman writes a letter to a man, if it does not become a veil for all that she thinks, it becomes at the very least a scarf. But the man who receives it, if he is accustomed to letters such as these and if he acts like a kind of psychological spy, then he will understand how to read it. He will not pay attention to the words but rather to its tone. The tone will be loving when the woman needs to hide a betrayal or an inclination to betray. The tone will be full of threats when she needs to hide something she fears. The tone will be peaceful and cool and emotionally balanced when she feels it necessary to augment the stormy voices in her heart—*and when all is said and done*, none of these fine generalizations will be at all useful if the man who receives the letter has too little invested in it.

And if this is the case with the writing of letters, how much the more so for the writing of books. Books written by women may indeed reveal the mysteries of this heart, but another thing is clear: We men will not discern these mysteries because we cannot understand the language.

But if we do learn this language—if we know, for example, the meaning of the word "yes" before noon and after noon, what "give me the glass" means on sunny days and what it means on rainy days, what it is that a woman says when she is silent and what she wishes to conceal in her speech—then it is very possible that when a woman writes us a story, it will indeed be possible to understand that world and that pain and those longings which we so desired to understand.

On the "Only Daughter"

(On Thirty Years of Literary Work for Dr. Hava Shapiro)[3]

Yosef Klausner

Originally published in *Hado'ar* (1938)

Today it is not surprising to find women writers of Hebrew prose or poetry in the Land of Israel: Women study Hebrew here just like the men, and at the Hebrew University in Jerusalem, women students constitute 30 percent of the student body, if not more.

However, thirty years ago, that was not the case. Women writers were a precious commodity at that time. I can think of only three names of women who published anything in Hebrew in the first years of the twentieth century.

And then Eim Kol Hai appeared on the Hebrew literary stage. I remember the impression her appearance made. Even Y. L. Peretz was impressed by her.

Since that time, Dr. Hava Shapiro has published sketches, critical essays, [and] portraits of writers and Jewish public figures in many of the famous Hebrew publications. I readily published many of her sketches and critical essays in *Hashiloah*. I remember the impression made by her sketch "The Brothers from Slavuta," which was published in *Hashiloah*. Deriving, as she did, from the famous Slavuta family, she knew not only how to tell of the event (when the righteous Shapiro brothers, printers from Slavuta, were sentenced to be beaten and run the gauntlet of rows of Cossack executioners, who beat them until blood flowed from their exposed flesh, and the yarmulke fell off the head of one of the "brothers"—and so he turned back in the direction of the cruel lashers, giving his body over to their beatings—only so that he would not have to walk four cubits with his head uncovered)[4] but also how to sense the wondrous fact (or legend) and elevate it to the awe-inspiring height of glorious folk religion.

3. Thirty years had passed since the publication of *A Collection of Sketches*.
4. Cf. Babylonian Talmud, *Kiddushin* 31a.

Dr. Hava Shapiro remains an "only daughter" in the Diaspora, in the same way she was thirty years ago. Hebrew literature has become concentrated in the Land of Israel, including among female writers and poets. But Eim Kol Hai does important cultural work in the Diaspora. Perhaps she recognizes instinctively that if the Hebrew cultural wellspring of the 16 million Jews in the Diaspora dwindles, the strong cultural tributary, which currently flows in the Land of our Hope, will also desiccate and dry up. But certainly she must feel abandoned and lonely in the Diaspora, cut off from the new life that continues to stream forth strongly in the Land of our Rejuvenation, even with all the bitter disappointments of the last few years, which brought foreign vernaculars along with the mass immigrations.

My blessing to Dr. Hava Shapiro on the occasion of thirty years of literary work follows:

May you merit to see many other Hebrew women writers in Israel and the Diaspora so that you will cease being the "only daughter," even in the lands of the Exile.

Appendix 1

Guide to the Jewish Press

(Related to Shapiro's Writings)

Title	Dates of Publication	Place of Publication	Frequency	Language	Supplementary Notes (Relating to Hava Shapiro)
Blätter für die jüdische Frau (Pages for the Jewish Woman), supplement to *Selbstwehr*	1925–1936	Prague	Monthly	German	
'Ein hakore (Eye of the Reader)	1923	Berlin	Quarterly	Hebrew	
Ha'am (The Nation)	1917–1918	Moscow	Weekly, daily	Hebrew	
Haboker (This Morning)	1909	Warsaw	Daily	Hebrew	David Frischmann and Uri Nisan Gnessin (contributors)
Hado'ar (The Post)	1921–2004	New York	Weekly	Hebrew	Menahem Ribalow (editor, 1923–1953) (Shapiro wrote to him, see Part IV)
Hador (The Generation)	1899–1900; 1904	Kraków, Warsaw	Weekly	Hebrew	David Frischmann (editor, 1901–1904)
Haderor (The Swallow)	1909	New York	Weekly	Yiddish	Reuven Brainin (founder)
Ha'olam (The World)	1907–1950 (w/ intervals)	Cologne, Vilna, Odessa, London, Berlin, Jerusalem	Weekly	Hebrew	Nahum Sokolov (founder and initial editor); mouthpiece of the World Zionist Organization
Hashiloaḥ (The Dispatch)	1896–1927 (with intervals)	Berlin, Odessa, Jerusalem	Monthly	Hebrew	Yosef Klausner (editor, from 1903), Hayyim Nahman Bialik (chief of literary section, 1904–1909); leading Hebrew journal of its generation

Title	Dates of Publication	Place of Publication	Frequency	Language	Supplementary Notes (Relating to Hava Shapiro)
Hatoren (The Mast)	1913–1925 (with intervals)	New York	Monthly, weekly, monthly	Hebrew	Reuven Brainin (editor, 1919–1925)
Hatsofeh (The Observer)	1903–1905	Warsaw	Daily	Hebrew	
Haynt (Today)	1908–1939	Warsaw	Daily	Yiddish	
Hazeman (The Times)	1903–1915	St. Petersburg, Vilna	Twice weekly, daily	Hebrew	
Hed hazeman (Echo of the Time)	(Same as *Hazeman*)				
Der Jude (The Jew)	1916–1924	Berlin	Monthly	German	Martin Buber (founder)
Keneder Adler (Canadian Eagle)	1907–1988	Montreal	Daily	Yiddish	Reuven Brainin (editor, 1915–1916)
Literarishe Bleter (Literary Pages)	1924–1939	Warsaw	Weekly	Yiddish	
Selbstwehr (Self-Defense)	1907–1938	Prague	Weekly	German	
Der Veg (The Way)	1915	Montreal	Daily	Yiddish	Reuven Brainin (founder)
Die Welt (The World)	1897–1914	Vienna, Koln	Weekly	German	Martin Buber (editor, 1901)

This table is based largely on "East European Hebrew Journals," compiled by Nurit Govrin, which is embedded as a PDF in Avner Holtzman's article "Hebrew Literary Journals" in the *YIVO Encyclopdia of Jews in Eastern Europe* (www.yivoencyclopedia.org/article.aspx/Literary_Journals/Hebrew_Literary_Journals).

Appendix 2
Catalogue of Literary Personalities
(Alphabetical by last name according to Hebrew rendering, unless the person is better known otherwise.)

Abramovitch, Sholem Yankev (pen name Mendele Mokher Seforim) (1835–1917), acknowledged founder of modern Yiddish prose with Y. L. Peretz and Sholem Aleichem; Shapiro wrote the first piece of feminist literary criticism in Hebrew on his stories. See "Female Types in Mendele's Stories" (1918).

Ahad Ha'am, see *Asher Ginsberg*

Ba'al Mahshoves, see *Isidor Eliashev*

Baron, Devorah (1887–1956), Hebrew and Yiddish short story writer, immigrated to Palestine in 1910

Ben-Yehuda, Eliezer (1858–1922) (b. Eliezer Perelman), pioneering father in the development of modern Hebrew; known especially for first comprehensive dictionary

Ben-Yehuda, Hemda (1873–1951) (b. Beila Jonas), Hebrew journalist and fiction writer, contributor to husband Eliezer's newspapers and dictionary project

Ben Avigdor, see *Abraham Leib Shalkovich*

Berdichevsky, Micha Yosef (1865–1921), Hebrew writer; acquaintance of Shapiro; studied at the University of Bern several years before Shapiro

Bershadsky, Yeshayahu (1871–1908), Russian Hebrew writer

Bialik, Hayyim Nahman (1873–1934), renowned Hebrew poet who exercised profound influence on Jewish culture; invited Shapiro to settle in Odessa (see diary entry for 7 July 1918 in Part II)

Bichovsky, Elisheva (1888–1949) (b. Elisaveta Ivanovna Zhirkova), Russian poet who later turned to writing Hebrew poetry; immigrated to Palestine; subject of an essay by Shapiro (see "Elisheva the Poet" in Part IV)

Bichovsky, Simeon (1882–1932), Zionist activist, teacher, literary critic, and publisher; close friend of Brenner and Uri Nisan Gnessin; husband of Elisheva

Brainin, Reuven (1862–1939), see Appendix 3 for extensive biography

Braudes, Reuven Asher (1851–1902), Lithuanian-born Hebrew novelist and journalist

Brenner, Yosef Hayyim (1881–1921), Russian-born Hebrew prose writer and editor

Brod, Max (1884–1968), German writer and critic; member of Prague circle of German-speaking Jewish writers; Shapiro reviewed his book in "Paganism, Christianity, and Judaism" (1924)

Buber, Martin (1878–1965), Austrian-born Jewish philosopher; editor of the Zionist weekly *Die Welt*; Shapiro reviewed his book in "Martin Buber and His Work" (1928)

Chagall, Bella (1895–1944), memoirist, subject of her husband Marc's paintings on occasion

Dinezon, Yankev (1856?–1919), Lithuanian-born Yiddish author, editor, and literary activist; life-long friend of Y. L. Peretz and acquaintance of Shapiro

Dubnow, Simon (1860–1941), Russian Jewish historian and proponent of Jewish Diaspora nationalism; among the Hebraists with Bialik in Odessa

Eliashev, Isidor [Yisrael] (pen name Ba'al Mahshoves) (1873–1924), first Yiddish literary critic, also a medical doctor

Elisheva, see *Elisheva Bichovsky*

Feierberg, Mordechai Ze'ev (1874–1899), Hebrew prose writer

Frischmann, David (1859–1922), Hebrew and Yiddish editor and literary critic; see "Memories of Frischmann's Life" in Part IV for Shapiro's reminiscence of him, and see his critique of her work in "Letter No. 14: *Letters on Literature*" in Part V

Ginsberg, Asher (pen name Ahad Ha'am) (1856–1927), Hebrew essayist and nationalist; widely influential cultural Zionist

Ginsburg, Shaul (1866–1940), editor of *Der Fraynd* and historian of Russian Jewry; published articles in the *Forverts* (1937–38) about the incident at the Slavuta printing press in 1835, which was translated into English by Saul Prombaum as *The Drama of Slavuta*; see Shapiro's account of this incident ("The Brothers from Slavuta") in Part II; Shapiro reviewed Ginsburg's work in "From the Recent Past (On the Historical Writings of Shaul Ginsburg)" (1938)

Gnessin, Uri Nisan (1879–1913), Hebrew prose writer and stylistic innovator

Gordon, A. D. (1856–1922), spiritual father of socialist Zionism and founder of Hapo'el Hatsa'ir; Shapiro wrote a report of his speech at the 1920 convention (see "Letter from Prague" in Part IV)

Gordon, Yehudah Leib (1830–1892), leading Hebrew and Yiddish poet; Shapiro quoted from his paean to Jewish women, "The Tip of the *Yod*," in her preface to *A Collection of Sketches* (see Part I)

Hacohen, Mordecai ben Hillel (1856–1936), Hebrew writer and Zionist

Herzl, Theodor (1860–1904), journalist and founder of modern political Zionism

Hindes, Mattathias (1894–1957), lawyer and banker in Warsaw; Zionist activist

Horodetsky, Shmuel Abba (1871–1957), historian of Hasidism; befriended Shapiro in Bern and developed a romantic interest in her (see diary entry for 24 January 1910 in Part II); Shapiro reminisced about Horodetsky in "The Historian of Hasidism of the Heart (To Commemorate Horodetsky)" (1931)

Imber, Naftali Herz (1856–1909), poet and Zionist who wrote the lyrics for "Hatikvah"

Jabotinsky, Vladimir (Ze'ev) (1880–1940), revisionist Zionist and cofounder of the Jewish legion of the British army in World War I; helped found *Betar* and the *Irgun*

Kabak, Aaron Abraham (1880–1944), Lithuanian-born Hebrew author

Kafka, Franz (1883–1924), Prague-based German novelist and short story writer; one of the most influential authors of the twentieth century

Kaplan, Eliezer (1891–1952), Zionist activist and Israeli politician

Katznelson, Rachel (1885–1975), literary critic and activist in the Labor movement in pre-state Israel; moved to the Land of Israel in 1912; married Zalman Shazar (Israel's third president)

Klatzkin, Jacob (1882–1948), Zionist activist; editor of *Die Welt*, 1909–1911; Shapiro reported on his lecture in "Letter from Prague (Lecture by Dr. Klatzkin)" (1921)

Klausner, Yosef (1874–1958), Jewish historian and Hebrew literary critic; editor of *Hashiloaḥ*; see "On the 'Only Daughter'" for his positive assessment of Shapiro's writing in Part V

Kleinman, Moshe (1871–1948), editor of *Ha'olam*

Levinsky, Elhanan Leib (1857–1910), Hebrew writer and Zionist activist

Lilienblum, Moshe Leib (1843–1910), Hebrew writer; championed religious reform, then acculturation into Russian society, and later Zionism

Lipson, Mordecai (1885–1958), Hebrew and Yiddish writer, translator, journalist, and editor

Lissitzky, Ephraim (1885–1962), American Hebrew poet

Ludvipol, Abraham (1865–1921), Hebrew journalist, publisher, and editor and Zionist activist; edited the Warsaw daily *Hatsofeh* from 1903 to 1905

Mapu, Abraham (1808–67), writer known for developing the novel in Hebrew

Melamed, Shmuel Moshe (1885–1938), writer, philosopher, and journalist in Hebrew, German, Yiddish, and English

Mendele Mokher Seforim, see *Sholem Yankev Abramovitch*

Nomberg, Hirsch David (1876–1927), Hebrew and Yiddish prose writer and political and social activist; served as editor of *Hatsofeh* from 1904 to 1905

Peretz, Yitzchak Leib (1852–1915), Yiddish and Hebrew poet, writer, and essayist and mentor to many; for his influence on Shapiro and her reminiscence of him, see "Y. L. Peretz: The Man and the Writer" in Part IV

Persky, Daniel (1887–1962), educator, journalist, and Hebrew activist who wrote for the Hebrew weekly *Hado'ar*; see Part III for Shapiro's letters to him

Pinski, David (1872–1959), Yiddish writer and playwright

Pukhachewsky, Nehama (1869–1934), Zionist pioneer and fiction writer; wrote early travelogue of her journey through the Land of Israel

Rabinovitz, Shalom (pen name Sholem Aleichem) (1859–1916), one of the founding fathers of modern Yiddish literature; satirist and writer of short stories, plays, and monologues

Rakovsky, Puah (1865–1955), memoirist; Jewish teacher and principal in Jewish girls' schools in Eastern Europe; see Part I for comparison to Shapiro

Ravnitzky, Yehoshua Hana (1859–1944), Hebrew and Yiddish writer, editor, publisher; cofounder of Moriah; founded Devir publishing house; collaborator with Hayyim Nahman Bialik

Reisen, Zalmen (1887–1941), scholar of Yiddish language and literature, editor, journalist, cultural activist; created groundbreaking biographical reference work

Shalkovich, Abraham Leib (pen name Ben Avigdor) (1866–1921), Hebrew writer and editor, founder of the publishing houses Ahi'asaf and Tushiyah

Shofman, Gershon (1880–1973), Hebrew writer

Sholem Aleichem, see *Shalom Rabinovitz*

Smolenskin, Peretz (1842–85), Russian Hebrew novelist, founder of *Hashahar*

Sokolov, Nahum (1859–1936), pioneering journalist of *Hatsefirah* in Warsaw and Zionist activist; participant in Y. L. Peretz's literary circle

Steinberg, Yaakov (1887–1947), Yiddish and Hebrew poet, essayist, translator, short story writer, and critic

Syrkin, Nahum (1868–1924), leader of Labor Zionists at first Zionist Congress

Tchernichowsky, Saul (1875–1943), Hebrew poet and translator; Shapiro wrote an essay on his love poetry, "Tchernichowsky: Poet of Love" (1929)

Wengeroff, Pauline (Paulina Vengerova) (1833–1916), author of a two-volume memoir in German; see Part I for comparison to Shapiro

Yankev, Shmuel (1874–1936), founder and publisher of the Warsaw daily Yiddish newspaper *Haynt* and served as its editor-in-chief and co-owner

Zederbaum, Aleksander (1816–1893), founder of *Hamelitz*, the first Hebrew weekly in tsarist Russia (the paper eventually became a daily)

Appendix 3
Reuven Brainin's Biography and Literary Influence

This biography of Reuven Brainin is based largely on Stanley Nash, "Reuven Brainin," *YIVO Encyclopedia of Jews in Eastern Europe.*

Like Shapiro, Brainin (1862–1939) had a voracious appetite for literary study and a nearly sacred passion for the Hebrew language and an aspiration to bring it from the margins to the mainstream of Jewish life. He also remained in the Diaspora throughout his lifetime, despite holding strong Jewish nationalist ideals (which became radically altered at the end of his life).

Brainin was raised in a traditional Jewish household in the Pale of Settlement (in Liady, Mogilev) and made his way as a young adult to the capitals of Europe. In Vienna he came under Peretz Smolenskin's influence and participated in Jewish student nationalist organizations. He launched the journal *Mimizraḥ umima'arav* (From East to West, 1894–1899), which focused on Hebrew and European literature, philosophy, and science. In 1896 Brainin moved to Berlin and participated in the burgeoning Hebraic culture there. Later critics regard 1902–1903, when Brainin edited *Luaḥ aḥi'asaf*, as the height of his literary career and influence. In general, Brainin encouraged Western-style belles lettres in Hebrew (in contrast to Ahad Ha'am's Jewish-centered academic style).[1] Brainin's contemporaries noted his personal charisma and engaging conversational ability, attributes confirmed by Shapiro's impressions.

By 1905 Brainin's star was waning; five years later he moved to North America to find work. He began editing the Hebrew weekly *Haderor* in New York but left for Montreal to edit Yiddish newspapers. But after four years, given his primary interest in Hebrew,[2] he returned to New York in 1916 to edit the Hebrew journal *Hatoren* with mixed success until 1926. The same year, he traveled to South Africa as a representative of the campaign to settle Jews in Birobidzhan. His support of this controversial plan led to a break with the Hebraist-Zionist literary world, which was altogether severed by his libel suit against Hayyim Nahman Bialik in 1929. Alienation from the

421

Hebrew establishment led him back to Yiddish and Montreal, where he edited *Keneder Adler* and *Der Veg*, inspired the creation of the Canadian Jewish Congress, and established Montreal's Jewish Public Library. He died at the age of 77 in New York, where he lived with his son, Joseph.

When Brainin first met Shapiro in 1899, he enjoyed a great deal of prestige in the world of Hebrew letters. However, few of his works are read today. Some scholars portray him as a "literary activist"; others refer to him as a *shayne schreiber* (Yiddish, literally "pretty writer," i.e., one who lacks depth).[3] Nevertheless, because of his extraordinarily prolific output of short items, his somewhat sensationalist work in biography, his heralding of Tchernichowsky, Ben-Yehuda, and others, and his ability to write about Jewish and non-Jewish figures in the natural sciences, Brainin is remembered today as an (albeit minor) player in the Hebrew revivalist movement. Brainin's editorial authority during his lifetime and the careful preservation of his writings after his death are, no doubt, contributing factors to the longevity of his literary legacy.[4]

NOTES

1. Nash, "Anti-Ahad Ha'am"; and Nash, "Hebraists," 45.
2. "My soul weeps secretly because I have abandoned Europe and my work in Hebrew literature" (23 March 1914, Montreal), Miscellaneous Autobiographical Writings file, Reuven Brainin Collection, Jewish Public Library Archives, Montreal.
3. Stanley Nash, e-mail correspondence (13 December 2005).
4. All but Brainin's diary is at the Jewish Public Library of Montreal; his diary is at the Jewish National University Library in Jerusalem. Brainin's son, Joseph, donated materials to the Jewish Public Library (1940–1942), including his father's desk and typewriter. See correspondence between Joseph Brainin and S. Temkin, President of Jewish Public Library (16 December 1939, 24 April 1940, 17 July 1940, 31 August 1942, 25 May 1945), Correspondence, Reuven Brainin Collection, Jewish Public Library Archives, Montreal.

Appendix 4
Timeline of Hava Shapiro's Life, 1878–1943

1790	Death of Rabbi Pinhas of Korets, disciple of the Besht and progenitor of the Shapiro family
1791	Establishment of Hebrew printing press in Slavuta (Ukraine) by Moshe (Pinhas's son)
1835	Arrest and exile of Shmuel Abba and Pinhas Shapiro (Moshe's sons)
1878	Birth of Hava Shapiro to Menuhah (Schoenberg) and Yaakov Shammai Shapiro
1880s	Studies Torah at home with brothers and local rabbi
1890s	Participates in local group of Agudat ḥovevei sefat ʻever (Society of Lovers of the Hebrew Language)
1895	Marriage to Limel Rosenbaum of Warsaw
1897	Birth of son, Pinhas
1899	First meeting between Shapiro and Reuven Brainin (Berlin)
1900	Moves to Warsaw and participates regularly in Y. L. Peretz's literary salon as of 1901
1901	First publication: "The Rose" in *Hador* with byline Eim Kol Hai (Mother of All Living)
1904	Separates from husband and moves to Vienna to study while son remains with his father
1906	Matriculates to University of Bern
1907	Divorces Rosenbaum
1908	Meets with Bialik in Odessa
1909	Publication of *A Collection of Sketches* (includes first feminist manifesto in Hebrew)
1910	Awarded Ph.D. and changes byline to Dr. Hava Shapiro; Brainin departs to United States and Canada
1911	Trip to Palestine with David Frischmann and her parents
1912	Moves to Berlin; reports for Hebrew journals over next twenty-six years; extensive travel
1914	Returns to Slavuta; frequent travel to Kiev
1919	Publishes "Female Types in Mendele's Stories" (first piece of Hebrew feminist literary criticism)
1919	Escapes to Czechoslovakia with son
1920	Interviews Tomas G. Masaryk, first president of the Republic of Czechoslovakia, and later publishes *T.G. Masaryk, His Life and Teachings* (1935)

1925	Final meeting with Brainin (18th Zionist Congress, Vienna)
1929	Marries Josef Winternitz; takes Czech citizenship
1941	Surrenders diary to stranger for preservation (first Hebrew diary by a woman)
1942	Admitted to mental hospital (released in January 1943 for impending transport)
1943	Death from "mental illness" (one week before deportation of Prague Jewry to Terezin)
1985	Discovery of Shapiro's Hebrew letters and postcards to Brainin (approximately 200)

Appendix 5
Shapiro Family Tree

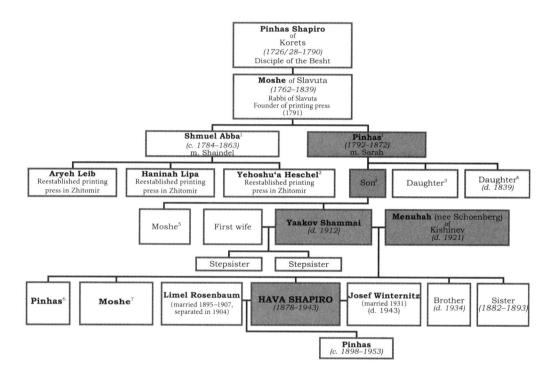

NOTES TO THE FAMILY TREE

1. Subject of Hava Shapiro's "The Brothers from Slavuta."
2. Hava Shapiro identifies Pinhas the Younger's only son as Yehoshu'a Heschel. This identification is not corroborated in other sources that identify Yehoshu'a Heschel as the son of Shmuel Abba.
3. Hava Shapiro reported (in "The Brothers") that her paternal grandfather and his sister lived with her at her childhood home.
4. Hava Shapiro claimed (in "The Brothers") that her great aunt portended the Slavuta brothers' demise.
5. Hava Shapiro described visiting her Uncle Moshe in Otwock; see letter (20 June 1904).
6. Hava Shapiro wrote asking for assistance with her eldest brother, Pinhas, who lived in Vienna; see letter to Menahem Ribalow (2 June 1938).
7. Moshe Shapiro delivered his sister's diary to Genazim in 1956. In 1913 he was listed as a librarian in a catalogue of Slavuta entrepreneurs (see jewua.org/slavuta).

Appendix 6

Hava Shapiro's
Places Traveled and Places of Residence (in bold)

(Culled from her diary and correspondence)

Date	Location	Involvement with Brainin	Notes
1878–1900	**Slavuta**		**Birth, childhood, marriage**
1899			
May	Berlin	First meeting with Brainin	
August	Wiesbaden		
1900–1904	**Warsaw**		**Resides with husband and son**
1900			
July	Slavuta		
1901			
July–August	Pyrmont		
August–September	Slavuta		
1903			
June	Slavuta		
September–October	Slavuta	Meeting with Brainin	
October 20–21	Warsaw		
October 31–December	Slavuta		
1904–1905	**Vienna**		**Studies as external student**
1904			

June 16–22	Warsaw		
June 23–26	Otwock		
July	Slavuta		
August	Warsaw		
1905–1910	**Bern**		**Student at University of Bern**
1906			
July–August	Slavuta		
October	Warsaw		
1907			
January	Paris		
July	Franzens-bad		
August	The Hague		8th Zionist Congress
September	Slavuta		
November	Vienna		
December	Munich		
1908			
March	Lausanne		
April	Vienna		
April	Lausanne		
Summer		Meeting with Brainin	
August–September	Slavuta		
October	Lausanne		
October–beginning of November	Warsaw		
November	Vienna		
December	Lausanne		
1909			
April	Warsaw		
April 24–25	Göttingen		Research for her thesis
1910			
Summer	Koblenz	Brainin immigrates to America	

July	Wiesbaden	Meeting with Brainin	
August	Slavuta		
September	Opatija		
December	Warsaw and Berlin		
1911			
Spring	Land of Israel		Travels with her parents and Frischmann
June–July	Slavuta		
1912–1914	**Berlin**		
1912			
November	Slavuta	Meeting [2 months?] with Brainin	
1913			
Summer	Slavuta		
1914–1918	**Slavuta**		**Intermittent travel to Kiev**
1918			
July–August	Odessa		
1919–1943	**Prague and Munkács**		**Escapes with son**
1919			
March	Slavuta		
1920			
Summer		Brainin in Europe, no meeting	
1923			
March	Baden and Vienna		13th Zionist Congress
Summer–Fall	Carlsbad and Berlin		
1925			
Summer	Vienna	Final meeting with Brainin	18th Zionist Congress

Appendix 7

Shapiro's Travels

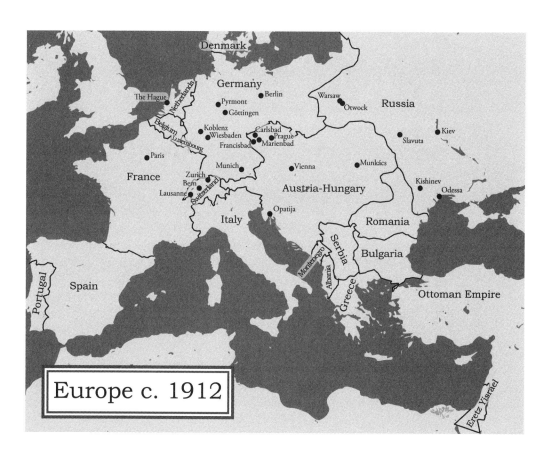

Europe c. 1912

Appendix 8
Hava Shapiro's Writings

The writings appear in chronological order, and the byline is given at the end of each entry, along with the corresponding page numbers of the Hebrew original in *Behikansi 'atah* [BA], where applicable.

HEBREW WRITINGS

"The Rose." *Hador* 1.48 (12 December 1901/2 Tevet 5662): 13–14. (Eim Kol Hai) BA: 43–47

"Wilting Roses." *Hador* 2.35 (21 October 1904/25 Heshvan 5665): 27–28. (Eim Kol Hai) BA: 53–54

"The Dreamer." *Hazeman* 254 (24 March 1905): 4. (Eim Kol Hai) BA: 65–68

"The Teacher." *Hazeman* 21 (7 February 1906): 2. (Eim Kol Hai) BA: 85–88

"Old Maid." *Ha'olam* 2.18 (6 May 1908/5 Iyar 5668): 245. (Eim Kol Hai) BA: 27–31

"Poet of Sorrow." *Ha'olam* 2.22 (3 June 1908/4 Sivan 5668): 299–300. (Eim Kol Hai) BA: 69–74

"Types of Women." *Ha'olam* 2.27 (8 July 1908/2 Tammuz 5668): 359–60. (Eim Kol Hai) BA: 33–37

"Broken Tablets (Notes)." *Ha'olam* 2.37 (18 September 1908/22 Elul 5668): 486–87. (Eim Kol Hai) BA: 75–79

"Days of Awe." *Hed hazeman* 209 (4 October 1908): 1. (Eim Kol Hai)

"On Literature." *Ha'olam* 2.39 (2 October 1908/7 Tishri 5669): 507–508; and 2.40 (9 October 1908/14 Tishri 5669): 519–20. (Eim Kol Hai) BA: 157–65

A Collection of Sketches. Warsaw: Edelshtein, 1909. (Eim Kol Hai) BA: 15–92

"Notes from My Journey to Eretz Yisrael" (in 3 parts). *Hed hazeman* 107 (26 May 1911): 1; 108 (28 May 1911): 1; and 117 (9 June 1911): 1. (Eim Kol Hai)

"Hauptmann's New Novel." *Hashiloaḥ* 28 (1913/5673): 563–67. (Eim Kol Hai) BA: 167–76

"Aphorisms and Typical Principles." *Hatoren* 1.10 (May 1914/Iyar 5674): 135–40. (Dr. Hava Shapiro)

"The Brothers from Slavuta (An Event that Occurred)." *Hashiloaḥ* 30.1 (1914/5674): 541–54. (Dr. Hava Shapiro) BA: 93–114

"From General Literature." *Hashiloaḥ* 31.1 (1914/5674): 90–96, 31.2 (1914/5674):267–73, and 31.3 (1914/5674): 549–55. (Dr. Hava Shapiro) BA: 227–37

"On Death." *Hashiloaḥ* 32 (1915/5677): 63–69. (Dr. Hava Shapiro)

"Rights and Obligations." *Ha'am* 31 (6 September 1917): 1–2. (Dr. Hava Shapiro)

"Female Types in Mendele's Stories." *Hashiloaḥ* 34 (1918/5678): 92–101. (Dr. Hava Shapiro)

"Y. L. Peretz, the Man and the Author." *Hashiloaḥ* 34 (1918/5678): 347–54 and 501–10. (Dr. Hava Shapiro) BA: 177–88 (partial)

"Feuilleton: Notes from Ukraine." *Ha'olam* 9.6 (21 November 1919/28 Heshvan 5680): 4–5; and 9.7 (28 November 1919/6 Kislev 5680): 4–5. (Eim Kol Hai) BA: 245–55

"You Must Not Forget!" *Ha'olam* 9.10 (19 December 1919/27 Kislev 5680): 2–4. (Eim Kol Hai) BA: 257–64

"Love in the Poems of Tchernichowsky." *Hashiloah* 35 (1919/5679): 151–57. (Dr. Hava Shapiro)

"Arguments." *Ha'olam* 9.25 (2 April 1920/14 Nisan 5680): 2–4. (Dr. Hava Shapiro)

"Meeting of Hapo'el Hatsa'ir and Tse'irei Tsiyyon" (in 3 parts). *Ha'olam* 9.26 (16 April 1920/28 Nisan 5680): 2–7; 9.27 (23 April 1920/5 Iyar 5680): 4–5; and 9.29 (7 May 1920/19 Iyar 5680): 7–8. (Dr. Hava Shapiro)

"Letter from Prague (World Convention of Hapo'el Hatsa'ir and Tse'irei Tsiyyon)" (in 3 parts). *Hatoren* 7.6 (23 April 1920/5 Iyar 5680): 11–13; 7.8 (7 May 1920/19 Iyar 5680): 10–12; and 7.9 (14 May 1920/26 Iyar 5680): 14–16. (Dr. Hava Shapiro) BA: 265–71

"Preparation (Letter from Czechoslovakia)." *Ha'olam* 9.34 (11 June 1920/25 Sivan 5680): 6–8. (Dr. Hava Shapiro)

"Letters from Czechoslovakia." *Ha'olam* 9.38 (9 July 1920/23 Tammuz 5680): 9–10. (H. Sh.)

"Letter from Switzerland." *Ha'olam* 9.50 (15 October 1920/3 Heshvan 5681): 4–5. (E. K. H. [Eim Kol Hai])

"Letters from a Tuberculosis Patient." *Hashiloah* 38 (1920–1921/5681): 122–31. (Eim Kol Hai) BA: 115–29

"Letter from Czechoslovakia." *Hatoren* 7.39 (24 December 1920/13 Tevet 5681): 6–9. (Dr. Hava Shapiro)

"Letter from Prague (Lecture by Dr. Klatzkin)." *Hatoren* 7.49 (4 March 1921/24 Adar I 5681): 9–10. (Dr. Hava Shapiro)

"Notes from the Congress." *Hatoren* 8.5 (7 October 1921/5 Tishri 5682): 38–40. (Dr. Hava Shapiro)

"Theodor Gomperz." *Ha'olam* 11.45 (30 November 1921/26 Heshvan 5682): 822–26. (Dr. Hava Shapiro)

"Martin Buber" (in 2 parts). *Hatoren* 9.2 (1 April 1922/3 Nisan 5682): 45–49; and 9.3 (8 April 1922/10 Nisan 5682): 42–52. (Dr. Hava Shapiro)

"Memories of Frischmann's Life." *Hatoren* 9 (January 1923/Tevet 5683): 84–89. (Dr. Hava Shapiro) BA: 301–11 (partial)

"The Jews of Czechoslovakia." *Ha'olam* 11.6 (21 February 1923/5 Adar I 5683): 128. (H. Sh.)

"Reuven Brainin, On His Intellectual Image." *'Ein hakore* 2–3 (April–September 1923/Nisan–Elul 5683): 74–82. (Dr. Hava Shapiro) BA: 313–24 (partial)

"Young Literature." *Hatoren* 10.4–5 (August 1923/Tammuz-Av 5683): 74–83. (Dr. Hava Shapiro)

"Two Books (Wasserman and Buber)." *Hatoren* 11.2 (April 1924/Nisan 5684): 72–79. (Dr. Hava Shapiro)

"Paganism, Christianity, and Judaism" (review of Max Brod). *Hatoren* 11.8–9 (November–December 1924/Heshvan–Kislev 5684): 47–57. (Dr. Hava Shapiro)

"From Czechoslovakia to Romania (Travel Notes)." *Ha'olam* 12.19 (9 May 1924/5 Iyar 5684): 369–70. (Hava Shapiro)

"Hebrew Education in the Russian Carpathians." *Ha'olam* 12.38 (19 September 1924/20 Elul 5684): 762–63. (Dr. Hava Shapiro)

"Roaming the Lands (Notes and Thoughts)." *Ha'olam* 12.46 (14 November 1924/17 Marheshvan 5685): 926–28. (Hava Shapiro) BA: 273–77

"Hanukkah Days." *Ha'olam* 12.52 (26 December 1924/29 Kislev 5685): 1046–48. (Hava Shapiro) BA: 131–35

"Passover Nights (In Memory of My Mother)." *Ha'olam* 13.14–15 (3 April 1925/9 Nisan 5685): 307–8. (Hava Shapiro) BA: 137–45

"Roaming the Lands (Among the Wanderers)." *Ha'olam* 13.27 (2 July 1925/11 Tammuz 5685): 514–16. (Dr. Hava Shapiro)

"Persons and Events (Notes from the Congress)." *Ha'olam* 13.36 (4 September 1925/15 Elul 5685): 698. (Dr. Hava Shapiro)

"Contemporary Russian Literature." *Hashiloaḥ* 43 (1925/5685): 76–87. (Dr. Hava Shapiro)

"President-Philosopher (Masaryk, President of Czechoslovakia at 75)." *Hashiloaḥ* 44 (5685/1925): 159–67. (Dr. Hava Shapiro)

"In Czechoslovakia." *Ha'olam* 14.2 (8 January 1926/22 Tevet 5686): 35. (Dr. H. Sh.) BA: 279–80

"Reuveni, Prince of the Jews." *Ha'olam* 14.45 (22 January 1926/7 Shevat 5686): 78–79; and 14.5 (29 January 1926/14 Shevat 5686): 99–100. (Dr. Hava Shapiro)

"Letter from Prague." *Ha'olam* 14.7 (12 February 1926/28 Shevat 5686): 133–34. (Dr. Hava Shapiro)

"A Story One Morning (Letter from Prague)." *Ha'olam* 14.18 (23 April 1926/9 Iyar 5686): 333. (H. Sh.)

"Zionism as Mediator Between Jews and Non-Jews (Professor Chajes' Speech for a Large Folk Meeting in Prague)." *Ha'olam* 14.22 (28 May 1926/15 Sivan 5686): 413. (Dr. Hava Shapiro)

"The Way of the Wind (Letter from Prague)." *Ha'olam* 14.23–24 (4 June 1926/22 Sivan 5686): 439–40. (Dr. Hava Shapiro)

"From Carpathian Russia." *Ha'olam* 14.41 (29 September 1926/21 Tishri 5687): 762. (Dr. Hava Shapiro)

"The Burden Carriers (Musings of an Observer)." *Ha'olam* 14.42 (8 October 1926/30 Tishri 5687): 778. (Dr. Hava Shapiro)

"The Land, the State, the Nation." *Ha'olam* 14.44 (22 October 1926/14 Heshvan 5687): 826. (Dr. Hava Shapiro)

"Among the Nations (For the Days of Hanukkah)." *Ha'olam* 14.52 (17 December 1926/12 Tevet 5687): 980. (Dr. Hava Shapiro) BA: 147–49

"Wedgewood and Greenbaum in Prague." *Ha'olam* 15.10 (11 March 1927/7 Adar II 5687): 193–94. (Dr. Hava Shapiro)

"The Erotics of Kabbalah." *Ha'olam* 15.12 (25 March 1927/21 Adar II 5787): 238. (Dr. Hava Shapiro)

"Paul Among the Jews." *Ha'olam* 15.43 (14 October 1927/18 Tishri 5788): 886–88. (Dr. Hava Shapiro) BA: 189–92

"The Romantic Movement Among the Jews and the Nations." *Ha'olam* 15.45 (28 October 1927/2 Heshvan 5688): 866–68; and 15.46 (4 November 1927/9 Heshvan 5688): 886–88. (Dr. Hava Shapiro)

"'Habimah' in Prague." *Ha'olam* 16.12 (23 March 1928/2 Nisan 5688): 234. (Dr. Hava Shapiro) BA: 283–84

"Jacob's Dream." *Ha'olam* 16.13 (30 March 1928/9 Nisan 5688): 242–44. (Dr. Hava Shapiro)

"Paul Among the Jews" (2nd printing). *Hado'ar* 8.21 (23 March 1928/2 Nisan 5688): 330. (Dr. Hava Shapiro)

"Martin Buber and His Work." *Hado'ar* 7.2 (4 June 1928/16 Sivan 5688): 28. (Dr. Hava Shapiro)

"Moses and Aaron: A Communist Interpretation." *Hado'ar* 8.30 (15 June 1928/27 Sivan 5688): 484. (Dr. Hava Shapiro) BA: 193–95

"Types." *Hado'ar* 9.6 (7 December 1928/24 Kislev 5689): 84–85. (Hava Shapiro) BA: 151–53

"On Contemporary Russian Literature." *Hado'ar* 9.10 (4 January 1929/22 Tevet 5689): 162–64. (Dr. Hava Shapiro)

"Tchernichowsky: Poet of Love." *Hado'ar* 9.20 (14 March 1929/2 Adar II 5689): 335. (Dr. Hava Shapiro)

"On Jewish Life in Czechia and Slovakia." *Ha'olam* 17.24 (13 June 1929/5 Sivan 5689): 474. (Dr. Hava Shapiro)

"Conquest of the Communities (Letter from Prague)." *Ha'olam* 17.54 (27 December 1929/25 Kislev 5690): 1056–57. (Dr. Hava Shapiro)

"An Exhibition of Israelite Artists in Prague." *Ha'olam* 18.11 (11 March 1930/11 Adar 5690): 215. (Dr. Hava Shapiro) BA: 285–88

"The Curse of Language." *Ha'olam* 18:11 (11 March 1930/11 Adar 5690): 215. (Dr. Hava Shapiro) BA: 289–90

"In Prague Communities." *Ha'olam* 18.22 (27 May 1930/29 Iyar 5690): 436. (Dr. Hava Shapiro)

"Letter From Prague." *Ha'olam* 18.30 (22 July 1930/27 Tammuz 5690): 593–94. (Dr. Hava Shapiro) BA: 281–82

"Western Judaism in Literature." *Ha'olam* 18.32 (5 August 1930/11 Av 5690): 628. (Dr. Hava Shapiro)

"Letter from Prague." *Ha'olam* 18.43 (21 October 1930/29 Tishri 5691): 855–56. (Dr. Hava Shapiro)

"The Image of Women in Our Literature." *Hatekufah* 26–27 (1930): 617–33. (Dr. Hava Shapiro) BA: 197–221

"On General Literature." *Hado'ar* 10.15 (20 February 1931/3 Adar 5691): 239–40. (Dr. Hava Shapiro)

"The Woman Reader: Where Is She?" *Hado'ar* 10.24 (8 May 1931/21 Iyar 5691): 386–87. (Dr. Hava Shapiro) BA: 223-26

"Moses." *Ha'olam* 19.21 (2 June 1931/17 Sivan 5691): 428. (Dr. Hava Shapiro)

"The Historian of Hasidism of the Heart (To Commemorate Horodetsky)." *Ha'olam* 19.42 (27 October 1931/16 Heshvan 5692): 839–40. (Dr. Hava Shapiro) BA: 291–93

"Surrounding the Congress." *Hado'ar* 12.33 (8 September 1933/17 Elul 5693): 538. (Dr. Hava Shapiro)

"Letter from Czechoslovakia." *Ha'olam* 22.1 (4 January 1934/17 Tevet 5694): 10–11. (Dr. Hava Shapiro)

"On Our Criticism." *Ha'olam* 22.30 (26 July 1934/14 Av 5684): 480. (Dr. Hava Shapiro) BA: 239–41

"Woman In and Out of Our Literature." *Ha'olam* 22.43 (18 October 1934/9 Marḥeshvan 5694): 651. (Dr. Hava Shapiro)

T. G. Masaryk, His Life and Teachings. Prague: Brit Ivrit, 1935. (Dr. Hava Shapiro) BA: 325–40 (partial)

"On the Change of the Presidency in Czechoslovakia." *Hado'ar* 15.12 (17 January 1936/22 Tevet 5696): 187–88. (Dr. Hava Shapiro)

"Habimah and Its Mission (Letter from Prague)." *Hado'ar* 17.17 (4 March 1938/1 Adar II 5698): 268. (Dr. Hava Shapiro)

"Czechoslovakia and the Jews (Letter from Prague)." *Hado'ar* 17.28 (29 April 1938/28 Nisan 5698): 389. (Dr. Hava Shapiro)

"From the Recent Past (On the Historical Writings of Shaul Ginsburg)." *Hado'ar* 17.30 (10 June 1938/11 Sivan 5698): 492. (Dr. Hava Shapiro)

"A Nation Rules Its Spirit (A Letter from Czechoslovakia)." *Hado'ar* 17.31 (17 June 1938/18 Sivan 5698): 502. (Dr. Hava Shapiro)

"PEN Congress in Prague (A Letter from Czechoslovakia)." *Hado'ar* 17.35 (29 July 1938/1 Menaḥem-Av 5698): 570. (Dr. Hava Shapiro) BA: 295–97

YIDDISH WRITINGS

"Froyen-Geshtaltn in Mendeles Verk." *Literarishe Bleter* 52 (27 December 1935): 841–42. (Dr. Hava Shapiro)

GERMAN WRITINGS

"Chanukah-Zage." *Selbstwehr* 19.50 (11 December 1925): 5. (Dr. Eva Shapiro)

"Die Schapfer der neuhebraischen Literatur." *Selbstwehr* 23.7 (15 February 1929): 6. (Eva Schapiro)

"Die Rose" (aus Sifrei ifchah). *Blätter für die jüdische Frau* 3.6 (23 April 1929): 1. (Dr. Eva Schapiro)

"J. L. Gordon: Zu zeiner 100 jarigen Gedenkfeier, 5591–5691." *Selbstwehr* 25.8 (16 January 1930): 3–4. (Dr. Eva Schapiro-Winterniss)

"Sokolow der Hebraer." *Selbstwehr* 25.4 (28 January 1930): 3–4. (Dr. Eva Schapiro-Winterniss)

"Zwei Koeniginnen." *Blätter für die jüdische Frau* 5.3 (27 February 1931): 1. (Dr. Eva Schapiro-Winter -niss)

"Die Dichterin Elisheva." *Selbstwehr* 25.44 (16 October 1931): 8. (Dr. Eva Schapiro-Winterniss)

"Unsere jungste neuhebraische Literatur." *Blätter für die jüdische Frau* 9.3 (7 March 1935): 3. (Dr. Eva Schapiro-Winterniss)

"Saul Tshernikovsky: Zu zeinem 60 Geborstag." *Selbstwehr* 29.58 (20 December 1935): 7. (Dr. Eva Schapiro-Winterniss)

"Abraham Mapu." *Selbstwehr* 31.49 (26 November 1937): 8. (Dr. Eva Schapiro-Winterniss)

PERSONAL PAPERS

Diary (1900–1941) BA: 353–412 (partial)

Letters

 to Micha Yosef Berdichevsky BA: illustration

 to Reuven Brainin BA: 415–81 (partial)

 to Mordecai ben Hillel Hacohen

 to Yitzhak Lamdan

 to Mordecai Lipson

 to Daniel Persky BA: 485–88

 to Menahem Ribalow

 to Editors of *Gilyonot*

BIBLIOGRAPHY

ARCHIVAL SOURCES

Genazim Institute, Tel Aviv.

Hava Shapiro, Diary (1900–1941), Folder 48058.
Hava Shapiro, Letters, Folders 18, 21, 69, 127, 196, and 253.

Hebrew University, Jerusalem

Reuven Brainin, Diary, File P8/14, Central Archives for the History of the Jewish People.

Jewish Public Library Archives, Montreal

Hava Shapiro and Menuhah Shapiro, Letters to Reuven Brainin, Correspondence III, Box t.
Additional Letters to Reuven Brainin, Correspondence III, Boxes k, r, and y.

National Archives of the Czech Republic, Prague

Files of Eva Shapiro-Winternitz, Fond PŘ 11-EO and Fond PŘ 1941-51, Central Office of the Prague Police.
Files of Josef Winternitz, Fond PŘ 1931-40, Central Office of the Prague Police.
Eva Winternitz and Josef Winternitz, Deportation Card Index, Vol. II, OVS/KTOVS.

Terezin Digital Resource Center Database of Victims

Card for Eva Winternitzora.
Card for Josef Winternitz.

WORKS CITED

Adler, Eliyana R. *In Her Hands: The Education of Jewish Girls in Tsarist Russia.* Detroit: Wayne State University Press, 2011.
Alter, Robert. *The Invention of Hebrew Prose.* Seattle: University of Washington Press, 1988.
Anctil, Pierre, ed. *Through the Eyes of the Eagle: The Early Montreal Yiddish Press 1907-1916.* Montreal: Véhicule Press (Dossier Québec Series), 2001.
Assaf, David. 2010. "Shapira Family." In *The YIVO Encyclopedia of Jews in Eastern Europe.* http://www.yivoencyclopedia.org/article.aspx/Shapira_Havah (accessed 25 June 2013).
Baader, Benjamin Maria. *Gender, Judaism, and Bourgeois Culture in Germany, 1800–1870.* Indianapolis: Indiana University Press, 2006.

Babel, Isaac. *Collected Stories of Isaac Babel*, Nathalie Babel (ed.). New York: Norton, 2002.

Balin, Carole B. "The Call to Serve: Jewish Women Medical Students in Russia, 1872–1887." In ChaeRan Freeze, Paula Hyman, and Antony Polonsky (eds.), *Jewish Women in Eastern Europe*, 133–52. Oxford: Littman, 2005.

———. "Havah Shapiro." In Paula Hyman and Dalia Ofer (eds.), *Jewish Women: A Comprehensive Historical Encyclopedia* (CD-ROM). Paula Hyman and Dalia Ofer. Jerusalem: Shalvi, 2007.

———. *To Reveal Our Hearts: Jewish Women Writers in Tsarist Russia*. Cincinnati: Hebrew Union College Press, 2000.

Balin, Carole, and Wendy Zierler. *Behikansi 'atah* [In My Entering Now: Selected Works of Hava Shapiro]. Tel Aviv: Resling, 2008.

Baron, Devorah. *Parshiyot mukdamot*, Nurit Govrin (ed.). Jerusalem: Mosad Bialik, 1988.

Bar-Yosef, Hamutal. *Hareshimah kegener shel ma'avar merealism lesymbolism besifrut ha'ivrit*. Tel Aviv: Katz Institute for Hebrew Literature Research, Tel-Aviv University, 1989.

Bashkirtseva, Mariia. *The Journal of Marie Bashkirtseff*, Mathilde Blind (ed.). London: Cassell, 1985.

Ben Avigdor [Abraham Leib Shalkovich]. "Leah mokheret dagim" (with "El ḥovevei sefar 'ever vesifrutah" [To the Lovers of Hebrew and Its Literature]). In Menuhah Gilboa (ed.), *Sippurim* [Stories]. Tel Aviv: David Rekhgold, 1980.

Ben Dov, Nitza. *Ḥayim ketuvim: 'al autobiografiyut sifruti yisra'elit*. Tel Aviv: Schocken, 2011.

Berdichevsky, Micha Yosef. *Pirkei yoman 1908-1921* [Chapters of a Diary], Avner Holtzman (ed.), 7: 128–35. Tel Aviv, 1997.

Berlovitz, Yaffah. "Elisheva Bichovsky, 1888–1949." http://jwa.org/encyclopedia/article/elisheva-bichovsky (accessed 25 June 2013).

———. "Prose Writing in the Yishuv: 1882–1948." http://jwa.org/encyclopedia/article/prose-writing-in-yishuv-1882-1948 (accessed 13 February 2014).

Bialik, H. N., and Y. H. Ravnitzky (eds.). *Sefer ha'aggadah*. Odessa: Moriah, 1908–1911.

Bichovsky, Elisheva. *Meshorer ve'adam: Al shirato shel Aleksander Blok* [Poet and Man: On the Poetry of Aleksander Blok]. Tel Aviv: Tomer, 1928.

Bloch, Simhah. "Dr. Hava Shapiro." *Hado'ar* 31.3 (16 November 1951/17 Marḥeshvan 5712): 57–58.

Blodgett, Harriet (ed.). *Capacious Hold-All: An Anthology of Englishwomen's Diary Writings*. Charlottesville: University Press of Virginia, 1991.

Brainin, Reuven. *Ketavim nivḥarim*. New York: Assaf, 1917.

Bruce, Iris. *Kafka and Cultural Zionism*. Madison: University of Wisconsin Press, 2007.

Čapková, Kateřina. *Češi, Němci, Židé? Národní identita Židů v Čechách, 1918-1938*. Prague: Paseka, 2005.

Carmi, T. *The Penguin Book of Hebrew Verse*. New York: Viking, 1981.

Caro, Barukh (ed.). *Kovets letoldot hasifrut ha'ivrit bedorot haaḥronim*. Tel Aviv: Genazim Institute, 1964.

Caruso, Naomi. "Chava Shapiro: A Woman Before Her Time." Master's thesis, McGill University, 1991.

———. "Mi hi Hava Shapiro?" [Who Is Hava Shapiro?]. *Yedi'ot 'aḥronot* (29 August 1986/27 Menaḥem-Av 5746): 20.

———. *Reuven Brainin: The Fall of An Icon*. Montreal: Canadian Jewish Congress, 2007.

———. "Reuven Brainin and the JPL Archives." *Prologue: Jewish Public Library Archives Magazine* 1.3 (October 2007): 1–3.

———. "A Shtetl Feminist: Sources in the Archives of the Jewish Public Library in Montreal." *Judaica Librarianship* 3.1-2 (1986–1987): 31–32.

Chagall, Bella. *Burning Lights*. New York: Schocken, 1946.

Clyman, Toby W. "Women Physicians' Autobiography in the Nineteenth Century." In Toby W. Clyman and Diana Greene (eds.), *Women Writers in Russian Literature*, 111–26. Westport, CT: Greenwood Press, 1994.

Cohen, Israel, ed., "Havah Shapiro." *Yedi'ot genazim: Sofrim 'ivriyim shenispu basho'ah* 81 (April 1973): 738–43.

Cohen, Michal Fram. "Separation Along Gender Lines: The Education of Sarah Feiga and Joshua Ber Meinkin." *Hebrew Higher Education* 5 (2013): 171–81.

Cohen, Tova. "The Maskilot: Feminine or Feminist Writing?" In ChaeRan Freeze, Paula Hyman, and Antony Polonsky (eds.), *Jewish Women in Eastern Europe*, 65–66. Oxford: Littman, 2005.

Cohen, Tova, and Shmuel Feiner (eds.). *Kol 'almah 'ivriyah: kitve nashim maskilot bame'ah hatesha'-'esreh* [The Voice of the Hebrew Maiden: Writings of Enlightened Women of the Nineteenth Century]. Tel Aviv: Hakibbutz Hameuchad, 2006.

Corrsin, Stephen D. *Warsaw Before the First World War: Poles and Jews in the Third City of the Russian Empire, 1880–1914.* Boulder, CO: East European Monographs, 1989.

Dubnov, Simon. *Toldot haḥasidut.* Tel Aviv: Dvir, 1967.

Elon, Amos. *The Pity of It All: A Portrait of the German-Jewish Epoch, 1743–1933.* New York: Picador, 2003.

Etkes, Immanuel. *Lita biyerushalayim.* Jerusalem: Yad Yitshak Ben-Tsevi, 1991.

Feiner, Shmuel. "Ha'ishah hayehudiyah hamodernit: mikra mivḥan beyaḥasei hahaskalah vehamodernah." *Zion* 58 (1993): 453–99.

Fischer, Gayle V. "'Pantalets' and 'Turkish Trousers': Designing Freedom in Mid-Nineteenth Century United States." *Feminist Studies* 23.1 (1997): 110–40.

Fogel, Yisrael. "Hava Shapiro hi 'eim kol ḥai'" [Hava Shapiro Is the "Mother of All Living"]. *Davar* (19 September 1986): 28.

Foner, Sarah Feige. "Mizikhronot yemei ne'urai" [Memories from My Youth]. *Shaḥarut* 4.6 (September 1919): 91–110.

Friedberg, Baruch [Hayim Dov]. *Toledot hadefus ha'ivri bepolaniyah* [History of Hebrew Publishing in Poland]. Tel Aviv: Impr. Gutenberg, 1950.

Friedenreich, Harriet. *Female, Jewish, and Educated: The Lives of Central European University Women.* Bloomington: Indiana University Press, 2002.

Frischmann, David. *Ba'arets.* Warsaw/Berlin: Achisefer, 1913.

———. "Hayada'ta et ha'arets? Reshimot masa' be'Eretz Yisrael" [Do You Know the Land? Notes of a Journey in the Land of Israel], pt. 5. *Hatsefirah* (9 June 1911).

———. *Kol kitvei David Frischmann* [Writings of David Frischmann]. Warsaw and New York: Lily Frischman Publishers, 1930.

Gilbert, Sandra L., and Susan M. Gubar. *The Madwoman in the Attic.* New Haven, CT: Yale University Press, 1977.

Gilman, Sander. *Franz Kafka: The Jewish Patient.* New York: Routledge, 1995.

Ginsburg, Saul [Shaul] Moiseyevich. *The Drama of Slavuta*, Ephraim H. Prombaum (trans.). Lanham, MD: University Press of America, 1991.

Gnessin, Uri Nisan. *Kol kitvei Uri Nisan Gnessin*, Dan Miron and Israel Zmora (eds.). Tel Aviv: Hakibbutz Hameuchad, 1982.

Gordon, Y. L. *Kol shirei Yehudah Leib Gordon: yeshanim gam ḥadashim* [Complete Poems]. St. Petersburg: Pines & Zederbaum, 1884. Reprint: *Kitve Yehudah Leib Gordon: Shirah* (Tel Aviv: Dvir, 1953).

Greene, Diana. "Gender and Genre in Pavlova's *A Double Life.*" *Slavic Review* 54.3 (1995): 563–77.

Haberman, Jacob. "Ludwig Stein: Rabbi, Professor, Publicist, and Philosopher of Evolutionary Optimism." *Jewish Quarterly Review* 86.1/2 (July–October 1995): 91–125.

Halevi, Yehudah. "Heart at Sea." In Yehudah Halevi, *The Dream of the Poet*, Peter Cole (trans.), 165–67. Princeton, NJ: Princeton University Press, 2007.

Harari, Yehudit. "Dr. Hava Shapiro (Eim kol ḥai)." In *Ishah v'eim beyisrael mitekufat hatanakh ad shenat he'asor limedinat yisrael* [Woman and Mother in Israel from the Biblical Period to the Decade of Israel's Founding], 189. Tel Aviv: Masadah, 1959.

Harif, L. "Dr. Hava Shapiro (*Eim kol hai*)." *Ha'olam* 22.11 (15 March 1934/28 Adar I 5694): 175–76.

Hauptman, Judith. *Rereading the Rabbis*. Boulder, CO: Westview Press, 1998.

Heschel, Abraham Joshua. *The Circle of the Ba'al Shem Tov*, Samuel H. Dresner (ed.). Chicago: University of Chicago Press, 1985.

Holtzman, Avner. 2010. "Shapira, Ḥavah." In *The YIVO Encyclopedia of Jews in Eastern Europe*. www.yivoencyclopedia.org/article.aspx/Shapira_Havah. (accessed 25 June 2013).

Hyman, Paula. *Gender and Assimilation in Modern Jewish History*. Seattle: University of Washington Press, 1995.

Jelen, Sheila E. *Intimations of Difference: Dvora Baron in the Modern Hebrew Renaissance*. Syracuse, NY: Syracuse University Press, 2007.

Johanson, Christine. *Women's Struggle for Higher Education in Russia, 1855-1900*. Kingston, Canada: McGill-Queen's University Press, 1987.

Kaplan, Marion. *The Making of the Jewish Middle Class*. New York: Oxford University Press, 1991.

Kelly, Catriona. *A History of Russian Women's Writing, 1820-1992*. New York: Clarendon, 1994.

Kieval, Hillel. *Languages of Community: The Jewish Experience in the Czech Lands*. Berkeley: University of California Press, 2000.

Klausner, Yosef. "Al 'bat hayeḥidah'" [About the Only Daughter]. *Hado'ar* (16 December 1938/23 Kislev 5699): 107.

Kleinman, Abby R. "Women in the Age of Light." In Renate Bridenthal and Claudia Koonz (eds.), *Becoming Visible: Women in European History*, 219–35. Boston: Houghton Mifflin, 1977.

Kovalchuk, Stanislav, and Artur Friedman. *Sholom, Slavutchani* [Goodbye Slavuta]. Self-published, 2001.

Kozachkov, E. Z. *Evreiskaia Zhenshchina v Literatur, Nauke i Iskusstve* [Jewish Women in Literature, Science, and Art]. Nikapol, 1917.

Kressel, Getzel. *Leksikon hasifrut ha'ivrit badorot ha'aḥronim*, s.v. "Hava Shapiro," 2: 968. Merhaviah: Sifriyat Polin, 1967.

Levinson, Avraham. *Hatenu'ah ha'ivrit bagolah* [The Hebrew Movement in the Diaspora]. Warsaw: 1935.

Lilienblum, Moses Leib. *Ketavim autobiografi'im*, ed. Shlomo Breiman, 3 vols. Jerusalem: Mosad Bialik, 1970. Originally published as *Ḥatot ne'urim* (Vienna: C. Breg, 1876).

Liljestrom, Marianne. *Models of Self: Russian Women's Autobiographical Text*. Helsinki: Kikoma, 2000.

Magnus, Shulamit. "Kol Ishah: Women and Pauline Wengeroff's Writing of an Age." *Nashim* 7 (2004): 28–64.

———. "Sins of Youth, Guilt of a Grandmother: M. L. Lilienblum, Pauline Wengeroff, and the Telling of Jewish Modernity in Eastern Europe." In ChaeRan Freeze, Paula Hyman, and Antony Polonsky (eds.), *Jewish Women in Eastern Europe*, 87–120. Oxford: Littman, 2005.

Mahshoves, Ba'al. "Hatekufah ha'aḥronah besifruteinu" [The Last Era in Our Literature], pt. 3. *Ha'olam* 7.7 (1913): 5.

Marcus, Jane. "Invincible Mediocrity: The Private Selves of Public Women." In Shari Benstock (ed.), *The Private Self: Theory and Practice of Women's Autobiographical Writings*, 114–46. Chapel Hill: University of North Carolina Press, 1987.

Marsh, Rosalind. "Realist Prose Writers, 1881-1929." In Adele Marie Barker and Jehanne M. Gheith (eds.), *A History of Women's Writing in Russia*, 175–206. Cambridge, UK: Cambridge University Press, 2002.

Mendelsohn, Ezra. *The Jews of East Central Europe Between the World Wars*. Indianapolis: Indiana University Press, 1987.

Mill, John Stuart. "The Subjection of Women." In Miriam Schneir (ed.), *Feminism: The Essential Historical Writings*, 162–78. New York: Vintage, 1971.

Miron, Dan. *Imahot meyasdot, aḥayot ḥorgot*. Tel Aviv: Hakibbutz Hameuchad, 1991.

Montefiore, Lady Judith Cohen. *Private Journal of a Visit to Egypt and Palestine*. Jerusalem: Yad Yitzchak Ben Tzvi, 1975.

Moseley, Marcus. *Being for Myself Alone: Origins of Jewish Autobiography*. Stanford, CA: Stanford University Press, 2006.

Nash, Stanley. "The Anti-Ahad Ha'am." *Hebrew Studies* 23 (1982): 239–48.

——. "The Hebraists of Berne and Berlin Circa 1905." In Glenda Abramson and Tudor Parfitt (eds.), *The Great Transition: The Recovery of the Lost Centers of Modern Hebrew Literature*, 44–58. Totowa, NJ: Rowman & Allanheld, 1985.

——. "Kotso shel yod" [The Tip of the Yod]. *CCAR Journal* 53.3 (2006): 107–88.

——. "Reuven Brainin." In *The YIVO Encyclopedia of Jews in Eastern Europe*. New York: YIVO Institute for Jewish Research, 2010. http://www.yivoencyclopedia.org/article.aspx/Brainin_Reuven (accessed 25 June 2013).

Nussbaum, Felicity A. "Eighteenth-Century Women's Autobiographical Commonplaces." In Shari Benstock (ed.), *The Private Self: Theory and Practice of Women's Autobiographical Writings*, 147–71. Chapel Hill: University of North Carolina Press, 1988.

Ortner, Sherry B. "Is Female to Male as Nature Is to Culture?" In M. Z. Rosaldo and L. Lamphere (eds.), *Woman, Culture, and Society*, 68–87. Stanford, CA: Stanford University Press, 1974.

Parush, Iris. *Nashim kor'ot: yitronah shel shuliyut* [Reading Women: The Benefit of Marginality]. Tel Aviv: Am Oved, 2001.

——. *Reading Jewish Women: Marginality and Modernization in Nineteenth-Century Eastern European Jewish Society*. Waltham, MA: Brandeis University Press, 2004. (English translation of *Nashim kor'ot*.)

Pukhachewsky, Nehamah. "Mishut ba'arets." *Ha'olam* 30 (25 September 1908): 496–98; and 40 (5 October 1908): 516–19.

Raider, Mark A., and Miriam B. Raider-Roth (eds.). *The Plough Woman: Records of the Pioneer Women of Palestine--A Critical Edition*. Waltham, MA: Brandeis University Press, 2002.

Rainer, Tristine. *The New Diary*. Los Angeles: Tarcher, 1978.

Rakovsky, Puah. *My Life as a Radical Jewish Woman: Memoirs of a Zionist Feminist in Poland*, Paula Hyman (ed.), Barbara Harshav (trans.). Bloomington: Indiana University Press, 2002.

——. *Zikhroynes fun a yidisher revolutsionerin*. Buenos Aires: Tsentral Farband fun Poylishe Yidn in Argentine, 1951. Translated into Hebrew as *Lo nikhnati* (Tel Aviv, 1951).

Reinharz, Jehuda, and Paul Mendes-Flohr (eds.). *The Jew in the Modern World: A Documentary History*. Oxford, UK: Oxford University Press, 2010.

Reisen, Zalman. *Leksikon fun der yiddisher literatur, presse un fililogia*, s.v. "Hava Shapiro," 4: 455–56. Vilna, 1928.

Rosenholm, Arja. "*Chuzhaia domu i zvezdam*: Female Stranger in the Diaries of Elena Andreevna Shtakenshneider." In Marianne Liljestrom et. al. (eds.), *Models of Self: Russian Women's Autobiographical Texts*, 119–40. Helsinki: Kikimora, 2000.

Rosenthal, Charlotte. "Achievement and Obscurity: Women's Prose in the Silver Age." In Toby W. Clyman and Diana Greene (eds.), *Women Writers in Russian Literature*, 149–70. Westport, CT: Greenwood, 1994.

Ross-Nazzal, James. "Jaffa and Jerusalem: The Ideal of Palestine Is the Reality." In "'Traveling with the Ladies': American Women's Travel Accounts of Palestine in the Nineteenth Century," ch. 7. Ph.D. diss., History Department, Washington State University, 2000.

Sadan, Dan. *Bein din leheshbon*. Tel Aviv: Dvir, 1963.

Schriber, Mary Suzanne. *Writing Home: American Women Abroad, 1830-1920*. Charlottesville: University of Virginia Press, 1997.

Seidman, Naomi. *A Marriage Made in Heaven.* Berkeley: University of California Press, 1997.

Shaked, Gershon. *Hasipporet ha'ivrit* [Hebrew Fiction], v. 1. Israel: Hakibbutz Hameuchad and Keter, 1978.

——. *The Shadows Within.* Philadelphia: Jewish Publication Society, 1987.

Shazar, Rachel Katzenelson. *Adam kemo shehu: pirkei yomanim ureshimot.* Tel Aviv: Am Oved, 1986.

Shofman, Gershon (ed.). *Peret: sippurim veshirim.* Vienna: A. Y. Shtibel, 1924.

Shur, Natan. *The Book of Travelers to the Holy Land: The Nineteenth Century.* Jerusalem: Keter, 1988.

Slutsky, Yehuda. "Slavuta." In *Encyclopaedia Judaica,* 2nd ed. (2006), 18: 672–73.

Smolenskin, Peretz. *Kol sifrei Peretz ben Moshe Smolenskin,* Reuven Brainin (ed.), 6 vols. Vilna: M. Katzenelenbogen, 1905. https://archive.org/details/kolsifreperetsbe06smoluoft (accessed 7 February 2014).

Stampfer, Shaul. "Gender Differentiation and Education of the Jewish Woman in Nineteenth-Century Eastern Europe." In Antony Polonsky (ed.), *From Shtetl to Socialism: Studies from Polin,* 187–211. London: Littman Library of Jewish Civilization, 1993.

Stanislawski, Michael. *Autobiographical Jews: Essays in Jewish Self-Fashioning.* Seattle: University of Washington Press, 2004.

Stanton, Domna C. "Autogynography: Is the Subject Different?" In Domna C. Stanton (ed.), *The Female Autograph: The Theory and Practice of Autobiography from the Tenth to Twentieth Centuries,* 3–20. Chicago: University of Chicago Press, 1984.

Ungerfeld, Moshe. "Dr Hava Shapiro (Esrim veḥamesh shanim lehirtsaḥah)" [Twenty-Five Years Since Her Murder]. *Hapo'el Hatsa'ir* 39.25 (26 Adar/26 March 1968): 20.

Weissler, Chava. "Prayers in Yiddish and the Religious World of Ashkenazi Women." In Judith R. Baskin (ed.), *Jewish Women in Historical Perspective,* 159–81. Detroit: Wayne State University Press, 1991.

Wengeroff, Pauline. *Memoiren einer Grossmutter: Bilder aus der Kulturgeschichte der Juden Russlands im 19 Jahrhundert* [Memoirs of a Grandmother: Scenes from the Cultural History of the Jews of Russia in the Nineteenth Century], 2 vols. Vol. 1, Berlin: M. Poppelauer, 1908; reprinted with Vol. 2 in 1910 and subsequently in 1913, 1919, 1922.

——. *Memoirs of a Grandmother: Scenes from the Cultural History of the Jews of Russia in the Nineteenth Century,* v. 1, Shulamit S. Magnus (trans.). Stanford, CA: Stanford University Press, 2010.

——. *Rememberings: The World of a Russian-Jewish Woman in the Nineteenth Century,* Bernard Cooperman (ed.), and Henny Wenkart (trans.). College Park: University Press of Maryland, 2000.

Werses, Shmuel (ed.). *Yedidot shel hameshorer: iggerot Miriam Markel Mosessohn el Yehudah Leib Gordon.* Jerusalem: Mosad Bialik, 2004.

Wood, Ann Douglas. "'The Fashionable Diseases': Women's Complaints and Their Treatment in Nineteenth-Century America." *Journal of Interdisciplinary History* 4.1 (1970): 25–52.

Woolf, Virginia. *A Writer's Diary,* Leonard Woolf (ed.). New York and London: Houghton Mifflin, Harcourt, 1954.

Yaari, Avraham (ed.). *Tseror iggerot Yalag el Miriam Markel Mosessohn.* Jerusalem: Mosad Bialik, 1936.

The YIVO Encyclopedia of Jews in Eastern Europe, 2 vols., Gershon David Hundert (ed. in Chief). New Haven, CT: Yale University Press, 2008, in cooperation with the YIVO Institute for Jewish Research. www.yivoencyclopedia.org/.

Yoktan, Rachel. "Ḥavah Shapira ('Eim Kol Ḥai'): Min hasofrot hari'shonot shel hasifrut ha'ivrit hahadashah." Masters thesis, Tel Aviv University, 1999.

——. "Zarkor al demut ne'elmah: Hava Shapiro--Eim Kol Hai" [Spotlight on a Forgotten Figure: Hava Shapiro—Mother of All Living]. *Kesher* 28 (November 2000): 21–27.

Zadoff, Mirjam. *Next Year in Marienbad: The Lost Worlds of Jewish Spa Culture,* William Templer (trans.). Philadelphia: University of Pennsylvania Press, 2012.

———. "Travelling Writers: The Creation of Eastern Jewish Hideaways in the West." *Leo Baeck Institute Yearbook* 56 (2011): 79–104.

Zederbaum, Aleksander. *Keter kehunah* [Crown of Priesthood], 139–41. Odessa: Zederbaum & Nitche, 1866.

Zierler, Wendy. *And Rachel Stole the Idols: The Emergence of Modern Hebrew Women's Writing*. Detroit: Wayne State University Press, 2004.

———. "Hava Shapiro: A Modern Literary Response to Eshet Hayil." *Shema Bekolah: Hear Her Voice* (2009): 18–19.

———. "Hava Shapiro's Letters to Reuven Brainin." *Nashim* 16.2 (2008): 67–97.

———. "In Those Days and in Ours: The Eight Days of Hanukkah with Hava Shapiro (1878–1943)." *Shema Bekolah: Hear Her Voice* (2011/5772): 1–3.

———. "My Own Special Corner, Sacred Beloved: The Hebrew Diary of Hava Shapiro (1878–1943)." *Hebrew Studies* 53.1 (2012): 231–55.

———. "Yoman/Roman: The Literary Diaries of Hava Shapiro and David Fogel." *Hador* 4 (2010): 58–69.

Zirin, Mary F. "'A Particle of Our Soul': Prerevolutionary Autobiography by Russian Women Writers." In Adele Marie Barker and Jehanne M. Gheith (eds.), *A History of Women's Writing in Russia*, 100–116. Cambridge, UK: Cambridge University Press, 2002.

———. "Women's Prose Fiction in the Age of Realism." In Toby Clyman and Diana Greene (eds.), *Women Writers in Russian Literature*, 77–94. Westport, CT: Praeger, 1994.

INDEX

Note: Bold locators reference images and photographs in the text.